"After decades on the Yucatán Peninsula, Everton brings us not the mysterious Maya of *National Geographic*, but, rather, a unique, honest, and moving portrait of ordinary Maya people struggling with the choices and stark changes modern times have forced upon their lives. This is a stunningly beautiful and informative work every bit the equal of Walker Evans and James Agee's much-heralded classic of the American South, *Let Us Now Praise Famous Men*. When it comes to the Maya, there's no other book like this, nor will there likely ever be another."

Paul Sullivan, author *Unfinished Conversations* and *Xuxub Must Die*

"Macduff Everton's *The Modern Maya* is a rare find. It is a scholarly monograph that is artful, a portrait of a people and culture in transition that is nuanced, honest, and at the same time conceptually rigorous, and clearly a labor of love that can remind anthropology of the heart behind the discipline. As Everton's title implies, this is not only a book about the past, and decades of relationship and research; it is also a work firmly rooted in the present, an apt illustration of the many ways one can be modern. Everton's photographs are luminous, and this is no less true here, but the gems in this book are the stories—the ways Everton's interlocutors live out, and live through, large-scale political, economic, and social transitions with clarity and grace."

Sienna Craig, Department of Anthropology, Dartmouth College, and author of *Horses Like Lightning: A Story of Passage Through the Himalayas*

"The Modern Maya are a people engulfed in the present, but rooted in the past. For too long that past has been suppressed. But a new cycle is beginning, and there is hope and optimism for the future. Macduff captures both ends of this process in a story based on long-term relationships, shared dreams, and connections to place and the land. This is an amazing agro-ecological history of the Maya."

Stephen R. Gliessman, Ruth and Alfred Heller Professor Emeritus of Agroecology, University of California, Santa Cruz, and author of *Agroecology: The Ecology of Sustainable Food Systems* and *The Conversion to Sustainable Agriculture: Principles, Processes, and Practices*

"Macduff Everton is that rare combination of gifted photographer *and* fine writer. This beautiful book should be of broad interest to both scholars and the general public."

Jeremy A. Sabloff, archaeologist, President of the Santa Fe Institute, and author of *The Cities of Ancient Mexico: Reconstructing a Lost World* and *The New Archaeology and the Ancient Maya*

"After a half millennia of colonization and its attendant horrors, perhaps the only true and lasting gift the white man, the European, the Hispanic, had left to offer the indigenous peoples of the Americas arrived rather belatedly, by default really, yet all the more precious perhaps because of that fact: the gift of preservation and remembrance, a promise in the hearts of that other tribe—anthropologists, archeologists, ethnographers, documentarians, filmmakers, writers, and photographers—who have dedicated their lives to the proposition that the trampled and defeated civilizations of the New World shall be neither lost nor forgotten, even as the twenty-first century threatens to assimilate their traditions and living remnants into a homogenized global mainstream. Macduff Everton's *The Modern Maya*, forty years in the making, is such a gift, not just to the people of Yucatán, but to anyone with a love for the individual story, the mesmerizing image, the nexus where the ordinary, as Macduff writes, becomes extraordinary and magical."

Bob Shacochis, National Book Award–winning author of *The Immaculate Invasion* and *Kingdoms in the Air*

"In addition to its wonderful photography, what makes *The Modern Maya* stand out is the time Macduff Everton has spent, and spent so well, among the people of time. Over more than forty years, he has befriended the Maya and they him, resulting in a deep, sensitive, and collaborative study of both individual lives and the life of one of the world's oldest, greatest, and most resilient civilizations. This book is essential for all who are curious about the Maya—and for anyone who wishes to understand the upheavals faced by traditional peoples everywhere in our unsteady world."

Ronald Wright, author of *Time Among the Maya*

"Macduff Everton's photographs are some of the most haunting and beautiful documents of Maya life—ancient and modern—I have seen. They provide viewpoints that are uniquely his own, and with artistry and sensitivity, they open up for us, the Western world, a window in the experiences of another people."

Linda Schele, coauthor of *The Blood of Kings*, *A Forest of Kings*, *Maya Cosmos*, and *The Code of Kings*

"I have been working with my faculty to find sources of literature regarding the Maya for our intercultural curricula. The ancient Maya and the Caste War period (1847–1911) are well documented and frequently updated, but books on the adaptation of the Maya to modern life over a significant period are rare. *The Modern Maya* is perhaps the only one, and it helps us to understand the processes of adaptation and a parallel process: the development and future of interculturality with a Maya context. I highly recommend this book for scholars and anyone interested in the Maya as well as the interaction between cultures."

Francisco Rosado May, Rector, Universidad Intercultural Maya de Quintana Roo

"Macduff Everton's portraits of Yucatecan people and their lives over forty years show Maya people as still successful, still having a conscious sense of balance, and still with a serenity in their gaze that belies the Yucatán's hot scrub and rainforest environs. Each of these photos demands reflection, because in each is a slice of what makes Yucatán and the people living there a model for us all. A Mayan phrase of leave-taking sums up Everton's photography, *"xicech yeteutz"*—"you go with beauty.""

Allan F. Burns, duPont-Magid Professor of Anthropology and Chair of the Department of Anthropology at the University of Florida, and author of *An Epoch of Miracles: Oral Literature of the Yucatec Maya* and *Maya in Exile: Guatemalans in Florida*

"Forty years is a lifetime—that's what you will encounter in Macduff Everton's new volume—a visual history of the living Maya on the Yucatán Peninsula—working, marrying, celebrating religious festivals—people you will get to know, while watching them grow, through Macduff's sensitive eye. He captures the sorrows and joys of Maya life—he shares with his reader his friendship and admiration over the many years of recording his visits. What a worthy way to spend forty years."

Justin Kerr, photographer and Mayanist

"Macduff Everton chose a felicitous title for his book, *The Modern Maya*, for despite the large number of tourists who visit Yucatán, a surprising number of the general public believe that the Maya have been extinct for hundreds of years. Macduff's forte is his presentation of panoramic photograph, portraiture, ethnographic detail, and fluid description, requiring the reader to look and to listen. Witnessing the extreme deforestation of Yucatán by outsiders, we are surprised to learn that these Mayas consider themselves to be forest people who lament the destruction of their environment. Jumping from the Mayan past to the forty years of Macduff's life among present-day Mayas, we are provided with an intimate view of their aspirations, their hopes, and their dreams."

Robert Laughlin, Curator Emeritus, Mesoamerica Ethnology, Smithsonian Institution

The Modern Maya

THE WILLIAM & BETTYE NOWLIN SERIES
in Art, History, and Culture of the Western Hemisphere

The Modern Maya

Incidents of Travel and Friendship in Yucatán

MACDUFF EVERTON

With contributions, investigations, and explorations conducted for
nearly forty years by Charles Demangeat and Hilario Hiler

UNIVERSITY OF TEXAS PRESS, AUSTIN

Requests for permission to reproduce material from this work
should be sent to:

Permissions

University of Texas Press

P.O. Box 7819

Austin, TX 78713–7819

www.utexas.edu/utpress/about/bpermission.html

∞ The paper used in this book meets the minimum requirements
of ANSI/NISO Z39.48-1992 (R1997) (Permanence of Paper).

Library of Congress Cataloging-in-Publication Data

Everton, Macduff.

The modern Maya : incidents of travel and friendship in Yucatan
/ by Macduff Everton ; with contributions, investigations, and
explorations conducted for nearly forty years by Charles Demangeat
and Hilario Hiler.

p. cm. — (The William and Bettye Nowlin series in art, history,
and culture of the western hemisphere)

Includes bibliographical references.

ISBN 978-0-292-72693-2 (cl. : alk. paper)

1. Mayas. 2. Mayas—Social conditions. 3. Mayas—Pictorial works.

I. Demangeat, Charles. II. Hiler, Hilario. III. Title.

F1435.E894 2012

972.81—dc23 2011033521

Contents

Foreword: Macduff Everton's Yucatán

CARTER WILSON

Yucatec Maya people have a reputation for hospitality to visitors, first noted by a European in Diego de Landa's account of their culture in the 1560s. Though close to five centuries of rule by the *dzul'ob* (whites) might have made the Maya more cautious, their kindness to strangers continues to the present. In *Maya for Travelers*, linguist Gary Bevington tells outsiders who are visiting Yucatán villages to expect to be asked soon after they arrive, "When are you leaving?" But don't worry, says Bevington, the next question is likely to be "When are you coming back?"

Macduff Everton became a beneficiary of the hospitality of the Maya and their pride in their way of life forty years ago. He gained people's trust by coming back again and again, by raising funds in the United States for his friends when hurricanes wiped out their resources, by lending a sick man in a chiclero camp the money to get across the peninsula to Mérida for treatment. Soft-spoken, hard-working, inquisitive without being intrusive, respectful, never averse to laughter or fun, Macduff had personal qualities that the Maya could admire. In time, they began to call on him for the use of his craft. He was asked to photograph weddings and people laid out for burial, because the family had no picture of the deceased (a function of itinerant photographers in North America in the nineteenth century). He was right to put "friendship" in the title of his book.

What you can tell about the relationship between photographer and subject in a portrait remains difficult to figure. The face is so mobile, expressing apparently contrary feelings in rapid succession; the camera itself is so quick to record; the odd moment is so easy to misinterpret. The issue becomes especially important where the cultural distance between subject and photographer is really a chasm. James Agee asserts that you can *see* the faith Alabama sharecroppers have in his collaborator Walker Evans in Evans's pictures of them. I think that you can also see the trust in Macduff's good intentions in the people in his Yucatán portraits. So many of them confront the camera unguardedly, confidently—their faces and their body language speak to the success of his effort to bridge the differences between them and him.

Among Macduff's advantages at the outset was the adaptability of youth. The corn tortilla, greens, beans, and fruit Maya diet with occasional meat appealed to him. In his account of a season spent with chicle gatherers, Macduff hardly pays attention to the physical hardship of living in a steaming, claustrophobic jungle infested with poisonous insects and snakes.

But even from the start Macduff was never rudderless—although barely twenty, he had already developed skills and purpose as a photographer and possessed (or did he acquire?) the kind of innocence that those seeking to understand people unlike themselves need. One of the anthropologists I trained with called this (lugubriously but rightly) "putting yourself in a state of unknowing." Unknowing is a liminal condition, being at the threshold: exhilarating, but a difficult frame of mind to stay in for very long. Macduff managed to remain there for extended periods. He once told me the two most important things he learned in his Yucatán work: "One, ask people what they are thinking rather than assume that you already know. And two, listen. You never know what someone might say and where it could lead."

These are extraordinary statements, especially coming from a person who is primarily a visual artist.

In U.S. anthropology in the 1960s a brief but earnest methodological scuffle pitted language-oriented ethnographers against those who claimed that natives of other cultures prevaricate at will and only visual evidence recorded by cameras on film can get at the "truth." But between *listening* and *looking* there probably should not be any either/or, especially when you are engaged in a task as daunting as ethnography. Working in another culture frequently points to the irony that the visual record taken alone does not always convey how other people see their world. (For me this disparity became most obvious when we were making a film about a Chiapas Maya fiesta and decided to follow two religious officials, our main "characters." After standing out in heavy rain for an hour waiting for a procession to pass, the photographer/director complained bitterly that *our* guy hadn't been in it. Neither the anthropologists nor the local spectators had noticed. It turned out that the official's son had marched for him, an acceptable and even unremarkable substitution for the Tzeltal townspeople, if not for our director.)

The combination of text and image has long seemed an ideal way to provide a vivid picture of how life is conduct-

ed by people far from the viewer/reader's experience. Although photographs have been used as illustrations in ethnographies, outside of magazine spreads like the ones in *National Geographic* relatively few attempts have been made to integrate writing and photography in a complex, textured portrayal of another culture on the scale that Macduff has undertaken. His work bears comparison with James Agee and Walker Evans's *Let Us Now Praise Famous Men*. Both are ethnographies not by professionally trained ethnographers. Agee, while claiming that most of us have not really yet learned how to look at photographs, recommends that the reader return over and over to the front of the book to gaze at the Evans images. Thus rather than a one-to-one or "illustrative" correlation of text with picture, Agee is proposing an evocative (or analogic) relation between the two. (Certain parallels do link Agee's writing to Evans's images: both often represent people by focusing on artifacts such as their tools, their furniture, or their rooms and both are intent on showing the mystery and beauty in the lives of the poor.) The problem with the book itself turns out to be that, while Evans's photographs are apparently direct and honest, Agee's attempt at forthrightness through self-disclosure comes to seem to many repetitious, ponderous, bombastic, and, though poetic and perhaps inspired, finally not worth the effort.

In *The Modern Maya: Incidents of Travel and Friendship in Yucatán* Macduff employs his photographs both as illustration and as evocation. His prose is straightforward. Though he himself narrates and thus becomes a character in his story, there is never any sense that he thinks the story is *about* him. He uses layout and size of image cinematically, directing the reader's attention and providing emphasis through a still-photo equivalent of motion pictures' well-known juxtaposition of long shot (or master), medium shot, and close-up. An acknowledged master of panoramic photography, he employs the wide views to give a sense of how the ancient Maya sites occupy the terrain but also for intimate interiors of present-day Maya homes and chapels. Though it is hard to imagine that many individuals have Macduff's collection of talents, this book will serve as a model for what *can* be accomplished with word and image working together.

Where Macduff differs from many of his peers who have photographed indigenous Mexico is in perceptible intent. Admirable modern photographers like Laura Gilpin have followed Frederick Catherwood, the great nineteenth-century illustrator, in using the Maya mainly as decoration or to show human scale in the ruined cities. Artists working in other parts of the country like Mariana Yampolsky, Graciela Iturbide, and Antonio Turok manage to avoid exoticizing indigenous people but feature them as representative (of "natural" or "essential" humanity?) rather than as individuals, so the purpose of the image seems to be mostly about the photographer's eye for pattern or for the surreal. Macduff's photographs are differently engaged, more intimate, more devoted to the people pictured and to the progress of their lives. In his point of view—his whole approach to ethno-graphic photography—Macduff's work reminds me most of Gertrudis Duby Blom's photographs of men and women in the Lacandon rain forest and, as I have said, of the spirit of Walker Evans's portrayal of rural southerners.

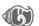

Almost since being overrun by the Spanish in the sixteenth century, Yucatán has been a disappointment to the Europeans: poor soil and too dry in the west and inhospitable jungle full of recalcitrant natives in the east; isolated, until recently reachable from the rest of Mexico only by sea; and, above all, a hard place to make a profit. Its being a backwater allowed the colonial system and what anthropologist Robert Redfield dubbed "the folk culture of Yucatán" in his 1930s study of the village of Chan Kom to persist into modern times. Sisal cordage made from the spears of the henequen plant came into worldwide use, and Yucatán boomed in the late nineteenth century. Henequen was dubbed Yucatán's "green gold," but social relations remained the same on the haciendas where the sisal fiber was mashed out of the plant—the Maya were now debt slaves to the hacienda instead of vassals to white overlords claiming ownership of the land.

After henequen went bust in the 1960s (when plastic cordage universally replaced sisal twine), the Mexican government and business leaders hit on the sugar sand beaches of the peninsula's Caribbean coast as the new resource to exploit. The result was Cancún, today a city of three-quarters of a million people which did not exist when I was first there in 1975, and later the development of the resorts of the Maya Riviera south toward the Belize border.

The sheer number of new visitors and their primary focus on sun, sea, and relaxation called for a new variety of tourism. The old typical Yucatán tour had followed a genteel pattern laid out in the 1930s when the Carnegie archeologists were still excavating the major Maya sites at Chichén Itzá and elsewhere. It included several days in La Ciudad Blanca (The White City), as Mérida was called then, moonlight rides in open horse-drawn carriages through the colonial streets, and guided trips to various ruins with overnights at comfortable, sedate hotels nearby. In the new tourism, the footfalls of the crowds threaten to dislodge the stones from the temples, the ancients and their cities take only one day or part of a day away from the beach, and the 500-year détente between the Maya and the Europeans is passed over entirely.

The versions of history (and even the versions of the present) given to us as tourists are constructed to keep us from dwelling too much on our own privilege while in the vacation setting and to keep the landscape—including its human element—looking pacific and pleasant by avoiding mention of past conflicts. The story given to casual visitors in Yucatán contains two great omissions: first, that the people making the beds and topping up the margaritas are the direct descendants of the builders of the Precolumbian cities; and second, that these same people, long treated as second-class citizens and mostly quite poor, have maintained a

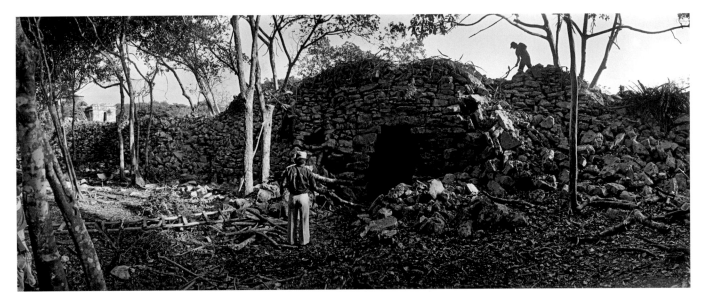

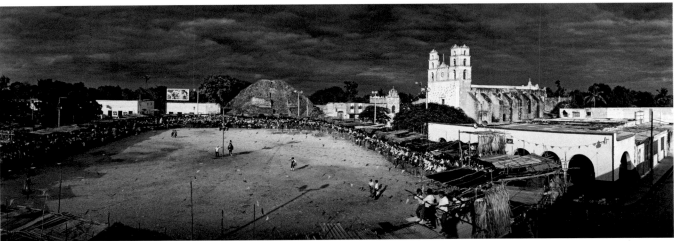

TOP: Workers clearing a wall at an archaeological site, Tulum, Quintana Roo, 1986. BOTTOM: A bullfight in front of a Maya pyramid and colonial church, Acanceh, Yucatán, 1990.

rich folk culture. It is now perhaps in danger of passing away but is still a source of enormous pride and the provider of a strong sense of well-being for them.

Without being history as such, *The Modern Maya: Incidents of Travel and Friendship in Yucatán* goes about correcting the casual and partial vision of the peninsula offered to the tourist. Often Macduff's strategy involves the way in which he employs his images. In the 1980s and 1990s he worked closely with some of the most gifted reconstructors of ancient Maya civilization (Linda Schele, Peter Mathews, Justin Kerr, David Freidel, Joy Parker) and provided them with meticulously conceived photographs of the sites, many in panoramic format, for books such as *The Code of Kings* and *Maya Cosmos*. (Talking with Macduff about these places is a special pleasure because of his intimate knowledge of them. He has studied how and when light falls on this wall or that arch and has thought a great deal about how to get the sense of relationship of a whole set of widely spaced monumental

buildings into a single photograph.) In this book, he places images of the achievements of their ancestors almost casually next to images of his twentieth-century Maya friends. The photographs are of a piece in their elegance and sweep, so the implication is clear: this *is* the current generation of a people who once wrote themselves very large in stone and stucco and no longer do.

Rather than dwelling on the usual question of why the Maya stopped creating impressive monuments even before the arrival of the Spanish, Macduff describes extant elements in Maya daily life which are elegant and sensible adaptations to their surroundings, such as the richly varied Maya milpa and the traditional house constructed entirely from natural materials and bound together with rope and vine rather than nails.

Robert Redfield's restudy of Chan Kom, published in 1950, had the memorable title *The Village That Chose Progress*. But traditional people seldom actually choose "progress." More

Maya guardian in front of stucco mask panel depicting the sun god. Kohunlich, Quintana Roo. 1974.

often progress is thrust upon them — and with bitter results, as happened when the family of Macduff's friends Dario and Herculana became split between Cancún and their home in Chichimilá. Much of what Macduff delighted in when he first arrived in Yucatán in 1971 appears to be passing from the scene or gone. How does a visitor, even a nearly endless-ly recurring one, deal with the feelings that these changes bring up? I know anthropologists who no longer go back to the places they once worked because the mystery and other attractions which originally drew them dry up when indig-enous people are forced into mainstream society. (Though I consider these sentiments wrong-headed, I sometimes give in to them. The ceremonial center of the municipio where I first lived in Chiapas, in the 1960s a serene valley dotted with

steep-roofed wattle-and-daub houses, has become a noisy, ordinary concrete and cement Mexican town that I don't much like visiting.) Macduff does a much better job than most. He reports his own sadnesses along with his Maya friends' feelings of loss but always understands the elements of necessity which drive their decisions when they have to abandon tradition. He is never so confused as to imagine that their old life was put there primarily for his aesthetic enjoyment. The setting may appear ordinary and mean in the photographs where people he knows have moved into "modern" situations, but the people remain themselves. Macduff's friend Dario, the master farmer removed from his cornfield and slopping soapy water on car tires at a hotel in Cancún, is Dario still.

Acknowledgments

Many people have been very generous with their time and advice. I owe them all a great deal, beginning with my friends in Yucatán who let me share their lives and provided me with a place to hang my hammock. They include Dario and Herculana, Ursina, Mari and Pedro, Omar and Sali, José and Florentina, Pedro and Heidi, Veva and Cornelio, Alicia and Juan, Felipe, Diego and Margarita, María and Pedro, Casimiro and Marcelina, Chucho and Heliodora, Eleut, Juliana, Victoria, and Julián, Pablo and Ofelia, and Marcelino and Isabela. Also Ramón Carlos Aguayo, Antonio Negro Aguilar, Susan Bohlken and Daniel Vallejo McGettigan, Cameron Boyd, Bush, Florinda Sosa Castilla, Mario and Guadalupe Escalante, Alfonso Escobedo and Roberta Graham de Escobedo, Alejandra García Quintanilla, Cynthia James and Jorge Rosales, Narciso Torres, Alfonso Tzul, Gavin Greenwood, and Orane Douxami, Sam Meacham, and Zacarias "Chaco" Quixchan. Scott Fedick and Anabel Ford let me accompany them during fieldwork, live at their base camps, and ask them endless questions. I really appreciate their patience, help, and encouragement.

Many people have read versions of this manuscript and made editing suggestions. They include Bonnie Bishop, Jeff and Wendy Burton Brouws, Annette Burden, Sienna Craig, Clyde and Frances Everton, Don Ewing, Mary Heebner, Carol Karasik, Fred Kenyon, John Lilly, Guillermo Olguin, Dorie Reents-Budet, Max Schott, Stevie Sheatsley, and Frank Pancho Shiell. Allan Burns, Scott Fedick, Hilario Hiler, Susanne Kissmann, Robert Laughlin, Simon Martin, Francisco Rosado May, Linda Schele, and Paul Sullivan all provided me with new information and personal observations that I have been able to incorporate into the text.

Charles Demangeat and Carter Wilson have worked with me for years—to back up my observations, suggest further reading and citations, and help shape the text. I obviously made digressions in my story over forty years, and they kept me focused. I owe them a huge debt of gratitude. Joan Tapper and Anthony Weller did me the service of polishing the English and showing me where to cut. Their final editing improved the book enormously.

I appreciate that some of my research was underwritten by editors at magazines whose assignments coincided with my investigations, beginning in 1973 with Jon Schneeberger at *National Geographic* and also including Keith Bellows, Dan Westergren, Linda Meyerriecks, and Carol Enquist at *National Geographic Traveler;* Kathleen Klech, Lucy Gilmour, Esin Goknar, Michael Shnayerson, and Cynthia van Roden at *Condé Nast Traveler;* Bob Friel and David Herndon at *Caribbean Travel & Life;* Patrick Downs at *Los Angeles Times Magazine;* and Joan Tapper, Albert Chiang, and Lori Barbely at *Islands Magazine.* I appreciate the tremendous and talented efforts of Theresa May, Leslie Tingle, Kathy Burford Lewis, and Carrie House at the University of Texas Press to bring this book to print.

I was nineteen when I first thought of doing this book. I never thought I would still be working on it in my sixties. From the beginning my parents offered encouragement, suggesting that it was better to follow a dream than never to try and forever wonder what might have been. I can't imagine a more wonderful gift. Charles Demangeat and Hilario Hiler have been true compadres as this book has expanded into what it is today, from sitting around a jungle table at night, writing in longhand under a kerosene lamp, to working on a laptop computer today and using an iPod to record interviews. We still share an excitement in revisiting friends and pursuing further adventures. As Charles has told me many times, "I'm never going to turn down a trip back to Yucatán!" And Hilario has never left.

This project has also affected my family—first my son Robert and then Sienna and Mary. Some suggest that Robert's cooking skills developed in response to the black beans and tortillas that I served for nearly every meal. They've had to live for many years hearing "just one more trip" as I headed back to Yucatán yet again and evenings where I'd disappear into the darkroom or my studio to work on the text. That they all still have an affection for Yucatán is a testament to the graciousness and hospitality of my friends.

I dedicate this book to my wife, Mary,
who inspires me with her creative energy, insights, and love
and gave me limitless support and encouragement
for a seemingly endless project.

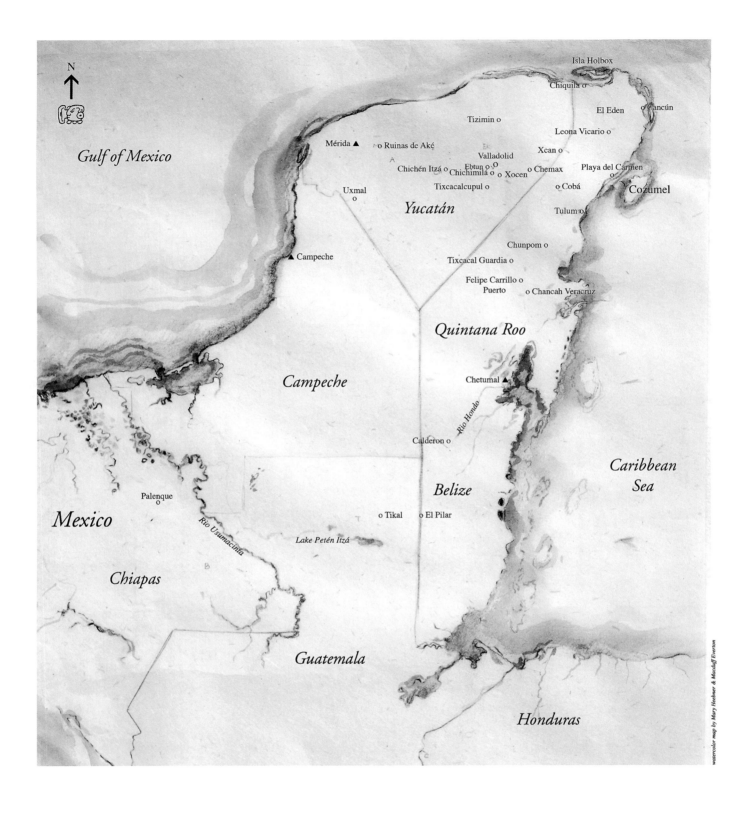

N

Gulf of Mexico

Isla Holbox

Chiquila o

El Eden
o Cancún

Tizimin o

Leona Vicario o

Xcan o

Mérida ▲ o Ruinas de Aké

Valladolid

Chichén Itzá o o Chichimilá o Xocen o Chemax Playa del Carmen

Ebtun o

Uxmal
o

Tixcacalcupul o

o Cobá

Cozumel

Yucatán

Tulum o

Chunpom o

Campeche ▲

Tixcacal Guardia o

Felipe Carrillo o
Puerto o Chancah Veracruz

Quintana Roo

Chetumal ▲

Campeche

Río Hondo

Caribbean
Sea

Calderon o

Palenque
o

Belize

Mexico

o Tikal o El Pilar

Río Usumacinta

Lake Petén Itzá

Chiapas

Guatemala

Honduras

watercolor map by Mary Heebner & Macduff Everton

The Modern Maya

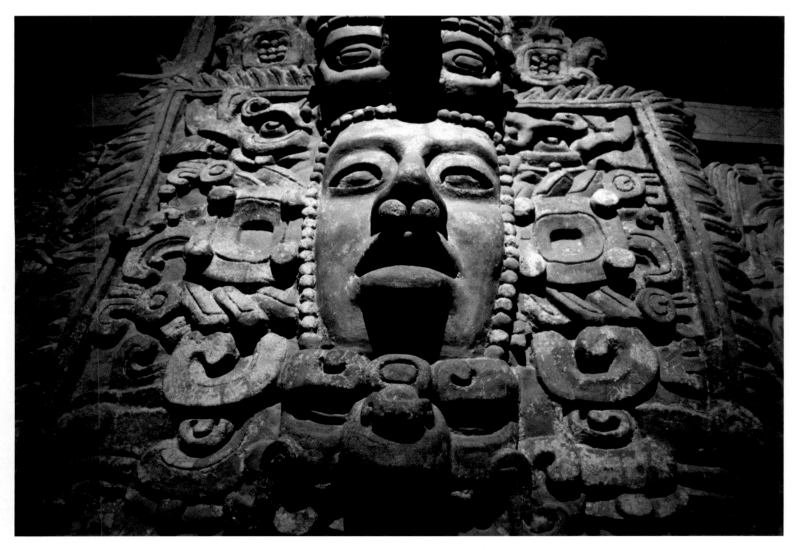

Kinich Ahau, sun god. Kohunlich area, Quintana Roo, Mexico, 1995.

The Maya have a particularly strong claim to the alliterative epithet of "mysterious" that has been applied to them. Even more than the cause of Maya decline, scholars have puzzled over the questions of how this civilization ever existed in the first place, and how, by implication, it could have lasted as long as it did. Most especially they have pondered the question of how it could have existed where it did.
NANCY FARRISS, *Maya Society under Colonial Rule*

To me, one of the greatest mysteries is why Maya culture should have reached its greatest peak in this region so singularly lacking in natural wealth, where man, armed only with stone tools and fire, had everlastingly to struggle with the unrelenting forest for land to sow his crops. Moreover, when he had wrestled the necessary area momentarily from the forest's grasp, he usually found a soil so thin and quickly weed-infested that after one or two crops, it had to be surrendered to his enemy, who lost no time in covering it once more with dense vegetation.
J. ERIC S. THOMPSON, *The Rise and Fall of Maya Civilization*

A Short History and the Legacy of the Maya Forest

An account of the ancient Maya and the collapse, or perhaps the slow crumble; in the field with archaeologists Anabel Ford and Scott Fedick, who find evidence that there wasn't an environmental catastrophe, and the legacy of the Maya Forest, a feral forest garden

Yucatán is the only major peninsula in the world outside of Antarctica that juts up rather than down. It is about the size of England, a thumb sticking into the Gulf of Mexico and separating it from the Caribbean Sea. It is a monotonously flat plateau formed by a geological base of uplifted Cretaceous and Tertiary limestone that was once an ancient reef system in a shallow sea. The Puuc Hills begin in the northwest but after a faint effort soon run out of height. Especially in the north the land is rocky and offers pockets more often than fields of soil to grow crops. Rainwater percolates through the limestone bedrock and flows to the ocean in a maze of underground rivers. More than seven thousand cenotes (from the Mayan *ts'onot*, a natural well or sinkhole) on the peninsula provide access to that water. Because it was impossible to irrigate fields without surface water, the Maya, especially in the northern half of the peninsula, were restricted to farming during the rainy season. During the dry season the peninsula can be as arid as a desert. Aside from the coast, where there are swamp forests, savannas, and wetlands, a tropical semi-evergreen forest covers the land. The low scrub forest and xerophytes in the north gradually become a tropical wet forest in the south, where a few lakes, streams, and rivers appear.

The Maya were just one of several cultures that flourished in Mesoamerica, a cultural-geographic area that extends from northern Mexico into Central America as far south as Honduras or even Costa Rica and Panama.[1] Mesoamericans could read and write using hieroglyphs, had books, charted the universe and the movement of the planets (especially Venus), used a complex and accurate calendar, had a pantheistic religion that included bloodletting and captive sacrifice, played a game with a rubber ball in a ball court for both sport and ritual, built pyramids, and domesticated corn (maize), beans, chili, tomatoes, cacao, and squash, among other crops. Few civilizations have lasted as long as the Maya—their world flourished for more than three thousand years.

The Maya world (linguistically, geographically, and culturally) encompassed the Yucatán Peninsula, including the present Mexican states of Yucatán, Quintana Roo, and Campeche as well as Chiapas and Tabasco and the current countries of Belize, Guatemala, and parts of El Salvador and western Honduras.

Archaeologists divide Maya history into three great periods—Preclassic (2000 BC to AD 300), Classic (AD 300 to 900), and Postclassic (AD 900 to 1524), which are further divided into subphases, such as Early, Middle, Late, and Terminal.

Beginning around 2000 BC, the Preclassic Maya emerged, probably borrowing elements from the Olmecs, a Gulf Coast culture. The Maya, like any culture that believes the earth is alive, used objects as symbols for the natural world. Their pyramids were mountains, and the doorways of their temples were mouths of the mountains—cave entrances. They created city-states ruled by kings and queens that supported an elite of nobility, artisans, scribes, and warriors. Farmers lived in and around the city-states, apparently much as current village Maya do: each family dwelling has its own garden and fruit trees. The farmers paid tribute in labor as well as produce, helping construct the temples, buildings, and monuments. Good trails and *sacbes* (roads) connected the city-states to each other, but everything had to be carried on people's backs because North America had no beasts of burden.[2] Distribution of food was local rather than regional. Trade was primarily restricted to essentials (such as salt, obsidian, flint, and rubber) and luxury items (jade, gold, turquoise, seashells, feathers, cacao beans, and animal skins).

Each Maya city-state had its own ruler, its own history, and its own link with the gods. A new social order appeared at the beginning of the Classic period; Arthur Demarest writes that it was noted for its elite architecture, propagandistic monuments, and flamboyant theater-state rituals where epicenters of Maya sites were constructed as stage settings for religious spectacles, often based on the divine lineage of the rulers.[3] As the larger cities became more dominant, they went to war to control trade routes and gain access to goods and commodities, to capture slaves and victims for sacrifice, and to win honor and glory.

The Maya culture reached its artistic and architectural zenith during the Classic period. Cities were built and rebuilt and expanded, especially in the southern lowlands (primarily the Petén in present-day Guatemala). Life in the palaces of the elite was luxurious. Kings claimed descent from the

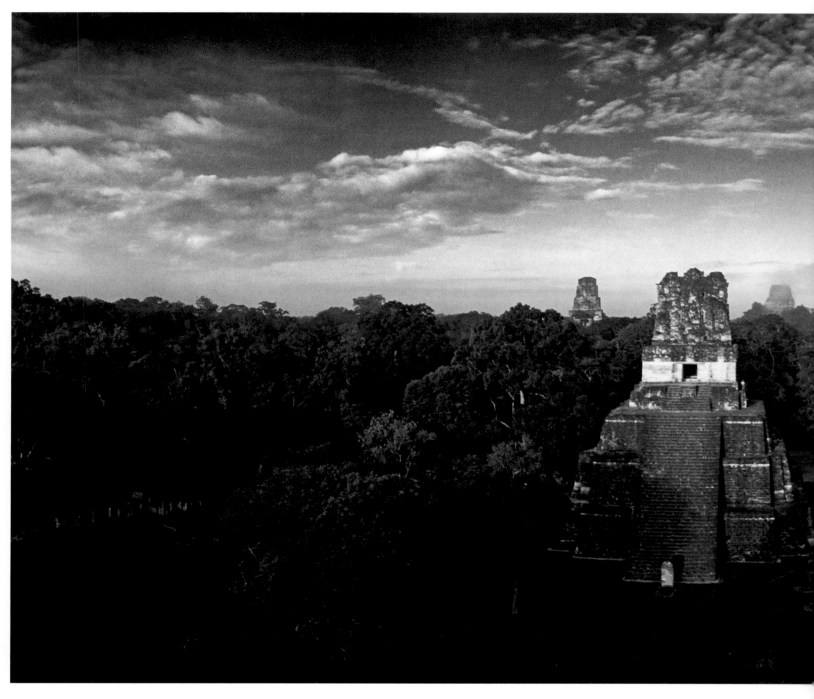

Sunrise, the Great Plaza of Tikal, Temple II, with Temples III and IV in background. Tikal, Petén, Guatemala, 1987.

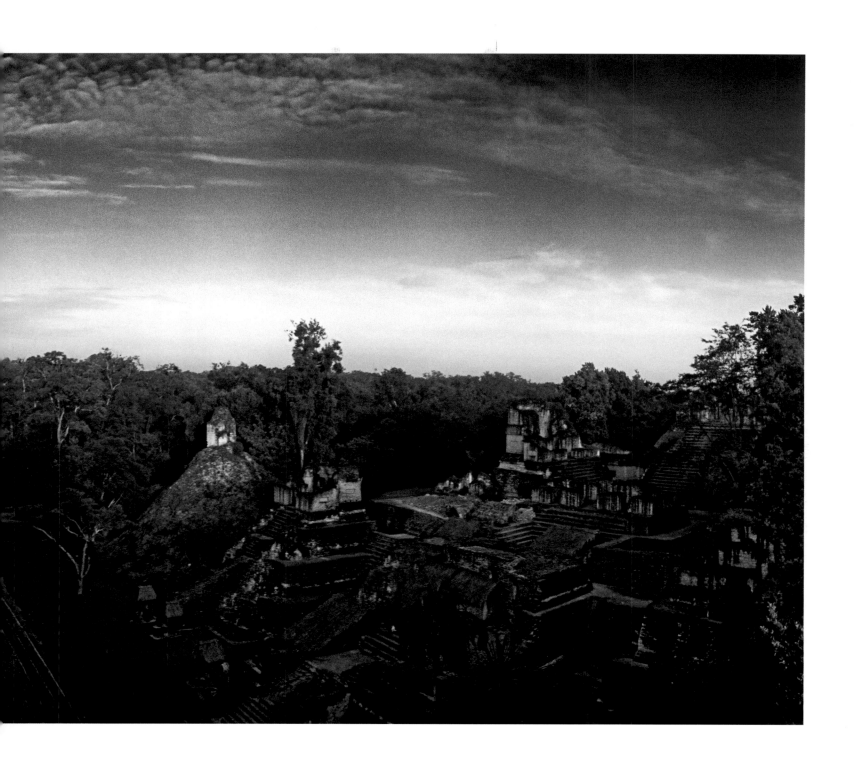

Temple IV. Tikal,
Petén, Guatemala, 1968.

gods, put up monuments to themselves, and honored their forbears and their divine connections. The moral, political, and natural orders became unified. A tremendous growth in population occurred, and the cities grew large and dense. Ultimately sixty or more fiercely competitive kingdoms appeared, leaving a political history of great complexity.[4] The end of the Classic period witnessed the decline of cities in the southern lowlands, but at the same time cities in northern Yucatán, especially cities in the Puuc region (such as Uxmal, Kabah, Sayil, and Labna) and Chichén Itzá, began to thrive as never before and commenced huge building programs.

Although the abandonment in the ninth century was an event tumultuous enough to be called the collapse of the Maya civilization, it was really more of a major economic, political, and demographic shift to the north than a collapse. Many hypotheses on why the Maya abandoned many of their cities in the southern lowlands have been offered; but the end of the Classic period occurred over at least 300 years and was different from city to city, region to region, so no single cause can explain what happened.[5] Although the civic centers were no longer maintained, evidence indicates that the Maya didn't leave the entire city.[6] This conundrum has led archaeologists to question whether it was a collapse or really more of a slow crumble — or, perhaps more accurately, a cultural transformation.

David Webster argues in *The Fall of the Ancient Maya* that it wasn't Maya civilization but the form of political leadership which collapsed when the kings, who had assumed the power of the gods, were no longer able to deliver what they promised.[7] Simon Martin believes that something momentous occurred around AD 800; when survivalists and revivalists could not rebuild the Classic world, it gradually expired.[8] Stephen Houston says that "the image of people dying in the streets is a caricature of what was taking place; these cities just become not very attractive places to live . . . People voted with their feet."[9]

Whether it was a political or natural crisis or a series of events that started the change, the outcome was that the divine rulers were no longer relevant and their dynastic centers were no longer kept up. As Prudence Rice, Arthur Demarest, and Don Rice write about putting the "Classic Maya Collapse" in perspective, "What actually collapsed, declined, gradually disappeared, or was transformed at the end of the Classic period was a specific type of political system and its archaeological manifestations: a system of theater-states, identified by Emblem Glyphs, dominated by the *k'ul ajawob* (holy kings) and their inscribed stone monuments, royal funerary cults, and tomb-temples, the political hegemonies of these divine lords, and their patronage networks of redistribution of fineware polychrome ceramics, high-status exotics, and ornaments."[10]

Those who propose the collapse point to overpopulation, environmental degradation, warfare, revolts, disease, or climatic changes (such as prolonged drought) as probable causes, either separately or in combination. In contrast, proponents of cultural transformation look at the changes that occurred and don't see a collapse. Patricia McAnany and Tomás Gallareta Negrón suggest that Maya society continued to exhibit a robustness "that defies the term collapse. During the Postclassic period, rulers reinvented themselves in a manner that afforded the best advantage in the context of an increasingly commercialized, pan-Mesoamerican world (from north-central Mexico to western Honduras) knit together by shared ritual practices."[11] When trade became more important than monumental architecture, the monolingual hieroglyphic royal inscriptions on monuments were no longer as vital and writing continued only in *codices* (painted manuscripts made from bark paper fashioned into long sheets that were made into screenfold books).[12]

Twentieth-century Mayanists such as Sylvanus Morley didn't call these eras Classic and Postclassic but referred to them as Old Empire and New Empire. Many archaeologists now believe that there was a change but not necessarily a decline, and some argue that Maya civilization flourished and even blossomed during the Postclassic period. Most of the hallmarks of the Classic period were in fact not beneficial to the majority of Maya. In a new political and economic order, the elite didn't dominate society as much as they had in the past. More people had access to participate in economic development — coastal and inland communities became wealthy by participating in exchange of products and the increased long-distance maritime trade around the Yucatán Peninsula and in other areas of Mesoamerica.[13] As Demarest points out, "Viewed in objective economic terms, many Postclassic states were larger and more successful than their flamboyant Classic-period antecedents."[14] With the florescence in the north, Jeremy Sabloff suggests that the essence of the Classic period didn't really end until the decline of Chichén Itzá around 1200.[15]

The Maya never "disappeared" and were never a "lost civilization."[16] In fact, they showed a remarkable capacity to invigorate or reinvent themselves while maintaining an essential continuity. The "collapse" might not even merit so much conjecture if the Spanish had not interrupted their history; several collapses, or rather a series of mini-collapses, had occurred over nearly a thousand years. While one city was declining or being abandoned, other cities were being built and reaching their peak. El Mirador, in present-day Petén, Guatemala, might have been the largest center ever built by the Maya, but El Mirador and the surrounding cities in the Mirador Basin collapsed around AD 150–200, in a process referred to as the Preclassic Abandonment.[17]

The Postclassic Maya continued to engage in trade and diplomacy with other American states. They practiced their own religion, spoke and wrote their own language, and presented an ethnic identity to outsiders. When the Spanish arrived at the beginning of the sixteenth century, the Maya were still a vibrant culture.[18] The Western Hemisphere was larger, richer, and more populous than Europe at the time of the conquest.[19] If we look at scenes described on pottery, people seem to have lived well. Certainly the upper classes

lived as well or better than their European contemporaries, in sumptuously furnished homes and palaces. The Maya enjoyed rich and intricately designed textiles, elaborate and beautiful headdresses and garments made of feathers, and furniture, utensils, sculptures, and musical instruments fashioned from tropical hardwoods.[20] When Hernán Cortés and the Spanish described the Aztec capital, they marveled at public toilets, how clean the city was, and the botanical gardens, unknown in Europe. Tenochtitlan was larger than any European city at the time—bigger than London, Paris, Madrid, or Rome. The Spanish were impressed—and then destroyed it.

It is hard to tell how many Americans the Spanish killed. Even more dangerous and deadly than their guns, their horses, and their weapons of steel were the diseases unwittingly brought by the Europeans, starting with Christopher Columbus. The Americans, who didn't know of plagues, gathered around victims rather than quarantining them. Nearly everyone became contagious. They died from smallpox, cholera, measles, plague, tuberculosis, typhoid, and typhus.[21] Ethnohistorian Henry Dobyns suggests that within 130 years of Columbus the American population had been reduced by as much as 95 percent, arguably the worst demographic calamity in recorded history.[22]

Disease killed men, women, and children, kings and queens, priests and warriors, merchants and artisans, farmers and slaves. Whole villages were wiped out. Cities and towns were reduced to villages. The human mind can't possibly grasp the unfathomable sorrow, the enormity of disease wiping out so many people, so many families, along with their hopes, dreams, aspirations, culture, knowledge, and history. We can only be amazed that so much of the culture survived and that an estimated 10 million people in Mexico, Guatemala, Belize, and Honduras still speak Mayan five centuries later.[23]

The Spanish conquest of the Aztec empire took only two years. Tenochtitlan became Mexico City, and the Aztec homeland was turned into a quilt of towns, large ranches, and farmland. The Spanish found the climate and topography of the Mexican highlands agreeable. Their colony grew dramatically. The Aztec were put to work on the ranches and in the mines.

The conquest of the Maya was much more ambiguous. The Spanish did not impress the Maya as gods—the Maya sacrificed and ate the first Spaniards they met.[24] Unlike the Aztec, they were not easily defeated, in part because they didn't have a central capital or king. When the Spanish landed on the Yucatán Peninsula, it was divided into at least sixteen autonomous provinces. The Spanish had to conquer each one separately. The Maya repulsed the first two Spanish attempts in 1517 and 1518. They fought fiercely, each province defending itself, but they didn't unite to defeat the Spanish. As the Maya weakened from disease, the Spanish were able to gain a foothold on the peninsula. Historians who marvel at how few Spaniards were necessary to conquer the Americas ignore the epidemics that swept through the land. Even

so, the initial conquest of the Maya wasn't finished until 1547.

The Spanish weren't completely successful, as they couldn't secure and defend the entire peninsula. Most of the eastern and southern portion remained an unconquered zone where many Maya fled. It provided plenty of room for refugees. Rather than dealing with this situation, the Spanish conveniently considered the porous frontier to be uninhabited, but it was the escape hatch for colonized Maya and the home of independent settlements.[25] The largest of these, the Itzá (of Chichén Itzá), continued to live as an independent Precolumbian kingdom around Lake Petén Itzá for more than 200 years after the Spanish first came to the Americas. As Nancy Farriss states, the Itzá "blurred the boundary between pre-Columbian and colonial, pagan and Christian, unconquered and conquered."[26] When the Caste War of Yucatán broke out in 1847, the frontier became home to the rebel Santa Cruz Maya.

At first the Maya didn't have to rebel: they could just leave, continuing a Precolumbian tradition. As Farriss states, "This may be because for so long in their history they have had (and still have, to a large extent) the choice of flight over fight when faced with intolerable circumstances."[27] The Yucatán Peninsula was crisscrossed with paths, and a Maya family didn't need much in order to move. A woman needed a grinding stone for preparing corn, which could be fashioned from the ubiquitous limestone. After the conquest, a man needed his axe and machete and seed for new crops. The forest provided everything else they required: the raw materials for a new household and furniture as well as food (fruits, roots, game) until they were able to enjoy their first harvest.

The Spanish did not find the climate and topography of Yucatán agreeable. The Spanish colony remained small and was concentrated in just a few locations, particularly Campeche and Mérida. But even more importantly, the peninsula offered no gold or silver. Yucatán became a colonial backwater, which enabled the Maya to retain an identifiable culture.

The Spanish who stayed in Yucatán established a number of cattle ranches to provide beef for local consumption but essentially lived off tribute that they exacted from the Maya (primarily corn, honey, wax, salt, and woven cotton cloth), not unlike the previous Maya nobility. Remarkably, except for those who worked as domestic help or participated in part-time or seasonal labor, many Maya had little contact with the Spanish. Contact was primarily through religion. Although most Maya were baptized and nominally became Roman Catholics, the Spanish made few attempts to teach them Spanish and educate them or to incorporate them into Spanish culture—and certainly not with any rights.[28] The Maya had nothing to gain by becoming Hispanicized: they would still remain inferior. Through their neglect the Spanish unwittingly allowed the Maya to continue their traditions.[29] The Spanish and the Maya lived in two different spheres, which meant that the Maya remained firmly embedded in the traditional life of their communities, with

their own village leaders.[30] This continued right up to the end of the eighteenth century, when the haciendas needed more land and more workers and began taking away the Maya's land and their political and economic independence.

At the beginning of the nineteenth century the Mexicans rose up against Spain and won their independence. Following suit, the Maya rose up in revolt in 1847 and drove nearly all whites from the peninsula. Fierce fighting would continue for more than fifty years, the longest native rebellion in the Americas. The rebel Maya never surrendered, choosing instead to retreat to jungle sanctuaries in Quintana Roo and live in as pure a form of Maya culture as possible.[31]

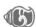

Every Mesoamerican culture cultivated corn (*Zea mays*).[32] It was first used as a food when nomadic groups, possibly in the Central Balsas River Valley in Mexico, began domesticating plants more than 9,000 years ago.[33] Corn originally was a short, spindly wild grass called *teosinte* with tiny cobs and two husks that easily parted. But when humans started planting the seeds, people and corn became interdependent. Corncobs developed from less than an inch long into large cobs that stored the sun's energy in kernels that would keep all year long. But the plant was no longer able to seed itself—it needed humans.[34] These early botanists developed the grain that would become the most productive food plant in the world.[35]

A diet of corn by itself leads to pellagra, a disease caused by a niacin deficiency.[36] At some point the Americans discovered that boiling corn with lime (calcium) provided niacin and dietary calcium as well as making a B vitamin in the corn available and that companion crops such as beans and squash combined to provide the essential amino acids and a complete protein. The combination was greater than the parts. As people settled and began depending on agriculture, their ability to forecast rainfall became increasingly important. Vessels to prepare and cook their food came into use, and they had time and a place to express their imagination as art. These various needs were the foundations for a civilization.

Corn was venerated by Mesoamerican cultures and is at the core of Maya religious belief. In the Popol Vuh, the sacred book of the ancient Quiché Maya, we are told that the gods fashioned humans from corn. In Precolumbian times, corn determined the Maya concepts of beauty, fashion, jewelry, and even burial practices, among other things. The Maize God is represented with an elongated head and an upswept coiffure, and the Maya tried to adopt this style. Mothers tied boards to their babies' heads in order to shape their soft skulls to mimic the shape of tapered corncobs. And grown-ups wore their hair in vertical swirls, mimicking the tassel of corn silk at the end of a cob.

A field of growing corn, rustled by the gentlest breeze, appears fluid and in motion, so the Maize God was often depicted as a lithe and graceful dancer bejeweled with jade, the color of sprouting cornstalks. One of the roles of the king was to be a ritual dancer.[37]

Corn appears even in riddles. "Son, go and bring me here ⟨the girl⟩ with the watery teeth" begins one riddle in *The Book of Chilam Balam of Chumayel*. "Her hair is twisted into a tuft; she is a very beautiful maiden. Fragrant shall be her odor when I remove her skirt and her ⟨other⟩ garment. It will give me pleasure to see her. Fragrant is her odor and her hair is twisted into a tuft. It is an ear of green corn cooked in a pit."[38]

The legend of the Maize God is a parable of the corn growing cycle. The Maize God goes into the Underworld and battles with the lords of death. Even though he is decapitated, which represents the harvest, he ultimately outwits the lords and is reborn again: young, handsome, and vibrant, just like the beautiful newly emerging shoots of corn during the next planting season.

Maya nobility wore jade jewelry and bright green parrot and quetzal feathers. They were buried with these ornaments in the hope that they too, like the Maize God, would outwit and defeat the lords of death in the Underworld and would be ready and well dressed for their resurrection.[39] When the Spanish tried to convert them to Roman Catholicism, the Maya had no problem understanding Jesus. Their Maize God was already a metaphor for life and resurrection. It is surprising that the Spanish, who were so good at synchronicity, didn't make communion wafers from corn.

So what else do we know about the Maya? According to Michael Coe, the Maya endowed their scribes and artists with more supernatural patrons and a richer mythology than any other culture, a clear indication of the status that writing and the arts held in Maya culture.[40] After the conquest, from the sixteenth to the nineteenth century, the colonial Maya in Yucatán provide their own history in the sacred Books of the Chilam Balam, named after a fifteenth-century Maya prophet who foretold the coming of the Spanish. *Chilam* refers to his title as interpreter of the gods; *balam* means jaguar but is also a common Mayan surname, so the book title can be translated as the Book of the Prophet Balam. The authors were taught to read and write phonetic Mayan by the Roman Catholic priests and knew that they often had to write so that outsiders wouldn't understand them, in order to avoid having their books burned by the Spanish. Depending on who was reading the books, the puns, riddles, and allusions either clarified or obscured the meaning. Nearly every town and village of size had its own Chilam Balam, an ongoing cultural and community history which included prophecies, religious and cultural traditions and history, what people remembered of their old culture after the conquest, medical treatises, petitions to the crown, and contemporary colonial history from the Maya viewpoint. Many passages were probably transcribed from hieroglyphic manuscripts, some of which were still in existence until the late 1700s.[41]

We also have the account of Bishop Diego de Landa, who wrote *Relación de las cosas de Yucatan* as a defense against charges concerning his overzealous and despotic behavior.

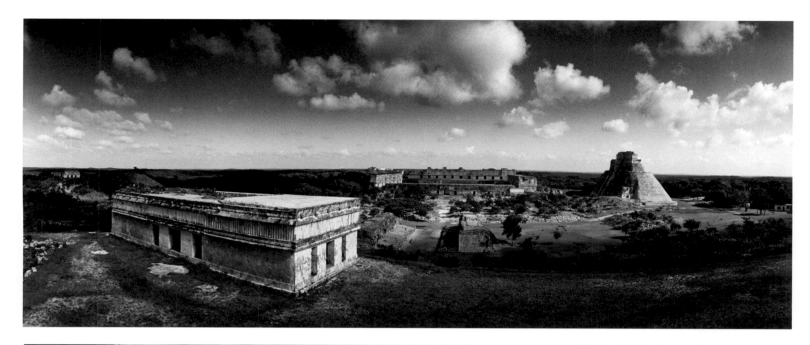

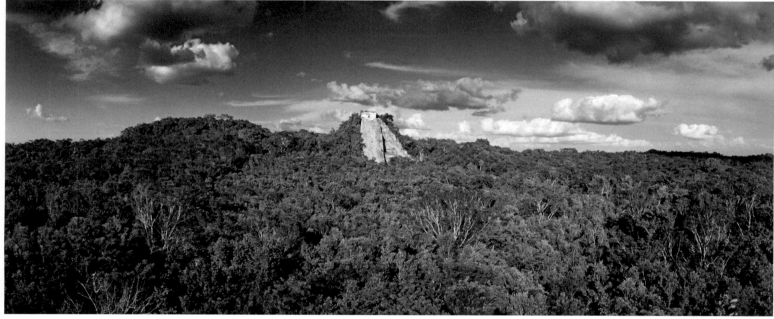

TOP: Uxmal, Yucatán, Mexico, 1987. BOTTOM: Nohoch Mul, Cobá, Quintana Roo, Mexico, 1987.

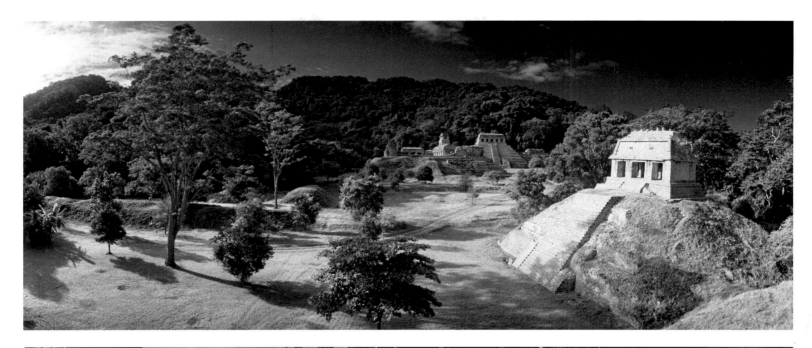

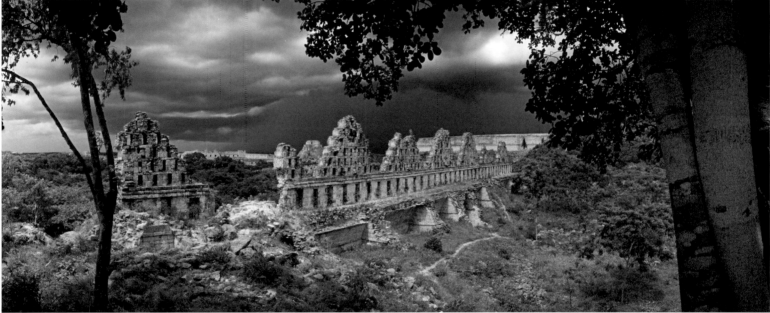

TOP: Palenque, Chiapas, Mexico, 1987. BOTTOM: Uxmal, Yucatán, Mexico, 1988.

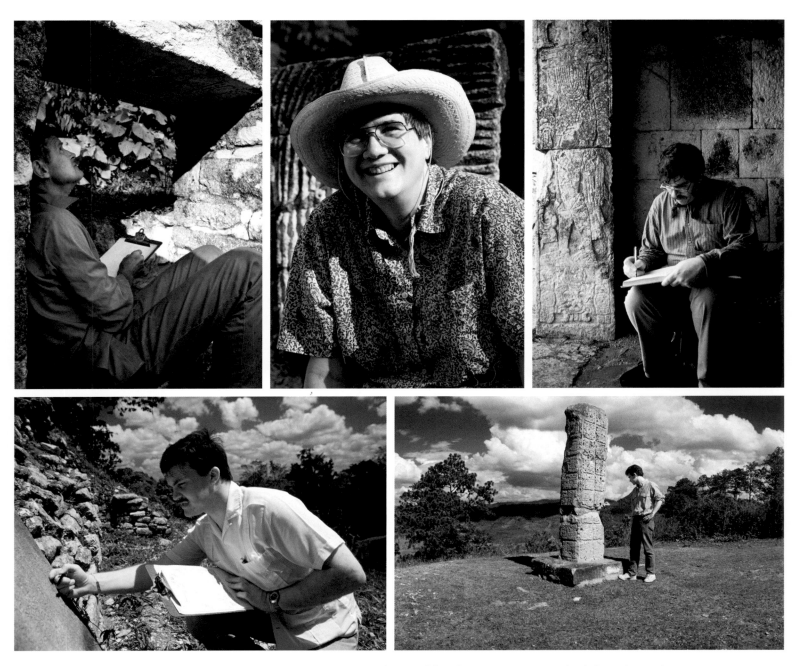

Mayan epigraphers working in the field. CLOCKWISE FROM TOP LEFT: Ian Graham, Yaxchilán, Chiapas, Mexico, 1986; Linda Schele, Copán, Honduras, 1991; Peter Mathews, Chichén Itzá, Yucatán, Mexico, 1994; David Stuart, Copán, Honduras, 1991; Nikolai Grube, Caracol, Belize, 1996.

In 1562 Landa was responsible for the auto-da-fé at Maní, a biblioclasm that nearly wiped out an entire Maya literary tradition. "We found a large number of books," he wrote, "in these characters [Maya writing] and as they contained nothing in which there were not to be seen superstition and lies of the devil, we burned them all, which they regretted to an amazing degree, and which caused them much affliction." The gathered Maya watched three thousand years of their collected culture burn. Landa, who later became bishop of Yucatán, claimed that Spain brought to the Maya "justice and Christianity, and the peace in which they now live." The Maya viewpoint was slightly different. They wrote in *The Book of Chilam Balam of Chumayel* that the Spanish introduced misery, strife, robbery, forced debts, and tributes to priests and the Roman Catholic Church.[42]

What we know of the Maya is fragmented — imagine, for a moment, that the United States was conquered: its libraries were burned and destroyed; its churches, schools, civic, state, and national government offices, museums, civic centers, and factories were destroyed; and many of its leaders were killed or died from disease. Then, after all this, the people would be told by their conquerors that they were ignorant and inferior because they didn't have a culture.[43]

Some of what we know has been passed down through the centuries through agricultural practices. Arturo Gómez-Pompa (professor of botany and plant science at the University of California at Riverside and winner of the Tyler Prize in Environmental Achievement in 1994) suggests that we study the present-day Maya farmers, because it is important to see if history can teach us anything. "It was the technological innovations of these people," he says, "that allowed the spectacular cultural centers to establish and flourish. Civilizations usually die or migrate when faced with environmental dilemmas. But the Maya have been living here for over 3000 years, and we know their successes and failures."[44]

Almost seventy years ago Ralph Roys could have been speaking for most Mayanists when he wrote: "The agricultural system of Yucatán offers a startling contrast to the architectural remains everywhere in evidence. Farming methods are, and always have been, so primitive that it is difficult at first sight to believe that they could ever have supported a civilization like that of the Yucatecan Maya."[45]

But an emerging group of botanists, agroecologists, epigraphers, archaeologists, and ethnographers as well as a host of others are studying the ways in which the Maya cultivated and managed their land. As their separate discoveries are combined, we begin to see just how many widely believed assumptions about the Maya lack nuance or are even incorrect. I'd been visiting Yucatán and living with the Maya for more than thirty years, documenting their lives. I wanted to ask about the hypothesis that environmental degradation led to the collapse of the Maya, so I met with archaeologists Anabel Ford and Scott Fedick while they conducted their field investigations. Both work in the Maya Forest, a lowland tropical ecosystem that is the second largest remaining

tropical rain forest in the Americas (after the Amazon), with 13.3 million acres. It extends across Mexico's Yucatán Peninsula and the Petén region of Guatemala and into Belize. The forest is young, dating from the end of the last Ice Age, and wasn't fully developed until 9,000 years ago. Evidence indicates that humans were already manipulating it 7,000 years ago.

Anabel Ford heads the MesoAmerican Research Center at the University of California at Santa Barbara (UCSB). She is comfortable living in the forest and can walk cross-country throughout the Maya zone, using a compass. In 1978, while still a graduate student, she cut a three-meter-wide thirty-kilometer trail connecting the ruined cities of Yaxha and Tikal. She was in charge of a crew of men and mules. They lived for nine months in the forest, cutting a straight path and mapping ancient Maya house sites along the way. "La Brecha Anabel" (Anabel's Path) is still used today.

Anabel believes that the archaeological record of the Maya includes the study of the environment in which they

Anabel Ford revisiting "La Brecha Anabel." Yaxha, Petén, Guatemala, 2006.

lived, and her focus is on how we perceive the forest.[46] She runs the El Pilar Project, an extensive archaeological site that straddles the border between Belize and Guatemala, thirty-two miles east of Tikal. "I'm calling it 'archaeology under the canopy,'" Anabel told me. "It's a more holistic approach to archaeology. Besides presenting the ancient culture at the site, I want to integrate the local community and preserve the contemporary culture as well as preserve the forest garden. You won't find what I'm doing anywhere else along La Ruta Maya, mainly because most archaeologists clear-cut a site before reconstructing the ruins.

"The Spanish tried to chop down the home gardens and farms when they started laying out their cities in the 1500s. There's a famous town ordinance issued in 1552 by Tomás López Medel that wanted all the houses close to one another without any big gardens. They'd allow fruit trees, but everything else was to be razed—they didn't understand their value.[47]

"Europeans are so culturally conditioned to think a carefully plowed field is beautiful and proper and good that it takes a while to see another system, let alone accept it. Well, here's the thing. We separate nature from culture, but in the tropics they are conflated—the Maya integrated agriculture into their broader system. They've been managing diversity and allowing it to happen for several thousand years, and their methods supported areas with populations three to nine times denser than today. In spite of the high density, there's no evidence that the Maya caused any mass extinctions of species or that species diversity or richness was diminished. More than 24,000 plants have been identified in the region, 5,000 of which are endemic. Interestingly, plant diversity in the tropics is often lower where humans have lived the longest—less in Africa, a little higher in Indo-China, but the Maya tropical forest is the second most diverse area on earth after the Amazon basin. It's ideal for many animals, birds, reptiles, and other life. For example, over two billion birds pass through during the peak of winter migration."

Anabel wanted me to see Tzunu'un, an ancient Maya residential neighborhood at El Pilar. She'd partially cleared and consolidated the single-family residential compound of five buildings erected around a courtyard—although only the footprint remained of some buildings. She'd also partially reconstructed two thatched roof huts on the platforms of the northern buildings, with an example of a whitewashed *coloche* (wattle-and-daub) wall. Another building would have been the storage/kitchen, while one was for sleeping. The eastern building was a low mound with terraced steps leading up to the stone footprint of what was once a private family oratory. A mound was all that remained of the western building. The southern building was more substantial. Four wide stone steps led up to two rooms. Parts of the walls still stood, as well as four wide stone benches. Anabel explained that this building was probably for receiving guests, like a present-day living room. In Maya art we see people sitting on similar benches.

We sat down. I leaned back against the stone wall, which was cool and refreshing on a hot afternoon. I closed my eyes and tried to visualize the room when it had been in use, with smooth plastered walls painted in primary colors, a corbeled arch ceiling, and animal skins on the benches. It would have been clean and sumptuous.

"Can you imagine the gardens around this compound?" Anabel asked. "We're here in an ancient Maya monument, and it doesn't feel any different to me than if we were sitting in one of your Maya friends' yard in Yucatán. Things haven't changed much. They have handy what they need. And they don't just have one thing—they have their medicine, their construction repair, their herbs, and their fruits. And their neighbors around them—you can see the other mounds in the distance—would also have herbs handy, fruits handy, construction repairs handy. The Maya supported a population far greater than today's, without the intensive cultivation of a single crop, and without plowing or extensively clearing the land.

"I think the ancient Maya had edible and regenerative root crops as well as home gardens, domestic, and cover crops. Then they had fruit, ornamental, and shade trees. The taller ones were managed foliage, and many are nitrogen-fixing legumes. And then at forty feet and above you have the emergent hardwood trees and palms. I think we can call the Maya Forest today a feral forest garden—it was once domesticated and now most of it's wild.

"But there were limits to what they could produce. The projections you hear exaggerate the reality. They're too high. Most estimates use 5.5 people per house in preindustrial societies, and I have no problem with that. But as you know from living with the Maya, each family has several structures—one for sleeping, a separate one for the kitchen, another one for corn storage. We're finding the actual average for the ancient Maya is 2.5 structures per family."

Anabel added: "When I walked from Tikal to Yaxha, I felt the places where the Maya lived and where they didn't. If you walk in the uplands with well-drained good soil, you see lots of these house mounds. When you walk into lower-lying areas, with hard earth, scrubby looking plants—there aren't any house mounds. So you realize the forest wasn't a seething sea of humanity, it's not two hundred structures per square kilometer everywhere, only where it's appropriate, and even then it's only forty to fifty percent of the terrain."

When I asked Anabel about the collapse, she brought up the hypothesis of environmental degradation leading to food shortages. Without accepting the premise, she asked me: what if there were food shortages, but for a completely different reason? She had noticed that most pottery samples from the Petén, starting around AD 600 to 700, had volcanic ash as temper in the pottery, and it continues to show up for nearly two hundred years. What if this indicated sustained volcanic eruptions in Mesoamerica? Volcanic ash is an excellent fertilizer. If eruptions deposited volcanic ash on the Petén, it would have increased crop yields. Once the volcanic activity ceased, crop production would decrease to earlier

levels. "I think it is important that we investigate all the lines of evidence, rather than making any assumptions."

Scott Fedick was working in the Yalahau wetlands region of northeastern Quintana Roo when Anabel introduced us. He is professor of anthropology and archaeology at the University of California at Riverside (UCR), one of the editors of *The Lowland Maya Area: Three Millennia at the Human-Wildland Interface,* and the editor of *The Managed Mosaic: Ancient Maya Agriculture and Resource Use.* I asked him if he thought environmental degradation led to the Maya collapse.

"I find it difficult to accept," Scott said. "Although the Maya weren't ideal farmers, they were very good farmers and knew how to manage their land. I think sometimes they had problems on a local scale, but they seem to have figured out what to do—changed their strategies and handled their resources very successfully. We've discovered local problems and we've seen local responses to the problems, and there isn't widespread evidence to suggest it all fell down around their ears at once, across a very large area. One question is how the Maya were able to maintain soil fertility and how they possibly repaired areas that might have suffered problems. And we've discovered something very interesting.

"In the wetlands where we're working there's a thick biomass mat called periphyton. It's mainly made up of about five or six species of algae, then a lot of different kinds of bacteria, and all kinds of little microorganisms. It's a huge biomass, and several species of the algae that make up the periphyton mat produce huge amounts of nitrogen and phosphorous in plant-available form. It's basically a super biofertilizer. In the wet season, the periphyton grows like mad, then in the dry season it dries out like a crust. Most of the organisms are just in stasis, and when the waters come back, they start growing again. So you can either harvest the mat, or you can harvest the dried stuff, or you can harvest the soil.

"Because it's in the wetlands, you get the development of a layer of this thick organic, almost peatlike soil that's super high in nitrogen and phosphorus. Some colleagues of mine up at UNAM [National Autonomous University of Mexico] have done greenhouse experiments, and it works as well as any modern organic fertilizer. In fact, you have to use just a little bit because it's so concentrated. A chemical ecologist at UNAM got interested in doing the chemical ecology of the periphytons because she was looking for toxins. In a lot of the wetlands you only find a small number of species of plants growing, so it usually means something in there is producing a toxin that prevents many species from growing. But it wasn't the case here, and what we've been doing is taking bulk soil samples from what we think are ancient Maya garden areas, looking for little teeny mollusk shells of aquatic species who feed on the periphyton. And we've been finding them in ancient Maya settlement areas.

"One of my graduate students, Beth Morrison, did part of it for her dissertation work. We took soil samples starting at the wetlands, going across about three and a half kilometers, then moving into an ancient settlement and out beyond it. She looked at all of the species of little mollusks that came out of these soil samples—of course there are hundreds in the wetlands or the wetland edge that floods. Away from the wetlands we got into areas where there weren't any aquatic species represented at all, but when she investigated an ancient Maya settlement, she started picking up aquatic species of mollusks again. And it's hard to come up with an alternate explanation for how these microscopic aquatic mollusk shells got three and a half kilometers from the closest aquatic environment, and into the middle of an ancient Maya settlement, unless they were transported there with the soil or the periphyton."

"But what about the evidence of droughts?" I asked. "Jared Diamond mentions them in *Collapse.* Even with a great fertilizer, without rain, you aren't going to have a crop."

"Hmm," Scott said. "One problem I have with these studies is that they were intended to track major long-term events. Even if there was a significant decrease in rainfall, such as in the southern Maya lowlands in the Terminal Classic, we don't know how it translates into impact on their agricultural system. It doesn't necessarily mean that it lengthened the dry season, so it may not have had much effect on agriculture. In some ways a little less rain might have been better—less weeding, for instance. So I'm not convinced by this interpretation of the evidence for drought having such a severe impact on the agricultural systems."

"In villages today," I said, "the Maya refer to certain foods as famine foods, such as *macal* [tannia, *Xanthosoma sagittifolium*], *ramón* [breadnut, *Brosium alicastrum*], and *camote* [sweet potato or cultivated yam, *Ipomoea batatas*]. They're known as crops that might be relied upon when others fail in times of drought, hurricanes, or plagues."

"Exactly," Scott answered. "We're finding some very drought-resistant plants in home gardens, particularly those in the Euphorbiaceae [*Euphorbia*] family, such as chaya [*Cnidoscolus chayamansa* and *C. aconitifolius*], manioc or cassava [*Manihot esculenta* and *M. utilissima*], and physic nut [*Jatropha curcas*]. The Precolumbian Maya would certainly have been prepared for drought conditions and weren't dependent on a single crop; they harvested a variety of crops year-round. A drought would affect yield, but the array of foods they were cultivating would be a buffer against starvation.

"I've been reviewing all the ethnobotanical literature on the lowland Maya and have compiled a list of over 500 species of indigenous food plants the Maya are known to have used in recent times—and the list is still growing![48] A lot of other indigenous plants are edible, but we don't know if the Maya used them in the past. Corn was undoubtedly important, but I think archaeologists have overstressed its importance. Characterizing it as synonymous with Maya diet is like saying Americans eat only hamburgers. I think maize could very well have been more of an elite food, particularly during the Classic period. You see it depicted in their iconog-

raphy and art, related to their gods, and usually only a rare and valued food would get that status. Corn is very hard on the land, and I think the more the Maya had land shortages, the less practical it was to grow it as a subsistence base. Corn became a status food, such as Kobe beef today."

"Nearly everyone," I said, "thinks of the Maya as corn farmers. But corn farming requires clearing the forest on a regular basis. If you're using a stone axe, you might want to weed existing fields or come up with another agricultural model that isn't as difficult."

"Yes," Scott agreed. "There is a big difference in technology between stone axes and machetes. I think that before European contact the tendency would have been to cull and clear a patch of land selectively and establish fixed-plot agriculture, in part because they didn't have machetes to clear and reclear, and secondary growth is actually a lot harder to clear than primary forest. I think the landscape outside the garden city would be a patchwork of cleared fields and a great variety of plots in various stages of controlled and productive regrowth. My guess is they'd start out similar to today's milpas, but maybe with more attention paid to leaving economically valuable trees within the plot. Today in some areas you see cleared milpas where many trees have been severely pruned rather than cut completely down, which allows the desirable trees to regenerate. I'm suggesting, and Arturo [Gómez-Pompa] and others have too, that the milpa would represent the first stage of controlled productive regrowth. And farming techniques certainly would have varied across the landscape in accordance with local population levels and resources.

"So they'd have raised some corn, but not on a large scale. Not until after the conquest, when they were more mobile and fleeing the Spanish, and there wasn't a shortage of land either. Slash-and-burn farming is often called shifting cultivation, and people who do it are often moving around a lot. In a disrupted society when people are changing location or even fleeing, swidden farming is actually a pretty good adaptation. But if you're living in one place with a lot of neighbors, corn farming isn't a good agricultural strategy."

"But what about Landa's observations," I asked, "that the Maya had home gardens and milpas—just what they have today? And Landa mentioned that they suffered from frequent famines if their corn crop failed. He certainly suggests that the milpa was their farming technique before 1492."

"By the time Landa arrived," Scott replied, "there had already been a very significant die-off of the Maya population, relocation of survivors, and destruction of long-established agricultural plots, particularly orchards. I believe it is Landa who mentions that a strategy of the conquistadores was to burn Maya orchards, which caused them much distress."

"So even though Landa was in the Yucatán only twenty years after the Spanish conquered the Maya," I said, "the effects of the Spanish, especially disease, had spanned seventy years and several generations. Thus his observations might have been correct for the moment, but skewed by so many disruptions?"

Scott Fedick searching for Maya rock alignments in savanna wetlands. Yalahau, Quintana Roo, Mexico, 2009.

"Exactly," Scott said. "Before the Spaniards arrived, land would have been at a premium. The Maya could afford to invest time—their labor—in more efficient production. But by Landa's time, so many Maya had died, and labor was scarcer than land. Farming could have regressed to the simplest and quickest way to produce a crop. And the Spanish required corn as a tribute, so they had to plant a lot of it."

"But what about some of the studies from bone samples of the ancient Maya that suggest that corn was contributing a large amount to their daily caloric requirement?"

"There are a lot of recognized problems with the interpretation of the isotopic data for C_4 plant consumption. One is that corn is not the only C_4 plant in the probable diet—there are about 7,600 species of plants that use C_4 carbon fixation. Another is that the C_4 signature is passed through the food chain—so animals that eat C_4 plants can pass it along to humans that eat their meat. There are also sample problems with the subpopulation tested."

"So you're suggesting the ancient Maya may have been much less reliant on corn?" I asked.

Scott nodded. "I think home gardens played a very important role and could have supplied a majority of the food. If

you look at places in the tropics like Java, which has some of the highest population densities in the world, they supply about ninety percent of their food from home gardens on plots between a quarter and a half hectare [one hectare is 10,000 square meters or 2.47105381 acres] of land."

"Which is about the same size as home gardens here today."

"Yes, and the same size we know from the Classic period. Combined with various kinds of outfield agriculture and forest management and forest gardening, they could have had a pretty sustainable system. They certainly raised corn, but nothing like the eighty to ninety percent of their diet that [Sylvanus] Morley suggests in *The Ancient Maya*."

"But it's probably what people ate in Morley's time," I said. "When I arrived in Yucatán, almost everything we ate and drank was connected to corn. So what do you think the ancient Maya raised in their home gardens?"

"Ramón, root crops, macal, manioc—we've got remains of manioc and other tubers going back to some of the earliest agriculture in the Maya lowlands. Also chaya, which is extremely nutritious, extremely productive. It could have been a very important food resource. We know the Maya domesticated it, but it doesn't leave much archaeological evidence. Another thing that distorts the role of corn is that it's highly visible in the archaeological record. Corn has very distinctive pollen that preserves very well; you can tell domesticated corn pollen from any other grass. When the cobs are used as fuel the carbonization preserves very well. Whereas with a leafy plant like chaya, you don't roast it, there are no durable parts to preserve. I don't believe you can tell the pollen from the wild versions; in fact, the domesticated version doesn't produce very much, because it mainly reproduces vegetatively. The same goes for the rest of the root crops; it's very hard to identify them in the archaeological record. Corn stands out in the archaeological record because we find it everywhere."

"What about fruit trees? Would they have had fruit trees like you find today? Avocados and . . ."

"Oh, yeah!" Scott excitedly told me. "The Maya Forest has more food-producing trees than any other known forest in the world. And we're finding that the ancient Maya probably domesticated a huge number of fruit trees. We're just starting to work with this. Nisao Ogata, a professor at the University of Veracruz in Xalapa, is one of the first to really look at domestication of fruit and nut–producing trees in the Maya zone. Up until now we've thought the heavy concentration of useful plants and trees had been through human selection—we never suggested they'd actually domesticated them, just cultivated them. It is going to be very interesting to follow his research."

"One thing I've noticed in the home gardens," I said, "is that when someone has a lime tree, it's the best lime tree. And if they have a *guaya* [kinep, *Talisia oliviformis*] it has the best-tasting guayas—if not, they cut it down and plant another. So you have this constant selection within each house garden of the best . . ."

"Exactly," Scott interjected.

"And spread across a village and throughout the peninsula."

"That's how you get domestication," Scott agreed. "You find trees here in the northern part of the peninsula that botanists say shouldn't be growing here because it is much drier than in the southern lowlands. And yet you have basically the same species—a different ratio—but still a lot of them. Arturo's one of the first to suggest that the ancient Maya probably brought them here to cultivate in their home gardens, and today you see the remnants of ancient home gardens. It really is a feral forest garden."[49]

"What is the difference between cultivation and domestication?"

"Cultivation refers to the promotion of plant growth by humans—weeding, watering, removing competitors, et cetera. Domestication is the process by which humans, through sustained selection, actually change the genetic makeup of a population so the 'domesticated' population differs significantly from the wild population. Domestication occurs along a continuum, so it's not always readily apparent when a plant has been domesticated. Very likely, a lot of trees, as well as other plants, were actually domesticated to some degree by the Maya. This is an area where research is really just getting started, with the potential to alter our perception of the relationship between the Maya and the forest profoundly."

"Because of this, it's really important to save the traditional, sustainable mosaic of forest farming and home gardens. This mosaic, with local Maya forest gardeners, is the true Maya Forest. Any plan to save the forest without them would be crazy. Look, they managed their forest, feeding larger populations than today, and preserved biodiversity over millennia. The Maya were and still are an amazing culture. There is much practical knowledge we can learn from Maya agriculture and forest management, both ancient and modern, that can be applied to help save the real Maya Forest—a forest with people."[50]

Arturo Gómez-Pompa, Scott's colleague at the University of California at Riverside, found that a series of small patches of tall forest in northern Yucatán, first identified as the original climax forest, was probably planted by the Maya to concentrate and protect useful plants. Called *pet kot* (circular wall of stones) after the old stone walls surrounding some patches, these managed seed banks help explain why there's no evidence of mass extinctions of species even in areas of intense use and high population density during the peak of the ancient Maya.[51]

Gómez-Pompa doesn't believe that the collapse of the Maya culture was triggered by an ecological catastrophe brought about by poor management of the environment; indeed the best way to undertake tropical forestry is by following their example. Today we are failing to maintain the bio-

logical diversity left to us by former generations. What were the biological and ecological conditions that permitted the conservation of all the living things in these regions? Why do we neglect the knowledge and experience in resource management techniques of local cultures? The knowledge of the traditional Maya is a key to decipher the past and perhaps a path for the future of all of us — as Winston Churchill suggested, the farther you look back, the farther you can see ahead. Gómez-Pompa proposes that traditional knowledge be recognized as generations of scientific fieldwork and that tried-and-true indigenous techniques be included in all management policies from now on.[52]

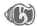

Anabel Ford told me that I had to meet a friend of hers who was a Maya forest gardener practicing a Maya technique of agroforestry. She was emphatic enough that I flew down to Flores, Guatemala, to meet her. She drove over from Belize and picked me up at the airport, alongside Lake Petén Itzá, the deepest lake in lowland Central America. Flores was originally an island city called Noj Petén, where the last Maya kingdom fell to the Spanish in 1697. The lake still bears the name of the Itzá, who claimed to have moved here from Chichén Itzá around AD 1300. This region is called the Petén, at the base of the Yucatán Peninsula. The area has hundreds of archaeological sites, and many consider it the heart of the Classic Maya zone.

Zacarias "Chaco" Quixchan lives in San Andrés, on the north shore, and traces his ancestors back to the Itzá, who did not welcome the Spanish when they arrived three centuries earlier. His farm is twelve kilometers outside of town, and his daughter Nineth drove out with us to show the way. On the outskirts were a checkpoint and a bar across the narrow dusty dirt road — the entrance to the Maya Biosphere. Recognized by the United Nations Educational, Scientific and Cultural Organization (UNESCO), it's the largest forest reserve in Guatemala, covering more than 21 million hectares (about the size of El Salvador) in northern Petén. The National Council of Protected Areas (CONAP), the government organization that protects the biosphere, has designated this entrance area a multiple-use zone within the reserve.

After passing through the checkpoint we came upon a *finca* (ranch) and a large sign near the gate announcing that we were entering the Valley of the Bulls, along with an impressive list of the varieties of cattle and horses raised there. We drove between large fenced pastures dotted with herds of cattle and a few remaining trees that hadn't been cut down. Military officers or families from the capital owned most of the fincas we passed. The road headed straight north. This initial area was the buffer zone for the reserve. We took a rutted track off into the beginning of a forest and drove for two kilometers until we reached a grove of allspice trees.

Chaco met us when we pulled in and parked next to stacks of freshly cut lumber from a cedar tree he'd just harvested. He welcomed us to El Triunfo. The smell of the saw-

dust was sweet and hung in the air. Just beyond were several rough board buildings, including a kitchen, a sleeping area, a henhouse, and a covered crib full of corn in husks. The ears were stacked vertically, layer upon layer, packed tight within the wooden walls; only the ends of the husks protruded.[53]

Chaco suggested that we tour his farm before the morning got any hotter. As we followed a trail, he pointed out plants and trees, giving their names and uses, and told us that the soil on his farm wasn't uniform — some was better and some even swampy, so he planted accordingly. He led us to a clearing where he'd planted his milpa. It was different from the Yucatecan milpas I was used to — he could plant his field in rows because of the lack of limestone outcroppings. Chaco explained that right after burning his field he first planted pumpkins, melons, and squash as a ground cover. Then he planted rows of bananas and papayas and between these planted heirloom varieties of corn and beans, tomatoes, chiles, macal, jicama, okra, chaya, amaranth, pineapples, yams, and other fruits and vegetables. He claimed that he had something to harvest every month.

I pointed to a seedling. "Is this an orange tree?"

Chaco grinned. "That's the next phase of my garden. The first phase is annual vegetables and fruits that grow quickly and abundantly. But I'm also planting rows of fruit trees between each row of bananas and papayas. In three or four years the fruit trees will start producing and I'll stop planting vegetables. I have four varieties of citrus, and I'm also planting avocados, allspice, *caimito* [star apple, *Chrysophyllum cainito*], *saramuyo* [sugar apple or sweetsop, *Annona squamosa*], *mamey* [*Pouteria sapota*], a native and a nonnative cherry, *annona* [custard apple, *Annona reticulata*], *guanábana* [soursop or custard apple, *Annona muricata*], guayas, mangos, coconuts, *nance* [craboo, *Byrsonima crassifolia*], tamarind [*Tamarindus indica*], and achiote. Within a year of starting my milpa I'll add hardwoods such as mahogany, cedar, *ciricote* [*Cordia dodecandra*], and *malerio* [mylady, *Aspidosperma* spp.]. I'll plant them near the bananas because they shade the seedlings. Later, when they need light, I'll cut down the bananas. The productive life of my fruit orchard is around sixteen years. Then the hardwoods will start to dominate the garden and shade the fruit trees. The hardwoods are like a gift. In twenty-five to thirty years I can harvest them then start my milpa over. So you see, there are three stages to my garden. And I mix everything together; so if a disease comes, it might only affect one or two species rather than all of them. I can't afford a monoculture."

"How large is this garden?"

"Two and a half hectares [a little over six acres]."

"And is this your only garden?"

"Oh, no," Chaco said. "I own forty-seven hectares. I have several milpas in different stages, so I always have fresh vegetables. I'm not planting as much corn. Since I'm not selling it anymore, I raise just enough for my family."

"What's over there?" I asked, pointing toward a beautiful tall tree at the edge of the milpa. "Is that a hardwood?"

"No, its wood isn't that good," Chaco answered. "But the

Zacarias "Chaco" Quixchan with his grandson, at his farm. El Triunfo, San Andrés, Petén, Guatemala, 2006.

mano de león [lion's hand tree, *Chiranthodendron pentadactylon;* also called Mexican hand tree, devil's hand tree, and monkey's hand tree] is wonderful for the animals who love its flowers. For that reason I don't cut it down."

Before lunch, Chaco led us to a garden where the orchard was ten years old and the hardwoods already twenty feet high. He was pruning the lower branches so the trunks grew straight and tall—more valuable as lumber. He'd harvested a cedar the year before and used the money to buy 7,500 hardwood seedlings to plant.

We walked through an orchard, planted on a slope, which was thirteen years old. The trees were in rows, and the spacing looked exact. Chaco confirmed that he used a formula of six meters between rows by four meters between the trees within the rows. He explained that in thin soil the roots have to spread near the surface and need room. To help improve the soil, Chaco had left a layer of leaves and clippings as a green mulch after weeding and pruning. At the bottom of the orchard was a wide patch of bright green leafy plants with a pale underside. The patch looked beautiful as a breeze stirred the leaves, and I said so.

"It's *moxan* [*Calathea lutea*]," Chaco said. "I sell the leaves in town. Everyone uses it for wrapping their tamales—for birthdays, baptisms, weddings. Especially for Día de los Muertos [Day of the Dead] and Noche Buena [Christmas Eve]."

"People order them first, and then you cut them?"

"Yes, except for Día de los Muertos and Christmas, when there's such a demand that I know I can sell every leaf I cut. It's a great plant because it grows back so quickly."

"Do you notice how damp it is here?" Anabel asked me. "Chaco takes advantage of a swampy area that most farmers consider marginal or worthless and finds the right plants and profits from it."

"I also have ceiba trees planted along here," he said. "They love water, and they're a magnificent commercial wood for plywood. They'll actually give me a lot more lumber per tree than cedar or the other hardwoods, because they grow so fast and they have a huge trunk. So I've planted them here."

We crossed the swamp on a trail. A wooden plank bridged the stream that ran along the bottom contour of the land. Chaco led us through another patch of moxan, past a line of two varieties of ceiba trees, into a small orchard of a local cherry called *manax* (*Pseudolmedia* sp.), nance, and 200 mahogany trees, then through another orchard to his nursery, where he was growing seedlings in raised beds.

"The forest is my schoolroom," Chaco explained. "It's where I find reality. I've had professors visit and tell me what I'm doing here shouldn't exist, but I'm doing it. I watch, and the forest teaches me everything I know. I realize my gardens are my retirement—also a legacy to leave my children. They'll never be hungry, and the forest is a continuous source of information and wealth."

On the drive back to San Andrés, Anabel and I talked about what we'd seen. "I liked what Chaco said about his gardens and his children," I said. "In that sense, the Maya Forest is a legacy forest."

"Exactly," Anabel said. "The more we know about the traditional Maya Forest garden practice, the better we can interpret the land use of the ancient Maya, because it holds the

secret of how the Maya balanced conservation and cultural prosperity. They had high-performance milpas like Chaco's, where the fields are never abandoned even when they are forested — they still receive his care. The technique you saw here was once practiced throughout the Maya area. Chaco has updated it by including plants such as banana and citrus that were introduced after the conquest. What impresses me the most is how he structures the nature of succession — what grows and what doesn't grow, what he plants, what he doesn't plant. Sometimes he allows specific volunteers and excludes others. He allows competition in early phases, such as a nonproductive shade tree, then eliminates it when it no longer serves his purposes. He orchestrates succession so it is an ongoing process that's inevitably evolving. He's increasing the soil fertility and the diversity of useful plants. He's a practical ecologist — as opposed to the theoretical ecologists I meet in academia."

"When you think of the great gardens of the world," I said, "most were created by an inspired individual over a relatively short period. But the Maya Forest garden is a story that spans hundreds of generations of gardeners — incremental and subtle changes — the *longue durée*. It's also very practical. The ancient Maya cities would've needed a constant supply of hardwoods for building projects. Without beasts of burden, they had to carry everything themselves, so they'd want the source as close to the destination as possible. If the Maya had cut down their forest as some people hypothesize, you're not going to have any lumber at all. But for three thousand years the Maya were building their big cities, and it makes sense that their forest gardens provided a constant source of hardwoods as well as crops of fruits and vegetables."

"Look at some of the Classic temples nearby at Tikal," Anabel said. "Some of the biggest hardwood lintels date from right before the abandonment. And today in Yucatán some of the best hardwoods are in village home gardens."

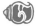

Before driving to Belize, we rented a boat to visit Mark Brenner and David Hodell and the crew from DOSECC (Drilling Observation & Sampling of the Earth's Continental Crust), who had built a floating drilling platform over the deepest part of Lake Petén Itzá.

We arrived right as they were pulling up a core sample. After getting a safety briefing and putting on hard hats, we watched the crew carefully open the casing to reveal a ten-meter-long plug of the lakebed. This was then cut into smaller sections and placed in PVC (polyvinyl chloride) pipe to be shipped to the University of Florida to be analyzed. Each container was coded so that they'd know its depth and place in a continuum of data that they hoped spanned many millennia, back to the Pleistocene.

As I drove Anabel's truck back to Belize I asked her what the pollen analysis showed. I knew that their studies helped reconstruct past changes in the earth's climate and could show broad changes over time, but they'd also been cited by

archaeologists who claimed that the Maya had precipitated an environmental catastrophe, leading to the collapse of Maya civilization and the abandonment of Tikal and other cities throughout the Petén. It had also appeared in popular literature such as Jared Diamond's *Collapse*.

"I have papers that Mark and David wrote along with three other scientific colleagues," Anabel answered. "They all examine the last 9,000 years and will give you an idea of the work they are doing."

"In the basal part of the sequence," Anabel summarized as I drove, "pollen of the Moraceae-Urticaceae group dominates, indicating the presence of tropical forest during the early to middle Holocene, around 6600–3600 BC. They say that the relative abundance of pollen of high forest taxa declined beginning around 2000 BC, indicating climatic drying or perhaps initial land clearance. They claim that their data show deforestation by prehistoric Maya with forest regrowth following the Classic Maya collapse, around AD 900, as reflected by a relative increase in Moraceae-Urticaceae pollen."

"Wait a minute," I said. "It sounds as if they began their study accepting the hypothesis that the Maya created an environmental problem as a given, and then they say their data confirm it. The archaeologists who believe the hypothesis are using the pollen research as proof of extensive deforestation. But it's still a hypothesis, awaiting proof, rather than a theory, right? No one has proved there was widespread environmental degradation."

"You've got it," Anabel said. "It's a tautology rather than a fact. We look at the same data and come to different conclusions. High-resolution sediment core samples from the Cariaco Basin, supported by core data from the Petén, show a period of climatic instability, with wildly fluctuating rainfall, both droughts and floods, between 4,000 and 3,300 years ago."

"Part of the El Niño phenomenon?" I asked.

"So they say. It's something we are seeing today. Because of these fluctuations I think the ancestral Maya foragers in the area responded by relying more on farming techniques and less on foraging. That process would have been highly creative with a lot of failures under very tough times. This eventually led to permanent settlements and the foundation of Maya civilization as well as the intensively managed high-performance milpa system we call the Maya Forest garden."

"But others are saying that the pollen count shows major forest disturbances and environmental degradation."

"Indeed. However, there's a major problem with current models that equate the rise and fall of Moraceae pollen in the Petén with the rise and fall of the surrounding tropical forest. The core samples only measure wind-borne pollen, and that means 98 percent of forest species are missing because they are pollinated by birds, bees, and bats."[54]

"You're kidding! They're identifying only 2 percent of all the forest pollen?"

"Actually it's really hard to know how much because a lot of the pollen can't be identified."

"Seriously?" I asked. "So their hypothesis is based on

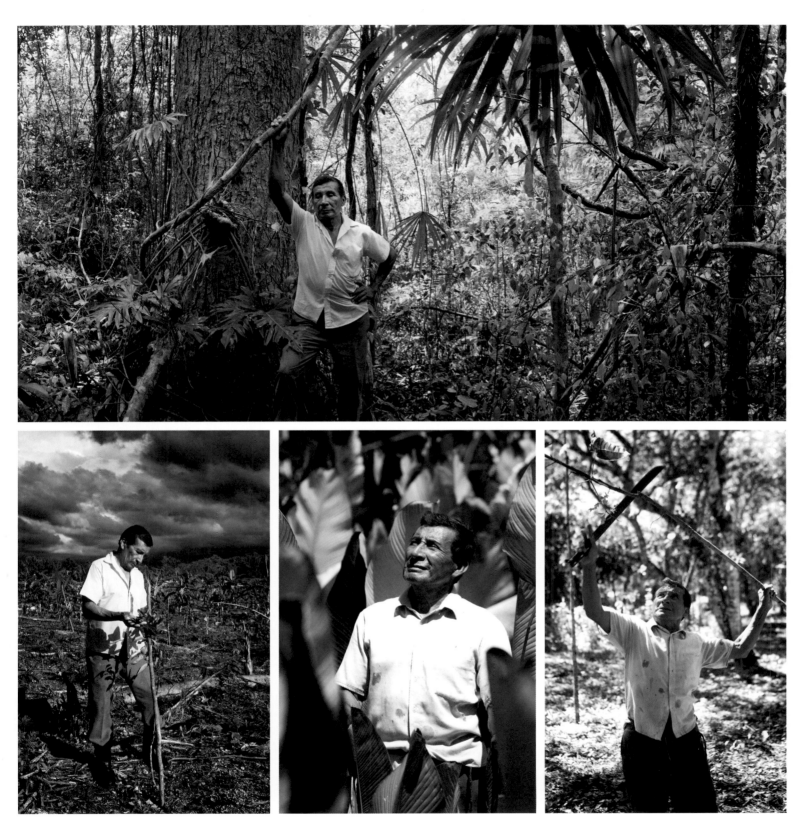

CLOCKWISE FROM TOP: Zacarías "Chaco" Quixchan, at his farm; trimming a branch from a young hardwood tree so that the trunk will grow straight and true; in a field of moxan; checking a citrus tree in his milpa. El Triunfo, San Andrés, Petén, Guatemala, 2006.

identifying less than 2 percent of all forest species, and from this they assume Maya agricultural practices led to environmental degradation? Even 3,500 years ago?"

"The core samples provide an excellent record of windborne pollen, but they can't record the existence of managed forests or even the majority of economically important plants. I think they can show a general human-forest relationship, and this is where I disagree with some of my colleagues. Looking at the same data, they see a deforested landscape and I see an increase in the open stages of the milpa cycle."

"But what about the buildup of clay found in the Petén Lake core samples that began 4,000 years ago? Isn't that being used as evidence there was widespread deforestation?"

"Yes it is. And if it was a unique event, it would be more convincing. But when you look at the core samples, you find several other instances of rapid clay intrusions long before humans were on the scene — 84,000 years ago, 55,000–50,000 years ago, and 24,000–17,000 years ago. I think it could be an indication of severe flooding from the period of climatic instability like the one I mentioned about 4,000–3,300 years ago. It may only be a coincidence that humans were beginning to occupy the area, and at the time of most of the latest deposits there wasn't a significant human presence. I don't think it is a reliable measure of deforestation by humans, especially since its onset and duration coincide with the growth and development of the Maya civilization."

"If you subscribe to their hypothesis, how were the Maya able to develop the greatest and longest-lasting culture this hemisphere has ever seen?"

"A very good question. I don't know. I also find it interesting when people such as Jared Diamond suggest that drought could have caused the collapse. If you look at the record, the weather was relatively stable at the end of the Classic period — nothing compared to what you see before 1000 BC and after AD 1200. The research I'm doing at El Pilar, looking at residential areas and the potentially cultivable landscape, shows that the Maya could have sustained their population levels even during a drought.

"I think the problem is people's perception of slash-and-burn. Even though the Maya have used fire as a management tool for thousands of years, people consider it destructive. Yet agroecologists assert that it is the best adaptation to the tropics. Still, you might as well say rape-and-pillage."

"Why not use 'select-and-grow' instead of 'slash-and-burn'?" I suggested. "After seeing Chaco's fields, I think it's more accurate and defines successive phases of the high performance milpa and regeneration, because the Maya are choosing what they keep or plant and actively protect and promote the growth of what they select."

"If we used 'select-and-grow,'" Anabel said, "it would reflect Chaco's technique of encouraging a tree when it is useful, such as when it provides shade for seedlings, but then cutting it down when they need the sun. It's a very practical system for selecting useful plants and trees. The forest, instead of being devastated, is in better shape and continues to grow. The Maya didn't farm a monoculture. They adapted their farming techniques to the varied topography, geology, and ecology — they had more than seventy domesticated crop species. I'm working with Ron Nigh, an ethnologist in Chiapas, and we think the Lacandon are another good contemporary example of the potential of milpa agriculture. They moved to eastern Chiapas from Yucatán in the late seventeenth or early eighteenth century, and there's no indication of biological or edaphic degradation. Ron has been living and working with them and has observed a degree of intensification rarely noted in the recent historical record. It provides an example of what the Maya commonly practiced in the past. The Lacandon have no problem with succession — we see a rapid regeneration to desirable tall secondary forest. It's a very sophisticated system that utilizes control of the seed bank, selective culling and burning, and aggressive weeding. They can eliminate bracken and invasive grasses so the succession is much quicker. If human interventions have functioned selectively to high-grade the species composition of supposed 'primary' forest to favor human needs over 5,000 years, then flora and fauna now recognized by conservation biologists to be endangered and in need of protection must have evolved under human management. If there's a mystery, it's the complex bio-systemic relationship between the forest and millennia of human interaction."

"But what do the pollen people say?" I asked.

I listened as Anabel read the report, but I had to stop her when they continued to find corn pollen after the abandonment.

"They actually say that? But there's no wild corn! Corn has to be planted by humans. It's impossible if they want it to support their hypothesis — it's a clear indication that the area wasn't abandoned."

"Well, Ron and I also think this is a problem with their hypothesis. And we have another question. Almost all the grasses they identify are the plants that appear in the milpa. It's easy to verify today. So obviously they are going to show up, but it doesn't indicate anything more than forest gardens."

"The Maya even use weeds for pest control," I said. "You know Francisco Rosado May's research with beggartick? It's considered an invasive weed. But if a farmer cuts it back every month it actually helps increase corn production, because the roots secrete a composition that destroys corn-sensitive nematodes and fungi."[55]

"Right," Anabel said. "You should expect an increase of grasses around houses and yards, but they're using this as proof that the forest was cut down. It could be that most of the grass pollen is corn. They often can't differentiate among grasses with only fragments. Maybe it's almost all corn pollen. Ron and I are proposing that the paleoecological data currently interpreted as showing that the Maya degraded their environment could actually show the opposite. The increasing dependence of the Maya on corn, rather than provoking deterioration, was actually coping with cli-

mate change. It was the underlying cause of the vegetation alteration reflected in the pollen record. We think there's overwhelming proof that the Maya gradually occupied and learned about their forest environment over millennia. Not only did the forest profoundly influence the Maya, but the Maya began to shape the forest too. The high proportion of useful plants in the contemporary mature forest in the Maya area is considered evidence for the anthropogenic forest garden. *Kanan kax* means well-managed forest, but it also means well cared for and learned from."

"So the pollen samples that show a disturbance in the forest could actually indicate a change — such as more fruit trees — rather than deforestation?"

"Absolutely. Everything points to pervasive disturbances but we think it shows fire, culling, and enrichment with species of economic value to humans. More data are emerging to support environmental continuity before and after the so-called collapse. Kitty Emory at the University of Florida — the same place as Hodell and Brenner — is looking at the stable isotopes in deer bones before and after the collapse to test the hypothesis of deforestation, and she's finding that deer are eating stable proportions of leafy plants and grasses during both periods. Casting further doubt on the notion of environmental degradation, Christine White, a bioarchaeologist at the University of Western Ontario, has discovered indications of habitual meat eating in her isotopic analysis of human bones during the same periods. You can't have this much protein without a healthy food chain."

"When the Spanish conquistadores arrived they were amazed at the abundance of game," I said, "and commented that they were so tame they seemed domesticated. I think you'd be hard pressed to support a hypothesis where you can go from an environmental disaster to the second most biodiverse forest in the tropics in such a short time. Instead of looking for outside factors for the collapse, I think there was a tipping point with the Maya when they no longer supported their royalty, who believed they were gods. The profusion of monuments, temples, and art during the Classic period came at a tremendous cost. Hubris, as much as anything else, contributed to the collapse. The Maya voted with their feet. They simply left. The period of the collapse in the Petén coincides with the florescence in Yucatán. Look at the colonial period when the Maya moved back and forth between the settled areas and Quintana Roo, the Petén, and Belize — it used to drive the Spanish crazy. Then, beginning in 1847 with the Caste War, hundreds of thousands of Maya moved around and resettled, and it continued into the twentieth century. I don't think things have changed that much. In Chichimilá I saw people leave when faced with a crisis. They could just pick up and carry their belongings on their back. They are incredibly self-sufficient and never owned much. The forest provided materials to build a new home and a starting point for farming."[55]

"They didn't *all* vote with their feet, because a lot of Maya stayed in the Petén," Anabel said. "But clearly something went wrong. I don't know if it was personal failure or politi-

cal failure. I would hope we come up with something that's testable."

"You could talk about the tremendous development all along the Caribbean coast," Scott Fedick told me. "You could mention the gated communities, the road building and the new highways going across the peninsula, the merchants with their stores full of foreign stuff, the huge influx of people and virtual settlements all along the beach, and the amazing amount of growth and activity — and you'd be talking about the ancient Maya during the Postclassic period! We're finding a strip of development that is virtually a continuous settlement all down the coast, just like today. But unlike today, as you move inland you find much bigger sites."

Scott joked that when he first started working in northeastern Quintana Roo "it was pretty much a blank spot on the map, with few known archaeological sites. It lies in a hurricane corridor so it's constantly getting pounded. Forest fires often follow the hurricanes. And then there are the swamps. It seemed like a perfect place to work."

The Yalahau region, west of Cancún and across the northern half of the Holbox fracture zone, covers nearly 3,000 square kilometers and includes 134 square kilometers of freshwater wetlands that extend south from the coast like long thin fingers. It's probably the largest freshwater system on the surface in the Maya northern lowlands, and the abundance of water is in stark contrast to the surrounding land. The area averages more than twice the average rainfall of Chichimilá or Valladolid, only thirty miles farther west. Since 1993 Scott and his students, and former students who have gone on to their own projects, have found and mapped nearly eighty archaeological sites. They've discovered that the area was heavily populated during the late Preclassic period (roughly 100 BC to AD 350) then abandoned. But nine hundred years later it was reoccupied during the Postclassic period, around AD 1250. Most of the earlier abandoned Preclassic settlements were rebuilt with Postclassic architecture, which meant that while the elite housing remained quite comfortable the new temples were smaller and more modest.

At T'isil, a Preclassic archaeological site with a Postclassic overlay, Scott may have found one of the highest structure densities, if not the highest, of any site mapped in the Maya lowlands — nearly 1,000 structures per square kilometer. In addition, Scott found hundreds of *ch'ich'ob* (rock and gravel mounds) that weren't included in the architectural count because they were probably agricultural features built up to support fruit trees and perennial shrubs. The Maya would throw their compost on the mounds as a mulch to hold moisture in the soil, so Scott often found pottery fragments — but that didn't mean anyone lived there.

I was able to join Scott in June 2009 while he was working in the Yalahau wetlands at El Edén Ecological Reserve. To reach El Edén, which Arturo Gómez-Pompa founded in 1993,

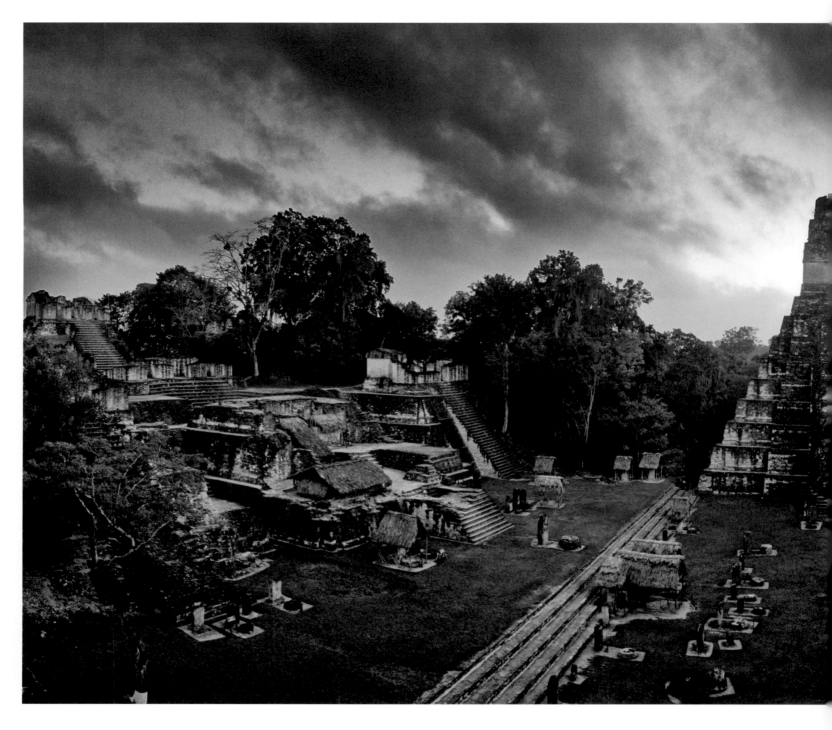

Sunrise, view of Temple I and Great Plaza. Tikal, Petén, Guatemala, 2006.

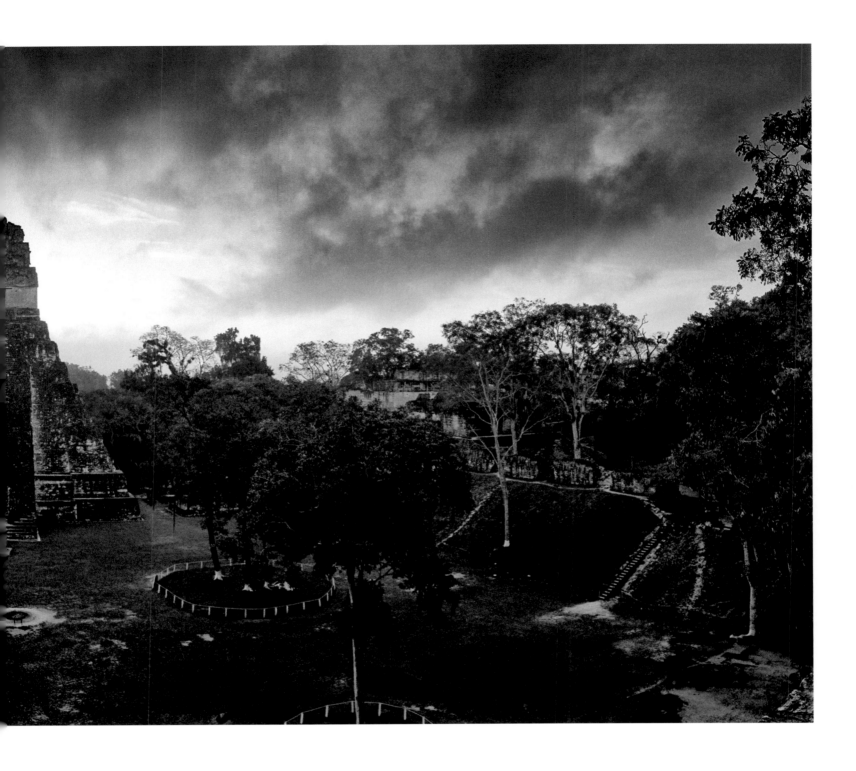

we turned off the Cancún-Mérida highway near Leona Vicario. For fifteen kilometers the road north was paved. Then we took a side road, little more than a trail widened to two tracks through the forest. It followed every contour, climbing over rocks and outcroppings that had never felt the blade of a bulldozer or road grader. Vegetation grew between the tracks, and the forest brushed against our vehicle. It took two and a half hours to drive eleven kilometers. We could have walked as fast.

El Edén encompasses 1,950 hectares of wetland and transitional forest—all the major ecosystems of the region. The reserve has the largest protected savanna in Mexico, and it floods during the rainy season. The water fluctuates about a meter between the wet and dry seasons. Scott is trying to discover how the Maya farmed the wetlands and whether the rock alignments he is discovering were a way to control water and soil movement. Scott and two graduate students were going to take elevation and water levels along a 600-meter transect line. Grabbing a machete, I helped Scott cut branches and trees so that they'd get a straight shot with their surveying instrument. A raucous flock of parrots landed on a tree nearby but took off as soon as they heard us.

"When I tell people where I work they think I must be really uncomfortable," Scott said as we were wading nearly waist-deep through a swamp, "but I think they'd be really surprised. As you can see, it's not bad at all. It's really pretty, there's a breeze nearly every day, and the water is pleasantly cool."

I had to agree. Cattails and sedges predominated in the open wet areas, and across the slightly higher ground were tasiste palms, calabash trees, and sawgrass. Botanical islands of *palo de tinta* (logwood tree, *Haematoxylon campechianum*) were dripping with epiphytes and orchids, and there were fingers of mature forest on higher ground. White puffy clouds streamed across the sky, suggesting afternoon showers.

Scott's remark reminded me that he and Anabel are members of a new generation of archaeologists. Not long ago most scholars from temperate climates were discomforted by the tropical heat, humidity, and omnipresent insects and reptiles, which probably contributed to their opinion of the tropics as a hostile environment, not conducive to producing a great civilization.[57]

"What are you finding here?" I asked.

"One thing I think we've learned," Scott explained, "is that what might look like wasteland to one set of eyes might actually be a very productive landscape if you figure out the right way to use it.[58] The Yalahau wetlands area has changed dramatically over the last two thousand years. It once supported a dynamic population, although today it appears empty and unlivable. During the Preclassic population boom around here, the water table was probably at least a meter lower. So the wetlands would've been very different. They probably didn't flood. But if the water table came up to where the soil just got moist, it could have been very good farmland.

"The Maya probably abandoned the area when the water table rose. But in the Postclassic period, when they moved back, the environmental record suggests that the water table was even higher than today. We're finding a lot of fish bones and fishing net weights in the middens, which seem to indicate the wetlands were permanent lakes. So the environment the Postclassic folks came back to was very different than it had been for the Preclassic. We have carbon dating from some sites showing occupation up into the 1600s, but we haven't uncovered a single European artifact. We are finding more evidence of a lot of movement of people over the past several thousand years, as conditions changed in the Maya lowlands."

"All this movement really interests me," I said. "We know that the Maya abandoned the Mirador Basin in the Petén around AD 150–200. You've found the Maya leaving northeastern Quintana Roo one or two hundred or so years later. Is our fascination with the 'collapse' in the ninth century because it's more recent and more dramatic because they stopped putting up big temples and stone monuments?"

"I don't know if one abandonment was any larger than the other in terms of how many people it affected," Scott answered. "The one at the end of the Preclassic happened in a lot of areas. We still don't know much about El Mirador other than that it was a massive site that today is very remote. Not much work has been done there."

"There were probably abandonments or shifts we aren't even aware of yet," I said. "Nancy Farriss believes that the archaeological record only hints at the number of flights, temporary or permanent, characteristic of the Maya whenever they are faced with crises. Today, for example, we're seeing the Maya leave their villages and move to the coast, or even the United States, because of a failure of political leadership. There isn't any work. Villages in Yucatán are just a shadow of what they used to be."

"Yes," Scott said, "and they're giving up the agriculture they used to do. Giving up the crops they used to plant. It's not because the environment is collapsing or they've overworked the land or anything like that. They've gone to work in Cancún."

"And they didn't abandon their villages overnight," I added. "It's more like a trickle. Not even noticeable at first. In the United States, Detroit would be another example. Because of the cumulative failure of business and political leaders, people abandoned a once vibrant regional center."

"Exactly. When archaeologists first recognize these collapses, our tendency is to think they happened all at once, very suddenly. But the more you look at the so-called Maya collapse, it's spotty. It's not all happening at one time, it's very uneven, and it's spread out over a hell of a lot longer time than we initially thought. People used to think the whole collapse took place within twenty-five years, at the beginning of the ninth century. I think we want to see it as an 'event,' and that's why we tend to think of things such as collapses and abandonments as catastrophic. We know

what Hiroshima looked like, what Dresden looked like—it is much harder to perceive a process stretched out over a long period.

"I'm impressed with the adaptability of the Maya in terms of the environment and their agriculture and making use of what's there. I think the more we learn, the more we'll find out how they were able to feed people under very different circumstances across the lowlands. It wasn't one kind of agriculture, it wasn't one kind of cultivation, and it wasn't one crop. I'd like to push the boundaries of our knowledge of how the Maya adapted to the environment and the changes in it.

"The Maya and their forest have a lot in common. They've developed and changed together over thousands of years. The Maya didn't battle the encroaching forest, they made it their own by cultivating it, modifying it, and learning from it. The greatest cultural achievement of the Maya has been their endurance. They've endured cycles of environmental change, political upheavals, wars, invasion, and mass mortality from foreign diseases, yet they're still around after three millennia. And they're still Maya. One thing I can't imagine is the Maya without their forest. Just as I know that their forest, as we know it, would not exist without the Maya."

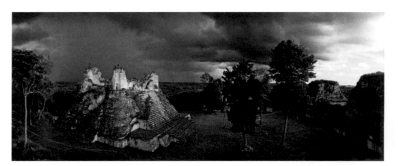

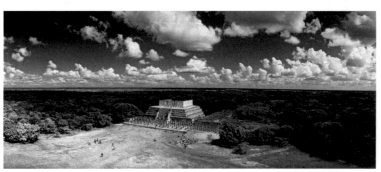

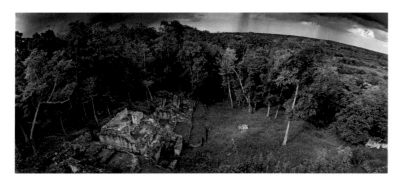

TOP: Becan, Campeche, Mexico, 1987.
CENTER: Chichén Itzá, Yucatán, Mexico, 1987.
BOTTOM: Becan, Campeche, Mexico, 1987.

10. Rice, Demarest, and Rice 2004:9. Part of the confusion is agreeing on the meaning of terms. "Scholars tend to talk past each other about what constitutes a 'decline,' 'collapse,' or 'transformation.' This problem becomes manageable only if we clarify these terms as referring to change in regional manifestations of Classic Maya civilizations, particularly political systems and political ideology. Perhaps the greatest problem has been that each group of archaeologists working on the highly variable Classic Maya polities have tended to project nature and processes in their own region of study as the universal model for culture change at the end of the Classic period" (Demarest, Rice, and Rice 2004a:546–547).

11. McAnany and Gallareta Negrón 2009:142–175.

12. Chase and Chase 2004:24–25: "The texts on Classic stelae and altars recorded predominantly political activity, neglecting other aspects of culture and history. Yet the extant Postclassic Maya codices indicate that Classic-era writing must have been used to record a much wider range of more practical information. None of the known Maya codices bear close resemblance to Classic monuments, as none record dynastic history. However (and contrary to popular belief), Long Count notation continued long after the ninth century in the lowlands (Tedlock 1992:247–248). The very striking examples of Postclassic art—innovative work that stressed different media than those generally favored in earlier eras—indicate that a vibrant culture still existed."

13. Masson and Mock 2004:367; Demarest, Rice, and Rice 2004a:558.

14. Many of the hallmarks of the Classic period "were in fact specific instruments of elite ideological and political power." Demarest 2004:277.

15. Sabloff 1990:123. Sabloff concedes that changes took place, such as no longer carving hieroglyphic inscriptions on monuments, but argues: "Still, as noted earlier, the overall similarities in site layout, architecture, religion, and probably sociopolitical organization far outweigh the differences. That is to say, Uxmal is as 'Classic' as Palenque."

16. McAnany and Gallareta Negrón 2009:164-165: "Finally, why is Western society so intrigued by the ancestors of contemporary Maya people and so willing to label one of their societal transformations a 'failure'? . . . we should consider whether the transformations that marked the end of divine rulership qualify as the apocalyptic collapse that some writers and movie producers want to suggest. Certainly, total systemic failure makes for a more dramatic plot-line, but with a descendent community of several million people, it is hardly an accurate assessment and is even denigrating to descendants who read that their ancestors supposedly 'died out' by the tenth century and that they are not related to the Classic Maya who built the cities—now in ruins—on which a mega-million dollar tourist industry has been built."

17. Webster 2002:188–191.

18. Demarest, Rice, and Rice 2004a:563–564. During the Classic period, major cities ritually sat the may, "a calendrical interval of 256 years consisting of thirteen k'atun cycles of twenty tuns (approximately twenty years) each, with each k'atun being seated in a subsidiary center within the may seat's realm . . . While generating great shifts in architectural investment and even in population distributions, the may-based political organization was inherently stable, having lasted from the Preclassic period up into Colonial times."

19. Wilson 1999.

20. Miller and Martin 2004: Chapter 4.

21. See Dobyns 1966; Mann 2005:92–133. After the conquest, famines became another killer affecting the Maya. "They caused exceedingly heavy losses among the Maya, with estimates running up to one-third or more of the population . . . the colonial system of supply, insofar as it functioned, did so generally without benefit to the rural, largely Indian masses, and often to their distinct disadvantage. Emergency grain shipments were destined exclusively for Campeche and Mérida, and the same held true for local supplies." Farriss 1984:60–64.

Malaria and yellow fever later swept through the Americas, killing both

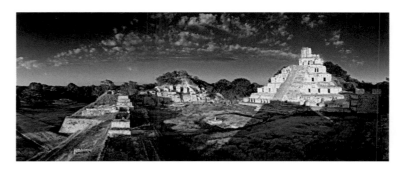

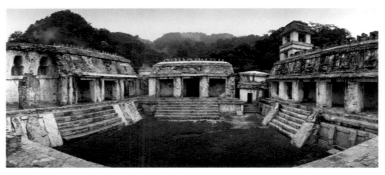

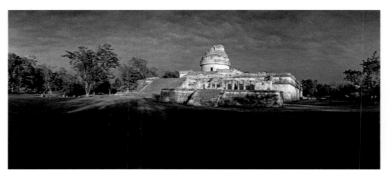

TOP: Edzna, Campeche, Mexico, 1994.
CENTER: Palenque, Chiapas, Mexico, 1987.
BOTTOM: Chichén Itzá, Yucatán, Mexico, 1990.

Spanish and Indians. They were introduced when the Spaniards brought over African slaves because there weren't enough Indians to do their work.

22. Cited in Mann 2005:93.

23. The linguistic family called "Maya" contains more than thirty distinct Mayan languages, including Yucatec Mayan. Montgomery 2004.

24. The first Spaniards to arrive in Yucatán were shipwrecked sailors who landed on the Caribbean coast of Quintana Roo in 1511. They were sailing from Panama to Santo Domingo, under the command of Pedro de Valdivia, and were shipwrecked near Jamaica. The few survivors drifted in a boat without a sail and were carried by the current to the coast of Yucatán. One account has thirteen survivors landing in Yucatán. According to Gerónimo de Aguilar, a sailor, the Maya who found them promptly sacrificed and ate five of his Spanish companions and enslaved seven (which leaves one unaccounted for).

Aguilar and another sailor, Gonzalo Guerrero, were taken as slaves. The two survivors couldn't have followed two more divergent paths. Guerrero was given to the cacique (chief) of Chactemal (Chetumal) and adapted to the Maya way of life. He tattooed his body, walked around nearly naked (from the Spanish viewpoint), let his hair grow, and had his ears, nose, and lips pierced. Guerrero rose from slavery to become a war leader and married Zazil, daughter of the chief. They lived in Oxtankah, located north of present-day Chetumal. Their children were the first Mesoamerican mestizos, the product of European and Indian blood. Guerrero is symbolically the father of all Mexicans.

Aguilar kept his Roman Catholic faith and didn't take a wife. In 1519 Hernán Cortés stopped at Cozumel, an island off the east coast of Yucatán, and was told by the friendly local Maya that two of his countrymen were being held captive on the mainland. Cortés sent envoys with beads for their ransom. Guerrero, who had a family and whose body was pierced and tattooed, chose to stay. Aguilar wept with joy when he was reunited with fellow Christians and soon provided invaluable service as Cortés's interpreter during his conquest of the Aztec. Díaz del Castillo 1956:43.

Cortés was unhappy that Guerrero did not show up and was thinking of going after him until Aguilar informed him that the people at his village had little gold. So Cortés instead bypassed the Yucatán in order to acquire land and riches for God, for his king and queen, and for himself. Two years later, on August 13, 1521, Tenochtitlan, the capital of Aztec Mexico, fell to Cortés.

It appears that Guerrero not only preferred to stay with the Maya but also chose to defend them from his own people. As the story goes, Guerrero was elected by the various Maya chiefs to lead the defense of Yucatán. He trained and prepared the Maya for warfare against the Spanish, and they resisted for more than twenty years. It wasn't until 1536, when Guerrero was reportedly killed while fighting the Spanish in Honduras, that the Maya lost ground. Francisco de Montejo the Younger established Mérida in 1542; within five years the political conquest of Yucatán was considered complete, although culturally the Maya conceded little to the Spanish.

Guerrero's Spanish contemporaries considered him a traitor and a sinner. "Guerrero sins only because he refused to abandon his wife and children, and because he respected and protected the culture in which he had chosen to live" (Romero 1992:14–15). The Spanish accused him of being evil and not being a good Christian, which led them to insinuate that he was really a Jew. Living among the Maya with a Maya wife was a "sin." With more than a hint of cultural arrogance, the Spanish could only ascribe the fierce Maya resistance to the leadership of a European rather than native chiefs.

Today a statue of a tattooed Guerrero holding the hand of one of his sons stands at Akumal, Quintana Roo. It looks east, facing the Caribbean and the sunrise. It is surprising that Guerrero's life hasn't been made into an adventure novel or film, in view of its cinematic qualities. His companions are killed or eaten, but he learns Mayan, gets tattooed, marries the chief's daughter, fathers the first Mexican, becomes a war chief and tactician for the Maya in their fight against the Spanish, and dies fighting his

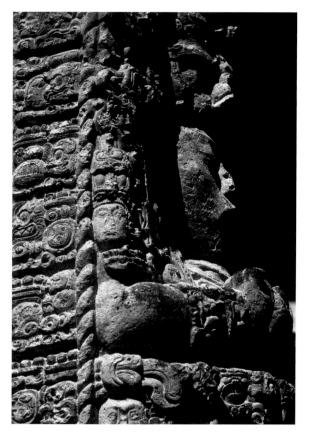

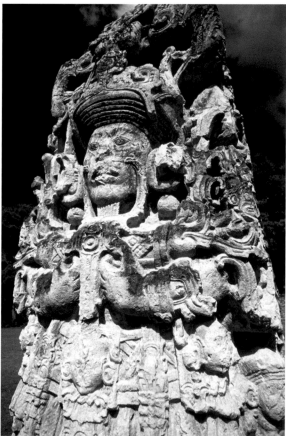

TOP: Detail, east side, Stela C, Ruler 13, Waxaklahun-Ubah-K'awil. Copán, Honduras, 1987.
BOTTOM: Detail, Stela B, showing Ruler 13, Waxaklahun-Ubah-K'awil. Copán, Honduras, 1991.

countrymen. Guerrero must have experienced incredible mental changes. He was the first European the Maya met. The Europeans had just come to the continent and knew nothing about the people or culture.

The year 1492 was momentous for Spain. For 800 years the Moors had been in the country. After the Arabs had conquered most of the Iberian Peninsula in AD 711, learning and the arts flourished. Muslims, Jews, and Christians lived and worked and worshipped in peace in Moorish Spain. At the turn of the millennium in AD 1000 Córdoba was the greatest and most cultured city in western Europe. The Spaniards, however, began *la reconquista* (the reconquest) to expel the Muslims from Spain. Especially in the south you can still find many town names ending with "frontera": the frontier between the Spaniards and the Moors was constantly changing. The Spanish were the only Europeans not to send soldiers to fight in the Crusades. They had their own religious war, which produced heroes such as El Cid. The centuries of warfare gave the Spanish a sense of identity and a common cause — their allegiance was to Spain and not to another culture or another religion.

In 1492 the last Moors were driven from Granada. A few months later Ferdinand and Isabella proclaimed that all Jews in Spain had to convert or leave, giving them only a few months to decide. The king and queen sought a Spanish unity based on religious orthodoxy and racial purity. The Spanish might have been ready to join in the Renaissance, but Ferdinand and Isabella based their actions on their faith and militantly headed in another direction. They initiated the Spanish Inquisition, making Spain the defender of Roman Catholicism.

The conquistadores who followed Columbus were infused with the heady victory over the infidels. They knew whose side God was on. Despite Ferdinand and Isabella's insistence on purity, most Spanish had Jewish and Arab blood, as Carlos Fuentes (1992:17) notes: "But who in Spain (or indeed ourselves, the Americans descended from Spain) was not integrated with the blood of Jews and Arabs after a thousand years of intimate coexistence?" The coexistence of cultures might have had more effect on the Spanish psyche than the official Spanish doctrine of racial and religious purity did. Even today the Moorish influence is still strong — a quarter of the Spanish language derives from Arabic.

It was a bold move for Guerrero to become a Maya and not only renounce his Europeanness and birthright but also actively fight his countrymen. He was the first to become the "other." We can only imagine what it took for him to move beyond the prejudices and see the Maya as people who had a very different society and culture. This was at a time when other Europeans were arguing that the Americans were savages and didn't even have souls.

Guerrero could have been merely opportunistic and happy not to be eaten or killed by his captors. But, unlike his cohort Aguilar, he didn't seem to dream of his escape or rescue. Aguilar knew that God was watching him: he refused the temptations of women, kept his breviary, and spent eight years praying for rescue. Guerrero took a wife and had children. Perhaps he simply fell in love.

The early sixteenth century had no travel magazines or documentaries and television shows to satisfy people's curiosity about other cultures and peoples. Guerrero had found himself in an alien and hostile world that somehow became neither to him. He went native, something that we aren't comfortable with to this day. In U.S. history some men lived with Indians and took Indian wives, but their wives were not accepted as equals in "polite" society. The French were shocked when Paul Gauguin went native in the South Seas. Perhaps Guerrero is not more of a hero in Mexico because Mexicans are still uneasy about embracing the Indianness of their culture. He set an example that many are unwilling to follow even five hundred years later.

25. "The colonial Maya changed residence with the facility and across distances that seem more typical of twentieth-century North Americans towing trailer homes along interstate highways than of peasant farmers

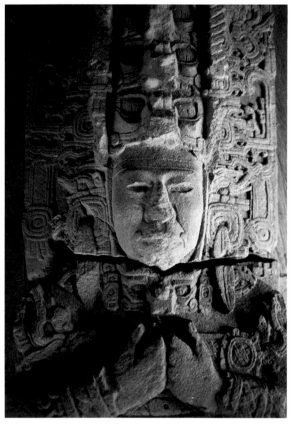

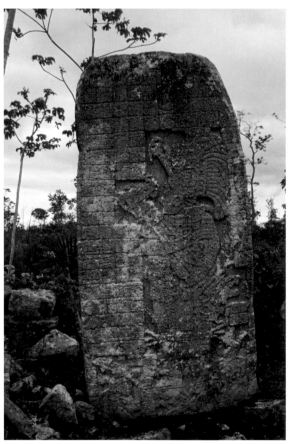

TOP: Detail, Monument 168, face of a sixth-century Maya king. Tonina, Chiapas, Mexico, 1992.
BOTTOM: Stela. Cobá, Quintana Roo, Mexico, 1967.

traveling on foot. Members of premodern agrarian societies in general may have been much more geographically mobile than has ordinarily been assumed, even before the large-scale migrations associated with industrialization. We may then be dealing with degrees rather than contrasts. Even so, the lowland Maya seem to have been uncommonly restless for a people defined as 'sedentary.'" Farriss 1984:199.

26. Farriss 1984:16. See also the excellent book *The Conquest of the Last Maya Kingdom* (Jones 1998). The Itzá weren't conquered until 1697. A Precolumbian Maya kingdom still existed less than eighty years before colonists wrote the Declaration of Independence in the United States. Think of what we might have learned if the Age of Enlightenment had reached the shores of colonial Mexico. This was like a plot for a novel by Sir Arthur Conan Doyle: a lost world, the remnant of a major civilization, continuing to live in jungle seclusion, harboring answers to untold secrets. That's the trouble with bureaucrats and religiously motivated conquerors. Secrets do not exist for people who think that they already know all the answers. The Spanish destroyed the last Maya kingdom: their art and books, their history and knowledge. The Lacandon, however, retreated to the forests in Chiapas and to this day have never been officially conquered.

27. Farriss 1984:72.

28. Some Spaniards, especially in the clergy, questioned the very idea of the right of conquest. "A debate on the nature of the conquered peoples and the rights of conquest raged through the Hispanic world for a full century, becoming the first full-fledged modern debate on human rights." Fuentes 1992:134.

29. "Insofar as Maya culture was preserved after the conquest, the chief credit must go to the unattractiveness, in Spanish eyes, of the region that had nurtured it. A chain of causal links can be traced back to this basic geographic 'fact,' coupled with the equally basic demographic fact of a large native population. Flowing immediately from them were the two interrelated and mutually reinforcing phenomena of a relatively low density of Spanish settlement in the region and a relatively low level of economic development. And these in turn fostered a marked degree of physical, social, and cultural distance between conquerors and conquered — a division into two essentially separate worlds articulating at only a few points. It is only within this context of relative isolation that the preservation of Maya cultural integrity can be explained." Farriss 1984:86. Until the end of the eighteenth century the Maya were often self-governing. Farriss 1984:356.

30. Ibid., 55.

31. See ibid., Chapter 12. See also Reed 2001; and Dumond 1997.

32. It is a little ironic that by the year 2000 the real corn people in the Americas are in the United States. Corn is in so much of what North Americans eat — in meat (most beef, chicken, pork, and even some fish are now corn fed) and dairy (corn fed) products and as an additive or sweetener (corn syrup sweeteners in soft drinks, fruit juices, sports drinks, etc.). Michael Pollan writes that more than a quarter of the forty-five thousand items in the average American supermarket contain corn. Although the contemporary Maya sometimes refer to themselves as the "corn people" and a Mexican might say "I am corn" or "corn walking," people in the United States have become "processed corn walking." As Pollan (2006:22–23) notes, quoting Todd Dawson, a Berkeley biologist, "we North Americans look like corn chips with legs."

33. For many years scientists and archaeologists believed that corn had been domesticated 7,000 years ago in the Valley of Tehuacán, in the highlands of Mexico. But through genetic testing, they are now pinpointing the Central Balsas River Valley and suggesting a date 9,000 years ago. This too could change with future findings.

34. Or, as Michael Pollan (2006:23) suggests, corn succeeded in domesticating humankind.

35. See Warman 2003.

36. Alkali processing changes the nutritional quality of maize. Sources of alkali (turning the water to a base pH, higher than 7.0) include the

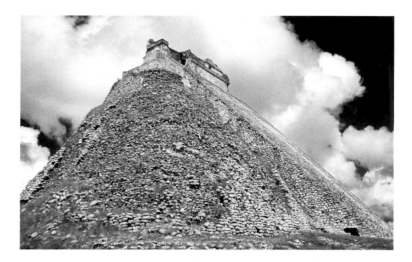

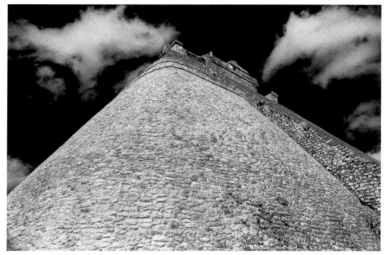

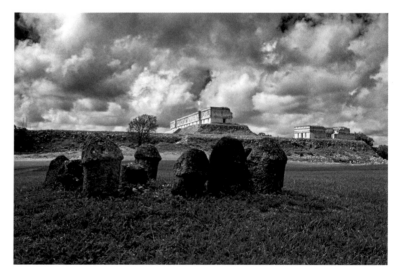

TOP: El Adivino. Uxmal, Yucatán, Mexico, 1967.

CENTER: El Adivino. Notice the amount of reconstruction since 1967. Uxmal, Yucatán, Mexico, 1969.

BOTTOM: Phallic stones in front of the House of the Governor and House of the Turtles. The phallic stones were moved before Queen Elizabeth visited the site in 1975. Uxmal, Yucatán, Mexico, 1967.

mineral lime from bedrock in many areas, commercial lye and soda preparations, and wood ash. Lime has the added benefit of increasing dietary calcium and liberates niacin by alkaline hydrolysis. Pellagra causes skin changes, severe nerve dysfunction, and diarrhea. This is an example of the danger of not paying attention to the human knowledge that accompanies a biosystem when corn was introduced elsewhere, including Africa and Europe. It became the food of the poor people, who suffered from pellagra. It is the only nutritional disease native to the United States. An estimated 10,000 pellagra deaths and 100,000 cases occurred in 1918, primarily in the cotton-growing regions of the South. These numbers increased through the Depression until bakeries added niacin to loaves of bread, which is why niacin is still advertised as an ingredient.

37. In 2010 archaeologist Stephen Houston of Brown University announced the discovery of the tomb of a Maya king at El Zotz, near Tikal, in Guatemala. The primary occupant, along with the bodies of six infants, was arrayed like a dancer. "We have known from the '90s on that a big role of kings was to be a ritual dancer," Houston said. "This is the clearest instance I have seen of the king being put in a tomb in that role" (Maugh 2010:A4).

"Dancing was probably associated with the maize god 'and is linked to fecundity, growth of the Earth, and sprouts of new seeds,' [Simon] Martin [an archaeologist at the University of Pennsylvania] said. 'It was a soulful, powerful thing' that emulated the swaying of maize" (Maugh 2010:A4).

38. Roys 1967:130. During the colonial period many towns and villages in Yucatán had their own Books of Chilam Balam, written in Mayan but using the European script, containing prophecy as well as chronicles, historical narratives, rituals, myths, almanacs, and medical treatises, some of which were copied from original hieroglyphic manuscripts that were still in existence at the time (*The Book of Chilam Balam of Chumayel* is the best-known example).

39. Miller and Martin 2004; Taube 1985.

40. Coe 2004.

41. Roys 1967:3.

42. Roys 1967:79; Tozzer 1941:205.

43. Try to imagine just how much of our knowledge we would be able to salvage among ourselves if we were conquered by a culture that didn't share the same technology, language, and history. We've put a man on the moon, built nuclear reactors, and mapped DNA, but how many of us would be able to continue that work? And what about just the day-to-day technology that we take for granted?

44. Gómez-Pompa et al. 2003:624.

45. Roys 1972:38.

46. Anabel tells a story to illustrate this. She was mapping and test excavating ancient Maya architecture in Belize when she found an obsidian production site, an important discovery because it was the first one found in the lowland Maya area. A year later Anabel wanted to return with her crew, but none of them understood where she wanted to go. So she described how to get there. "Along a road, past a house, come to a hillside, turn right, up a draw." She thought that she was giving very clear directions and that they should have known exactly where the site was because they'd been there with her. But they didn't. The more confused they were, the more perplexed Anabel became; finally one of her crew said, *Ah, donde está el aguacate.*

"Where the avocado tree is," Anabel said, snapping her fingers. "At that moment all of them knew exactly where I wanted to go. I don't know how they map their world. I don't know what they see when they're walking along. But clearly my view was a Western view, a driver's view. And my view was taking in everything alongside the road. And for them, their view was the forest view. I worked there, I excavated there, and I didn't see the avocado tree. Of course, when we returned I saw it. They knew how to get back to the avocado tree. And all I knew was how to drive or walk to landmarks that I thought were really distinct." She asked: "What was important? For them it was the avocado tree. I knew what they'd learned about

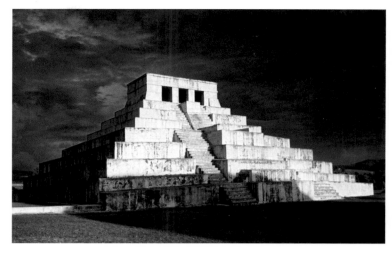

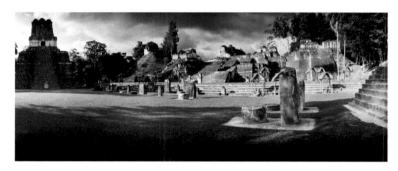

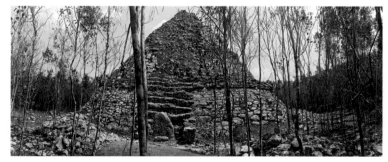

TOP: Structure 1. Zaculeu, Guatemala, 1968.
CENTER, TOP: Chichén Itzá, Yucatán, Mexico, 1987.
CENTER, BOTTOM: Tikal, Petén, Guatemala, 2006.
BOTTOM: Nohoch Mul, Cobá, Quintana Roo, Mexico, 1987.

the forest was literally walking in their fathers' and grandfathers' footsteps when they were small boys, and this provided me with an insight to what they'd been taught."

47. "Therefore I order that all the natives . . . construct houses close to one another . . . And they should not sow any milpas within the town, but it shall be very clean. There shall not be groves, but they shall cut them all . . . so that shall be clean, without sown land or groves; and if there were any, they should be burned" (Roys 1952), http://www.marc.ucsb.edu/elpilar/community/Ten_Years_Achievement.php#2.

48. As of 2010 the list of food in the Maya forest includes 288 fruits, 67 leaves, 60 seeds, 34 roots/rhizomes/tubers, 22 flowers, 12 young inflorescences/spadixes, 25 pods, 7 saps/latexes, 4 nuts, 4 barks, and 3 grass grains (including maize). That's 526 edible parts from 512 edible species; some plants have more than one edible portion, and some of the plants on the list have edible portions not yet unidentified.

49. For a contemporary account of transporting plant species, see Chapter 5, note 11.

50. Any plan to exclude the very peoples who lived and shaped lands that are worth saving is patronizing, shortsighted, and unscientific. Many areas in the world that conservationists and environmentalists hope to save still have indigenous peoples living in them. Many of them now include conservationists, along with exploitive businesses such as big oil, metal, timber, and agriculture, as their enemies. See Dowie 2005.

51. Bainbridge and Gómez-Pompa 1995.

52. Gliessman et al. 1985; Gómez-Pompa and Kaus 1990. Gómez-Pompa has been active in studying wetfield agriculture, which was extensively used in Precolumbian Mesoamerica and is practiced today in the Valley of Mexico. A *chinampa* (a Nahuatl word meaning "net of branches") is a strip of land surrounded by water. The most famous chinampas are the floating gardens at Xochimilco, on the outskirts of Mexico City. Wetfield agriculture eliminates the need to drain natural wetlands in order to practice dryland agriculture. The archaeologist Jeremy Sabloff (1989:126) believes that "much of the Aztecs' success rested on their ability to reclaim swampland, and to build chinampas, or artificial fields for cultivation." They built up land from weeds and mud, held it together with wooden stakes and branches, and planted willow trees, whose roots formed a living web to hold the soil. Farmers could grow crops year-round, using the muck at the bottom of the canals as an excellent fertilizer. In addition, they could fish in the canals from their gardens and were never in need of water. In the last twenty years experimental chinampas have been started in the states of Tabasco and Veracruz. Crop yields from chinampas have been higher than those produced under modern agricultural systems practiced in Mexico. "To our knowledge chinampas are the biologically richest agroecosystem known today in which most of the flora is managed and used. The sustainability of the chinampa agricultural system is based on management of high biodiversity." Jiménez-Osornio and Gómez-Pompa 1989.

53. The ears were two years old, a corn variety called *sac tux*. Chaco said he planted *criollo* (heirloom) corn because it stored well. The new varieties mold after only two months.

54. The ancient Maya were famous for their honey. It was a major trade item. Part of the Maya legacy is that Yucatán is still the leading honey-producing state in Mexico, which is one of the leading honey exporters in the world.

55. Significantly, there is no Maya word for "weed," in the sense of a plant that is purely a pest. Loob, however, does mean a plant that is not notably useful. It has a focal reference to a small tree, *Eugenia mayana*, that is proverbial for its lack of utilitarian benefit. Yet even this tree is used as a cough medicine and is admired for its attractive appearance. The weed concept has come recently, along with the Spanish word for it (*maleza*). *Plaga* (pest) has also entered the vocabulary, referring to insect pests, since Maya has no good equivalent, though evaluative words like *k'as* (bad) are applied freely. Anderson et al. 2005:119.

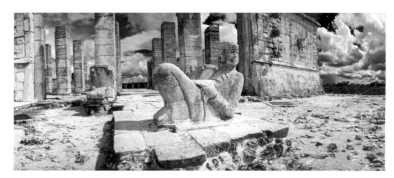

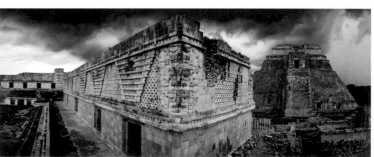

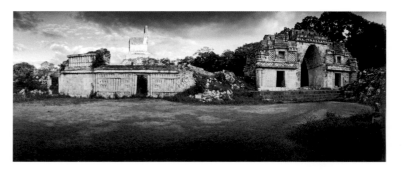

TOP: Chac Mool on top of Temple of the Warriors. Chichén Itzá, Yucatán, Mexico, 1987.
CENTER, TOP: Uxmal, Yucatán, Mexico, 1994.
CENTER, BOTTOM: Labna, Yucatán, Mexico. 1987.
BOTTOM: Wendy Ashmore and Richard Leventhal, codirectors of the archaeological project, in front of stucco façade on the Castillo. Xunantunich, Belize. 1994.

56. "The relatively well-documented migrations resulting from the Caste War serve to illustrate this ease of movement. From the mid-nineteenth century until well into the twentieth, much of the eastern half of the peninsula and almost the entire southern lowlands were in a state of flux. Refugees crisscrossed the area and entire polities shifted residence with the readiness of nomads. All wars are disruptive to some degree. The point here is the scale of these movements and especially the apparent facility with which the Maya, including women and children, were able to move long distances quickly, set up new households and plant new crops, and then move on again when necessary, baffling both their government adversaries and the historians who have since sought to trace their moves through the written records.

"Such movements were a long-established Maya habit dating from well before the Spanish conquest, which itself displaced many people. Native chronicles and oral traditions record a number of pre-Columbian migrations within the region . . . Flight, temporary or permanent, has been the characteristic Maya response to crises throughout their recorded history . . . The ease of escape may have lowered the Maya's level of tolerance, and it may also have checked their pugnacity, predisposing them to a certain docility, but one with definite limits. We have no way of knowing because there is no record indicating how many Maya chose to flee, let alone what particular circumstances spurred the decision in each case." Farriss 1984:73–76.

"The well-documented colonial patterns may help to interpret earlier cycles of consolidation and dissolution that are only hinted at in the archaeological record. The movement can be gradual and need not result from any massive cataclysm. The term 'collapse' is generally used when referring to the end of the Classic period of pre-Columbian history and also the end of the hegemony of Mayapan in the Postclassic. But if the behavior of the colonial Maya is any clue, perhaps the less dramatic metaphor of 'crumble' would be more appropriate: people deserting population centers little by little. They sometimes moved long distances, but of equal long-term demographic significance was a slow trickle out to the surrounding countryside — a colonial Maya flight to the suburbs." Farriss 1984:199–200.

57. See ibid., Chapter 4, "The Elusive Social Bond." "To me, one of the greatest mysteries is why Maya culture should have reached its greatest peak in this region so singularly lacking in natural wealth, where man, armed only with stone tools and fire, had everlastingly to struggle with the unrelenting forest for land to sow his crops. Moreover, when he had wrestled the necessary area momentarily from the forest's grasp, he usually found a soil so thin and quickly weed-infested that after one or two crops, it had to be surrendered to his enemy, who lost no time in covering it once more with dense vegetation." Thompson 1954:26.

58. For the past few years Scott has been collaborating with a group of soil scientists from UNAM, led by Dr. María de Lourdes Flores. These were the first soil samples from the Yalahau region, and it turns out that the soil is often better than expected.

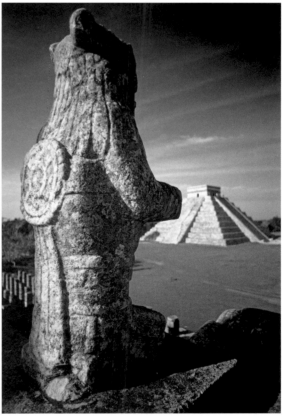

TOP: Yaxchilán, Chiapas, Mexico, 1986.
BOTTOM: Chichén Itzá, Yucatán, Mexico, 1994.

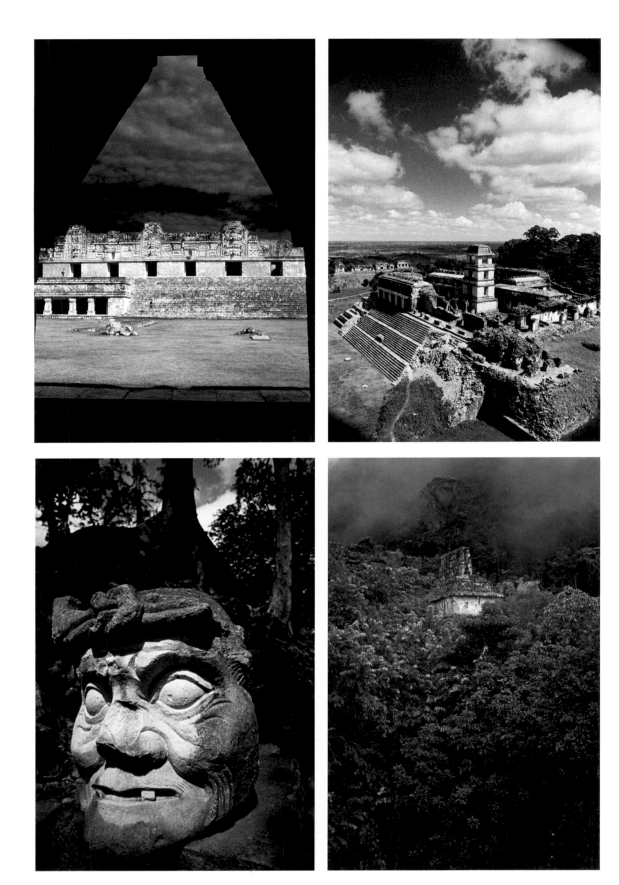

TOP: Uxmal, Yucatán, Mexico, 2004.
BOTTOM: Copán, Honduras, 1991.

TOP: Palenque, Chiapas, Mexico, 1969.
BOTTOM: Palenque, Chiapas, Mexico, 1998.

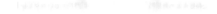

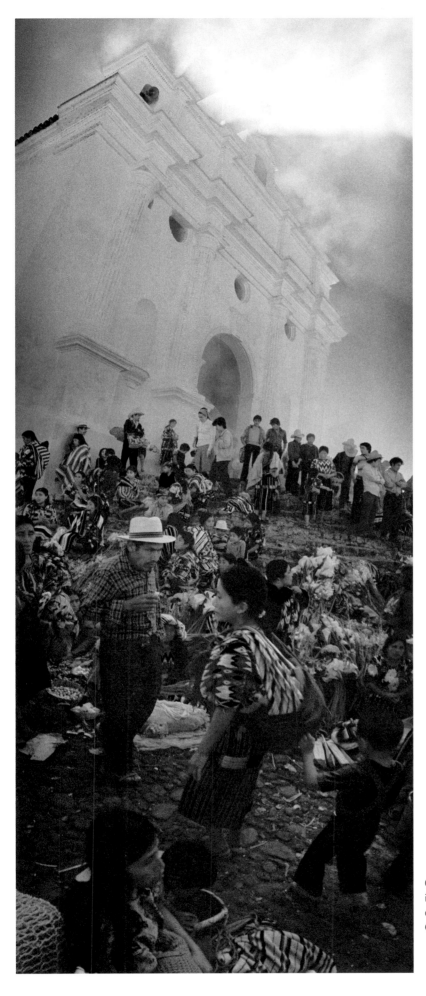

Church built on a temple site. The sun shining through the rising incense in this scene gives an indication of how arresting a ceremony could have looked when a priest or king stood on the top of a temple. Chichicastenango, Guatemala, 1987.

Jacinta Chi Tun, in doorway of her house, with her children. Monte Cristo, Yucatán, 1971.

I believe in serendipity—all we have is our own personal vision and sharing it is how all thought and discoveries end up coming about.
LINDA SCHELE, Maya epigrapher, 1987

Introduction

An account of the modern Maya: incidents of travel and friendship in Yucatán and how I met Charles Demangeat and Hilario Hiler; this book project now extends over four decades and includes important chapters in the lives of the Maya

It was near midnight on a rainy September night in 1967 when I boarded the train in Chiapas bound for Yucatán. When it came to a stop the next morning in the middle of the jungle, I walked to the vestibule at the end of the Pullman car and looked out through the open upper half of the door. Dark storm clouds gathered overhead; puddles, opaque in the flat light, were proof that it had been raining hard. The forest crowded the tracks. What had been lumps of greenery as we sped past in the train now took on individual identities and shapes. The air was sweet with rot and fecund growth.

Up near the locomotive the train crew was deep in conversation. A few minutes later the conductor came into our car and announced that because of Hurricane Beulah the next several kilometers of railroad track bed were too soggy for our train to proceed. However, he continued, the train from Mérida was stuck on the other side, so we would all simply switch places with the passengers on that train and resume our trip. What I hadn't seen was the maintenance crew that had flagged us down. They'd arrived on pushcarts. Once they cleared off their equipment and some railroad ties, they started to ferry passengers and baggage between trains.

So I first came to Yucatán on a handcart, with two crew members pumping the handles up and down, propelling us through the Maya Forest. It took hours to transfer everyone. Then the train from Mérida backed its way home. By the time we got to Campeche there wasn't a cloud in the sky and it was hot. I got off and walked to the bus station so I could visit the ruins of Uxmal, which I could only reach by road. Pedestrians packed Campeche's narrow colonial streets. The pastel walls of the buildings reflected the heat; it was like walking inside an oven. I drank five Pepsis waiting for the bus to leave—in 1967 bottled water was rare.

The road to Uxmal, which then continued to Mérida, was a narrow strip of highway without any shoulders running through the scrub forest jungle. We stopped for passengers all along the way—anyone who stood on the road and waved down the bus. At this hour it was mostly Maya men returning home from work in their milpas. They all wore blue denim pants, blue denim shirts, sandals, and palm-leaf sombreros. Most carried a rifle or a shotgun along with a machete, and they handled them as tools rather than weapons. The women dressed in *huipiles* (commodious garments in the form of a billowing "T," brightened by an embroidered bouquet of flowers and designs across the bodice and hem).

The bus driver and his conductor traded jokes with each new passenger; soon we all assumed the camaraderie, much like high-spirited, confident fans on their way to the big game. I was sitting near the front, grateful that I was included in the fun. We all put our windows down, and the rushing air cooled us. We passed through small villages with streets lined with neat drystone walls in front of rectangular houses with clean-edged thatched roofs. The stone houses and walls were whitewashed with lime, and gardens of flowers and kitchen herbs made them look tidy and pretty. The villages had exotic names, such as Boxol, Suc Tuc, and Macampixoy, that were pretty to say (the *x* in Mayan is soft, pronounced *sh*).[1]

Passengers got on and off not only in villages but along the road wherever a marker—for instance, a soft drink bottle on a pole—indicated a path back into the forest where a family lived. We climbed low hills and dropped into jungle hollows: we would hurry up to slow down. Shadows lengthened, and we entered fresh pockets of cool air.

We stopped for a hunter carrying a deer and several great curassows (*k'aambuul* in Mayan, *Crax rubra*). The bus driver and conductor jumped down to load the deer into the baggage compartment and immediately asked the hunter to sell them one of his birds. He said no, so for the next fifteen kilometers they regaled him with a description of how they would prepare the pheasant-like bird if only they had one, who might come to dinner, and how they would serve it. The hunter was shy and embarrassed, which the other passengers found entertaining. When the driver complimented him on his marksmanship, suggesting that it was probably an indication of his sexual prowess, the hunter finally agreed to sell them both birds and was left in peace.

We proceeded through more villages and then passed through the Maya ruins of Kabah, which straddled both sides of the road. Stone masks covering a long building built of limestone smoldered in the last rays of the sun, with shadows casting relief. Soon afterward I saw a pyramid rise above the forest and knew we'd come to my stop.

There is no town or village at the ruins of Uxmal. The driver let me off in front of the elegant Hacienda Uxmal, at that time the only hotel. Across the highway was the entrance to the archaeological site, already closed for the evening. It took a few minutes to say good-bye to everyone on the bus.

The hotel let me hang my hammock in an outbuilding which no longer exists. With no place to eat other than the hotel, which was beyond my means, I had to make do with a couple of oranges I'd bought at the bus station.

At dawn I walked into the ruins. I didn't meet anyone. A low mist obscured the ground, and the ruins emerged in a haze of golden light; the long white limestone House of the Governor appeared to glow. All around me flocks of birds provided a polyphonic concert. As I listened I picked out a bird song that I'd heard before on a movie soundtrack when the director wanted the audience to know that they were in a jungle. As the sun burned off the ground fog, I climbed up the narrow steep steps of the Pyramid of the Magician, a massive, thick structure. I began to understand the layout of the city and saw buildings that I wanted to visit, many with stonework adornments that appeared similar to the cross-stitched, intricate patterns on the Maya women's huipiles. Vegetation hid many buildings but also acted like the setting for a precious jewel.

Around 9 A.M. big, puffy clouds formed and began to float quickly across the sky, providing shadow and depth for the shots. I didn't have much film, so I waited for hours to frame images and capture the best light. I kept working until a guard interrupted my concentration and told me they were closing the ruins. I hadn't even had breakfast, and it was already dinnertime. I finished off my stash of oranges.[2]

I'd been in Yucatán only a day and was enchanted. I'd come to Mexico at nineteen and had already photographed in central Mexico, Oaxaca, and Chiapas, on my way to South America to record archaeological sites and make ethnographic studies for an educational film company that had provided me a huge itinerary and a minuscule budget. They'd offered me the job because I knew how to travel cheaply, having worked my way around the world when I'd left home at seventeen. I'd picked up a camera in Europe and sold my first photo stories when I reached Japan. I was learning photography by doing it every day. I was also learning to become an ethnographer while becoming a photographer. Because I'd seen devotees worshipping at ancient living temples in India, Ceylon, Nepal, Burma, Thailand, and Cambodia, I could visualize the American archaeological sites as active temples.

Although I was just learning Spanish, I didn't feel uncomfortable, even as my first impression of Yucatán was that I didn't like the flatness and the forest felt claustrophobic. I tried to overcome this by climbing the pyramids. But Yucatán immediately entered my dreams and my imagination. Arriving in Mérida, the first colonial capital of the peninsula, I felt that I had entered a chapter of a history book when I took a horse-drawn carriage taxi down cobblestone streets between colonial buildings nearly 500 years old.

I traveled east from Mérida by bus, passing through henequen (sisal) fields first planted in the nineteenth century and villages built around haciendas from that period. A couple of hours later I arrived at the ruins of Chichén Itzá. At that time the road ran right through the middle of the ruins and the bus stop was beneath El Castillo, the largest pyramid.

Continuing across the peninsula, I discovered that Yucatán was a land of empty spaces, especially on contemporary maps, where huge areas remained unmarked. I entered these blank spaces when I walked from Chemax through the jungle to the ruins of Cobá. Afterward I traveled to the Caribbean coast to Puerto Juárez (near present-day Cancún), which was neither a city nor much of a port but merely a few buildings and a wooden wharf with a passenger ferry over to nearby Isla Mujeres. South of Puerto Juárez, at Puerto Morelos, I caught the ferry to the island of Cozumel, twelve miles off the coast. I saw so many different hues of blue in the Caribbean that I needed to redefine the color. I'd already been around the world, but this was the first time I'd seen blues the color of my dreams.

Something else made an impression on me. Even though I was a stranger, the Maya invited me into their homes and made me comfortable and welcome. I felt that Yucatán's real treasure was its people. I decided that I wanted to work on a book project portraying the living Maya.

While most history chronicles the famous, this book is about the lives of ordinary people who are the soul of their culture. "Facts that go unreported do not exist," writes the Italian reporter Tiziano Terzani. "If no one is there to see, to write, to take a photograph, it is as if these facts have never occurred, this suffering has no importance, no place in history. Because history exists only if someone relates it."[3]

When I first planned to tell their stories in the 1970s, none of us thought we'd still be working together nearly forty years later. I felt that I'd finished our project in 1991 when the University of New Mexico Press published *The Modern Maya: A Culture in Transition*. Since its publication, however, so many significant events have occurred on the peninsula and in the lives of my friends that we need to add another two decades to their stories. What happened?

First, the North American Free Trade Agreement (NAFTA) put nearly 3 million Mexican farmers out of work. For the Maya, who had an agrarian culture, this had a devastating effect—so much of the knowledge that is in their culture is connected to the way they farm. When they stop farming, they lose the understanding of their relationship with the land that's built into their farming system. If the young people of one generation aren't learning in the field with their parents, that information is lost. Then there are the Evangelical sects who forbid their members from participating in most community activities in which the entire village had taken part. And tourism became the major industry, transforming the Caribbean coastline into some of the most valu-

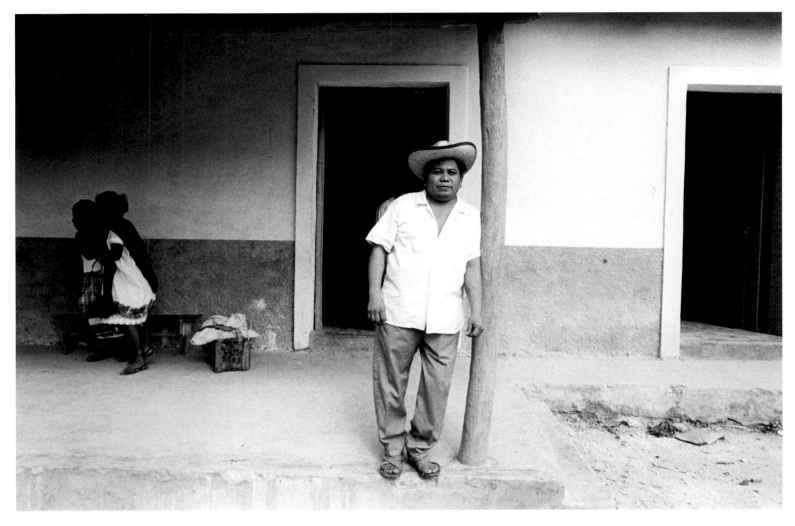

Petronilo Tuz May in front of his store. Chichimila, Yucatán, 1971.

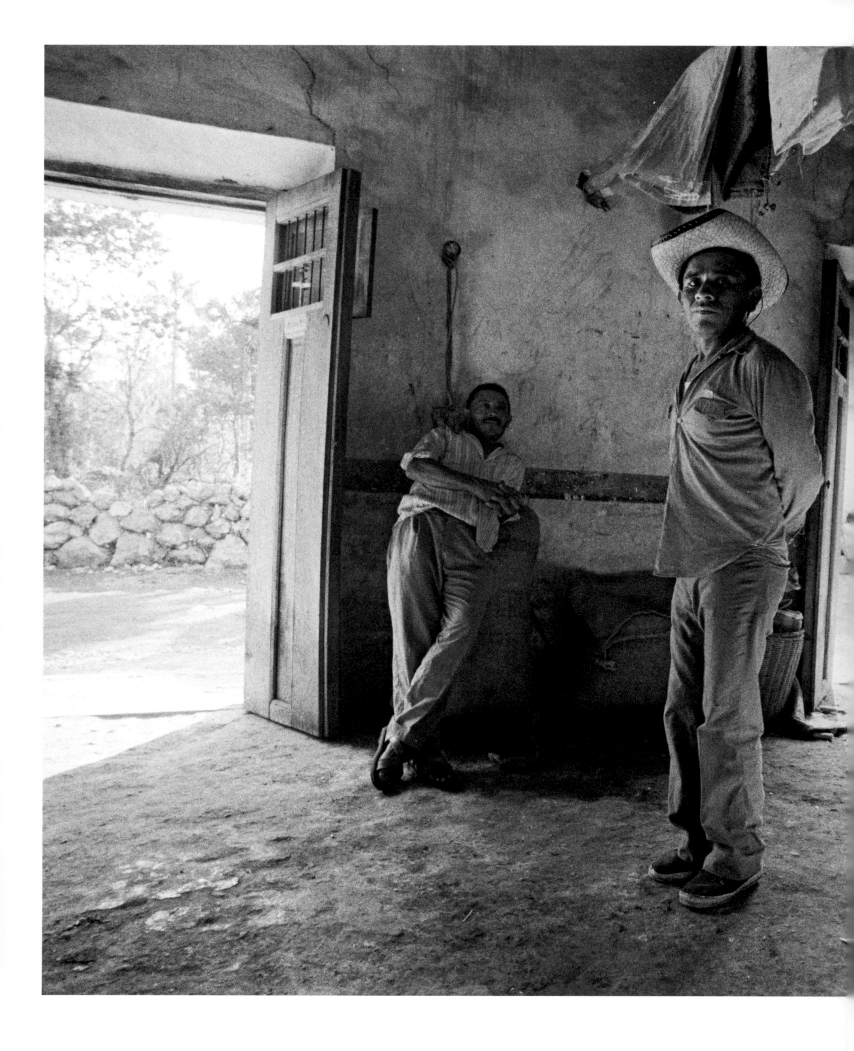

Enelio Puc Poot waiting for the music to begin. Enelio asked
me to photograph him dancing while we were both attending
a baptism party. Almost everyone moved out of the way.
Chichimilá, Yucatán, 1976.

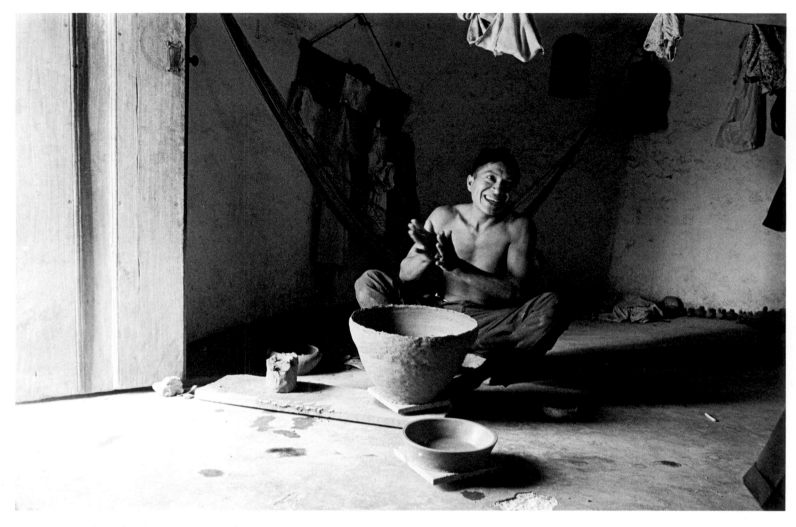

Fernando Uicab Pech, a potter who uses the coil technique. Ticul, Yucatán, 1971.

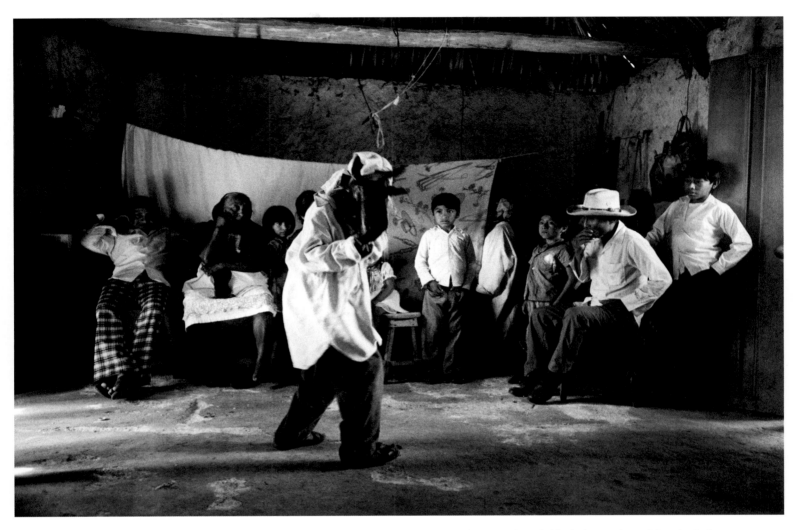

Christmas day as celebrated in Dzitnup: the devil sweeps through the village, stealing something from every household. Abraham and Isaac follow the devil to recover the loot and give it to the church. Small boys play the masked roles, which helps assure that the villagers control the amount the devil takes. Tribute is usually paid in corn. Dzitnup, Yucatán, Mexico, 1975.

Fernando Puc Che and his wife, Florencia Caamal Tus, resting in a hammock with their daughter, Lidia María Puc Caamal. Chichimilá, Yucatán, 1976.

A woman who wanted her portrait taken in her house with her prize possession, her radio. Tixhualatun, Yucatán, 1971.

able real estate in Mexico. Now the Maya are the masons who build the hotels and the maids, gardeners, janitors, bellboys, drivers, bartenders, and waiters and waitresses who serve the more than 10 million tourists who arrive each year to explore the Yucatán Peninsula, visit its archaeological sites, and relax on the white sand beaches along the Riviera Maya.

Cameras and photographs are ubiquitous in U.S. culture, and often snapshots define our memories. It's hard to think of a world without a Kodak moment, but that's exactly what I ran into when I first started photographing in Yucatán. No one in a village had a camera, so the few photographs that people possessed commemorated special events such as weddings and baptisms. Villagers went to the nearest city that had a photo studio. They stood at attention in front of the camera in their best clothes, stiff as soldiers, with nary a smile or twinkle. No one owned snapshots. We had no common background to explain the documentary work that I wanted to do. They'd never seen the "Day in a Life" photo essays that *Life* magazine had made famous. The idea of making a photographic recording of their lives didn't make sense to them on several levels. Not only had they not seen anything like this among their family and friends, but they also had never seen Maya appear in movies, commercials, or advertisements.

When I went around with my camera, at first they treated me like the village idiot: tolerated, indulged, and humored. But being the village idiot was a great entrée into village life in many ways, because no one considered me a threat. So they let me photograph them. Everything changed when I came back and gave them photos. Over the years my friends became increasingly sophisticated in their critical appreciation of photography and began to understand what I was doing. They started to suggest photos. They would invite me to photograph not only ceremonies or special occasions but also daily occurrences. For my part, I learned that they were uncomfortable with silhouettes of themselves or with any photograph that made their skin color appear dark, so I tried to give them lighter prints.

I first photographed Fernando Puc Che in 1971. Several years later, in 1976, his mother died and was buried. In 1980, according to local custom, his family dug up her bones, freeing the cemetery plot for another burial—a common enough practice in areas of very rocky soil. The bones were put into a small white box to be kept in his father's house. That evening there was a *rezo,* a service and celebration in remembrance of his mother, accompanied by ritual drinking. About 3 A.M. Nado (Fernando) and I were finishing off an umpteenth bottle of rum. He had been reluctant to let me photograph him years before. But as we drank in the jungle darkness outside of the house, he told me, "Macduff, you are one son of a bitch." He passed me the bottle, and I waited to hear what he would say.

"Today we dug up my mother," he continued, "and my children don't even remember her. But because of you, because of the photographs you took of me, my children—and their children, and their children's children—will know who I am, and what my life was like." He reached for the rum, took a swallow, and raised the bottle in a toast. "You've made me immortal. People will remember me."

Two other Americans became interested in my documentation at an early stage, and we became fast friends. Hilario Hiler and I first met in 1969 when I returned to the ruins of Palenque. He invited me to visit him in Chichimilá, Yucatán, where he was learning Mayan and doing research. When I arrived a year later, I found that he'd really immersed himself in village life—he'd already bought a house and married the woman next door. He graciously invited me to make his home my base. Soon afterward Hilario and I met Charles Demangeat when we stopped to help a broken-down circus truck on a lonely stretch of unpaved jungle road in Quintana Roo. He was an anthropology student from the University of California at Santa Cruz who had gone to see the Maya ruins and stayed, finding work traveling from village to village with El Circo Mágico Modelo, a regional Yucatecan family circus. Soon the circus provided me with another base for work.[4]

This book began as the effort of three young friends who thought we could finish our project within a year or two, drawing from our collected experiences.[5]

On my early journeys to Yucatán I traveled with my son Robert (I married in 1968 and my wife left me in 1970, but she also left her five-year-old son with me: the finest farewell gift I've ever received). We invited neighborhood children to join us, and several indeed visited. Traveling with children can be the most wonderful way to see a country. They ask questions that adults forget to ask, so their experiences informed my views. Furthermore, a single man traveling with a child or children is not threatening, which inevitably led to invitations that I wouldn't have received otherwise.

Andy Johnson accompanied me first as a child and later as an adult. Bonnie Bishop, another University of California student and artist, visited for two extended periods. The artist Dale Davis traveled with me. The artist Mary Heebner and I explored Yucatán before we were married in 1988 and several times afterward, including an extended trip with her daughter Sienna. In the 1990s I traveled and worked with Linda Schele, Peter Mathews, and Justin Kerr on *The Code of Kings: The Language of Seven Sacred Maya Temples and Tombs.* Charles, Hilario, and I, along with archaeologist Dorie Reents-Budet, led a class for the University of California at Santa Barbara. My parents visited. My son and I toured Yucatán again after he grew up and wanted to rediscover his memories. Once I started working as an editorial photographer for publications such as *Condé Nast Traveler, Life, Time,*

Diana Cupu and her husband, Marcelino Chi Pech. She wore her wedding shoes for the photo. Monte Cristo, Yucatán, 1971.

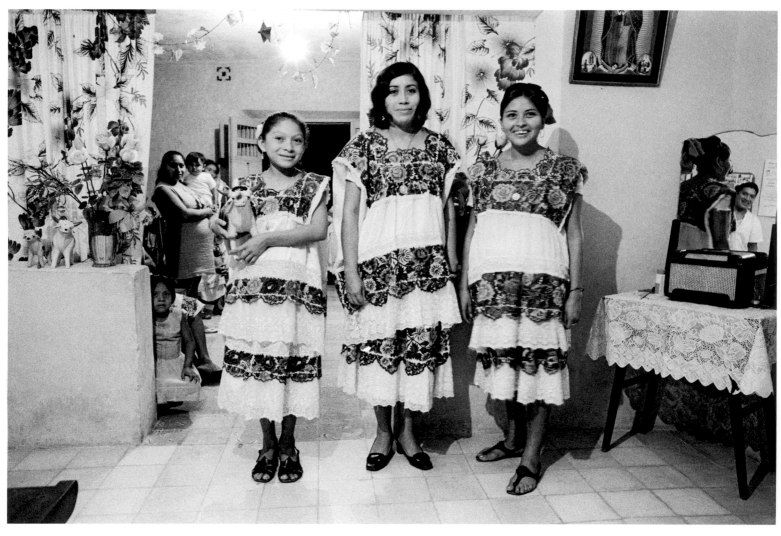

Three women dressed for a dance during the *gremios* (guilds). Ticul, Yucatán, 1971.

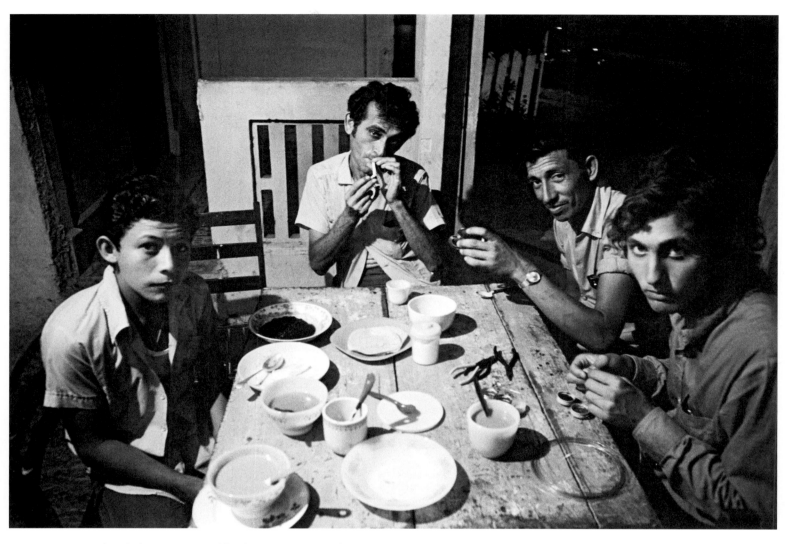

Circus people with El Circo Mágico Modelo relaxing at a restaurant after a performance (Charles on the right). Chetumal, Quintana Roo, Mexico, 1971.

New York Times Magazine, Smithsonian, Islands, National Geographic Traveler, and others, I was often able to return to Yucatán and concurrently work on the project. I mention this because after a while traveling to Yucatán was like returning home.

Mark Twain points out that travel is fatal to bigotry, prejudice, and narrow-mindedness. By traveling we begin to realize how many of the things we take for granted aren't the universal truths we once were led to believe. So much of our reality is shaped by our culture. At the start of this project I attempted to be objective but found it impossible to look at another culture objectively. Once I realized the futility, I was not only able to appreciate the differences between our cultures but able to immerse myself in Maya culture and document it.

I quickly realized that I was observing a culture in transition. Until just a few years before I arrived, Yucatán had long been separate from the rest of Mexico both culturally and geographically. Swamps and jungle cut off the peninsula and made it feel as isolated as an island. The primary way to reach Yucatán had been by boat and in the twentieth century, for those that could afford it, by airplane. Yucatán was connected to Mexico by rail only in 1950 and by a paved highway only in 1961. Road building increased dramatically in Yucatán in the early 1970s, nearly tripling in the first few years after we arrived.[6] Remote areas suddenly had roads and bus service, with electricity and potable water not far behind. At the same time the government started building Can-

cún. Yucatán ceased being a backwater and soon would become a primary destination. That is when everything really started to change.[7]

By the mid-twentieth century Yucatecans were either *dzules* (Mayan for foreigners) or mestizos. Dzules included the upper class, those descended from the Spanish, and people of mixed blood who were Mexican in outlook and spoke Spanish — and, of course, any foreigner. The term *mestizo* in Mexico usually denotes a person of mixed blood rather than an Indian; however, in Yucatán it is rather confusingly used to describe the traditional Maya who live and dress as rural Maya. The Mayan word is *mazehual* (plural *mazehual'ob*), originally a Nahuatl word for "the people," which in Yucatán now means the Maya, the people of the land.[8]

The Maya were composed of three main geographic and social groups — those long acculturated to Spanish and Western influences, those recently acculturated, and those just starting to experience acculturation. Generally speaking, the first category included the Maya in the northwest, especially around the capital of Mérida and other larger towns. The second category included people in villages recently reached by roads. The last group lived in areas that had been ignored, especially the rebel Maya zone in Quintana Roo, descendants of the Maya who had fought in the Caste War of Yucatán.

We wanted the Maya to become real for the reader rather than pretty pictures, so I decided to do a series of stories on individuals engaged in different types of work and to shoot in black-and-white rather than color. These individuals became my friends, and you will meet them and their families in this book. Here, then, are my friends' stories. For reasons of privacy, I've had to change some people's names.

NOTES

1. The word "Mayan" is used to describe the language. Everything else—food, dress, culture, sites, architecture—is "Maya," both as a noun and as an adjective.

2. Twenty years later I was again photographing at Uxmal. One evening the bartender at the Hacienda Uxmal and I got into a deep conversation. He ended up showing me his own concoctions, culminating in a drink that he called Los Siete Diablitos (The Seven Little Devils)—a half-ounce each of tequila, rum, gin, vodka, and sugar water, mixed with lemon juice, ice, and very cold mineral water. When a large party of touring Germans came to the bar and started placing their orders, I decided to go for a walk before resuming our discussion.

When I found the gates to the ruins open and unattended, I walked in. A Sound and Light show was in progress. It was a moonless night, and the sky was pitch black. As I toured the site the monuments around me were alternately bathed in yellow, red, blue, and green lights. I stopped and looked around, realizing what the Mexican government had created: the world's largest black velvet painting.

3. Terzani 1997:46–47.

4. I stopped to see if we could help when we came across several circus vehicles broken down in the middle of the highway south of Carrillo Puerto, as there was no traffic. Don Luis, the circus owner, didn't need help but invited us to a performance in Limones as a way to thank us for stopping. It was the start of a long friendship.

I soon learned that Don Luis and El Circo Mágico Modelo were famous throughout the peninsula. Along with the annual town fiesta, the arrival of the circus was one of the highlights of the year, especially in the era before electricity and then television. At first Don Luis was content to let me visit and photograph. I'd stay for a few days or a week then go off on other projects. That changed, however, when I showed up in Tixkokob. It was summertime when the circus played the henequen zone in Yucatán, and they didn't put the big top up because of hurricane season. Charles was featured as the Human Torch and Snake Charmer and a man of superhuman abilities. Under the glare of the spotlight he'd take off his cape and lie on his back on a bed of broken glass. Then two burly roustabouts would struggle to put a large rock on his bare chest. As Don Luis urged the crowd to think of the weight of the rock pressing down on his bare flesh as he lay on the broken glass and the music built to a crescendo, Darko, the eldest son of Don Luis, would come out of the shadows carrying a sledgehammer and start to walk menacingly toward Charles. It was all over-the-top melodrama. Don Luis would shout a warning to Charles and the audience, but of course Charles couldn't move or defend himself because of the huge rock on his chest. The audience would scream when Darko came close and swung mightily at the rock. As it broke, Charles would throw the pieces off, jump up smiling, and grab Darko's hand. The two would salute the audience, who by this time were applauding wildly.

Charles decided that he couldn't have all the fun, so he told Don Luis and the audience that he'd like everyone to meet a friend of his, his former instructor when he was a navy frogman. So I became *comandante* of a frogman unit. The following week Don Luis added that I was also a knife thrower and the grandson of Buffalo Bill and Annie Oakley. As we played other villages I gradually learned that I was the leader of the frogman unit that had recovered the *Apollo 11* space capsule and the first person to shake hands with Neil Armstrong. The astronauts captivated people's attention around the world, even in the remote villages of Yucatán, and Don Luis wanted to capitalize on my supposed friendship with the astronauts.

Don Luis made sure that we became celebrities—at least in Yucatán. Certainly his circus gained some status by having such international stars, but it was much beloved in Yucatán in and of itself. Don Luis had a wonderfully wicked sense of humor. I learned that my role as Comandante Macduff was to be the straight man for his monologues and prevarications, none of which he would tell me about before the performance. Often I was as

TOP: El Circo Mágico Modelo. The circus didn't put up the big top during hurricane season. Sinanche, Yucatán, 1971.
BOTTOM: El Circo Mágico Modelo and the big top in a village plaza. Yucatán, 1971.

amused as the audience — although I tried not to laugh while I heard my latest exploits for the first time.

I quickly learned that it was easier to take photographs in a new village when I was an international circus star rather than a stranger. The circus always welcomed us (we still visit them; Hilario's daughter Benina married Alejandro, the youngest son of Don Luis, and recently we've connected on Facebook).

Often after a performance Charles and Carlos and Darko (Don Luis's eldest sons) and I would take off to explore a new area, driving all night. We'd listen on the car radio to Radio Belice, which played reggae and soul, or to a powerful station out of Little Rock, Arkansas, that played rock and roll, or to a Colombian station that we usually only got from 3 A.M. to dawn, which played *cumbias*. Some nights we'd get in the car and drive to an archaeological zone so we could watch the night skies from atop a pyramid and wait for the sun to rise.

5. When Charles, Hilario, and I began the project, there were few examples of the kind of book we envisioned. John L. Stephens's *Incidents of Travel in Yucatan*, illustrated with drawings by Frederick Catherwood and published in 1844, certainly provided a precedent. The closest photographic examples were the "Day in the Life" essays in *Life* and Matthew Huxley and Cornell Capa's *Farewell to Eden*. Later I read Alistair Graham and Peter Beard's *Eyelids of Morning* and Peter Matthiessen and Eliot Porter's *The Tree Where Man Was Born*. These books combined writing and photographs.

Writers such as Malcolm Lowry, D. H. Lawrence, Graham Greene, Jim Harrison, and Cormac McCarthy have portrayed Mexico as a country where violence lies just under the surface, ready to explode at any time: Latin passion simmering like magma within a volcano. I found a country where people were sensitive, kind, and helpful, where the ordinary could become extraordinary and magical. That the two visions of Mexico exist side by side is beyond dispute, but I've been lucky to know the latter for most of my forty years visiting Mexico.

6. In 1970 the state of Yucatán still had barely 1,551 kilometers of passable paved and unpaved roads. By 1975 that number had increased to 4,266 kilometers. The road building was part of a government plan under President Luis Echeverría (1970–1976) to bring rural areas and peoples into the mainstream economy, especially groups that were self-sufficient and relied on barter, like the Maya. Even telephone service came to some towns — usually an office where you would speak to a local operator, who would contact a regional operator, who then would speak with an operator at the place you were trying to call. At some point in the day or night, you might get to speak to the intended party.

7. When I first arrived in Yucatán in 1967, it still had a steam locomotive on the narrow-gauge railroad. Soon afterward it was sold to Disneyland and began puffing around the park in Anaheim. In Valladolid the steamroller was powered by a belching steam engine. You could hear it coming from blocks away. Horse-drawn carriages were used as taxis in Mérida, Motul, Izamal, and other towns. Some Yucatecans still drove Model As and Model Ts.

The pace of life was slower then. I remember visiting the fishing village of Celestún on the Gulf in 1974, famous for flocks of flamingos that live in nearby lagoons. The fishermen used a truck that was over fifty years old. The cab's frame was made of wood. The truck's radiator leaked, and they'd wired a bucket underneath to catch the water. Every few minutes the driver would stop, jump out, and empty the now nearly full bucket of water back into the radiator. Then he would jump back in the cab and drive until the bucket filled again, trying to avoid the potholes, whereupon he would repeat the process. It's a way of life that has disappeared.

People were poor. I remember a villager who sat up in a tree at night with a rifle and a flashlight. He used the flashlight to spot a wild pig, shot it, and then spent the rest of the night in the tree in the dark waiting for dawn rather than use the flashlight to walk home, which would drain precious energy from the batteries. Most roads were unpaved. Most villages didn't

TOP: Mario, Charles Demangeat, and Andy Johnson on top of a circus bus arriving in a village square. El Circo Mágico Modelo. Yobain, Yucatán, 1971.
BOTTOM: My role as Jesus Christ in a play about the life of San Martín de Porres, the first black saint from Latin America, patron saint of mixed-race people. I got to perform miracles. El Circo Mágico Modelo. Yobain, Yucatán, 1971.

have electricity or running water. Villagers gathered around the wells, and much of the daily news and village gossip was communicated as they pulled up their buckets of water. Certainly running water has made life easier today, but villagers lost a social dynamic that hasn't been replaced. Television was a novelty. Villagers would gather in front of a window or doorway of a store or house that had one. Men wore sombreros instead of baseball caps. Many transactions in the villages involved barter rather than cash. To get places you often had to walk on a trail, because there wasn't a road. Distances were measured in time rather than kilometers. We might be told that a village was a three-hour walk away.

8. This anomaly resulted from applying the term *mestizo* to the pacified Yucatec Maya to differentiate them from the rebel Maya during the Caste War of Yucatán. Hervik 1999:26.

Charles and I tried to find a Spanish word for *dzules*. In Chiapas and Guatemala they use *ladino*, and Nelson Reed (2001) uses the term in his book on the Caste War. But no one uses it in Yucatán. *Vecino* (literally "neighbor") is a local term used by Maya to refer to outsiders who move into a village. It has the clear connotation of "someone not of my culture." Maya and dzules alike usually refer to themselves or to someone else by wealth or class (*pobre* [poor person], *rico* [rich person], *campesino* [farmer], *mazehual* [person of the land], *comerciante* [merchant]) or by town. The status of the town can indicate their culture, class, and level of modernity. For example, when Dario mentioned that he was from Chichimilá, Yucatecans knew he was a campesino. Reed (2001) says that in the nineteenth century the very rich white elite of the peninsula called themselves the *gente decente* (decent people). When we pressed our dzul friend Mario Escalante, who lives in Valladolid, for a term to refer to them, he paused for a moment before suggesting, "How about *hijos de la puta* [sons of bitches]? That's what we call them!"

Consider "Yucatán." It's not a Mayan word—it's made-up. "Since the Spanish came, the Yucatán Peninsula has been the Land of Misunderstanding" (Anderson et al. 2005:xv). Several explanations of how the area got its name have been suggested. One is that when the Spanish asked the Maya where they lived, the Maya answered that they didn't understand—*matan cub a than* (Restall 1998:122).

Charles suggests another explanation, based on his own personal experience. When he was first learning Mayan he found that people often couldn't understand him. The Maya women would giggle and say *utz a tan, utz a tan* (how curious or cute your speech is). Charles could imagine the Maya doing the same when meeting the Spaniards and repeating the phrase when the Spanish asked them more questions. He believes that this is a more likely source for the made-up word "Yucatán."

TOP: My son Robert and I with Hilario and Fina, her son Ermilo, and her sister María in their kitchen. Chichimilá, Yucatán, 1971.
BOTTOM: Charles Demangeat performing as a snake charmer. El Circo Mágico Modelo. Oxkutzcab, Yucatán, 1971.

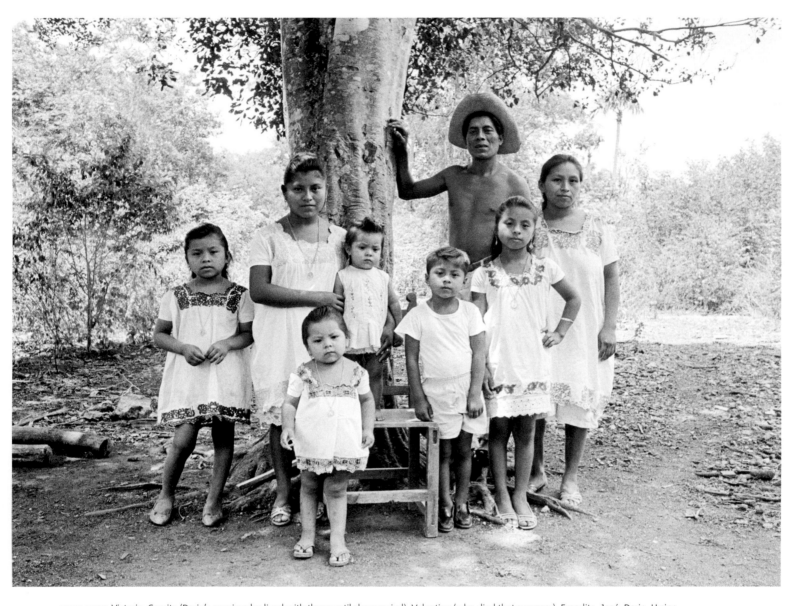

FROM LEFT: Victoria, Cruzita (Dario's cousin who lived with them until she married), Valentina (who died that summer), Emerlita, José, Dario, Ursina, and Herculana. Chichimilá, Yucatán, 1971.

To the native it is clear that since everything in nature belongs to the gods, man may use the products of nature only if he has divine permission and help, and that he must recompense the gods for such privileges. So he asks the favor of the gods in the preliminary tasks of the milpa, and expresses his gratitude for their help when the maize has developed. In fact, almost all the work of the milpa is accompanied by some religious act or petition or thanksgiving.
ALFONSO VILLA ROJAS, *The Maya of East Central Quintana Roo*

| The Milpa

An account of Dario Tuz Caamal, a Maya farmer, and his wife, Herculana Chi Pech; the Maya practice of growing vegetables, herbs, fruits, and hardwoods at their farm and home garden and agricultural traditions and ceremonies thousands of years old

Dario Tuz Caamal was the first person I met when I visited Chichimilá in 1969. At the time his village was famous for its cooks, its hammock makers, and its *h'men'ob* (sing. *h'men:* those who divine, curers, shamans). In Chichimilá, situated just five kilometers south of the colonial city of Valladolid, midway between Mérida and the Caribbean coast of Quintana Roo, villagers carried on forms of Maya traditions that traced back thousands of years. It was an old village; I found foundations of ancient Maya buildings in their yards.

Dario is the Maya friend whom I've seen the most in forty years of visits to Yucatán. He married Herculana Chi Pech in 1958 when he was nineteen and she was seventeen. They had twelve children, eight of whom lived. When I met them Dario and Herculana always appeared happy to be with each other and traded glances as if they were newlyweds. Often at the end of a hard day of work they would exchange massages, a tonic for tired muscles and relationships.

Like most mazehual'ob at the time, Dario was a *milpero* (farmer, from the Nahuatl and now Spanish word *milpa*). Hilario and I would often accompany Dario to his milpa. One afternoon in the spring of 1971, with the weather as hot and humid as a sauna, we helped him cut firewood. Our perspiration soaked and stained our blue denim work shirts. The light was glaringly bright and so intense that it gilded the edges of the few clouds in the blazing blue sky. Dario was clearing a field on his land before the rainy season began. We used machetes and axes to cut up trees that Dario had felled and stacked the logs to the side, where they would be safe when he burned his field. Each day Dario would carry a load back to his house. Firewood was a daily necessity—he and Herculana, like everyone else in Chichimilá, cooked on an open fire. No firewood meant no heated meals, no hot tortillas, no hot water to bathe, and no fire to watch at night.

We each tied up a bundle of firewood with lengths of handmade sisal rope and then attached our *mecapales* (tumplines). We centered the loads on the small of our backs and pulled the tumplines onto our foreheads. We walked bent over. My mecapal cut into my forehead, and my neck muscles tingled from the weight. I watched my footing along the rocky trail, straining occasionally to look up to see where I was going.

The trail was rough and uneven, a sinuous ribbon only as wide as the loads we carried. It skirted trees and followed the contours of the rocky limestone outcroppings that were pocked with sharp, jagged edges like lava or worn and slippery, polished from use. A forest thick with vines, saplings, and trees limited our view; their roots were like veins that crisscrossed and embraced the limestone as they searched for soil. We watched our step to avoid tripping on the roots or the rocks or wedging a sandaled foot between them. We carried our machetes in scabbards strapped to our waists. If a vine or branch had grown too close to the trail, whoever was leading would cut it back. Leaves in shades of brown and yellow littered the forest floor and seemed a perfect camouflage for snakes. I kept my eyes open and my head down.

As we reached the outskirts of Chichimilá, the trail widened into uneven streets of compacted earth and exposed limestone bedrock. At first almost all the houses were built in the traditional Maya style, with pole walls, guano palm roofs, and floors of hard compacted dirt, like the street. As we got closer to the center we started passing houses made of stone that had cement or tiled floors and tropical cedar doors. The main house could be right on the street. If it was set back, you entered the property through a gate of sliding poles that kept larger domestic animals in and others out. Most households had at least three buildings, if not more, on their property—a main house for sleeping, another as a kitchen, and one for storing corn. Each yard was surrounded by meter-high rock walls on at least half a hectare (a little over 1.2 acres). The shift from forest to village was gradual because each Maya household had a large home garden (*solar* in Spanish), planted with herbs, spices, vegetables, ornamentals, fruit trees, and seedlings for transplanting to the fields as well as plants and trees for medicine, dyes, building materials, and forage.[1]

We reached Dario's house near the village center and dropped our loads on the street outside his front door. When his children ran out to greet us, Dario laughed and pulled José, Ursina, and Victoria into his arms. We sat down in the road to rest, leaning against our bundles, and wiped away the sweat from around our eyes. Hilario leaned back and closed his.

"Sometimes I wonder why we carry these loads," he said. "It seems that our life is full of these hard, time-consuming jobs."

Dario was untying his bundle of firewood and turned to look over at Hilario. "It's God's wish," he suggested. "In life it's very difficult to help our fellow human beings, yet each of us feels a need to do this. So in order for us not to feel insufficient or helpless, God has given us these loads to occupy our time."

I laughed when Hilario translated this for me. It was just the sort of comment I was learning to expect from Dario. His neighbors often came to him for counsel. Rather than answer a question directly or tell them what to do, he would more often offer an allegory to help them solve their own problems. He listened well and responded with ebullient optimism. *Ma'alob uts'a tuukul,* he would say. "Good. Your thoughts are beautiful."

In those years, when we were younger, it seemed that we always had time to enjoy ourselves. We could work in his field and still have time to go swimming in the cenote before heading back to relax and play with his children. What I remember most about Dario still holds true today: he finds the beauty in life. *Hats'uts'!* Dario says. "How beautiful, how good!"

Herculana was full of life. When I first arrived neither of us spoke much Spanish, so we communicated with smiles and gestures. Herculana had a disarming smile which let me know that even when I felt a complete fool and spoke less intelligibly than a two-year-old she still enjoyed my company. In learning the language, I was sensitive to nuance. Herculana always welcomed me in her home, no matter what time of day or night.

Herculana would offer me a bucket of hot water for a bath if I was visiting in the late afternoon. The evening bath is an almost inviolable tradition among the Yucatec Maya; you bathe every evening unless you are sick. I found it ironic that many city dwellers in Valladolid and Mérida had plumbed bathrooms but few had hot water, while in the villages, deemed more primitive, the Maya considered bathing with cold water uncivilized and a shock to a body tired and hot from working all day.

Herculana would heat my bucket over her kitchen fire. I carried it into the main house, separate from the kitchen. It was a single room where everyone slept in a hammock. During the day the hammocks were tucked away over a rafter or hung along the wall. The bathing area was hidden behind a curtain of blankets put up so the bather had privacy even though a lot of other people might be in the room. A small slab of concrete improved the earthen floor in the bath area, with a drain for the water leading out through the wall. I put the bucket next to a small stool, sat down, and poured water all over myself with a *luch,* a bowl made from a gourd of the calabash tree (*Crescentia cujete*) scraped clean on the inside

and hard and polished from use on the outside. Once I was wet, I soaped myself then rinsed off. Now came the time I liked best. Since I still had more than half of the bucket left, I splurged by pouring all the hot water over myself at once. It felt like a delicious luxury.

Dario and Herculana each had responsibilities. Dario repaired and maintained the household structures, which he himself had built. He grew their food at his milpa, brought home firewood, and in the evening made hammocks for sale. When he wasn't at his milpa, Dario earned money by digging wells and by quarrying and breaking stones needed for construction. Herculana cooked, sewed, drew water, and washed clothes. They often helped each other. At first Herculana had sometimes helped Dario at the milpa, but now one of the older children would accompany him instead. She could also weave hammocks, although she didn't know as many stitches as he did. Dario often helped pull water from the well across the street, filling the large clay jars in the kitchen as well as stone troughs for watering the animals. Together they cared for their children, made rope, dried chiles, shucked corn, cleaned beans, and looked after their chickens, turkeys, and pigs and their home garden, where they planted fruit trees, flowers, vegetables, and herbs.

In their yard they tended several *ka'anche'ob,* raised garden beds made from lashed poles for growing herbs, tomatoes, radishes, onions, chiles, and other plants, high enough that their chickens, turkeys, and pigs couldn't reach them. They used a luch to scoop water from the buckets and sprinkle it over their smaller plants. On hot days during the dry season they could spend hours watering, particularly citrus trees and other non-natives. They hauled bucket after bucket after bucket from the well and dumped them at the base of the trees.

Dario and Herculana had built a main house with a separate kitchen behind it that was very traditional and typical for Chichimilá circa 1971. The traditional Maya house is one room, semicircular at both ends and anchored by forked main posts at each corner of an interior rectangle. It typically has two wooden doors in the middle across from each other, one in front and one in back. The earthen floor is raised several inches above the ground, with a rock retaining wall holding the compacted *saskab* (calcareous white marl) and small stones; this footprint is exactly what archaeologists look for when surveying for house mounds of the ancient Maya. Roofs are made from guano palms (*Sabal* spp.) woven into a lattice of roof beams and roof supports. The palm leaves insulate against the heat, allowing hot air to rise and pass through while keeping out the rain.

Traditional Maya houses are more like living organisms than static structures, a product of a physical and emotional relationship with the environment that is sustainable, intimate, complex, and profound. Leaves are turned into a roof. Trees become posts and beams and walls. Every post and

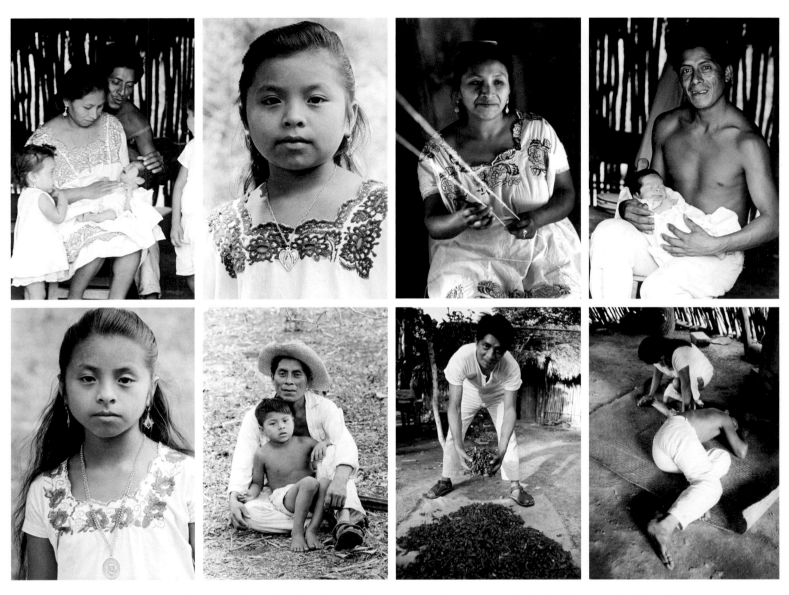

TOP, LEFT TO RIGHT: Dario and Herculana with newborn Gonzala, 1971; Victoria, 1971; Herculana preparing string (made of henequen fiber) for making hammocks, 1974; Dario with his newborn daughter, Gonzala, 1971. BOTTOM, LEFT TO RIGHT: Ursina, 1971; Dario and José, 1971; Dario with chiles that he's drying in his yard, 1971; Herculana giving Dario a massage, 1976. They often exchanged massages after a day of hard work. Chichimilá, Yucatán.

beam has its name. Maya villagers know exactly what they have to cut when they go out into the forest. They know what length and of what hardwood to cut the main posts, what length to cut the beams, what poles will compose the walls, what thick vines to cut to shape the oval ends, how many palm leaves to harvest for the thatch roof, and how much wrapping vine they need to tie the whole house together. Once they have collected their materials, they can complete a pole house in a matter of days. Typically they call together friends and family to help tie up the house with vines.

The Maya household has similarities to the traditional Japanese household in that its clean, simple design has been perfected over centuries. A Maya home is a dialogue between nature and builder that has been honed for millennia—evident in depictions of similar-looking thatched-roofed houses on the façades of stone buildings at archaeological sites such as Uxmal and Labna. Built from local materials and suitable for the climate, it responds to its environment. The Maya transform something living into a functional home, and its livingness cannot be separated from the object. The combination symbolizes shelter and sanctuary while affirming life. Dario and Herculana's house was a domicile with soul and tranquillity. Almost everything they used in their daily life was grown around them—their shelter, their utensils, their furniture, the hammocks they slept in, and the food they ate—and was a product of their work in collaboration with nature and the Maya gods of the rain and forest.

When you live in a house of pole walls you are subtly aware of everything around you. The shadow of a cloud passing overhead affects the light filtering into the house. When a breeze springs up, you not only feel it but also hear it rustling the thatch. You hear a plum drop from a tree. A chicken clucks, a turkey gobbles, a rooster crows, a pig grunts, a dog barks, a child runs past. The house shelters you without insulating you from your surroundings.

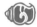

When Hilario, Charles, and I first visited Yucatán, few people had bicycles, let alone cars. To get around, you walked or, if there was a road, took a bus. We often had to walk to villages on forest trails, because few roads existed. Distances were measured in *leguas* (leagues), the distance you could walk in an hour (often about four kilometers). Although this measurement was inexact in actual kilometers, it was very helpful in planning a trip, as it reflected the condition of the jungle trails. In the evening, house interiors were lit by cooking fires, by candles, by kerosene lamps. Few people could afford batteries for flashlights, so they walked with a candle, one hand cupping the flame so that it wouldn't go out. Or they let fireflies, stars, and moonlight illuminate their evening strolls. Everyone slept in a hammock, and in the winter we often put coals from the cooking fire underneath to keep warm.

Dario taught us many things that made living in Chichimilá easier. Hilario found Dario such a good teacher that he

never left Yucatán—he soon bought property, married, and started a family. Thirty years later Nelson Reed referred to Hilario as an interpreter and ambassador to the Maya in his revised edition of *The Caste War of Yucatan*.[2]

Dario helped Hilario acclimatize to village life. First, Hilario needed a hammock. Villagers will spend half their lives in one.[3] Dario, a hammock maker, explained to Hilario how to break one in.

"You don't just jump in the middle, which is a natural inclination when you see something so inviting and beautiful," Hilario advised. "Instead you carefully sit on the edges and stretch it out before you get in. You take a *k'anche'* [wooden stool] and roll it up and down inside the hammock. Anything bad that has been passed through from the hands of the maker to the hammock is expunged through the k'anche'."

Hilario learned to draw his water from the neighborhood well. "I bought a well rope, a pulley, and two galvanized buckets, essential items in a land of wells. To avoid disputes over who had to replace a pulley or an old rope or bucket, each household had its own and brought it when the family members came to the well. They'd usually leave their pulley during the day, when a dozen or more could be attached to the crossbar above the well, but at night they'd all be removed. Dario showed me how to tie the excess rope in a knot so that the knot stopped at the pulley above when the bucket hit the water below, and how to whip the rope at the moment the bucket hit the surface so that it tipped and filled with water.

Hilario continued: "From the Maya women, I learned to use my legs and back muscles more than my arms when I pulled up a full bucket and to coil my rope on the masonry rim of the well to keep it off the ground so it wouldn't get dirty and contaminate the water when lowered again."

A second galvanized bucket was kept at home and used for heating bathwater each evening. Dario explained that buckets had formerly been made of bark. By 1971 even the poorest families had galvanized buckets, except for a few households that made buckets from old tires cut in half.

Hilario bought a *suum* and mecapal, the rope and tumpline used to tie and carry firewood and loads. In those days every village had someone who made them from native sisal. He also ordered a *sabukan*, a bag also made of sisal woven on a back-strap loom. Dario told the craftsman to customize the bag for someone as tall as Hilario, with the flat shoulder strap long enough to double as a tumpline when Hilario carried a heavy load in his bag.

"Dario told me that I'd need a *coa*, a couple of machetes, and an axe for farming," Hilario said. "The coa is a long-handled curved knife, excellent for weeding among stones. Machetes come in different sizes; the larger for cutting bush, and the smaller for peeling bark, fashioning poles, or slicing open foods such as squash, oranges, or watermelons. I bought an axe head and spent a day carving a handle from a choice hardwood I found in the forest. I had to buy a three-sided file to sharpen these tools. It took me hours to get the

edge beveled correctly, to be sharp enough to cut yet not so thin that hardwoods would bend it.

"Once my machete was sharp and ready to use, I watched Dario use his. He seemed to squat slightly with his legs apart. He swung his machete at a 60-degree angle to a branch or trunk so that the blade passed with the grain instead of against it, being careful that the blade didn't glance off and hit his leg. Dario taught me that the time to cut wood for construction and building was three days before the full moon to eight days afterward. Otherwise, he told me, it would soon be full of termites."

Hilario bought a pair of sandals in Valladolid made of leather with tire soles and learned how to walk in the jungle. "Their open sides made me pay attention where I placed my feet on the rocky trails," he said. "Dario showed me how to cast my eyes around, watching the trail so as not to stumble or brush up against tick-laden leaves, while also looking for diverging trails, markings, and animals. For the first year I found this very hard and could only look at the trail to avoid stumbling and falling."

Hilario became acquainted with the local insects. During the rainy season mosquitoes were more than a nuisance; they carried malaria and dengue fever. During the dry season a small bright orange chigger appeared. "Dario showed me how to remove these using a piece of dried guano leaf," Hilario explained, "as I found them nearly impossible to remove with my fingers. Dario also warned me of another small insect picked up around cattle and pigs that burrowed in your foot around the nails and laid a nest of eggs. You needed to dig them out or the eggs grew and the sore festered."

"I learned that there were several types of ticks: the snake tick, the wild pig tick, and the most common, the cattle tick. Ticks could be as small as pinheads. They could congregate on branches and leaves near trails waiting for blood. I sometimes found twenty or thirty hanging on a leaf, almost weighing it down, and when I found them before they found me I toyed with the ticks, passing my hand nearby, driving them into a frenzy. Since they were waiting for warm bodies, I carried a Zippo lighter and incinerated them on the spot."

When the ticks found Hilario first, Dario demonstrated a remedy of tobacco soaked in cheap white rum. When he applied this mixture to his pants and legs, the ticks fell off. The Maya thought it was because they got drunk. The keys to avoiding infection were keeping insects off your body and checking yourself every night.

Dario helped Hilario navigate the intricacies of Maya etiquette. "I discovered that the Maya thought that knowing someone's name was sharing an intimacy with them," Hilario told me. "Until you become well acquainted, it's not considered necessary or even desirable for someone to know your name. A name identifies and personalizes its owner. Knowing someone's name is power. You can be located, called into a conversation, invoked in an incantation, or singled out of a crowd by your name.

"I learned that the Maya have a habit of saying 'huhhh' when someone else is talking. This completes a cycle of communication, acknowledging to the speaker that you are listening. Learning Mayan gave me insights on how they viewed the world. For example, a friend might ask me, 'Make a gift to me of water,' but if he wanted a cigarette, he'd say, 'Give me a cigarette.' The difference is that something not genuinely important can be simply asked for, but something as life-giving as water, corn, or a kiss is acknowledged as a gift not only from the person giving it but also from the greater being."

Hilario found that handshaking was not a Maya custom. When they did offer their hand it was limp, rather than a firm clasp. "It surprised me at first," Hilario said. "Some people might describe it as a 'fish handshake.' I was raised in a culture where a firm handshake conveyed strength, health, and manliness. However, once, in the middle of one of these handshakes, I suddenly saw that it had its own beauty. It stopped bothering me. I think that it reflects the Maya's profound awareness of the impermanence of life and that everything is in a state of flux, including friendships, because I discovered that the grip of my friends often became firmer as our friendship became firmer."

Each culture regards drunken behavior differently. "I found most Maya men weren't light social drinkers," Hilario told me. "Instead, if they drank—once a week, once a month, or once a year—they'd dedicate an afternoon or evening or even several days to serious drinking. This custom provided an opening for me really to get to know people. I would visit them and make a gift of a bottle of rum. Hospitality required them to open it, and drinking together led to conversation. I found out that once a bottle was opened, you didn't leave until it was empty. On the other hand, Maya women rarely appeared drunk in public. They might have a drink or two at a wedding or baptism or other social events, but nothing more."

Hilario learned that Maya hospitality requires the host to provide water if a visitor asks for some and a stool to sit on just inside the door. And if the host is eating, the visitor is invited to share in whatever they have. Beyond these simple courtesies, there aren't many further obligations. Maya etiquette doesn't require hosts to stop and entertain, and no one is offended if they don't. The hosts continue to do whatever they were doing, and the guests can join in or sit and wait, or the hosts might stop their work to focus on conversation.

"As with every learning experience," Hilario said, "I made mistakes. Soon after I first arrived in 1968 Herculana gave me a hot bucket of water and left me alone in her kitchen to bathe. I saw what looked like a comfortable large stool and sat on it during my bath. It turned out to be the tortilla-making table. They forgave me, but for months afterward they removed it whenever I took my bath."

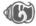

Dario, José (his eldest son), and I sat on stools around a low table. Herculana served us bowls of black beans and, on a

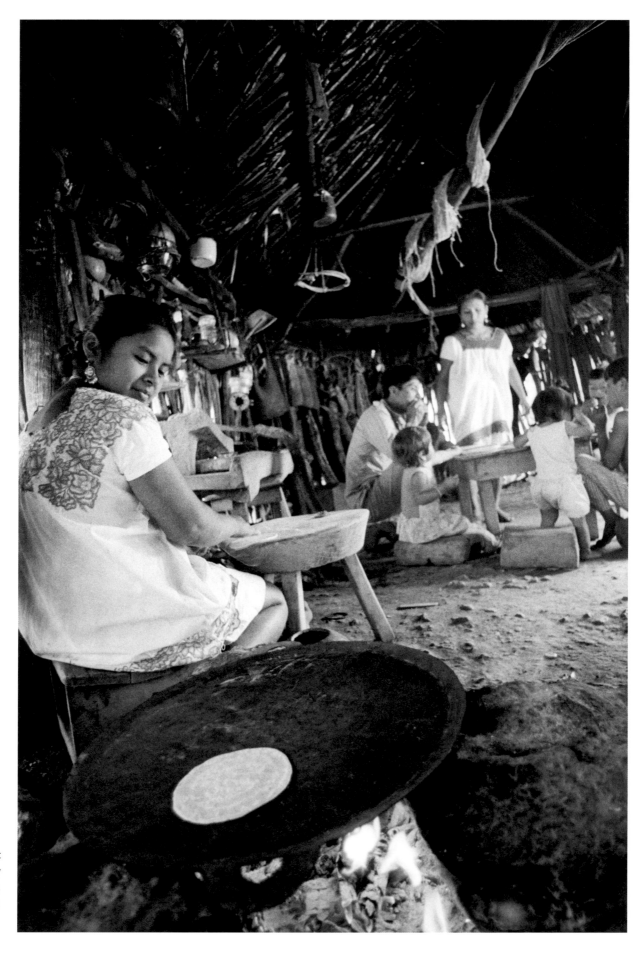

Ursina preparing hot tortillas as her family eats. Chichimilá, Yucatán, 1976.

separate center plate, slices of lime and a garnish of chopped onion, radish, and coriander leaf from their raised garden. At the center of the table were slices of chile habanero, also homegrown. It is the hottest and the most flavorful chile I've ever eaten. It has so much oil that just tapping my tortilla against it made my bite of tortilla and beans spicy. Once I began to enjoy chile habanero I discovered that I didn't lose my taste buds—something I never would have believed the first time I took a bite and my mouth erupted in flames. Later I read that chiles release endorphins, which explained why I was soon eating them with everything. They also increase your metabolism, so they actually help you lose weight.

Eating black beans with corn tortillas creates a balanced diet—each plant is deficient in an essential amino acid that happens to be abundant in the other—and an excellent source of protein and fiber, along with antioxidants. Herculana and her daughters Victoria and Ursina, who had already eaten, made tortillas for us as we dined. They sat at a low tortilla-making table next to the traditional Maya three-rock cooking fire, *k'obenil k'ak'* in Mayan. The three rocks were set in a triangle, about six inches apart, and firewood was fed from three sides—you controlled the temperature by the type and size of the firewood and by pushing in or pulling out the wood. On top rested a *xamach* (comal), the griddle for making tortillas. They patted small balls of *sakan* (masa) on a square of cellophane. I asked Herculana if she'd ever used a banana leaf instead, which I'd read had been the custom. "Oh yes," she answered. "Up until I was fifteen. That was before there was cellophane. You had to heat the banana leaf on the comal so it got soft and clean before you could use it."

Herculana and the girls flattened the tortillas with one hand, rotating and forming the edges with the other. This kept the tortilla round and of even thickness. *Pak'ach* is the Mayan verb for "make tortillas," and pak'ach, pak'ach, pak'ach is the sound of patting out tortillas. The sound changed as they used the fingertips of one hand to make it round and used the palm of the other to flatten it, like a conga player beating out a delicate rhythm.

Ursina heated each tortilla on the comal, which in Herculana's kitchen was the top of a 55-gallon drum, tempered from years of use as a griddle. As a finishing touch, Ursina placed each tortilla directly on a bed of coals that she had pushed to the edge of the fire until the tortilla puffed up with air. She'd quickly remove it and slap it against the table to knock the air out. *Ku hok'ol u saay u wah,* she'd announce: "It's a tortilla that puffs and is therefore well made."

After eating dinner, we all moved from the kitchen into the house. Dario brought in a basket of ears of husked corn to shuck. He spread a mat on the ground, and he and his children gathered around it on low stools. Using a *bakche'* (husking tool made from a deer horn), he pried one row of kernels from each ear. As his children rubbed these ears against each other, the kernels fell onto the mat. While they worked, the children told him of their day, their classes at school, and the household work they'd done. When they asked him about his day at the milpa, Dario told them that he'd seen signs of armadillo and deer, which was notable because those animals had become scarce around Chichimilá.

Herculana scooped up five or six kilos of corn kernels and put them in a bucket of water to boil for the next day's meals. She first cleaned the kernels by stirring them and skimming off everything that floated to the surface. Then she added a heaping handful of powdered lime, mixed it into the water, and put the bucket over the kitchen fire. When it came to a boil, she stirred the kernels again, letting them boil until the outer hulls were somewhat soft and flexible. She'd occasionally take a kernel of corn and bite it to see if it was done. When she was satisfied, she put the bucket off to the side to cool and soak overnight.

The next morning Herculana washed the corn with clean water, vigorously rubbing the kernels together to remove the hulls. She did this repeatedly until the rinse water was no longer yellowish and contained no more hulls. Corn at this stage of preparation is called *k'u'um* in Mayan (hominy, or *nixtamal* in Mexican Spanish, from Nahuatl) and is ready to be ground into sakan on a stone metate, in a hand mill, or for a fee at the noisy gas-powered mill operating in the center of the village. Going to the mill was a daily social event. Herculana and her daughters would wash, put on a clean dress, comb their hair, pat on talcum powder, even add rouge and maybe lipstick, then head for the plaza. There they'd meet other village women and girls, similarly dolled up, with their own k'u'um to grind. As they waited in line they'd hear the latest gossip from each part of town. It was a social break from their other household chores.

Sakan was used each day for breakfast, lunch, and dinner. It was mixed with water and heated as an early morning drink. Dario would carry a ball of it out to the milpa and drink it with cenote water for his mid-morning snack. Herculana might use it as a sauce ingredient for the day's main meal. And of course it was patted into the mountain of tortillas they ate each day.

Sakan was also fed to the dogs, parrots, chickens, turkeys, ducks, and any other birds and animals around the house. Larger animals like pigs and horses were fed a mix made of husks, k'u'um, and leftover food.

Dario and Herculana supplemented their diet with eggs and vegetables, and for special occasions they might kill one of the animals they raised. When Dario hunted, he could bring home agouti, deer, armadillo, peccary, and game birds.

Dario and Herculana, like nearly everyone else in Chichimilá, had a home garden. Each garden might have 60–80 species, for a total of 100–200 species altogether in a village. When I arrived in Chichimilá I was surprised that the yards often looked random and even untended compared to a European-style garden until I asked about individual plants and trees. Then I discovered that nearly everything in the yard was tended—either planted or nurtured if it had sprouted on its own. Each plant had a name, purpose, and value. It might be food, medicine, dye, forage for animals, flowers attractive to bees, or decoration.

Every household grew chaya, a leafy green often likened

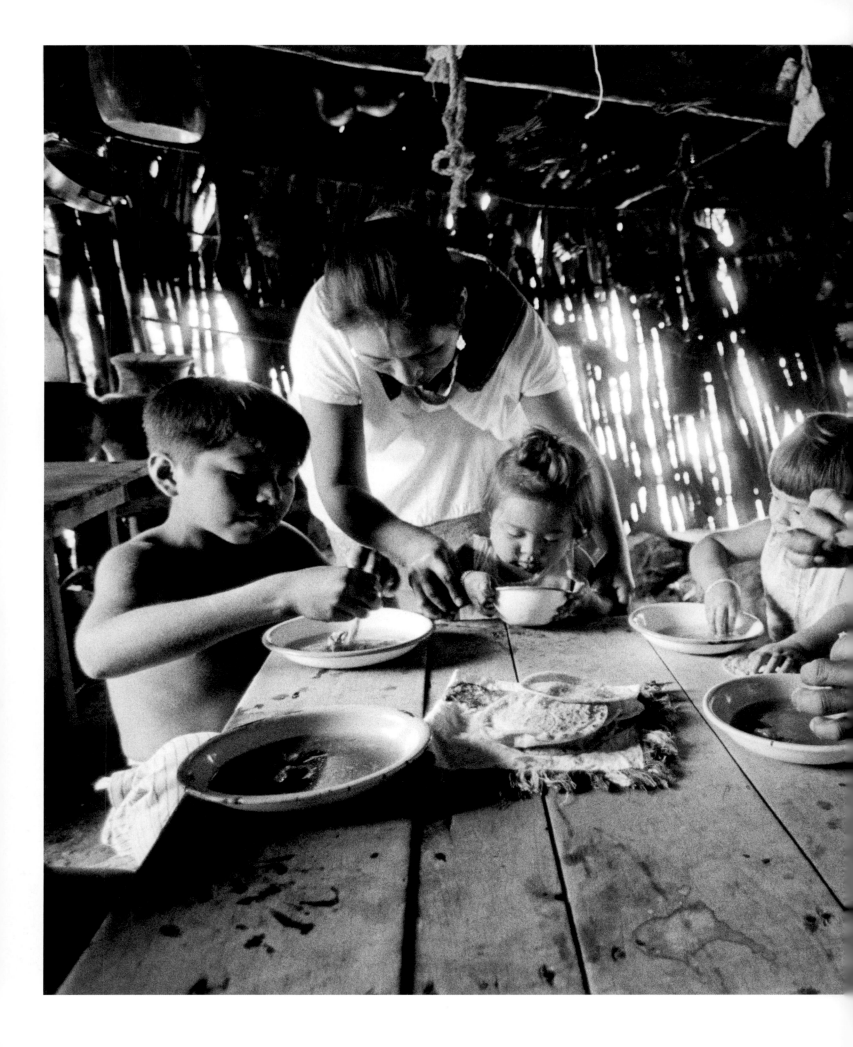

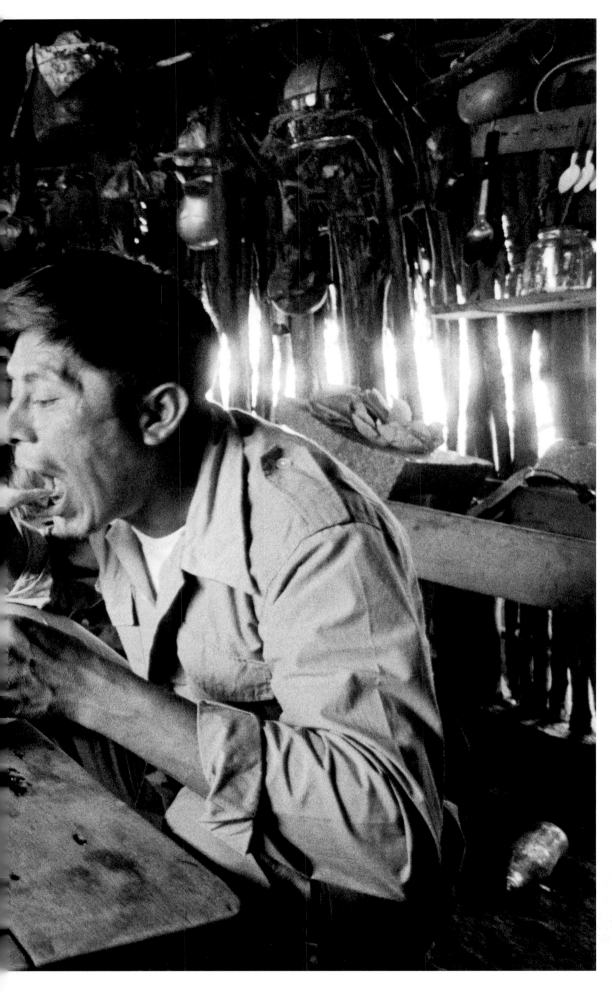

Tortillas wrapped in a cloth to keep them warm and placed in the center of the table. Portions of tortillas are used as spoons for scooping the black bean soup. Chichimilá, Yucatán, 1976.

to spinach, though the flavor isn't the same (in English it's called tree spinach). The bush can grow almost twenty feet high, but it's rare to see one in a Maya village more than six to eight feet tall. That's because the younger plants have more tender leaves and are easier to pick and because it is so easy to grow a new bush—you just break off a branch and stick it in the ground.[4] Chaya has four times as much protein as spinach and is high in calcium, iron, Vitamin A, and Vitamin C.

Squash is another important part of the Maya diet. They eat it fresh in season and roast the seeds throughout the rest of the year, often ground into a powder for their drinks, breads, and sauces. The Maya refer to squash and chaya—like other cultivated crops such as ramón, manioc, camote, physic nut, sweet potatoes, macal, and various roots—as *yo'och óotsil* (poor people's food). We can surmise that over the millennia the Maya have depended on such foodstuffs to supplement their diet in good times and for sustenance in seasons of crop failure and other hardships.

Although a milpa is popularly thought of as a cornfield, it is really a polyculture, with the milpero giving each crop attention. Dario and his family ate well when harvests were good. Besides corn, Dario grew squash, black beans, lima beans, black-eyed peas (*espelon*), lentils, chiles, tomatoes, cherry tomatoes, watermelons, cantaloupes, honeydews, chayotes, peanuts, pineapples, sesame seeds, sweet potatoes, yams, cassavas, camotes, jicamas, arrowroot, papayas, mangos, bananas, and other fruits, vegetables, and spices in his milpa. At home he and his family grew chaya, onions, garlic, radishes, cabbages, mint, marjoram, parsley, cilantro, basil, epazote, lettuce, and several varieties of tomatoes and chiles, some of which he also planted in his milpa. Their orchards, both at home and in the milpa, provided papayas, mangos, coconuts, *bonetes* (*k'uunche'* in Mayan, *Jacaratia mexicana*), several varieties of bananas and plantains, avocados, limes, several varieties of sweet oranges and a sour one used for seasoning, grapefruits, a few varieties of sapodillas (*Manilkara zapota*), guayas, *caimitos* (star apples, *Chrysophyllum cainito*), allspice, several varieties of tropical plums and cherries, *guanábanas* (soursops or custard apples, *Annona muricata*), cherimoyas (*Annona cherimola*), figs, *cocoyol* (coyol palm, *Acrocomia mexicana*), guavas, pithayas (dragon fruit, *Hylocereus* sp.), and tamarind.[5] When a crop was in season, Dario and Herculana shared it with a network of friends and family, who in turn shared theirs. Although everyone grew something, not everyone grew the same species.[6]

The longer I stayed in Yucatán and visited different homes, the more I noticed that the fruit trees at each home were usually excellent. If a tree didn't meet expectations, it was cut down and another one was planted until a good one flourished. This is an example of how the Maya manage their home and forest gardens and provides an insight into the Maya Forest and how it may have evolved. Although it may appear wild and untamed, it's really the result of thousands of years of being cut, burned, and shaped by selective management.[7]

The Maya and the conquering Spanish looked at the land and saw two completely different realities—the difference between Spain and Yucatán could hardly be greater.[8] The hot tropical forest must have appeared particularly alien, hostile, and sinister to the Spanish—a wild, tangled, and inhospitable jungle—and the idea of controlling nature must have seemed an epic mission. And the forest presented a metaphysical danger, in its rampant growth and ability to make things disappear—they saw that it would quickly reclaim an abandoned field or house.[9]

In contrast, the Maya saw a forest garden and knew the names and uses for everything around them. For the Maya the forest is a bright mosaic that offers food, medicine, dyes, and building materials—everything needed to sustain their life. It is their larder, their warehouse, and consequently they are very comfortable there. For many Maya, going into the forest is similar to people in the United States shopping at Costco. Over here are home improvement and building materials, over there is the pharmacy, and down this aisle we have produce—meat, vegetables, and fruit.

The Spanish did not understand, let alone appreciate, Maya agroforestry practices that mimicked the diversity of the forest. They did everything they could to alter the tropical landscape so that it would more resemble the European ideal of neat grids and fields, something under control.[10] The Spanish provided the Maya with machetes and axes and encouraged forms of slash-and-burn agriculture different from their Precolumbian method of select-and-grow and more of a threat to the environment. As a result, under colonial rule the Maya became primarily corn farmers rather than polycultivators, leading many people to hypothesize that this new agricultural technique had led to the "collapse" of the Classic Maya six hundred years earlier.[11] Anthropological studies estimated that by the twentieth century 75 percent of the contemporary Maya diet consisted of corn.[12]

That seemed like a lot of corn to Hilario and me. Hilario had studied cooking at the Cordon Bleu in Paris, apprenticed for two years in the kitchen of the famous La Coupole in Montparnasse, and then worked as a chef on two continents. He decided to make a study of the ways the Maya prepared corn. He found that the Maya ate fresh corn, cooked in its husk, only during the first few weeks of harvest. The rest of the year they used the dried ears of corn stored at harvest time. Breakfast and lunch usually consisted of a corn drink with roasted corn tortillas. Black beans, the basic plat du jour, were eaten with hot handmade tortillas, folded and used as spoons to scoop up the meal. Each bite required a new corn spoon, and they needed a lot of them. Tortillas aren't mentioned in the early Spanish accounts of the Maya after the conquest, so they may have been introduced from Central America. Instead the Spanish referred to corn breads, collectively known as *wah;* Hilario found dozens of variations that could be baked, steamed, or cooked over a fire on a griddle.[13]

The Maya corn drinks were just as interesting, ranging from simple to more complicated recipes. Hilario noted sev-

en main variations made from water and corn, with many nuances.[14] He also found that the Maya had some very refined and highly developed sauces that he put in the category of haute cuisine. "Maya cuisine, and in a broader sense Mesoamerican cuisine, is very old," Hilario said. "It has been refined over millennia and can be as subtle as any in the world. I believe the underlying premise is that corn is a gift from the gods."[15]

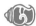

In 1971 I hoped to attend a Ch'a Chaak ceremony. Yucatán is like a desert during the dry season; but as the rainy season approaches, the dry heat of February and March gives way to April's humidity. Even early in the morning the air can be so heavy that it presses against you when you walk.

One day I was sitting with two men in the shade of the ceiba tree in the center of Chichimilá.

"It's hot," one said.

"Even the air is hot," the other said.

"It is. You can burst into flames just walking outside."

By the end of April farmers were burning their fields, anticipating the rainy season. The smoke hid the sky and turned everything yellow, even golden. The sun was a brilliant pendant of reddish purple whenever it shone through. From out at sea, sailors said that the glow at night looked as if the whole peninsula was on fire. The flames in the fields were brilliant orange. Sometimes fires spread and burned grass, vines, and bushes that were still green, producing a dense black smoke. The smoke was acrid, and I had trouble breathing.

In May the villagers knew that it was time to talk to the rain gods, something they did every year at this time. They'd cleared and burned their milpas and now waited for the rains in order to plant their crops. Ideally the farmer plants right before the first rains—if it doesn't rain, then the birds and animals will find the seeds before they sprout. It is critical that the rains water the young plants. This is an intense and important time for farmers who depend on the natural cycle of rains for all of their sustenance; rain ceremonies are held in May, June, and July all over Yucatán. But this year it hadn't rained at all in May in Chichimilá, and the farmers spoke in more urgent tones of petitioning the *chaaks* (rain gods). This was a topic discussed in every household.

The most important chaaks are the four that stand in the sky at the cardinal points, followed by innumerable chaaks for every type of rain and storm. They ride across the sky and spill rain from their gourds. Many of them live in caves and in the cenotes. Each neighborhood in Chichimilá planned to petition the chaaks at its own Ch'a Chaak.

Dario and Hilario's neighbors assembled for theirs in the backyard of don Adub. His land bordered the forest at the outskirts of Chichimilá at one of the cardinal points of the village: the eastern entrance, colloquially known as "the way to Xocen." The morning of June 6 was particularly hot. It was literally a "sun day," with no cloud in the sky to offer rain or shade. Don Adub's large yard was enclosed by a dry stone wall and cleared around his thatched-roof houses. Hilario and I walked up to the men who had already gathered, waiting in the shade of several fruit trees. Other than Dario, I didn't yet know any of them. They were dressed almost alike in denim work pants and a shirt, sandals, and hat.

I'd brought my cameras, but I wasn't sure if it would be appropriate—or permitted—to photograph the sacred event. Hilario is a gregarious man. He enjoys talking to people and, more importantly, listens to their stories. He laughs, jokes, and cries, and he'd immersed himself in the life of his adopted Maya neighborhood. He introduced me to his neighbors. Everyone greeted me, and I mumbled back a greeting in Mayan. Then Hilario spoke on my behalf to ask permission of don Anastasio Chi Chiau, the officiating h'men, to photograph the ceremony. Don Tasio was a slight man with refined features and was well respected for his ability to recite the prayers in both Mayan and Spanish. As a h'men who divines in matters of both personal and community import, don Tasio was both a Maya lay priest and a curer who conducted Maya religious ceremonies and performed the function of a spiritual doctor. He asked me why I wanted to take photographs. I explained that I knew things were changing. The ceremony had been different when he was a child and would be different for his grandchildren, and my photographs would be a record of how he did the ceremony. The idea of documentary photography was new to him, but he readily agreed that customs were indeed in transition. He gave me his permission. I promised that I would bring him photographs when I returned.

Finishing a cigarette, don Tasio walked over to the altar, a wooden table set in an open-sided thatch-roofed hut. The altar had an arch above it and was aligned so that he faced east. Don Tasio placed thirteen gourds of the sacred sakah (a corn drink used only as a sacrament). The moist dough was mixed with water. Don Tasio arranged an incense burner and a cross at the center until he was satisfied with their placement then began praying in a soft murmur.

In the sixteenth century the Roman Catholic Church condemned Maya religion as pagan and worthless. The Spanish forced the Maya to renounce their gods and become Christians, part of a "civilizing" mission that "was one of the more ambitious programs of social engineering in recorded history."[16] But the Spanish priests tended to overlook the domestic Maya ceremonies (forest, milpa, and household) that were dedicated to the humbler spirits in the Maya cosmology, as compared to continuing the practice of human sacrifice. The priests thought of these rites as less dangerous and only venial sins. The clergy tolerated the village shamans, who directed the ceremonies, as long as they didn't create any problems.[17]

At the same time the priests also encouraged a Christian-Indian syncretism. Maya rituals were co-opted and Romanized when the Spanish strategically built their churches on top of temple platforms where the Maya were accustomed to worship.[18] Even though the Maya had a multitude of gods

and demons, the Spanish had an equivalent plethora of saints, angels, and demons. Throughout Mexico the Roman Catholic Church incorporated local festivals into the Christian calendar and gave Christian counterparts to the indigenous gods, assisted by the appearance of the brown-skinned Virgin of Guadalupe to the Indian Juan Diego in 1531 at the former temple of Tonantzin, an Aztec earth goddess. The Virgin became the adored patron saint of Mexico.

But the Maya didn't have to make a choice between one or the other: Nancy Farriss argues that the result wasn't simply a layering of Christianity over a pagan base but instead "a set of horizontal, mutual exchanges across comparable levels." The Christian cosmos wasn't that different from that of the Maya—both were complex, multilayered systems.[19] Already a devout people prior to the arrival of the Spanish, the Maya obliged the priests and continued their traditional practices. Four hundred years later, in 1971, don Anastasio had no problem in performing an ancient Maya ceremony and praying to the chaaks, to the Holy Trinity, and to a multitude of Roman Catholic saints and Maya gods. That some of the gods resided in the church and some in the forest was considered a natural aspect of their respective functions.[20]

As don Tasio prayed, the farmers retreated to the shade of a tropical plum tree to prepare the offerings. Dario brought over several pails of sakan, each covered with an embroidered cloth to keep it damp and protect it from dust and insects. As a couple of the men began patting out large tortillas, others stacked them to form a thirteen-layered ceremonial *noh wah* (big bread). They started by laying one of the fat tortillas on a bed of *bob* (*Coccoloba belizensis*) leaves and sprinkling it with *sikil* powder (roasted and ground squash seeds). Then another tortilla was placed on top and sprinkled with sikil powder, followed by another. The layers separated by sikil symbolized the layers of clouds in the thirteen-layered Maya celestial world. On the top layer Dario pressed a sign of the cross. He filled the indentations with sikil powder and poured a small amount of *balche'* (the sacred wine made from water, honey, and the bark of the balche' tree, *Lonchocarpus longistylus,* which ferments quickly into an intoxicating drink that is both emetic and purgative). Then they wrapped the bread in bob leaves and tied it with strips of tree bark. It was ready to be baked in the *pib* (earth oven).

Meanwhile, another group of farmers prepared the pib. They loaded firewood into the rectangular hole they'd dug earlier that morning then stacked rocks on top. They lit the wood on fire, heating the rocks, which would in turn cook the breads once the firewood had burned and the oven was ready.

The men explained that they were preparing three breads of thirteen layers, three of nine layers, three of seven layers, three of six layers, and twelve to fifteen more of five layers each, depending on how much sakan they had. They put the sign of the cross and its crown on the top of the thirteen-layered and nine-layered breads and pressed three or four holes into the rest of the breads. Depending on who was explaining this to me, these represented the four corners of the farmer's

milpa or the chaaks of the cardinal points or the *balams* (jaguars), the guardians of the night and of the forest. The sikil powder placed in the holes was sustenance for the chaaks and the jaguars. This was very important because they needed the protection of the deities so that snakes wouldn't bite them while they worked their fields, they wouldn't fall into a hole, thorns wouldn't scratch them, and they wouldn't cut themselves with their axes or machetes.

Don Tasio's assistant passed out gourds of sakah that had been blessed on the altar. It is thick, almost like porridge, and we had to chew it as we drank, swirling our gourds to keep the larger pieces of corn from sinking to the bottom. Since the corn had not been boiled with lime, the hulls hadn't separated and been washed from the drink, and they stuck in our teeth.

Most of the wood in the pit had been reduced to coals by the time the men finished layering the breads. They removed any wood that was still burning and used poles to level and break up the stones. It was hot, intense work; their sweat sizzled and steamed when it fell on the rocks.[21] A bed of hot rocks and coals was left in the pit. Over this they placed a layer of bob leaves and then the wrapped breads, and on top of this they added some hot rocks that they'd laid aside. They covered the earth oven with more leaves and then a sheet of corrugated tin and a layer of dirt.

With the sacred breads cooking in the earth oven, the men moved back into the shade of a plum tree and relaxed. Some sat around talking, while others played cards. Don Anastasio continued praying as he offered the sacred sakah to the deities. He also offered balche'. His assistant went around with a small coconut shell and gave every man and boy a cupful of the blessed drink.

We could hear the wives and mothers and sisters of the farmers busy in don Adub's kitchen preparing the meat of the animals slaughtered for the chaaks' feast. Traditionally the farmers hunted deer, wild turkey, and peccary, because these wild animals were under the care of supernatural guardians. But wild game was becoming hard to find, so now the h'men blessed and purified domestic turkeys, chickens, and pigs.

The women cooked the meat in a stew, adding freshly ground corn, annatto, pepper, cloves, oregano, garlic, and salt. They simmered the stew in large cooking pots set over several fires set up in the kitchen for the occasion, stirring them with long wooden poles. We could hear them talking and laughing, having their own party, and occasionally some of them would come outside. Though they didn't join us directly in the rituals, I was surprised that the women were there; I'd read in earlier accounts that women weren't even allowed to be in the area during a rain ceremony.[22] Later I observed other ceremonies and saw that the Maya were adept at improvising and breaking traditions while nevertheless being faithful to the spirit of their religious rituals.

When don Anastasio took a break from his praying, Hilario, Dario, and I talked with him. He sat in the shade of a tree and lit a cigarette. I asked how he'd become a h'men. Anasta-

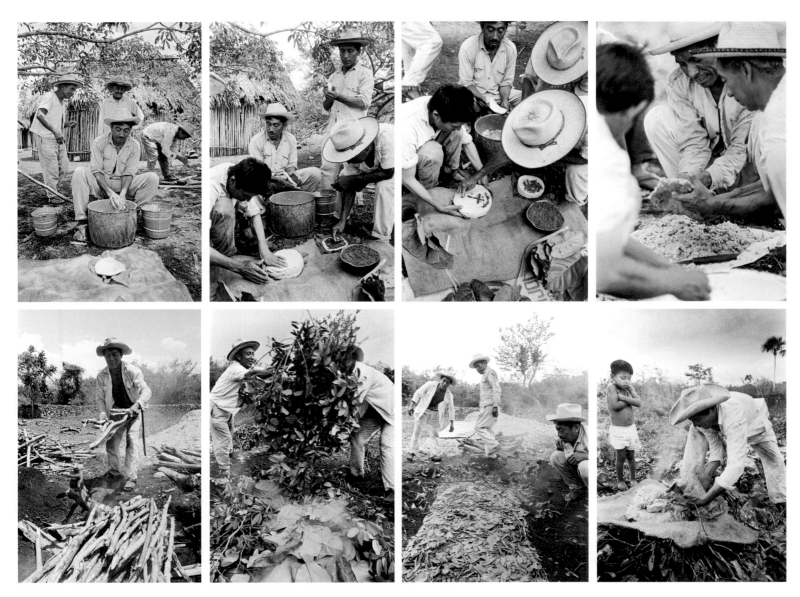

Preparing ceremonial breads and the earth oven at Ch'a Chaak. Chichimilá, Yucatán, 1971.

ABOVE: Dario and his neighbors removing the ceremonial breads from the earth oven at a Ch'a Chaak. The kitchen where the women are working is in the background. Chichimilá, Yucatán, 1971. FACING PAGE: Dario's stepmother doña Simona (*left*) and her neighbors doña Romaria Chi, doña Benidicta, and doña Felipa preparing meat stew for a Ch'a Chaak. Chichimilá, Yucatán, 1971.

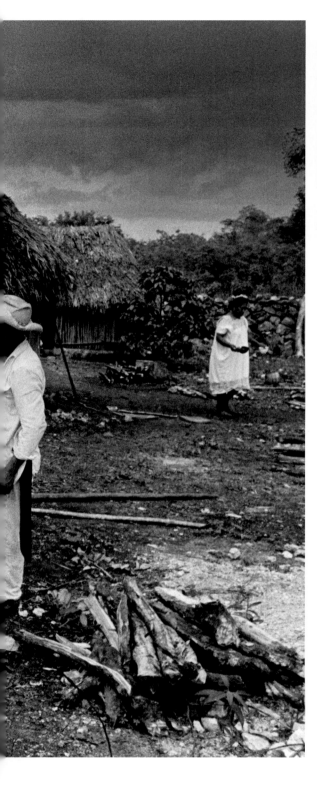

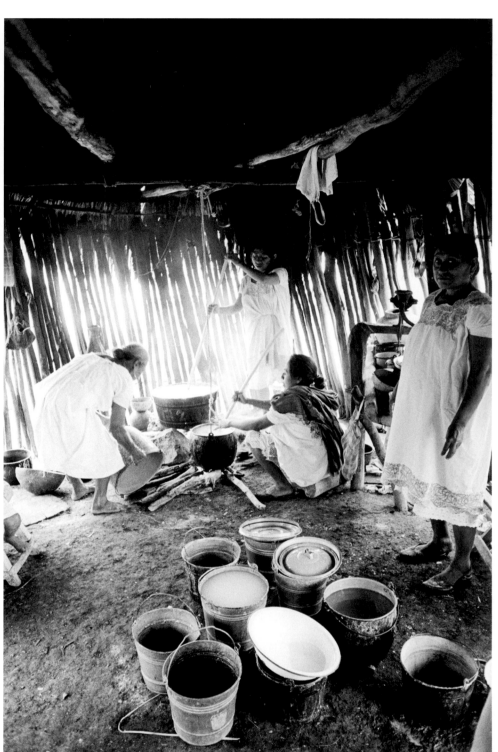

sio took several puffs on his cigarette, watching the smoke, before he replied. "When I was seventeen, I was walking through the woods, carrying a load of corn from my father's milpa. A *kutz* [wild turkey] was scavenging at the side of the trail as I passed. I did not have my slingshot or my rifle so I could not shoot it, and it flew into a nearby tree. But when I looked at the ground where it had been feeding, I discovered a *sastun* [crystal]. When I picked it up the turkey began to speak, and it told me that his was the word of God and that I should carry the sastun home with me and dedicate my life to divining and healing, in service to the great spirits and to the people of my village."

The Maya regard animals as spiritual beings and social persons—not human persons, but persons nonetheless—and part of society. As Eugene Anderson and Felix Medina Tzuc point out, "They communicate with humans and share with them a conscious participation in a sacred cosmos."[23] I later found that such stories of animals talking to humans were common among the Maya and were frequently the inspiration for someone to become a h'men. In 1974 Charles interviewed five h'men'ob in Chichimilá.[24] "Each one told me a similar story," he explained. "They'd been inspired to become a shaman by an encounter they had with an animal in the woods—all but one was with a bird. Most Westerners would probably laugh at such a notion. But if we'd been brought up in a culture which believes that animals can communicate with people, we might be prepared, when we meet one in the wild, to interpret such encounters ourselves in a way similar to the way in which the Maya experience them."[25]

The heat remained oppressive, but on the eastern horizon clouds were building. I was surprised at how quickly they filled the sky. Once the breads were baked, the farmers scraped away the earth from the pib and removed the tin sheet and layers of leaves. Don Anastasio's assistant made three offerings of consecrated sakah over the open earth oven, each time indicating the cardinal directions, in the shape of a cross. As the men pulled out the loaves of bread, it started sprinkling. Fat raindrops splattered on the hot rocks and sent clouds of steam into the air. The men laughed and turned their faces to the sky.

The rain changed everything. It was no longer oppressively hot. Invigorated, the farmers continued to laugh as they unwrapped the leaves from the corn breads and carried the loaves to the altar. They were still smiling when they brought gourds of the meat and sauce from the kitchen. Don Anastasio began dedicating the offerings to the gods as his assistant lit candles.

Underneath the plum tree the men broke up the two thirteen-layer loaves into a pail of meat sauce composed of sakan, ground squash seed, and chicken. They filled several gourds with the thick stew they call *sopa*, added a few cooked chicken legs, then hung the gourds above the altar.

After allowing time for the gods and saints to hear their prayers and to partake of the feast, don Anastasio's assistant removed the communion offerings and helped distribute them. Don Anastasio called out the name of each farmer. As they filed slowly past the altar on their knees, he asked that their harvest be bountiful. Each man kissed don Anastasio's hand and made the sign of the cross.

Then it was time to eat. We all served ourselves portions of sopa, added more sauce and meat, and broke off pieces of the large heavy consecrated loaves of corn bread. The chicken legs were the spoons to eat with. They joked and laughed, pleased with the change of weather. It continued to sprinkle and suddenly became chilly as a wind sprung up. As each farmer left he took a portion of food home, along with a couple of fat cigarettes of native tobacco that don Anastasio had rolled in cornhusks, the cigarette of Chaak. It rained throughout the night.

Dario owned the land he farmed, although most milperos worked *ejidos,* lands collectively managed by the villagers, combining communal ownership with individual use. He'd inherited 2,500 *mecates* (about 247 acres) when his father died. In Mayan the word for milpa is *kol,* which literally translates as "clear a field." A Maya farmer clears the forest for the planting of crops that require direct sunlight, though he may spare useful trees such as wild fruit trees, guano palms used for thatching, or trees whose blossoms attract bees. Or he may choose to leave an area of his measured forest standing and thin it rather than clear-cut it, cultivating the useful trees and plants already growing there. He may plant more of some species while eliminating those he doesn't want. This is an example of the Maya farmer's respect for the forest—he fells trees, but not all the trees.[26]

The farmer builds a corncrib at the milpa for temporary storage of his harvest before he can carry it home. If the milpa is nearby, the farmer usually constructs a simple *pasel,* an open-sided thatched roofed structure where he can hang a hammock to rest in the shade or wait out a rainstorm or spend a night defending his field from animals. If the milpa is farther away, the farmer may spend more nights at his field than at his home; his *pasel* will have pole walls and a cooking area. His family may even join him for months at a time. If several farmers, often an extended family, have distant fields close to each other they may each build a house in the forest for their families and add a separate kitchen: first a communal one and then one for each family. If they begin a milpa elsewhere, these buildings may be abandoned or may become the start of a small forest settlement, known as *kahtal* in Mayan. This is how a new village can be formed.

Before a farmer fells the jungle, he needs to lay out the measured boundaries of his new field. Dario explained that this is when a farmer becomes familiar with the land he'll be working. "If it is high forest where he's never worked before, he might discover a cave or a little entrance to a cenote or a ruin." The farmer creates the perimeter by cutting straight

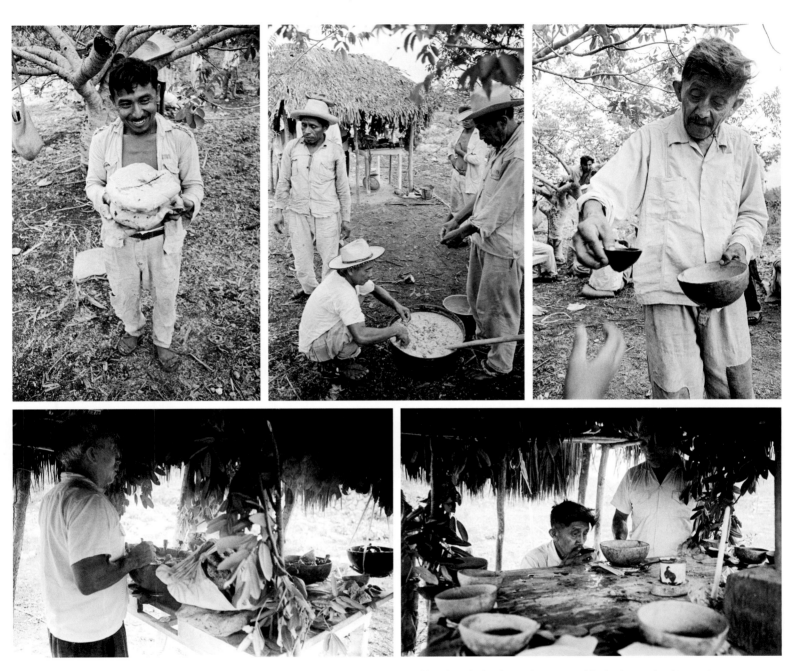

CLOCKWISE FROM TOP LEFT: a milpero proudly carrying two of the baked ceremonial breads cooked in the earth oven at a Ch'a Chaak; men breaking up the ceremonial breads and mixing them with the broth to make a sopa for the feast; Clavio Tun, who is helping don Anastasio, passing a little coconut shell cup of balche' to all the men participating in the rain ceremony; don Anastasio and don Clavio at the altar; don Anastasio placing the food on the altar and offering the feast to the gods. Ch'a Chaak, Chichimilá, Yucatán, 1971.

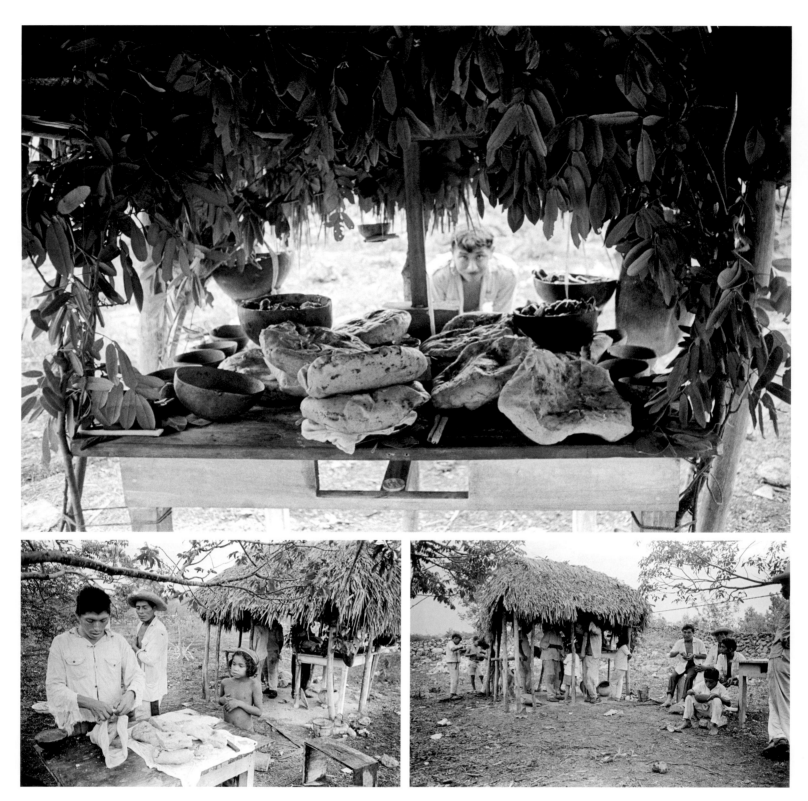

Farmers feasting after the gods have partaken of the food placed on the altar. Ch'a Chaak, Chichimilá, Yucatán, 1971.

lines into the forest and asks the help of a friend to stretch a line twenty meters (one mecate) long. He marks each mecate with a *xuuk'* (mound of three or four stones).[27] An area of fifty mecates can support a small family. Most milpas around Chichimilá were from fifty to three hundred mecates, depending on the size of the farmer's family, his access to land, and whether he planned to raise surplus corn to sell.

After measuring his field, the farmer needs to clear the forest months before he starts to burn so that it will be dry. He begins by cutting down the smaller brush and trees with a machete and a coa to give himself room to work with an axe. Then he drops the larger trees on top of the brush, trying to cover the ground uniformly so that the fire will burn evenly.

The farmer pulls out choice pieces of hardwood to be carried home for posts and beams in house building as well as straight and forked poles for wall and fence construction. If he doesn't use them himself, he can sell them. He also puts aside a supply of firewood for the home hearth, cutting and stacking it away from where he will burn, and will carry it home throughout the year. In places with free-roaming cattle, the farmer pulls out long poles and short forked ones to build a sturdy *suup'* (fence) to keep the animals out.

Burning the field must be done before the rains come. The time of burning (and subsequent planting) is a topic of intense discussion among all the farmers. They might consult the h'men, but most of all they observe indicators well known to all, such as the color of their cooking fires, the direction of the wind, or the shape of the clouds.

Before burning, the farmer cuts any new growth that's sprouted and clears a *guarda raya* (firebreak) around the outer edges of his field to contain the fire. He'll often ask friends to help with the burning, not only because it is hot, intense work but because he'll also need help if the fire jumps the perimeter. It can suddenly become dangerous if the wind shifts or gusts. Ideally the farmer wants a slight wind to spread the fire across the field. The fire should burn the brush completely, not leaving any large logs. The heat loosens and enriches the soil and kills the insect life in the ground. This is important because there is no frost in Yucatán, and burning rids the field of insects that might eat his crops. If the field doesn't burn completely, the farmer will face the labor-intensive task of burning again. This entails dragging half-burnt logs and piles of brush and making new piles in order to have enough fuel to burn well.

"When I was young and just learning to be a milpero," Dario told me, "I once burned my milpa too soon. 'What have you done?' an old farmer scolded me. Then he explained when to burn. 'Don't burn with a north wind because it doesn't give you the burn that you want. Wait for the east wind, and not just any east wind, but the hot one that comes at night, and when you get up at dawn, even before you do any work, you find that you're already sweating. It heralds hot weather and the time to burn.'"

Most milperos burn within a couple of weeks of each other in April, covering the whole peninsula in smoke. It is as if the world has jaundice. The sun turns red and the sunlight yellow. Some Maya believe that the smoke clouds signal the chaaks, calling for the rainy season.

This is a good time for making lime. The farmer prepares a raised platform of logs, putting dry logs of hot burning woods such as *chacah* (gumbo limbo, *Bursera simaruba*) and *chechen* (black poisonwood, *Metopium brownei*) at the bottom and then longer-burning green logs at the top. The farmer piles small limestone rocks in a round mound on top of the platform and then sets it on fire. In about twelve hours he is left with a pile of quick lime. He'll add it to the corn that the family boils each night and use it for whitewashing, for making mortar and plaster, and for painting the trunks of fruit trees against the night cutting ants.

When the ground is wet enough to sprout the new seed, it is time to plant your field. A harbinger of the time to plant is when a particular type of ant and a type of termite grow wings, evidence to Dario that the ground is so wet that they need wings to get around. Another sign is when the small yellow flowers of the cedar tree begin to drop and cover the ground. The farmer will also consult with his fellow farmers, and they might all decide to plant at the same time after a heavy rain. This is a momentous decision—too soon or too late and the farmer won't have a good harvest.

"Herculana and I were married in Valladolid, on Mother's Day, May 10, 1958. It rained that very afternoon, a good soaking rain that lasted for four hours. My father and I looked at each other. The next morning we were up before dawn and walked out to our milpa. It was a very good year. I got my seed in early," Dario told me.

The farmer usually plants two regional varieties of corn. *Xmehen nal* is a quick-growing corn that can be harvested after two and a half months. *Xnuk nal* requires four months. The farmer prefers xnuk nal, which is larger and gives a better yield; but if a hurricane or lack of rain cuts short the growing season, the farmer can fall back on his xmehen nal crop. The farmer sets aside his biggest and best ears of corn from the previous harvest for seed and uses the kernels from the middle of the cob rather than the smaller kernels from the ends. He'll often plant beans in one section of the corn, so that the cornstalks become the beanpoles. The preferred bean to plant is *frijol del país* (*Phaseolus*), meaning local to Yucatán. It is larger than the small black bean imported from Veracruz and much tastier, according to the Maya. A farmer will also plant an assortment of vegetables and root crops (either from seeds or from seedlings and cuttings started in his home garden) in a separate area of the milpa measuring about five mecates, known as *u pach pakal* (behind the corn planting).

Dario planted with a gourd around his waist filled with seeds and his *xul* (metal-tipped planting stick) in his left hand. He would lean forward, jab a hole in the ground with his planting stick, then toss five or six corn seeds with his right hand, cupping his fingers so they funneled the seeds to

the hole. As he stood up, he'd slide his foot forward, pushing the earth to cover the seeds and the hole. Then he would step forward a pace and repeat his gestures.

Dario planted with the repetitive moves of a practiced dancer. He was careful, so that he wouldn't have to stop to pick up the seeds. Blackened stumps and limestone outcroppings pockmarked his fields and made it impossible to plant uniform rows in the fire-stained earth. In one area with corn he also planted pole beans, whose vines would climb up the cornstalk as they grew. In another area he planted three varieties of squash, which would spread out and provide a good ground cover.

A farmer really likes the next rains to come within a few days of planting; otherwise the ants, raccoons, birds, rats, and squirrels will dig the seeds up and eat them before they germinate. Under favorable conditions, the corn sprouts within a week. If the farmer sees that there is room between the clusters of seedlings, he'll do a second planting to fill the gaps.

Almost as soon as his seeds have sprouted, the farmer has to weed. He'll need to do this at least twice during the growing season. This work is intense. If neglected, weeds strangle the crops. Often weeds are chopped back rather than pulled up by their roots. Using a coa and machete, Dario could weed six mecates or more a day. The weeds left on the ground become a green mulch. The Maya have names and descriptions for corn from the time it appears until it's harvested. When a farmer says his young corn plants are the height of rabbits, his neighbors know what he means. During the growing season, if you ask a farmer how he is or how things are in his village, he'll start by telling you about his corn crop. Whether it is kernels (*ixim*) or the plant or ear (*nal*), the Maya farmer doesn't call it "corn." He calls it Santo Ixim and Santo Nal or Santa Gracia (Holy Grace) or simply Gracia (Grace), denoting its spiritual essence, its sacredness, and the inextricable linkage of the farmer, his sustenance, and the gods.

Dario was completely dependent on the weather to water his crops because the rivers in northern Yucatán are below ground. None of the milperos had irrigation systems for their fields. Once we were at his milpa when the wind suddenly picked up and roiled the clouds in the sky. Within minutes raindrops were pounding us. We were drenched, but Dario started laughing. "This rain is like money from heaven," he shouted. "It ensures me a good crop. *Hats'uts'!*"

The time to harvest the corn begins as early as September or October and lasts until January and February. In November or December when the corn plants have grown tall, the ears have matured, and the stalks and leaves turn brown, the milpero bends the stalks to keep the rain from damaging the corn and birds from stealing the drying ears. The bean vines continue to grow on the cornstalks until the end of the year, when they are harvested. Animals want to eat the farmer's corn, so during this crucial period the farmer might spend nights in his cornfield with a slingshot or a shotgun. It's a good time for hunting.

The farmer looks at each ear when he harvests his crop. If the husk is in good condition, he leaves it on to protect the corn against mice, bugs, and moisture during storage. If the husk has been damaged, he removes it with a husking tool. His family eats these ears first. The farmer prepares a place to store the corn both in the milpa and at home. Sometimes it is inside his house or in a covered shed in his yard. A few villagers in 1971 were still known to put a boa constrictor in the shed to control mice and rats.

When the first fresh ears of corn mature on the stalk, the farmer performs a thanksgiving ceremony at his milpa, where he makes *pibil nal* (ears of corn roasted in an earth oven). On the way home he gives two or three ears of the fresh-cooked corn to everyone he meets on the trail, and he might leave six ears at the edge of town. These are for anyone to eat. At home he holds a religious feast, inviting his neighbors to eat the fresh baked corn along with new corn atole. Each farmer holds his own thanksgiving ceremonies in his home—not all on the same day but drawn out over the weeks of first harvest. It is a wonderful time of the year in the village. There is fresh corn![28]

The milpa cycle is accompanied by religious acts, petitions, and thanksgiving. The ceremonial offering of sakah is a simple ritual that a farmer performs in the milpa. He might offer sakah before he begins to cut down his milpa, or after burning but before planting, and then again after he plants or when the corn is high, so that the sun won't shine too hard and burn it. Dario offered sakah at least once during each corn season. He liked to make his offering after he'd finished his first weeding, when the young corn plants were knee high. He'd carry out to his milpa a gourd of water and a ball of sakan wrapped in a handkerchief.

Dario would select a place in his milpa to make his altar, preferring a *ka'lap* (a low spot in the terrain, a pass between two little hills)—a power spot where the chaaks would like to pass. Facing east, he'd make a simple altar by using two parallel poles with cross-sticks and place six *leks* (calabash bowls) on it. He'd mix the water and corn dough together and divided the sakah between the leks. Dario explained that when you give sakah, you are providing a cool place for your conversation with the gods (*táan u ts' u síis óol u ti'al u t'aantik*). When Charles and I asked Dario what he meant, he patiently explained: "This cool place is like the shadow when a cloud passes by on a hot day. When the rain clouds pass by, they drop the rain on the cool place defined by your offering of sakah. I attract the rain by providing a quiet and attractive spot. It is my call for rain."

Dario offered prayers so that the milpa would be protected and he'd be allowed to make a good harvest and no bad animals would harm the crops. If he had a specific name for a feature of the milpa, Dario called it out. If not, he'd sim-

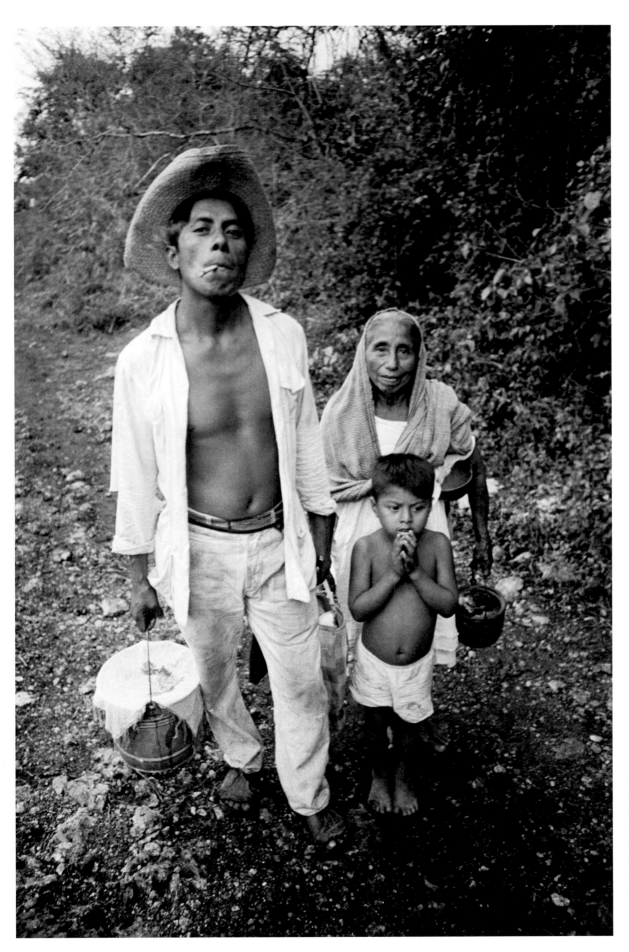

Dario, his stepmother doña Simona, and his son José on their way home after the Ch'a Chaak ceremony. Dario smokes a hand-rolled cigarette made from local native tobacco and carries a pail of ceremonial food. Doña Simona carries a pot of the meat stew. Chichimilá, Yucatán, 1971.

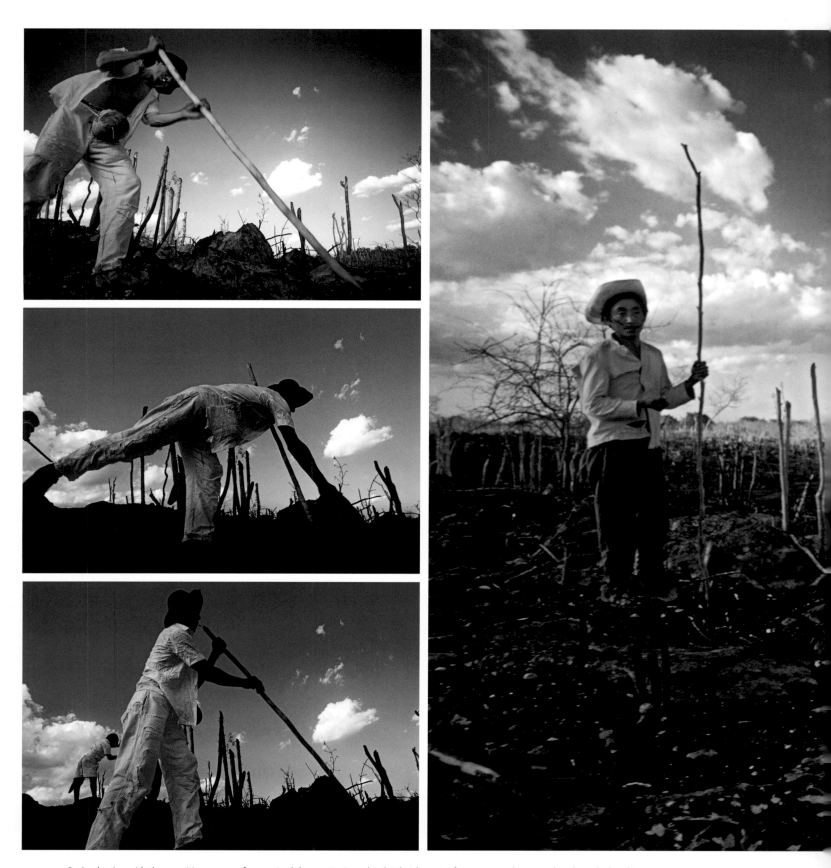

Dario planting with the repetitive moves of a practiced dancer; Dario and Gabriel Nahuat Ay, from Xocen, plant Dario's milpa. Chichimilá, Yucatán, 1974.

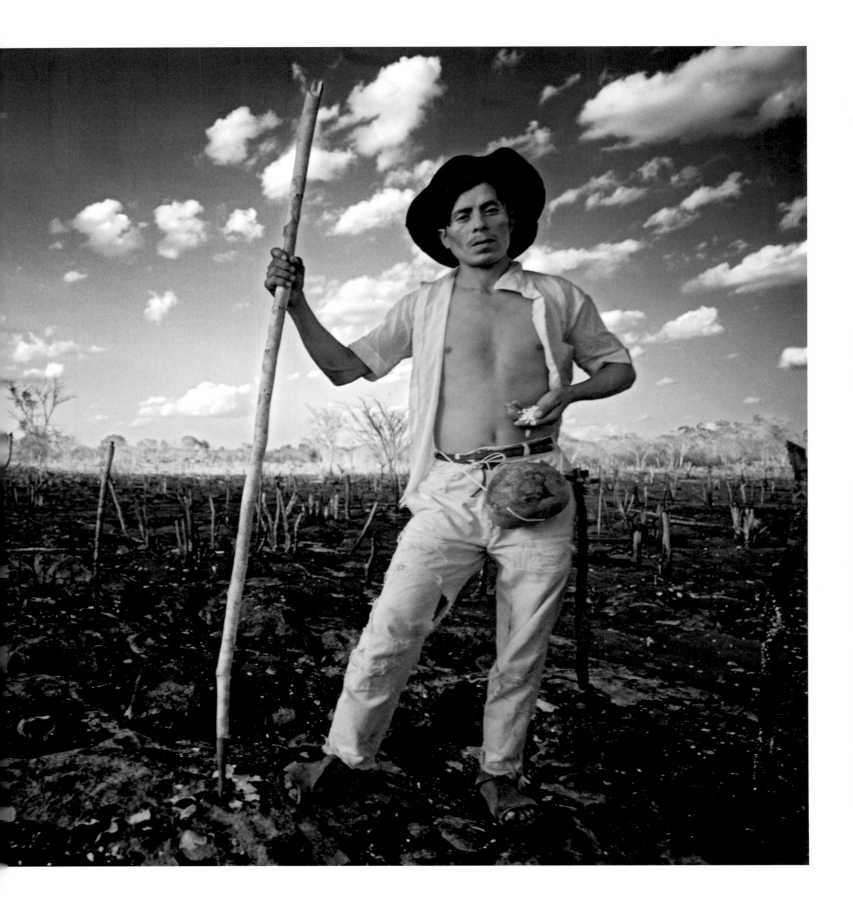

ply describe the feature—such as the hills, the low places, or the rocky spot near the cedar. His prayer was to the guardian of each of the locations and also to the *dueño* (owner) of the trails.

Even the animals had their saints, and Dario offered his prayer to them as well. "At night," he explained, "the animals go out like people—they have their business and they have their social appointments. They'll visit the cenote; they'll visit all the natural features of their world. If they visit the milpa, they'll stop and eat. But it's better for me if they don't. So I pray that the animals will detour around my milpa and follow another path. Except for the night birds—I like them to visit my milpa. The day birds hurt me, but the night birds, like the owl, hunt other animals such as gophers and rats. They help me."

Dario would wait an hour after he said his prayers, enough time for the gods to receive them and spiritually drink the sakah he offered. "You give the sakah away to your friends if they are with you in the milpa. Or if you are alone you take a leaf and flip a little sakah in each of the cardinal directions," he said. "When I offer sakah, my work will be free of hazards—or at least the hazards won't harm me. If I'm not careful, a snake can bite me or a rock or stick can get in my way. If I'm walking and a vine trips me up, it got in my way. If you're walking and twist your ankle by stepping wrong on a rock, it got in your way. But if you are working and you fall and nothing happens to you, it's because you've already been mentioned in the prayers."

The farmers perform many other ceremonies in the milpa and at home. They might ask for a good harvest or pray for the health of a newborn child. "It's an exchange," says Dario. "You exchange your offering for the health of your child." The *loh* ceremony, consisting of seven prayers, lasts for hours and is performed to cleanse and renew a person or place. It requires the help of a h'men to offer the appropriate prayers and the help of others to prepare the pib and all the food. "While poor people like me might do a small prayer," Dario commented, "a rich person might do a large prayer, a table offering, a loh."

Even in a communal ceremony, Dario explained, you did not need to be rich to participate. "If you are poor," he said, "you can buy a kilo of meat to donate, along with a half kilo of sikil, and prepare two kilos of sakan."

Dario says that working at his milpa gives him peace of mind and makes him feel a free spirit. Certainly the work is arduous, but he alone decides when he works, in accordance with the necessities of the milpa and the gods; when he devotes himself to his wife and children; and when he attends to chores around their house. A good harvest provides enough food for the year, and if there is a surplus he can trade it for what he can't grow or make himself.

"I'm happiest in the forest and here at my milpa," Dario told me years later, on a May morning in 2006. We'd walked out at dawn to his same plot of land that he'd first taken me to thirty-five years earlier. Dario was planting his field. As he worked he discovered some macal he'd planted the year before. He stopped, got down on the ground, and clawed at the dirt until he worked the tuber free. "Here I spend my time," he said. "It gives me pleasure. There's no one out here to bother me. And look." He grinned, holding out the macal root. "A little bit of work and I have food to take home and eat and enjoy the fruits of my labor."

A man appeared at Dario's doorway and asked for water. He squinted at us, his eyes adjusting from the bright sunlight outside. I recognized him as Antonio, a mentally challenged man who lived in Chichimilá. Because he wasn't harmful to himself or anyone else, he was left to wander freely. In pre-Hispanic times, some Mesoamerican cultures treated mentally challenged people as special individuals. Today in Mexico, as in most of the Western world, people may close their doors on them and mothers encourage their children to flee.

But not Dario. He asked Antonio to wait at the front door and walked back to the kitchen behind his house. He came back carrying a bowl of *chokó sakan* (corn drink). Antonio quickly slurped it down and handed the *jícara* (calabash bowl) back to Dario, who asked him if he'd like a bath.

Antonio nodded and sat down. José, Dario's eldest son, came over and offered to let him play with his yo-yo while his father prepared the bathwater and curtained off a portion of the room. After his bath, Antonio came out from behind the curtain, slicking his wet hair back with his hands. He looked clean and very happy, showing his teeth as he smiled.

After several months photographing Dario in his milpa and home in Chichimilá in 1971, I developed a roll of film in Mérida and brought prints to give to Dario and his family. While his children talked excitedly about their photos, he pulled me aside. He asked if I could do him the favor of driving him to a doctor in Valladolid. Valentina, his three-year old daughter, was ill. He'd already called in a h'men, who had killed a chicken and sprinkled its blood around the entrances to the house and the yard to keep away evil winds.

The doctor in Valladolid prescribed a medicine. At first it seemed to work, but later that night, after we'd gotten in our hammocks and fallen asleep, Valentina's coughing awoke us. It was a wracking cough that seemed to be shaking her tiny body apart. She would cough, spit, cry, and cough again. Dario and Herculana tried to console her, but she coughed all night long. I was sure it was tuberculosis, and I was worried for all the others. It felt as if death had come into the cramped confines of the room. Valentina died soon afterward.

When you ask parents in villages in Yucatán how many children they have, they often tell you how many have been

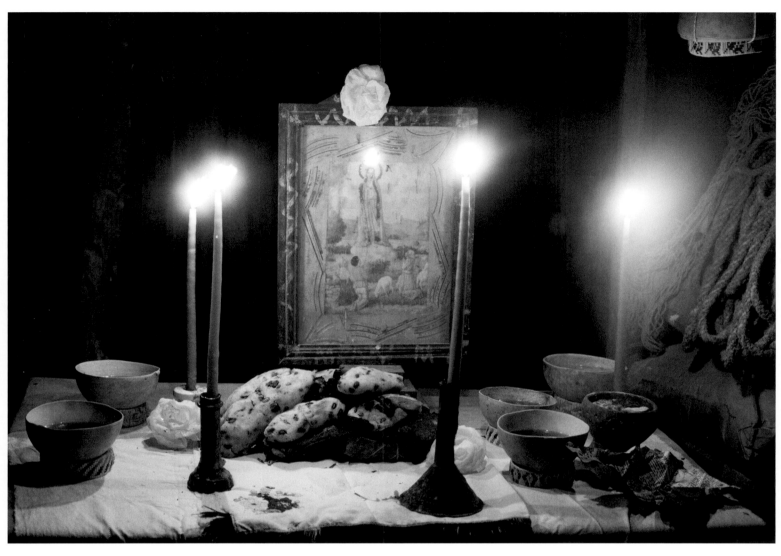

Offering on an altar in Dario's house. Chichimilá, Yucatán, 1971.

born and how many are living. The Maya rely on their traditional medicine and remedies and often consult with a h'men and *hierbatero* or *hierbero* (herbalist). They also visit doctors and health clinics in the towns or nearby cities that have them; but they can't afford more than the most rudimentary health care, so illnesses that require a specialist go uncured. Parents and doctors instead provide a hospice, treating symptoms until the disease takes its toll.[29]

Dario and Herculana lost four children to disease. My parents also lost a child, my sister, who died of childhood diabetes, and I saw how much they suffered. There probably has not been a day since she died that they don't remember her. It is all parents' nightmare to outlive their children. Among the Maya it is a regular occurrence.

Dario dug wells to earn money. Around Chichimilá he had to dig them twenty-two meters deep before he reached water. It was exhausting work, loosening a half-meter of limestone at a time with dynamite and digging out the rock by hand with a bar, pick, and shovel then hauling it out, one bucket at a time.

While digging a well, Dario once uncovered a cave system but never reached the end. He brought Hilario to explore, with flashlights and a rope. Hilario also never reached an end. The Maya have found many caves like these and believe that they are passageways of the *alux'ob*, dwarflike forest spirits with special powers that often live in cenotes and caves and can help a farmer. Dario spoke to me several times of a legend that when the Maya built their sacbes above the ground to connect Maya cities such as Chichén Itzá to Uxmal or Cobá, the *alux'ob* built similar roads beneath the ground but sealed their trails when the Spanish arrived.

Dario offered Charles a job helping him dig a well at a ranch southeast of Chichimilá. They traveled by bus to a marker along the highway to Tihosuco and walked eight kilometers east into the jungle. Two families that were related lived at the rancho. This would be home for Charles and Dario for the next forty-five days.

Charles already knew the most obvious sign for water. A ceiba (*yaxche*) tree often indicated a cenote underneath, an entrance to Yucatan's underground river system.[30] Nearly every old Maya village or town is founded around a yaxche, with either a natural or dug well near its trunk. The Maya consider it the tree of life that spans the thirteen levels of the heavens and the nine levels of the underworld. But if they dug deep enough, they could find water anywhere once they reached the water table. Dario hoped to encounter a natural cavern in the rock at water level. If not, they would carve their own cavern for the water to pool, what he called the *campana* (bell) of the well.

Charles and Dario dug a well 23 meters (about 75 feet) deep, down through the layers of red earth, white saskab, and limestone. They used a pickaxe, a digging bar, a scoop, their hands, and dynamite, removing the rubble with a bucket and rope. When they hit rock they would pound a one-inch hole 10 to 12 inches deep with the bar, pack it with dynamite, and run a fuse up to the surface. The scary part was when the charge didn't explode: they'd wait a while before peeking over the edge to look down the hole. They would wait even longer before climbing back in to see what went wrong.

It was tedious, mind-numbing work. They would take turns, one working in the hole, the other working above ground, hauling out bucket after bucket of the rubble. Climbing in and out of the hole was the fun part. They would brace themselves against opposite sides of the circular well and work their way up or down, finding footholds and handholds in the rock. While they worked they didn't talk, separated at either end of their hole. But every afternoon about four they would stop work and relax for the rest of the day. This is when Charles learned to speak Mayan. He discovered that living in the jungle was simple but very comfortable. The families provided them three home-cooked Maya meals a day, and he learned to savor black beans and hot handmade tortillas. After several years with the circus, traveling nearly every road and performing in a new town or village weekly, this was a completely different pace of life, which he enjoyed immensely.

When I first arrived in Yucatán, Chichimilá didn't have electricity, so there were no movie theaters or televisions, and only a few people owned transistor radios (batteries were expensive). With few outside diversions, villagers looked forward to the visit of a traveling circus and even more so to the annual fiesta of their village—as excitedly as people in the United States look forward to Christmas. The fiesta, which often lasts a week or more, is a religious celebration honoring the local patron saint that mixes the sacred (prayers, masses, processions) with the profane (gambling, dancing, bullfighting, shopping, eating and drinking). Everyone attended the village fiesta.

If they could afford it, Chichimecos (those from Chichimilá) might join the festivities at nearby villages, especially if a relative lived there, and also the Feria de Candelaria held in the barrio of Candelaria in Valladolid. Starting at the end of January and continuing through February 3, it celebrates Candlemass, the Feast of the Purification of the Virgin. As the only city in the region, the fiesta attracted not only people from Valladolid but also Maya from other surrounding towns and villages. The afternoon bullfights and evening dances were especially popular and offered an opportunity to socialize.

On January 25, 1976, I invited Dario and Herculana to go with me to the Vaquería (Cowgirl Dance) on opening night. For many it was the most exciting dance to attend because everyone danced to *jarana* music, a holdover from colonial times. The dance took place in a large walled-in yard near the center of town. Strands of lightbulbs were stretched above us

Dario harvesting. Chichimilá,
Yucatán, 1976.

between palm trees, and above the bare bulbs were the twinkling stars. The tropical air smelled sweet from a thousand freshly washed and scented bodies, with hundreds of women wearing their most elaborate *ternos,* the traditional three-piece formal attire of Maya women. It consists of a richly embroidered huipil with a lace-trimmed hemline, a *jubón* (*hep' tsem* in Mayan: a wide, flat embroidered square flounce attached to the neckline of the huipil), and a *fustan* (*pik* in Mayan: a waist-slip worn under the huipil, embroidered and trimmed with lace). Their faces and necks bore traces of talcum powder, with their cheeks rouged apple-red and their mouths brightly lipsticked. Gold sparkled from earrings and necklaces, adding to the illusion that each woman was a rare tropical bloom. Many wore bright red, green, blue, or yellow ribbons in their jet-black hair. Some had sequins; all sparkled and shone. Some men tried to be equally colorful by wearing, for example, a pair of turquoise pants, a shiny green satin shirt, a white hat, and a pair of locally crafted blue leather high-heeled dancing sandals. It was the one night when both villagers and townspeople dressed as Maya, or at least in the stylized rendition of what was considered the folkloric tradition of the region.

Dario and I were conservatively dressed in white pants, white guayabera shirts, white hats, white sandals, and red bandanas tied around our necks. Herculana was beautiful in her huipil. Victor Soberanis y Su Orquestra, featuring a saxophone, clarinets, trumpet, drums, and electric bass guitar, were set up in a corrugated metal band shell. For the Vaquería they played traditional jaranas, in either 6/8 or 3/4 rhythms. To a casual observer, the jarana is danced something like shifting gears in a truck while double clutching several times a second, with a little tricky footwork thrown in. I had started taking photographs when two of the prettiest women asked me to dance. I immediately said yes and maneuvered so that we were in the most crowded area of the dance floor, where I hoped I wouldn't stand out, as I didn't know what I was doing. I looked up and saw a group of Maya women, sitting three rows deep, with laughter in their eyes and big grins on their faces, nodding encouragement—so I kept trying. The stomping on the wooden platform by some of the dancers was tremendous; when I felt the concrete floor move, I was really impressed.

A number of people of the Valladolid upper class invited me to their tables, eager to make my acquaintance and be seen with an American. That is, until they found out I was with Dario and Herculana. A few were drunk and began yelling at Dario. "Hey, corn farmer, shouldn't you be out in your field planting?" they began, then got nastier. Dario had to restrain me. He told me it was not unusual. It was something that he and most Indians in Mexico live with. He gently pushed me away from their table, and we joined a group of dancers who were neighbors from Chichimilá.

I've never gotten used to how my Maya friends are treated by Mexican dzules. Ever since the Spanish arrived, the Maya have been reminded that they are the lowest caste. As an outsider, I try to make a difference; although I might be able to

make a point, too often I forget that for my Maya friends it usually isn't worth the embarrassment and the consequences. I can leave, but they can't. This is their home, and they wake up to personal and institutional racism every day.[31]

"How do we deal with history?" the Native American poet Simon J. Ortiz asks in his preface to *From Sand Creek.* "Indian people have often felt we have had no part in history . . . Indians had been 'conquered,' so it didn't really matter anymore. We had been made to disappear. We were invisible. We had vanished. Therefore we had no history. And it was almost like we deserved to have no history. That was the feeling. But we did exist. We knew and felt that deeply. Innately.

"At this point in history, Indians are still not accepted as full participants in and members of world human cultural society. If they choose to, they can accept that severely restricted role, but then they will have to tolerate that role's social, political, and cultural limitations. Or they can be who they are, absolutely and completely. This means, I think, that they will have to consider themselves to be enjoined within the social-cutural-historical schematic of 'victors and victims' but insistent upon the value and integrity of their own human cultural existence."[32]

A few months later, agents of the United States Drug Enforcement Administration (DEA) flew a helicopter low over Chichimilá, searching for marijuana. They spotted several plants growing in Dario's yard. When they landed, they arrested him. He was taken first to Valladolid then to Mérida. The police beat him and tried to get him to confess. They were convinced that he was part of a larger conspiracy. "Where are the seeds?" the agents kept asking Dario. "Who gave you the stuff?" Following an erroneous tip, they were convinced there was a heroin lab in the jungles behind Chichimilá.

Actually Dario *was* part of a larger group—he'd been brought up like many Maya to believe that God provided mar-

Dario and Herculana. Chichimilá, Yucatán, 1971.

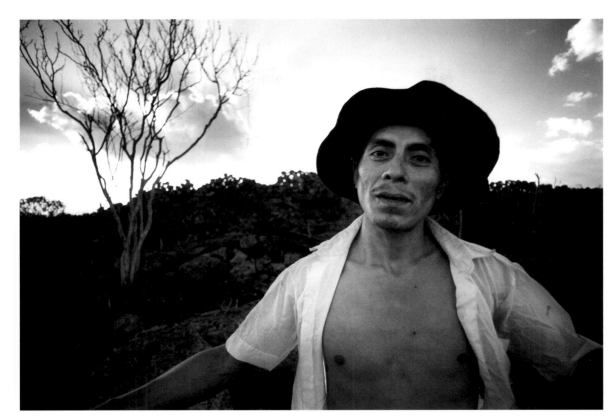

Dario in his milpa. Chichimilá, Yucatán, 1974.

ijuana to make life bearable for a hard-working man (women rarely smoked). He had marijuana plants in his garden, along with other herbs and spices and native tobacco. For thousands of years Americans had prized smoke as the evidence of a divine manifestation. Incense and cigarettes and pipes of tobacco or marijuana all produced smoke and were an inextricable part of his culture. Dario was neither a drug dealer nor a smuggler. The Maya at this time had no drug problem. Not all men and no children smoked it—everyone understood that you only got to smoke, if you chose to, after you took on the responsibilities of adulthood and hard work. Mayas didn't smoke and party; it was a small pleasure that was earned and a gift from God to help make backbreaking work under the hot sun a little more tolerable.

But the DEA officials didn't care about Amerindian culture. They simply wanted to boost their statistics on the War on Drugs.[33] When I contacted the governor of Yucatán to plead on Dario's behalf I was told by his aide that the U.S. government was exerting tremendous pressure to give Dario jail time. He was given a five-year, three-month sentence and sent to prison in Mérida. The judge handling Dario's case suggested that he might be given a lighter sentence if Ursina, Dario's eldest daughter, came to live with the judge's family as a maid. But he did not make clear the extent of the duties he expected from her, so Dario never agreed.

Charles had left the circus and was working in Alaska when he heard the news of Dario's arrest. "I remembered Dario as a hard worker who had very little money," Charles

told me later. "I knew his family would suffer as much as he would. Since I was doing well, I thought the least I could do was help them out. I wired money to Herculana, but I found out in a letter from Hilario that she had trouble cashing it at the post office. It seems the postmaster couldn't fathom an Indian woman receiving funds from abroad. So instead I sent the money to Ursina, who spoke Spanish and was better prepared to deal with bankers and the postmaster in Valladolid. I continued to support them for the next five years.

"I made several trips to Yucatán during this time and always made a point of driving Herculana to Mérida so she could see Dario. She usually brought Pedro, their youngest child, who was born after Dario was arrested and had never seen his father anywhere except in jail. One time a flat tire delayed us. Even though we arrived only a few minutes late for visiting hours, the jailers refused to let Herculana in. She cried.

"Frustrated and saddened by the whole thing, and as it was late, I took her to a hotel for the night. I ushered her into her own room, hoping a warm bath would make her feel better after our disastrous day. When I knocked on her door a half-hour later to take her out for dinner, she still hadn't bathed. This woman who had pulled countless buckets of water out of a well and heated it for her nightly bath did not know how to draw a bath from hot and cold water faucets into a tiled tub. At that point I realized how little she understood about the outside world and the whole system that had taken her man away."

1. A home garden is also called a dooryard, kitchen, or orchard garden or *solar* or *huerto familiar* in Spanish. At La Unión and Álvaro Obregón in Quintana Roo, Francisco Rosado May recorded up to 110 plant species in home gardens of only one-fourth hectare. Arturo Gómez-Pompa has found 60 to 80 species in a family plot and a total of 100 to 200 in a village and noted that these kitchen gardens "probably originated with the ancient Maya and played a very important role in the domestication or semidomestication of many plant and animal species. In these gardens, the Maya probably germinated the seeds of forest trees that would subsequently be transplanted to more distant agroforestry plots. These seedbeds may have played a very important role in the domestication of tropical plant species." Bainbridge and Gómez-Pompa 1995.

2. Reed 2001:xvi. Hilario was brought up in Paris, Dublin, Puebla, New York, Los Angeles, and San Francisco. His father, Hilaire Hiler, was a pioneer modernist painter who was highly regarded by his friends and contemporaries. His parents' friends included Henry Miller, James Joyce, Anaïs Nin, e. e. cummings, Man Ray, Kay Boyle, Marc Chagall, Amedeo Modigliani, Constantin Brancusi, Ernest Hemingway, Lawrence Ferlinghetti, Marcel Duchamp, Ezra Pound, and William Saroyan. Pick up a copy of Anaïs Nin's *Diary* and you'll see references to his father. Henry Miller also mentions him. Hilario attended public schools and an English boarding school and learned Spanish and French while living in Mexico and France. At Wesleyan University he studied in the world music program, specializing in south Indian music.

3. Villa Rojas 1945:52.

4. It appears that all plants of *chayamansa* (the most common variety in Yucatán) are clones. Ross-Ibarra 2003.

5. "Yucatán offers a wealth of tropical fruits," Hilario told me. "And the Maya have something to say about each one. Papayas, for example, come as small as your fist or as large as a watermelon and range in color from green to yellow to orange. They aren't consistent in taste; even plants right next to each other vary. They're temperamental. Seeds for planting should be taken from the middle of the female fruits. Discard the seeds at the ends. According to popular belief, what distinguishes a female fruit is the point at the bottom curving in rather than protruding out. A successful farmer plants his seeds while hungry and naked at midnight when there's no moon. Others argue that you want a full moon to do this so the papaya won't grow too tall. To this day, I'm not sure of all the tricks with papaya. One time I had some choice papaya seeds I was going to plant. It wasn't midnight, and I wasn't naked, but it was late in the afternoon, and I hadn't eaten, and I had a neighbor come over, a Maya friend, and he said he'd help me plant. So I gave him half the seeds I had in my hand and we both proceeded to plant. Now when these plants grew, the ones he planted remained short and close to the ground, and the ones I planted went way up in the air, which actually isn't advantageous when getting the fruit down. I was amazed that without exception his plants had grown all the same, much shorter and smaller than mine. Both produced fruit of a good size, but mine were considered to be more flavorful and sweeter. Why these things happen, I don't really know, but it's a reason why there are so many folk sayings about the papaya. You can tenderize a steak by wrapping it in papaya leaves, which contain strong enzymes. If you pick a papaya, don't get the sap from the stem on your skin, as it causes burns and is especially dangerous to the eyes. This is not a folktale. Fruit vendors in the market often scratch the surface of papayas so the sap dries out.

"The Maya usually eat fruit during the heat of the day rather than early in the morning or at night. A word of caution—the Maya feel that drinking alcohol and eating the red banana [*plátano morado*] is a deadly combination."

6. In research conducted around Chunhuhub, Quintana Roo, Eugene Anderson found 122 locally grown plants used for food. In addition he found 330 plants used medicinally and felt that this number might only be a small

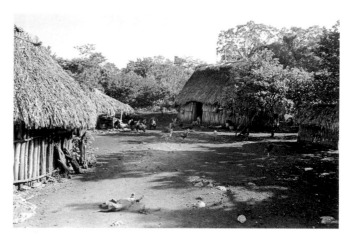

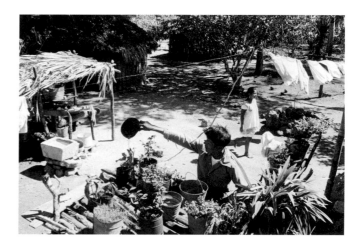

TOP: Typical yard with separate buildings for sleeping, kitchen, and storage. Chichimilá, Yucatán, 1971.
CENTER: Hilario Hiler. Chichimilá, Yucatán, 1971.
BOTTOM: Dario watering herbs and seedlings in a raised bed. Chichimilá, Yucatán, 1976.

fraction of the whole. Another 168 plants were used as ornamentals, and 62 species were used for timber. He adds that minor uses are important: "Plants provide animal forage, wildlife food, basketry materials, nectar and pollen, tannin for hides, soil-quality indicators, dyes, drugs, toys, soap, disinfectant, and ritual and symbolic values . . . There is even a plant whose sticky leaves are used to trap fleas." Gómez-Pompa et al. 2003:537.

7. Ibid., 540. See the chapter "A Short History and the Legacy of the Maya Forest" above: the ancient Maya had a complex agricultural system that made a point of conserving biological diversity. We have no evidence that the Maya caused any mass extinctions of species or that species diversity and richness were diminished. Over 90 percent of today's forest is useful to the Maya, and it is the second most biodiverse habitat in the world.

8. "There is no 'nature' in Maya. Maya speakers must borrow the self-consciously learned Spanish word *naturaleza*. The Maya distinguish between the settled world—*kaaj*, 'community' and *kool* [*kol*], 'fields'—and the *k'aax* ('forest'). These interpenetrate. K'aax soon returns to reoccupy abandoned fields, and even invades the town. All k'aax is merely regrown fields—for the Maya are aware that most or all of the land has been cultivated, and any farmer can relate the cultivation history of plots that appear 'virgin forest' to the outsider. The k'aax is the habitat of things that are *baalche*, 'things of the trees,' as opposed to *'akbij*, 'tame,' or *'alakbij*, 'household reared,' a distinction that separates nature from nurture. But there is never a contrast between 'man' and 'nature,' *hombre* and naturaleza . . . they never seem to take on the extreme view of traditional Hispanic Mexicans, who see nature purely as a threatening presence to be dominated or destroyed." Anderson et al. 2005:120–121.

For the Maya a closed canopy forest, an open field, and a managed orchard are all a sequence of farming plots that reflect "a highly managed, anthropogenic landscape . . . the 'Maya Forest Garden.'" In truth, a milpa field is never abandoned; it is reforested. This conflates the cultural and natural world: "it is more accurate to think of the milpa cycle as a rotation of annuals with successional stages of forest perennials during which all phases receive careful human management." Ford and Nigh 2009:216.

I asked Francisco Rosado May, the rector of the Universidad Intercultural Maya de Quintana Roo, about the Maya definition of nature in January 2011. He asked his colleagues; their consensus was that *síináalil* (from the origin or existence of something) and *yóok'ol kaab* (face of the earth) were words that expressed nature in Mayan. This did not contrast this essential definition with culture. I think that Eugene Anderson is perceptive when he says that there isn't a dichotomy between nature and culture in the Maya world, as there is in the Western world. The Maya don't make such distinctions.

9. Farriss 1984: Chapter 4, 160–161, note 44 on 459. "Nature continued to be represented as a malignant force in nineteenth-century Latin American literature. And the same opposing imagery of towns versus countryside found in the reports of the colonial friars in Yucatán was elaborated in a lengthy sociopolitical manifesto by the Argentine statesman Domingo Sarmiento, in which he attributes all that was evil in his country's history to the wilderness of the pampa and its effect on man."

10. On Spanish New World settlement patterns, Farriss writes: "To create an urban setting even more controlled than in the homeland was one defense against an unfamiliar and therefore threatening physical environment, and against equivocal feelings about the alien peoples who inhabited it." She goes on: "The 'characteristically Spanish' grid pattern of urban layout that is ubiquitous in Spanish American towns dating from the colonial period was not, in fact, common to Spain at all . . . The pattern has usually been seen as a reflection of a new Renaissance ideal of order and symmetry." Farriss 1984:161.

11. "Finally, the introduction of steel axes and saws encouraged forms of slash-and-burn agriculture that were far more ecologically destructive than the indigenous methods of pre-Columbian agriculture . . . Another result of these changes was the obscuring to modern study of pre-Columbian

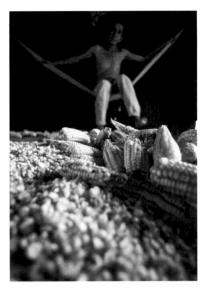

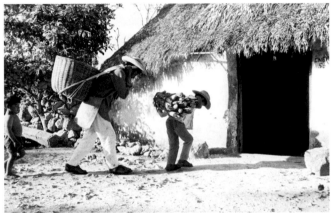

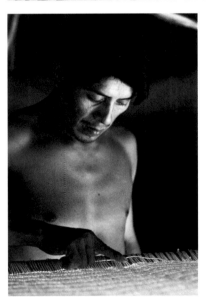

TOP: Francisco Puc Poot sitting in a hammock in his house, with a pile of corn kernels that he's removed from ears of corn. Chichimilá, Yucatán, 1974.
CENTER: Dario and José carrying loads of corn and firewood, returning from their milpa. Chichimilá, Yucatán, 1976.
BOTTOM: Dario weaving a hammock. Chichimilá, Yucatán, 1974.

patterns of agriculture, settlement strategy, commodity production, and ecological adaptation." Demarest 2004:290.

12. Anderson et al. 2005:48. They report that this still remained true for the traditional cultivators in 2005.

13. Bishop Landa never mentioned tortillas when he wrote about the recently conquered Maya, although he describes many other methods of corn preparation. "On inspecting the town and entering the houses our men found in all and each one of them a great quantity of turkeys all prepared and dressed for eating by those Indians. Besides these things they also found much corn-bread and other supplies such as drinks, and a dish made of meat mixed with corn-bread called by those Indians tamales." Tozzer 1941:90.

Hilario noted the corn breads and tamales that he found in Chichimilá. *Wah* is the general Mayan word for any corn bread that can be baked (in an earth oven), steamed, or cooked over a fire on a griddle.

Variations of *noh wah* (big bread) are prepared for the Ch'a Chaak (Rain Ceremony) and other religious rituals. *Kanlahun tas wah* (fourteen-layered bread) and *yahaw wah* or *oxlahun wah* (thirteen-layered bread) are large corn breads with sikil powder (roasted and ground squash seeds) sprinkled between layers. Sometimes ground *frijol* is alternated with the sikil. The breads are then covered in bob leaves and cooked in a pib. *Pibil wah* indicates breads baked in a pib.

Tamales (corn dough with a filling) are wrapped in leaves and either steamed in a pot or baked in a pib. *To'obil wah* refers to wrapped breads, usually in banana leaves. *Holoch i wah* means bread wrapped in cornhusks. *X-mak'ulan* is a flat and rectangular tamale named for the edible leaf of the plant (*Piper auritum*) in which it is wrapped, which imparts a licorice flavor. It is filled with a mixture of chiles, sikil, and *ib* (a Yucatecan white bean). *Tuti wah* is formed into an oval sausage shape and filled with beans, chiles, and sikil. Ch'a Chaak *wah* is stuffed with pork or chicken and is eaten with a sweet *atole* (corn drink). In Tihosuco it is always prepared for November 8, the Despedida (Farewell). It is sometimes prepared at other times when people, especially pregnant women, feel like it, according to Teresa de Jesús Pat of Tihosuco, a student and field investigator at Universidad Intercultural Maya de Quintana Roo.

Steamed tamales are elaborate dishes, often made by several people working together in a Maya home. They may include a filling of egg, turkey, chicken, pork, deer, or other meats and are wrapped and tied in banana leaves. Families within a village become famous for their particular style. Doña Simona, Dario's stepmother, was particularly famed for hers and was frequently brought to other towns to cook. Steamed tamales are made for special occasions, such as Christmas, and often served with hot and frothy cocoa.

There are two distinct types of steamed tamales in Chichimilá. "The *tamali'* has a smoother consistency because the sakan is put through a sieve," Hilario explained, "whereas the *sakah i tamali'* is coarser and has a stronger flavor. Both of these are made the following way. You make a thick corn atole, more like a mush, with lard, which is beige in color. Then thicken the meat broth with sakan and add spices, including achiote paste made from annatto seeds, which turns it orange. This mixture is called *k'ol*, a staple of Maya cuisine. Place a layer of the corn mush on prepared banana leaves. In the middle, spread a portion of k'ol. On top of this place a slice of tomato, a few leaves of epazote, and a filling of deboned and shredded meat or egg. Wrap it in the banana leaf, tie it securely, and then steam it for at least a couple of hours or overnight."

Hilario compiled a list of other kinds of steamed tamales. *Xpelon wah* uses black-eyed peas as a filling. Several varieties of tamales use chaya either as a filling or as a wrap, including *brazos de reina* (a brazo is a long, thick tamale that resembles an arm—in this case a queen's arm; also sometimes called a *brazo de indio*) and *dzotobilchay* (chaya stuffing), both made with sikil, eggs, and chaya and served with a tomato and chili sauce.

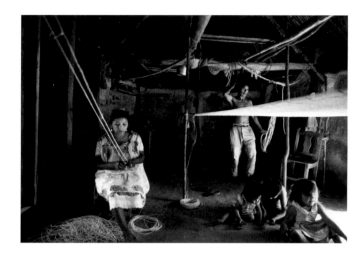

TOP: Herculana preparing henequen string while Dario uses it to weave a hammock. Chichimilá, Yucatán, 1974.
CENTER: Dario lighting dried brush to burn a field in springtime before planting. Chichimilá, Yucatán, 1974.
BOTTOM: Dario carrying his torch and lighting fires to burn his field in springtime before planting. Chichimilá, Yucatán, 1974.

Women in Chichimilá also prepare tamales for sale that are smaller and have less of the filling than those for special home occasions. *Vaporcitos* are small, firm steamed tamales wrapped in a banana leaf or cornhusk that usually have a bean filling and are served with a spicy tomato sauce. They are sold out of a bucket on the streets and in market stands in Valladolid.

Bishop de Landa might not have found tortillas in the Precolumbian cuisine, but today they are eaten with just about every meal. Tortillas are made from corn sakan that contains no sugar, salt, or yeast. Wah is the common tortilla provided with a meal. *Wah hay pak'ach* refers to the typical homemade tortillas patted out on a table and toasted on the comal at home. *Pim* or *pem chuk* is a thick tortilla formed in the hands. Men often cook them on the coals of a fire when at work in their fields and in the forest. *Op* is a day-old tortilla toasted crisp over the morning fire and is a favorite for breakfast, accompanied by a gourd of warm *chokó sakan* (creamy hot corn drink), coffee, or chocolate. *Sak pet* (a tortilla cooked only on one side) and *op'o' suk pet* (a large, well-cooked tortilla) are both cooked slowly until well done, keep well, and are taken when traveling. *Xix wah* is made by pouring the residue left in the sieve from various corn preparations on a griddle. It is large, grainy, and toasted. *Is wah*, also called *tumben wah* or *chepet*, is a tortilla made at harvest time from fresh corn.

The names of a number of tortillas reflect what has been added to the sakan. *Bu'ulil wah*, also called *muxub*, includes cooked and strained black beans, along with a little lard, mixed into the dough. *Sikil p'us wah* adds sesame seeds. *Sikil wah* adds roasted and ground squash seeds and salt. The seeds can also be added whole; they roast while the tortilla toasts. Sometimes people simply add a little lard to the sakan to enhance the flavor. You have to be careful turning the tortilla over on the griddle, because the lard can burn your fingers. A *churepa* is sweet, and a *ch'ooch' wah* is salty.

Today machine-made tortillas have pretty much replaced handmade tortillas throughout Yucatán. "They just don't taste as good," Hilario laments, a sentiment expressed by the Maya themselves. "Handmade tortillas are absolutely delicious, and they are being lost. Just as walking into a French bakery can overwhelm the senses, a fresh sikil wah stimulates the salivary glands."

Machine-made tortillas change a whole way of eating. When the members of a household stop making their own tortillas, they also stop making their own sakan, a vital ingredient in the preparation of so many Maya foods.

14. This is the list of corn drinks that Hilario compiled in Chichimilá, to which Charles and I have added additional research.

Sakah is the sacred drink offered to the gods by a h'men or a farmer during ceremonies. It is made from clean kernels of corn boiled in a bucket of water without adding lime or washing away the hulls. The kernels are then washed, ground in a hand mill, and mixed with water. Sakah is drunk as a sacrament, rarely salted or sweetened. The ancient Maya had a sakah made from cacao (chocolate) and corn.

P'ukbil sakan is simply sakan dissolved in cold water, salted or sweetened. It is quick to prepare, as it requires no heating and sakan is always available in the house. *P'ukbil sakan* is used as a quick snack for hungry youngsters and drunk by farmers who have carried a ball of sakan with them to their fields. *P'ukbil* means to drink in gulps, which is how you swallow the lumps that settle to the bottom. But it's not the favorite because it's not drunk warm and is grainy. The Maya prefer *chokó sakan* and often start their day with it. They dissolve sakan in water and heat it until creamy, usually adding salt rather than sugar.

K'eyem or *pozole* is ground hominy. It's a special treat for the farmer to take a ball of this to work. The Maya return *k'u'um* (corn boiled with lime and then rinsed clean) to the fire and boil it until the kernels swell and pop open. The drained corn is ground and formed into a large ball that is stored in a luch with a cloth covering. K'eyem is often drunk cold, mixed with water and salted, or sweetened with sugar, honey, or even grated coconut.

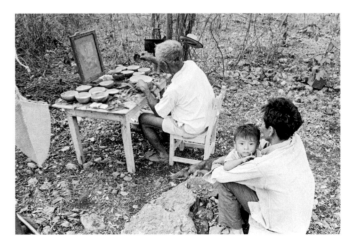

TOP: Smoke rising from a burning milpa during the spring. Near Chichimilá, Yucatán, 1971.
CENTER: Agapito May, h'men from San Ramón, with his grandson Antonio Puc May, performing a loh in a forest clearing. Chichimilá, Yucatán, 1971.
BOTTOM: H'men Agapito May performing a loh in a forest clearing for his son-in-law, Nicasio Puc Che, who is holding his son, Antonio Puc May. Chichimilá, Yucatán, 1971.

K'ah or *pinole* has an elusive flavor that conjures up roasted peanuts, coffee, and chocolate, but it's made with toasted corn, allspice, and star anise. The Maya roast clean, dry corn kernels on a griddle and lightly toast the spices. They grind this mixture into a powder, which keeps well and is often carried while traveling, and add it to water, cooking it thoroughly until it is frothy and the tiny ground pieces of corn are tender. After bubbling up three times, pinole is done, according to a saying.

X-ta'an is pinole that includes cacao and cinnamon. The dried powder can also be mixed cold with water. Herculana often prepared pinole powder for Charles to take with him in his journeys into the roadless jungle.

Che'che' ixi'm (literally "raw corn") is made from raw kernels run directly through a hand mill, added to a pot of water, and stirred. Everything that floats to the top is removed with a strainer. Then the liquid is brought to a rapid boil three times. Using the hand mill leaves little chunks of corn that give the drink a nutty texture. It's the only food offered to mothers for the first few days after giving birth, because the Maya think it encourages the flow of their milk.

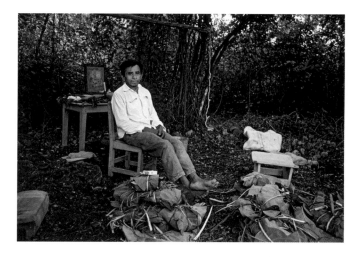

Atole or *sa'* is the national corn drink of Mexico. It has many variations. Typically, corn is boiled with lime, ground into sakan, passed through a sieve, and then boiled again. The Maya generally drink it salty, often with chile, but it may also be sweetened to taste. Some of the Maya variations include *sikil sa'*, atole with added sikil powder; *ts'ambil sa'*, atole left to ferment overnight for a stronger flavor; *tan'chuk sa*, atole made with ground chocolate, anise, and allspice; and *ch'uhuk sa'*, a sweet atole with coconut and nutmeg. *Is ul* or *tumben sa'* (literally "new atole") is made from fresh corn, boiled without lime. Everyone looks forward to it during the first weeks of each year's harvest.

15. Corn also thickens the plot of the Popol Vuh, the sacred book of the ancient Maya. The Maya generally have a slow heart rate and low blood pressure, which may be attributable to their diet, and also have a high metabolism. Their love for wordplay and outrageous puns might also be attributed to their corny diet. "A Corny Dictionary" was the headline of the *London Times* review of Robert Laughlin's *The Great Tzotzil Dictionary of San Lorenzo Zinacantán*. As a result of the review, the Smithsonian gave Laughlin a promotion, and Senator William Proxmire presented him with a Golden Fleece Award (for supposedly wasting taxpayers' money). Before publication of the dictionary, no one could read or write Tzotzil. It is responsible for the rebirth of Tzotzil literature and culture among the highland Maya.

16. "Of all the colonial institutions established in Yucatán, the Catholic church, through its parish clergy, unquestionably represented the most palpable presence among the Maya, exercising the most direct and powerful influence on their temporal as well as their spiritual lives. This was partly by default, given the exceedingly thin presence of other Spaniards in the Maya hinterland. But it was also because the clergy conceived of evangelizations, and their Christian ministry in general, as part of a broader 'civilizing' mission that was necessary for the new faith to take firm root. This mission has been called the first example of applied anthropology in the New World." Farriss 1984:90.

17. "It is in fact highly likely that this decidedly folk level of religion has functioned with scant modification from very early times, long before the arrival of the Spanish and probably long before the arrival of earlier invaders who came from central Mexico with their religious cults. It would seem that this humble domain of belief was no more affected by foreign conquest or changing elite fashions than the way of life with which it enmeshed.

"Superstition might be foolish and futile and even wicked at times. It did not pose the same threat to Christianity as idolatry, nor the same threat to the social and political order on which Christianity rested. The shaman's power, though far from negligible, operated within a very circumscribed sphere. It was the upper level of the Maya priesthood, the deities they served and the public rituals they and the civil-religious leaders performed,

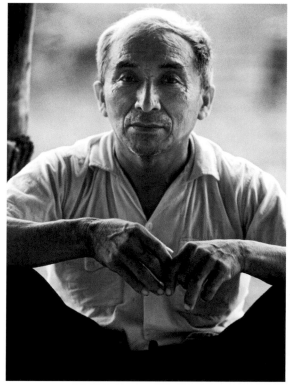

TOP: H'men Hilario Tun with ceremonial breads at a harvest ceremony. Chichimilá, Yucatán, 1971.
BOTTOM: Don Anastasio at a Ch'a Chaak. Chichimilá, Yucatán, 1971.

that is, the state religion, with which the friars were in competition and which they sought to replace." Farriss 1984:288–289.

18. For example, one of Yucatán's largest celebrations is the annual fiesta in Tizimín. It's believed that in Precolumbian times the Maya made pilgrimages to worship three powerful gods—Yum Chaak (God of Rain), Yum Kaax (God of the Forest), and Yum Ik (God of Wind). The Roman Catholics built their church on top of the temple and substituted carved wooden images of the Three Wise Men for the sculpted clay Maya gods. The Maya continue their January pilgrimages to Tizimín to this day. Irigoyen 1973:18.

19. For decades after the conquest the Maya continued their clandestine worship of their gods and idols. Soon the Spanish clergy only tolerated the ceremonies associated with the forest—hunting, farming, and beekeeping—which were performed away from the town center. "This does not mean that the Maya abandoned their corporate efforts to maintain the cosmic order, only that the community as a whole, and particularly the civil-religious elite, were channeling their efforts through a new set of sacred beings and sacred rituals. These were the Christian saints and the Christian liturgy. And if they were not an entirely new set, they at least had new names and new houses . . . Both Spanish Christianity and Mesoamerican paganism, then, represented richly complex, multilayered systems instead of any one pure type. Only if we recognize that they confronted each other as total systems and interacted at a variety of levels can we begin to make some sense of postconquest religious change, not as a shift from one type to another (the standard model of conversion), nor even necessarily from one level to another (the modified 'emergence' model) nor as the superimposition of Christianity on a pagan base (a common syncretistic model applied to Latin America), but as a set of horizontal, mutual exchanges across comparable levels . . . Some confusion no doubt did exist, but much of it may disappear if we cease to see polytheism and monotheism as mutually exclusive alternatives. They can represent . . . simply two different levels—the parochial and the universal—within the public sphere of religion, which can coexist with each other as well as with the magical level." Farriss 1984:293–299.

20. Villa Rojas 1945:101.

21. The rocks heated in the pib are known as *sin tun*. Indeed *chokoh sintunbil ha'* is Mayan for steam bath, a treatment for ailments in Precolumbian times and now a popular treatment at spas along the Caribbean coast.

22. Thompson 1932:59.

23. Anderson and Medina Tzuc 2005:xi.

24. Charles interviewed several h'men'ob of Chichimilá for Miguel Bartolomé and Alicia Barabas, Argentinean anthropologists working on their study *La resistencia maya*.

25. "They [Maya] have a superb grasp of objective reality, based on countless years of interacting with it. They use dreams and visions, as well as interaction and systematic learning, because dreams and visions work. They do not always provide accurate information, but neither does ordinary observation and interaction. Dreams and visions are often accurate when they integrate subconscious cues and long-buried, half-forgotten knowledge." Gómez-Pompa et al. 2003:543.

The shaman's power is the ability to journey to the place where the gods, ancestors, and spirits reside. "This place, which the ancient Maya called Xibalba, the 'place of awe,' is real and palpable. It is real because millions of people over the millennia have believed it to be real, and have shaped their material environment to accommodate that reality." Freidel, Schele, and Parker 1993:34.

For a completely different take on Xibalba, see Weller 2004.

26. This sounds straightforward enough, but Alejandra García Quintanilla, a professor at the Universidad Autónoma de Yucatán, notes an ambiguity for the Maya farmer that goes back to ancient times. The Chilam Balam (the series of books written after the conquest by the Maya to record their history) relates how humans were created to sustain the cosmic order. The farmer needs to respect plants, animals, and all that

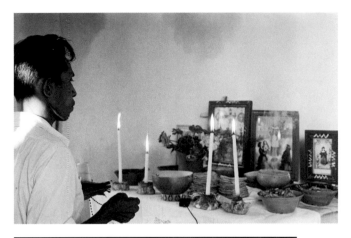

TOP: Private service in front of the altar in a home, orchestrated by a man who knows the prayers. Chichimilá, Yucatán, 1971.
BOTTOM: H'men'ob at a house to perform a private ceremony. Chichimilá, Yucatán, 1974.

exists in the forest. But he also has to break the mandate and cut down the forest in order to feed himself and his family. The farmer knows that for the forest to survive it has to remain the same, even as he selectively improves it. García Quintanilla (2000:255–285) says that some Maya attribute the tangled second- and third-year growth of weeds in the milpa to the gods of the forest, who send those plants to invade the field so that it becomes hard to control and so that the farmer doesn't cultivate for more than a few years. At the end of the corn-growing cycle, the farmer isn't abandoning his farm—he's returning it to the gods of the forest from which it came.

27. In the Popol Vuh, at the time of cosmic creation, "to shape and order this newly created cosmos, the gods measured its sides and corners with cords, an action parallel to those of Maya farmers when they prepare their maize fields with measuring cords." Foster 2002:183.

28. Dario described the ceremony. "You make pibil nal," he said. "You need four or five people to help you. You get together with your friends that work milpas near you. It's a lot of work. You have to gather the leaves of *yaxnik* [fiddlewood, *Vitex gaumeri*]. You have to gather the leaves of *subinche*. You have to get the firewood, and you have to dig a big hole for the pib, one and a half meters long by one meter deep. You need to take your pick and your shovel to dig the hole, and your machete to cut away any roots you might encounter. And you need to bring your axe to cut big logs of firewood. You pile the logs 1.5 meters high above the pib and on top of that you put some big rocks, at least ten of them. Then you light it on fire. You let it burn down into the pib so that you are left with the hot rocks and just a few smoldering embers.

"Then you put the corn in the pib and you cover the top with green corn husks and with the leaves of yaxnik or subinche. If you add yaxnik, it drips a green, sweet-smelling juice over the baking corn. If you add subinche, it gives flavor and tints the corn purple. Then you cover the pib with earth and let it cook all night. The next day when you open the pib the steam rises to the sky like incense. It is the invitation to God."

The farmers tie together fifty-two ears of corn in pairs by their husks and hang them over poles on each side of an altar they've constructed near the pib. When the farmer does this he says *tin holche tin nal* (I am stringing my corn), which describes the act of hanging the pairs of corn over the poles, thirteen pairs on each side. In addition the farmers place six *jícaras* of *tumben sa*, atole from freshly harvested corn, in the center of the altar.

Dario added: "I leave six ears of corn and a jícara of tumben sa for the one who cares for the earth. I place this on the ground in another part of the milpa. I also dedicate my offering to La'Kah, because it is the cenote near my milpa. I leave an offering for the *gavilán* [hawk] too so he keeps the squirrels out of my milpa."

29. The number one cause of death in Mexico is diarrhea, and many people are malnourished. In 1986 the Pan-American Health Organization found that half of the 2 million babies born each year suffered physical or mental defects due to malnutrition. One hundred thousand of them die before the age of five, although the Mexican government doesn't include malnutrition as a disease. The report also suggested that Mexico should focus more on preventing disease rather than curing it. Mexico has so many doctors that some are unemployed, because they congregate in large cities rather than spread out to rural areas. Twenty percent of Mexicans never see a doctor or get medical attention. That would have amounted to 16 million people in 1988. Oster 2002: Chapter 5.

30. To find out more about the freshwater rivers flowing below the surface of Yucatán, I spoke to Sam Meacham, a cave diver, director of the Quintana Roo Aquifer System Research Center (CINDAQ), and a member of the Explorers Club.

"Sixty-five million years ago," Sam explained, "a meteor estimated to weigh a trillion tons, traveling at 20–40 kilometers a second, slammed into the planet and hit near here. It was ten kilometers long—it was like hurling Mount Everest at the earth. There was such an enormous pressure wave created as it fell to earth that even before it hit it was generating its

TOP: Offerings hanging in a gourd above an altar at a Ch'a Chaak. Chichimilá, Yucatán, 1971.
BOTTOM: Participant adding an offering to a gourd at an altar at a Ch'a Chaak. Chichimilá, Yucatán, 1971.

own crater. It also created such a vacuum that some of the ejecta from the impact actually escaped into space, and it's quite possible that fragments of the Yucatán and perhaps the meteor are on the surface of the moon. At the time Yucatán was a shallow tropical sea. Since then over 1,500 meters of limestone has built up over the eons; and although it is hard for the human mind to reference this, the ring of cenotes that mimics the edge of the meteor crater is actually one and a half kilometers above the crater itself, so the impact continues to reverberate millions of years later through the geology. And then, on top of this global catastrophe, you have the Maya building their civilization."

Sam continued: "Cenotes are the lifeblood that flows beneath the surface. There are probably seven to eight thousand of them here on the Yucatán Peninsula, but they aren't all the same. Cenotes along the Quintana Roo coast are different from those farther inland in that they are often entrances to flooded horizontal cave systems that are full of stalactites and stalagmites—which means they were dry during successive Ice Ages. As the glaciers melted and the waters rose, the caves flooded, and that is the current geologic state that we find them in. Cave divers are finding evidence of prehistoric human life from at least 10,000 years ago, as well as Pleistocene megafauna including elephants, camels, and horses. The most notable one is in the Narajal cave system, where a human skeleton is 500 meters back into the cave system at a depth of around 21 meters. It turns out to be a woman, and uranium carbon dating shows the skeleton is well over 10,000 years old.

"These cave systems serve as major conduits for fresh water as it travels from the interior of the peninsula out to the sea. Through hydrological study we have also been able to show that there is a flow of salt water coming inland. So there is a very complex interchange of fresh and salt water that we don't understand yet—and the cave systems are the major conduit for all of this. We still don't know where the salt water is going. Potentially it could be flowing across the entire peninsula over to the Gulf, which, it turns out, is lower than the Caribbean. When you look at the outflow, you see a massive amount of water being transported through the caves. Hydrologic studies show that while 96 percent of the storage of fresh water in this region is in the rock matrix, 99 percent of its flow is through the cave systems.

"We've also discovered different levels of cave systems. Along the Riviera Maya, the freshwater lens is between 10 to 30 meters in depth before you hit a saltwater layer, and there is a shallow cave system that runs from the surface down to about 30 meters that includes the fresh water. Then there are also cave systems at a much deeper level—over 100 meters—that are massive conduits. The deepest one that has been explored is the Dos Ojos cave system, which is 119 meters deep. It has one magnificent room that is 40 meters from ceiling to floor, 100 meters long and 100 meters wide, and it's full of salt water. The deepest cenote yet found is near Homún, southeast of Mérida, where divers have gone down more than 550 feet and still couldn't see the floor—or the side walls or the ceiling. They felt that they were quite literally in an abyss. No one has been to the bottom of that one. *National Geographic* tried to put in a remote-operated submersible, but it didn't work."

Sam added: "We are finding a lot of cenotes with skeletons and archaeological material, and the common perception, due in part to the Sacred Cenote in Chichén Itzá, is that sacrifice is the reason the skeletons are there. But that may not be so. We're finding bones that were put into ceramic funerary pots that were then placed in caves or tossed into cenotes. These cenotes were the embarkation point for the symbolic voyage to the beyond, to Xibalba, the Maya underworld. But one of the things Dr. Luis Marín Stillman, one of the leading experts on the hydrology of the Yucatán Peninsula, has found is that the ancient Maya knew something about hydrology. Their well for getting water was upstream from the ones where we are finding skeletons, presumably to keep their water from being contaminated.

TOP: Cenote. Dzitnup, Yucatán, 2001.
BOTTOM: Cenote. Dzitnup, Yucatán, 1971.

"For me, the most gripping part of our discoveries is that a civilization has lived on top of this land and for a long time they've tried to imagine what was down below. Xibalba was at the core of their cosmology, and I feel that we are beginning to peel back the layers. There are Maya communities around these same cenotes today that want to know what's down there too—they are inviting cave divers to explore cenotes where they forbid other people to swim. With modern technology we can come in, dive into their cenote, take digital photographs and digital video and come back to the surface, dry off, download our photographs to a laptop, connect that laptop to a digital projector, and then show the community what's down there. Personally that is one of the most satisfying things that I do. Cenotes are time capsules, and we can bring their past to the surface."

31. For example, when Cancún was being built, you didn't find Maya in positions of authority—they were the hired help and were treated by many of the Mexicans as second-class citizens. In 1988 when I was in Cancún setting up arrangements for a UCSB extension class on the Maya, I invited my goddaughter and her siblings to come swimming with me in the hotel pool where the students were going to stay. Very quickly the hotel's staff asked them to leave. When I protested that they were my guests, they still insisted that my goddaughter would not be able to play in the pool. I went to see the manager, who turned out to be from Mexico City. The only reason they were singled out, I said, was because of the color of their skin.

"We've never had a Maya stay here, so of course we assumed she didn't belong," the manager told me. But he said that Cecilia could continue playing since she was my goddaughter. But when her uncle Felipe came to join us, he was stopped by security, who wouldn't believe that he could have a friend staying in their hotel and would not even bother to check. It was deeply embarrassing for Felipe.

In 2001 I went to the Cancún airport to switch rental cars and brought along Pedro, Dario's youngest son, and Omar, his brother-in-law. A federal policeman stopped us near the airport entrance. He wanted to know why they were with me. Pedro and I were interrogated separately to see if our stories matched. Apparently the policeman couldn't believe that I would be with an Indian unless it was for some nefarious purpose. He had a very hard time believing that I'd known Pedro's father for thirty years and that we were friends.

I was surprised and dismayed, because I'd seen real advances in Cancún. I meet more and more Maya working in middle management at hotels and restaurants. Many now are trilingual and speak English, French, German, Italian, or even Japanese as a third language. They work at the front desk of major hotels, as waiters, as cooks and chefs, and as restaurant managers.

32. Ortiz 2000:6–7.

33. President Richard Nixon created the DEA in 1973 as a way to appear to fulfill a campaign pledge. He'd run for reelection in 1972 on law and order; but since most law enforcement is local, he had to find an area that fell under federal jurisdiction—narcotics. Nixon concocted a crisis and responded with his War on Drugs—even as the Central Intelligence Agency (CIA) was financing its own programs in Southeast Asia through drug dealing. The War on Drugs has been an abysmal failure. Far from containing drugs, it has globalized the problem and has led to corruption in countries as diverse as Afghanistan, Burma, Colombia, Mexico, Panama, and the United States. In 2008 Tracy Wilkinson reported on the release of a Brookings Institute report. "The United States' war on drugs has failed, and will continue to do so as long as it emphasizes law enforcement and neglects the problem of consumption . . . The former Mexican president, Ernesto Zedillo, in an interview, called for a major rethinking of U.S. policy, which he said has been 'asymmetrical' in demanding that countries such as Mexico stanch the flow of drugs northward, without successful efforts to stop the flow of guns south. In addition to disrupting drug-smuggling routes, eradicating crops and prosecuting dealers, the U.S. must confront the public health issue that large-scale consumption poses, he said. 'If we

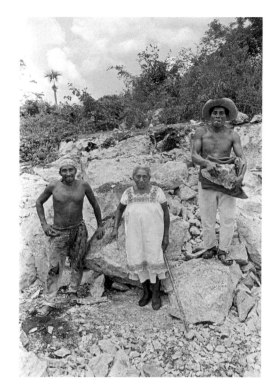

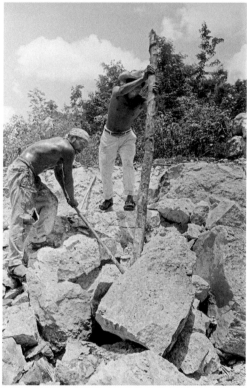

TOP: Víctor Rejón Cohuo, his mother, María Exaltación Cohuo, and Dario, breaking rock to sell. Chichimilá, Yucatán, 1971.
BOTTOM: Víctor and Dario, breaking rock to sell. Chichimilá, Yucatán, 1971.

insist only on a strategy of the criminal pursuit of those who traffic in drugs,' Zedillo said, 'the problem will never be resolved.'" Wilkinson 2008b.

Terry Nelson, a federal agent for thirty years with the U.S. Border Patrol, the Customs Service, and the Department of Homeland Security, suggests that the current emphasis on waging the war on drugs is doomed to failure, unless we treat drug use as a public health issue. "My years of experience as a federal agent tell me that legalizing and effectively regulating drugs will stop drug market crime and violence by putting major cartels and gangs out of business. The Department of Justice reported that Mexican cartels are America's 'greatest organized crime threat' because they 'control drug distribution in most U.S. cities.' If what we've been doing worked at all, we wouldn't be battling Mexican drug dealers in our own cities or anywhere else. There's one surefire way to bankrupt them, but when will our leaders talk about it?" Wilkinson 2008a.

"We've spent a trillion dollars prosecuting the war on drugs," Norm Stamper, a former police chief of Seattle, told *New York Times* columnist Nicholas Kristof. "What do we have to show for it? Drugs are more readily available, at lower prices and higher levels of potency. It's a dismal failure." Kristof writes that there are three consequences for the forty-year war on drugs. First, the United States now incarcerates people at a rate nearly five times the world average. Second, it has empowered criminals at home and terrorists abroad. And third, the United States has squandered resources—$44.1 billion annually—seven times as much on drug interdiction, policing, and imprisonment as on treatment. "Moving forward, we need to be less ideological and more empirical in figuring out what works in combating America's drug problem." Kristof 2009.

In 2011, the Report of the Global Commission on Drug Policy, a nineteen-member commission (including former U.N. Secretary General Kofi Annan and George Shultz, President Ronald Reagan's secretary of state) stated that, "The global war on drugs has failed, with devastating consequences for individuals and societies around the world." Blow 2011.

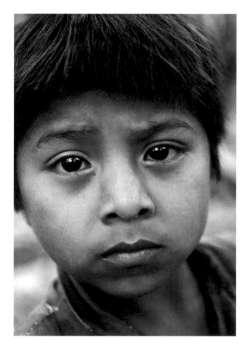

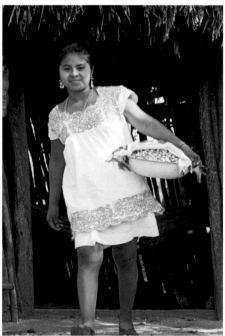

TOP: José. Chichimilá, Yucatán, 1976.
BOTTOM: Ursina headed to the mill with a bowl of corn that has soaked overnight. Chichimilá, Yucatán, 1976.

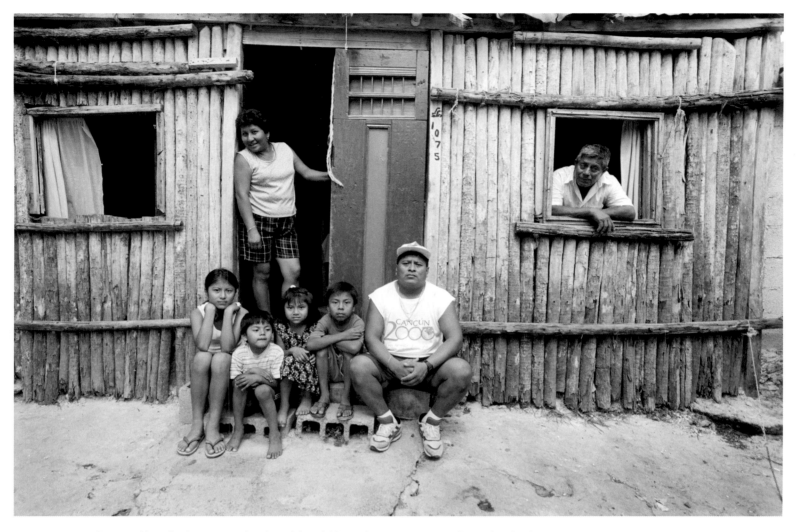

Dario with José and his wife, Florentina Canche Chi, and their children, Julieta, Jesús, Nanci, and Miguel, at their home. Cancún, Quintana Roo, 2001.

Yucatán is Maya. Any outsider that wishes to understand our problems and our possibilities needs to understand this simple fact.
FELIPE CARRILLO PUERTO, former governor of Yucatán (a champion of the Maya)

Anthropological enquiry suggests that all societies classify animals and plants in similar ways. Paradoxically, in the same cultures that have seen large advances in biological science, practical knowledge of nature has dramatically diminished.
SCOTT ATRAN, DOUGLAS MEDIN, and NORBERT ROSS, "Evolution and Devolution of Knowledge: A Tale of Two Biologies"

II The Milpa and Cancún

The continuing account of Dario Tuz Caamal and Herculana Chi Pech: his release from prison and finding work in Cancún; the immediate effects of NAFTA on the subsistence farmer in Mexico and the rising rate of depression and suicide in Yucatán

Herculana pulled a hammock down for me to sit in and told me about Dario when I visited her in 1980. He'd endured his fourth year in prison, and she spoke with no hope that he might be released early. I had gotten nowhere when I tried to help. The DEA still wanted him in jail to bolster its statistics. I hadn't found any way to speed Dario's release. Even though he was a model prisoner it hadn't reduced his sentence.

It was a cold, quiet morning with a chance of rain. Dario's stepmother doña Simona joined us. I watched Ursina working at a treadle sewing machine. She smiled at me whenever we caught each other's eye, but neither of us knew what more to say. Herculana sat back-to-back with a visiting neighbor woman in a hammock. Herculana resumed using her needle and thread to make lace to ornament the fancy slips worn with huipiles. She would sell the lace to support her family.

Behind them through the doorway, I could see chickens and a few dogs walking around searching for food. One of the dogs edged up near the entrance to the kitchen and watched the youngest daughter at a small, low table eating beans and tortillas. The dog inched closer, stole a tortilla, and ran off. We all yelled at the dog then laughed.

A whirlwind of dry leaves came down the street and darted into the house, dying with a rustle inside the doorway that left goose bumps. Pedro noticed that I had photographs for them in my bag, so I brought them out and passed them around. Everyone in the room laughed happily over the pictures of themselves—until they came to those of Dario before he went to prison.

"He's not the same . . . ," doña Simona began telling me. She started weeping. A rooster crowed in the backyard, and some pigs squealed as a dog chased them down the street.

Dario was released only after he had completed his full sentence.

Prison life was very hard for Dario. He was used to having his family around him and working in his milpa. When he was freed he returned to farming and digging wells. One day he was setting dynamite charges, deep in a hole. He had five to place and was working on the fourth charge when he suddenly felt vulnerable. He had never before been afraid, but on this day he had a premonition that he would die if he wasn't careful. He called up to his assistant that he was climbing out. His assistant pulled up the tools with a rope, and Dario climbed the twenty meters to the surface.

"What's wrong?" his assistant asked. Dario didn't answer. He sat and smoked a cigarette. Then he smoked a second one. He never again dug a well. Instead, following his children, he looked for work in Cancún. The same week a friend of his was blown to bits while using explosives to make holes for electrical poles along the highway from Valladolid to Cancún. They found pieces of him scattered all over the road.

While Dario was in jail, his eldest children had come of age and, like many of their generation, left their village to work in Cancún. When Dario joined them he found a job in the hotel zone at the Camino Royale Hotel. Dario quickly learned that the best-paying jobs were those where he would be tipped. His bosses saw that he was a conscientious worker and asked him to wash the executives' cars each day. Sometimes he received a tip.

Herculana hated Cancún. She didn't adapt to the city and ended up refusing to live there. She'd mutter *hach k'aas* (how ugly or bad) whenever Cancún was mentioned, and everyone knew she thought Victoria, her second daughter, and José, her eldest son, were two examples too many of Cancún's influence. Victoria had two daughters without a father, and José drank too much.

Herculana felt that in Cancún nobody cared. You could live next to people and not even know who they were. She even allowed a proselytizing Protestant sect in Chichimilá to teach dressmaking to Conchi (María Concepción), Mari (Emerita), and Sali (Gonzala), her daughters who still lived with her, hoping that they would learn a trade that would keep them in Chichimilá or at least in Valladolid. Once they came of age, however, they married and moved to Cancún.

The daughters and their husbands and other Maya of their generation are the ones who settled Cancún and made the city function. They took the jobs that tourists often don't

see. They built the hotels, paved the roads, dug the ditches, helped install the electrical and water lines, filled the propane tanks, ran the gasoline pumps, stacked the shelves in the stores, worked in the kitchens and laundry rooms. There was plenty of work, and plenty of teenagers to do it who were coming from villages all over the peninsula.

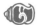

I visited Yucatán in 1988 with my future wife, Mary Heebner, and Andy Johnson (who'd first met Dario and Herculana and their family when he'd come to Yucatán with me in 1971 as a twelve-year-old). When I first met Mary I felt that she was a woman I could spend the rest of my life with, but it took many years before she'd acknowledge any feelings for me. Then, as I was heading down to Yucatán, she surprised me by inviting herself on the trip. It turned out to be a magical romantic journey that changed our lives—we married the next year. Of course we had to visit Chichimilá.

Dario was home when we arrived. He came home every Saturday afternoon, and every Sunday night Herculana would give him a large stack of fresh bright-yellow handmade tortillas wrapped in cloth to take back to Cancún. The separation was especially hard on Herculana: she was still raising a family, and Dario was gone most of the week.

I asked Dario how I could meet up with him in Cancún. He told me that the easiest way to find him would be to pick him up at the hotel when he got off work. The next week when I went to look for him I found thousands of Maya getting off at the same time. They lined Paseo Kukulcan trying to flag taxis and buses already so full that people were hanging out of the doorways.

Dario was where he said he would be. As I drove to his home he gave me directions in a mixture of Spanish and Mayan, waving to co-workers as we passed taxis and buses. It was strange riding with him amid the sleek hotels, wide palm-lined avenues, and people running along the sidewalk in color-coordinated jogging suits. It was more like Las Vegas or Miami—we were in Yucatán but we weren't. Cancún is designed for sybarites. It offers everything except the authentic culture of the place it's the gateway to.[1] It was so different from Chichimilá that I immediately asked Dario what he thought about life in Cancún.

"The hotel work isn't hard," he said. "My body doesn't ache like it used to after a long day at my milpa. We can improve ourselves if we want to. The hotel has classes if we want to learn another language. We have health care. But I miss Herculana."

Dario lived with his daughter Ursina and her husband Roque in a rented flat-roofed cement block house subsidized by Roque's employer. They and their four children shared the house not only with Dario but also with Ursina's eight-month-pregnant sister Victoria and her two young children and her brothers José and Venancio. The twelve family members shared two small bedrooms, a bathroom, and a narrow living room/kitchen dominated by an altar to consumer

technology that included a color television, a Sony Betamax, and a record and cassette player. Chairs and couches faced the television from across the room. When we arrived all the children were seated, watching Japanese cartoons dubbed into Spanish. Ursina and Victoria were at the stove toasting a dinner of ham and cheese sandwiches over the gas rings on slices of white Pan Bimbo.

Victoria held up a hand swathed in bandages in a hello and explained how she'd been burned in an accident at work at MakBurger.

"My boss immediately sent me to see a doctor. Right away," she said. "They paid for it. I haven't been to work for four days, and the doctor says I have to stay home another week until my hand heals."

"She gets paid even if she doesn't work," said Dario, impressed.

A flash of lightning lit up the room. Thunder followed only a second later, drowning our voices, and the walls took on the reflected hues of the cartoons on the television.

Tun kilba Yun Chaak, Dario said. "The god Chaak is thundering!"

The raindrops suddenly beat down on the roof as if we were inside a drum.

"We went diving at a cenote near Tulum today," I said, nearly shouting, trying to be heard above the storm. Dario looked over and cocked his head, waiting for me to go on.

"It was raining like this, the thunder and lightning. Andy and Mary climbed down the roots of a tree into a cave where they were safe. But I was still aboveground with my hand on the tree, following them, when suddenly this bright light hit the tree and traveled down my hand. I feel lucky to be here at all."

"Were you hurt?"

"I was shocked. You feel it, but then, because it hurts, you know that you are alive. So I was really happy but also angry at the same time because I almost died right in front of my *novia* [fiancée]. I know better!

"After the storm, we drove back to Tulum and went into a restaurant," I continued. "I was so thirsty, but they didn't have water, so I ordered a beer. I remember Mary asking me if I was okay, if I was trying to get drunk, and I didn't understand why she would say that until she told me I'd just drunk six beers right in a row. I didn't even realize it—I was so thirsty."

"You're lucky," Dario said. "There was a man killed in Chichimilá by lightning."

"And in my village too, right in my house," Roque said. "A storm came like this, lightning and thunder all around. We had a wire coming into our house and the electrical socket was fastened on a post. The little boy from next door was sitting on a stool leaning against this post, and the lightning hit the electrical lines. A big ball of flame came into the house and followed the wire right to the socket and knocked the poor boy off his stool. He died. Others were sitting next to him, but no one else was hurt."

Roque strung up a couple of hammocks after dinner, and

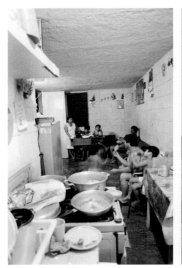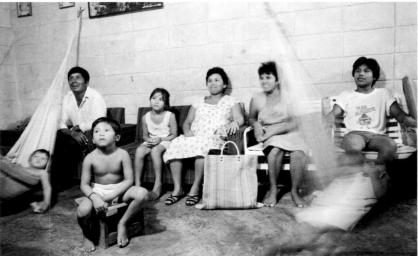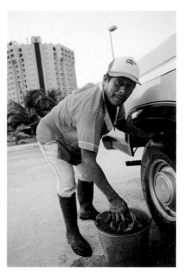

LEFT: Toasted sandwiches on a kitchen stove in Ursina and Roque's house. Cancún, Quintana Roo, 1988; CENTER: The family watching television in Ursina and Roque's house. Cancún, Quintana Roo, 1988; RIGHT: Dario washing his boss's truck at the hotel. Cancún, Quintana Roo, 1988.

the adults joined the kids in front of the television to watch *Lucha Libre*, an entertaining Mexican wrestling show. "How did you decide to come to Cancún in the first place?" I asked Dario as an advertisement came on offering illuminated Virgin of Guadalupe hubcaps.

Dario leaned toward me so I could hear him. "When I got out of jail, I thought I might move to Mérida," he said. "I could work there and everything you need is very cheap. I thought that I could save money. Some people in my village were building nice houses and becoming modern so I thought I might become modern too.

"But Herculana didn't want to move to Mérida because her parents were living in Chichimilá. 'Okay,' I told her. Then friends suggested I join them in Cancún. At first I said no, but my kids are here so I came here too."

"What do you think about all these changes?" I asked.

"I think it is good. Before, you had to go to Mérida to see modern things. Now even we have electricity and paved streets in Chichimilá."

"It seems like just a few years ago when we went with you to your milpa, you were teaching your sons to farm. Now they come to Cancún to work."

"I still have my milpa," Dario said, "although I pay my neighbor to farm it. The money I make here I spend back in my village."

"What about José?"

"He's not interested in farming. Neither is Venancio. They'll live here in Cancún."

"What do you think will happen in Chichimilá when the children there don't plant milpas? What about the next generation? Will anyone still do a Ch'a Chaak?"

"Of course they will," Dario answered. "The villagers won't forget. They'll always do it."

"But who'll do it if your kids aren't milperos?" I insisted.

"There will always be milperos. We won't abandon our way. Like me, even though I'm living here, the day I'm needed in Chichimilá, I return."

"What about your grandchildren who are being raised here in Cancún?"

"Well, maybe they won't know the village ways, but they won't forget their culture. My grandchildren are speaking Mayan even if it's not the true Mayan—it's mixed with Spanish. Maybe it's like when the Spaniards came. We didn't forget who we are."

As the news came on the television, two of Dario's grandchildren, bored, climbed onto his lap. He smiled and looked over at me.

"They are the reason I'm here in Cancún," he said.

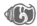

Herculana was overjoyed when Dario moved back to Chichimilá and quit commuting to Cancún. They built a new cement-block house with money he'd earned. However, he hadn't earned enough to retire. They were getting old and had no insurance, no benefits, no social security. They were also raising Victoria's young daughters, Ligia and Daniela. So Dario continued to work in his milpa. He sold flowers, firewood, poles for building, and guano leaves for roofs. He raised chickens, turkeys, and pigs. He still had fame as a healer and set bones and gave massages. He also made hammocks.[2] As in most premodern agrarian societies, their only old-age insurance was their children—when the day came that Dario couldn't work anymore, they would take care of him.

"Forgotten in all the talk about birth control and family planning," Charles pointed out, "is that it only works if economic factors support smaller families. For Dario, his livelihood, especially as he ages, depends on a large family. The common perception among outsiders is that a large fam-

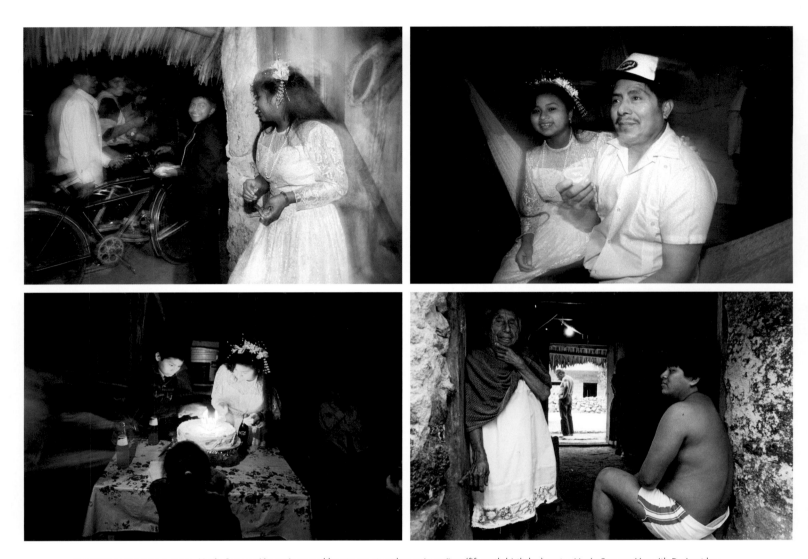

CLOCKWISE FROM TOP LEFT: María Concepción saying good-bye to guests at her *quinceañera* (fifteenth birthday) party; María Concepción with Dario at her quinceañera; Doña Simona and José in the doorway; Pedro watching as María Concepción cuts her quinceañera cake. Chichimilá, Yucatán, 1990.

ily is hard to support, with more mouths to feed and more clothes to buy. Dario was always poor by our standards, but he was always able to get by through hard work. He and Herculana raised their children at the prime of their lives when they had the most energy. They invested in their family. They made sure their children went to school. They fed and clothed them. When Dario can no longer work, he and Herculana will depend on their children for support. The more children you have, the more assurance you have that you'll be taken care of. Just as Dario and Herculana took care of their parents, their kids will take care of them. There is no viable government alternative."

Moreover, village life favored those with a large family. The cost of housing wasn't an issue, as they all lived in the same room. Children helped with the many chores. The girls helped doing the laundry, cooking, taking care of the animals, babysitting, sewing, hauling water from the well, and working around the house. The boys helped their father in the milpa, hunted, collected firewood, and helped build and maintain their houses. The family lived from subsistence farming. They did nearly everything themselves, and it required all their help and contributions. And the harsh reality was that several children would die early.

The reason many Mexican Indians married early and had large families goes back to the conquest, when so many indigenous Americans died from disease and bloodshed—the population is estimated to have been reduced by as much as 95 percent within the first hundred years.[3] The Spanish desperately needed laborers for their farms, ranches, mines, building projects, and domestic help. They pressured the Indians to marry very young and procreate. The average age at matrimony of the preconquest Maya was twenty, but under the Spanish the age dropped to twelve for a girl and fourteen for a boy.[4] When Mexico gained its independence in 1821, the nation continued promoting population growth through the 1970s, even as Mexico became the most populous Spanish-speaking country in the world and the eleventh most populous in the world.

A large family isn't working for the Maya anymore, and it isn't practical for Mexico. Dario and Herculana's children are planning smaller families. Today, with former subsistence farmers entering the national labor pool, large families are an economic disaster. Mexico's market economy can't absorb the millions of new workers every year. Unemployment rose to double digits in the 1980s, and underemployment was a staggering 40 percent. It shouldn't be a surprise that a lot of Mexicans risked crossing the northern border to look for work. Those who stayed behind began suffering from increased stress and spiraling crime. In the 1980s about half the workforce earned $3 a day, and wages haven't increased much in the ensuing decades. In 2006 a Maya laborer in Chichimilá earned only $4.50 a day and more than 50 million Mexicans, nearly half the entire population of the country, were earning less than $4 a day. With families no longer growing their own food and providing for their own needs, wives and even young sons and daughters have to work outside the house in order to help make ends meet.[5]

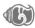

In March 2001 Charles, Andy Johnson, and I flew into Cancún and drove to Valladolid to work on a story on cenotes for *National Geographic Traveler*. Andy brought along Skylar, his nine-year-old son.

We checked into the Mesón del Marqués, a hotel on the main *zócalo* (plaza) of Valladolid. It was Friday night, and the zócalo was teeming with people. They'd gotten off work, gone home to shower and put on clean clothes, and now were back, walking around where they could see and be seen. They were anticipating their evening. The air was redolent with talcum powder, perfume, and aftershave.

Fat heavy raindrops started falling, and within seconds it was a drenching downpour, as if a bucket was being emptied over us. People started running from the square to stand under the arcade or at shop entrances. Lightning struck nearby, with simultaneous thunder; the flashes illuminated people running. Then a brilliant flash lit up the square as if it was daytime amid a huge crash of thunder: the city was suddenly plunged into darkness.

For a moment it was quiet. No one said anything. There was no music from radios, no chatter from televisions, just the sound of raindrops. But then everyone started talking as one. People lit candles in their houses and in stores and hotels. Traffic splashed through the puddles, red taillights trailing their reflections on the wet pavement. When the rain stopped after twenty minutes, people gathered in the streets waiting for the power to return. A dance was scheduled, and parties, and movies at the cinema. A rainstorm is a welcome relief, but everyone wanted electricity.

We drove out to Chichimilá. Without electric lights on, it reminded us of when we'd first come to Yucatán. We could see candles and cooking fires through the pole walls. Villagers sat in front of their homes, and people walked with candles or flashlights. Even so, it was easy to see how much had changed. It had once been difficult to drive to Dario's. The road had been a trail, good for walking or for a horse but with rocks and limestone outcroppings that you had to go around. You had to drive very carefully. Now the road was paved and level. In fact we passed Dario's without noticing. The landmarks had disappeared, made more confusing by neighbors who had driveways and cars parked along the road. I backed up to where I thought his house should be, and we got out. Where once everyone would have come to the doorway to see who had arrived, now no one came. Cars were no longer an event.

We waited out on the street and talked, unsure in the darkness if we had the right house. Not only Dario but also his neighbors had built new homes: concrete-block hous-

es with flat concrete roofs instead of thatched guanos and poles. We could see television antennas silhouetted against the stars.

"Don Carlos?" we heard Dario whisper from inside a house. He'd heard Charles's voice and came out and gave each of us a big hug and a kiss. We talked for ten minutes, standing alongside the road, enjoying the coolness of the evening. We told him about the rainstorm in Valladolid and asked him if it had rained as heavily here. He answered that it hadn't rained at all, and we nodded. It reminded us that the weather in Yucatán often comes in little cells. Here but not there. Even we could see that the rain gods had passed by with only one bucket between them, an obvious sign not to forget to make offerings to the chaaks.

Dario brought us inside his house, which he'd rebuilt with cement-block walls and a tiled floor. Herculana met us at the door and gave us each a big hug and kiss and introduced us to Ligia and Daniela, who were doing their homework by candlelight. They looked just like their mother when she was their age. We greeted them in Mayan, and Charles complimented them when they answered us. Ligia explained that they'd learned it from their grandparents.

It reminded us that on a previous trip Charles had mentioned to a friend that one of Dario's daughters was speaking no Mayan but only Spanish to her children—and not good Spanish at that. "Don't worry," our friend assured us. "My daughter is doing the same thing. But I'm seeing to it that my grandchildren speak Mayan, just as Dario and Herculana will do the same for their grandchildren."

Andy asked Dario if he was still making hammocks, so Dario showed us a new one, which had taken him three weeks. He handed one end to Charles and took the other, and they stretched it out. It was so wide that he was able to incorporate five designs within it. Charles told Andy that it had been years since he'd made a hammock, but he hadn't forgotten the skill involved or lost his appreciation that Dario's hammocks lasted years, even decades.

We heard a refrigerator start up again, and Herculana tried the light switch. As the light came on Andy joked that people were all going to turn their lights back on at the same time and would knock the power out again. No sooner had he said it than the power went out. Everyone laughed. For the next couple of minutes the lights flickered on and off as we looked at the hammock. When we found out that it was for sale, Charles, Andy, and I decided among ourselves who would be the lucky one to buy it. As we talked, I noticed a movement high on the wall, near the ceiling, and I shone my flashlight on it. It was a scorpion.

Herculana brought a pole and handed it to Andy. Dario pulled off one of his plastic sandals and also handed it to Andy to use to squish the scorpion. Andy chose the pole. We shone our flashlights and watched. Andy jabbed the pole, and the scorpion fell to the floor, dead. Dario tossed it into the street. Andy asked if it was okay to leave it there. Maybe someone would step on it; maybe a child could get hurt.

Dario explained that the ants would quickly take care of it.

"It has a strong bite," Herculana said.

"It's dangerous," Ligia offered.

"Huhhh," Dario said. "One time I was very sick for a few days. Maybe a cold or the flu. I had a headache. A fever. Finally I decided I had to go to town for medicine. It was early and still dark. My clothes were hanging on the wall. I pulled on my pants and then put on my shirt. I felt something rub against me but I didn't think anything of it. But when I adjusted my shirt and pulled it tighter in order to button it—whap!—I got bit. It was a scorpion."

"What happened?" Andy asked.

"I got over my sickness!" Dario laughed. "It went away immediately. The bite cured me. I didn't have to go to the doctor."

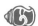

Dario was making repairs to his house when Charles and I arrived the next day. A frame to his kitchen door was broken. Instead of having hinges, the door swung on wooden pins at the top and bottom that fit into sockets on the frame and allowed it to open and close. The bottom portion had rotted from exposure, so Dario had taken the frame out and was turning it upside down. Charles and I helped him position the door and held it as he reattached the frame to the house. He tied it with wire instead of jungle vines. As we worked he mentioned a fiesta in Yokdzonot, a village south of Tixcacalcupul.

"You want to go eat relleno at my cousin's?" he asked.

Dario didn't have to say it twice. *Relleno negro* (literally "black stuffing," referring to the black sauce) is the richest, tastiest food in Yucatán. It is traditionally made with turkey (a ritual food and the only large domestic animal of the Maya in Precolumbian times) and ground pork, along with burnt chiles, pepper, cumin, oregano, cloves, achiote, lard, onions, epazote, tomatoes, eggs, limes, and salt (chicken often replaces the turkey today). It takes days to prepare and is served only during fiestas and special occasions such as baptisms and weddings because it's so labor intensive. It's cooked in a pib; but when restaurants in Mérida and Cancún prepare it, they cook it on top of a stove. Their relleno isn't nearly as flavorful and thick as when it simmers overnight in an earth oven.

As soon as we'd fixed the door, we drove to Yokdzonot. Dario's cousin lived right next to the road. When we arrived, Dario shouted out the car window, "We've come to eat relleno!" Charles and I couldn't have agreed more, and we all jumped out of the car.

Utz', replied his cousin, Silvano Caamal Poot, as he came out of his house. "Excellent." *Oken,* he said, waving us in. "Come in." During fiesta everyone is invited. Besides offering the good meal, the fiesta was the pretext to visit, an important function within the extended community. Silvano offered us warm beers as we settled into hammocks. His house

had traditional pole walls and a hard-packed dirt floor covered with a thick dusting of dirt. Like Dario, Silvano was a well digger and farmer. He worked the earth. While Dario was in prison, Silvano had helped Herculana and her children with produce from his farm. For five and a half years he made sure they didn't starve, part of a community-based network of friends and relatives that village Maya rely on as their social safety net.

Silvano's wife, his mother, and his three daughters were in the kitchen behind the house and within minutes brought us bowls of the relleno along with stacks of hot yellow tortillas made from freshly ground corn. We each tore a quarter of a tortilla off, folded it into a spoon, and took our first bites of tortilla and relleno. It was as wonderful as we remembered it to be.

As is common enough, our conversation turned to food. Silvano apologized that he couldn't serve us relleno with wild turkey. He and Dario said that they couldn't buy cartridges in order to hunt. It wasn't that they were prohibited, but they weren't available, and Dario thought the scarcity indicated that the price was going to go up. Soon we were brought another stack of hot tortillas. I mentioned what a treat it was to eat handmade tortillas and how hard it was to find them anymore.

"The *tortillas de máquina* [machine-made tortillas] are okay when hot and fresh," Dario said, "but later they don't taste good. On the other hand, the handmade ones keep very well. You can reheat them, or when they're dry, you can roast them and they're great for breakfast. In Chichimilá perhaps only eighty families still prepare handmade tortillas. That's hardly anyone. Most people today want their food fast. There are people who don't even want to prepare their food." Dario looked up from his plate of relleno and shook his head. "In Cancún a lot of people pay for their food and pay someone to wash their clothes and iron them. So they spend all the money they make, even end up in debt. They would ask me how I made it on my salary. I told them how my wife made tortillas and raised chickens, that we did it ourselves.

"These days, even in the pueblo, some girls don't want to get near the animals. 'Oh, they stink,' they say. The same girls pay to have their nails done. As for us, we cut our own nails—with a machete!" Dario joked.

After we ate, we walked across the road to pay our respects to the tiny church built by the half-dozen families who lived in Yokdzonot. Like so many Maya villages, the small community had been built around a cenote, and a large ceiba grew next to it. Indeed the name "Yokdzonot" means "over the cenote." The rustic church had a ragged tarpaper roof and pole walls on a low, raised rock foundation. It looked more like a humble house than a church, and nothing outside indicated that it was a sacred space.

Inside, however, strings of brightly colored tissue paper with stencil-cut designs hung from the rafters. On top of a plastered altar draped with embroidered cloth were candles, flowers, and a large wooden cross wearing a *sudario* (an embroidered cloth, which made it look as if the cross was wearing a huipil), along with smaller crosses also wearing sudarios. Curved boughs of palm fronds framed the altar, and above was a wooden frame brightly covered with colored paper. The altar and the plastered low rock wall foundation were painted pale blue, and the pole walls were an even lighter shade, nearly white. The light filtering through the walls was not unlike the light passing through stained glass. It was delightful but muted and created its own patterns. We lit candles and placed them on a rough wooden stand in front of the altar then sat on benches along the side. Just sitting there invited contemplative worship.

"This is a Maya church," explained some villagers, who turned out to be more of Dario's aunts and cousins. "Not a Spanish church as in Tixcacalcupul."

After some moments of silent prayer we walked outside. I picked up a seedpod underneath the ceiba tree. It had burst open, exposing the kapok silk filling.[6] I'd read that the ancient Maya had used the silk from the ceiba, but I'd never met anyone today who did. Silvano said he knew of some people who used it, and he picked up a twig and showed me how to spin it. "My grandma used to make candle wicks in this way," he said. "We also spin cotton for candle wicks."

Dario and Herculana were both very busy planning for their youngest son's wedding in Cancún the following Saturday. Pedro, who'd been born when Dario was in prison, had grown to be a handsome, thoughtful, self-assured, and happy young man. He worked as a waiter, spoke a little English, received decent tips, and, as the youngest, appeared to be the most at ease in both the city and the village. He was marrying a very pretty young woman from Chichimilá.

Dario and Herculana told us that we must come to the wedding, as Charles was Pedro's *padrino* (godfather). After spending several days exploring cenotes, we returned to Chichimilá to pick up Dario. It was midnight before we were underway, so Charles found a station from Havana on the radio that played hot tropical music—a helpful antidote to prevent me from falling asleep while driving. Luckily traffic was light. It was a sign of progress that nearly every car and truck had both headlights and working taillights and we didn't see any livestock on the road.

We talked to stay awake. Dario told us a story about getting around Yucatán before the highways were built. As a child he'd sometimes accompany his father, a traveling salesman for a businessman in Valladolid. He'd sold hammocks and bought and sold cattle. Dario said that walking from town to town with his father had made him curious to visit new places. When he grew older, he would walk everywhere. And when he didn't walk, he ran.

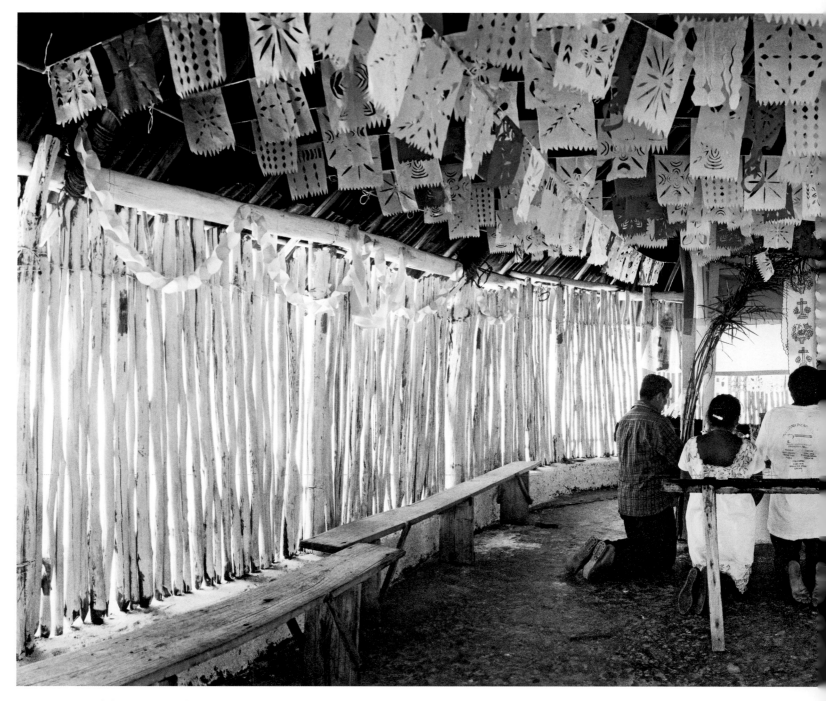

Dario and Silvano praying at the Maya church. Yokdzonot, Yucatán, 2001.

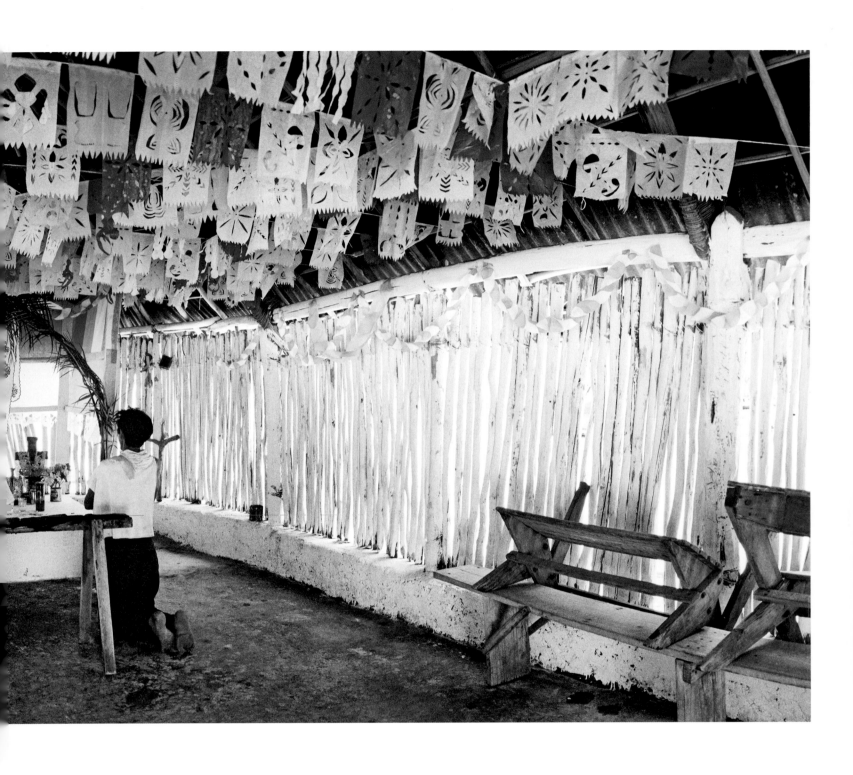

"I was a bachelor then. If I knew that there was a fiesta in another town, even if it was far away, I would run for six or eight hours, fifty or sixty kilometers or more! There weren't any roads then, only jungle trails, *pura brecha* [just a path]."

"Wouldn't you get tired?"

"I could walk and run all day and night. I could go farther and faster than a man on a horse. I could go anywhere. If I got tired, I'd sleep on the trail."

"So where did you go? Did you go all the way to Belize? How long would it take you?"

"No, I never went to Belize, but it would probably have taken four days—the same for the city of Campeche, where my daughter now lives. Many of my friends would go to El Territorio, looking for chicle. I always went to Leona Vicario [a chicle center in the former federal territory, now state, of Quintana Roo] for the fiesta. They had a great fiesta!"

"And if you were on the trail for days and nights, what would you eat?"

"I'd bring a little pozole, and once in a while I'd find something on the trail. Or maybe I'd pass an abandoned rancho and pick a plum or a sour orange. Or maybe I'd find a *calabaza.*"

"A squash?" Charles interrupted. "That's a cultivated plant—something that is grown in the milpa. You don't see that growing wild."

"Yes," Dario agreed. "But someone coming home from his milpa might drop a seed, and it might take root and then everyone coming by will notice it and weed or build a little soil around it. It would be my luck to find it when it was ready to eat!"

"Huhhh," we said. For years Charles and I had observed our Maya friends do similar things. In fact, the Maya have been tending their forest for millennia. Archaeologists and botanists such as Anabel Ford, Scott Fedick, and Arturo Gómez-Pompa now refer to today's Maya Forest as a feral forest garden.

Charles and I got into Cancún at 3 A.M. and drove to Mari and Pedro Alejandro's house. Even at this late hour, as we hung up our hammocks, everyone else got out of theirs to welcome us. It was another hour before we got to sleep. Two hours later we were all up at dawn to finish the week-long preparations for the wedding that evening. We were all bleary-eyed but excited for Pedro.

The whole family worked together to bring it off. Mari and Herculana killed, plucked, and prepared the chickens and turkeys for the relleno. All the sisters went to Victoria's to make tamales. Ursina was in charge of the flower arrangements. Dario and his sons and sons-in-law gathered at the home of José, the only family member who had a yard big enough for a pib for cooking the pavo relleno negro. They dug the pit, collected rocks, and went off to cut firewood. Instead of cutting the firewood in the forest and carrying it

on their backs using their mecapals, they scavenged wood scraps and poles from construction sites and brought them back in the trunk of José's car.

I helped by performing a taxi service. I ended up visiting all the kids' homes. They had started moving to Cancún in the 1970s, and more than two decades later all of their houses were still either under construction or being remodeled. For example, one room of Mari's cement-block house had a door and a lock, but the rest of the house didn't yet have windows, doors, electricity or plumbing, furniture or shelves, or other features that make a house a home. The interior walls had recently been plastered. A large pile of sand for mixing cement blocked the driveway. Her bathroom and kitchen were temporary, waiting for more money to continue construction.

Mari gave us a room to hang our hammocks in. It was new, with a large hole for a window that gave us a view of the neighbors a scant three feet away. We heard them, we smelled what they were eating—and, since they shouted to be heard over their ubiquitous radio, we knew what they were thinking and how they were feeling. Other neighbors, though quieter, were just as close on the other two sides.

What a difference between the Chichimilá home they'd grown up in and the homes that they were now building in Cancún. In 1971 Dario and Herculana could afford to build a house if they provided the time and labor. They could live in a house they built themselves from materials they cut themselves and carried to their house site. Thirty years later their children's houses in Cancún didn't have the same organic relationship with nature.[7] They bought materials and hired workers, and their houses took years to finish because construction costs were high. The houses were built piecemeal, whenever they could afford to improve them. The lots for the workers were small—commonly eight by twenty meters. Since the houses were endlessly under construction, the yards weren't landscaped, if they had any land to landscape. They didn't have gardens or trees for food or shade. Formerly rooted in the soil in Chichimilá, now they had no soil in Cancún.

"Today the kids don't perform a loh ceremony to dedicate their home," Dario lamented. "Instead they have a house-warming party. *Pura fiesta. Pura cumbia. Puro baile* [Just partying with music and dancing]. They dance and they laugh with no thought of God. In the old days this was not a laughing matter. We conducted ourselves with formality, with respect. The h'men would perform his rituals and offer sakah. It's an ancient custom. The loh's purpose is to cleanse and bless the area."

José's house was built out of cement blocks, poles, wood, and tarpaper on a limestone outcropping. It was more organized than most and had a nice feel. It was small for two people, let alone his family of six, but Florentina (his wife) was neat and

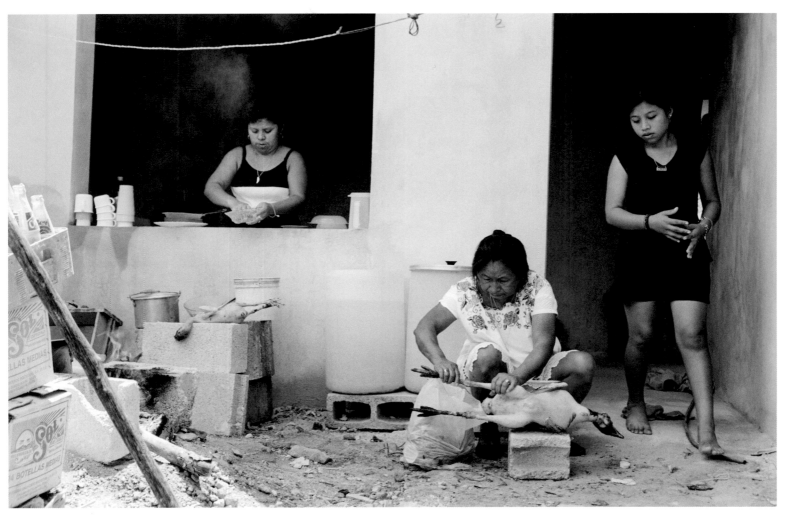

Emerita, Herculana (cleaning turkey), and Daniela preparing a wedding feast at Emerita's unfinished house. Cancún, Quintana Roo, 2001.

had found a place for all their possessions, either on shelves or hung from the walls and rafters, much as you find in village homes. They raised rabbits behind the kitchen.

José had a bit of a front yard. To make the pib they dug a rectangular hole one meter by two meters in the only spot that wasn't rock. When the pib was ready—after the fire burned down and the rocks were red hot—Mari supervised as her brothers placed the cauldrons of relleno negro into the pib. Once it was in place, José and Omar (Sali's husband) stirred the relleno. "It's going to be hot and spicy," Dario said happily as we caught the strong smell of chile in the air. Unlike a religious ceremony where tasks might be rigidly prescribed according to gender, here everyone worked together.

Pedro covered the cauldrons with several layers of banana leaves, using green sticks as support. With his machete he cut longer sticks and slats and placed them over the entire pib, which he and his brothers and sisters covered with green, wet banana stalks and then a piece of tin. Finally they covered it all with earth. The relleno would cook all night.

Ursina asked me if I would give her a ride to her house and then to the church—she had to meet the florist who was delivering the bouquets and flowers. I told her that her house would be the seventh family member's house I'd visited that day. She laughed. "The Tuz family," she said. "We've made a lot of nests in Cancún."

While we waited for the florist to arrive, Ursina told me that she now worked selling flowers to tourists in the evening. Her daughter often accompanied her. She bought the cut flowers each afternoon. They wouldn't last long, especially in the heat. On a good night she would sell fifteen to twenty roses at 15 pesos ($1.63) each. When you included the cost of the flowers, the taxi rides, and her time, she didn't make much. For a village woman with scant education and commercial skills, however, the work was better than most that she could find. Ursina said that when she married she and her husband considered whether to live in his village or in Cancún. They first settled in Nuevo Xcan, where he worked with his father. But Ursina couldn't find any work and also couldn't sell anything, because none of their neighbors had any money. In Cancún she could sell a few flowers or could sew something and sell it, and she made a little pocket money.

As Ursina told me about her job, I looked at her and thought about the many times women had come up to me to sell flowers, especially when I was traveling with Mary, and how few times I'd actually bought any. I suddenly had a nightmarish thought. I would see a woman with flowers out of the corner of my eye and ignore her. I realized I wouldn't have recognized Ursina at a glance, especially since she'd cropped her hair short in a Western cut. If I had ignored Ursina or someone else I knew and she had recognized me, I would have died of embarrassment. Just thinking about it

made me sick to my stomach. I knew that I'd buy a lot more flowers whenever I was in Yucatán.

"How come you don't raise *nicté* [*flor de mayo;* frangipani or plumeria, *Plumeria rubra*] or other flowers that grow here?" Charles asked Ursina. "You wouldn't have to pay the florist and you could distinguish yourself by promoting a Yucatecan blossom that smells great." She didn't have an answer.

Charles later lamented that the bright-eyed Maya girl he once knew was now reduced, at least in his eyes, to a Cancún flower vendor. She was a pawn in the dominant Mexican society, part of the worldwide notion that roses, grown en masse and exported everywhere, are the flowers of love.

Pedro's wedding was divided into three parts. First was a Roman Catholic church service at 7:00 P.M., followed by a reception and Mexican party. A Maya feast would be held the next day. For Dario, there was no question that he must put on all three, each with its layers of duties, costs, and obligations.

As Pedro's godfather, Charles helped Dario with some expenses. He noted that Dario had to host not only the family gathering required by Maya tradition—which years before might have been the only obligation for the marriage—but also the Mexican-style Cancún fiesta with food, a wedding cake, cold beer, and tropical music. Dario didn't say what he had worked out with the bride's family, but it appeared that the burden of costs had fallen on him.

Charles had bought a fancy guayabera shirt in Valladolid so that he'd look presentable. I got a haircut at a barbershop near José's and put on my good clothes. Pedro asked if we could drive him to the church, so I took our rental car to be washed, vacuumed, and polished. The car-wash crew laughed and made jokes when they found out it would be for a wedding, but—since nearly everyone in Mexico is a romantic—they did an excellent job of cleaning it.

Pedro, Charles, and I were the first to arrive at the church. It was large, simple, modern, and close to a major intersection in downtown Cancún. Pedro had asked me to be their wedding photographer, so I started my job when he and Charles met with the Spanish priest. As soon as I got out my cameras a couple of men wearing cameras and flashes around their necks came over. They were local wedding photographers. The men asked me what I was doing. Didn't I know there was a union of wedding photographers? If I wasn't a member I'd have to stop.

Pedro was amused. *Bax ka walik?* he asked them in Mayan. "How are you?" They didn't understand and didn't reply. He explained that I was a family friend and not someone he'd hired. He then turned and spoke to us in Mayan, and his comment about the photographers made us laugh. They were not amused to be left out of the conversation but agreed that they'd let me shoot this one wedding. If I ever came back, though, I'd have to join their union.

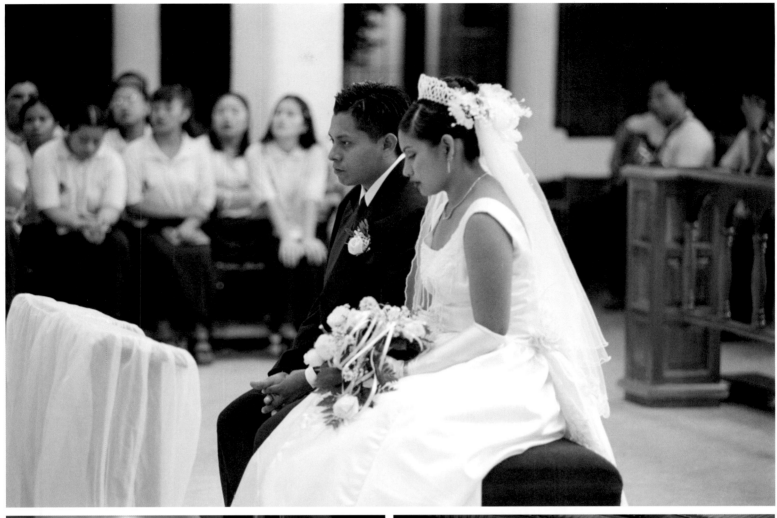

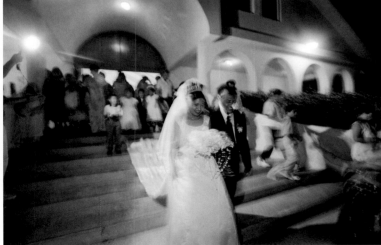

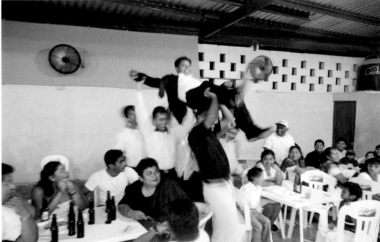

Pedro and Heidi's wedding and reception. Cancún, Quintana Roo, 2001.

Friends and family from Chichimilá and Cancún attended the service. Thirty years before all the women would have been wearing their finest huipiles, but now only Herculana and a few others wore theirs. After the ceremony, Pedro and Heidi asked me to photograph them with all the guests, a few people at a time—a couple, a family, or a group of female or male friends. It was a warm night, and some sweated in their polyester clothes more than others. I took photographs, changed rolls, and took more photographs. The sound of traffic murmured like ocean waves.

After the last obligatory photograph we drove Pedro and Heidi to the reception. They didn't want to arrive early, so we bought cold beers and drank them on the beach in the moonlight and neon of the hotel zone. Charles, as the padrino, slipped Pedro a hundred-dollar bill.

A live band was playing a cumbia when we arrived at the reception. Dario had rented a dance hall, and people were sitting at tables set up around the dance floor. On one side Dario and Herculana received their friends' congratulations,

while across the room Heidi's parents did the same. A lot of well-wishers were from Chichimilá. Hilario had come from Tulum, and Andy and his son from Valladolid. Children ran around the huge salon and played with hundreds of balloons.

Pedro and Heidi, who were both good dancers, made the rounds welcoming everyone and escaped to the dance floor as often as they could. Later Pedro removed Heidi's garter and threw it to the bachelors. Heidi threw her bouquet to the eligible women. Pedro's friends picked him up and, to the tune of a funeral march, carried him solemnly then threw him up in the air and caught him. Afterward Pedro and Heidi cut their cake and shook up a bottle of champagne that fizzed over anyone silly enough to stand too close. It was a modern-day Mexican wedding.

The next morning, after a few hours of sleep, we drove to José's and uncovered the pib. We took the large pots of relleno straight from the earth oven, put them in the trunk of the car, and drove to Sali's for the Maya celebration. Heidi's parents and most of her extended family arrived shortly afterward. As Hilario pointed out, this was the important social purpose of this feast—to bring the families together. We learned from Dario that Pedro had stolen his bride. Heidi's father was upset when she ran off with Pedro to Cancún, but after about a month he forgave her and gave his blessing. Now the families were working it out over relleno in Cancún, where neither set of parents lived.

Guests spilled out of the house into the small yard in back and into the driveway and street in front. It was a hot day, and the yard had no shade trees—no trees at all. Andy was distressed. He couldn't believe that these transplanted villagers had no trees in their yards. "In Chichimilá everyone has a home garden. They have fruit trees that give you shade. They smell nice. They feed you. But there aren't any here at all." No one was listening, however. Herculana and Sali had started serving relleno, and for the moment Cancún was perfect.

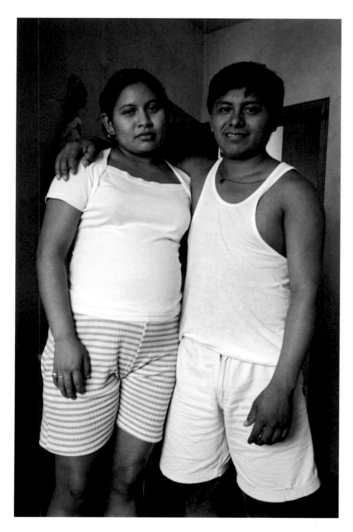

Pedro and Heidi, newlyweds, after announcing that Heidi was pregnant. Cancún, Quintana Roo, 2001.

I asked Pedro and Heidi what their plans were.

"Our dream is to return to Chichimilá with enough money so that we can build a house and raise our children. Cancún is not a good place for that." Pedro paused, looking at Heidi. "But we can't go back now. In Chichimilá, if you are a campesino or the son of a campesino, you are always seen as that. If you aren't a teacher or a politician—and they are all corrupt—there is no chance for advancement. It's very illogical. They don't see who you are. Here in Cancún, people respect personal determination, they recognize your hard work, and you have a chance to advance. I have opportunities here that I don't have at home."

Sali overheard the conversation. "Yes," she added, "but for a woman there still isn't much opportunity. She can be qualified for a job, but she's still not accepted as an equal."

Pedro nodded his head in agreement. "We have a lot to overcome." Though Pedro and Heidi said they wanted to raise their kids in Chichimilá, they faced the quandary of how to make a good living and figured it would take ten or twenty years before they could move back. Soon afterward they announced that Heidi was pregnant.

Six months after the wedding, in November, I returned with my son Robert, who had last been in Yucatán twenty years before when he was still a teenager. It was a bumpy flight because of Hurricane Michelle. We landed at night in Cancún and drove to Valladolid on a deserted road in a fierce rainstorm. By the next morning Robert was already enjoying the sights and smells and sounds of Valladolid and Yucatán. He said that it was fun to start filling in memories.

That evening Antonio "Negro" Aguilar invited us to watch game seven of the 2001 World Series with him. I couldn't think of any better place to watch it outside of actually being at the game. Negro is "Mr. Béisbol" in Yucatán.

Negro had been the first Yucatecan to play baseball in the United States, scouted by Joe Cambria of the Washington Senators, who was responsible for discovering many of the early Latin American baseball players. Negro, who'd gotten his nickname because he was dark-skinned, was known all over Yucatán as a star and a local hero. But when he was sent to Morristown, Tennessee, with the Mountain State League at seventeen, he was shy, unknown, and spoke no English. He ordered "hamaneggs" for every meal until he learned to say "hamburger." Even then it took a while before he began to eat well. He never forgot the loneliness of being a stranger in a foreign country and how kind some people were to him. When I lived in Valladolid, Negro always invited me to spend holidays with him.

"I remember," he would tell me in his baseball English, "I be many miles away from my family on big holidays. Everywhere fiesta, and I think of home. I know, I know, I remember. It not be that way this year for you. You have home here in Valladolid, Yucatán, with Negro." He'd gesture like an umpire: "You not strike out!" he'd exclaim. "You safe! You safe at home!"

Negro owned a grocery and sporting goods store and supplied most of the baseball equipment for the area. He spoke Mayan as well as Spanish and was different from many dzules in Valladolid in that he didn't belittle my friendships with the Maya. When I first met him in 1971 he was police chief of Valladolid. When I noticed that none of his policemen wore guns, I asked him why. He told me that it didn't take him long to figure out that most of the problems were domestic situations where he needed to be more a psychiatrist than a policeman, and, he explained, psychiatrists didn't need guns.

I got to play for Negro when he was managing the Valladolid team. We would travel on weekends to other towns. Representing Valladolid as a player was somewhat like working with the circus. I crossed from being a visitor and traveler to being a local. I was invited to celebrations and, more importantly, into people's lives. Negro helped facilitate the photographic work that I was doing, and we enjoyed each other's company.

While we watched the World Series we second-guessed the team managers and talked. Negro told me how much Valladolid had changed, and that started us telling stories recalling the past. But there was one event that I was afraid to bring up.

Negro's eldest son, Gordo, had followed his father into law enforcement and become a federal highway patrolman. In 1986 Negro told me that he was worried because Gordo had been assigned to patrol an area in the state of Veracruz where drug growers were trafficking. They'd recently set an ambush and killed seventeen of his son's co-workers and their guides. Negro feared that his son might stop a car or truck without realizing what it carried and the driver or passengers would shoot first. So he rejoiced when Gordo was assigned to Yucatán.

But one day in 1994 I found Negro sobbing when I walked into his store. "They've murdered my son," he cried, tears rolling down his cheeks. We hugged as he told me that Gordo had stopped to help a car with a flat tire on the toll road to Cancún, just outside of Valladolid. While he was helping them change the tire, the occupants of the car shot him in the head from behind. It turned out that they were drug runners. The two murderers were apprehended but subsequently escaped. Negro was furious. Nobody killed a policeman and got away with it. As the former police chief, he knew the police always protected their own. But this case involved a Colombian connection and too much money for justice to prevail.

As we watched the World Series, Negro casually mentioned that Gordo had had a girlfriend in Chetumal. I stopped watching the game and looked at Negro. "And?" I asked, motioning with my hand for him to continue.

They'd had a child, now ten years old, whom Negro and Cholly visited regularly. Their grandson, according to Negro, was exactly like Gordo at that age. ¡I-gua-li-to! Negro said joyously. "Exactly the same. He walks the same. Runs the same. I think that God sent Gordo back to me in his son."

When we arrived in Chichimilá I was surprised to find Herculana in her hammock. When she saw me, she covered her mouth with a cloth. My first thought was that she had tuberculosis, but Dario told me that she'd lost her strength. She couldn't eat without vomiting and had trouble drinking liquids. Her granddaughters showed me the medicine she was taking, explaining that one pill was supposed to help her eat and another pill helped her sleep. Otherwise, they said, she'd lie awake and seemed lost in morbid thoughts.

A doctor diagnosed Herculana's symptoms as depression. He prescribed diversions for her—a walk around the neighborhood, a visit to a friend, or even going to see a movie. He informed Dario that if Herculana lost her will to live, she could die. Dario and his granddaughters told me this in front of her, as if she wasn't there—and she wasn't.

I was shocked. Herculana always had been so full of life, and now she was just lying in her hammock. So I decided we should take her on a road trip. If the doctor had prescribed a diversion, I would provide one. We'd drive to Monte Cristo, a farming village where Herculana's brother lived. She'd wanted to visit him for years. We'd last gone together in 1971.

We made preparations to leave the next day. Daniela and Ligia helped us pack a bag for Herculana. They would stay home so they wouldn't miss school and would care for the animals. They were old enough now to take care of themselves; besides, Herculana's illness required special measures.

Dario, Herculana, Robert, and I fit comfortably in the rented Jetta. We put Herculana up front where she could see more, hoping that she would become involved in the trip. She didn't talk and moved only with assistance. I asked Dario about the road to Monte Cristo, and he assured me it was good.

"*Petrolizado* [tarred]?" I asked.

"Yes, it's paved. No problem."

It was a pretty day. Though Herculana appeared to watch the road, she didn't say anything. We were still getting the fringes of Hurricane Michelle. But that meant wind-whipped puffy clouds against a rain-washed sky, and the road looked clean and bright. We drove east from Valladolid on the highway to Cancún and turned off at Xcan. The road immediately turned muddy then rocky—big, uneven rocks. I drove very slowly, but even so our rental car bottomed out. The road was so bad that I wasn't surprised when we didn't meet any other traffic. In fact it wasn't a road as much as a track. After fifteen kilometers our engine started knocking. I drove for another couple of minutes, but the sound got worse. I stopped the car, and Robert and I looked underneath. A trickle of oil was quickly becoming a lake. We'd punctured the oil pan.

I didn't have enough oil to get back to the highway and couldn't afford to ruin the engine. I'd driven bad roads like this since I was a teenager and had never had this happen before. I knew I'd been lucky, but of all days, with Herculana sitting silently in her seat, in the middle of nowhere . . . I couldn't believe it. This was supposed to be a fun outing for her!

We'd passed a few milpas after turning off from the highway but no villages. We had no choice but to walk fifteen kilometers back out to the highway. We decided that Robert would stay with Herculana. In the event another vehicle passed that could tow the car, Robert would drive. Robert didn't speak Spanish or Mayan, but it didn't matter—Herculana hadn't said anything for weeks. He was rereading Reed's *The Caste War of Yucatán* and was content to stay. We left them all of our water.

We followed the thin line of oil that ran down the middle of the road. It glistened in the sun, giving off the colors of the rainbow. The morning was hot and steamy from the recent rain, and Dario and I were soon sweating. We walked among hundreds and hundreds of yellow and white butterflies that flitted about the road, attracted to pools of rainwater. I found that I had to slow down to keep pace with Dario. I knew that he would be sixty-four in December, but it still came as a shock. Dario hadn't just walked through the forest—he used to run. He told me that he was tired and that the *golpes de la vida* (life's hard knocks) were catching up to him. He said that just the year before he had been out at his milpa carrying a load of tomatoes when he'd jumped across a hole leading to a cave—something he'd done all his life. But this time his legs didn't have the same power, and he fell. He hit his head hard and lost his sack of tomatoes down the hole. The fall made him question his physical abilities.

After five kilometers we encountered a young man on a bicycle. We offered to pay him if he would bring back a truck to tow us. I gave him forty pesos in advance. Dario was convinced that the boy would arrange for a truck, so we walked back to the car. Herculana was still sitting in the front seat. We moved her into the back seat so that she wasn't in direct sun. Robert was still enjoying his book, so Dario and I went to look for the shade of a tree where we could talk.

I asked Dario how the Ch'a Chaak had gone this year. His answer stunned me. He told me that there hadn't been one in Chichimilá. Only a few years earlier every neighborhood had its own rain ceremonies, sometimes more than one to a barrio. Dario himself had suggested that the tradition would never die. The Maya had probably been performing a variation on this annual ceremony for 4,000 years.

"It's the Evangelicals," Dario explained. "A lot of milperos have converted. And they have no time for our ceremonies. They won't participate because they say we're superstitious. They even ridicule us. One of them came to a ceremony and asked why we were creating a meal for gods who didn't exist. He mocked the gods. He clapped his hands and commanded the gods to come to eat to prove they existed."

"And did anyone ask him to prove his god existed?"

Dario shook his head. "There are lots of changes. For example, a former h'men in town is now an Evangelical. All he does is a bunch of testimonials and hand-clapping. Another neighbor of mine doesn't go to any church, and he doesn't do any prayers because he doesn't want to spend his money. He says it's all stories. My neighbors used to participate and now they don't." He told me that two h'men'ob were still living in Chichimilá, but not enough farmers got together to have a Ch'a Chaak. So he'd decided to do his ceremony alone that year, taking a chicken out to his milpa as an offering.

While the Evangelicals were unraveling a cultural thread that held the community together, NAFTA was ripping the cloth apart. Cheap corn from the United States had flooded the market, driving the price down. Europe and the United States were subsidizing their farmers with billions of dollars each year and exploiting every loophole to avoid real trade

concessions. It was forcing millions of farmers in Mexico out of business and creating a situation with dangerous biological implications.[8]

"Cheap American corn in Mexico," warns Michael Pollan, "threatens all corn—*Zea mays* itself—and by extension all of us who have come to depend on this plant. The small Mexican farmers who grow corn in southern Mexico are responsible for maintaining the genetic diversity of the species. While American farmers raise a small handful of genetically nearly identical hybrids, Mexico's small farmers still grow hundreds of different, open-pollinated varieties, commonly called landraces."[9]

The changes also had cultural ramifications. The farmer and poet Wendell Berry writes: "When we change the way we grow our food, we change our food, we change society, we change our values."[10] So now the fruits of Dario's labor, which he'd once referred to as his "gold," were no longer of much value. Until recently, wages for working in the milpa were usually paid with products of the milpa, particularly corn. Now laborers wanted cash, Dario said, and the milpa produced no profit. "There are very few farmers left in Chichimilá," he told me. "Most of the town's men are working in Cancún. A young man can't afford to be a farmer anymore. This is the change we are experiencing."

I later asked Stephen Gliessman, professor of agroecology at the University of California at Santa Cruz, about this. "NAFTA has done nothing positive for the Mexican farmer," he explained, "because they can't compete with subsidized agribusiness in the United States. Whole communities are shutting down, as villagers have to look for work in factories or head north to cross the border. In fact, NAFTA has completely undermined a way of life, a relationship Mexican farmers have had with the land that has evolved over millennia. All knowledge that is in the culture is connected to the way they farm. When their farming system fails, they not only lose their ability to grow their own food, they lose all the culture and understanding of their relationship with the land that's built into those farming systems. The milpa is an incredible system of living with the land—it produces, it conserves, it is a way of managing the forest and the animals that live in that forest. How do you replace that when it is mostly in people's heads, mostly in their experience they share from generation to generation? If only one generation isn't in the field learning from their parents, the information is lost."[11]

I remembered what Allan Burns had written less than twenty years earlier. "The most significant social division in the Yucatán Peninsula is that between Mayan people and non-Mayan people. Many Maya would phrase this difference as being one between people who make a milpa or corn garden and those who do not."[12]

Dario and I continued talking about farming until a truck arrived to tow us. A mechanic in town fixed the puncture with

a weld as we waited in the shade of a tree next to the highway. When we added oil, the car ran fine. Dario and I decided to skip Monte Cristo and head straight for Cancún. We would deliver the wedding photos and Herculana would see all her children and grandchildren. The trip could still be a success. When we arrived at Sali and Omar's house, Herculana went into a room, sank into a hammock, and didn't come back out.

The next morning at breakfast Sali remembered that it was Herculana's sixty-first birthday. Omar and I went to buy a birthday cake and candles for her. Sali coaxed Herculana out of her hammock. She smiled when we sang happy birthday and mustered enough breath to blow out her candles. But we didn't cut her cake. We put it in the fridge, waiting for her grandchildren to get out of school at noon. Herculana didn't return to her hammock but sat in the backyard while Sali grilled chicken and prepared *botanas* (appetizers). Robert and Pedro went on a beer run. When they returned I asked Pedro if he could dance the jarana with a beer bottle on his head—it's a famous Yucatecan dance. Pedro demonstrated it and then offered to teach Robert, using a plastic pop bottle half-filled with water. Trying as hard as he could, Robert couldn't keep it balanced on his head. Herculana giggled each time the bottle fell, then she laughed. She even turned to Dario and smiled and spoke to him.

When Robert ended his dancing lesson, Pedro and I sang the ranchera song "No Me Amenaces" (Don't Threaten Me) for her. Our singing, bad as it was, should have brought tears to her eyes, but instead it brought laughter. It surprised all of us to see Herculana come back to life. We devised ways to keep her laughing. Omar found a mask that he put on and a wig for Dario to wear. We played music and we danced, and Herculana joined us. She was very weak and we had to hold her up, but we jumped for joy.

Herculana's grandchildren were delighted to come home from school that day and find the adults acting so silly. They asked their grandmother to blow out her candles again so we could cut the cake. Herculana even ate a little. And she danced again. More of her kids arrived, and she danced with Dario, Pedro, José, Omar, Robert, and me.

We drove back to Chichimilá late in the afternoon. Herculana talked and laughed. We counted out loud the more than one hundred *topes* (speed bumps) in the villages, keeping a running total as we crossed each one. It was a simple, mindless diversion, but it kept Herculana looking out rather than inward and kept her talking, if only repeating numbers. At Nuevo Xcan, we bought a *queso de bola*, a large ball of imported Dutch Gouda cheese enclosed in red wax. It was what she said she wanted for her birthday. When she smiled, we got what we wanted.

Charles and I visited Herculana's doctor in Valladolid. He told us that Herculana's case was particularly severe. He said that the problem of depression among the campesinos was

obviously worse because of a lack of money—they can become depressed but usually don't seek help until it is really bad.[13]

"They tell me they don't feel good. I ask them: what hurts? What is the problem? They answer that they just don't feel good—nothing specific. Then I ask them the key question—the golden question. I ask them if they are sleeping okay. If they tell me no, I know it is depression. Insomnia only makes depression worse. And, of course, they want me to give them a pill so they will wake up tomorrow feeling perfect.

"If they don't find a will to live, they can die. They may commit suicide. They should be seeing a psychiatrist to understand and work out their problems. But the economic reality is they can't afford it. One session alone could cost more than a month's wages. It is really a shame."

Hilario was concerned to hear about Herculana's depression. He'd just returned from Mérida, where he'd met a doctor who worked at a mental institute. The doctor told him that Yucatán had the highest rate of suicide in the country, even as suicides are dramatically increasing throughout Mexico. The *Diario de Yucatán* and *Sureste,* two of the leading daily papers on the peninsula, even started a suicide report as a year-end feature.

The most common suicide method was using a hammock rope. Victims simply put the weight of their neck on the rope and bent their knees. Their weight did the rest. Death came quickly. The Precolumbian Maya had a history of hanging. They believed that suicides went directly to the Maya paradise. Diego de Landa wrote: "They said also and held it as absolutely certain that those who hanged themselves went to this heaven of theirs; and on this account, there were many persons who on slight occasions of sorrows, troubles or sicknesses, hanged themselves in order to escape these things and to go and rest in their heaven, where they said that the goddess of the gallows, whom they called Ix Tab, came to fetch them."[14] We must keep in mind that anything Bishop de Landa wrote about the Maya might have been intended to absolve the Spanish—and specifically Landa—from blame for the deaths of Mayas killed by Spaniards, including those who might have chosen suicide over torture.

Ixtab, the Maya goddess of suicide, appears in the Codex Dresdensis, hanging from the sky by a rope around her neck. The rope is not fashioned into a noose. It is suspended in a "U" shape with the weight of her neck resting at the bottom of the "U." Her eyes are closed in death, and a black circle (representing discoloration due to decomposition) appears on her cheek.

When Mary and I drove out to Chichimilá in July 2002 I wondered if Herculana would be okay. I hadn't heard any updates. Ligia saw us first and shouted that we had arrived. Dario came and gave us a hug and a kiss. He took Mary by the hand and led her inside and told us that Herculana was bathing and was much better. She was talking, eating, and working.

Herculana broke into a big smile and laughed when she saw us. "What a beautiful smile you have," Mary told her as they hugged. "It's how I remember you." Herculana was animated, smiling, and laughing, the center of the conversation. She asked about Robert and Charles and Andy and proudly told us that Pedro and Heidi now had a baby daughter named Lupita. She was very pleased that José had given up drinking. Now he could use that money to improve his house and have time to enjoy it.

Later Dario told us that Herculana had only started improving a couple of months before. He showed us a card that Ligia made in school for Herculana, decorated with glitter and watercolors on parchment. She had spent a lot of time on the card. Inside it read: "There are many choices, but don't choose death!"

Mary invited Ligia to come swimming with us at the cenote at Dzitnup. I'd swum there since 1971, when I first explored it with Hilario. At that time the cenote was virtually unknown.[15] There wasn't a road. We'd walked to the cenote from Chichimilá on trails through the forest and milpas. The cenote was in a farmer's field, and we entered it through a hole in the ground. We crawled down a natural passage until the cave abruptly opened to a cathedral-sized room. A narrow shaft of sunlight entered through a hole in the ceiling where the surface had collapsed. Roots seeking water penetrated from the surface, stretching down sixty feet or more. Stalactites lined the ceiling, and drip-castle stalagmites emerged from the water and cave floor. A beam of sunlight reflected off the pool like cut crystal in every imaginable shade of blue. Ripples caught the light when we entered the water and danced and flickered across the ceiling and cave walls. My son Robert was six, and he thought I'd brought him to a magic fairy castle. Mary visited years later with me in 1988. The experience made such an impression on her that it inspired her to create a suite of paintings and helped her fall in love with me.

Ligia was fifteen but, like many Maya girls, didn't know how to swim. Mary and I took turns with her. Mary went first. They stood on a rock ledge waist deep in the water. Ligia quivered and shook and clung to Mary like a little crab but never stopped smiling. Mary showed her how to float and gave her support. Ligia put her face in the water and swam five feet to Mary and then ten feet. After a while Mary and I traded places. I asked Ligia if she wanted to swim around with me into the deep water. She could hold onto my neck and ride on my back. She said she was scared but wanted to do it.

I swam a slow breaststroke and spoke calmly to her, pointing things out to keep her mind off her fear. We swam to the other side. Once we got away from the crowd, everything about the cenote became magical again, as I remem-

Herculana dancing with Dario on her birthday, accompanied by Pedro and Omar. Cancún, Quintana Roo, 2001.

bered it. I felt Ligia relax her grip on me. As we swam into a shaft of sunlight that blocked everyone else out, Ligia giggled.

Charles and I returned to Yucatán in February 2003. We flew all day, and it was late by the time we arrived at Sali and Omar's house in a Cancún barrio. No lights were on when we knocked. Omar came out, rubbing the sleep from his eyes. He wasn't surprised to see us, he said, because he'd dreamt that we were coming.

Omar asked us if we were hungry. He and Sali had been the padrinos at his neighbor's son's baptism earlier in the day, and the feast was still going on across the street. We could eat *cochinita pibil* (pig cooked in an earth oven) if we were interested. Of course we were interested, we answered.

Omar and Sali's neighbors were from Sacalaca, a traditional Maya village in the interior. They welcomed us and pulled up chairs for us to join them. We sat at tables set up for the celebration in the front yard of their unfinished cement block home. The mother of the newly baptized child and her mother-in-law served us fresh handmade tortillas and plates of cochinita pibil. It was rich, greasy, juicy, and succulent. There was a slight breeze of salty, humid tropical air from the Caribbean. It was great to be back on the peninsula.

The child's grandparents had come from Sacalaca for the baptism. The grandfather was a milpero whose father was Sacalaca's oldest and wisest h'men. When we asked if the farmers in Sacalaca still performed a Ch'a Chaak each year, he said that they did. He laughed as he told us that the Evangelical milperos, despite disavowing the ceremony, nonetheless waited until the Ch'a Chaak before planting their own fields.

We asked if Sacalaca had other h'men'ob. He said that his father was the only one. In response to our question about what would happen when he died, he replied that the next oldest and wisest would become the h'men. He added that the neighboring villages had h'men'ob. He didn't feel that there was a shortage of wise men who knew how to perform the ceremony. Even though all his sons were working in Cancún, he didn't think that farming was in danger of disappearing, at least in the central part of the peninsula where he lived.

While we were talking, two of his sons came over to join us. Although they weren't milperos like their father and grandfather, they still went back to their village every year to participate in their fiesta. When they saw us take out our notebooks, they asked if we were anthropologists. They said that they liked to study the Maya too—to study their own culture. They were proud to be Maya. As we ate and drank, we talked about the Caste War. Clearly they knew their history and had done some reading either in school or after they left. We didn't turn in until 3 A.M.

When we got up at 7 A.M. Omar and Sali were getting their eight-year-old son Diego off to school. Sali asked how we'd slept. Charles replied that he'd slept wonderfully. "Oh yes," Sali agreed, "the hammock lets your bones rest."

Sali went off to the market and brought back some fresh tamales wrapped in banana leaf for breakfast that she'd bought from a woman from Nuevo Xkan who arrived early every morning in Cancún with tamales, freshly ground corn sakan, and produce. Sali was pleased that the market now had a section *del pueblo* (from the village): homegrown products that included everything from handmade tortillas to honey and more varieties of beans, chiles, fruits, and vegetables. Many vendors wore their huipiles. Sali liked the food and the childhood memories it brought back, but she told us that she had no intention of actually moving back to Chichimilá. She also told us that she was pregnant. Her baby was due in May; although she'd had an ultrasound, she didn't want to know its sex before it was born.

After breakfast we visited Mari. Her house now had a front door in a new location, and the bathroom was tiled and more attractive than many bathrooms in mid-range hotels in Cancún. It was colorful, clean, and cheerful, descriptions that I've never before used to describe a bathroom in the barrios of Cancún. From my last visit two years earlier at the time of Pedro's wedding, I hadn't expected things to improve so rapidly. She and her husband had put their money into making their life and living conditions better, and they had in fact improved. It was just a matter of time.

The next day we drove to Chichimilá and found Dario clearing his milpa, getting ready to burn. We followed him back home as he pedaled his tricycle (a bike with a large two-wheeled platform in the front) loaded with firewood and fence poles. We put another load in the trunk of our car.

Dario immediately told us about Hurricane Isadora, which had hit in September 2002. He said that it rained for days, a warm, salty rain, just as his corn was flowering. Isadora had damaged some milpas much more than others. While Dario had lost most of his crop, he felt lucky that he hadn't lost it all and attributed the harvest he did get to having planted early and at a propitious time.

"On the eighteenth of May, I went to Cancún because it was my son Venancio's birthday. However, the whole time I'm in Cancún I'm thinking about my milpa. My head is roiling with thoughts," Dario explained, twirling his hands around his head. "When Venancio said he wasn't going to have a party, I came straight back to Chichimilá. I got back around two in the afternoon and went straight to my milpa to burn. I'd only cut fifteen mecates, and I set it afire with my fire stick. It went up in flames. It was very hot and burned well.

"The next morning it rained. I'd burned just in time. If I'd been lazy and come home and not burned, I would have

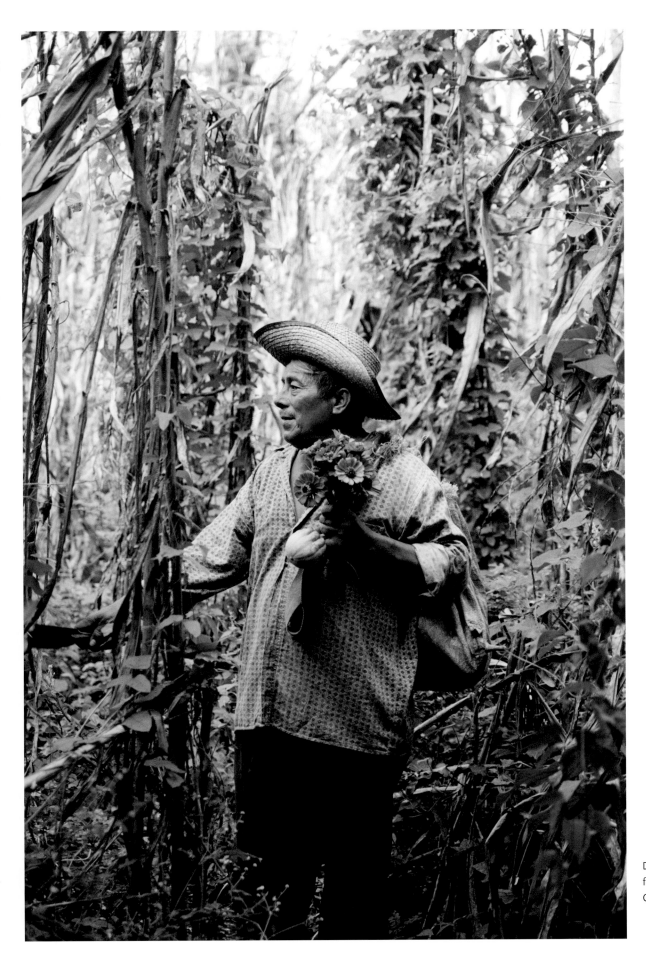

Dario in his milpa with cut
flowers to bring back to Herculana.
Chichimilá, Yucatán, 2001.

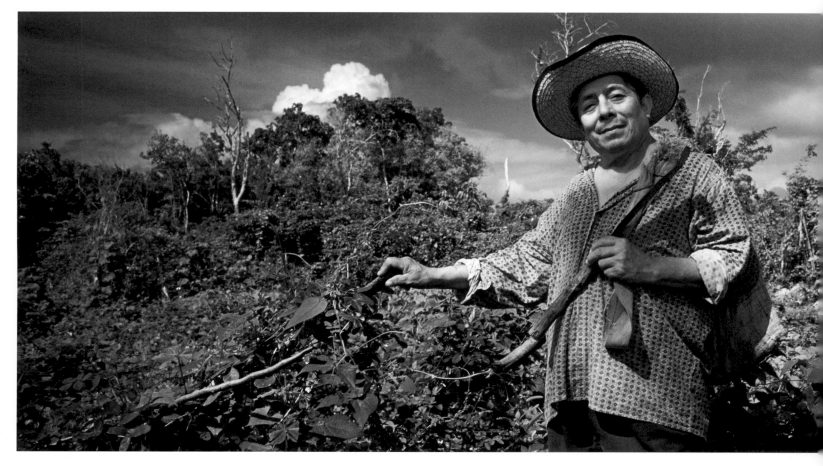

Dario in his milpa. Chichimilá, Yucatán, 2001.

missed it. But I could feel that it was time to burn—I just knew it. I got my seed and planted. Some people around here thought that it would have been better to wait. They planned to plant in June; but when it rained that day, and they hadn't burned, they had to wait, and they lost time. So when Isadora came, some of my corn had already matured and I got a harvest—not a great one, but I got something. Those who planted later lost everything. I know men who got only six kilos of corn for a season of work—less than you can eat in a day.

"Timing is critical. You have to follow your instincts. I have a friend who helped his wife for fifteen days a few years ago during harvest, selling hammocks in Valladolid. He knew that he should have been harvesting but instead went every day to Valladolid. When he did return to his milpa, the white-nose coati had already harvested it for him. He hardly got anything. You have to take care of your milpa, even if no one is paying you.

"Last year we were castigated. Hurricane Isadora wiped us out all over Yucatán. But there are some years when everything goes so well." Dario smiled broadly. "You plant your corn and it grows straight. No wind sways it. It grows so tall, giving big, beautiful *elotes* [ears]. Even the animals— the birds, the *jabalis* [peccaries], the *tepezcuintles* [pacas], the squirrels, the armadillos, the bands of *tejones* [white-nosed

coatis]—they don't bother your field." Dario laughed joyfully at the thought. "That is a wonderful year."

Dario had now been farming the same land for over forty years. He found that physical labor was harder as he got older and that he took longer to heal when he was hurt. Dario didn't know how much longer he could continue. He mentioned that his sons suggested he sell his milpa so that he and Herculana could enjoy the profit. Dario had given it some thought. He knew that his kids weren't going to preserve and cherish the farm—they'd sell it as soon as he died. A group of businessmen in Valladolid wanted to subdivide his land for homes. He understood that he'd be paid something, but the businessmen would realize the serious profits.

Dario confided that for some time he'd been collecting cedar seedlings around his house and in the nearby forest. He'd cultivate them first in his home garden then transplant them to his milpa. Just the day before, he said, he'd transplanted twenty-five. His plan was to plant more every year and start harvesting them to provide a steady sustainable income. When I asked Dario when he thought he would see his first profits from his forestry project, he chuckled and

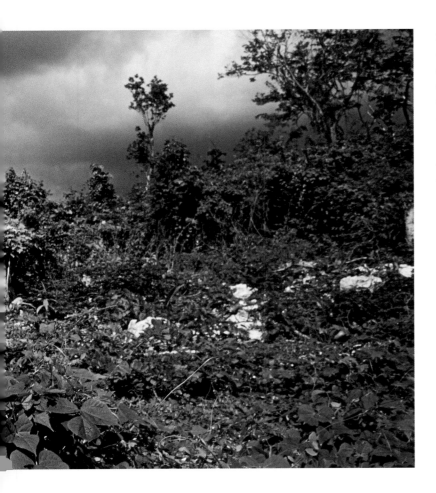

married son and his family. The other structures included a corn storage house, an enclosed area for an outdoor bath, and covered pens for his animals. There was a well-cleared area around the structures, and every day one of the women would sprinkle the hard-packed ground with water and sweep it.

Celso had a large garden with raised beds filled with black soil that he'd dug from a particularly rich vein of earth in his yard. He had installed drip-lines that required a lot of manual intervention because the gravity-fed village water system had such low pressure. A handmade fence of branches, poles, and logs protected the garden from their domestic animals. He and his daughter Rufina tended onions, radishes, tomatoes, marigolds, lettuce, chiles, cherry tomatoes, cabbages, chayas, cilantro, and garlic. To a Western eye, the many bushes and trees growing on his property outside the vegetable garden area appeared to be a hodgepodge jungle, random and unkempt. When I asked Celso to show me around that part of his yard, Victoria, his eleven-year-old granddaughter, came along.

I pointed to the closest tree. "What is this?"

Kopte, Celso answered in Mayan. "*Ciricote* in Spanish [*Cordia dodecandra*]. It's a hardwood and has a fruit that is good to eat after you boil it. We use the rough leaves to clean a luch."

"And this?" I asked.

Chakah, Victoria said, quickly looking up to her grandfather for confirmation. "You can use the bark for skin irritations and sores." Celso nodded agreement. I knew the tree as gumbolimbo (*Bursera simaruba*)—in Belize they call it the tourist tree because of its red peeling bark.

Victoria took charge as our guide, proceeding to show us fruit trees, hardwoods and vines used for construction, and herbs and plants used in ceremonies and for curing a number of ailments. Celso's wife María was known as an herb doctor and evidently had instructed her granddaughter too. Victoria pointed out trees that were good for fodder or that attracted birds, animals, and especially bees. Celso let his granddaughter show us around and answer our questions. We were impressed by the extent of the botanical knowledge that her father and grandparents had taught her and by how many useful and valuable trees and plants were in the yard. There was such a difference between the tilled garden and fruit orchard in the immediate backyard, which were orderly and swept clean every day, and the forest growth in the rest of the yard, which appeared so overgrown and neglected that it was easy to assume that it wasn't part of the home garden. After an hour and a half we'd covered only a quarter of the property. Victoria had named everything we'd looked at—every plant, every tree, and its use and season.

A few hours later Victoria came with us when we drove south on the road to Xuilub and then walked four kilometers out to Celso's milpa. As we walked along the trail, I pointed to other trees, vines, bushes, and plants—challenging her to see if there was anything she didn't know. But she gave me a name and a use for everything I indicated. Sometimes she'd

said that we should go for a walk to his milpa. He led me to a grove of cedars. Dario hugged the first one we came to, demonstrating just how large the trunk was.

"I planted these forty years ago," Dario said proudly. "I think the reason was that I remembered visiting ranches when I was a kid, and most of them had big trees, mostly cedars, near the main house. I just had this feeling when I was near them. I thought that they had a presence, like a respected elder. I asked about them. Every time someone would answer that their father or grandfather had planted it. I knew that I wanted to do that too. So I did, and now I have a lot, more than five mecates. My brother-in-law is a carpenter and has been asking me for years to sell him these trees." Dario laughed and shrugged his shoulders. "I'm in no hurry," he said. "*Hats'uts'!* They are so beautiful!"

One day we visited Dario's compadres Celso and María, who lived in the neighboring village of Xocen. Celso's home was similar to that of many villagers. His yard covered five mecates and was bounded by a stone wall. He had eleven structures in his yard, only two of which were for living—one for his family including his wife and daughter, the other for his

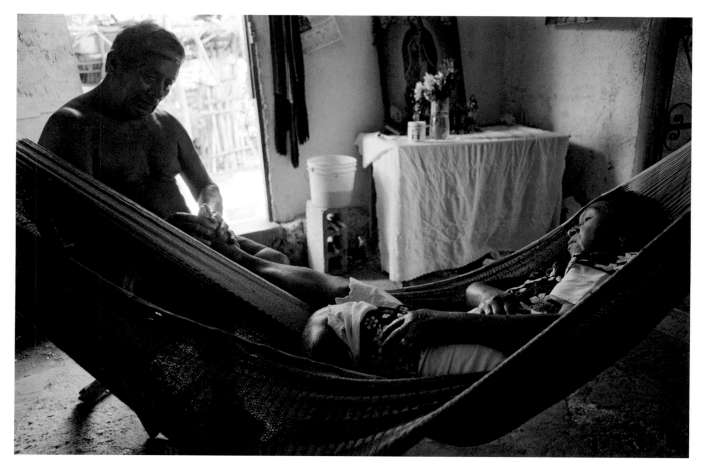

Dario massaging Herculana's feet. Chichimilá, Yucatán, 2005.

look back at Celso, and he'd nod his head to corroborate what she'd said. Victoria was delightful.

We gathered up a *batea* (wooden washbasin) and some clay water jars that Celso wanted to bring home from the hut that he'd built in his milpa. He had yet another milpa four kilometers farther along the trail at the kahtal he'd founded at Xmaxtun. Like most farmers, Celso kept more than one home. His milpas were too far from Xocen to walk back and forth every day, so he and his family often would stay at the milpa for weeks at a time. I decided to count how many buildings Celso's family owned. I arrived at eleven structures in Xocen, one at the milpa we were visiting, and four more at Xmaxtun—sixteen structures for seven people. I know that some archaeologists want to assign five people per structure in order to deduce the population of the ancient Maya in Precolumbian times. However, the contemporary Maya could serve as an indication of how many structures a family might build.

Herculana looked at a photograph of herself that I'd taken twenty-five years earlier, when Dario was in jail. She held it up for Dario and us to see. "This is when I had strength," she said. "When my children didn't have a father. I built a house with the help of my sons. I put the *guanos* [palm leaves used for thatching] on my house. I had strength. I had energy. I had to do the work of two people. Look, in this photograph I'm making rope! I can't do that anymore. I can't see well enough."

Charles leaned over and gave her a hug. "You're not the only one. Macduff and I were just talking about our aches and pains this morning."

The problem with visiting friends you've known for a long time is that you see yourself getting old through them—they hold up a mirror. Soon we were showing each other our scars. Dario had cut through his sandal and foot with an axe. Charles had lost the tips of two fingers in an accident. Dario had another scar on his leg from an accident. It reminded Charles to ask Dario for a massage for a recurring back pain.

Before I had come down on this trip, Mary had helped me pick out a six-month supply of vitamins for Herculana. We'd chosen a formulation that provided the necessary minerals and vitamins needed for a mature woman's good health, plus protein supplements. We knew from her doctor that her diet wasn't supplying many of her needs.

I wanted to take Herculana on another excursion. Although I didn't dare try to go to Monte Cristo again, we made

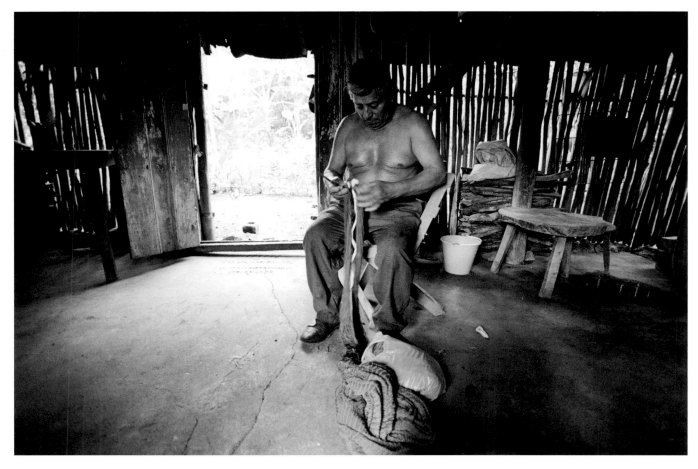

Dario in his kitchen wrapping up two of his hammocks. Chichimilá, Yucatán, 2001.

a couple of trips to visit friends. Everywhere we went their friends and family fed us. Upon returning, our car would be full of food and even a live chicken. Charles commented that this wonderful custom of family and friends provisioning each other with foodstuffs ensured survival when times were hard and was generously idyllic in good times.

Driving home to Chichimilá, I looked in my rear-view mirror. Dario was sitting next to Herculana. When he saw me in the mirror he smiled. *Hats'uts',* he said. "How beautiful!"

When I first wrote these chapters, I opened by marveling at how Dario always seems to find the beauty in life, even in times of difficulty. I added that I felt I'd witnessed his loss of innocence. But conversations with friends and family have made me reconsider. I realize that the person who lost his innocence was me. I was the one who thought that Dario and Herculana's life was idyllic. They were in love and took time to enjoy each day's magic moments, or rather they would find something good each day. But I also knew that they'd lost four of their children in infancy to disease.

When Dario was insulted as an Indian, I learned the depth and breadth of racism in Latin America. When foreign agents from the United States arrested him in his backyard, in his own village, I found that I was powerless to help—just as when NAFTA put millions of farmers out of work.

Five hundred years of Spanish and Mexican rule had prepared Dario for the difficult life of being an Indian in Mexico. In contrast, I'd grown up with a belief in the innate goodness of humans and the optimism that I could work for change (that idealism is now tempered by experience). I know that I've learned something from Dario about how to look for the little moments in each day that make life bearable and worth living in spite of hardship. *Hats'uts'!*

In *The Global Soul* Pico Iyer asks how to keep the soul intact in the face of pell-mell globalization. He quotes Simone Weil, who said that "to be rooted is perhaps the most important and least recognized need of the human soul." So how have the Maya continued to keep their culture?

Michael Coe argues that the 7.5 million Maya today are survivors, and the qualities that have "kept the Maya people culturally and even physically viable are their hold on the land (and that land on them), a devotion to their community, and an all-pervading and meaningful belief system. It

is small wonder that their oppressors have concentrated on these three areas in incessant attempts to destroy them as a people, and to exploit them as a politically helpless labor force."[16]

But I think the Maya have survived because they've been socially and economically marginalized, abused, and neglected. They kept their culture because they were never welcome in the other culture. Their strength was their community, which gave them an identity exclusively theirs. Had they been accepted and given a chance to become economically successful, they would have assimilated hundreds of years ago. Their Maya identity would now be reduced to an annual ethnic fiesta.

Today Mexico calls for its rural indigenous people to be more integrated into the Mexican economy and culture but provides no supporting infrastructure.[17] That world doesn't exist for Indians—they are always the outsiders in Mexico, in their own homeland.

For example, how many local Maya bankers, doctors, or lawyers are there in Chichimilá? Chichimilá has no banks or doctors' or lawyers' offices. From the time of the Mexican Revolution until recently, the PRI (Partido Nacional Revolucionario/Institutional Revolutionary Party, Mexico's "official" party) ruled the country as a mammoth, protected, unaccountable, inefficient, and corrupt one-party state that didn't respond to its people. It used people's poverty and vulnerability for its own political benefit. The government doled out services from its urban centers of power as if they were favors, in a system of patronage designed to ensure political fealty. As a result, towns throughout Mexico performed almost none of the functions normally associated with a town government and had no money for the most basic services.[18]

Pedro and I sat in hammocks talking. He held Lupita, his new daughter, on his lap. She smiled just like her grandfather Dario. In the background the television was tuned to the evening news. Pedro told me how much more they could make of their lives here in Cancún than their parents could in the past in Chichimilá. "I know that we don't make as much money as Americans," he said, "but we imagine we live very much as you do."

I looked around at the cement-block house—four hammocks hung in a room that was at once living room, dining room, kitchen, and bedroom—filling an eight- by twenty–meter lot. But his current living situation was irrelevant. It was his attitude that mattered. He was optimistically expecting more from life and trying to make the most for his family. He believed that he would succeed. That was the American way.

That was also the conundrum. For Pedro, there wasn't much of a Maya way to compete with the Mexican or American way. No magazines, movies, film stars, writers, politicians, and popular dreams promoted the Maya way. Near-

ly everything "Maya" in the region has been co-opted from the Maya—the Riviera Maya, Playa Maya, Puerto Maya, Costa Maya, Ruta Maya, and archaeological sites. It was others who were making money from being "Maya." It was a celebration of the Precolumbian Maya, not the contemporary Maya.

I was not surprised that Pedro, an intelligent, ambitious young Maya, was following the American dream. I looked at him and said, *Hats'uts'!* What else was I to say?

Charles and I arrived at Dario and Herculana's in the midst of a heat wave. The summer of 2008 was the hottest anyone could remember. *Kil kab,* Herculana said, after she gave us both a big hug and a kiss. "It's sweaty." She waved her right hand as if fanning herself. *Hach kil kab!* she emphasized. "It's really sweaty!"

Usually April and May were the most uncomfortable months, right before the rainy season began, when the heat and humidity built to an apogee of sweaty agony. Then the rains would bring relief, clear the air, and lower the temperature. This year, however, little rain had come, and each month got worse as the summer wore on. The hot air was as thick and sticky as syrup. I could take a shower and be sweating before I dried off.

Everywhere we visited someone would soon exclaim *kil kab,* accompanied by a fanning motion. The heat was exhausting and made people tired. It kept everyone awake at night, and there was little else to think about. Crops in the milpas wilted under the sun. Cornstalks had flowered, but the ears weren't maturing without water. "We've lost our harvest," farmers told us, resigned to a hard year.

Dario surprised me when he suggested that we visit his milpa. "I want to show you my cedar trees," he said. When Hurricane Wilma had struck the peninsula in October 2005, the winds had knocked flat whole swaths of forest. As the downed timber dried, wildfires burned across Yucatán and Quintana Roo, even touching a part of Dario's milpa. When I visited him soon afterward, Dario had showed me a grove of blackened cedar trees in his milpa.

Dario told me that he'd continued to tend the cedars that had survived the wildfire and even planted more. He wanted to show me new saplings as well as trees he'd planted decades earlier. Herculana, overhearing our plans, returned to the room wearing a clean huipil and a shawl to shade her from the sun. She announced with a smile that she was coming too. Surprised, we readily agreed.

The trail to the milpa was rocky and narrow, used only by Dario to tend to his fields. We slowed to Herculana's pace, and Dario, who'd brought along his coa, stopped to cut her a walking stick from a tree branch. When we passed a large rock Dario asked her if she needed to rest or wanted to wait for us to return. Herculana shook her head. "I want to see these cedar trees of yours," she said decisively.

After walking for half an hour, we came to a grove of cedars, their tops reaching several meters above the surround-

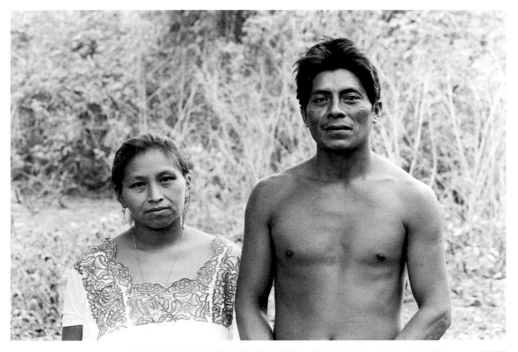

TOP: Dario and Herculana. Chichimilá, Yucatán, 1971.

BOTTOM: Dario and Herculana with a cedar tree. Chichimilá, Yucatán, 2008.

ing forest. Dario started clearing around some of them so that we could easily see their trunks and appreciate their size. He proudly motioned at the trees. "I planted over a hundred cedars here twenty years ago."

"These are twenty years old?" Herculana sniffed, looking around. "I thought they'd be bigger!"

Dario laughed. "Okay. If you want to see bigger trees, follow me."

Dario plunged further into the grove. After a few minutes we heard him getting farther and farther ahead of us. Herculana stopped and said she'd wait for us to come back, but Dario shouted, "Hey, come and look at this one!"

We found him clearing around two trees that were larger in circumference.

"That's more like it," Herculana teased. "This tree you could cut into boards."

"They are nice and straight," Dario agreed.

"You could build tables or doors," she said.

Dario stopped and looked at his wife. "Take a picture of us next to this tree," he asked me. He posed Herculana on one side of the cedar and himself on the other. Suddenly Herculana threw her arms around the tree and hugged it.

Hats'uts', she said.

Hats'uts'. Dario laughed, embracing the moment.

NOTES

1. You would think the least they could do would be to feature an Ux Mall in a faux Puuc style—once they do, I want to open up the Dios Boutique.

2. For years Charles encouraged Dario to make deluxe hammocks with innovative colors and designs and sold them for him abroad. Now Dario had a reputation for his grand hammocks and sold them locally, when he wasn't giving them to his children and grandchildren.

3. Mann 2005.

4. "A significant drop in the age of marriage occurred from around twenty in preconquest times to around fourteen for men and twelve for women: that is, as soon as they ceased compulsory attendance at doctrina or catechism classes and became liable for tribute . . . The cause of the drop seems, again, to be Spanish pressure . . . By insisting on earlier marriages, the Spanish may have helped to increase the rate of fertility among the Maya. They also simultaneously increased the burden on the young family through the imposed household division, and in so doing they may have quite unwittingly lowered the rate of infant survival and inhibited the population recovery they sought." Farriss 1984:173.

5. Oster 2002: Chapters 1 and 3: The figure of 50 million Mexicans living on less than $4 a day comes from Dresser 2006.

6. "The husks appear gray and rough, but on the inside they are lined with a bed of lustrous fibers known as kapok silk. The slippery fibers become the stuff of beds, pillows, and shipping containers or insulation for airplanes, sound studios, and hospitals . . . increasingly, however, synthetic fibers are replacing them. During the dry season the gray pods split open and the whitish silk is blown about." Schlesinger 2001:113.

7. I wondered if the cell-like boxes that restrained the body might cramp the soul and the creative mind as well. I knew that government housing was literally giving Yucatecans a pain in the back. Although everyone in Yucatán sleeps in a hammock, government subsidized housing being built for workers didn't take that into account. Yucatecan governor Graciliano Alpuche Pinzón discovered that it was creating a problem that he called *sindrome de la hamaca* (hammock syndrome). The rooms being built were too small to stretch a hammock across correctly, so people couldn't sleep properly. Instead of correcting this by making the houses a little larger, a bureaucrat suggested that homeowners sleep in shorter hammocks. No one makes shorter hammocks. A hammock is designed to fit a human body—any shorter and they'd be uncomfortable.

"The architect should be hauled off to jail," Mario Escalante, a businessman in Valladolid, told me as we walked through a brand-new housing project there. "Because it is a crime what he did. Think how many people are affected. You have thousands of families who are so happy to finally own a home. After a few days they wake up and their backs hurt. So now you don't have happy workers, and they aren't as productive. So the employer also suffers.

"The plans for the federal housing were probably drawn up in Mexico City, or at least in a colder climate, where an intimate room might be helpful for heating. But here in the tropics the rooms should be larger, with higher ceilings and multiple windows and doors to allow a breeze to cool the interior so the houses don't become little roasting ovens. Which they will become, of course, since all the trees were cut down to build the houses in the first place. And there is very little yard area. It's crazy, because the land is cheap. Adding a few more feet to the size of the house and yard, as well as landscaping with trees and areas for gardens, would make them more livable."

Mario shook his head. "Everyone suffers because the architect is too lazy to investigate how people actually live and how wide a room needs to be in order to hang a hammock. It would take five minutes to find this out." He added emphatically: "No! It would only take a minute or two!"

8. The large subsidies paid to U.S. farmers contribute to global overproduction of staple crops such as corn and have driven down world commod-

TOP: Ursina, with flowers, at the church before Pedro and Heidi's wedding. Cancún, Quintana Roo, 2001.
BOTTOM: Herculana's birthday party, with Robert Everton joining the musical festivities. Cancún, Quintana Roo, 2001.

ity prices. This has forced millions of small farmers out of business not only in Mexico but all over the world. Small, unsubsidized Third World farmers can't compete. In 2002 analysis showed that the United States was selling surplus wheat on world markets at prices 46 percent below the cost of production and corn at 20 percent below cost. These subsidies undermined many countries' efforts to overcome poverty; the direct result was that millions of farmers left their farms for the city and joined the unemployed labor pools. The Carnegie Endowment reported in 2003 that more than 1.3 million Mexican corn farmers had lost their livelihood due to NAFTA. In 2006 this figure had risen to 2.8 million farmers. Dickerson 2006.

9. "This genetic diversity, the product of 10,000 years of human-maize co-evolution, represents some of the most precious and irreplaceable information on earth, as we were reminded in 1970 when a fungus decimated the American corn crop and genes for resistance were found in a landrace in southern Mexico. These landraces will survive only as long as the farmers who cultivate them do. The cheap corn that is throwing these farmers off their land threatens to dry up the pool of genetic diversity on which the future of the species depends. Perhaps from a strictly economic point of view, free trade in a commodity like corn appears eminently rational. But look at the same phenomenon from a biological point of view and it begins to look woefully shortsighted, if not mad." Pollan 2004.

10. Berry 2009:xii.

11. "Anthropological enquiry suggests that all societies classify animals and plants in similar ways. Paradoxically, in the same cultures that have seen large advances in biological science, practical knowledge of nature has dramatically diminished." Atran et al. 2004:395.

When Prince Charles addressed the Slow Food Movement Conference held in Italy in November 2004, he stated: "Imposing industrial farming systems on traditional agricultural economies is actively destroying both biological and social capital and eliminating the cultural identity which has its roots in working on the land. It is also fueling the frightening acceleration of urbanization throughout the world and removing large parts of humanity from meaningful contact with nature and the food that they eat." "Slow Going: Rolling Back the Tide of Processed Food," *Morning Edition*, November 24, 2004, Sylvia Poggioli reporting from the Slow Food Movement Conference in Turin, Italy, http://www.npr.org/templates/story/story.php?storyId=4185366.

12. Burns 1983:8.

13. The World Health Organization (WHO) estimates that depression affects about 121 million people worldwide and that fewer than 25 percent of them have access to effective treatment. The symptoms of depression can include feeling blue, a loss of interest in what normally would give you pleasure, low self-esteem, loss of appetite, problems sleeping, low energy, and poor concentration. If the problem is severe it is very hard for people to take care of themselves, and around 850,000 choose suicide every year. Depression is one of the leading causes of disability, and WHO projects that by 2020 it will be second in the ranking of DALYs (Disability Adjusted Life Years—the sum of years of potential life lost due to premature mortality and the years of productive life lost due to disability). It is a growing global epidemic. In countries as diverse as the United States, India, Russia, and Germany, the rate of depression is already 10 percent of the population.

14. Tozzer 1941:132.

15. The cenote has become justly famous, with a road, parking lots, guards, an enlarged entrance with a staircase, and electric lights. For years the villagers of Dzitnup ran the site cooperatively and divided all the profit. It was one of the few success stories where the indigenous people prospered in the tourist trade. Then, around 2000, a villager secretly sold the cenote to a businessman in Piste (Chichén Itzá). This led to fighting among the villagers and lawsuits; ultimately, the businessman won in court and took private possession of the cenote.

16. Coe 2005:242.

17. I recently drove through Wyoming, Idaho, and Oregon and noticed

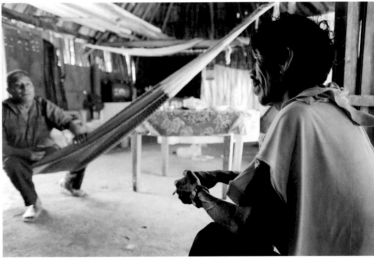

TOP: Herculana with her mother, Venancia Pech Ciau. Chichimilá, Yucatán, 2001.
BOTTOM: Dario with his cousin, Silvano Caamal Poot. Yokdzonot, Yucatán, 2001.

that the small rural towns, some with populations of even less than 300, usually had a bank, a fire department (it might be volunteer), a police department or a sheriff's office, an emergency medical facility, a gas station, and a motel and café. Some also had new or used auto and/or farm equipment dealers. Many had a supermarket. Chichimilá doesn't have any of these things. Although Chichimilá has 8,000 inhabitants, I realized that I had always considered it a "village" because it had no services that I associate with a "town." It is the same all over the peninsula and has been this way for centuries. The dzules are concentrated in the larger cities, where the services are.

18. "In Mexico, economic growth has largely come without true development precisely because municipalities are so incapable. Indeed, I believe many Mexicans' impoverishment has almost as much to do with this as with low wages. When jobs come to a city, so do people wanting those jobs. But local government cannot hope to keep up with the infrastructure demands this economic boom has created." Quinones 2001:317.

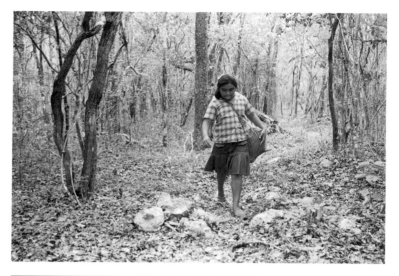

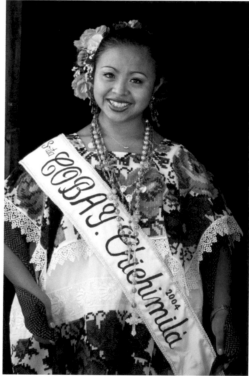

TOP: Victoria Dzib Nahuat, Celso's granddaughter, walking in the Maya Forest. Xocen, Yucatán, 2005.
BELOW: Ligia, after winning Miss Chichimilá. Chichimilá, Yucatán, 2004.

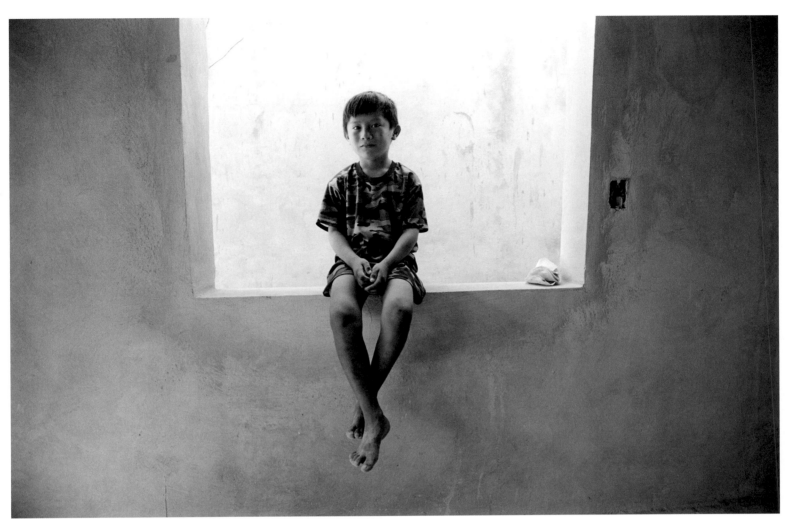

Luis, Emerita's son, sitting in an unfinished window opening of their house. Cancún, Quintana Roo, 2001.

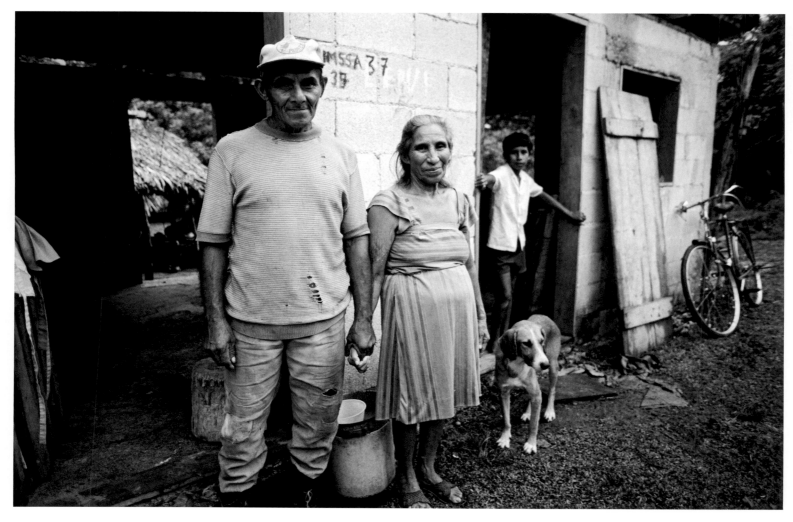

Pacio Diego Venerado Jiménez Chi, his wife Margarita, and their grandson Roque. Calderón, Quintana Roo, 1992.

All kinds of riff-raff run together in a chicle camp, mostly men who are wanted somewhere by the law. Fights in the camp are frequent, drunkenness is usual, and stealing and smuggling are daily occurrences. From the collector's camp, these blocks [of the dehydrated resin] are hauled out on mules, often requiring days and weeks over trails . . . Sometimes enterprising bandits hold up trains of 20 or 30 mules and mules and gum disappear, leaving only a few dead chicleros as mute records of what has happened. Fantastic are the tales that can be heard in the evening around the chicleros' camp fire, and most of them are true.
FRANS BLOM, Maya archaeologist, *Tribes and Temples*

III | Chicleros: A Season in the Jungle

An account of Diego Jiménez Chi and Cornelio Castro Salazar, chicleros, who lived in the jungle along with their wives and children during the rainy season to bleed the chicozapote tree for the resin used to make chewing gum, and what happened when gum manufacturers supplanted the resin with petroleum products

Cobá seemed to be in the middle of nowhere when I first visited in 1967. Although it is a massive archaeological site covering some seventy square kilometers, I could hardly see anything because of heavy jungle undergrowth. I knew that I was surrounded by the vestiges of temples, pyramids, courtyards, ball courts, and other buildings, but most remained overgrown mounds. It was impossible to convey the extent of the ruins in a photograph. I climbed a pyramid for a better view and saw an unbroken canopy of forest stretching to the horizon, with bumps and hollows indicating more overgrown mounds.

During the Classic period Cobá was a regional capital with a population of more than 50,000 people. Numerous *sacbes* (Maya roads) radiated out of the city, connecting Cobá with the Caribbean coast to the east, and another led more than sixty miles west to Yaxuná, near Chichén Itzá.

It had taken me a day to reach Cobá. I'd read that a trail from Chemax led to the ruins, so I bought a few supplies in Valladolid—beans and corn flour, oranges, some eggs which a restaurant hard-boiled for me, and an Almon Ris candy bar—and caught a bus. Hurricane Beulah had recently swept across the peninsula, and I saw its effects everywhere. In fact, the word "hurricane" may come from the Mayan language: Huracan is the god who represents the unharnessed forces of nature that cause rain and flood in Maya creation stories.[1]

I arrived in Chemax late on a damp, gray afternoon. I carefully picked my away across the town square, around fallen trees and broken branches and other debris. I attracted an entourage of curious villagers as I headed for the city hall. What I needed was a guide. I had neither a map nor a compass, and the ruins were in a big blank spot on the map of Quintana Roo. When I explained that I wanted to walk to Cobá, the villagers seemed to agree immediately on who should guide me. One of the men was sent off to look for him. Minutes later I was led to a street corner, in front of a cantina, and met a Maya in his early twenties. Although Benito reeked of alcohol, all the villagers gathered around us assured me that he would be a good guide. He spoke Mayan, and his knowledge of Spanish was as poor as mine. Using Spanish as our common language, we communicated in nouns and unconjugated verbs and hand gestures. Benito

agreed to meet me at dawn the following morning and would bring a packhorse. He would charge me forty cents a day for his services and eighty cents a day for his horse. These prices were within my budget.

That night I met the *presidente* (mayor) of Chemax, a jovial man who enjoyed the diversion that I'd brought to his town. He invited me into his office. Along with a lot of the other village men, we sat and smoked. He told me that I could hang my hammock in his office—it was cleaner than the jail. Everyone wanted to teach me Spanish and Mayan, and we stayed up late into the night. I was the only show in town.

Benito arrived early, and we left at daybreak. We walked down a street with stone buildings then past houses of poles with thatched roofs. We passed a well where young girls in huipiles were drawing water. Smoke from the breakfast fire drifted from every house. Soon we reached a narrow, rocky trail leading into the forest. We tried to talk as we walked. Our conversation revolved around Benito shouting out the Mayan names for tropical flora and my repeating them until he was satisfied with my pronunciation. The sky was bright blue, and it was getting hot. As the sun dried the sodden earth, the air felt like a sponge absorbing the moisture.

The hurricane had left the trail littered with debris and dead snakes: coral snakes, rattlers, terciopelos (*Bothrops asper*), and other pit vipers. After several hours, we came to a small rancho in a clearing. Benito suggested we stop for lunch.

Anselmo Caamal, a blind farmer, was sitting in his hammock inside his pole-walled house, listening to soul music on Radio Belice on his transistor radio while his parrot commented in Mayan. He was able to farm by hiring men to do the work for him. He'd ride his horse into town, usually with a son on foot guiding him.

Anselmo invited us for lunch. While we ate tortillas and beans, Benito arranged to rent another horse. I didn't want the expense, but Benito assured me that we'd need it. As they talked I listened to Otis Redding, Aretha Franklin, and James Brown.

Benito and I rode out on our small tick-ridden bony horses. We didn't have saddles, just a burlap bag as a pad with a breast collar and a britchen strap—it was more like a set-up for packing the animal. The sun gave way to clouds, and

within an hour it was raining again. I had a slicker, but it rained hard and steadily, soaking and chilling us. Soon my legs were itching. It felt as if I was being bitten, but I couldn't see anything. Finally I jumped off my horse and discovered that my legs were covered with small, pin-sized ticks (*garrapatitas*) almost impossible to pick off and as numerous as raindrops. We rode on.

The trail was flooded. At dusk we entered a swamp and continued slowly. The water was soon up to our horses' bellies. The storm and jungle canopy blocked out what little light there was. We had to use flashlights, picking our way through silhouettes. My horse foundered several times; when we reached the deepest part, he just stopped and seemed to give up. I jerked him up, holding my camera bag above my head in case I had to jump off.

We finally arrived, wet and itching, at the rough camp of Domingo Falcón Kinil, the guardian of the ruins. He and another guardian invited us to hang our wet hammocks and mosquito netting. I had no change of clothes or blanket: I was traveling light, having left the rest of my gear with the mayor of Chemax. I sat near the fire and tried to get warm and get rid of the ticks. My legs looked like a monochromatic Georges Seurat painting that had come alive. It was taking forever to pull the ticks off singly until I found that my Cutter's Insect Repellent got rid of most at once. I ate a hard-boiled egg for dinner.

I spent two days exploring Cobá. Domingo, happy at the diversion, joined Benito to show me around. We crawled through roofs into buildings where the Maya elite had once lived or worked, and Domingo showed me some of the carved stelae where contemporary Maya pilgrims still lit candles and incense at their bases. Before we left, Domingo asked me to sign a visitors' book. Most pages were blank: few outsiders had ever visited.

I wanted to visit the ruins of Tulum, and we were only fifty-six kilometers away. But we knew that part of the trail was flooded and the weather was iffy, so we returned to Chemax. Benito and I were on the trail without flashlights long after nightfall (our batteries had died). After we returned the horses to the blind milpero, we still had several hours to walk. Starlight filtered through the trees as we followed a vague outline of the white limestone rocks that pocked the trail. We took turns leading. It was very quiet—as quiet as a snake lying in the trail. I worried that the only reason my guide asked me to take the lead was because we'd seen so many poisonous snakes. I tied an empty plastic canteen to my belt so that it swung at knee height. That way my knee would hit it with each step and make a sound. *Bonk. Bonk. Bonk.* I hoped the noise would scare any snakes away. I felt foolish, but I didn't want to get bitten. So I continued to walk and bonk my way through the otherwise silent night.

Suddenly we heard singing ahead and soon met a man reeking of rum, who was straddling a mule laden with supplies. I could hear the creak and jingle of more mules behind him. The only light was from the tip of his cigarette, which lit up each time he took a drag. He offered us a cigarette then pulled out a carton and handed me a pack. We smoked a couple of cigarettes and talked, although Benito didn't say anything.

"Talk" is a loose term. The man said something—I recognized some words—then I tried to say something. He would laugh, hand me his bottle of rum, and signal for me to drink up. We'd say a little more then have another drink and a few more drags on our cigarettes. I understood that he was a *chiclero*, a man who collected chicle, the sap of the *chicozapote* (sapodilla, *Manilkara zapota*) tree that is the base for chewing gum. His *campamento* (camp) was still a night's ride away. I was impressed that he would take off alone in the middle of the night. I figured that if anyone could teach me to enjoy the jungle, it might be a chiclero.

When I got back to Mérida, I talked with William Harben, the American consul, who shared my interest in the Maya and Yucatán.[2] This was before the threat of terrorist attacks drastically changed the procedures at consulates and embassies. It was easy to talk with the consul, and visitors were sometimes treated like extended family. (Morris Hughes, the new vice-consul, let me store my film in his refrigerator for months at a time when I returned in 1970).

I told the consul that I wanted to document the chicleros before they disappeared. He advised me to be careful—an American had recently been robbed and murdered in the area where I'd been, and a chiclero had been arrested. Chicleros were usually included in any discussion of the dangers of the jungle, along with poisonous snakes and plants, disease-carrying insects, jaguars, and packs of peccaries. Since the beginning of the twentieth century, when the chicle industry in Quintana Roo began to take off, the chicleros have had a reputation for being bandits, murderers, convict laborers, and renegade Maya, safely beyond the reach of the law, who would kill any intruders at their jungle outposts. Leona Vicario, Quintana Roo, was once the largest chicle-processing area on the Yucatán Peninsula. When the chicleros were paid for their chicle thousands of men would party—drinking rum, dancing, and having sex with prostitutes. Even into the 1950s and 1960s it was reputed to have "the worst murders, brawls, and hair-raising, authentic cases of crime in all of Mexico."[3] But the contemporary chicleros were reputed to be much less violent, and many came from Yucatecan villages.

Humans have chewed gums for millennia. The Greeks masticated an extraction from the mastic tree mixed with resin to freshen their breath and clean their teeth. North Americans chewed the sap from spruce trees and passed the habit on to early European settlers, who later made a gum of sweetened paraffin wax. The Maya referred to chicle as *itz* (a sacred secretion of life) and chewed the sap as well as burning it as incense.

In a chance encounter on Staten Island in the mid-nineteenth century inventor Thomas Adams met exiled Gen-

eral Antonio López de Santa Ana, the former Mexican president who had led Mexican troops at the Battle of the Alamo. Santa Ana thought that chicle latex could be a substitute for rubber and gave Adams some to experiment with. Adams tried to vulcanize the chicle latex but was unsuccessful. It was this failure that led to his discovery of modern-day chewing gum when he decided to sweeten the bland sap and add flavors. Soon its popularity spread worldwide.[4]

Sapodilla or chicozapote trees growing in the Maya Forest were the primary source for chicle. By the twentieth century Adams, Wrigley's, and other gum manufacturers were importing millions of pounds of chicle each year. Chicle became the greatest source of wealth for the Territory of Quintana Roo. But by 1967 many gum companies were already using synthetic petroleum-based gums, and I wondered how long chicleros would continue to work on the peninsula.

In 1971, four years after I visited Cobá, I finally spent a season in the jungle. Pablo Canche Balam, a friend I'd met in Tulum, invited me to accompany him to his chiclero camp during the rainy season, when the trees would be full of sap. He told me to meet him in August, but the rainy season was late, so I camped on the beach at Tulum and waited. Although my son Robert had returned to Santa Barbara, Andy Johnson, a twelve-year-old neighbor, had joined me. Andy was cheerful and outgoing and captivated nearly everyone we met. His parents thought that half a year spent in Yucatán would be highly educational for their son—they'd already taken him and his siblings around the world in a bus when he was four.

One day while we were in a store buying supplies, we met two families from Chichimilá who were also waiting for the chicle season to start. When we discovered that Dario and Hilario were mutual friends, we started spending time together. Unlike most chicleros, Cornelio Castro Salazar and Pacio Diego Venerado Jiménez Chi had brought their wives and children. Diego and Margarita had a young daughter, María. Cornelio and Veva also had a young daughter, Alicia, and four sons. Luis and Elmer, the eldest, were working as chicleros, Cornelio Jr., at thirteen, was learning, and Felipe was only four years old.

Diego and Cornelio were in a precarious position. They'd come from Chichimilá and were living in a house lent them by their patron, who advanced them credit toward supplies. But every day they weren't collecting chicle they were sinking further in debt. They were far from their homes, migrant workers at the mercy of the weather, waiting for a seasonal job to begin.

Margarita and Veva made sure that Andy received a mother's attention and invited us over until we were eating almost all meals with them. In turn, Andy and I shared the fish, conch, and lobster that we caught diving in the waters in front of our camp at the beach.

In late August a hurricane threatened the coast. The sea turned dark and turbulent. For four days the wind howled, bent the palm trees, roiled the sky and sea, and blew the sand till it stung. I listened to bulletins on Radio Belice, ready to evacuate, but we were only getting an edge of the storm. It didn't rain.

In early September Cornelio and Diego prepared their campamento. It was in tall forest seventeen kilometers south of Tulum just off the new dirt road that the government was building from Tulum to Carrillo Puerto. Andy and I helped construct a one-room house in an open area next to a recently abandoned quarry used during the road building. We contributed planks and other treasures we'd collected at the beach to help ready the camp before they brought out their families.

At night we ate beans and made our own thick tortillas—a travesty of the perfectly round, thin ones that their wives and daughters made. Cornelio and Diego jokingly referred to them as "chiclero tortillas." Our misshapen efforts prompted them to talk about their wives. They liked the idea that once the women arrived in camp they would have someone to make regular tortillas, do the cooking, and wash their clothes. But these were things that men say in front of other men. They were proud of their wives for being strong enough to live in the primitive camp and looked forward to coming back each day to a camp that was also a home.

Veva and Margarita improved the main house as soon as they arrived. It served as both kitchen and living quarters for both families. The women, helped by their children, resurfaced the rocky floor by hauling in buckets of saskab then stamped on the marl until the floor was compacted and smooth. They constructed washstands for laundry, told their husbands where to build shelves of poles lashed with jungle vines, and set up their corn grinder along one wall. Andy and I built a kitchen table from the planks that we'd found beachcombing.

Pablo set up his camp nearby too, so we had no shortage of jungle hosts. Although the plan was to stay at Pablo's, Veva and Margarita insisted that we stay with them. I wasn't about to argue with them. It only took part of a day to build an open-sided hut where Cornelio's son Luis, Andy, and I could hang our hammocks. I even added a desk from poles so I could use my Olympia Deluxe portable to type up my notes.

We slept in hammocks with *mosquiteros* to protect us from mosquitoes so large that we joked they needed co-pilots just to take off. A mosquitero is a large rectangular piece of cheesecloth reaching to the ground, with conical protrusions that the arms of the hammock pass through. Two sticks at both ends, perpendicular to the hammock and held taut by twine, keep the mosquitero from collapsing and turn it into a diaphanous white tent. When I got into my hammock I felt as if I was floating inside a cocoon, but all night long I could hear the buzzing of the mosquitoes outside my net.

The chicozapotes needed at least five years between bleeding, so the chicleros had to change location every year. They'd use their camp for the season and then abandon it. The forest provided the building materials and would efface

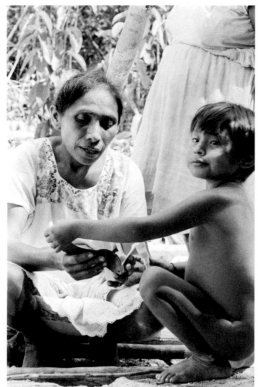
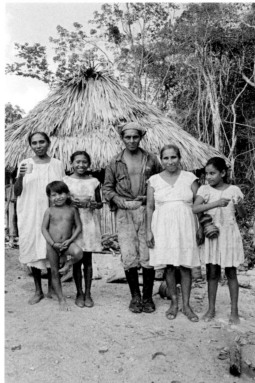
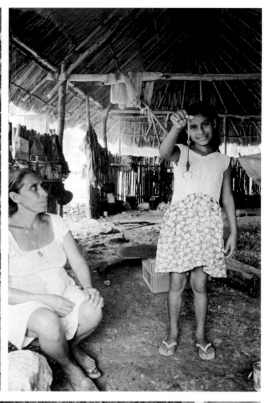
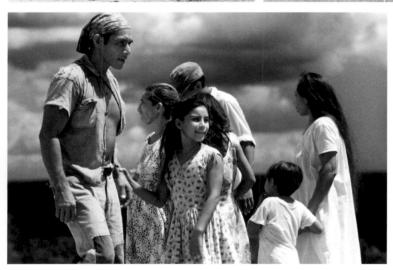
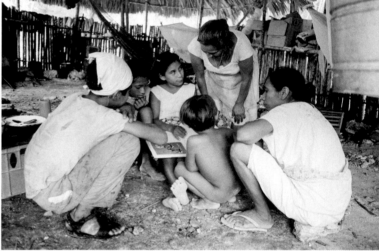

CLOCKWISE FROM TOP LEFT: Veva and Felipe; Veva, Felipe, Alicia, Diego, Margarita, and María in front of our seasonal housing; María showing her mother a scorpion she caught; Cornelio Jr., Alicia, María, Felipe, Margarita, and Veva looking at a book in the kitchen, Campamento Manuel Antonio Ay, Quintana Roo, 1971. Diego, Margarita, Elmer, María, Alicia, Felipe, and Veva, Cobá, Quintana Roo, 1971.

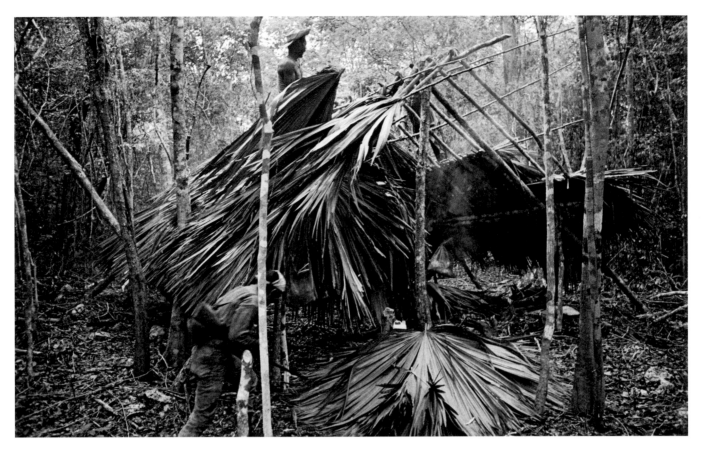

Diego visiting chicleros in a nearby camp who are roofing their temporary house. South of Tulum, Quintana Roo, 1971.

the chicleros' efforts when they moved on. They had built, tied, and fashioned similar houses many times.

The men prepared their equipment. They spent a day sharpening their machetes, putting an edge from the tip to within six inches of the handle. These last six inches were left dull so they could grip the machete with both hands. These machetes were used only for bleeding the chicoza-pote; they were too sharp to cut firewood and do other tasks that might nick and dull them. The men boiled their canvas chicle-collecting bags, removing the previous year's stickiness, and checked their climbing ropes and spikes, looking for defects that might injure or kill them.

Everyone had a job. Ten-year-olds María and Alicia helped their mothers cook, collect firewood, and fetch water from a cenote a hundred yards away, with the aid of five-year-old Felipe. Thirteen-year-old Nelo (Cornelio Jr.) sometimes helped his sister Alicia but also joined his brothers Elmer and Luis in preparing their equipment.

Veva and Margarita set up two fires: one for cooking, the other for making tortillas. They served the men and older boys first and then ate with their younger children. After washing the dishes, they served hot chocolate and coffee. Almost every meal included black beans and tortillas. Elmer and Diego carried guns when they went out to work in the hope of adding meat to our diet. Elmer hunted at night even

after a full day's work and shared the wild pig and game birds that he shot. We also ate pocket gophers that Diego's dog caught. The gophers were roasted over the fire without being cleaned or gutted. Their singed, blackened, naked bodies were then served as a main course. Andy looked aghast and even more so when, as guests, we were served these treats first. I was very impressed that Andy gamely ate a few bites with me before insisting that anything so tasty had to be shared with everyone else.

The chicleros' generosity embarrassed me. I knew that their supplies were being charged against an account based on chicle that hadn't been collected, but they insisted on feeding us. Landa had written four hundred years earlier about the Maya's generosity: "The Yucatecans are very generous, and hospitable; since no one may enter their houses without being offered food and drink of what they may have had during the day, or in the evening. And if they have none, they seek it from a neighbor; and if they come together on the roads, all join in sharing, even if little remains for themselves."[5]

I wanted to reciprocate. When the road from Tulum to Carrillo Puerto opened, bus service started immediately. So I took a bus to Chetumal, the capital of the territory, to buy staples and fresh produce. I returned with 150 pounds of corn flour, black beans, oatmeal, sweetened condensed

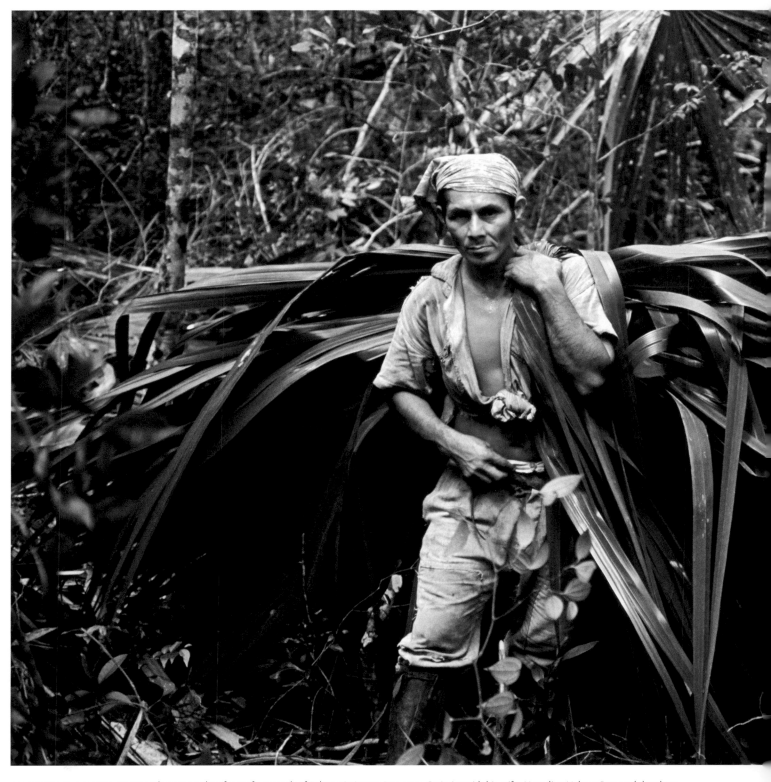

CLOCKWISE FROM LEFT: Diego with guano palms for roofing, south of Tulum, Quintana Roo, 1971. Casimiro with his wife, Marcelina Nahuat Puc, and daughter, Elizabeth Jiménez Nahuat; María with my parrot, Suc Tuc, Campamento Manuel Antonio Ay, Quintana Roo, 1971. Elmer, Andy, Luis, Diego, and Cornelio Jr. walking on the new highway through the Maya Forest between Tulum and Carrillo Puerto, south of Tulum, Quintana Roo, 1971.

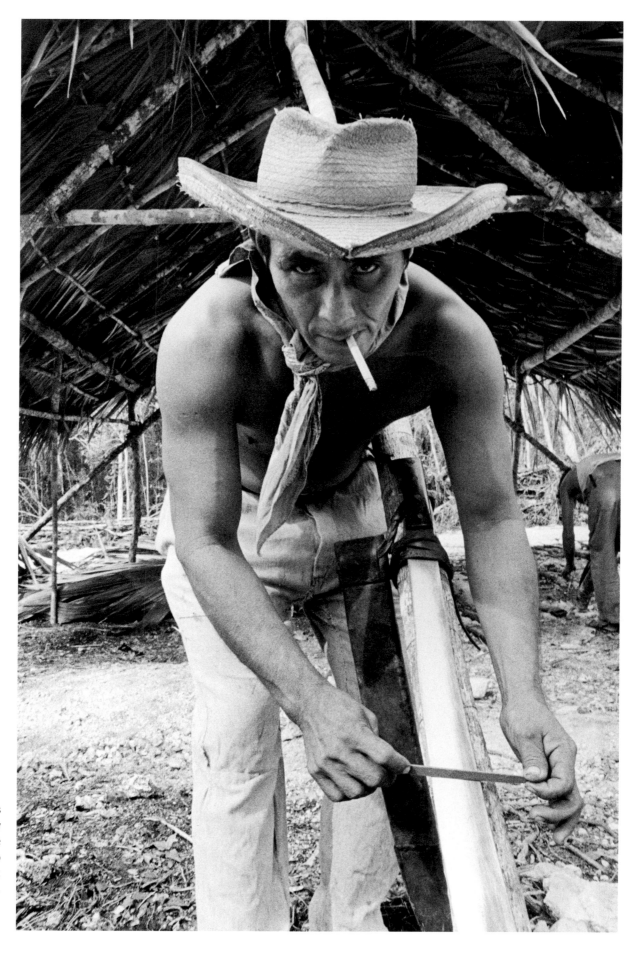

Diego sharpening his machete, getting ready to bleed chicozapote trees. Campamento Manuel Antonio Ay, Quintana Roo, 1971.

milk, eggs, cocoa, coffee, oranges, bananas, Gouda cheese in balls covered in red wax, pineapples, and vegetables. Though Andy and I presented the food to the camp, we had to remind them every day that it was for everyone.

For example, Felipe might ask his mother if he could have scrambled eggs. Veva would tell him no, they didn't have any eggs, even though I'd just brought fifteen dozen. Andy or I would then ask if we could have scrambled eggs. When she said yes, if that was what we wanted, we'd ask her to make enough for everyone. We had to pass out the fruit. If we tried to make cocoa and coffee Margarita or Veva would take over, and we had to insist that everyone would have some. Finally I spoke with Diego.

"You told me that your house was my house."

"Of course," he answered.

"Well," I explained, "my food is your food."

Diego smiled and nodded his head in agreement. It had no effect at all.

I was sleeping in my hammock when the first drops on the guano roof woke me. I could smell the rain. Everyone was smiling the next morning, excited because it meant that the season could begin. But the rain didn't stop. Water ran off the low-slung thatched roof in sheets while strong gusts of wind blew it in through the open sides of the house.

The men couldn't start working until the rain stopped, so we remained in camp. It grew cold, a bone-chilling dampness made worse by inactivity. We made up ways to pass the time. At first we sat around the table or lay in our hammocks, telling stories. Then our obsession was playing cards. We played all day and long after dark. We would have endless conversations; no matter how seriously they began, they usually ended in laughter.

With so little activity, we weren't curious when Cornelio kept to his hammock. The evening of the third day of the rain, Elmer joined us for dinner and cards. A couple of candles lit the table. Veva stood up from the cooking fire and came over with a stack of hot tortillas. She stopped to watch Elmer and Luis eat. When she didn't put the tortillas down, they looked up at her.

"Your father is ill," she said.

"He'll get better, won't he?" asked Elmer, glancing over at his father.

"He can't move his arm. He'll need to see a doctor in Mérida."

"So why is he here?" Elmer asked. He angrily tore a piece off his tortilla and used it to spoon up a mouthful of black beans. "If you are asking for money, why don't you say so?"

"We need your help," Veva pleaded. "We don't have any money."

Cornelio shifted in his hammock, but his sons didn't look in his direction. They continued eating and kept their eyes lowered.

"How many times have you heard me tell him, 'Stop working so hard, old man, you're not a kid anymore?'" Elmer asked. "I tell him, and tell him, and does he listen? No!"

"He doesn't need your advice, he needs your help!" Veva said.

"How am I supposed to help?" Elmer threw down his tortilla and stood up. He gestured at his mother and his father, his shadow jumping wildly in the candlelight. "I've tried to help. You think I don't care? I haven't started work either, and already I've borrowed too much. I can't ask my patron for more."

"Yeah," Luis agreed. "You think I can go and say, 'Hey, don Tomás, my old man has gotten sick, so advance me another month's wages?' Hah!"

"Why can't he borrow the money?" Elmer asked.

"They said because he's an old man, you would need to guarantee it."

Elmer and Luis looked defiantly at their mother then sat down and resumed eating. Veva started to cry. Alicia and Felipe, sitting to one side, were also crying, hugging each other tightly. The noise of the rain became thunderous in the awkward silence, and the wind tugged at the guano palms in the roof.

Veva reached for Nelo. "Is he going to be my only support?" she challenged her older sons. "A thirteen-year-old boy doing a man's job?" Nelo squirmed at the sudden attention.

"I didn't say I wouldn't help at all," Elmer said, "but I can't right now."

Diego left the table, and he and Margarita got in their hammock. Andy and I went outside and splashed over to our hut. The rainwater filled the hollows and covered the floor. We were careful not to let our blankets fall from our hammocks when we got in.

The next morning I offered Veva the money that Cornelio needed for his medical treatment. She refused it but soon afterward asked if I could speak with him. Everyone else in the hut got busy elsewhere or left when I walked up to his hammock. Cornelio smiled and tried to rise but fell back. He reached out his good hand and took mine.

"It is a sad day when a son—two sons refuse to help their father," he said. "And yet you offer to help me."

"It . . ."

"Don't." He squeezed my hand. He looked at Veva, who had joined us. "I will accept your offer only if you realize that this is to be a loan and not a gift. And one other thing. My house in Chichimilá is always yours too. Please, don Macduff, never hesitate to stay there."

We put Cornelio on the next bus that passed our camp. After eight days it stopped raining.

Each morning I went out with Diego, Luis, and Nelo as they looked for chicozapotes to bleed. Most of the trees bore old scars from previous seasons. Their work was hard, time-consuming, and repetitive. Diego began by clearing away vines

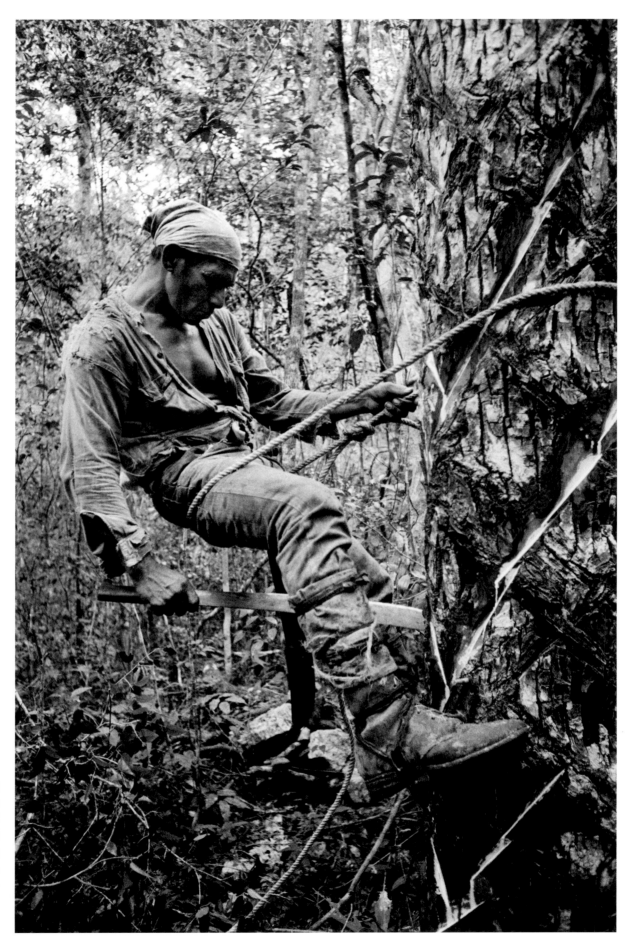

Diego cleaning out a channel that he's cut in chicozapote to collect the resin (chicle) used as the base for chewing gum. South of Tulum, Quintana Roo, 1971.

and low saplings from the base of a tree. Starting at shoulder height, he worked down, slashing V-shaped right angle gashes in the bark. Immediately the milky-white resin oozed thickly from between the bark and hardwood. At the base of the tree he hung his collecting bag by a peg, slipping the lip of the bag under a cut in the bark appropriately called a tongue.

Diego then strapped on his spikes over his shoes and wrapped an end of rope around the tree.[6] Tying himself inside the loop with a bowline, he cut and climbed as high as he could, telling me he felt a responsibility to realize the tree's full potential. Diego averaged eight trees a day. He never knew beforehand how much sap each might give. A thin one could yield a kilo, while a much larger chicozapote might give less. He collected his bags each afternoon unless a tree was particularly good; in that case he might leave the bag all night.

Diego wished for rain each night, followed by a cool, cloudy day. Rain during the day not only made the trunk slippery and dangerous to climb but would wash away the chicle. Too much sun or wind dried the resin on the tree.

Each day we went farther from the camp to find trees. Archaeologists owe the discovery of many Maya ruins to chicleros who found them while working deep in the Maya Forest. The stands of chicozapotes growing at ruin sites attest to the importance of the chicozapote to the Maya.[7] They used it for door lintels and in the construction of their temples. The wood is so hard that carved lintels more than a thousand years old survive. Chicozapote also produces a delicious fruit. Today the Maya plant chicozapotes in their home gardens, and most farmers keep them when they clear their fields.

The Maya Forest smelled of fecund growth and rotting decay. It was an enveloping mosaic with myriad shades of green that changed with the light, from the shadows to brilliant spots of sunlight filtering through the canopy. It was unlike, say, the green of Ireland, where you can be intensely aware of the color but also see a horizon and a sky. Here I was inside a constricted green world with no horizon. Tree trunks and snaking vines made it hard to see more than twenty or thirty feet, while overhead I could only glimpse patches of sky—everything growing sought the sun before branching out to form the canopy.

I've spent a lot of time living outdoors. I've worked as a muleskinner and packer and whitewater river guide. My favorite places are in the high country above timberline where the land is wild and the horizon appears infinite. I found the jungle claustrophobic. I had a hard time getting my bearings, especially when it was cloudy or raining. Since I never carried a compass I couldn't completely overcome my disorientation, but the Maya took such pleasure in being in the forest that they showed me how to relax by example.

As we walked through the forest, Diego and Luis told me the names of each tree and whether it gave fruit, if bees liked its blossoms, if the wood was good for building, what animals the tree attracted, if any part was good for medicine.

Slowly I started to feel more comfortable. As soon as we give something a name or a face, we know it; it's the unknown that is scary. I stopped calling it a jungle and started calling it a forest.[8]

We knew a storm was building when the sky overhead turned Payne's grey, then black.[9] The light dropped four f-stops in two minutes. The raucous jungle noises ceased; an ominous quiet settled in its place. Cold gusts of wind started rustling leaves as the treetops shivered. Then we heard the rain coming as it struck the leaves of the canopy. At first it was a muffled noise, as if thousands of people were running in heavy boots toward us. As it got louder we felt the raindrops—first a splatter, then a deluge. An inch of water quickly collected on the ground.

Whenever rain caught us away from camp we quickly cut guano leaves to use as an umbrella. We squatted and tried to stay dry, each of us balancing a leaf over his head. We would crowd in—Diego, Luis, Nelo, Andy, and I—taking pleasure that we shared this predicament together, even as a humid chill settled under our skin and into our bones until we felt we would never dry out.

One time I asked Diego about the dangers involved in his work. Diego lit a cigarette and blew smoke at a cloud of mosquitoes that had joined him under his fragile umbrella. He told me that he'd fallen twice—once when his machete glanced off the trunk and sliced through the rope holding him, the other time when the tree was wet and slippery and his rope slipped.

"It happened so quickly. Suddenly my feet were over my head, and then I crashed down on my back. I fell twenty-five feet. I hit very hard. I thank the Lord I didn't land on any rocks or stakes! But I felt terrible. My chest and ribs hurt, I thought I was going to vomit blood, but it was only water. If it had been blood . . . well, a person who vomits blood can die."

"Did you go to a doctor?"

"No," he answered incredulously. "No, I was too deep in the forest. I'll tell you what I did." He started to laugh. "I got up, and when I knew I wasn't going to die, I started looking for another chicozapote to climb. I found a good one about eighty meters from where I fell, and then, all of a sudden, I'm up in a tree and I realize, hey, wait a minute, I've just fallen from one." He laughed. "It was a good tree. It gave a lot of resin."

"So you've never been seriously hurt?"

"No, never. God has looked after me."

"Did your father teach you?"

"My father was a hierbatero. He died when I was nine. My mother needed money, so I started gathering chicle when I was twelve. A man from Chichimilá was working in camp. When he was getting ready to sell his chicle to the patron, he told me to add mine to his, and he'd pay me. I agreed because he was from my own village—he'd look after me. He told me at the end of the season that he'd give me my money when we got back to our pueblo. When I went to his home, he said, 'Boy, I haven't been paid yet either. Come back tomorrow.'

"Each time I returned he told me he hadn't been paid yet. Finally, my mother didn't have any money for food. I told him I had to buy some corn. That's when he told me not to bother him anymore, he wasn't going to give me anything.

"'Lord help me,' I told him, 'when I'm grown and no longer a boy, I am going to return and pay you back for cheating me.'

"But when I grew up, my compassion also grew. I came back, and this man seemed so old, I forgave him. I couldn't hit him. I didn't do anything." Diego laughed deep in his throat then shrugged. "Those things happen."

The forest is home to jaguars, ocelots, deer, peccaries, tapirs, monkeys, armadillos, agoutis, coatis, opossums, wild turkeys, partridges, quails, curassows, doves, parrots, toucans, hawks, eagles, vultures, and many smaller animals. Most abundant of all is the insect life—mosquitoes, ants, termites, gnats, bloodsuckers, fleas, flies of different sizes and appetites, hornets, ticks, chiggers and other pests, butterflies, wasps, Yucatecan stingless bees, and fireflies that sparkle at night. And there are reptiles, including a lot of snakes.

When I first accompanied Diego and Luis, I didn't know what I feared most—getting lost or venomous snakes. The first time I ran into a *cuatro narices* (literally "four noses"; terciopelo, *Bothrops asper*), it had just swallowed an animal and was sluggish and lumpy. Even though it is the largest, most dangerous snake on the Yucatán Peninsula, I didn't bother it and it didn't bother me. Víctor Rejón Cohuo, Diego's brother-in-law, spent six months confined to his hammock after being bitten by one. It happened when he was alone and deep in the jungle, so he ate the root of a plant that he knew as a snakebite remedy. Víctor believed that chewing the root saved his life. The venom of most snakes is injected into the flesh or muscle and absorbed into the bloodstream through the tissues. If the snake had injected directly into a large vein, Víctor would have died.

Víctor had a friend who was also bitten in the leg by a pit viper. The friend pulled out his machete and hacked away the entire area of flesh—bite, meat, and calf—thus eliminating the venom in a few quick strokes. His friend considered it the only sure way of keeping himself from dying from the bite. I was surprised that he didn't bleed to death.

Hilario noticed that many Maya, even chicleros, were ignorant about serpents. "Being forest people," Hilario said, "the Maya are very sensitive to things in nature—what animals eat, where they sleep, when they breed, what their nests look like. But they have a problem with snakes. They're superstitious about them. They have no positive identification for snakes, unless you agree that their saying all snakes are venomous is positive identification.[10] The Maya used to venerate the snake, although that too may have been out of fear as much as respect. Just look at the ornamentation on their buildings. There are the entwined serpents on the West Building of the Nunnery at Uxmal, and at Chichén Itzá there are the feathered serpent columns, as well as the pyramid of K'uk'ulkan, named for the Maya feathered serpent god and constructed so that at the equinox a rattlesnake appears to be descending the stairway—a body of light and shadow that ends in a carved stone serpent's head at the base of the pyramid.

"Once I caught a boa constrictor, and my companions thought it was a snake that could sting you with its tail. The Maya tell stories of snakes that have retractable legs to chase you and others that grab their tails and roll after you like hoops. Maybe the reason they have this trouble is that in the Bible snakes are portrayed as evil.

"But you know me. Snakes stimulate me. If I see one, I like to catch it or at least look at it. Just the other day I was on a trail and caught another boa. A milpero came by and asked me why I didn't kill it. I told him, 'You know, boa constrictors are worth a lot more alive than dead. You can keep them where you store your corn and they'll eat the rodents. The circuses will buy them, the tourist hotels will buy them, even tourists might buy them.' But I was talking to the wrong man. About three days before, he had been out measuring his milpa when his son was bitten by a pit viper and died. So this fellow had no sympathy for my story," Hilario said. "He thought the only good snake was a dead one, and you might say that's a common Maya belief."

Pablo Canche told me that snakes don't like tobacco. He'd smoke a cigarette and throw the butt in front of him. Then he'd smoke another and throw the butt to his right. Smoke another, throw it to his left. And finally he'd smoke a fourth and throw it behind him: the four cardinal points. He believed that he could then spend the whole night safe.

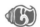

"Bandits!" Veva and Margarita shouted as we came back to camp for lunch. They ran out to meet us, followed by Alicia, Felipe, and María who joined in the alarm. "They waited until you left, then came and stole the roof of the hut!" they said excitedly, pointing to the building that Diego and Cornelio had built for curing the resin. "The lazy cowards," Margarita added contemptuously, "stealing from women and children rather than going out and cutting the guanos themselves."

"They've left?" Diego looked around the clearing.

"Hours ago. They weren't going to wait for you!" Margarita said.

"They just took the guanos?" he asked.

When Margarita answered yes, Diego seemed to relax. He told me that he didn't think the bandits would return. After lunch, we left to cut new guanos. We returned to a spot in the jungle where Diego had discovered a grove. The wide guano palm leaves are perfect for thatching roofs and grow on long, thin stems extending from a narrow trunk. The palm is so important to the Maya that they leave at least one or two leaves on each plant even when cutting deep in the jungle so that it will regrow.

When we had enough, we bundled them and carried the

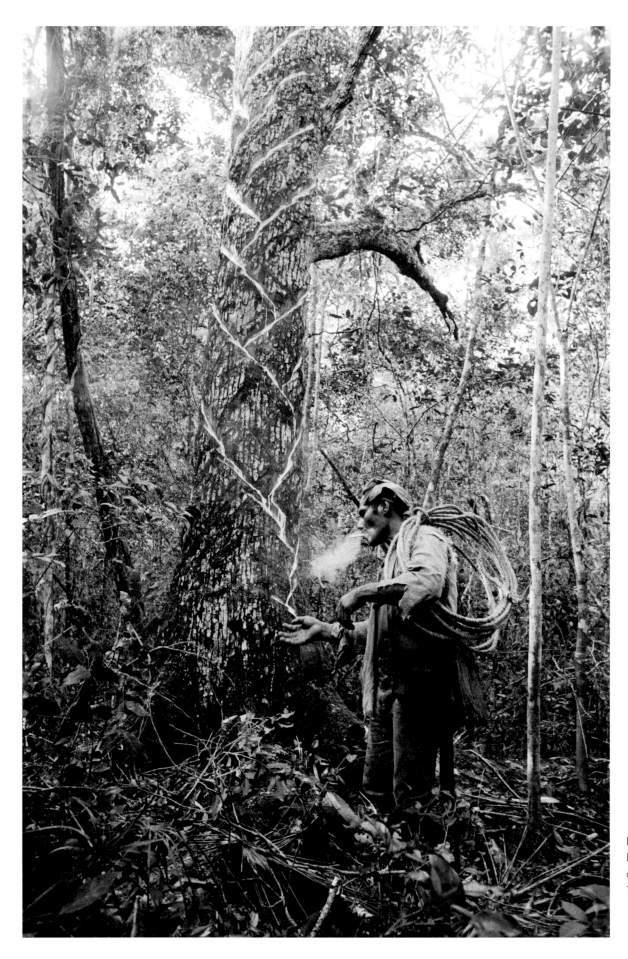

Diego taking a cigarette
break after bleeding a
chicozapote tree. South of
Tulum, Quintana Roo, 1971.

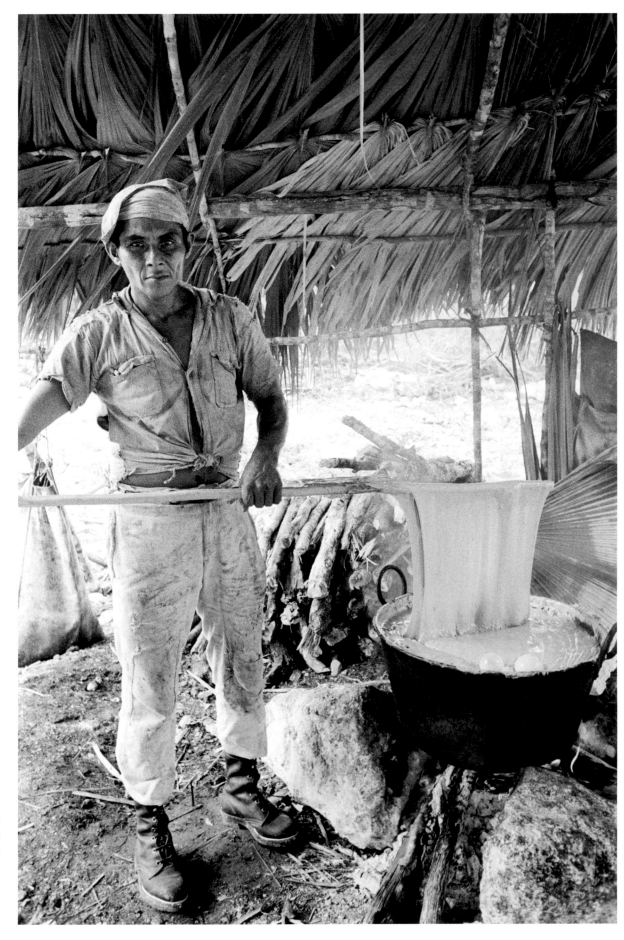

Diego stirring a cauldron of boiling chicle. Campamento Manuel Antonio Ay, Quintana Roo, 1971.

weight of the leaves on our backs. They were cumbersome and spread wide behind us. Luis led the way back to camp. With our bodies bowed forward from the weight, we tripped over vines and rocks. When trees blocked our way, we rushed the gap, hoping that our momentum and weight would carry us through, but not so quickly that we would fall on our faces. As we stumbled and tripped, we started laughing at each other, which eased the tension that had hung over us since we'd heard the word "bandits." I called Luis a *tortuga*—he looked like a turtle because only his head stuck out of the shell of leaves covering him. He laughed and called Andy a blond-haired turtle. We were laughing and joking so loudly that they heard us in camp before we got there. Veva came running out to meet us.

"My old man is back!" she shouted happily, laughing and clapping her hands together. She came up and grabbed my hand. "Cornelio has returned!"

We all dropped our loads and hurried into the hut. Cornelio was in his hammock. He raised his hand with a little twist of greeting. We all talked at once, welcoming him back. He looked twenty years older, but we told him that he looked a lot better. He laughed, calling us liars, then wanted to know how the chicle was running, how many kilos everyone had collected so far. He wanted to know everything about the season.

As he listened, he kept turning to watch Veva patting out tortillas for dinner. Whenever she looked up, they smiled at each other, and Cornelio would turn and smile at us. "I'm a little tired right now," he said, "but I'll be up soon."

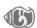

A week later Diego had collected enough chicle to boil it. This step was needed to reduce the sap from a liquid to a solid, which made it much easier to transport. Elmer borrowed a *paila* (large cauldron) from a camp of chicleros at Chunyaxché. A chewing gum manufacturer from the United States had supplied the cauldron many years before. Many chicleros' knowledge of English consists of the words "Wrigley's" and "Chicago."

The morning was warm and bright, so nice that the men decided to work a half-day before cooking. Andy and I stayed in camp to cut and stack firewood. We were using an axe and machete on deadfall when Luis came back. He held up his left hand, which was dripping blood and wrapped in a bandana, and asked if I would help him clean it up.

"What happened?"

"I was up in a tree," Luis explained nonchalantly, "clearing a channel when I slipped and cut myself with my machete."

I looked. He had laid open his thumb down to the bone.

"You're going to need stitches."

"No," he objected. "Just clean it. I can't waste the time. I have too much work to do."

Veva was surprised to see Luis and ran over when she saw the blood. She immediately told him he had to see a doctor.

"Wrap it up for me, please, don Macduff."

"You need to see a doctor," Veva insisted.

Luis shook his head and laughed.

"You crazy fool!" Veva said. "Soon you'll be as sick as your father. The nerve of you to make fun of *his* stubbornness. What are all my men doing?"

"Okay," Luis agreed, "if it gets worse, I'll go see a doctor in Carrillo Puerto. I'll lose days of work and lots of money, but for you, Mama, I'll go see a doctor."

"Get out of here!" Veva demanded. "You're making fun of me, and you're nothing but a fool!" She whirled and strode back to her cooking fire.

I told Luis it would be hard to stop the bleeding without stitches. Luis asked Andy to bring him some chicle and for me to crush a cigarette then mix them together. We applied the mixture to the cut.

"This will work," he assured us.

When I finished wrapping his thumb, Luis laughed and left the hut. Veva got up from her fire to watch him walk across the clearing, the anger draining from her face. She started to smile then turned and put her arm on my shoulder.

"They may be fools," she said, shaking her head. "The good Lord knows that. But at least they are my fools."

We had a fire going when Diego and Nelo returned. We helped Diego put the paila on it. As the cauldron warmed up Diego scoured the inside with a small cooking of chicle. He scrubbed the resin against the sides and around the bottom until he was satisfied that it was clean. Then he half-filled the paila with chicle. It needed to be stirred continuously so it wouldn't stick. Veva and Margarita took their turns. Even Cornelio joined in to prove he was getting stronger, ignoring everyone's protests. Diego had let others know that he would be cooking, so a number of chicleros from other camps dropped by to socialize and share in the stirring. We hung hammocks in the cooking shack and talked as hundreds of bright yellow butterflies circled around us, attracted by the sweet, yeasty aroma of the boiling chicle.

Soon the conversation got around to how difficult it was to work as a chiclero.

"Things are getting harder each year," Diego said. "We get paid the same, year after year, but what we buy costs more—our machetes, our food, our equipment."

"Huhhh," the chicleros said, nodding in agreement.

"And each year," Elmer added, "we have to go deeper into the jungle, only to find someone has already worked the best trees."

"I don't think I will *chiclear* much longer," Diego finally said. "It's hard to tell, but I'm thinking of working a milpa next year."

"In Chichimilá?" I asked.

"No, I don't think so. Maybe up around the town of Tizimín. I've heard of friends who moved there who have wonderful harvests."

Everyone agreed. One chiclero passed out cigarettes, and we contemplated the problem as we smoked. Each chiclero added his opinion. Some thought they should join a chicle

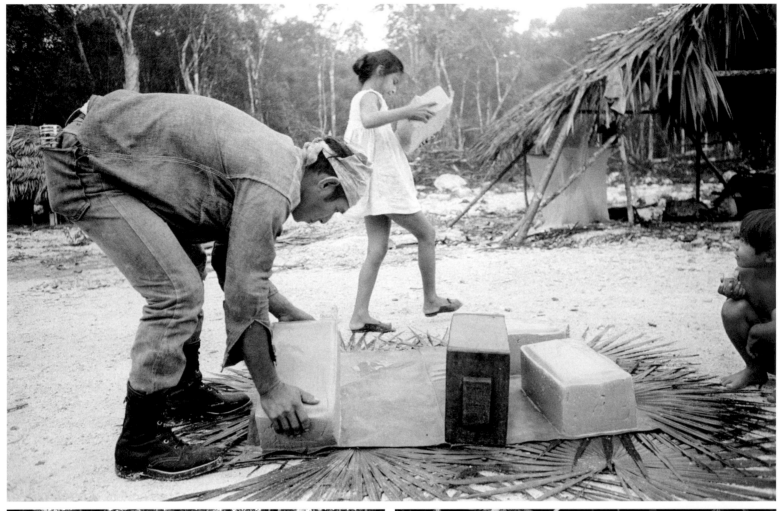

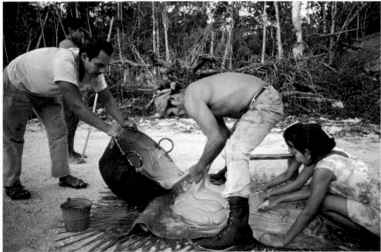

TOP: Diego and María with blocks of chicle, Campamento Manuel Antonio Ay, Quintana Roo, 1971. LEFT: Casimiro, Cornelio Jr., Diego, Alicia, and María emptying boiled chicle from cauldron to mold into blocks, Campamento Manuel Antonio Ay, Quintana Roo, 1971. RIGHT: Martín Canche, Pablo's brother and Diego's patrón, in his store with Diego's blocks of chicle, Tulum, Quintana Roo, 1971.

cooperative to guarantee better prices. Others thought that going back to farming might be best.

As the afternoon wore on, the visiting chicleros headed back to their camps. We cooked for six hours, until the chicle didn't give off a trace of milky film when little bits were dropped into water. Running a stout pole through the handles so that we could lift the heavy cauldron from the fire, we carried it outside. We had to continue stirring it even off the fire so that it would cool, lifting the chicle high into the air with the stirring stick. Gusts of wind caught the stretched chicle and formed big bubbles. They'd pop loudly and splatter over the sides of the cauldron, to the joy and delight of all.

Diego pulled off a handful of chicle and gave me a piece.

"This can last you a lifetime," he said. "It's pure and doesn't fall apart like the Chiclets you buy. You can chew it and hand it down to your kids." He laughed. "Or even your grandchildren!"

The chicle took another hour to cool. We spread a large piece of canvas on the ground and soaped it until it was wet and sudsy so that the chicle wouldn't stick. On it we poured the chicle and worked it into a wooden mold, forming twelve-kilo *marquetas* (blocks) that we could easily transport once they were cooled and solid.

All the children tried to help and were excitedly waiting to find the cans of sweetened condensed milk that Diego had dropped into the cauldron. As soon as the blocks were formed and the area was cleaned up, we opened the cans. The milk had caramelized and tasted like candy—*dulce de leche*. We ate it, dipping with our fingers. The butterflies still flew around us, their yellow wings golden in the late afternoon sunlight.

Elmer decided to cook his chicle the next night over at Pablo's camp—the trees were flowing so well that he didn't want to lose any time cooking during the day. He invited me to help. I walked over at 2 A.M. My flashlight didn't work, so I used a Maya jungle trick of making a torch from a hardwood stick to find my way. With my machete I made numerous cuts at one end, about an inch or two deep, until the ends splayed. When I stuck it in the fire it lit quickly. It glowed dimly like a burning cigar as I walked the two kilometers. But if I waved it back and forth it burst into bright flames, lighting up the trail.

I found Elmer already cooking when I arrived. We took turns stirring and talked constantly to stay awake. At one point while I was stirring, Elmer stopped chopping wood for the fire and began to laugh and then dance.

"I feel great!" he shouted, throwing his head back and giving several sharp, piercing yells. "You think this is hard work, climbing trees and collecting chicle? It's only play." He grinned and waved his machete. "It's a game for me. I love being out here! Because here I'm free. You know how important that is for me?"

He didn't wait for an answer. "Here my patron isn't looking over my shoulder saying, 'Elmer, do this for me, Elmer, do that!' Here I am only responsible to myself! But not in town! In town, if everything goes well, the boss congratulates himself. In town, if things go wrong, the boss blames you." Elmer snorted in derision. "That's why I like it here. Even though I know my patron is screwing me, I don't have to see and listen to him." He laughed again then brought his machete down swiftly, cutting a piece of firewood with one stroke.

"It is hard to get a good job," he said seriously. "My father complains that I should have gone to school more. But listen to me, Macduff. Since we were very small and first entered school, my father always pulled us out of class each season to accompany him to the chiclero camps.

"It's not the place of a son to talk back to his father, but how is it my fault that I didn't go to school when my own father took me out? How is it my fault that I now return to the jungle to work? It is the only thing I was taught."

Elmer took a deep breath then let out a low whistle. "Listen to me," he said softly. "I don't wish to speak against my father because I know he couldn't afford to support us unless we came with him. But I resent being told I am lazy, especially in front of company. Now he's going to try to provide an education for my sister Alicia because she's smart. She'll get to venture into areas where I never had a chance to go." Elmer looked at me intently and broke into a grin.

"I start by telling you how happy I am here, but I end up complaining." He laughed and shook his head.

Since the night Veva asked him for money for a doctor, Elmer had been helpful and solicitous to his parents and his younger siblings. While his father had been away seeing the doctor, Elmer made sure there was food in camp, hunting every night.

Pablo joined us at dawn. As soon as Elmer emptied the paila to form his marquetas, Pablo started cooking his chicle. When it began raining he wrapped a sheet of plastic over himself and kept stirring. Elmer climbed into his hammock to rest, waiting for the rain to stop before going out to find more chicozapotes to bleed.

Pablo liked his camp. In fact, he liked it so much that it became his rancho, his milpa. He named it and the adjacent cenote "Angelita" and has continued to farm there for forty years now.[11]

Margarita caught a bus into Tulum and delivered the blocks of chicle from the first cooking to the patron. Martín Canche, a storeowner and Pablo's half-brother, weighed it and entered the sum against Diego's debt. Diego's first cooking yielded forty-two kilos, worth $0.96 per kilo. Martín sold the chicle to a gum syndicate, which sold it to chewing gum manufacturers for approximately $5 a kilo. Diego earned $41 for three months of waiting and work. He was still in debt.

Our camp grew as more family members arrived. Diego's

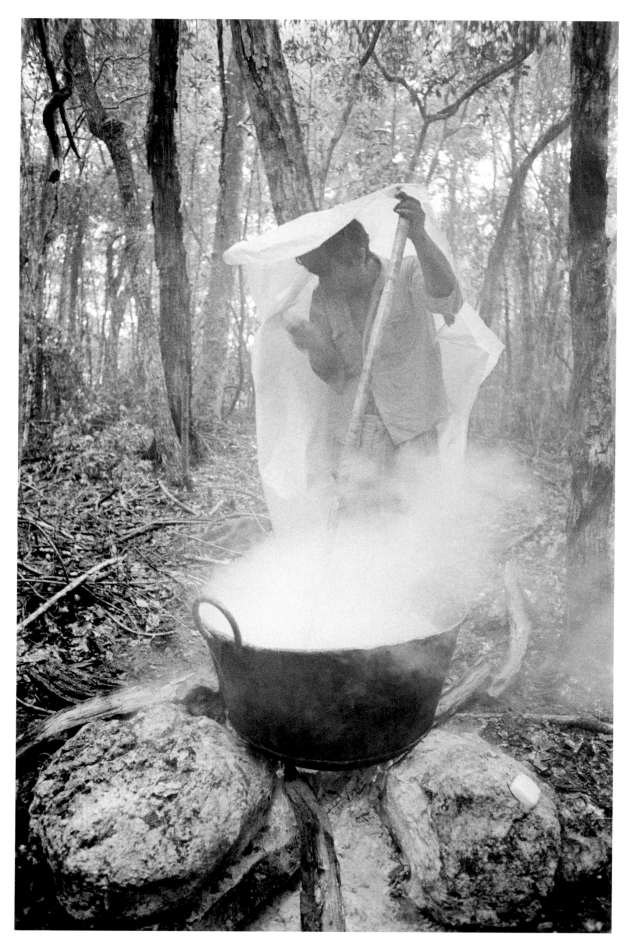

Pablo cooking his
chicle in the rain.
Campamento Angelita,
Quintana Roo, 1971.

brother Casimiro came with his wife, Marcelina Nahuat Puc, and their young daughter Elizabeth and built a hut. Alba, Cornelio and Veva's eldest daughter, arrived with her husband Benito. A friend from the United States visited and brought Bonnie Bishop, a woman I hadn't met before. We got along very well.

The weather in October and November was good for the chicleros. Diego's season improved: by the end of it he had collected and sold over 500 kilos. Diego felt the season was a success, though he still wasn't sure how long he would continue to work as a chiclero. Cornelio's health improved, and soon he was working as hard as everyone else. In December Cornelio and Veva repaid the money they'd borrowed—it was a point of honor for them and a very happy moment, as Cornelio felt good.

Two years later, in 1973, I came down with Andy and Bonnie as well as Andy's older sister Vicky. We spent Christmas Eve in Chichimilá with Veva and Cornelio. He and his sons were now working in a chiclero camp south of Carrillo Puerto near Uhmay. On a whim we decided to spend a few days camping on the beach at Tulum before they had to go back to work. Twelve of us piled into my pickup. We didn't pack much, but Cornelio had the foresight to bring along several liters of local Valladolid rum. Cornelio, Veva, Bonnie, and I rode in front. After passing Carrillo Puerto, where we turned north toward Tulum, Cornelio opened one of the bottles. We drank small toasts at first—to friendship and little remembrances. Then Cornelio started toasting landmarks we remembered. We tried to find the place where our camp had once been. When he started toasting the kilometer road markers, we realized that Cornelio didn't need a pretext for a toast to keep on drinking.

Traffic was light, and we made good time despite having to dodge potholes and ruts in the dirt road. We passed a tall dead tree where scores of buzzards perched like burnt leaves. Three had their wings fully extended, turned toward the hot sun.

"Are they drying their wings?" I asked Cornelio. "Or trying to cool themselves?"

"Who knows, compadre? Let's drink to those who don't know!" he said happily.

"Old man! Stop speaking foolishly," Veva said sharply, then laughed self-consciously. "He's getting crazy from the rum."

"Princess of my dreams . . . ," Cornelio sang, hugging his wife clumsily in the crowded cab.

"*Viejo* [old man], what are you doing?" she said, pushing him away. "Don't be a fool and a drunk in front of our compadres!"

Cornelio laughed and bobbed his head back and forth.

"Queen of my heart," he said, "our compadre is our friend because he accepts the fool and drunk in me. He will let me sing and that, old woman, is what a friend is. We respect each other for what we are and what we might be, but we don't mistake the two!" He kissed his wife on the cheek and passed her the bottle to finish before joyfully singing her a love song.

Cornelio liked to drink and, like most Maya men, placed little importance on maintaining an appearance of sobriety. He wasn't embarrassed to be drunk. In fact, he really seemed to enjoy it. Some men would act completely soused after only one drink. When I discovered that drunkenness provided a legal excuse for ignoring the rules in colonial times, it started to make sense. The Maya could be punished for drunkenness, but Spanish penal law also allowed a defense of diminished responsibility for any act committed while intoxicated. "According to some of the clergy," Farriss writes, "the Maya often used drunkenness as a pretext for insolence and insubordination to both their own leaders and their Spanish masters, and could convincingly feign the symptoms whenever convenient." Drunkenness, actual or feigned, was a state of freedom.[12]

At Tulum we hung our hammocks among the coconut palms along the beach, where the breeze kept most mosquitoes away at night. During the day we fished. Andy and I swam half a mile out to the reef, which teemed with life. It didn't take long before we'd speared enough with Hawaiian slings to feed everyone. Each evening we grilled our catch over the fire.

Near Tancah we discovered a large sheltered cove so shallow that we could walk out hundreds of feet and only be waist deep in the clear turquoise water. It was perfect for Alicia and Veva, who didn't swim. They joined us to splash and play. They sat waist deep in the water as if they were in a bathtub and lathered themselves with bars of soap then washed underneath their huipiles. Soon the two of them were covered in suds. When they dunked themselves their huipiles billowed from their shiny clean bodies and left a ring of soapsuds on the surface that the small waves dispelled. They sat in the water, rubbing all the soap out of their dresses, dunked themselves one last time, and stood on the beach to dry off, giggling.

The chicle industry began to decline in the 1940s and 1950s when petroleum-based synthetics became the main ingredient of chewing gum. By the 1970s the demand for chicle had substantially dropped. Though many chicleros were still working, their meager earnings no longer justified the hardship and long hours. Diego, like many other chicleros, found other work.[13]

When the Mexican government offered good land to settlers in order to open up the forest along the Río Hondo—the deep river forming the border between Mexico and Belize—Diego decided to move there. A year later, in March 1974, Hi-

lario, Bonnie, and I went with Casimiro to visit him. Since there were no roads, the only way for us to get there was on a Mexican naval patrol boat that sailed upriver twice a week from Chetumal at 5 A.M.

I was excited. On a peninsula where most rivers are underground, I'd never traveled by boat. Suddenly I was on a jungle river cruise. It was a treat to move smoothly along the water after years of driving on dusty and potholed roads. The crew was friendly. We glimpsed wild animals along the shore, coming down to drink, and a deer swam across the river in front of our bow.

The settlements were so new that they didn't have either potable water or medical facilities. The navy provided both twice a week.[14] At each stop the crew and colonists shouted greetings as the sailors filled the settlers' jugs, cans, bottles, boxes, and pails with fresh water pumped from the boat's storage tanks. During this commotion, the medical officer (usually using a nearby house as a treatment room) received a steady flow of patients—a mother with a young child with breathing problems, a case of mumps, a farmer with cracked ribs from being thrown by his horse, a pregnant young woman in her eighth month. If patients were too ill or injured for dockside treatment, they'd return on the boat to Chetumal to go to the hospital.

It was 8 P.M. before we arrived in Calderón. We walked up to Diego's house. His daughter María met us, looking very pretty and giggling as she played with a *tigrillo* (margay, the smallest feline in the forest, resembling a small slender ocelot). She told us that Diego had found the cub in the jungle—a hunter had shot its mother. María was helping raise it. But it was hard, she explained, because it was no longer a kitten and kept killing and eating her neighbor's chickens. Although María tried to be serious, she kept laughing as she told us about her cat. She also excitedly told us that her father was teaching her how to swim.

Before supper we took a candle and bathed in a warm creek that gurgled over stones and boulders. I couldn't get over hearing the sound of water and bathing in running water.

Diego had so many things that he wanted to show us. Early the next morning we visited his milpa. He'd had a good harvest, and his field was tall and thick with cornstalks. Diego took us swimming in another creek then in a cenote, where he was teaching María to swim. He took us to a new settlement, a two-hour walk away. Diego explained that most of his neighbors were from northern Mexico and didn't know the way of the forest. Most were homesick and not used to the climate, so they struggled. But, according to Diego, the land was so rich that they rarely left if they could stick out a growing season. Returning to Calderón in the dark, I was happy to be back in the forest with Diego.

The following day Bonnie and I accompanied María and a couple of her girlfriends down to the pier on the Río Hondo to fish for her tigrillo. One of the girls accidentally dropped her line and without thinking jumped in after it, forgetting that she didn't know how to swim. Bonnie saw her sink and dove in and saved her life.

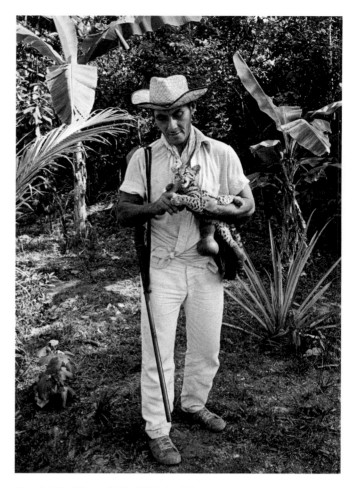

Diego holding his pet tigrillo. Calderón, Quintana Roo, 1974.

Diego, Margarita, and María seemed very happy in Calderón and returned to Chichimilá at least once a year, usually in February for the fiesta. But as the years passed, they stopped coming.

Cornelio and Veva's daughter Alba and her husband Benito asked Bonnie and me if we would be the *madrina* and *padrino* (godparents) at the baptism of their baby daughter Cecilia on February 3, 1974. When we said yes it added another layer of kinship to our relationship.

From colonial times the Maya have embraced godparenthood. You can be a godparent at a baptism, a wedding, a fifteenth birthday (*quinceañera*), or even a pilgrimage—nearly anything both sacred and secular. It is a system to build fictive kinships, which becomes understandable when you consider how many people died from disease and famine, particularly in times past. Having additional kinships was very important for survival and rebuilding networks. And that has continued to this day: a godparent is often chosen with the thought of creating a social link to provide direct help.[15]

The next year (1975) I spent Christmas Eve with my compadres. The weather was so cold that we could see our breath. When I arrived early in the morning, Luis asked me to come across the street with him. He told me that his neighbor, an old woman, had died at 4 A.M. Her family was now asking if I would photograph her as she was lying in wake.

A group of neighbors standing at the doorway of her house made room for us to pass and I saw Leona Tuz May lying on a table. Her family had bathed her in a *batea*, wrapped her in a mantle of new cotton cloth, and laid her on her back, with her arms across her chest.[16] Four tall candlesticks framed the table. The candles sputtered as they burned in the cold air. Her casket rested on stands in front of her.

"She will lie in state for twenty-four hours," Hilario explained as he told me of Maya death rites. "Relatives and friends and neighbors come by and give their last salutations. After the burial the family offers everyone food and something to drink. They also offer liquor, especially to the men who carry the coffin. For a day or two, those who carry the coffin are not supposed to plant things or touch young children, especially infants, or be around sick people, because they have consorted with the spirit of the dead. So the family plies these men with rum and encourages them to gamble. You don't see a lot of gambling among the Maya, but at wakes it's encouraged. They play card games and other games of chance. There isn't any dancing, but people stay late into the night. The family passes out cigarettes and rum and hot chocolate and *pan dulce* [sweet breads from the bakery] to the women and children, and everyone cries and moans and expresses feelings of sorrow and loss of the loved one."

Hilario continued: "I wasn't able to see either my father or mother after their passing. After my father's death, I was living in his studio in Paris, and I always had this feeling that he'd be coming up the stairs with some new paints in his hands or food after going shopping. So, as for myself, I now recognize that visiting and touching the corpse of a loved one is so important because you truly know that that person has gone and won't be with you again in a physical form. The Maya understand this."[17]

I returned to Chichimilá on February 10 for the annual fiesta. I found Veva and Cornelio's house full of friends and relatives, many with their spouses and their children. Cornelio saw me first and held out a bottle.

"Bring a glass, Veva. We must drink a toast to our compadre who is honoring us with his return for our Fiesta de Chichimilá!" He smiled, waving a bottle, then took a sip.

"Old man, don't drink from the bottle!"

"My mouth is as dry as a day in April," he said, dancing away from her. "But you are right, *mi amor* [my love]." He took the glass she offered him.

"Compadre," Veva said as she came up to me, "make yourself comfortable. You are in your home and . . ."

"Pssst! Compadre!" Cornelio interrupted, waving a full glass.

"Please," continued Veva, "no matter how long you wish to stay . . ."

"My goodness, princess!" Cornelio laughed. "Can't you see that our compadre is dying of thirst? Let us first welcome him with a drink, and then we can welcome him with words." He gave me an ample portion of *aguardiente* (cane alcohol), saying: "Drink up, compadre. Tonight we celebrate that the celebration begins tomorrow! The fiesta gives us a moment or two of diversion and reminds us that another year has passed. It is a time to renew our friendships!" He saluted everyone in the room

That night twenty of us slept in the single room of the house, with hammocks hung from every rafter, pole, and beam. The smaller children slept together, up to four in a hammock, while married couples slept in larger hammocks. It was chilly, so I pulled my blanket tight, tired from the long bus ride from Tulum.

I was no sooner asleep than someone woke me by turning on a transistor radio, tuned to a station that broadcast many loud advertisements and very little music. I was surprised that anyone would be so impolite as to do this with so many of us sleeping in the same room. Then, even with the noise of the radio, I heard a rustling sound. I hoped it meant that someone would turn off the radio or at least change the station.

They did neither. Instead someone turned on a competing radio, tuned to a station broadcast from Honduras. Then someone turned on a third radio. One radio advertised a movie coming to Valladolid, the second played Los Latin Brothers and Los Corraleros de Majahual, two great Colombian cumbia bands, while the third featured Yolanda Del Río singing a very tearful ranchera. I started laughing. I wondered if they were all so drunk that they were oblivious to anyone else in the room—yet how could they be, with all three radios blaring? I tried to look around, but it was pitch black in the closed room. Then someone shook my hammock to get my attention.

"Yes?" I said, not needing to whisper with all the noise. But no one answered. I leaned forward in the dark to feel along my hammock to see who was shaking it. No one was there. But my hammock was still shaking. Then I realized that no one was trying to attract my attention—just the opposite. Couples were making love, with the radios providing what little privacy was possible under such crowded conditions. All the hammock ropes were tied to the posts and beams, so the house proceeded to dance to the tropical rhythms blaring from three radios in the fiesta night.

On a warm August evening in 1976 I was coming in from feeding the horses where I was living in California. A dove came gliding out of the twilight and landed near me. I didn't

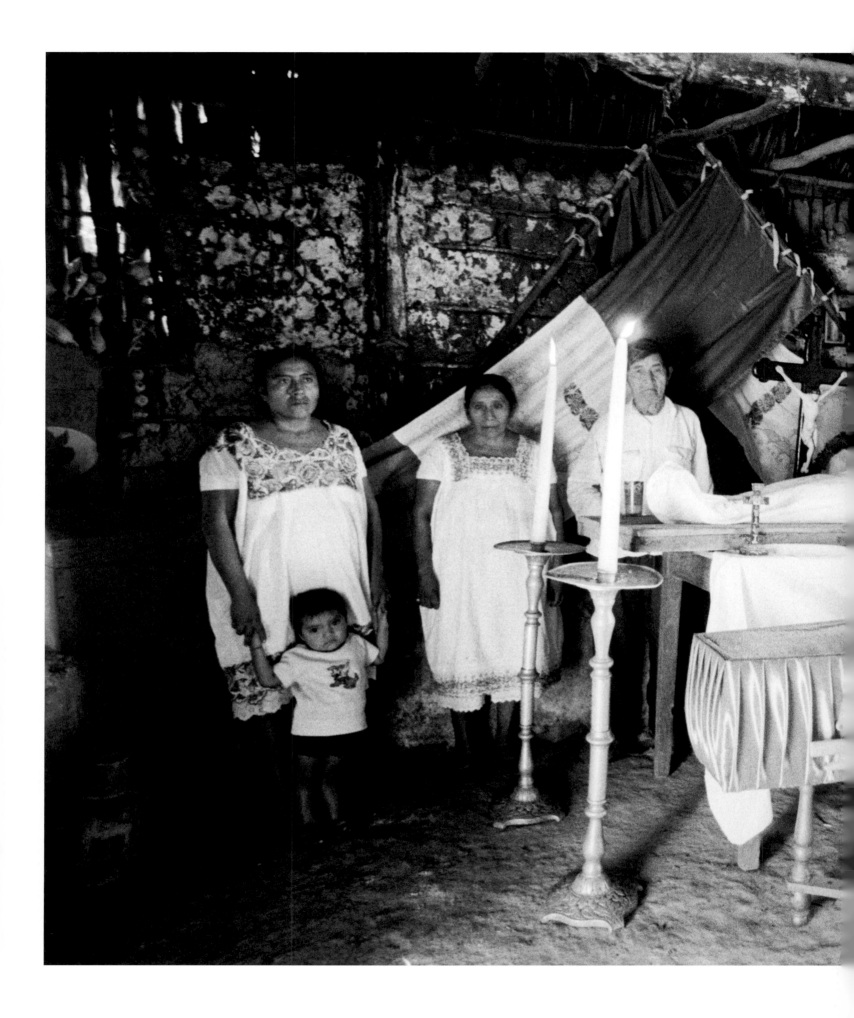

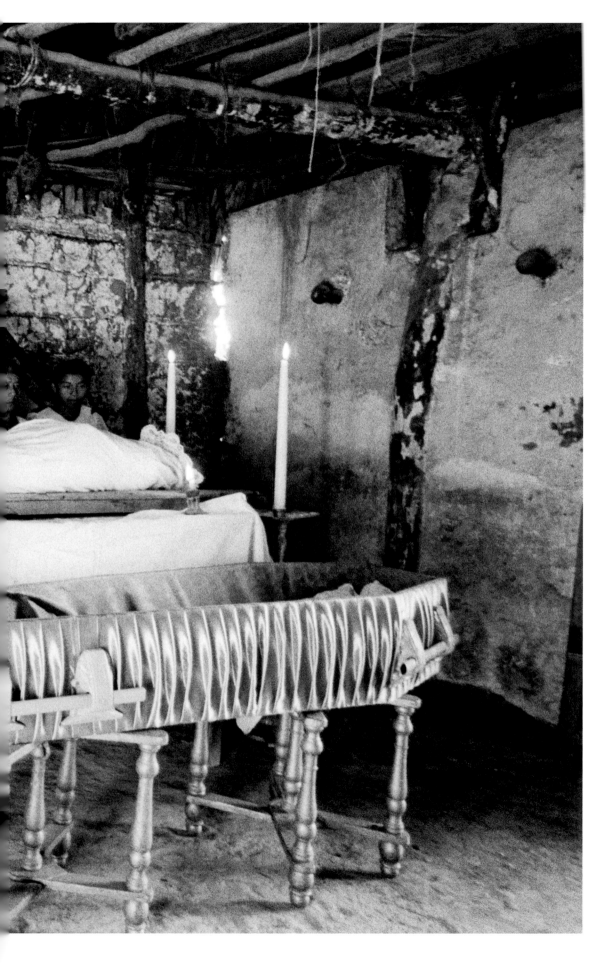

Leona Tuz May lying wrapped in sheets during a death vigil before being placed in her coffin. Chichimilá, Yucatán, 1975.

move at first, thinking that it must be hurt and probably frightened, so it surprised me when it walked toward me. When I knelt down and put out my hand, the dove hopped up on my finger. I carried it to the barn where I was living so that I could look at it in better light. I couldn't see anything wrong with it. Its wings were fine, it had no cuts on its body, and its heartbeat wasn't too fast. It let me rub its head—ruffling its neck feathers high as a parrot does so that you can scratch it more easily, ducking its head because it trusts you. I gave it food and water, but the next morning the dove was dead.

Soon afterward, I received a letter from Hilario. "August 2, 1976. Very sad news. This morning at 6:30 in front of his house your compadre don Cornelio Castro Salazar was hit by a truck and died a few hours later. His sons who are off working have been sent for. I have just returned from paying my respects—Oh! What sorrow. He's now gone as we know him—a great chiclero and man."

I keep thinking that if we were capable of a last gesture, my compadre would have tried to say good-bye. My only regret was putting out water for the dove. I should have found some rum.

In 1980 the United States terminated the importation of chicle from Mexico. That act practically eliminated what was left of the industry. All of Cornelio and Veva's sons had found work around Cancún or on cattle ranches around Tizimín. Pablo collected a little chicle but primarily worked at his milpa at Angelita, his former chiclero camp. Diego continued to farm in Calderón.[18]

Andy Johnson and I visited Diego in August 1988. It had been fifteen years since he'd moved to the Belizean border and fourteen since I'd last visited him there. The new road to Calderón ran through sugar fields then tropical forest and small milpas. Calderón was now a small clearing of houses around a large grassy field. The government had moved the town inland from the river and border.

Everyone we asked knew Diego. As we followed their directions and drove down the final lane, we saw three homes. "I hope it's not that one," I said to Andy, pointing to a cement-block house that looked neglected. Just then Diego came out from behind it. He stopped when he saw us, and recognition flooded his face.

"I haven't been here for over a month!" he said excitedly. "How lucky you came now. I just returned last night." He looked at Andy. "You're not a child anymore. How many years has it been?"

A crowd of neighbors gathered, curious about the arrival of visitors in a car. "What's going on, Diego?" one shouted.

"Nothing," Diego answered. "My brothers have arrived to visit me. We're going to eat lunch." He laughed and hugged us again. He led us to the open shed connected to the back of his house. Lying in a hammock was a man with a black eye and wild hair.

"Nicolás Cauich Hau," he said, introducing himself as he sat up. He pushed back his matted, uncombed long hair and pointed to his eye. "It's an infection," he explained. "I don't know how I got it, but it started bothering me a couple of days ago."

"Don Nicolás has been watching my animals while I was away," Diego explained as he made fat chiclero tortillas to eat with the black beans simmering on a small fire. He told us that he and Margarita had visited their daughter María in Chiquilá, near Holbox on the northern Quintana Roo coast. She'd married a man she'd met as a girl in Calderón, who now worked as a fisherman. To be closer to their daughter and grandchildren, Diego and his wife had invested in a boat and motor with their son-in-law. The fishing and weather had been poor, so Diego had returned with Roque, his eldest grandson, to check on his animals and his milpa before returning to Chiquilá to give fishing another chance.

"I didn't know you were a fisherman," I said.

"I'm not, but I need to find a way to live," Diego replied. He stopped making tortillas to look at me. "I'm going to be fifty-six this coming November 1. I used to be very strong, but now I work only a little and I get tired. When I was a chiclero, I fell from trees several times. Here in Calderón I was clearing my milpa and a tree fell on me. It knocked me down but luckily didn't crush me. Then I was in a bus accident that killed two people. I also got kicked by a cow and flew twenty feet in the air. A horse kicked me too, right in the chest." He laughed. "It's amazing that God has kept me alive, but now I am feeling all the effects. The golpes de la vida have caught up with me."

Diego told me that he missed his friends in Chichimilá and wished his daughter didn't live so far away. A bus trip was expensive. After fifteen years in Calderón he only had an unfinished block house and a tired body to show for his efforts. I sensed the weariness that Diego described. He looked up when he heard a sound from inside his house.

"My grandson must be waking from his siesta," Diego said. "Let me go check." He stopped at the doorway. "You could take our photo," he added, his smile widening. "I love him very much."

I took pictures of Diego with his seven-year-old grandson in front of his large cassette player. In the evening, after his grandson went to bed, Nicolás went off and reappeared with a container of straight alcohol that was probably 180 proof. When we declined to join him, he drank it himself and passed out in a hammock.

"I don't think his black eye is from an infection," Diego said. "He drinks too much. He probably fell down and doesn't remember." He looked at his friend sprawled in his hammock. "He'd never purposely injure my animals, but I'm afraid he might pass out and forget to put the chickens in their coop at night or forget to feed and water my horse. It worries me when I leave. He's not a bad man, but alcohol dominates him."

Around four in the morning, Nicolás woke up and stumbled around. He began muttering and grumbling. Finally he

flung himself across the room, hitting my hammock and proclaiming that he was going to kill Andy and me.

"Nicolás, *una cortesía, por favor*," I interrupted him. "Show some courtesy, please."

"What is it?" he asked.

"Can you continue in the morning? I'm trying to sleep right now."

"Sure," he said, returning to his hammock.

When I told Diego about the incident in the morning, he laughed, but he repeated that he was worried about leaving his animals with Nicolás. He wasn't sure what he'd do when he returned to Chiquilá.

Diego didn't want Andy and me to leave. He saddled his horse and wanted photographs of everyone riding it. Because I brought photographs each trip, my friends sometimes organized photo shoots for pictures they wanted, but this time I knew that Diego was trying to find ways to prolong our stay. He took us out to his milpa and picked fresh corn. When we got back to his house, he ground the corn and made new corn tamales. As we were eating, the wind picked up and the sky turned black. We could hear the approaching rain. It was an unexpectedly fierce tropical storm. We ran inside the house to get out of it and lay in our hammocks waiting for the rain to subside. Diego brightened when he realized the storm might make the road impassable. A butterfly flew through the room.

"Was that a bird?" Diego asked. "I just saw it out of the corner of my eye. Sometime a bird flies through a house, even wild doves. People say that they are the spirits of friends who have died."

Three months later I visited Diego with Charles, Hilario, and Pablo Canche. We wanted to make sure he was alive after Hurricane Gilbert and bring him the photographs of him with his grandson and Andy. Diego and Margarita were not surprised to see us. "We saw a fat little angel," they both said when we pulled up. It was a sign that a friend would come to visit.

Like everyone else on the peninsula after the hurricane, Diego shared his story about the horrible loud noise of the wind and the wild rains. They'd escaped unharmed.

Diego and Pablo, who hadn't seen each other since Tulum, reminisced about the rainy season we'd shared when they were both chicleros. Pablo still worked on and off as a chiclero, but Diego didn't.[19] Diego showed Pablo his milpa, and Pablo was impressed with how rich and bountiful the soil was. On the drive back to Tulum, he remarked that he'd certainly consider moving to Calderón if he lost his land to the government and its tourism schemes. He'd rarely seen soil that was so deep and fertile and yielded such harvests.

Four years later, in 1992, I brought Diego a copy of *The Modern Maya: A Culture in Transition* and introduced my wife Mary and my stepdaughter Sienna. Diego mentioned again that he might be moving to Chiquilá or move back to Chi-

chimilá. But when I was visiting Yucatán with my son Robert nine years later, in November 2001, I found out that Diego was still in Calderón. No one had seen him, but Alicia and Veva told me that his brother Casimiro had moved back to Chichimilá. They told me that he'd had an operation and now walked with a cane, like an old man.

Robert and I went to see Casimiro reluctantly—I remembered him as a person who drank too much and was too friendly when he wanted to ask a favor. But when he came out of his house to meet us at his gate, Casimiro was quieter, more relaxed. He told me he'd stopped drinking. He was now an Evangelical preacher. He'd started a temple in Dzitnup and went there regularly. As we talked, his wife Marcelina came out to greet us and invited us in for lunch.

Casimiro wanted to see his brother too, so he joined us on the drive south, through Tihosuco and Carrillo Puerto to Calderón. I was able to point out to Robert places we'd visited in 1971, as he was keen to recall memories that were still wisps in his mind. Casimiro and I talked. We hadn't seen each other for years, so we had a lot of gaps to fill in. When I'd first met him, he'd traveled everywhere by foot. One time he guided a man from Oklahoma along the Quintana Roo coast from Tulum south to Chetumal. He could trek in the jungle for days or weeks—it didn't matter to him. But he'd developed a problem in his hip; doctors had to replace it. Casimiro wished that he could still go for long walks, but now it was painful even to take a step. He needed a cane to walk.

Near Chetumal we headed west toward Escarcega on the highway that runs across the southern part of the Mexican portion of the Yucatán Peninsula. The road had been widened and improved, with new signs promoting the Maya ruins along the route that includes Kohunlich, Xpujil, Becan, Chicaná, and Calakmul.

The turnoff to Calderón ran southwest. The road passed through rolling hills and fields of sugarcane that extended to the horizon. We paralleled the Río Hondo, so soldiers patrolling the border manned several roadblocks. The road was poorly maintained, full of potholes and with few warnings for the speed bumps. Even signs for the villages had disappeared.

We parked in front of Diego's house, which looked the same as before, and shouted a hello. Margarita came to the door and invited us in. I told her that I brought greetings from her brother Víctor and also from doña Veva and other friends. She asked me how Casimiro was.

"Why don't you ask him yourself?" I replied. "He's standing right next to me." Margarita covered her face in surprise. She hadn't recognized either of us.

"This is the problem when you don't visit your friends and family," Casimiro told her. "There are many of us in Chichimilá who want to see you."

In a few minutes Diego rode up on his bicycle. I passed along greetings from his friends in Chichimilá. ¿*Son viejitos también?* he asked. "Are they old too? Like me?"

It had been more than ten years since Casimiro and Diego

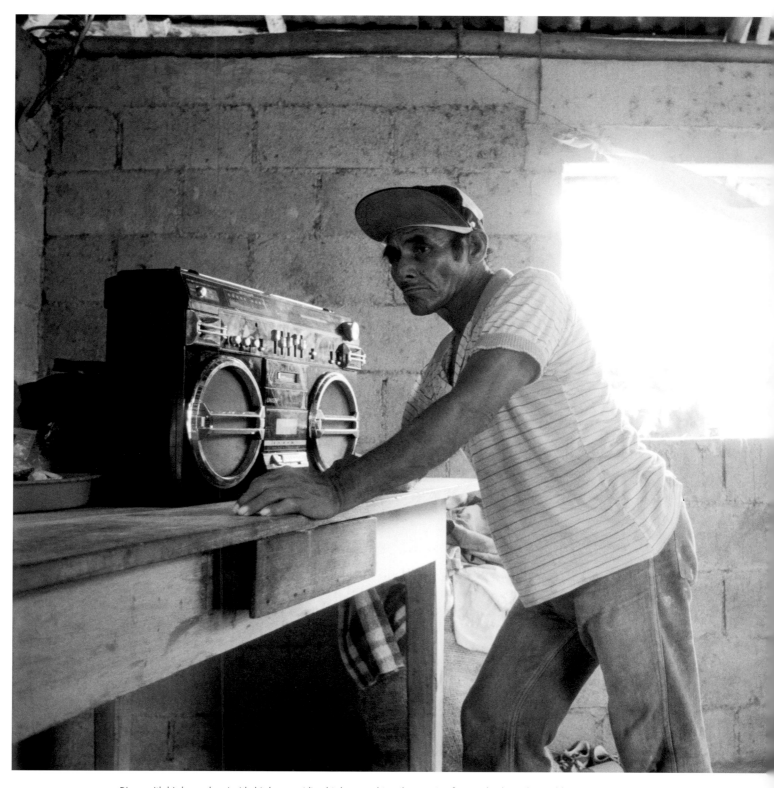

CLOCKWISE FROM LEFT: Diego with his boom box inside his house; riding his horse to his milpa; cutting firewood at his milpa, Calderón, Quintana Roo, 1988; Diego and Margarita in front of their house with María and her children, Calderón, Quintana Roo, 1992.

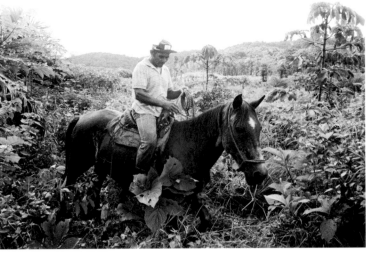

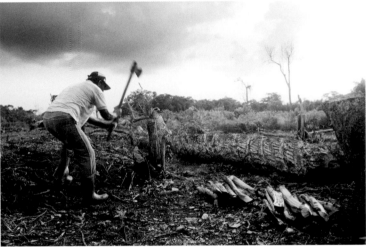

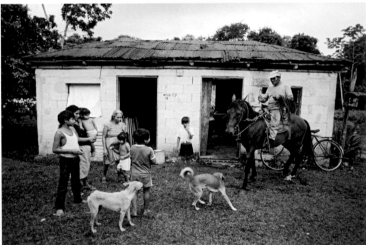

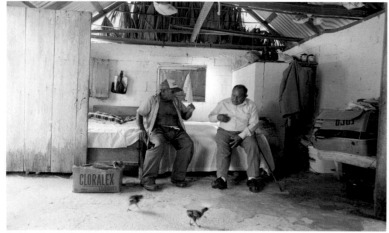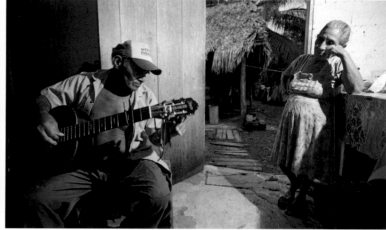

LEFT: Diego and Casimiro. Calderón, Quintana Roo, 2001. RIGHT: Diego and Margarita. Calderón, Quintana Roo, 2001.

had seen each other. The first thing they did was compare their health. They found that they'd both given up smoking and drinking. Casimiro explained to Diego about his hip replacement. Diego told us he had a trussed hernia, which he showed us. He needed to keep it wrapped or it would drop, he said. It limited what he could do. He also had rheumatism or arthritis and a problem with his eyes. His back and legs hurt. It was hard for him to stand after sitting. In fact, he ached all over. But his whole posture changed when he went outside to chop firewood. Watching him work was like seeing a rag doll come alive. He swung his axe in fluid and apparently effortless strokes, and thirty years seemed to fall away. Diego was still strong. He was precise. In minutes he had a neat pile of firewood.

Still, Diego had trouble finding employment. He'd just turned sixty-nine and made $1 a day working for another man in his milpa. Diego complained that it wasn't even enough to buy a couple of soft drinks for his grandchildren.

I asked Diego how his milpa was. He answered that he hadn't planted a milpa in three years—he couldn't make a living from farming because of NAFTA. I was flabbergasted. The whole reason Diego had moved to Calderón was because the land was so rich and bountiful. "If you don't even have your milpa, why are you here?" I asked.

Diego believed that if they tried to sell their house and property, no one would pay what it was worth. In fact, if his neighbors knew he wanted to move, they'd wait to see if he would abandon it. He had no friends here.

Casimiro told Diego that land in Chichimilá was still affordable and property next to his place was for sale. When Diego was noncommittal, Casimiro asked me to say something to his brother.

"Why don't you return?" I suggested. "You act as if you're a slave to your property. You still have a lot of friends in Chichimilá who'd help you build a nice house. It might not be

built of block like this one, but what good is a house if you aren't happy living in it?"

But Diego hesitated. The small, unfinished block house was the only thing he had to show for investing thirty years in Calderón. Among his peers, a block house was a step up from a traditional Maya home. If he moved, he'd lose status.

That evening Diego suggested that I move my car from the street and put it alongside his house. When I asked him if things were safe, he said everything was fine but moving it would be safer. Diego wouldn't say anything more, but I'd read that there were gangs in the area. Youths from Mexico and Central America had migrated with their parents to the United States but ended up along the southern Mexican border after being deported for criminal activities. Many had lived most of their lives in the United States, didn't even speak much Spanish, and had no skills beyond assault and robbery and no home to go to when they were deported.

At dusk Margarita boiled hot water for baths. The bathing area was in the backyard, a two-by-two-meter square with walls of guano palms over a meter high for privacy, a rock to sit on, and a bath mat of poles lying on the ground to stand on. We took turns, and by the time I took my bath it was dark. Light spilled out of the doorway along with the sound of Diego strumming his guitar. The house seemed warm and friendly.

Diego and Casimiro sang duets and some hymns. We found out that Diego had also become an Evangelical preacher. However, neither brother let his faith dominate the conversation; nor did they try to convert me.

Diego told us that he'd bought his guitar to keep himself company. Now that he didn't drink, his former friends had stopped visiting him. Robert and I thought we might understand this when Diego and Margarita went to bed after having hot chocolate and bread. It wasn't even 7 P.M. when Diego turned off the lights.

I visited Casimiro a little over a year later, in February 2003. It was early evening, and his house was dark. When I called out his name, no one answered. His dogs barked fiercely and rushed the gate, baring their teeth. I drove back toward the plaza, but I saw him in my headlights, bicycling toward me, holding his cane in one hand. So I turned around and followed him home.

Casimiro was alone. We sat at his kitchen table. It was quiet, and we spoke softly. His dogs came in and curled up at my feet, waiting for me to pet them. I asked about Diego. Casimiro told me that he hadn't heard anything since we last visited him. I asked how his wife and daughters were, and he told me his news.

His younger daughter Esther had been working in Valladolid at the *maquiladora* until she was laid off because of a downturn in the U.S. economy. Failing to find another job in Valladolid, she found work selling products door to door in Cancún. She seemed happy with the job, Casimiro told me. But the police had just notified him that his daughter had been kidnapped and raped by a *wach* (outsider: a Mexican who wasn't from Yucatán). She'd knocked on the door of the house the man was staying at. Afterward, he'd driven several hours south toward Chetumal, where he dumped her along the highway. Luckily, soldiers stationed in Limones had discovered her still alive. They rushed her to a hospital in Cancún. Casimiro's wife had just left to be with their daughter, and he was following in the morning.

Casimiro told me this in a very matter-of-fact, tired voice. He and I looked at each other, and I told him how sorry I was. He got up and heated water. He served me chamomile tea and himself a cup of coffee. We both wanted to do something but sat there silently, humbled by our inability to do anything more. The soldiers were looking for his daughter's assailant but didn't even know his name.[20]

Mary and I had just missed seeing Diego and Margarita when we visited their daughter in Chiquilá in 2006. María told us that Diego had had an operation for his hernia and spent several months with them while he recuperated. As we talked we were surrounded by kids and grandkids and introduced to sons and daughters-in-law. María and her husband, Pedro Ramírez León, now had nine children and five grandchildren. Pedro told me that they'd lost so many of their memories in Hurricane Wilma—all their photographs and their copy of *The Modern Maya A Culture in Transition*. Though they lived far back from the beach, the storm surge had flooded their house and neighborhood. Even so, their house was bright and full of life, and I commented on it.

Pedro and María exchanged glances. "We want Diego and Margarita to move in with us," Pedro said. "We can look after them."

"I don't understand why my dad doesn't come," María added. "We can take care of them. And here he's with his grandchildren and great-grandchildren. They love him. In Calderón they don't have any friends. But he won't move."

"He likes his block house," I said.

"But a house is empty without friends!" Pedro said.

Pedro's remark reminded me of my last visit to Calderón. The morning we left, as Robert and I took down our hammocks, Casimiro spied a wasp's nest near the top of the roof. He pointed it out to us and explained that it was a bad sign. A wasp's nest meant the house would be abandoned. I told Casimiro that we should take it for a good sign. It might mean that Diego and Margarita would return to their friends and family.

NOTES

1. "Hurakan was the unharnessed forces of nature in creation myths." Bunson and Bunson 1996:91.

"Dictionary compilers favor a Taino (Arawak) origin for the word 'hurricane' (which came into English from Spanish or French) over a Mayan origin, but the Taino word itself would have been borrowed from the Quiché homeland, which was a center of far-reaching maritime trade." Tedlock 1985:343.

Another Mayan word that seems to have entered the English language is "shark," given that they were known as "sea-dogs" until the sixteenth century, when the Mayan word *xok* may have come to denote the fish.

2. Paul Sullivan wrote me that "Harben was consul in Mérida from 1965 to 1969, but the position was just a cover. Harben was a career CIA officer (1955–1975 or later), identified as such in a nifty old East German publication, *Who's Who in the CIA*. Mention of Harben's true identify was also made in a book by once-prominent Mexico City journalist Manuel Buendia, *El CIA en Mexico*. (Buendia was assassinated only a few weeks after publication. Of course, the CIA was suspected. It eventually emerged he'd been assassinated upon orders of the head of Mexico's Federal Security Directorate—an organization disbanded in the 1980s.) One of Harben's reports to CIA central, based upon his conversations with Americans resident in or passing through Yucatan in July 1967, is reproduced on-line—It doesn't mention you. After Mérida, Harben went on to become 'Science Officer' (yeah, right) at the U.S. Embassy in Moscow, and then 'Political Officer' (yeah, right again) at the U.S. Embassy in Phnom Penh during the U.S. bombing and invasion of that country. One finds numerous mentions of Harben by Googling 'Harben, genocide.' (As regards genocide, he was apparently against it and said so in secret cables to superiors, to no great effect, it seems. After that he got stuck sitting in on arms control talks somewhere in Europe.) I recall reading somewhere that in those years Mérida had the second largest CIA station in Mexico and that they were dedicated to monitoring Cuba and Cubans in Mexico."

In 1971 when I was living in Tulum I ran into an American who was working with the Mexican authorities. He would show up patrolling the coastline in his four-wheel-drive vehicle equipped with a powerful searchlight, looking for Cubans.

3. Mathews and Schultz 2009:86.

4. For a lively and interesting account of chewing gum, see ibid.

5. Tozzer 1941:98.

6. Most chicleros used spikes. A village handyman had fabricated Diego's out of rebar and leather. But Luis climbed barefoot (*pata limpia*). After he climbed the first tree he'd built up a layer of chicle on his feet. His father had worked barefoot until recently. It saved on expenses but of course was dangerous—if a machete blow glanced off the tree and hit his foot, he had no protection at all. I brought down a dozen pairs of professional lineman spikes from the United States on my next trip for Diego and Cornelio and his sons, and Andy brought down several pairs of boots.

7. It has been widely assumed that the reason for the concentration of chicozapote at archaeological sites was that the Maya planted them. A new hypothesis suggests that bats, who like to live in old ruins, bring back the fruit of the chicozapote and disperse the seeds freely. Mathews and Schultz 2009:14.

8. However, there are numerous examples of Indians in the Americas who find the jungle or forest to be the repository of danger and the demons that beset any culture. Jonathan Raban writes perceptively in *Passage to Juneau* about the tribes along the coast of British Columbia who lived all their lives along the shore and on the water, rarely venturing into the dark, mysterious, and dangerous forest that blocked out the sky and was the realm of the bear. In the Amazon basin, the forest belongs to the jaguar.

In Yucatán the forest belongs to the Maya. It's their home, where they are the most comfortable. I once asked Dario if he was afraid of the forest. He was confused by the question, so I explained that some anthropologists

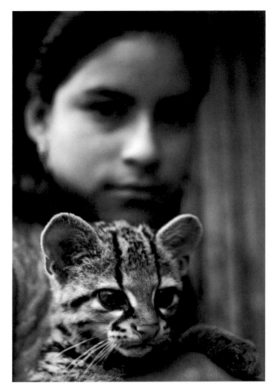

TOP: María with her pet tigrillo. Calderón, Quintana Roo, 1974.
BOTTOM: María and Pedro with their children and grandchildren. Chiquilá, Quintana Roo, 2006.

suggested that the Maya feared the forest. None of my friends had ever mentioned it, so I was surprised to read this and wanted to ask him about it. Dario looked very serious. After a moment, he said, "They say there are people afraid of the forest because of tigers."

"Tigers? There aren't any tigers here," I said.

"No," Dario laughed. "Here we have wild turkeys. They roost at night in the trees, and if you bring a rifle and shoot them you won't be hungry. But sometimes people are afraid of the dark."

"That's true everywhere."

"In that case, why would someone be afraid, then?" Dario asked. He was intrigued by the question and tried to find a reason why someone would say this. Although Dario, Diego, Cornelio, Luis, Elmer, Pablo, and most of the people we worked with were not afraid, many contemporary Maya are afraid not only of animals and snakes but also of getting lost or being caught out in the forest after dark. Not everyone works in the bush and is comfortable in the forest. Stonemasons, carpenters, shopkeepers, and many women wouldn't spend much time in the forest, let alone at night. And Maya folktales are full of the dangers that begin at twilight, including the *Xtabay* (a female demon that lives in the trunk of the ceiba tree and appears at dusk as a beautiful woman to lure men to their death) and *alux'ob* (tiny magical beings that guard field and forest and can be helpful or harmful).

9. A bluish dark gray color named after British watercolorist and art lecturer William Payne (1760–1830). Rather than simply combining black and white, he suggested mixing lake, raw sienna, and indigo. This exquisite color is often seen in gathering clouds before a storm or in a roiled sea.

10. "Although today some rural Maya recognize that certain species are harmless or even beneficial, the prevailing attitude toward snakes is fear, and they are generally killed at every opportunity." Lee 1996:417; also see Burns 1983:244.

11. The cenote was oval, about eighty feet across, and open to the surface. In early morning light the water looked black. Trees grew to its edges. In season, we could swim around and pick guayas off the overhanging branches and enjoy the fruit as we floated on our backs.

In the 1970s Hilario and Charles were the first to dive Angelita. Entering the cenote in scuba gear, they thought that the cenote was only a hundred feet deep, with a silty bottom. But when they reached what they thought was the bottom, they discovered that it was a strange fog that they could sink into. Carefully poking their fins down, they worked their way deeper, expecting to touch bottom. After about ten feet they suddenly broke through into crystal-clear water again. The fog was now above them. They'd smelled a stinky odor in the fog, so they moved back up into it and took their regulators out of their mouths to taste it. Hilario recognized it as hydrogen sulfide (sulfuric acid), not commonly found in cenotes but encountered from time to time. Formed from the decay of organic debris fallen into the water, the acid collects at the interface of salt and fresh water, and in some cenotes it is dense enough to be toxic and corrosive. Exposed skin burns and stings.

Looking down, Hilario and Charles could see that the cenote was at least twice as deep as they'd initially thought. They descended into a massive vein that fed the cenote with no end in sight. Above them, the fog glowed red, with a cosmic swirl where they'd passed through. Since then Angelita has become popular among cave and cenote divers. Pablo earns money by charging a small admission. Dive operators come by his house in Tulum to register guests and pick up the key for the locked gate.

I was surprised to open the *New York Times* on December 29, 2010, and see on the back page of the A section a full-page underwater color photograph of Cenote Angelita, part of the "México the Place You Thought You Knew" campaign by Mexican tourism. Looking at it and knowing that millions of other people were also seeing it, I remembered standing next to Pablo at his chiclero camp in 1971 when I first saw Cenote Angelita. I wondered what Pablo would think if he saw the advertisement. Had anyone

TOP: Naval patrol boat bringing fresh water and a doctor. Calderón, Quintana Roo, 1974.
BOTTOM: Diego bleeding a chicozapote tree. South of Tulum, Quintana Roo, 1971.

asked his permission to run the ad? Would he receive a small increase in revenue from more visitors to his cenote?

12. Farriss 1984:196.

13. Petroleum-based synthetics began replacing chicle resin because of depletion of chicle trees due to overbleeding, shipping, and related problems during World War II, an increase in import and export taxes, and the comparative cost advantage of synthetics. It didn't help that some chicleros adulterated their chicle with resins from other trees as well as stones to increase the volume and weight. Mathews and Schultz 2009:64–65.

14. Almost all settlements in Yucatán were founded around a water source—either found (such as a cenote) or created (such as a well). In this case, it appeared that the government was so keen on establishing settlements that this process was reversed. Most rural communities didn't have medical service, so having a doctor pass through on such a regular basis was quite rare.

15. I observed that pharmacists were often asked to be padrinos—if your child is sick, it's helpful to have a padrino who can dispense medicine.

"Among the Maya, godparents do not seem to have become foster parents to an orphaned godchild. The purpose was to create bonds between the adults to replace or supplement ones that had been or might be severed through sudden death or migration . . . essential for economic and social survival . . . That such a system had to be provided by the Maya themselves is indisputable. They certainly could not count on the Spanish for much help. Neither the state nor the church, through which most public charity was channeled, made any provision for destitute Indians except in the cities, and that was very meager." Farriss 1984:258–260.

16. Hilario was told that the ancient custom included using the bathwater to make an atole or pinole that all the mourners would drink.

17. There was another reason why Leona lay in state for more than twenty-four hours. People are universally afraid of being buried alive. The medical term for this is taphephobia, and it was so rampant in Europe during the eighteenth, nineteenth, and early twentieth centuries that inventors got rich off casket designs that offered means for escape or warning bells and breathing tubes. Some caskets had the bell on top of the casket, to be rung before being interred, while others had strings attached to the hand or foot that would ring aboveground if a person came back to life after being buried.

The phrase "graveyard shift" originated in Victorian times when a person was on duty in a cemetery overnight in case anyone rang for help from the casket. Similarly the term "wake" began as "waking" the dead (having a body present from death to burial in case the person "wakes up"). The basis for this fear was that people occasionally came back to life after being pronounced dead. They actually were only unconscious or comatose or suffered from catalepsy, a trancelike affliction characterized by suspension of sensation, muscular rigidity, and fixity of posture. They looked dead but weren't.

There are numerous historical cases of near-burials and actual burials of people who were not yet dead, and the newspapers loved playing up incidents in which the deceased revived at the funeral service or at the cemetery. Some people left instructions in their wills on how long they were to be left lying before burial. This reached an extreme in 1858, when the Duke of Wellington died and was not buried for two months. They could have named an English blue cheese after him.

18. After the collapse of the chicle industry in 1980, when the United States stopped importing chicle, a revival occurred in the 1990s, driven by a growing appreciation of natural products in Japan and Korea. Chicleros even started a few cooperatives with the hopes of attaining fair wages and reasonable working conditions. Companies such as Glee Gum in Providence, Rhode Island, and JungleGum in Gainesville, Florida, created a boutique industry of natural chicle chewing gum available on the Internet and through specialty retail grocery stores. These companies targeted consumers seeking natural products, who were willing to pay extra for organic,

TOP: Chiclero bathing. Campamento Angelita, Quintana Roo, 1971.
BOTTOM: Margarita, María, Felipe, Veva (holding Beatriz), and Alicia, with blocks of chicle to take to the patrón. Near Campamento Manuel Antonio Ay, Quintana Roo, 1971.

sustainable, Fair Trade (ensuring that the workers are paid a fair living wage), and high-quality foods.

A recent development is tourist interest in the history of the chicle industry. For example, locals created a full-scale model of a chicle camp in Central Vallarta (inland from Puerto Morelos along the line of the former chicle narrow-gauge railroad), and another was built at the Dr. Alfredo Barrera Marín Botanical Garden in Puerto Morelos.

The Quintana Roo state government announced plans to finance a replica chicle camp near Chacchoben after it became the third-most-visited archaeological site on the peninsula (after Tulum and Chichén Itzá) when cruise ships started landing nearby at Majahual. To date, it has not been developed. Mathews and Schultz 2009.

19. Pablo continued to work on and off as a chiclero until 1998, when he and the other chicleros weren't paid for their gum. The syndicate of chicleros called for a strike until they were paid. "They never paid us," Pablo said, "so we haven't collected chicle since. It's just as well. It's hard and dangerous work. I'd rather be at Angelita, my milpa."

20. Casimiro thinks that counseling has helped Esther recuperate from her ordeal. She married in September 2008. Esther and her husband work for a hotel near Playa del Carmen. They both commute five hours daily from Chichimilá, where they live with Casimiro and Marcelina.

TOP: Andy and Diego. Cobá, Quintana Roo, 1971.
BOTTOM: Andy and Diego. Calderon, Quintana Roo, 1988.

FROM LEFT TO RIGHT: Veva, Alicia, Benito Uc holding Beatriz, Cornelio, Alba holding Cecilia, Cornelio Jr., Felipe, and Willie (Benito and Alba's oldest son). Chichimilá, Yucatán, 1974.

It would even seem that the Spaniards brought Christ to America in order to crucify the Indian.
MANUEL ABAD Y QUEIPO, bishop of Michoacán

IV Doña Veva and Alicia: Two Generations of Women

An account of Genoveva Martín Kumul and her daughter Alicia and how Alicia grew from a girl in a jungle chiclero camp to becoming a bilingual teacher, as well as her marriage and children, and the effects of the Evangelical movement in Maya towns

My comadre Genoveva Martín Kumul married my compadre Cornelio Castro when she was nineteen. Veva spent her early married life following her husband every rainy season from one chiclero camp to another. Their eldest sons, Luis, Elmer, and Cornelio Jr., became chicleros; and Alba, their eldest daughter, married a chiclero when she was thirteen. But Cornelio confided to Veva that he wanted something more for Alicia. His dream was that his youngest daughter would become a schoolteacher.

Thus in 1972, when Cornelio and his older sons went off to work in the jungle, Veva stayed in Chichimilá with Alicia and Felipe so that they could go to school. Veva opened a stand in the plaza to sell *refrescos* (soda pop), *licuados* (fresh fruit drinks), and *granisados* (snow cones). It provided her with an income while her husband was in the jungle.

Veva and Cornelio had two houses of pole walls and guano palm leaf roofs on their quarter-hectare house plot. A drystone wall nearly four feet high marked the perimeter, with an entrance gate in the wall facing the street—two posts with holes that poles could slide into and out of. The yard was earth and stone, packed hard enough around the house that Veva swept it every day. They grew allspice, caimito, guanábana, tamarind, sweet orange and sour orange, plum, and chicozapote trees that offered shade, fruit, and seasoning. Veva grew herbs in elevated *ka'anche'ob*, and Luis had planted a plot of pineapples. Chickens, turkeys, and pigs roamed the yard. At the southern corner of their property, in the front along the road, was the neighborhood well.

In 1976 Alicia's parents gave her a big quinceañera (fifteenth birthday) party. It is a rite of passage in Mexico, when a girl becomes a woman. In order to pay for the party, Veva sold one of her pigs. Like many women in the village, she raised animals and sold her chattel when she needed funds. Cornelio and his sons slaughtered the pig in their front yard then sold the meat to neighbors.

On February 24 Veva and I took an early bus to Valladolid to go shopping for the quinceañera. The morning light was crisp and yellow and the air still cool. By 7 A.M. the market in the center of town was already jammed. Sellers lined the sidewalk and spilled into streets clogged with cars, buses, trucks, and pedestrians. The vendors were Maya from surrounding villages who brought fresh fruits, vegetables, spices, and herbs from their gardens and farms. They displayed their produce on homemade wooden stands or arranged in piles placed on pieces of plastic that they put on the sidewalk or stacked in brightly colored plastic buckets or enameled metal bowls. They cried out offers in Mayan and Spanish while drivers honked and shouted so they could pass.

The main market was an old high-ceilinged building a block from the plaza, saturated with the smells of blood, meat, and produce. You could close your eyes and find your way around the market from the odors. The butchers were in the center. They hung their meat from hooks or laid it out on wide stained and pocked concrete counters. Different butchers offered different meats, primarily beef, pork, or fowl. They sometimes sold smoked wild game—deer, agouti, wild turkey, peccary—the dark meat rich with the smell of a smoking fire. The butchers were busy, their aprons bloody, as they weighed their sales on hanging scales. Between sales they sharpened their knives with whetstones. They made a production of this, and each butcher had his own rhythm. Together they played a morning concerto. Around the meat counters vendors offered fresh eggs, tomatoes, squash, habanero chiles, cilantro, chayas, chayotes, jicamas, onions, potatoes, beans, shucked corn, vanilla, allspice, oranges, tangerines, limes, grapefruits, coconuts, and other seasonal fruits, including pitayas, guanábanas, pineapples, tamarinds, soursops, watermelons, hog plums, mangos, papayas, nances, and zapotes.

Along one wall leather workers sold sandals, belts, machete scabbards, and other goods that reeked of freshly tanned hides and oil. Along another side were booths of ready-to-eat food—*panuchos* (fried tortillas stuffed with mashed black beans, with shredded turkey and lettuce on top), *salbutes* (from a Mayan word meaning "fried mincemeat," served on a fried tortilla), empanadas, *vaporcitos*, *tortas* (sandwiches), tamales, shrimp or octopus or conch *cocteles* (cocktails), tacos, fried eggs, black bean soup, *sopa de lima* (bitter kaffir lime soup), *caldo de pollo* (chicken soup), fried fish, meat, and chicken, and the daily specials. This section smelled of hot grease, fried food, and smoke from the cooking fires and charcoal. Other stands specialized in

smoothies—licuados made from fresh fruits mixed with milk or water, with protein powder, cocoa, and eggs as options. On the corner was the *tortillería*. Hot tortillas came off a conveyor belt amid the noise of the machinery and heat and the smell of roasting masa blasting from the oven. A steady stream of customers came through the doors.

Veva had a list in her head. I followed, carrying her purchases. We walked along and filled our bags with enough to feed forty or fifty guests. When we got home, Alicia greeted us and said that she was heading into Valladolid herself to pick up her gown and to put in song requests for the local radio station. I wished her a happy birthday and then didn't see her for the rest of the day.

Alicia's celebration would begin with an evening communion service at the Roman Catholic church in the town plaza. I bathed, put on my best clothes, and walked to the church. In the center of Chichimilá a ceiba tree marked the location of the cenote around which the ancient town had been founded. Its high, spreading branches provided shade in the large and irregular plaza, around which stood the grade school, several stores, a corn mill, stone houses, a few pole houses with guano roofs, and the seventeenth-century colonial church. The once grand church looked rundown. Weeds and trees grew from the roof. It had once been a large Franciscan mission, complete with cloister, but now the highway ran through the place where the *atrio* (enclosed forecourt of the mission) had stood. Near the church were two wooden refresco stands, one of which belonged to Veva and Cornelio.

Cornelio was already standing in front of the church, looking very proud. He wore freshly ironed pants and a white guayabera shirt. He grabbed my hand and started talking excitedly, telling me that he was so proud of his daughter, so pleased that she was getting an education and was doing well in school. As he talked he also greeted friends arriving for the service. They all were in their finest clothes, scented with bath soaps, talcum powder, and perfume.

Cornelio did not stop talking until he spied his daughter coming toward us a bit unsteadily in her new high heels. Alicia looked dramatically different, and it wasn't just because she was wearing a pink gown and matching gloves and a crown of white lace. Nearly every girl in Chichimilá had long black shiny hair, but we could see that Alicia had just cut hers. It was now in a perm, which radically changed how she looked. We didn't know what to say.

Alicia smiled sweetly, and Cornelio and I felt awkward. We wanted to congratulate her; but she was too dressed up for a hug, and a handshake didn't seem appropriate either. So we both told her she looked lovely. She smiled again and looked anxiously around for her maids of honor.

A quinceañera celebration is very much like a wedding in that the girl wears an elaborate dress and has maids and escorts in place of bridesmaids and groomsmen. Her seven maids arrived in coordinated full-length blue gowns that they'd made themselves. They wore white gloves and lace crowns and were nervous and self-conscious. They broke into giggles whenever they spoke. Alicia's seven male escorts soon arrived, all wearing dark pants and white shirts, trying their hardest to look serious and grown up. They still looked like boys. Several wore the very popular large cowboy belt buckles patterned in fluorescent colors, psychedelic beacons positioned above their groins.

Alicia had chosen her teacher as her padrino and stood with him during the communion service, in front of her family, friends, and neighbors. As the service wore on and the priest continued to speak at great length, the congregation began to fidget and cough. Some men went outside to smoke, but they couldn't escape: loudspeakers mounted on the church exterior allowed the priest's words to reverberate across the plaza.

Finally the service ended. We streamed out and walked home as a noisy, happy group, talking and laughing. All along the road villagers came out to congratulate Alicia. This was before everyone had a television, so a neighborhood birthday procession was a pleasant diversion.

Veva and Cornelio had transformed their house. A single table, covered with a green floral print tablecloth, was in the middle of the room. In the center was a three-tiered cake that Veva had ordered from a bakery in Valladolid. It was smothered in white and pink frosting, rich with swirls, scallops, and curlicues, and crowned with a doll in a billowing white gown. Fifteen candles were waiting to be lit.

People filled the room, standing around or sitting in chairs that Veva had borrowed from neighbors. Everyone was talking about Alicia. Some discussed whether she would be married soon, while others argued her progress in school—she was part of the first generation of village girls who planned to finish high school. But what everyone really wanted to comment on was Alicia's hair. In 1976 it was a very bold step for a village girl to cut her hair. It meant that she wanted to be seen as a city girl (*catrina*) who wore Western clothes rather than a mestiza who wore the traditional huipil. This was confusing, because everyone agreed that Alicia was still a Maya girl. Everyone also agreed that she looked quite different. It wasn't that she'd worn a Western dress—it was already the fashion for village girls celebrating their quinceañera to wear gowns that were styled after wedding gowns—but none of her maids of honor had cut their hair. This was very much Alicia's decision.

While everyone was talking about Alicia, she came up to me and asked me to take some photographs. She asked everyone to move back so that she could pose next to the table and cake, first with her parents and Luis, then with her padrino and madrina, her maids and male escorts, her friends and neighbors, and finally alone with her cake.

Now the party could begin. Cornelio and Luis handed out soft drinks and prepared *jaibolitos* (highballs) of rum and cola for the older guests. Veva served the food that she'd spent all day preparing. Luis hooked up a portable record player, and we moved the table and the birthday cake to one side to make room for dancing. The maids slipped out to

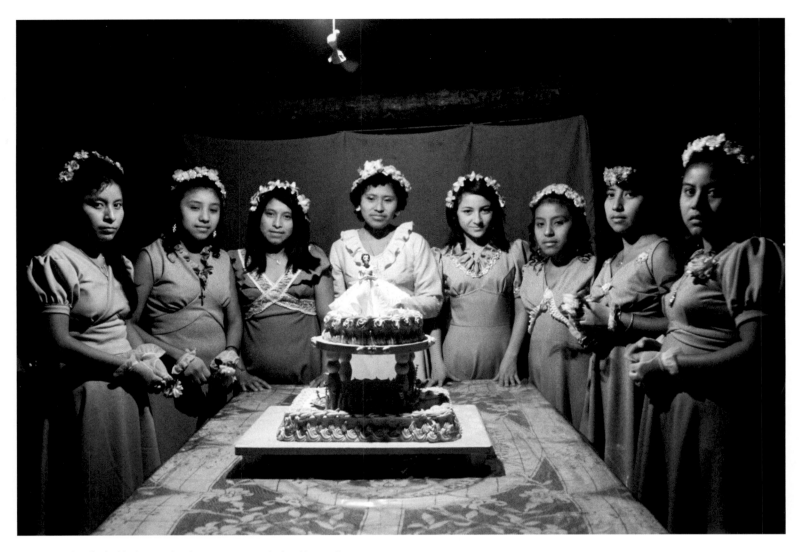

Alicia flanked by her maids at her quinceañera. Chichimilá, Yucatán, 1976.

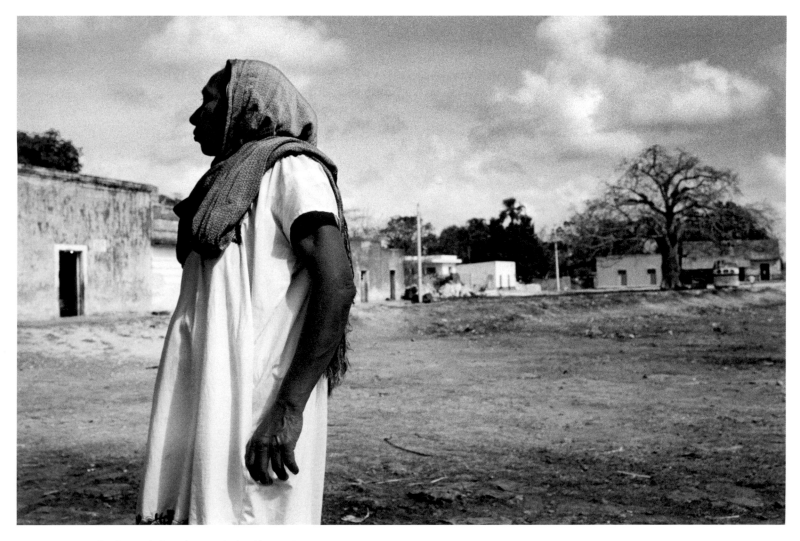

Veva in the plaza with the ceiba tree. Chichimilá, Yucatán, 1976.

change from their gowns into huipiles or dresses. Everyone ate, drank, and danced. After Alicia blew out her candles, we ate cake. The party was still going strong when I left at 4 A.M.

Cornelio and his older sons drank much too much. They either found an excuse or didn't need one to raise a toast. One night a few months after Alicia's birthday party, we could hear Luis coming home long before he arrived. A hundred yards down the road he swore loudly to let us know how drunk he was. Veva, Alicia, and Felipe continued talking with me as if they had heard nothing. They couldn't ignore him, though, when he began breaking empty beer bottles on the pavement in front of the house.

"What a fool my son is," my comadre tried to joke. When she saw that I was staring out through the pole walls, she put her hand on my arm.

"Don't go outside," she told me. "It's best to ignore him. Either he'll go back to drink or he'll fall asleep." We tried but couldn't help laughing when he yelled insults at an obnoxious neighbor that we would have liked to have said ourselves. The rest of the neighborhood remained quiet and dark as if everyone was asleep. Luis broke another bottle and swore at the darkness then stumbled into the house. He looked at us wild-eyed and awkward, stopped short by the bright lightbulb hanging from the rafter. He squinted and leaned against the opening.

"I am going to kill myself," he announced loudly. He came over and fell into me, trying to keep his balance. Luis could have been a handsome man, but drink accentuated his worst features. He sprayed spittle as he struggled to speak. I put my arm around him and asked him if he would like me to read to him from their Bible. I said this because a couple of nights before he had come home very drunk and asked if I would read it to him. But he'd fallen asleep before I could.

Luis pulled down a hammock and took a seat. He relaxed as I spoke quietly to him. He asked if the Bible could explain why one person is born in the Yucatán and another in the United States. And what determines who is born wealthy or poor, male or female, sick or healthy, into a large family or a small family? He went on about the disparities of birth and what we agreed we had no control over. He asked if I could explain it. He laid back in his hammock and fell asleep.

Luis searched for truth in the bottle. He was a serious and often ugly drinker, unlike his father, who took joy and delight in drinking. His father celebrated life when he drank and wanted to dance and sing, tell stories, laugh, and enjoy his family and circle of friends. In contrast, Luis turned introspective and sullen. He told me that he knew drinking was bad for him then smiled slyly and said it was also good.

A few weeks afterward Luis came home drunk and fell in the well when he tried to pull up a bucket of water. His neighbors rescued him, primarily, I think, so he wouldn't contaminate their drinking water—although his drunken insults probably made it a difficult choice. When we were

alone my comadre would cry unashamedly about her son's drinking. His behavior hurt her deeply, as he was her first-born and she loved him dearly.

Veva's typical day started at 5 A.M. when she slipped out of the hammock she shared with Cornelio. It was chilly, so she found her sweater and pulled it on over the huipil she'd slept in. She stepped into a pair of plastic shoes and walked from the house where they slep over to her kitchen. Veva coaxed her cooking fire back to life, squatting down and blowing on the embers. She added twigs and kindling and, once it was burning brightly, put on a pail of water. She washed the dinner dishes, rinsed them in the hot water, and air-dried them on a wooden table. Water that spilled onto the dirt floor was quickly absorbed. At dawn Veva went into the yard and collected eggs from the chickens. As the sun climbed and warmed the interior of her kitchen, she prepared a breakfast of black beans, scrambled eggs, and fresh tortillas for her family. Afterward, Felipe and Alicia hurried off to school; Luis, Elmer, and Nelo went to work in Valladolid; and Cornelio stayed to help with chores.

Veva fed her chickens, turkeys, and pigs then heated more water and washed the dishes. She fetched water from the well in front of her house, making several trips in order to fill the clay *ollas* (jars) in her kitchen. That way she wouldn't have to go to the well each time she needed water.

Meanwhile Cornelio prepared one of the homemade syrups that they used at their refreshment stand for flavoring drinks and snow cones. He boiled a mixture of barley over the fire until it was sufficiently reduced then poured the syrup into liter bottles, corking them with corncobs. Veva rinsed the bucket of corn that she'd boiled and soaked overnight and drained it, leaving kernels ready for grinding into masa for the day's meals.

The morning was already hot, and it was time to open their stand. Veva combed her hair and put on a clean huipil. She and Cornelio walked downtown along the road, Cornelio carrying the bottles of syrup and Veva her pail of corn.

In the plaza Cornelio unlocked and raised the hinged front, which doubled as an awning for the stand. After wiping the counter, he bought a block of ice from a store for the snow cones. He put it into a metal-lined box and covered it with a wet cloth to keep it cool. Veva drew water from the plaza cenote and filled a barrel so that they could wash their drinking glasses. Once they were ready for business Veva took her bucket of corn over to the corn mill. She got in line with her neighbors and listened to the latest gossip over the whine of the gas-driven mill. Lacking local papers and radio, village women would meet at the mill and the wells to share local news in the course of doing their daily chores.

Since business was slow, Veva took her freshly ground corn home, covering the pail with a cotton cloth to keep dust and insects off and the sakan moist. At the house she gathered up all the dirty clothes and took them outside where

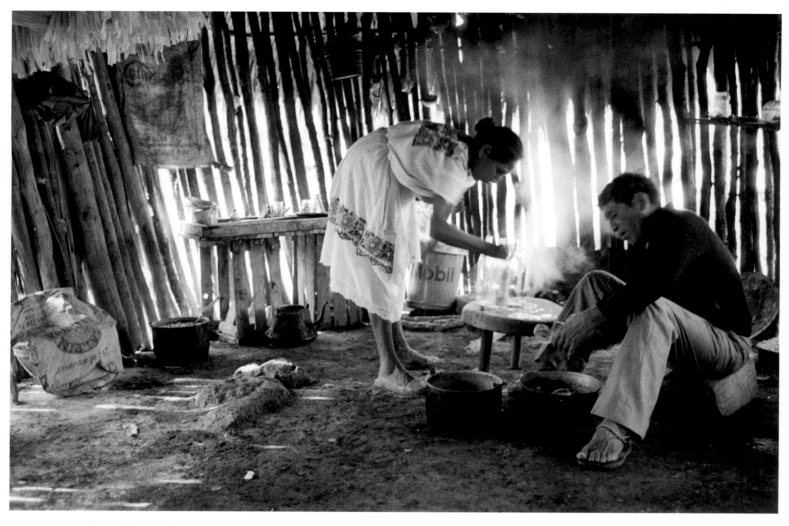

Veva and Cornelio bottling fruit syrup to use at their refreshment stand. Chichimilá, Yucatán, 1976.

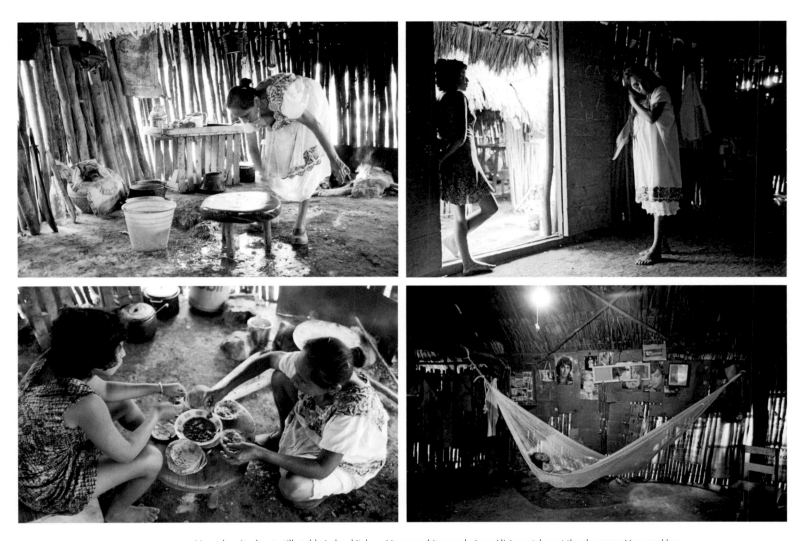

CLOCKWISE FROM TOP LEFT: Veva cleaning her tortilla table in her kitchen; Veva combing her hair as Alicia watches at the doorway; Veva and her granddaughter Cecilia sleeping in a hammock; Alicia and Veva eating together before the men return from work. Chichimilá, Yucatán, 1976.

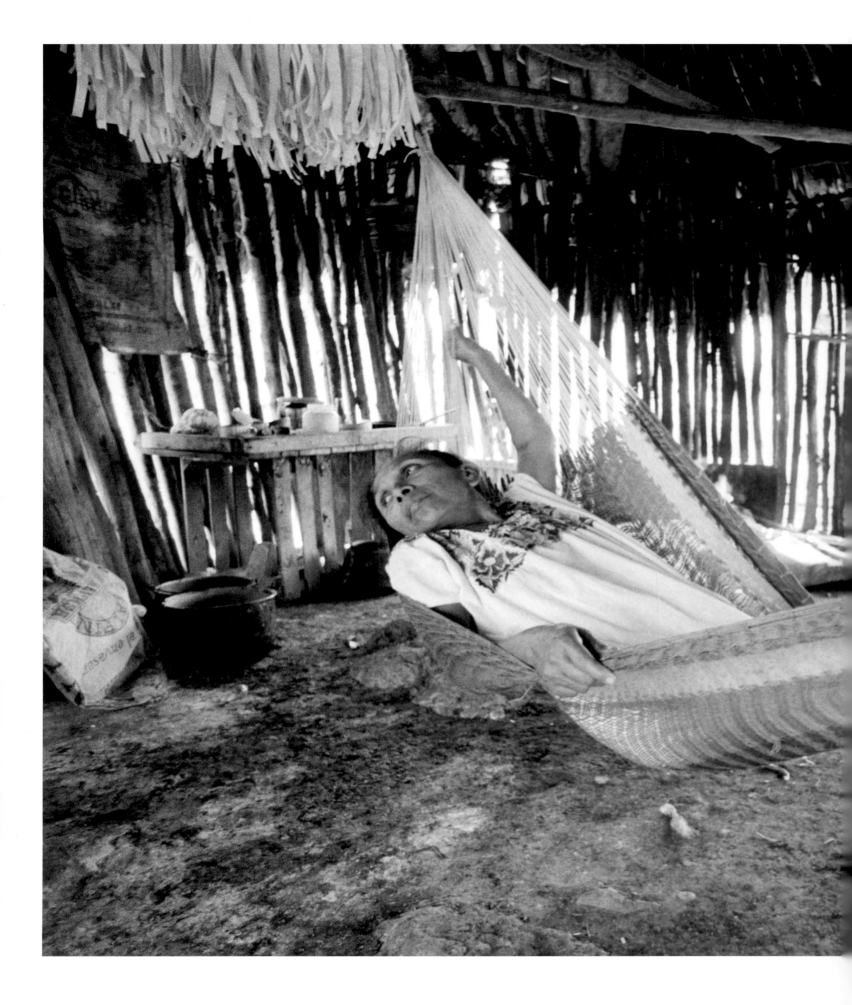

Veva enjoying a brief respite from a busy day.
Chichimilá, Yucatán, 1976.

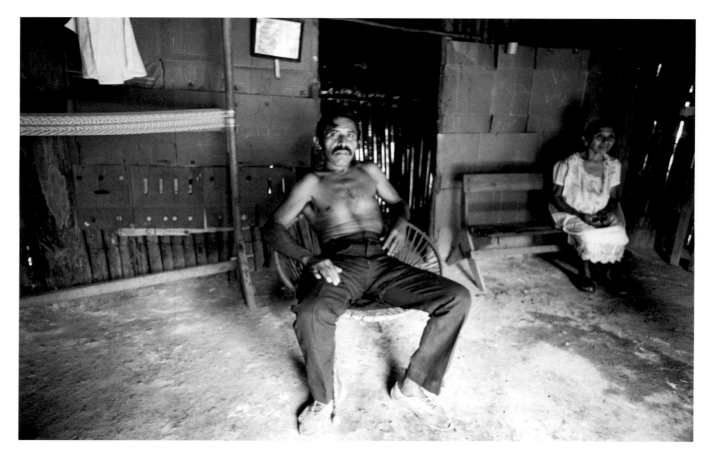

Luis and Veva. Chichimilá, Yucatán, 1990.

she had set up her batea. It was placed on blocks waist-high and at an angle so that water collected at one end of the washtub hollowed from a single piece of cedar, so Veva could watch the street and see who passed by as she worked. Doing the laundry was hard work, but before she could even start she had to haul more buckets of water. A neighbor passing by saw her and came in for a visit, talking as Veva scrubbed. Veva hung her wash on a sisal rope stretched between trees. She twisted open the strands of the rope, inserted a corner of wash in it, then let go; the tension held the clothes pinched tight.

Veva made lunch and walked back to the plaza with a hot meal of black beans and fresh tortillas for Cornelio and herself. They took turns eating and serving customers. The heat was oppressive and very good for business. Villagers walked by carrying parasols against the blistering sun. Hot blasts of wind formed dust devils that raced across the plaza. The heat made everyone thirsty and tired. Customers chose flavors for their snow cones and drinks from the bottles of syrup along the wall—strawberry, barley, pineapple, sweetened condensed milk, coconut, lime, rice, and tamarind. They could sit in the shade of the stand and watch other villagers arrive and leave on buses that stopped beneath the ceiba tree. It was an inexpensive respite from the heat and encouraged people to stay and talk and buy another cool drink. Cornelio and Veva made small talk with their customers. From their vantage point they watched and heard a lot of what went on in the village.

The heat slowed everything down until 3 P.M., when classes got out. The schoolkids screamed and shouted as they ran across the plaza, but many stopped to buy a snow cone. They kidded, yelled, played, and sat around the stand for more than half an hour. Alicia and Felipe helped their parents until their classmates left, then Veva took them home.

Felipe changed from his school clothes and took his machete to collect firewood in the nearby forest. Alicia helped her mother with household chores. Together they sprinkled water on the floor to cut the dust and swept it with a cornshuck broom. Afterward they went outside and swept the yard clean. Alicia drew more water from the well for dinner and evening baths, refilling the clay ollas. Then she helped her mother bring in the laundry from the line. Since they didn't have hangers, closets, or wardrobes, they put away their clothes in folded piles wrapped in plastic or stored in boxes on hanging shelves or in bags hung from the wall.

Leaving Alicia to finish, Veva returned to her kitchen. She stoked her cooking fire and started heating black beans and making tortillas for dinner. Late afternoon sunlight passed

through the walls in thin yellow ribbons, brightly striping the interior. Alicia joined her mother. They sat at a table, quickly patting out tortillas from balls of masa, rotating each one till it was round and thin. Half-turning, they placed it on a comal, the metal griddle over the fire. They put the hot tortillas into a cloth inside a gourd that kept the tortillas warm. As they worked, Alicia told her mother about school. Through the slits of the kitchen's pole wall they watched movement out on the street, where their neighbors were getting in and out of taxis and buses.

After dinner Alicia began her homework. Veva stole a moment for herself to lie in her hammock. It was the first rest she'd taken. She would lie back and look around her kitchen, not even fully getting into the hammock. She rocked back and forth, floating momentarily in time, before getting up and brushing out her long black hair. When Felipe returned with firewood, he ate dinner as his mother made him hot tortillas and then started his homework.

Veva boiled a pail of corn and set it aside to soak overnight, ready to take to the mill in the morning. Next she heated water for their baths, which they took in turns at one end of the sleeping house, sitting on a stool behind a blanket stretched across the room for privacy. Afterward Veva put on a clean huipil. I found it amazing that the women who work so hard and live with dirt floors not only wear white dresses but somehow keep them gleamingly clean—even if they sometimes turn them inside out toward the end of the day.

Cornelio closed their refresco stand at dusk. He waited for his sons to return from their work before he ate dinner. Veva served them and then heated their bathwater. She climbed into her hammock around 9 P.M.

Veva's daily schedule and contribution to the well-being of her family was exhausting. Alicia, in her struggle to be a model student and become more than a village housewife, didn't have a role model among her siblings for what she wanted to do. But she did have the encouragement and support of her parents. Her father was her champion and really believed in her. When he died six months after her fifteenth birthday, hit by a truck on the road in front of their house, it was a very hard time for everyone.

On a chilly, windy day in 1980 I visited Veva and found her alone. The light was cold and brittle, without any of the sparkle that often suffused a tropical day. A flight of parrots circled the house, chattering and squawking before landing in a tree. The humid cold chilled us to the bone. I told her that the ports along the coast were closed due to the *norte,* the north wind that came all the way from the Arctic. The newspapers mentioned that it could snow in Florida.

We went inside and sat in hammocks to get out of the wind. Luis had covered portions of the pole walls with cardboard and decorated them with pictures he'd cut out of popular magazines, comics, and newspapers, but it didn't keep out the cold. The house was designed for the heat of the tropics. The only thing that glowed was the cooking fire, bright in the gloom. Everything seemed gray, especially the clouds, which were about to pour rain again.

Veva told me that her roof leaked and that the wind drove the rain in through the pole walls. She needed more guano palms to seal the roof, but Luis had done nothing. We saw five girls pass outside and stop at the well. We could hear their murmuring and sudden laughter as they filled their buckets. Veva massaged her fingers and cracked her knuckles. I asked her if they hurt. She looked up at me in surprise and told me it was just a habit. She laughed and got up to serve me a bowl of black beans.

Veva sat on the small stool next to her fire and made me tortillas. We talked about the local economy and how the men needed to go to Cancún to find work. She mentioned that she was having trouble supporting herself since Cornelio's death. The government had no program to help the village widow of a man who'd worked in the jungle. She'd also lost the concession for her refresco stand, a victim of village politics. She had to rely on her family to support her. Luis wasn't working much and drank what he earned. Elmer had married a girl from Piste and they'd just had a baby, so he couldn't help. Nelo was working in Cancún after quitting work as a chiclero, lamenting that even the big trees hadn't given much sap. He also had a drinking problem, so he didn't send much. Felipe was still in school. Her real hope, Veva said, was Alicia, who was working as an assistant kindergarten teacher in the village of Chan Cenote.

It was cold, and we both shivered. Neither of us had warmer clothes. That evening we put loose coals from the fire underneath our hammocks to stay warm.

Alicia was hired to teach a bilingual Spanish-Mayan kindergarten class in Tixcacalcupul, a village twenty minutes south of Chichimilá. She commuted by bus or taxi. In 1983 she married Juan, a soldier from Veracruz stationed in Valladolid. Without having met me, he sent a very nice letter to introduce himself, along with a photograph of him and Alicia on their wedding day. He'd left the army because they were transferring him to Baja and he didn't want to leave Alicia and Yucatán. He also informed me they were expecting a child the following March. Their first child was a girl, Abril, followed three years later by Josué. Juan found a job in Valladolid, and Alicia continued to teach in Tixcacalcupul. They saved enough money to build a stone house in front of the thatched house she'd grown up in.

Hilario and I visited Veva in March 1986. The first thing she did was to show off Alicia's house. She was so proud of her daughter, who was still teaching in Tixcacalcupul, and made

sure we saw that Alicia now had two radios, a television, and a refrigerator. Veva offered us a cold drink from the refrigerator and apologized for not having beer. She announced that she no longer drank, as she was now an Evangelical.

We took our soft drinks and went around in back. Veva's house was showing its age, the pole walls leaning more than ever and starting to twist on themselves. Veva mentioned that she didn't have any money for repairs and hoped that her house would be okay. We pulled down a couple of hammocks. Once we were relaxed, Veva brought us up to date with news of family and friends.

Alicia and Juan had just lost their six-week-old son to heart problems. Juan was working in Cancún, where he could make more money than in Valladolid. Alba and her husband Benito were also in Cancún, and my goddaughter Cecilia was now thirteen. Veva didn't think Cancún was a good place to raise children. Just the week before, she told us, a young girl had been abducted and killed. The police had found a lot of someone else's skin underneath the girl's fingernails. Veva prayed that it would lead the police to find the assailant. She hadn't seen Diego or Margarita for years—they were still getting by in Calderón.

We hadn't talked for five years, so Veva asked me for news from California. I told her that I had finished my undergraduate degree and gone on to graduate school and that my son Robert had graduated from high school. The more we talked, the more I felt at home, but I knew I'd been away for too long.

Gilbert was the strongest hurricane ever measured in the Western Hemisphere when it slammed into the Yucatán Peninsula on September 14, 1988. Winds of 175 miles per hour cast ships up on land, twisted radio and microwave towers into pretzels, snapped electrical and telephone lines, knocked down trees, and almost completely defoliated the jungle canopy along the coast. The wind and rain damaged homes, businesses, and farms. Luckily the hurricane lost strength as it crossed the peninsula, and many areas escaped its full power. Charles and I were in Santa Barbara, California, about to lead a tour of Yucatán for a University of California class along with Dorie Reents-Budet, an archaeologist then at UCSB. We convinced the administration that we could still do the class, and no one dropped out.

Charles and I came down several days early and headed directly for Chichimilá. Alicia and Veva were in the front yard washing clothes when we arrived. They pointed to Veva's house, which was leaning at a crazy angle. "You couldn't believe the noise," they both said in unison. "It sounded like a steam engine coming right across the sky. Everything shook."

It was the noise that they remembered most. They described the wind as being as loud as anything they'd ever heard and said that it didn't stop until the eye passed overhead. They told us how frightening it was. Almost all the roofs made of guano palms survived, but those of corrugated tin and tarpaper didn't. Gilbert had applied the coup de grâce to Veva's house. If we talked too loud, the house would fall over.

Charles and I were prepared to help. We'd sponsored a benefit in Santa Barbara for Maya victims of the hurricane the night before we'd flown to Mérida. Friends, a restaurant, and a local band assisted us, and over two hundred people showed up. We raised several thousand dollars.

Juan, Alicia's husband, contracted workers to cut new wood and rebuild Veva's house for $200. Doña Veva was the first of many people that we were able to help, and it was all the sweeter that she was my comadre. We brought along photographs taken at the benefit so that the Maya could see who was helping them. Finding out that complete strangers cared enough to donate money both surprised and comforted them.

Several weeks later, after we'd completed the UCSB class, Charles, Hilario, and I picked up food in Valladolid and a package of balloons and drove out to Chichimilá. The workmen were just finishing Veva's house when we arrived—it was six meters long and three meters wide, with two doorways opposite each other on the long sides. The floor was compacted earth, the walls were poles, and the roof was guano palms. Veva was overjoyed and was joined by Alicia and Juan and their children. We brought in a table, stools, and chairs and hung hammocks in order to celebrate the housewarming. We blew up the balloons and let them float around the room as we crowded in to celebrate. Luis showed up too, home from a new job in Valladolid.

We started telling stories, and Charles asked Alicia if he could ask her a question. "For years I've been meaning to ask you why you decided to cut your hair for your quinceañera. Wasn't that really making a statement here in Chichimilá? None of your friends had short hair. For fourteen years you were a village mestiza with your long hair and huipil. Suddenly you cut your hair, put on a modern dress, and you're a catrina, a city girl."

We all looked at Alicia. "I wasn't the only one," she protested. "Most girls who turn fifteen go into Valladolid, get their hair cut, and put on a dress."

"Not back then," Charles said, and we all nodded in agreement. "You were the first."

"I was imitating one of my friends." Alicia laughed, discounting the importance of what she'd done. "She had relatives living in Mexico [Yucatecans still refer to the rest of Mexico as if it is a separate country]. She must have seen how they celebrated a fifteenth birthday party there because we started celebrating that way here in Chichimilá. We wanted to be fashionable." Alicia paused. "After that, I still wore my huipil."

"But you have to agree," Charles stated, "that if a girl cuts her hair and changes to Western dress she usually doesn't put her huipil on again."

"That's true," Veva said. "We see that all the time."

"I don't wear huipiles as much now," Alicia said. "But it's because they're more expensive than a store dress. It used to be just the opposite."

"Even so," Hilario said, "some girls in the village don't wear huipiles because they are ashamed, or even speak Mayan."

"I know," Alicia agreed. "It's often their parents who teach them that. They think they're helping them—only letting them speak Spanish so they can get work in the towns or in Cancún. But take me, for example. I couldn't have gotten my job as a bilingual teacher if I didn't speak Mayan." She stopped and looked at her husband. "Our children will speak both."

Juan nodded.

"How many are you going to have?"

"Just two and no more," they said. They laughed when they realized that they'd answered in unison.

"Really?" Charles asked, looking surprised. "You have six brothers and sisters, Alicia, and your older sister has ten children, with another on the way. And you're only having two? That's a huge difference!"

"Everything is now so expensive," Juan explained. "Before, a family could have ten or fifteen children and be able to eat on just the work of one man. His family would help him. Now both the husband and wife need to work to support the family—so if you have more children, life is more expensive. It's better if we only have two."

"Couples around the world are making the same decision," Charles agreed.

"Life was less expensive before," Alicia said. "For example, we have modern things, such as our refrigerator, but they often cost more than we make."

"I think education has improved," Juan added, "but students are learning less because they're distracted by television and tape players."

"Hmmm," Hilario said. "I was just talking with doña Herculana, Dario's wife. She surprised me when she said life is better today because now that Dario is working in Cancún she knows they will have food. Before, she never knew if she was going to have enough until after the harvest."

"That might be true, but take me for an example," Juan said. "I make $44 [U.S.] every fifteen days working on a road crew. A shirt or a pair of pants costs around $17 each. The day I need to buy a pair for work, that leaves me with $10 for food, and no money for clothes for anyone else in my family." He shook his head. "And how much does a kilo of meat cost? $4.50. And then when you add the cost of condiments, beans, and tortillas?"

"These days both husband and wife need to work to survive," Charles said. "That's exactly my predicament raising a family in the United States."

"And it means the husband has to accept his wife as his equal," I said.

"But sometimes a husband is so jealous that he won't even let his wife work," Juan stated. "There's a lot of immorality today; you hear about it all the time, so it is on people's minds. But Alicia and I have mutual trust. She's not going to deceive me, and I'm not going to deceive her."

"So you're not jealous of each other?" I asked.

"Well, a little bit." Juan laughed. "But let's say 'good jealousies' rather than 'bad jealousies' that lead to shouting and blows. I've seen problems when the wife makes more than her husband. 'I'm a man, you're a woman. Stop working,' that sort of thing. But Alicia and I have an agreement to discuss our problems. In our case, Alicia makes more than I do. She makes $160 a month, and I make $88. We've agreed that everything we make goes toward family expenses, so it

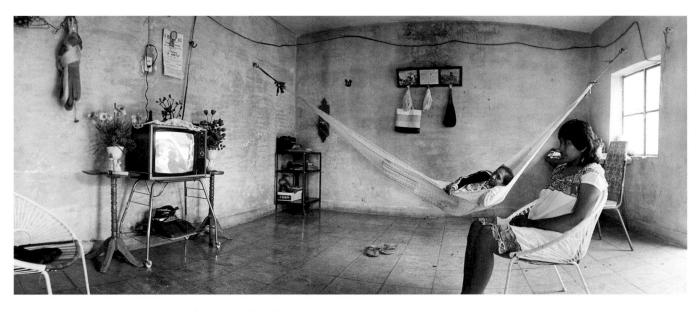

Veva and Alicia watching television in Alicia's house. Chichimilá, Yucatán, 1986.

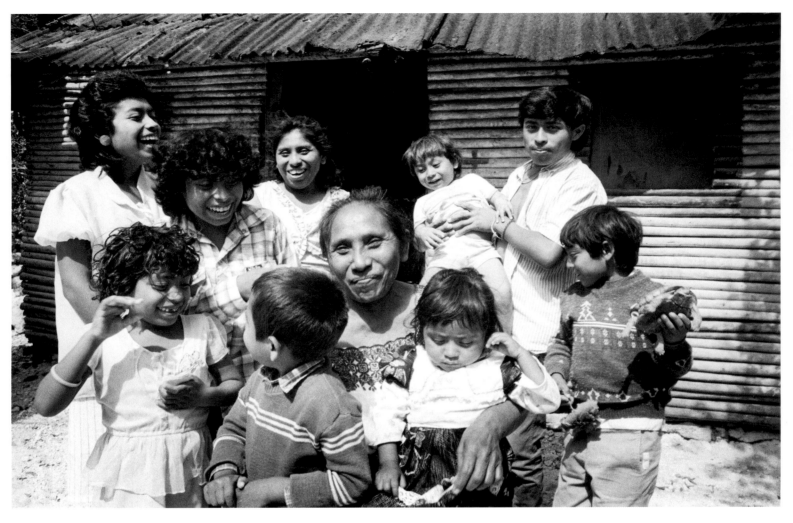

Veva with her daughter Alba and her grandchildren. Cancún, Quintana Roo, Yucatán, 1980.

hasn't been a problem for us so far—not like with some of the men I work with."

"I'm impressed that you talk about this," Hilario said.

"Yes," Veva said. "It's a good change for the village."

Juan and Alicia both grinned at this double compliment.

"What about when you first met?" I asked. "I grew up in a small town where everybody knew what everybody else was doing. Was there any reaction when Juan, a dzul, started seeing you, Alicia?"

"There sure was." Alicia laughed. "Starting with my mom! She didn't want me to see him. She called him a *wach* [an outsider, particularly a Mexican soldier], and others in the village made up terrible stories so that I wouldn't want to see him. But he was cute." Alicia giggled. "My girlfriends thought he was cute too."

Juan laughed and put his arm around Alicia. "I first saw Alicia in the park in Valladolid. I didn't know anything about her, but I knew she was the woman I wanted to marry."

"Right then?"

"Immediately!" he said, snapping his fingers and breaking into a big grin. "I found a girlfriend of another soldier who was a friend of Alicia's, so she could introduce us. Then I started jogging out to Chichimilá every day as part of my military exercises. At first I timed it so I would see Alicia when she went to the plaza to grind corn at the mill. It was there that I told her my intentions were marriage. I then asked doña Veva permission to visit her daughter at her house because we were meeting in the streets and it wasn't proper. I was afraid her neighbors would speak poorly of her and make assumptions that weren't true. Doña Veva gave her permission."

Veva was smiling and nodding in agreement.

"I think that's when she started thinking better of me. Fifteen days later I came with my father—he was also in the military and stationed here—to ask for Alicia in marriage and arrange the date of the wedding." Juan again snapped his fingers several times. "¡*Rápido* [fast]! We didn't waste any time. But that's when Alicia played a dirty trick on me to see if I really was sincere."

Alicia and Veva both laughed, but Alicia looked a little sheepish.

"Alicia visited me, and I told her how happy I was to be marrying her. 'There's just one problem,' she said. 'What is it?' I asked her. 'I have a daughter.' She presented Cecilia to me. I didn't know she was Alicia's niece and your goddaughter, don Macduff. But I told her it wasn't important—in fact I was happy that I would already be a father. That night I told my mother that Alicia wasn't a señorita but a señora. She didn't consider it a problem either."

"It was a test to see if he really loved me," Alicia said with a laugh, "and he did." She squeezed his hand.

"When you ask for the hand of a woman in Veracruz, where my family comes from, the custom is to prepare a lot of food and for five days you party—eating and drinking. This is just for asking for the girl. Five days of fiesta."

"It's the same here," Veva said.

"I asked around and found out it's generally just for a day," Juan continued, "so I brought food and brandy and arrived in Chichimilá with my mom and dad."

"I was here with my comadre," Veva said, "and we both started crying and crying . . . " She couldn't go on because she'd started giggling, and she covered her face with her hands.

"Alicia's friends and neighbors joined us and we had a great party," Juan said, "and that's how doña Veva accepted me."

"What about the neighbors?"

"At first they were suspicious and made up stories," Alicia said. "But now they accept Juan."

"It was lucky we trusted each other," Juan explained. "Some of the stories were really nasty. At one point we asked each other if there was anything the other should know about so we would hear it directly and not from another person. We hadn't done anything we were ashamed of—but you wouldn't have thought so from the gossip in this village." Juan turned serious. "There is a fellow who to this day doesn't speak to me out of embarrassment for things he said. There were a lot of people who didn't want us to get married because I was a soldier and I wasn't from around here. Some of the guys even tried fighting me, but since I wasn't afraid, they didn't pursue it. If they'd sensed I was afraid, they'd have jumped me for sure."

"What are your plans now?"

"We're going to stay," Juan said. "Alicia told me she was born here and she wanted to die here, so I don't want to ask her to move because she wouldn't be happy. I might have to work elsewhere for short periods. Once, before I met Alicia, I was here in Chichimilá for a baseball game in the plaza. I looked around and thought how tranquil the village seemed. I figured that this was a place I could spend the rest of my life."

"What about Cancún?"

"We could both make more money, but our children would suffer. It is easy to fall into bad habits there."

"One thing I've noticed," I said, "is that often the men returning from Cancún get drunk on their day off."

"It's true," Alicia agreed. "Their kids only know their fathers when they're intoxicated. One of our neighbors is only seven, but he's drinking. Imitating his father. On the other hand, our children have never seen their father drunk."

"Josué doesn't have any fear of me," Juan attested. "When I come home he runs to greet me. But a child with a drunk father knows fear."

"Not all drunks are nasty," I said. "Alicia's father was a happy drunk. My compadre liked to sing and dance and kiss his wife."

"He was never insulting," Veva added, smiling, "and he was never drunk out on the streets. He'd be home by six. If there was music, he'd take me dancing, even if we had to go to the next village."

"I never met him," Juan said. "I've heard stories about him, but I think I only really know him because of your photographs, don Macduff."

"He was a wonderful friend," I said. "He'd be so proud of both of you. He'd congratulate you on your marriage and he'd be so pleased that Alicia is a schoolteacher. That was his dream."

"Sometimes we'd talk early in the morning before Alicia was awake," Veva explained. "Cornelio would stand by her hammock and say to me, 'This is my daughter who will take care of you when I die. She's going to be a teacher. When I'm old and bent over walking with a cane and can only sit in the doorway guarding my grandchildren, this is the child who will support us.' I asked him why he thought Alicia would take care of us when we had four sons. 'She's only a girl,' I told him. But he'd laugh. He said our sons would probably marry women who didn't know how to work. But he said Alicia was smart, very smart."

"You're kidding!" Alicia said. "I don't know any of this. I never planned on becoming a teacher. I was going to be a nurse. I studied for it but I didn't like it. I looked around for work and that's when the opportunity to teach came up. I never remember my father saying he wanted me to become a teacher."

"Huhhh," Veva said. "That's what he said, and he was right. Now you are supporting me and here I am, sitting by the doorway taking care of my grandchildren."

"I'd like to toast to my compadre," I said, raising my glass of fruit juice, "who will always live as long as we remember him."

"He was a man who knew how to laugh," Hilario added. "A toast to a good jungle man, a good husband and father."

We made other toasts—to Veva, to her grandchildren, to better times, and to our *paisanos* (people from the same country) who contributed to the hurricane relief fund. I'd brought several large empty frames and a box of photographs that went back to our stay in the chiclero camp, including more of Cornelio. As we looked at the photographs they decided which ones should go on the wall. Luis, who hadn't spoken much during the evening, suddenly became very animated and intrigued with the selection and began arranging them so that they would tell a story. I brought out glue and scissors, and he was busy long after Alicia and Juan had left to put Abril and Josué to bed in their stone house.

Later that night Hurricane Keith approached the Yucatán Peninsula. It got very cold, and I couldn't sleep. I lay shivering in my hammock until Veva came over, bringing a couple of sticks from her cooking fire. She knocked the burning embers onto the ground beneath my hammock. The heat immediately came up around me. I thanked her and fell asleep.

Despite the best intentions, Alicia and Juan would soon have two more children, Miriam and Atalia. They moved to Valladolid when the government offered subsidized housing for low-income workers in a new neighborhood. They put very little down and the monthly payments were affordable, with only 4 percent interest. That was remarkable in Mexico, where interest on bank loans could be much higher. Juan turned the living room of their new house into a store, where he sold basics, sweets, and soft drinks to their new neighbors.

Juan had a succession of jobs, but nothing as permanent as Alicia's teaching position. He developed a few personal problems, which culminated in a religious conversion and being born again as a Jehovah's Witness. Although they are considered an Evangelical sect in Mexico, Jehovah's Witnesses are often considered a cult in the United States.[1] They talk about how depressing and horrifying conditions are in the world, cultivate real fear, and point out that accepting their interpretation of salvation is the only secure way to a glorious paradise. Juan shared his faith with all his friends and began proselytizing in neighboring villages. Whenever I visited, anything we talked about would soon turn to whether I was saved. Juan wasn't satisfied when I told him that I had already accepted Jesus. He told me that his religion was the only true one and that he wanted to save me. I liked Juan and enjoyed talking with him, but he had a habit of answering for everyone. If I asked Alicia or their children a question, Juan frequently answered for them.

When I first came to Yucatán, the Maya would ask me my religion. I answered, *Soy católico* (I'm Catholic). And in turn they all would tell me, *Somos católicos también* (We're Catholics too). In fact, nearly everyone in the smaller towns and villages was Roman Catholic, though Maya religion was most often a Christian-Indian syncretism. At that time a village might have an Evangelical church, but it usually had only a few members. There were also Mormon missionaries: young men in white shirts and ties, walking or riding bicycles, looking well scrubbed and earnest. They made few converts.

When the government built roads into rural areas in the 1970s, the Maya went from barter to a cash society. They found themselves in a more costly world that they hardly recognized. Inflation worsened as Mexico devalued the peso again and again in the 1970s, 1980s, and 1990s. The economic crises caused many to leave the agricultural lifestyle that their Maya religion in large part supported. People felt powerless. As their desperation increased, some sought solace in new religions.

Roman Catholic priests were spread thin in rural areas. One priest might have 8,000 parishioners in several towns, rather than a single congregation. A priest's role in a congregation involves much more than conducting a church service and celebrating the Eucharist. Parishioners depend on a priest for guidance, counsel, consolation, and moral support for difficult decisions. As Mexico's Indians looked to the church, they saw few Indian priests and realized that none of the 132 Roman Catholic bishops in Mexico were Indian. Shockingly, there is no record of a single Indian priest during the three hundred years of colonial rule.[2] The Roman

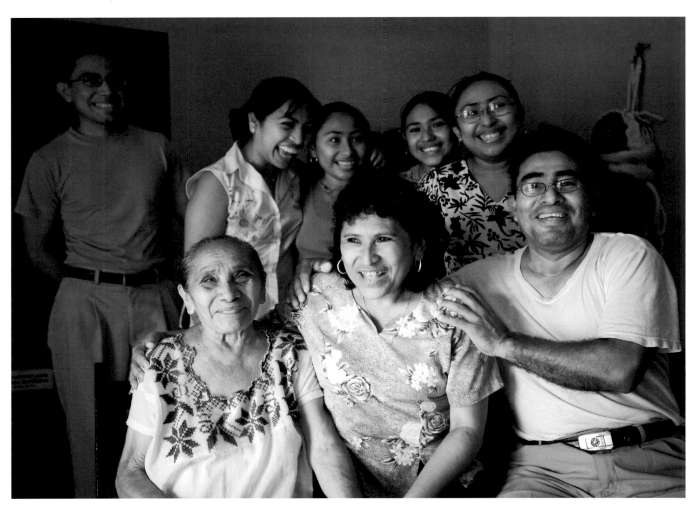

Veva with Alicia and Juan, and, in the back, Josué, Reina Marlene (a neighbor), Atalia, Miriam, and Abril. Chichimilá, Yucatán, 2003.

Catholic Church had seen the role of the clergy as a position of power and made no room for Indians.

Pope John XXIII tried to make the church relevant to the people. He convened the Second Vatican Council in 1962 to end centuries of what he called "holy isolation." He wanted the church to be brought up to date and adapt to the challenges of the day, to free itself of hierarchical order, inquisition, and theological and intellectual suppression. Roman Catholics in Latin America had formed grassroots movements that promised a church that paid attention to social justice and human rights. The movement applied the revolutionary roots of the message of Jesus to class struggle—if we really are our brother's keeper, how can anyone allow people to starve and suffer? Oppression of the poor was no more than institutionalized sin. Liberation Theology reconnected the church with the poor that it had neglected for so long. But Pope John Paul II brought back the conservative elements and the old orthodoxy when he ascended to the papacy in 1978. As a Pole who'd lived under communism, he reacted to the Marxist rhetoric in the theology rather than the grassroots cry for justice and for confronting centuries of abuse and poverty.

The Evangelicals filled this void. Their churches sprang up in villages and towns throughout the country. Passionate, contemporary, and direct, the Evangelicals offered an active church led by local ministers. They held services and Bible study groups conducted in Spanish and Indian languages. Because they forbade alcohol, the Evangelicals appealed to women whose husbands drank and abused them. Millions of Mexicans, no longer content with the religion they grew up with, converted.

While the Evangelicals enjoyed success, their relentless proselytizing created strife. In central Mexico they set off a controversy when they condemned animal sacrifices that were a traditional practice of the local Huichol people. In Guatemala they attacked the Roman Catholic Church for allowing certain Maya customs to continue—including the sacrifice of chickens and the use of liquor to honor saints.

In San Juan Chamula, Chiapas, a municipality a few miles from San Cristóbal de las Casas, the tradition-minded highland Maya expelled more than 30,000 people when Evangelicals wouldn't participate in community functions. The battle turned bloody. People were beaten and killed. Neither side was willing to compromise. The Evangelicals insisted on presenting their opinions as facts. The traditional Maya refused to give up their culture—the issue for them was not religious freedom but preserving their identity. Local caciques (village chiefs) were fighting to maintain economic control and power, which exacerbated the problem.[3]

Francisco Rosado May, rector of the Intercultural Maya University of Quintana Roo, cited additional political reasons for the influence of the Evangelical churches: the Mexican government is not transparent in its actions and decisions and lacks decent social policies, an adequate educational system, and protections for the individual and community rights of indigenous populations. The intolerant and compassionless message that some Evangelicals preach is a simple salve for needy, spiritually hungry people who've had very little or no education and are not exposed to ideas other than those that they hear during worship services.

Juan converted his family. Veva told me that she saw a truth when she became a Jehovah's Witness. When I asked about it, she closed her eyes and raised her voice. "I changed for salvation," she said with finality.

I asked Felipe, Veva's youngest, why he hadn't become an Evangelical like his mother and sister.

"I tried," he said. "I wasn't that devout a Roman Catholic so it was easy to change. I was an Evangelical for two years. I did it for my mother and because they said Evangelism was an American religion. My mom's new religion is very strict, whereas Roman Catholicism is much more flexible. One day we were supposed to confess our sins out loud, and I honestly thought that they would be pleased if I confessed. I was single and I had a girlfriend. I confessed to premarital sex. They suspended me. They called me a fornicator and suspended me for so long that I never went back."

Felipe later married Bárbara, a young woman in Chichimilá. "When Felipe was married," Veva tried to explain, "I wasn't at his wedding. I was his witness at the civil ceremony, but my religion wouldn't allow me to go to his wedding at the Roman Catholic church or to the fiesta afterward. I sent his uncle to represent me. I love my son very much. Bárbara knows I love her too. I love my grandchildren. But I couldn't go."

Veva looked off, and her voice became a whisper. "You think it didn't hurt me not to go to my son's wedding?"

Later Felipe told me that he tried not to take it personally, but he thought that it was a strange religion that would divide a family.

Felipe and Bárbara found work in Valladolid at *maquiladoras* (assembly plant factories). The raw materials or parts are imported duty-free and the finished product is exported duty-free. Nothing made at the plant remains in Mexico. Factories exist to take advantage of cheap labor; profits remain with the foreign owners. The first maquiladoras were clustered along the Mexican-American border, but Yucatán encouraged businesses to locate to the peninsula, offering inexpensive shipping to U.S. gulf ports as well as attractive tax and property incentives. One incentive for locating in Yucatán was a poverty level that guaranteed low-wage workers.[4]

Felipe worked from 8 A.M. to 6 P.M. five days a week for Jordache. In 2001 he earned $43.20 a week, with $5.40 deducted for his lunches. Bárbara worked from 8:15 A.M. to 5:45 P.M. six days a week for Hong Ho (which made shirts for brands such as Gap and Banana Republic) and earned $54 a week, with $5.40 deducted for meals. The salaries didn't go very far. They had to pay for transportation to and from work and for child care. They earned so little that any expense was significant.

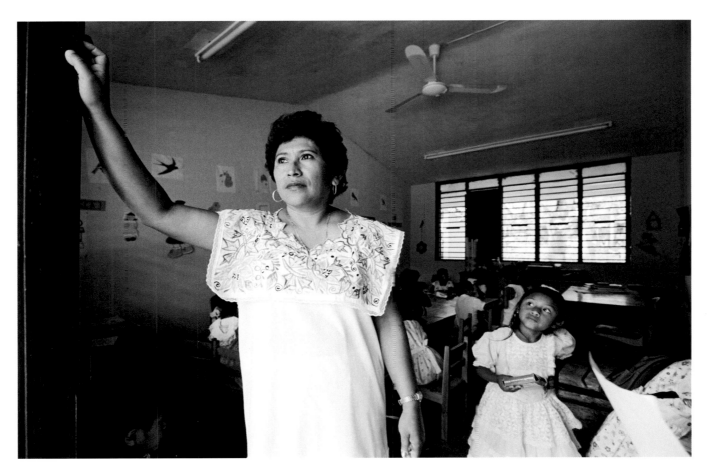

Alicia in her classroom. Tixcacalcupul, Yucatán, 2001.

Their bosses were very strict. Felipe's were Americans and Costa Ricans and Barbara's were Chinese. They locked the gates in the morning; if you weren't on time, you didn't work that day. There were no excuses. They didn't even allow employees to talk while working.

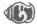

Alicia was promoted to director of the bilingual kindergarten in Tixcacalcupul where she taught. It was the only bilingual education the four- and five-year-old students would receive. Once they graduated to primary school, they would be taught in Spanish. Alicia had twenty-three students; seven still spoke only Mayan. Even though the law provides for bilingual education past kindergarten, it is rarely supported.

Mexico has had a problem educating Indians since the conquest. Colonial education began with the best of intentions with special schools for gifted Indians, who excelled at learning Spanish, Latin, and Greek. But the students embarrassed the Spanish. It wasn't proper that their subjects knew as much as they did. They didn't want Indians who could translate Virgil; they wanted Indians who would work in the mines and on the ranches for low or no wages. Educated Indians who might aspire to positions of leadership and sub-vert the Spanish monopoly on power were the last thing the Spanish wanted. By 1553 the Spanish forbade any accounts and histories of the conquest to be sent to the Americas, let alone any that might praise one of the Indian cultures.[5]

So how much progress has been made in the 500 years since the Spanish arrived? Can a Maya villager today compete with a Hispanic student from Mexico City, Guadalajara, Monterey, or even Mérida? In 2006 the Mexican government invested an average of $730 per student per year in urban areas and $63 per student per year in indigenous areas.[6]

Although millions of people still speak Mayan, many children will not learn their parents' first language. Sometimes it is the parent who doesn't teach the child, worried that speaking an Indian language is a handicap. At other times the school system insists upon Spanish and punishes speaking Mayan in the classroom. Repressing a language is a big step in repressing a people. Language is the repository of cultural tradition. Language diversity is as important to our cultural survival as biological diversity is to our physical survival. Today the majority of the world's languages are in danger of disappearing. Of the world's 6,500 living languages, more than half are spoken by fewer than 10,000 people. Most of these are expected to die out within forty years unless a new generation of speakers learns them. According

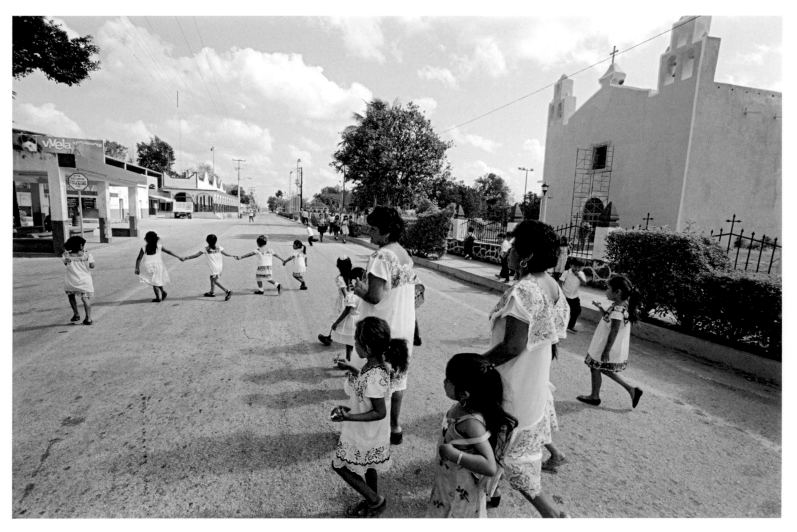

Alicia with her students on an excursion. Tixcacalcupul, Yucatán, 2001.

CLOCKWISE FROM TOP LEFT: Veva, Chichimilá, Yucatán, 1976; Abril, Alicia's daughter, Chichimilá, 1992; Alica at the chiclero camp, Campamento Manuel Antonio Ay, Quintana Roo, 1971; Veva with her mother, María Cruz Cumul, Chichimilá 1990.

to Andrew Woodfield, director of the Centre for Theories of Language and Learning in Bristol, England: "The fact is, no one knows exactly what riches are hidden inside the less-studied languages . . . By allowing languages to die out, the human race is destroying things it doesn't understand."[7]

Mexico alone has 288 living languages. Words are the genes of any culture: if the words disappear, so do the knowledge and the culture.

Veva came running out to greet Mary and me when we returned in July 2002. She gave us each a big hug and a kiss and told us that she was going deaf. So we yelled our greetings, and she laughed. Instead of inviting us into her house, Veva took us next door. Juan and Alicia had moved back to Chichimilá—they were renting out their house in Valladolid and only had a year more to pay it off. Veva was clearly pleased that the whole family was home. Abril was now eighteen, Josué was fifteen, Miriam was twelve, and Atalia was eleven.

There is such a pleasure in seeing old friends. We got caught up with each other's news and shared in the little joys, triumphs, and sorrows in our lives. Everyone was excited to see Mary again, and they all had questions for her. When Josué asked her about the Internet, Juan interrupted, asking me if I thought the Internet was bad. Without waiting for an answer, he told us that he considered it a font of pornography. Mary came to Josué's defense and told Juan that the Internet could be a library at his fingertips and that she had a website she hoped his kids could look at. Juan shook his head, which meant that we were about to be subjected to a monologue. Mary squeezed my hand and suggested we go outside, where the air was cooler.

Half a year later I was back in Chichimilá, this time with Charles. We were making a pilgrimage to nearby Xocen and the Cross of the Center of the Earth during a period of Maya religious celebrations. In 1973 Veva, Cornelio, Alicia, and I had walked out to the Cross, before there was a road, and lit candles at the holy shrine. But Veva and Alicia couldn't do that any longer because their new religion forbade it. Even lighting candles was pagan. When Alicia went to Xocen now, it was to proselytize with Juan.

It was late afternoon when I arrived at my comadre's house. She was next door with Juan and Alicia. They were about to hold an Evangelical service in their house—they'd covered a patio with a concrete roof and turned it into a meeting room. Juan told me it would be fine if I wanted to take photographs.

Veva and Alicia took their seats in the front row. Josué and Abril were in charge of the music and sound. They sat at a control panel at the back of the room. While they were setting up, Juan tested the microphone at the lectern and told me a little bit about the service. I asked him if I could get a photograph of Alicia at the lectern—would she perhaps speak or read a lesson from the Bible?

Juan smiled but shook his head.

"Women can't teach a man," he said. "It's in the Bible."

At first I thought he was joking. I started to joke too, until I realized he was serious. My father is an Episcopal priest and missionary, so I was raised in a church. My father preached a Christian ethic that promoted compassion, respect, tolerance, belief, and forgiveness.[8] I was so upset by what Juan told me that I had to leave soon after the service started.

Luis was outside, leaning against Veva's house. When he saw me, he staggered over and wrapped his arms around me so that I had to hold him up. He was very drunk. He released one arm and gestured at Veva's house. "This is your house," he told me. "It is my house and you are always welcome."

He lowered his voice and asked me to lend him ten pesos to buy a bottle of beer. When I gave him the money, he released his grip and stumbled out of the yard. I heard him work his way down the street toward a store, shouting insults and talking to himself in Spanish and Mayan, experiencing both salvation and damnation and letting everyone know it. Next door I could hear Juan lead his congregation in a hymn.

I got in my rental car and drove back to Xocen. Juan's statement really bothered me. I couldn't sleep that night. I wanted to talk to Alicia. I couldn't fathom how people could suggest that God was so mean and small-minded that women weren't considered equals or allowed to speak. And what kind of God would forbid a mother to attend her son's wedding?

The next morning I drove down to Tixcacalcupul to give Alicia a ride home from work. It was also a chance for me to photograph her working with her students in her classroom. After class ended at 11 A.M., we sat in the shade on a low step outside her classroom, waiting for all her students to be picked up. Traffic passed intermittently on the main road between Valladolid and Carrillo Puerto, rumbling as the drivers downshifted for the speed bumps, then whining as they sped away.

"Alicia," I said, working up my courage. "You have taught for twenty-two years. You own a house in Valladolid and another in Chichimilá. You've gone from being a young girl living in a jungle chiclero camp to being a bilingual schoolteacher. Your own children speak Mayan, and your husband learned Mayan. Your family is healthy. You take care of your mother, who lives next door to you. None of your immediate family smokes, drinks, or take drugs. Your eldest daughter is going to college to study business administration. What you've accomplished is amazing. Using you as an example, what do you think is the role of a woman today?"

"Today there is a place for women in the workplace," Alicia answered. "Before, a girl was simply prepared for marriage: how to cook, how to wash, how to sew. Women were not treated equally. Parents discriminated against their daughters. They couldn't see the benefit of educating a girl. Even today this is a problem. Parents don't extend as many opportunities to their daughters. But it's shortsighted, be-

cause it's usually the daughters who take care of their parents in old age. If they were able to earn more, their parents would be better off."

Alicia flicked away a fly and continued. "Up until fifteen years ago girls would only study until the sixth grade, if that. Now they continue through high school and go on to technical schools and colleges. There are no limits to what a woman can personally do now. Today a woman can even be accepted as a politician."

She flicked the fly away again. "But there is still a problem with fighting between husband and wife. Usually the woman doesn't say anything. And there might be more cases of adultery right now, at least I hear of it, and I think the reason is because of the *telenovelas* [television soap operas]. They give people the idea that it's okay. There are also more divorces. But with both parents working, both contributing to the well-being of the family, the woman has become as important as the man. They are both equals."

I asked her who did the cleaning and washing in her home.

"I wash the clothes, but Juan cleans the house. Before, a man would never grab a broom or a mop and now they do." She laughed and proudly said, "He says I am the queen."

"So the two of you are equals?"

"Absolutely," Alicia said with conviction.

"Why did Juan say yesterday that a woman couldn't stand up to read a lesson?"

Alicia looked at me a moment. "The Bible says a woman can't teach a man."

"But that is exactly your job in life. You're a teacher. You teach both men and women."

"They're just children."

"But we're all children in the eyes of the Lord," I said.

"My job as *maestra* [teacher] is secular," she said in a tone that made me feel I was one of her students. "In the Bible it says only men can teach. A woman and children have to listen." Alicia quoted a verse to back up her statement, folded her arms, and began to tell me about the true path to salvation. When I tried to say something, she only raised her voice.

"Your explanation is very good," I said, trying a different tack. "You're teaching me, and I'm a man. And I'm really proud of you for everything you've done. Because of that it hurts me to hear someone tell you that you can't do something or be something."

"Don Macduff," Alicia replied in exasperation. "This works for our family. Changing religions helped us. Juan was drinking and we fought. When he was born again it gave him responsibility. I was happy to cede him the leadership because now he wasn't drinking and the two of us were working together again to raise the family."

She looked me straight in the eye. "It is a small price to pay."

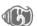

On Mother's Day 2005 I brought my comadre flowers from the market in Valladolid. I'd found a lei of *flor de mayo*, the fragrant plumeria. When I called out a greeting from the gate, Veva appeared in the doorway of her house, the one we'd rebuilt after Hurricane Gilbert. I saw Luis also come to the door. Veva gave me a hug and a kiss. She laughed and told me, as she always did whenever I visited, that she was hard of hearing and I'd have to shout. She giggled and took the flowers, happy because Luis was home.

Veva told me how relieved she was that Luis had quit his job at the ranch. She'd worried that a snake would bite him; with his slingshot Luis had just killed a rattlesnake that was two meters long. He showed me the tooth of an agouti, an animal sometimes considered a pest in the milpa. He told me that Maya fathers would string one on a little collar and put it on baby boys so that they too would be good at digging up the milpa.

We took a walk in the back garden so Luis could show me how he was taking care of it. He was very pleased with his work, but he really wanted to show me that he was taking care of his mother. He'd planted new rows of pineapples and was attending to all the trees—allspice, lemons, oranges, plums, and zapotes. Veva hadn't stopped smiling. I hadn't seen my comadre so happy for ages. When we walked back inside Luis told me he was happy I'd come because this was my house too, and I was always welcome.

I told him that I knew that and was happy to be home.

1. Charles Taze Russell, who based his religion on Bible prophecy, founded the Jehovah's Witnesses in the United States in 1884. They claimed that they were the sole channel of information between God and humanity and that Jesus had returned to earth in 1874 to set up his kingdom and would annihilate the wicked in 1914. When that didn't occur, they declared that Jesus was actually setting up his kingdom in 1914 and that the Apocalypse would occur in 1925. When that didn't happen, more than half the members of the Jehovah's Witnesses left the organization. Starting in 1968, the Watchtower Society prophesied that Armageddon would arrive in 1975. Many members quit their jobs and sold their houses, awaiting the Great Day. When it didn't arrive, many left the church. Current members don't seem bothered that these predictions didn't come to pass or that their religion is at odds with science. They meet regularly for Bible study, although they rarely actually read the Bible—they use a study book and read magazines and tracts published by the Watchtower that include questions and answers on things to be discussed. The problem is that the answers are already provided, so that the questions don't require any independent thought or introspection. As with other cults, there are deprogrammers and groups to help people leave the Jehovah's Witnesses.

2. Farris 1984:334.

3. In a bizarre twist, some expelled Chamulans didn't find that their new religion satisfactorily replaced the culture and customs they'd given up and have since converted to Islam. San Cristóbal de las Casas now has a mosque.

4. Providing jobs is so important that many maquiladoras don't pay for their land or buildings. The government subsidizes all utilities, including water and electricity. One of the few success stories is a second-generation orthodontics robotized factory run by Maya women. The women only have a grade-school education, whereas other factories doing the same work require their workers to have a college education. But the managers in Yucatán discovered that Maya women who embroidered and stitched already had the skill to operate the machinery. "Some doubt exists to the actual benefits of maquiladoras to the local economy, since many concessions are made to bring them in in the first place, none of the products reach the local markets, and the employees are nothing more than a pair of hands with not much in the way of career development in the offing. Maquiladoras are hated by many locals (especially among the well-off female population) since these new options for employment are located close to villages and towns that have traditionally supplied Mérida with a generous stock of maids, gardeners, chauffeurs, thereby resulting in a drastic shortage of same." Hollmann 2008.

5. "Colonial education was a system of learning best defined as guided intelligence. Furthermore, the system of publication that went with it was also sometimes highly restrictive. Only six years after the conquest of Mexico, the Crown ordered no further publications of Cortés' letters to Charles V relating the events of that conquest. Spanish royalty did not wish to foster the cult of personality of the conquistadors. In effect, we were forbidden to know ourselves. In 1553, a royal decree prohibited the exportation to the Americas of all histories dealing with the conquest. This is not to mention any histories praising the defeated Indian cultures." Fuentes 1992:143.

6. Martínez 2006.

7. "We have inductive evidence based on past studies of well-known languages that there will be riches, even though we do not know what they will be. Perhaps Waimiri-Atroari or Guugu Yimithir will give us some really important new information. The argument for conserving unstudied but endangered plants has a similar logic: strange plants may contain medically valuable ingredients, so there ought to be a presumption in favour of their survival. It seems paradoxical but it's true." Woodfield 1995:34–36.

8. "Sacred texts," writes Charles Kimball, "are the most easily abused component of religion. Daily newspapers and broadcasts are filled with examples of religious and political leaders citing selected verses or phrases

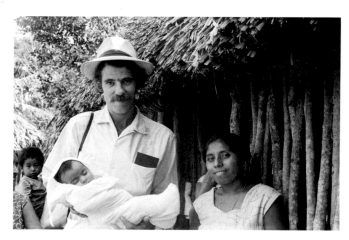

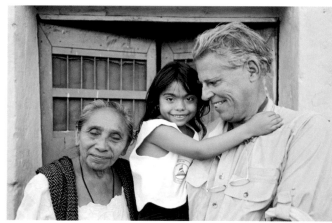

TOP: Holding my goddaughter Cecilia, with Alba, my comadre. Valladolid, Yucatán, 1974.
BOTTOM: Holding my goddaughter Cecilia's daughter Kandy, with Veva. Valladolid, Yucatán, 2001.

from the Bible or Qur'an in support of policies that affect the lives of millions. Sacred texts provide an accessible and authoritative tool for promoting an agenda or cause."Kimball 2002:53.

Marc Brettler, co-editor of *The Jewish Study Bible* and a biblical scholar at Brandeis University, was interviewed by Robert Siegel on *All Things Considered*, January 20, 2004. He points out that the Old Testament includes 613 different commandments according to traditional rabbinic counting. Don Lattin, religion writer for the *San Francisco Chronicle*, explains the problems with the Ten Commandments. "Even the Bible contains two versions, one in Exodus 20:1-17 and a slightly different one in Deuteronomy 5:6-21. There are, of course, various English translations of those ancient Hebrew texts. By some counts, there are actually Twenty-nine Commandments, not Ten Commandments. 'Thou shalt not commit adultery' is either commandment six or seven and originally only forbade sex with a married woman. Married men were free to have sex with other females. That's because establishing paternity, not maintaining sexual purity, was the reason for that commandment. Then there are the commandments in the next chapter of Exodus, which allow fathers to sell their daughters into slavery (21:7) and say that 'whoever curses his father or his mother shall be put to death' (21:17)." Lattin 2003.

When we read the Bible, my father told us that these were oral stories, because most of the desert tribes didn't know how to read and write. Writing the stories down occurred over a period of a thousand years—most of it in Hebrew, but some in Aramaic, and much of the New Testament in Greek. Before the invention of the printing press, each Bible was copied by hand, and over the centuries many unintentional mistakes and intentional changes dramatically altered the meaning of the original text. Some people who copied the texts could hardly read. The Bible has now been translated into 2,300 languages. Each translation is only as good as the translator. They should be translated directly from the original but often aren't, so each mistake is compounded. As an example of how large a difference a slight variance could make, my father cites two translations: "Peace on earth and goodwill to men" and "Peace on earth to men of goodwill."

My father points out that people get so involved in the wording that they lose sight of the meaning. He thinks it rather foolish to think that God wanted us to take everything so literally; otherwise why did Jesus use parables to teach his followers? It's important to remember that language had to be symbolic when writing about God. And in a sense there are no original texts of the Bible, just various ancient manuscripts that preserve the oral traditions handed down from generation to generation. The Bible implies that humans have the responsibility to use our inherited "gifts" in a positive manner. God gave us brains to use to read and to learn from the writings of scholars and teachers who have spent years studying and translating the Bible. These scholars present different points of view, and we need to decide which to accept or reject. It is God's story but inevitably our words.

My parents have a Christian compass to guide them. Their belief in God lets them accept other religions and other cultures. My father believes that God has revealed himself to many different people in many eras in many different ways and many different languages. He finds a lot of truth in many religions—and if you compare them—many similarities. Although he feels that Christianity is perhaps the fullest revelation of God and the most complete, it is not the only valid religion. Because of that, he respects others who hold similar beliefs by a different name. He believes that there's a problem with any group that doesn't allow its members to visit other churches to explore their faith tradition. "One way to understand what other religious groups teach and believe and how they worship," my father once told me, "is to attend one of their services. By attending you aren't condoning or adhering to their beliefs. However, you have a better understanding of their religious heritage. Broadening your religious experience can strengthen your faith, rather than diminish it."

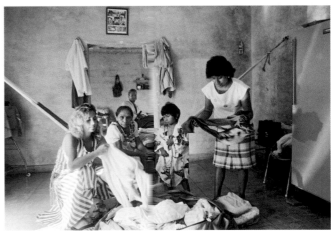

TOP: Bonnie Bishop and I baptizing our goddaughter Cecilia. Valladolid, Yucatán, 1974.
BOTTOM: Mary with Veva, Abril, and Alicia. Chichimilá, Yucatán, 1988.

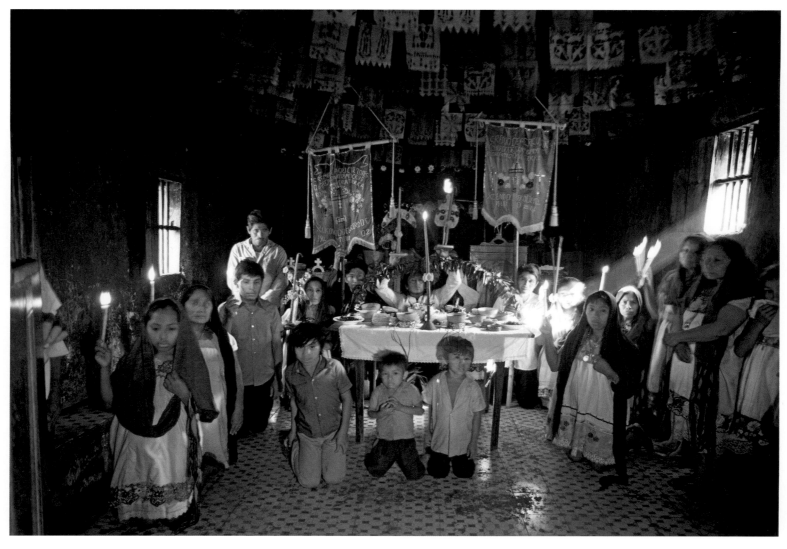

Pilgrims at a shrine, Santa Cruz Tun Chuumuk Lu'um. Xocen, Yucatán, 1976.

The fiesta is celebrated every year to give us a moment or two of diversion and to remind us that another year has passed.
CELSO DZIB AY, XOCEN, March 1, 1975

Physical anthropologists tell us that scientifically speaking there is no such thing as race. But for most of recorded history, we must deal with people unaware of this recent finding and for whom race was a palpable reality. It may be that all groups are inherently "racist" in the sense that physical differences are the easiest way to distinguish the "us" from the "them." Another view, not necessarily incompatible, holds that racism is a byproduct of any unequal encounter between two racial groups, as in a colonial situation, in which racial differences become a convenient a posteriori criterion and justification for unequal access to wealth and political power.
NANCY FARRISS, *Maya Society under Colonial Rule*

V Xocen: The Saintly Cross of the Center of the Earth

An account of the miraculous Saintly Cross of the Center of the Earth, the Caste War of Yucatán, and the Santa Cruz Maya; we attend religious celebrations in Xocen, talk with a Maya priest, and visit our friend Celso Dzib May and his wife, María Equilia May Tun

When Hilario suggested that we all take a walk on a spring day in 1971, we left early while the air was still cool. Hilario's wife Fina and my six-year-old son Robert joined us. We took the Xocen trail that passed in front of his house in Chichimilá. We were in the dry season when many trees lose their leaves, so the sunlight passing through the forest canopy was more dappled than usual. The rocky path was a ribbon of light through the forest, and the ground was a palette of earth tones, from tans to deep red soils. Although the land was relatively flat, the well-worn trail dipped and climbed; and any attempt at a straight line was quickly interrupted by limestone outcroppings. We had to walk single file. At five kilometers we passed through Xocen and continued another kilometer and a half past the village center until we reached a chapel lit by morning sunshine, standing in a clearing in the forest.

The chapel was a small rustic version of a Yucatecan colonial church: thick plastered stone walls, double doors, and an *espadaña* (raised gable) topped with a masonry cross. The interior was as cool and dark as a cave; my eyes had to adjust before I could see everything. The floor tiles were colored squares against a white background. Paper pennants in bright colors hung in rows from the ceiling. Candle smoke had added a dark stain to the walls. Directly in front of us was an altar, almost as wide as the room, covered in floor tiles. A thick stone cross emerged from the altar. Its arms were covered with a *sudario* (embroidered cloth). Hanging from the neck of the cross were beeswax and metal *milagros* (ex-votos offered as a reminder of a petitioner's particular need).

Hilario pulled out candles from his sabukan. We each lit three and placed them on a wooden stand in front of the altar.

"This is Santa Cruz Tun Chuumuk Lu'um," Hilario whispered, "the Saintly Cross of the Center of the Earth. The Maya believe that the cross extends to the center of the earth and that it is very, very old. This is a very holy place because the cross told the ancient Maya where to find their first corn seeds.[1] Today pilgrims, especially farmers, come from all over the peninsula to light their candles before it. After the conquest, the Spanish tried to move the cross; but they couldn't because it is made from a stone so large and set into the earth so deep they never could finish excavating it."

When the Spanish arrived in Yucatán, they often held religious ceremonies in mission churchyards, oriented to the cardinal directions. The yard usually included four chapels at its corners, known as *posas*, and in the center was a cross. It was easy for the Maya to continue their own beliefs because that shape is found in art and architecture throughout Precolumbian America. It symbolized the four corners or four directions and the ceiba tree: the tree of life, the World Tree of the Center. As David Freidel, Linda Schele, and Joy Parker point out, "The Christian cross became, quite literally, the pivot and pillar of their cosmos, just as the World Tree had been before."[2] The Maya's appropriation of the cross became abundantly clear in the nineteenth century when they began worshipping a speaking cross that spoke to them in Mayan.

The Caste War of Yucatán erupted in July 1847 when the Mexicans in Valladolid executed Manuel Antonio Ay, the local Maya cacique of Chichimilá, for allegedly plotting against them. The Maya responded by successfully attacking the nearby town of Tepich, and their victory inspired others to fight. What began as a social and political conflict soon escalated into a savage racial war. Ironically, it was the dzules who had armed and trained the Maya in modern warfare. For three hundred years the Maya hadn't had a warrior class, and then the Mexicans created one. Between 1821 and 1855, immediately after independence, Mexico underwent forty-two changes of government. Yucatán underwent just as many, with factions pitted against each other amid shifting allegiances and coup plots. The dzules gave the Maya guns and pressed them into serving as soldiers in their political skirmishes. The unintended consequence was that the Maya gained modern weapons and learned European military science.

The dzules, distracted both by political intrigue among themselves and by an attempt at independence from Mexico, didn't respond quickly to the Maya revolt. Vastly outnumbered by the Maya, they offered Yucatán's sovereignty to the United States, Great Britain, and Spain, if one of them would just come in and wipe out the rebel Indians. All three

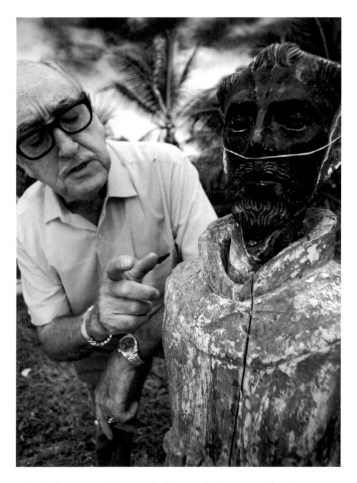

Pablo Bush Romero with a recently discovered saint captured by the Santa Cruz Maya during the Caste War. Akumal, Quintana Roo, 1974.

nations declined after President James K. Polk invoked the Monroe Doctrine, so Yucatán set aside its aspirations for independence and agreed to remain a part of Mexico in exchange for help in suppressing the revolt.[3]

The Maya took town after town. Many dzules, fearing that the machete-wielding rebels would slaughter them all, fled to the coast and escaped by boat. By May 1848 the Maya were on the outskirts of Mérida. But to the surprise of the remaining dzules, the Maya didn't attack. Instead they returned to their villages. Popular history says that the Maya, farmers all, realized that it was time to plant their crops and went back to their villages.[4]

The story sounds apocryphal. Another reason could be that the rebels weren't picking up new recruits as they got closer to Mérida. Although these more Hispanicized Maya were at the bottom of a socially and ethnically stratified society, their life was stable, and they probably felt uneasy at upending the social order. More likely the rebels felt that they'd achieved what they'd set out to do. They had won back the land stolen from them. The dzules could keep their city of Mérida. Since the sixteenth century the Maya had been farmers, not warriors nor city folk, and their leaders rose from the

ranks. It is reasonable to believe that the Maya had little interest in occupying Mérida.

Given this reprieve, the dzules soon regrouped, counterattacked, and started winning back territory. To punish the rebels they burned villages and farms and slaughtered men, women, and children. As the rebel situation became direr, approximately 100,000 Maya retreated and fought from the forests.[5] Hope was running out when a Maya discovered a small cross carved on the trunk of a mahogany tree at the entrance of a cenote deep in the jungle.

The cross spoke: the Christian God spoke to His people in Mayan! As word quickly spread among the rebels, they realized that they now had a direct link to God in heaven and that Roman Catholic priests were no longer the intermediaries, the official conveyors of God's word. In contrast, the dzules found the Maya's appropriation of their religion to be blasphemous and an affront to their beliefs—God had always been on their side, for Christ's sake!

The cross claimed to be the Trinity itself, and the original cross became three. The Maya could believe that God spoke to them through His cross because it was His symbol. They readily accepted the cult of the cross because it revived practices and ideas already deeply rooted in their religious tradition. Their ancestors had worshipped speaking idols, and the Maya had continued to commune with the spirit world through religious rituals.[6]

Ironically, the Spanish had allowed the Maya to maintain their own identity and dream of an independent future because they hadn't integrated the Maya into society. "The Caste War," notes Farriss, "reveals not only the profound resentment against the dzuls long harbored by the Maya, but also the social and cultural vitality that had enabled them to sustain through the centuries of colonial rule such a strong sense of their own identity, with an independent even if not fully remembered past and a vision of an independent future."[7]

Few communities before the Caste War had resident priests, so a member of the village Maya elite, in the position of *maestro cantor* (master singer), knew the services and performed many functions of the clergy. In charge of liturgy and catechism, they were shadow priests. They had also kept the oral traditions and in the eighteenth century were probably the authors of the Books of Chilam Balam (chronicles written in Yucatán by the Maya). During the Caste War they resumed the role of the Maya *ahkin* (chief priest; literally "sun king").

The Speaking Cross revitalized the rebels. After making adjustments so that they became the favored children of God and the dzules became the unworthy ones, their religious worship centered on their devotion to crosses, personified like the gods of old. The cult of the cross gave the Maya the self-identification, security, and higher authority to continue fighting. They were particularly dangerous because of what they had learned from the dzules. God could tell them what to do. So when they went out to kill they were not being

bloodthirsty or savage: they were following God's orders.[8] Out of this emerged a theocratic-military society commanded by the *tatich* (patron of the cross), in which every male was both citizen and soldier. The Maya didn't make a distinction between the sacred and the secular in either theory or practice.[9]

A village founded where the cross was discovered soon developed into both a holy city and the rebel capital: Noh Cah Santa Cruz Balam Nah (Great Town of the Holy Cross Jaguar House). In 1860 the Maya built a massive stone church for the crosses.[10] Soon a speaking cross appeared at several other rebel villages. If a sacred cross (Santa Cruz) was captured by the dzules, a new one would take its place. Whereas before they'd been called *sublevados* (rebels) or *indios bárbaros* (barbaric Indians), now they were the Santa Cruz Maya.

The rebels traded with the British in British Honduras (present-day Belize). The British, who didn't want to see the Caste War expand across the Río Hondo into their territory, decided to appease the Maya rather than oppose them.[11] The British treated the Santa Cruz Maya as a sovereign group and supplied them with arms and munitions for decades, even sending envoys. The Santa Cruz Maya paid for their purchases with booty and timber concessions.

Surprisingly, the Yucatecans also conferred sovereignty on the Santa Cruz Maya. In 1855 they resolved that, if they couldn't win the fighting outright, they would declare the Caste War over and Noh Cah Santa Cruz a sovereign nation so that further skirmishes would no longer be considered internal revolution—an example of nineteenth-century political spin.[12]

In any case, the Caste War continued unabated. Each year the two sides invaded each other's territory, pillaging, plundering, and burning whenever possible. The war left the more fertile but dangerous frontier zone between the two cultures a no-man's-land, resulting in the rapid growth of haciendas cultivating henequen in the northwest, which was suited to the area's drier rocky soil. The entire eastern section of Yucatán was conceded to the rebels, and the war continued into the twentieth century.

For the dzules, political intrigue in Mérida was much more exciting and remunerative than dying in the fetid Yucatecan jungle. There was another problem: when a commander went out against the rebels, he wasn't sure what government and political party would be in control when he returned. Yucatecan politics involved rival cliques fighting over profits and maintaining a delicate balance in which each faction got its turn in power. It was a situation where greed simply overcame any suggestion for social improvement. The Caste War festered along the frontier. Every year brought some more deaths, but not enough to require them to do anything.

A turning point occurred when Mexico and England signed the Spencer-Mariscal Treaty in 1893. Besides determining the boundary between Yucatán and British Honduras, it also specifically stopped the sale of guns and ammu-

Church damaged in the nineteenth century during the Caste War. Tihosuco, Quintana Roo, 1971.

nition to the Maya. With no way to resupply, it was only a matter of time before they could no longer fight major battles. In 1901 Mexican troops, under General Ignacio Bravo, captured Noh Cah Santa Cruz, but they found it abandoned—the Maya had slipped into the jungle. The Mexicans renamed it Santa Cruz del Bravo and used it for their headquarters (the town would later be renamed Felipe Carrillo Puerto, after the popular governor of Yucatán and friend of the Maya, who was assassinated in 1924).[13]

The Santa Cruz Maya continued to worship their miraculous crosses, kill trespassers, and refused to surrender. To this day they entertain hope that the queen of England will help them in their struggles.

"The Caste War of Yucatán is without question the most successful Indian revolt in New World history," writes Victoria Bricker.[14] But it came at a stiff price. Bruce Vandervort notes: "In terms of sheer human suffering . . . the 1847–1900 Caste War between Maya rebels and state and federal authorities may have cost some 200,000 to 300,000 lives, from a third to a half of the country's total population. In some areas of Yucatán, around 75 per cent of the population died in the fighting."[15]

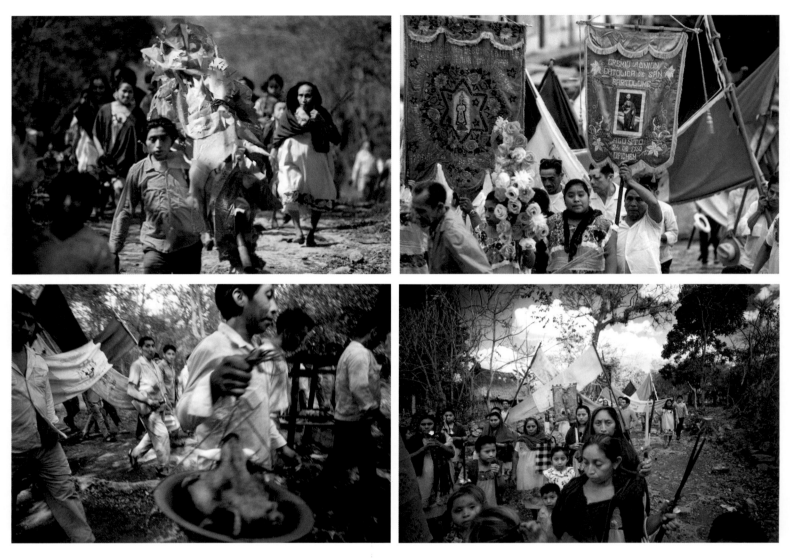

Gremio procession to the shrine of the cross, Santa Cruz Tun Chuumuk Lu'um. Xocen, Yucatán, 1974.

It wasn't military might but chewing gum that finally ended most of the fighting. When chewing gum became popular, entrepreneurs wanted to bleed the chicozapote trees found throughout the rebel Maya territory. In 1918 General Francisco May, one of the leaders of the Santa Cruz Maya, granted concessions for chicle collecting. For the first time, instead of killing outsiders, the Maya worked alongside them.[16]

To this day, the Santa Cruz Maya have never officially surrendered. Although their crosses no longer speak, the sacred villages are their civil and religious centers, each with its own sacred cross. The sacred shrine villages today are Tixcacal Guardia, Chancah Veracruz, Chunpom, and Tulum (another shrine center at the village of San Antonio Muyil, northwest of Tulum, was overrun and burned by Mexican soldiers in the nineteenth century and never resettled by the Maya, but its cross was successfully hidden). Much like the city-states of the ancient Maya, each has its own satellite villages that assist in ceremonies, fiestas, and guard duty. Of all the Maya in Yucatán, the Santa Cruz are the most resistant to change and most conscious of retaining their cultural autonomy.

For many people the Caste War of Yucatán is only a footnote in the history of the peninsula, but for the Maya it is still a current event. When I first arrived in Quintana Roo in 1967, many villagers had fought against the Mexicans or knew someone who had.[17] One of the last conflicts where soldiers and Santa Cruz Maya fought and killed each other had occurred only thirty-four years earlier.[18] The long war has affected Yucatecan and Maya societies to this day.[19]

Charles discovered the specter of the Caste War firsthand in 1975 when he walked on forest paths with Pablo Canche Balam, our chiclero friend, from Tulum to Valladolid. It turned out that dzul public officials in Valladolid had made promises of civic improvements to the inhabitants of Kanxoc, a village near Xocen, but hadn't fulfilled their pledge. The people of Kanxoc have a reputation for being belligerent. The angry villagers marched into Valladolid to file a grievance with the mayor. When he wouldn't give them an audience, they looted a liquor store, yelled and shouted threats, then walked the nineteen kilometers home. Things didn't improve when they shot the tires of a car of a government official who tried to drive into Kanxoc the next day. The federal government responded by sending soldiers from Valladolid on a large sweep of the forest and settlements around the village.

Pablo and Charles were still deep in the forest southeast of the village when they met an old mazehual coming along the trail. The man spoke with Pablo and said it would be very dangerous to pass through Kanxoc, as Charles would be taken for a spy. Pablo and Charles agreed to make a wide detour. This innocuous-looking old man was a messenger on an important mission to warn Maya in hamlets throughout the roadless forest that the soldiers were coming. As for the unrest, no more shots were fired, although everyone was on edge for months afterward.

The Spanish word *gremio* means guild. In many towns in Yucatán, you can find gremios dating from the time of the Spanish colony that represent the livelihoods of a community (for example, the potters' guild, the cattle ranchers' guild, and the merchants' guild). Some gremios are open to everyone, while others are open only to members. Once a year the guilds celebrate a week that includes communal feasts, processions, and religious observances.

I first experienced a gremio festival in 1971 when I visited Ticul on the day of the cattlemen's guild. It seemed as if everyone in town was dressed for the evening dance. The women wore their finest ternos or huipiles. The men wore white pants, guayaberas, and their dancing sandals, some with heels (like cowboy boots). Before the dance, the guild put on a fireworks display. Men and boys lit rockets and pinwheels—touching their cigarettes to the fuse—and the crowd oohed and ahhed. There were no barriers, and we were all jammed together. At one point one of the rockets misfired and took off horizontally through the crowd, bouncing off people and walls until it finally came to a stop underneath a woman wearing a huipil. The rocket glowed like a roadside flare beneath her dress, outlining her with an ethereal green light. For a moment the woman did not move, and the crowd was transfixed as if we were viewing an X-ray. Then she seemed to move in slow motion, until the rocket expired. Amazingly, she wasn't harmed. We all gave a collective sigh of relief; we'd just witnessed something we'd never see again.

My next gremio experience was in Xocen in February 1974. Although a road had just reached the village, few cars or trucks did. Paths wound down the center of the village streets, polished and compacted from constant foot traffic. The village had no electricity, so the hum was the sound of neighbors, animals, birds and the rustle of the wind rather than televisions and machinery.

I'd made several pilgrimages on foot to the Cross but had rarely met anyone else at the shrine, so I wasn't expecting to see a crowd spilling out of a yard near the village center. An acoustic band was playing extended jaranas, a style of old Spanish music adopted by the Yucatecans as their own. Everyone I met was friendly, and several in the crowd invited me to join them in a drink of rum and invited me to take photographs when they saw my camera. Even without my asking, they tried to answer my questions. They told me that the celebration was communal, traditional, and would last a week. I learned that all the gremios in Xocen were made up of agriculturalists—such as farmers or beekeepers. Xocen was home to the Cross that belonged to all the mazehual'ob of the region, so gremio celebrants even came from villages in Quintana Roo. Each day of the weeklong celebration had a *cargador* (sponsor); we were sitting in the yard of today's sponsor. His duty was to make sure that everything was taken care of, including firewood for all the cooking, raw ingre-

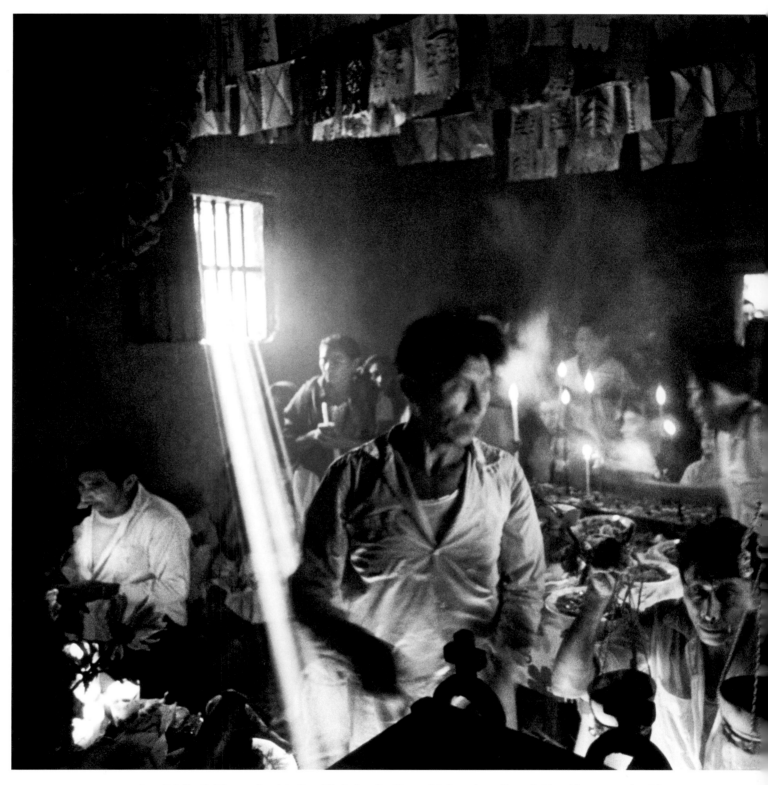

CLOCKWISE FROM TOP LEFT: Jorge Koh (*front*) at the gremio celebration at Santa Cruz Tun Chuumuk Lu'um, 1974; milagros fashioned from wax and metal around the neck of a cross, 1971; Basilio Nahuat (*left*) and Gustavo Tun, two pilgrims with candles and crosses made from beeswax, 1976; offerings on the altar in front of the cross during a gremio celebration, 1974. Xocen, Yucatán.

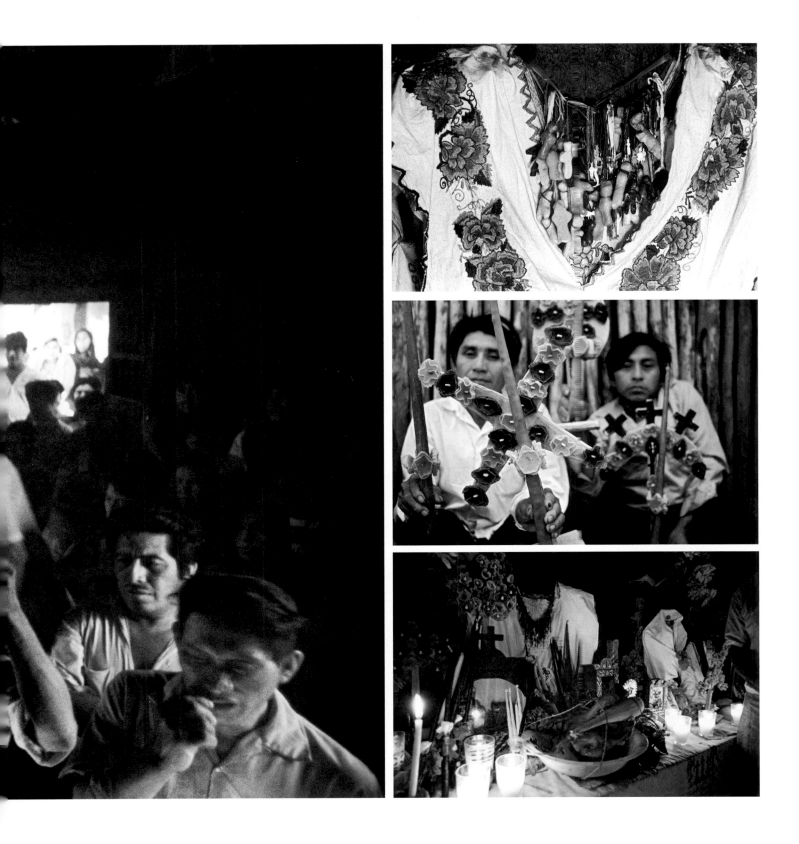

dients to prepare the relleno negro (corn, chickens, pigs, turkeys, spices, and chiles), corn for tortillas and breads, and balche' and rum to drink. He was also responsible for the banners and altar arrangements, the offerings and fireworks, and the saints and crosses as well as the musicians and the Maya priest. The cargador had a year to make arrangements, calling on his kinfolk and circle of friends and community to help. It was an expensive role and required a lot of work and orchestration.

One day earlier, the cargador's assistants had gone to the church in the center of town and brought back three crosses (the Santíssima Trinidad), brothers of the Cross of the Center of the Earth. The three crosses were also intriguingly referred to as the Gavilán de Cristo (Hawk of Christ) or the Gavilán de Tres Personas (Hawk of Three Persons). They would carry the crosses out to the jungle shrine and, after prayers, walk them back to the church in the center of town, where the next day's sponsor would take over.[20]

The previous day the cargador and his helpers had prepared offerings of food in earth ovens. The breads had cooked relatively quickly and been removed, but the relleno negro baked overnight. In the morning they'd opened the oven and offered the rich fragrant food, along with fresh handmade tortillas, to everyone, including me when I arrived. The men suggested that I have another shot of rum, because we would soon all walk to the shrine in a great procession.

As they said this, a group of worshippers came out of the sponsor's house and spread apart to unfurl the embroidered and appliquéd banners that they carried on poles. Others brought out offerings they'd prepared. A man next to me lifted an *horqueta*, a pole with a fork of three branches from which he'd created a basket using jungle vines, making it bright and gay with colored tissue paper. He'd filled it with ears of corn, black beans, white beans, squash seed, and lentils, the products of the milpa and the sustenance of the mazehual'ob. Another fellow clutched a turquoise plastic bowl containing a pig's head with an ear of corn stuffed in its mouth. One man held a large glass jug of honey on his shoulder, and behind him was a man with an offering of yams and squashes. On my left a man appeared with another pig's head, this one in a yellow plastic bowl. Men and women gathered to share the privilege and burden of carrying the saints and crosses in their shrines of wooden boxes with glass fronts. Still others brought *ramilletes* (bulbous bouquets of paper flowers).

Many offerings were decorated with colored ribbons and tissue paper with designs cut in it. Most of the women wore their finest huipiles, and many carried long, unlit candles (either store-bought paraffin candles or handmade beeswax candles). I excused myself from my *compañeros* (companions) and started to photograph. After a short shuffling of banners and shrines, everyone fell into place, and the procession began. We walked out of the yard and onto the path leading to the Cross. The band determined our pace, and we walked slowly as men lit rockets and fireworks. The raucous

noise was a contrast to the piety of the pilgrims. We passed the last houses of the village and entered the forest. The path to the chapel was as wide as a street but rocky, and the forest canopy shaded the trail. It was the first time I'd walked into the jungle in a procession; because it was the dry season, we walked on a carpet of fallen leaves.

When we arrived at the chapel, pilgrims took turns crowding inside. I stood in the open-sided gallery as worshippers added their candles to a long wooden stand already ablaze with dozens of tapers. Those carrying offerings filed into the chapel and gave them to the Maya *priostes* (sacristans) to be blessed and put on the altar. Some of the offerings were used immediately, such as the honey used to sweeten the sakah and to make balche'. When I poked my head in, Jorge Koh, one of the priostes, motioned me to come behind the altar so that I could set up my tripod and document the service and blessing. Normally the chapel was cooler; but with all the burning candles and people filing in, it was like a sweat bath. The priostes began their liturgy, and a stream of pilgrims paid their respect.

Outside, off to one side of the chapel, a group from a village in Quintana Roo was preparing food for the following day's gremio. They'd dug a trench for the pib and heated the rocks and were lowering five galvanized tubs into place. Before covering the oven with tin and earth, the men took turns stirring the relleno with long poles. Since they weren't from Xocen and didn't have a local house available to them, they did everything in the public space at the chapel.

Two years later I returned to the shrine with Hilario, bringing photographs I'd taken that day. We presented them to Jorge Coh Wo, one of the priostes. A group of pilgrims from another village was there for a prayer service. When they saw the photos they promptly asked if I would photograph them at the cross.

We'd ridden out to Xocen on Hilario's motorcycle on the dirt road from Chichimilá. Today it's paved and extends to Xuilub, then on to Cobá and Tulum. Before, you had to walk to Xocen—and you had to want to go there. The villagers were friendly and wanted to share their shrine and their faith with us. They appreciated our attention, just as anyone might feel good if you show interest and respect. They facilitated my making photographs.

Soon after the road was put in, however, that friendliness and openness began to be tempered when strangers drove in, took videos and photographs, and left—remaining strangers, without any interaction. Sometimes it made the villagers feel that they were nothing more than an amusement for outsiders. It seemed disrespectful, and they worried that someone would make money selling postcards. So they put up signs forbidding photography.

Xocen became a favorite locale among anthropologists, particularly those at INAH (the Instituto Nacional de Antropología e Historia), which had a regional office in Mérida. In the early 1990s María Alicia Martínez Medrano, a teacher from Mexico, successfully turned the music and dance of the

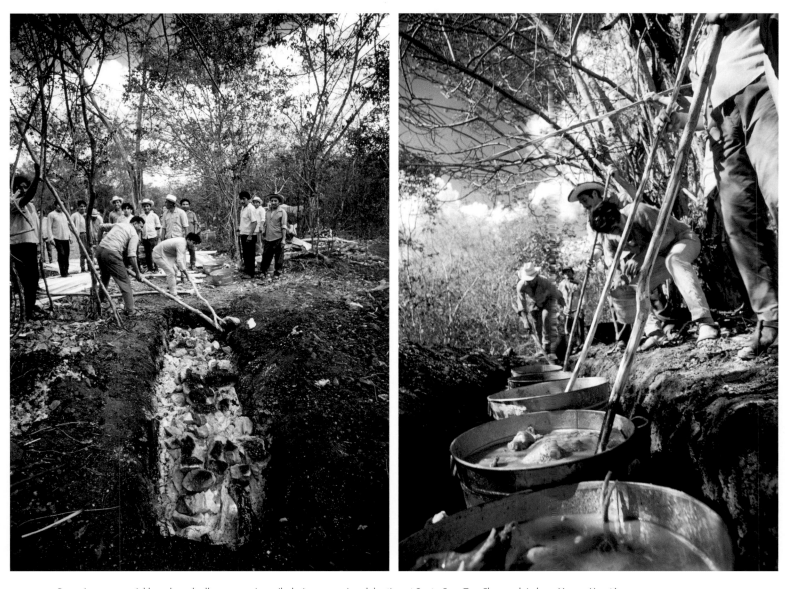

Preparing ceremonial breads and relleno negro in a pib during a gremio celebration at Santa Cruz Tun Chuumuk Lu'um Xocen, Yucatán, 1974.

Xocen fiesta into a folkloric pageant where the village troupe members actually made money by "being Maya."[21]

Consequently, Xocen gained a certain fame among outsiders as the religious and cultural center of the modern Maya. Even Carlos Salinas de Gortari took an interest and visited Xocen in October 1990 when he was president of Mexico. He saw that the villagers were poor and some were sick. He asked them what they wanted. As president, he'd give them something as a gesture of his power—it was the way the PRI ran the country, dispensing necessary services as favors to assure that people voted for its candidates. Salinas expected the villagers to ask for the same things as other towns and villages did: a clinic, a school, potable water, or financial help for their community. The people of Xocen consulted among themselves before asking the president of Mexico to find their book.

Alejandra García Quintanilla, a professor at the Universidad Autónoma de Yucatán, told me what happened next.

"Salinas was flabbergasted by their request. He asked them, 'What book?' and the villagers replied, 'Our book. It measures a meter wide and a meter high and is written in Mayan. It is alive and grows a page a day. If you touch it, it bleeds. It is big and thick and wise, and many things are written in it, and no one made it.'

"They told Salinas that many years ago the people of Valladolid came and borrowed it then returned it. The people of Chichimilá came and borrowed it then returned it. And then the people of Valladolid asked to borrow it again, but this time they didn't return it. The people of Xocen thought the people of Valladolid had shown their book to the gringos, who took it. That was how the Americans had invented railroads, watches, airplanes, rockets, satellites, computers, and all modern technology: it was all written in the book of Xocen. The president listened to the villagers. Then he turned to his staff and said, 'Find their book.'"

Alejandra continued: "His staff called anthropologists, archaeologists, and librarians. This was the only time any of us had gotten a call from the presidential office, and there was nothing we said or did that helped. Salinas was used to granting requests, and we could tell from the phone calls that he was getting really annoyed that he couldn't find the book. A Maya village had stymied the president of Mexico."

Obviously the Xoceneros were asking for the return of one of their sacred texts. Salinas wasn't able to find *The Book of Chilam Balam of Xocen*. The president's attention to Xocen confirmed that the village was still central to the political geography of the Maya and home to the Saintly Cross of the Center of the Earth.

A new rebuilt chapel is no longer rustic and cavelike. Now it is the size of a church, with a facade in a quasi–Classic Maya meets Maya Mission style. Although the stone cross is still rooted in the earth, the altar is now adorned with symbols of Mexican Roman Catholicism, including several Virgins of Guadalupe.

Early on February 11, 2003, Dario, Herculana, Charles, and I drove out to Xocen. We'd returned to attend another gremio celebration and to share photos that I'd taken thirty years before. A work crew was cleaning the area around the shrine when we arrived—whitewashing, painting, setting things up. Following Dario's suggestion, we announced our intentions to the priostes and introduced ourselves in Spanish. When Charles switched to Mayan they broke into big grins, and everyone came over to listen. With a formality that we'd learned over the years, Charles explained that we'd lived in the area and visited many times to light candles at the cross and that we'd come to attend this year's gremio festivities. As the men nodded to show that they were listening, we pulled out my photographs from 1971, 1974, and 1976.

The men crowded around, recognizing friends and neighbors, parents and relatives and other loved ones, even after thirty years. They joked about how young everyone looked. One of them laughed loudly and pointed to a photograph of a man who was praying fervently. He held it up so that everyone could see, and his friends were also amused.

"Now he's an 'hermano'—an Evangelical." They chuckled. "He won't be coming to the gremio," one of them added. "His religion forbids it."

As the men discussed how much some of them had changed, I noticed the alterations to the shrine. I missed the bright hand-cut paper pennants that used to hang across the room and make the shrine look gay and happy. Before, nearly everything placed on the altar was from the surrounding forest. The milagros that hung from the neck of the cross had been handmade from beeswax. Now they were small ready-mades of tin (arms, legs, and other body parts that needed the attention of the miraculous cross) or color photographs of the supplicants, attached with thread and hung from the cross. Today most of it was store-bought or a product of technology. Nonetheless, the essence of the offerings remained the same: a colorful and profuse display of faith.

The men gathered the photographs and handed them back—even though we had said that we'd brought them for the church. Returning them was a formal way of clarifying that we had said what we intended. With equal formality, we declared that the photographs were a gift, a document of previous years, and asked permission to photograph again to document the changes that had occurred.

They nodded their heads as they listened, then spoke briefly among themselves. One answered for the group, speaking in his most formal Mayan and glancing down rather than looking at us. He told us that they could see that we honored the Cross and thanked us for bringing the photographs from long ago. He asked whether we would bring photographs back if we took new photographs. I said that we would. He gave us permission to photograph again but asked—only half-jokingly—if we could please return before another thirty years had passed.

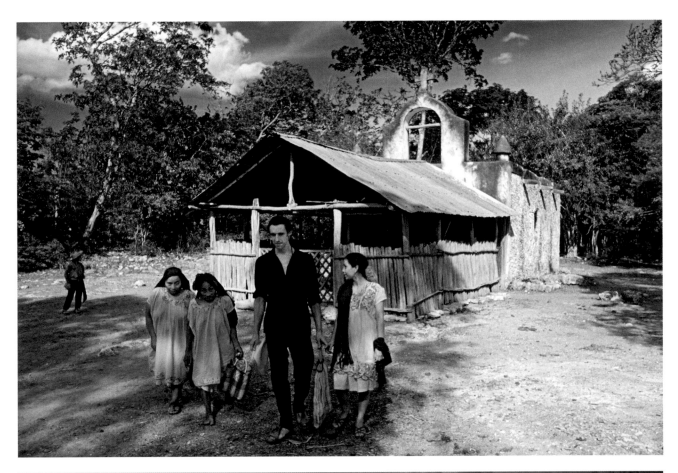

TOP: Hilario and Fina with three other pilgrims in front of the shrine, Santa Cruz Tun Chuumuk Lu'um. Xocen, Yucatán, 1971.

BOTTOM: Remodeled shrine, Santa Cruz Tun Chuumuk Lu'um. Xocen, Yucatán, 2001.

Later, as we were leaving, they asked if we would voluntarily make a donation to the Cross. What they really needed, they said, was a bathroom for the women who visited and sometimes spent all day preparing food offerings. They'd petitioned the president of Mexico, but he hadn't responded. We were noncommittal about personally making such an expensive contribution but said we would pass word of their needs to others. We gave them some money and, because it was already a hot day, bought refreshments for the priostes and the work crew from a temporary concession set up for the gremios.

Four days later Charles and I left Dario's house in Chichimilá for Xocen. We'd stay with our longtime friend Celso Dzib Ay and his wife, María Equilia May Tun. Celso was a farmer and musician—he played drums with the Xocen music and dance group—and María was a healer. We stopped by the market in Valladolid and bought meat, fruit, vegetables, and five bottles of rum for our hosts and for the sponsor of the gremio. We met a friend who told us that Vicente Fox, the current president of Mexico, was coming to Valladolid. We wondered if a delegation from Xocen could personally ask for a contribution to the shrine and the women's toilets.

When we arrived we found out that Celso was in Mérida with the folkloric group, so María asked her son Eliseo to take us over to meet Germán, the sponsor for the following day's gremio. We presented him with our offerings of food and rum, and he gave me permission to photograph after talking with us.

Germán's yard, surrounded by a drystone wall, was full of fruit and shade trees as well as raised beds of vegetables, herbs, and spices. His thatched-roof house and the kitchen next door sat on a little rise. At least fifty people were working together in his yard, along with a band. The musicians were sitting in the shade of a tree, playing jaranas on a saxophone, trumpet, trombone, and drums. Around open fires men stirred large kettles filled with corn or the ingredients for relleno negro. In the kitchen women were preparing a feast. Inside the house some men were constructing an altar on top of a table, weaving an arch above it from jungle vines and boughs. At another table an older man was blessing the alcoholic drinks, dividing a large bottle of rum into smaller plastic Coke bottles so that it would be easier to distribute.

Germán and others responsible for the day's gremio had their specific duties and rites, and everyone else pitched in to help prepare a communal offering to the shrine. There was time for everything: you could work, talk, drink. You could take a break and have a smoke or listen to the music. It was a hot afternoon, and the day had a tropical rhythm.

I went over to help two men open a pib and bring out steaming noh wah, the large corn breads cooked in banana leaves in the earth oven. We talked as we unwrapped the breads. One of the men introduced himself as the ahkin, the Maya priest who would conduct the ceremony at the Holy Cross. At forty-seven, Alfonso Dzib Nahuat was relatively young for a h'men. He was personable and joked as we worked. I told him what I was doing and called Charles over when I found out that Alfonso was Celso's nephew. Though we'd never met before, he treated us as if we were friends and told us that his nickname was Ponzo.

Late in the afternoon the ahkin came up and asked if we wanted to take a walk with him, as he needed to go to the Cross. Although we expected that many others would join us, it turned out that only he and his assistant and Charles and I walked the kilometer and a half to the shrine. He had a lot of questions for us and agreed that his culture was changing and should be documented.

When we got to the Cross, the priostes welcomed Ponzo and greeted us with smiles. A man with a tricycle with a cargo platform had pedaled ahead of us, transporting the noh wah we'd taken out of the pib along with other offerings and a large container of balche'. We helped the ahkin carry it in, and he invited us to watch him work.

Ponzo set up a small wooden table in front of the Cross and spread a white cloth embroidered with bouquets of colored flowers. Setting up reminded me of when I'd been an acolyte in my father's church. Before or after a service, when the congregation wasn't present, I could walk around the altar without having to whisper or wear vestments. But even while cleaning up, sweeping, vacuuming, or changing the flowers on the altar, I was always aware that I was in a consecrated spot. Ponzo appeared to be a religious man who enjoyed the humor in life. He joked as he worked, and I felt very much at home helping him set up his altar. At one point he looked up from his preparations and, seeing that I wasn't photographing, said: "Hey! Are you going to document this, or what?" I got out my camera.

I photographed the priostes putting leaves on the altar in front of the stone cross. They told me that the altar symbolized fertility and the leaves were the *sombra* (shade). It was similar to what Dario had explained about providing a cool place for the gods when he offered sakah in his milpa.

I photographed the ahkin as he prepared his table with a wooden cross adorned with a sudario centered at the back of the table, transforming it into an altar. In the middle of the prayer, Ponzo suddenly turned to me and said, "Whoa, don't take too many pictures right now because it's only going to get better! Just watch!" He laughed and continued praying. Then he placed more leaves on the altar and on top of these stacked the noh wah bread, a censer for copal, offerings of cooked chicken, and gourds containing balche' until the altar was overflowing. The priostes moved a stand for candles and a prie-dieu into place, and the ahkin knelt down to pray.

"We're offering you this," the ahkin said as he started the service, "so you might wipe out our sins. And so we don't become sick." His words came out forcefully, like shotgun blasts. He smiled and laughed as he prayed; piety and joyfulness are a tremendous mix. He turned to us: "We offer to God so that He gives us life, good health, rain, harvest from the land, and money."

After each prayer, the ahkin came to each of us—the priostes, his assistant, Charles and I—and made the sign of the cross with his thumb above his first finger. Each of us did

Musicians during a gremio at don Germán's. Xocen, Yucatán, 2003.

Alfonso Dzib Nahuat celebrating a service at the shrine, Santa Cruz de Tun Chuumuk Lu'um. Xocen, Yucatán, 2003.

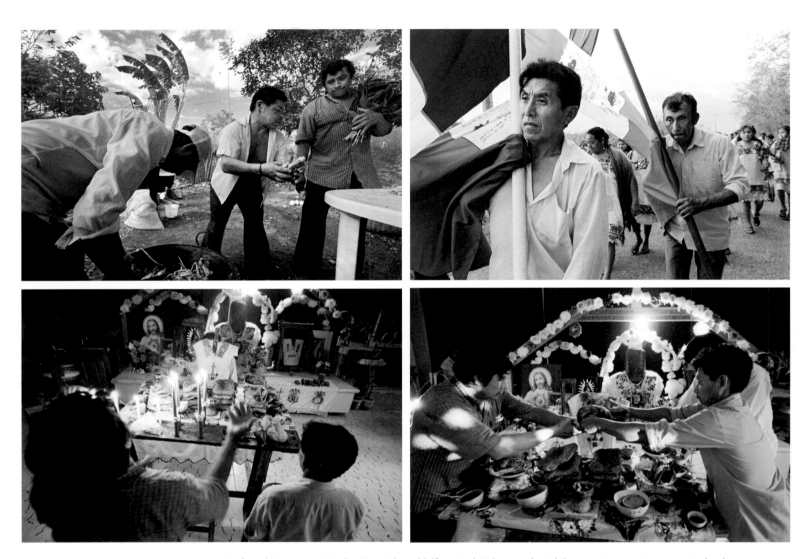

CLOCKWISE FROM TOP LEFT: Preparing food during a gremio in don Germán's yard (Alfonso Dzib Nahuat on the right); a gremio procession; preparing the altar, Santa Cruz Tun Chuumuk Lu'um; Alfonso Dzib Nahuat celebrating a service at the shrine. Xocen, Yucatán, 2003.

203

the same in return. Then the ahkin pressed his thumb to our thumbs; as we pulled our hand away, in one fluid motion, we kissed the back of our own thumbs. A couple came in but didn't participate in the service. They lit their candles, prayed, and left.

Every few minutes the ahkin's acolyte served us a jícara of balche' from a pail. They'd added toasted cacao, which we were told is the way balche' is usually served in Xocen, which gave it a crunchy texture and a smoky taste that offset the sweetness. The ahkin enjoyed his balche'—the priostes said that he was being playful because he'd drunk a lot that day.

The side doors were open: the light dimmed as day became night. The sound of cicadas became louder, and the bird songs changed with the gloaming. I heard the hoot of an owl. Inside the shrine, the candlelight began to brighten the walls. A lazy breeze was visible whenever it shook the copal incense from its upward spiral.

After his last *oración* (prayer)—he'd prayed for two hours—the ahkin stood in front of the altar and fashioned a cross from the leaves. He added sikil powder to a jícara of balche' and covered it with an embroidered cloth. Lifting the jícara and one of the noh wah breads, he ordered a prioste to ring a hand-held bell as he consecrated them while singing a "Hallelujah" loudly in Spanish.

We did not go up to a communion rail. Instead, as the prioste continued to ring the bell, the ahkin came to us. He held two small jícaras and filled them. We drank both of them, one at a time. Then we drank again after he refilled them. He broke the bread and gave us each a piece. He touched the bread to the jícara four times, facing the four directions, saying, "The body of Christ, this is your communion."

It was one of the finest religious celebrations I've attended. I felt privileged that Ponzo had invited us to an intimate service that had been so direct and spiritual. Afterward, Charles and I walked back to Germán's. The evening was pleasantly cool. With no streetlights and no traffic (few villagers owned cars and even fewer visitors passed through at this hour of the night), we walked down the center of the highway, guided by starlight. The night smelled fresh. Looking at the sky, we marveled at the ancient Maya and their knowledge of the heavens. Although it was 10 P.M. when we got back, a lot of people were still helping out at Germán's. Inside his house the altar had been completed, with offerings on the table. I asked Germán if he wanted a photograph of himself and the other men who had helped him.

I meant it as a way to thank him, as a courtesy for receiving us so kindly, but it turned out that this was not an easy question for him to answer. He consulted with the other men. They asked if everyone would get a separate copy. I told them yes. How soon would I bring back photographs? I didn't know, so I told them that. They looked at each other and started conferring. As Indians do throughout the Americas, the Maya often resolve problems through discussion until they arrive at a consensus. For the next hour they discussed whether they wanted a photograph and, no doubt,

the implications of such a photograph: would others in town be opposed to it, would it be a simple memento for the participants, would it be a historical document of value to succeeding generations, would someone make a postcard and make money from it? While they discussed this, Charles and I sat outside drinking *copitas* (wee drams, little drinks) of rum with some of the others. When they finally reached a decision, they called for us to come inside. They asked me to take their photograph. All nine men stood proudly in front of the altar. Since they were obscuring it, I suggested that they kneel and then took their picture.

Early the next morning we returned to the shrine. Charles had commissioned a prayer for his family. Maya come from all over the region for the same purpose because everyone knows the Cross's healing power. We met with the priostes, and Charles handed them a box of candles and the fee of forty pesos.

It was Sunday morning, and there were a lot of people at the shrine, unlike the previous evening. Families paid their respects to the Cross. Some walked with bowed heads; others crawled on their knees. Most of the children got up and ran around, even during prayers. We heard their laughter and the slap of their sandaled feet.

The prioste asked that Charles and I sit in the front pew during the prayer. He turned to Charles to get the pronunciation of his children's names: Josef, Djamila, Dante. Charles had to repeat Djamila's name.

I believe in prayer, so I prayed for my father who was fighting melanoma cancer. I prayed for my sister. Even though she had died twenty years earlier from childhood diabetes, I couldn't stop the habit. I prayed for Herculana and Dario, for Veva, Alicia and Juan, Luis, Felipe and Bárbara, Diego and Margarita, Casimiro and his wife and daughter . . . I had a long list.

Germán was serving relleno negro to hundreds of people when we returned. It was hot, and we looked for shade. Women were taking turns making thousands of tortillas over open fires—people all used the tortillas as their utensils. They were working nonstop in the heat, so I walked down the street until I found a store that had cold drinks and bought them refrescos.

When they gave me a bowl of relleno negro and a stack of tortillas, I was in heaven. This Maya ambrosia is rich and spicy, yet subtle. I've been all over the world in my editorial work for magazines and have had the good fortune to eat in three-star Michelin restaurants in France as well as highly rated restaurants on five continents. But relleno negro, cooked in a pib, remains one of my favorite meals.

The musicians played as we ate, and the men passed around blessed rum. In the early afternoon we filled the street and carried the saints and shrines and offerings of food out to the cross. The band accompanied the proces-

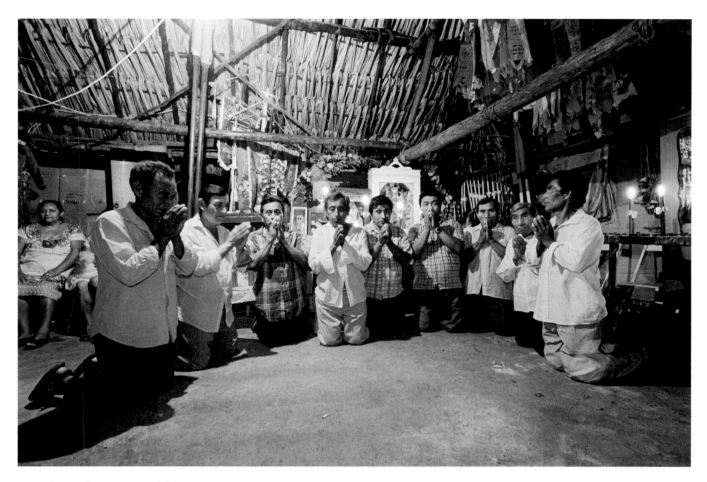

Men in front of altar at don Germán's house, Xocen, 2003.

sion, and men set off fireworks and rockets. I was busy photographing when a man came up and brusquely told me that I had to stop.

He introduced himself as the *comisario* of the village, a political office distinct from the Maya shrine's religious hierarchy and one that was embroiled in the partisan fighting between PRI and PAN (Partido Acción Nacional/National Action Party), the two main national political parties in Mexico. I thought that we'd done everything correctly and respectfully. We'd asked permission of everyone we thought we needed to ask—the priostes at the shrine, the ahkin who conducted the prayers and ceremony, and the sponsor of the gremio. But in the end everything is about politics, and we'd neglected the secular officials of the village. Now the drunken comisario was shaking me down, reminding me that we should have slipped him some money.

I was repelled. As a person of faith I was enjoying worshipping True God at the shrine of the Santa Cruz. I appreciated the communal aspect of Maya faith and how they were pulling together each day in their homes to make offerings to God. For two days I hadn't experienced the hypocrisy, politics, and judgmentalism that can turn faith into feuds. This was faith as my father had taught it to me. The ahkin and the priostes understood that I respected their faith. Don Ger-

mán and his friends had spent the previous evening discussing the full implications of documentary photography when they considered whether or not they wanted me to photograph them in front of their home altar. The comisario's concern, however, was solely greed.

I left, because the last thing that I wanted was anything to disrupt the religious celebrations. Afterward, when Charles and Celso and his family returned from the shrine, they told me that the comisario wanted a payment or he would arrest us. There was even a rumor that we'd already escaped, which Charles had overheard. He noted that no one seemed to notice the dzul, who was a foot taller than anyone else, standing right there among them.

I guess we shouldn't have been surprised. Herculana had warned us, "Be careful, those Xoceneros are *muy bravos* [very fierce]!" They indeed had a history of jailing outsiders, if only for a day or two. Many years before, they'd jailed Dario and Hilario for swimming in the town's cenote. And they had jailed Agueda Ruiz Padilla, a Mexican anthropologist, accusing her of stealing from the town after she'd angered the comisario by protesting the lucrative illegal sale of alcohol.[22]

Celso was upset. "They'll have to kill me before anyone harms a guest in my house," he told us. "I'm going to load my gun."

Hearing that, Charles and I decided that we had to leave so that our presence didn't disrupt the gremio. We'd return when the comisario sobered up. We certainly didn't want Celso and his family to suffer any repercussions. Before leaving, however, Charles wanted to treat Celso and his family to an ice cream in Valladolid.[23] I decided to stay and write up my notes.

They had a most curious tale to tell when they returned. After buying ice cream they had walked slowly around the town square. It's a pretty park in the historic colonial center of Valladolid, with a fountain in the middle and paths radiating out among flamboyant trees, gardens, and S-shaped seats called *confidantes*. There couples can sit looking straight ahead in opposite directions or lean toward each other—a perfect place to gossip and tell secrets and maybe kiss, if no one is looking. It was a warm Sunday evening, and they were enjoying walking around the plaza. Suddenly a young man with a military haircut blocked their way.

"We've been watching you," he said darkly, opening his jacket to show a pistol in his waistband.

Bax ka walik? Charles asked, to see if he spoke Mayan. "How are you?"

"Just remember that we're watching you," the man replied in Spanish. Charles could feel his glare even through his sunglasses. He turned and left.

We tried to make sense of this warning. When we mentioned this to a friend in Valladolid later, he told us that the man must have been advance security for President Fox. There'd recently been more trouble in Kanxoc. The last thing Mexico wanted was a Zapatista-like incident close to Cancún and the tourist-rich Riviera Maya. A white man walking with Maya was reason enough for an agent to be suspicious.

"You should have seen how many people arrived this year in Xocen!" Celso told us in 2005 when we visited him a couple of days after the annual May 3 celebration of the Day of the Cross. "They flew into Mérida and then chartered buses and taxis to come straight to Xocen. They even came from France!"

"Some wore Aztec costumes and danced in front of the church," his son Eliseo added excitedly, "and many circled the Santíssima Trinity on their knees. They brought candles and even said prayers in English!"

"They brought a lot of offerings to the Cross," Celso said. "They brought so much stuff—refreshments and sweets and tacos! Everything was given to the priostes, who then gave them to the people. Some dzules from Valladolid brought a big cauldron of pig and a big box of machine-made tortillas, and after the prayer the priostes gave it away on little plates until there wasn't any left!"

"There was a man from Valladolid who drove here in his truck. In the back he had two popsicle push carts. After the priostes blessed the carts, they gave the popsicles away to ev-

eryone. And then the man went back to Valladolid and got more popsicles!

"And other people gave bottles of anis and cigarettes, and even an orchestra came and played!"

"People must have been taking a lot of photographs," Charles ventured. "Even video, right?"

Celso vehemently shook his head. "No, not anyone. No photographs allowed, inside the church or outside. Nowhere. But there were a lot of fireworks. Huackk!" he said, mimicking the sound of an explosion.

Charles shook his head in amazement. "New Agers discovering Xocen. What a wild education for everyone!"

When we told Celso that we'd come to interview the ahkin, he wanted to accompany us to his nephew's house. We went at dusk, as the day cooled. A chorus of cicadas announced nightfall as the sky outside segued from purple to black. We called out when we got to the gate of Ponzo's yard, a customary Maya practice to let a household know that someone has arrived to visit. Ponzo's thatched house was built in a natural hollow that was lower than the street. A pretty girl about fifteen years old came out to greet us. Because of the twilight, she was almost upon us before she recognized Celso. She immediately called out to her father that his uncle had come to visit. She looked at Charles and me and our notebooks and pens and camera bag and asked if we were journalists and if we'd come to interview her father. It was only three days after all the pilgrims had inundated the village.

When Alfonso got to the gate, he recognized us from the gremio two years earlier when we'd photographed him. He turned to his daughter and told her to prepare the house for visitors then invited us in. A single electric lightbulb hung from a cord. A half-finished hammock on a vertical loom was pushed back against the wall, and a sewing machine was near the door. Alfonso's daughter sat down at it and smiled. After offering us stools, Alfonso sat down beside a small table that held a basket of spindles. He picked one up and started sanding it. He told us that they were for weaving hammocks and that he fabricated them from hardwoods and sold them for two pesos each.

I reached in my sabukan and brought out the photographs I'd taken at the gremio. His daughter came over to look. When she carried them into the shadows at the back of the room, we realized that Alfonso's wife was sitting there in a hammock. We hadn't seen her, and she hadn't said anything. Alfonso seemed pleased with the photographs. He said that they brought back good memories: we could ask him any question we wanted. We started with the history of the Cross of the Center of the Earth.

"Ah," Alfonso began. "At one time the Spanish wanted to move the Cross to the church that's in the center of this town. But when they tried to dig the earth from around the Cross, they only found rock, just rock!" Even when not conducting a ceremony, his words sometimes seemed to explode from deep within him.

"The foot of the Saintly Cross was entirely in stone. There

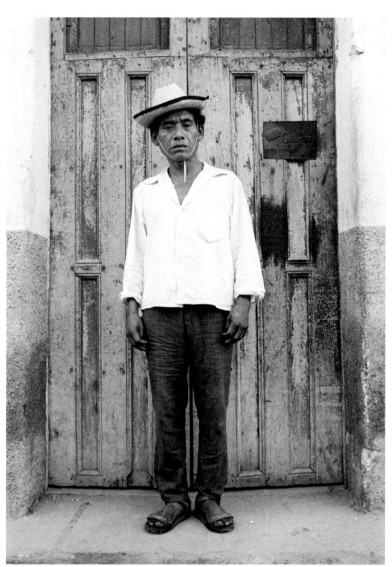

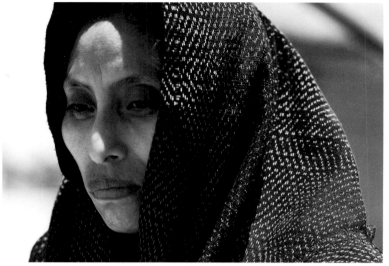

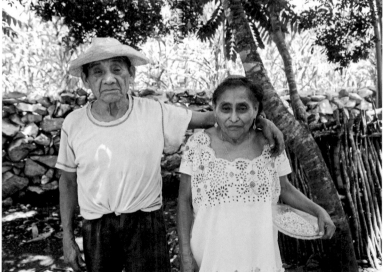

LEFT: Celso Dzib Ay, Valladolid, Yucatán, 1976. TOP: María Equilia May Tun, Chichimilá, Yucatán, 1974. BOTTOM: Celso and Maria, Xocen, Yucatán, 2008.

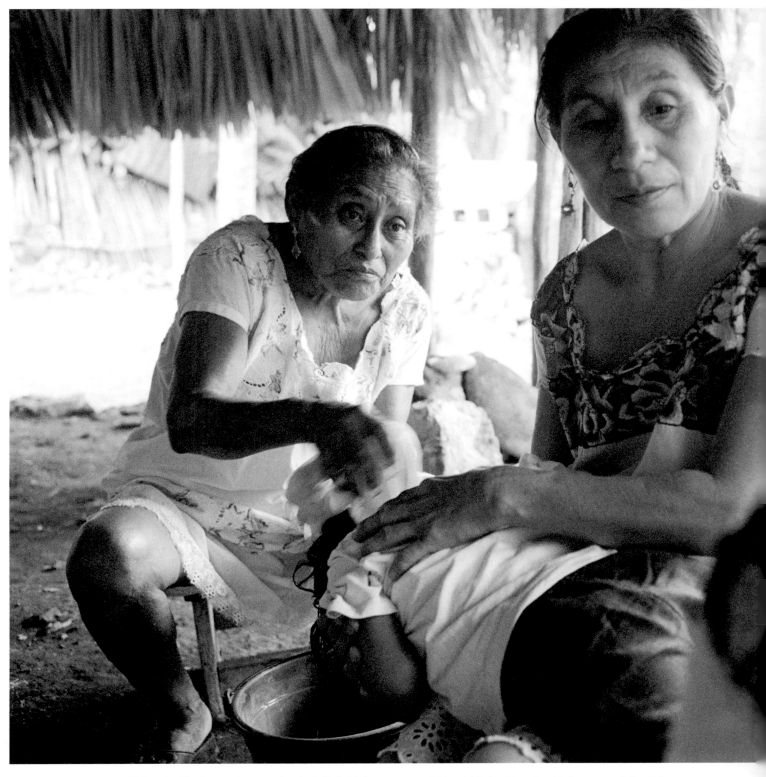

CLOCKWISE FROM ABOVE: María, a local healer, pouring water that she boiled with leaves over a neighbor child's head to reduce his fever, 2005; Rufina Dzib May making tortillas in the kitchen, 2008; María, Victoria Dzib Nahuat, and Rufina, 2008; Victoria reading a schoolbook, 2008. Xocen, Yucatán.

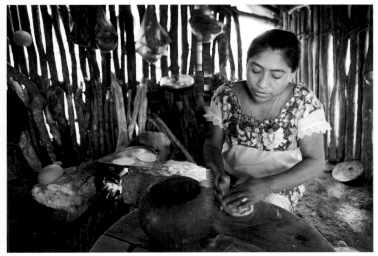

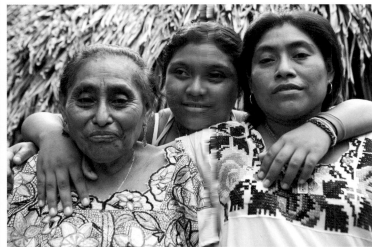

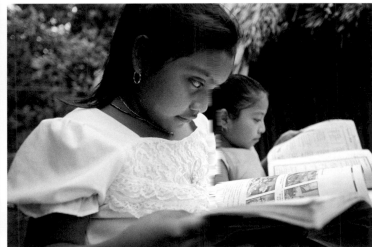

was nowhere to dig around to get it out. Now, on the north side was a hole, not too big, but the ancestors investigated and removed a little stone from the hole and saw that underneath was water. It was a cenote. And so the ancestors made their promises. 'Let's build a church here. We ought not to move it. The Cross must stay here in the rock.'"

"Huhhh," Celso said, nodding his head in assent.

"And so they built a church," Alfonso said. "A little house of guano. Later they built a small stone chapel. Then they found in front of the Saintly Cross two more crosses—three in all. The other crosses didn't have their feet in stone like the Saintly Cross. Then they found the Testamento."

"The Testamento?" I asked.

"Yes, a sacred book. Our grandfathers read the Testamento de la Santa Cruz in pure Mayan." Alfonso reached down and picked up another spindle to sand before resuming his history. "There is a Testamento to read each year. On the first of January, you open the book and on each page, for example, it reveals which illnesses will be suffered for the year. You know, vomiting, diarrhea, fevers, whatever. Each month is explained in the scriptures of this Testament, and so the ancestors understood how they were to cure them, as it told which plants to use. Once they found the plants they could prepare the antidotes and defend themselves against the sickness. There were no doctors or hospitals in those ancient times. Not only that, the book told us how to prepare the milpa and what days to burn. Then it would rain strongly so we could plant, and by September they were ready for the harvest. You count the days, as there are thirty days in each month, and there are twelve months in each year, so the ancestors were interested in how each day and each month was written."

Alfonso was referring to the book that the villagers had asked the president of Mexico to find for them.

"Today things are not the same," Alfonso stressed. "Our grandfathers had no candles to read by, so they used a torch prepared in a way that we call *ta*. One held it, while the other read."

"Was the book made of paper?" Charles asked.

"Yes, it's made of paper, but it's alive!" Alfonso almost shouted. "The ancestors say that this paper bled when you opened it. The book taught us important things. But we loaned it to Chichimilá, and then to Valladolid, and little by little it left until it got to Mérida, and they never returned it. One month, two months, three months passed, one year, and they never returned it. So the Spaniards took the book. Among my grandfathers [the ancients] there used to be people who knew the stories, but not today."

A young man came in through the door pushing a bike, which he leaned against the house wall. Alfonso introduced us to his sixteen-year-old son. The boy came over and stood next to his father, who continued the story. His son looked at us curiously but didn't interrupt.

"My grandfather, my son's great-grandfather, was famous. He knew how to do the ceremonies, how to be a h'men. He knew how our grandfathers did things. Today we only have

what's in my head and the ancient stories our grandparents told us from the Testamento—such as how they knew a time would come when we'd have airplanes. And this was before there were airports! And they predicted cars. There were no roads for cars at that time, just trails, but the ancients said that they would come. How did our grandparents know a car would come? How did they know that a person would use a flashlight or a lantern? It was all in the Testamento, read long ago by our grandfathers."

Alfonso often searched for a word in Spanish as he spoke, and his daughter and son helped him. They were both intelligent and respectful and clearly interested in our questions and their father's answers. Several times they clarified for us what he had said and, conversely, explained to their father what we had said.

"We know what worked for us in olden times," Alfonso continued. "For example, we are now in the month of May—it's the time for us to plant our milpas and to do a Ch'a Chaak. We pray to God and ask Him to hear us, give us goodness, and water the earth. That is what we know how to do, to defend our lives and carry out the ancient ceremonies. So we continue doing it. We don't forget it. It's cultural."

"And you learned from your father?"

"Yes!" Alfonso answered. "From my father and my grandfather. They were both h'men'ob. My grandfather lived to be 130 years old. He was stooped, but he didn't have any holes in his teeth!"

"When did you become a h'men?"

"I tried to do what my grandfathers and father did." He smiled. "I learned young, when I was about twelve. My father told me to remember how I was to do the ceremonies. So even when I was small I was always thinking, wherever we went, how each ceremony looked, how it was to be presented, and I recorded it in my head."

"And your father conducted prayers in the chapel of the Center of the Earth?"

"Yes, my father prayed there and my grandfathers too."

"And your son?" I asked. "Will he also become a h'men?"

"Yes," said the ahkin.

"No," said his son. He smiled sheepishly and shook his head. He looked at his father, but neither said anything more.

"Is there another h'men here in Xocen?" I finally said. "Are you the only ahkin?"

"No. Permit me to explain. Each sponsor chooses a h'men. For example, don Germán invited me. When he is done and passes the responsibility to another, the next sponsor chooses a h'men. If he invites me, I'll give the prayers again."

"What about the priostes at the shrine?"

"The people have an election every three years to change priostes, unless one is reelected."

"Is one in charge?"

"Yes, there is a number one, as well as a two, a three, and a four. But all decisions are made by consensus."

Charles asked what was the relationship between the cross in Xocen and the cross in Chunpom, one of the Santa Cruz Maya sacred villages.

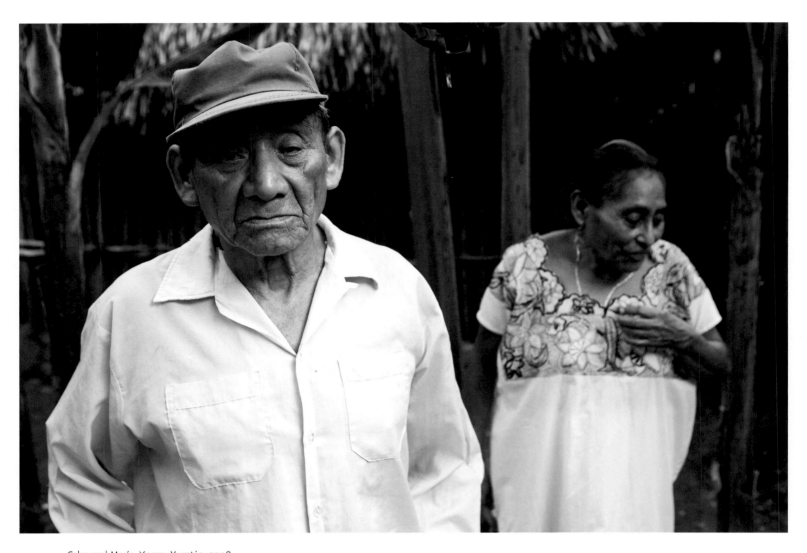

Celso and María. Xocen, Yucatán, 2008.

"Each town needs to pray on May 3. It is the Day of the Cross and a day for putting our hands together and for everyone to work for God because we are good Roman Catholics."

"But how do you compare what you celebrate here in Xocen with Chunpom? Have you been there?"

"Yes."

"So, how does it compare?" Charles asked again.

"It's different," Alfonso said. "In Chunpom there is a group of maestro musicians who play *música maya* [Maya music], the way they play it in Tulum and Tixcacal Guardia [two other sacred villages]. They are from small villages, and it's pure Maya. They use violins and drums. Here we have an orchestra. Another thing. They make balche' wine, but they only put the cuttings to boil. We do it the old way. We prepare it green: the bark of balche' soaked in water with some honey. We don't heat it or bake it, nothing like that. We offer it to God, and in twenty-four hours, when we open it, it's like a glass of beer with bubbles. Then we drink it with gusto! For a moment when it passes, it warms you, and it's nutritional. But they do prepare their corn the same way that we do."

"What relationship does the Cross of Xocen have with the crosses of Chunpom, Tulum, and Tixcacal Guardia?"

"They are brothers of the Santa Cruz of Xocen. We pray to the Saintly Cross because we are Catholics. We need the Cross because it is God's symbol."

"Are any of their crosses from Xocen?"

"No, let me explain. Long ago there were three crosses here. And they tried to take two away. But they didn't get more than a few meters from the chapel before there was no longer any firewood, not one stalk of corn, not even one chile left. So the people asked the h'men how they could take a Santa Cruz. And the Holy Cross declared that if they wanted to take a cross they needed to bring offerings of corn, money, angels, and animals for seven days and to pray day and night. The people did this, and after seven days nobody knew where the sacred crosses had gone. Only one remained. Thus, once the people had gathered all the seeds and all the monies and all the animals, the crosses went out. So now the people have the brothers of the Santa Cruz. And someday, in the final times, they will join together again."

"What do you mean?" we asked.

The ahkin looked over at his uncle then back to us. "Man, the day that we really need them there's no way that they're not going to come together!"

After taking leave of the ahkin, we visited don Germán. I gave him the photographs I had promised—one for each man in the photos. We stood underneath a street lamp looking at them. Germán's wife held them up and smiled. "These are good for memories, to show our children the things that we have done," she said.

Charles spent Christmas 2005 with Celso and María in Xocen. He brought his two sons and daughter with him. It was one of the coldest nights of the year, and Charles and Celso put coals underneath all of their hammocks to keep them warm. Celso's daughter was wearing a beautifully embroidered sweater over her huipil, not typical of Yucatán, and Charles asked where she'd gotten it. It turned out that Celso had returned from Veracruz only a few days earlier and had bought it for her there.

"Veracruz? What were you doing in Veracruz?" Charles asked. Celso explained, in his detailed and looping manner, that a man and a woman who had come to Xocen looking for actors chose Celso after an audition. They told him to report to Playa del Carmen, so his son accompanied him on the bus. They thought that Celso would be away only a few days; but instead the agent put Celso on a plane for Veracruz, where he worked for some guys making a movie for three months.

Celso did not know the name of the film he'd worked on. But he excitedly described the mountains and waterfalls he'd seen on location and how the cameras were mounted on cranes and dollies. The most interesting part of the work was that he'd gotten to speak Mayan. He'd been intrigued by the other Indians he met on the set—a few from Quintana Roo and Yucatán—and many others from all over Mexico and even the United States. He'd helped coach them how to speak Mayan. What he'd really liked was the paycheck. The work was easy, he said, and he'd brought home about four thousand dollars (more than he could usually make in a couple of years in Xocen), some of which he'd already spent on building a new house to repair the old one that was on the verge of falling down. Charles, hearing Celso's description, gradually realized he'd worked on Mel Gibson's *Apocalypto*.

"Hey," Celso said. "Listen to the music I found in Veracruz."

He put a CD into a player and handed the cover to Charles. It was a recording of Son Huasteca, traditional folk music from Veracruz, played by a trio on violin and two guitarlike instruments, the jarana and *haupanguera*. Charles nodded his head to the beat. Celso turned up the volume. He moved into the yard and started dancing by himself, his hands clasped behind his back, his eyes almost closed. He did his jarana dance steps. As he raised his arms and began to spin, a big smile came across his face.

Don Celso died on January 5, 2011.

1. "The most revered Mazehual cross was La Santíssima Cruz Tun, uniquely a stone cross kept in a thatched chapel south of the village of Xocen, below Valladolid. It was said to have existed before the dzul came, and to have spoken and told the forefathers where to find seed in a cave, which was the beginning of making cornfields. It reached to the center of the earth and lay beneath the center of heaven (like the ceiba tree); thus it has direct access to God. It also was lord of the animals, because next to it was a *sartejena*, a rain-filled hollow in the rock where animals came to drink. Christian Mazehual came from great distances to pray at this cross." Reed 2001:45.

One thing I've discovered in traveling around the world is how many cultures place the belly button of the world smack dab in their own front yard. Even though Xocen doesn't appear on most maps of Yucatán, let alone Mexico, it is an important locus of the modern Maya world. Robert Laughlin, an anthropologist with the Smithsonian Institute and author of the incomparable *Great Tzotzil Dictionary of San Lorenzo Zinacantán*, once pointed out to me the belly button of the earth, a physical landmark for the Tzotzil Maya in Zinacantán, just west of San Cristóbal de las Casas. Saul Steinberg brilliantly captured the New York sense of being at the center of the world with his *New Yorker* cover (March 29, 1976) "View of the World from 9th Avenue."

2. Freidel, Schele, and Parker 1993:39. Today in Yucatán a cross is given water, as if it is a living tree. Reed 2001:149. The contemporary Maya believe that a cross (or saint or image) is not alive or sentient but that sentient spirits can live in it. Freidel, Schele, and Parker 1993:177.

For a discussion of the mission churchyard (*atrio*) and the analogy to the form of the ancestral village and the ancient Maya cosmos, see Perry and Perry 1988.

3. However, a number of independent Americans responded. The first North American filibusters came to Yucatán in 1848, led by Colonel Joseph A. White. They had dreams of re-creating in Yucatán what the Americans had just succeeded in accomplishing in Texas. The Yucatecans offered the soldiers eight dollars a month plus 320 acres of land to settle on; 938 volunteers sailed from New Orleans to Sisal. Many were killed in the fighting. Reed 2001:122–124; see also Dumond 1997.

4. Leandro Poot offered an oft-quoted explanation: "When my father's people took Acanceh they passed a time in feasting, preparing for the taking of T'Ho [Mérida]. The day was warm and sultry. All at once the *sh'mantaneheeles* [winged ants] appeared in great clouds to the north, to the south, to the east and to the west, all over the world. When my father's people saw this they said to themselves and to their brothers, 'Ehen! The time has come for us to make our planting, for if we do not we shall have no Grace of God [corn] to fill the bellies of our children . . . '

"Then the Batabes, knowing how useless it was to attack the city with the few men that remained, went into council and resolved to go back home. Thus it can be clearly seen that Fate, and not white soldiers, kept my father's people from taking T'Ho and working their will upon it." Thompson 1932:70–71.

5. Overtures of peace were made to the Maya. The bishop of Yucatán wrote a letter to his wayward Indian "children." He complained that his heart was full of pain over all the killings the Maya had committed and hoped that they would give up fighting.

The bishop's "children" wrote back a letter dripping with scorn for his hypocrisy. "And now you remember, now you know there is a true God? . . . Why didn't you think of the true God when you were hurting us?" Dumond 1997:113.

Peace was elusive. No one leader spoke for the Maya; even if one leader came to an agreement, it didn't mean that he could persuade any of the other leaders to commit. The Maya were not part of a regular army—it was a popular uprising. They all had their personal grievances, and some were pursuing their own personal ambitions and glory. And it wasn't as if the

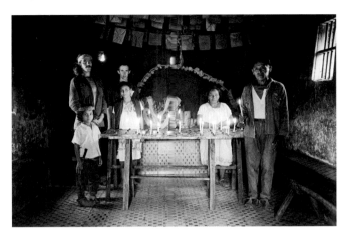

TOP: Macduff and Robert, Hilario and Fina, a pilgrim, and Teodocio Nahuat Canche at Santa Cruz Tun Chuumuc Lu'um. Xocen, Yucatán, 1971.
CENTER: Church damaged in the nineteenth century in the Caste War of Yucatán. Tihosuco, Quintana Roo, 1976.
BOTTOM: Street leading up to a bombed-out church. Tihosuco, Quintana Roo, 1971.

dzules were setting an example of unity. Even as they were fighting the Maya they were still fighting among themselves.

6. The nineteenth-century Yucatecan historian Serapio Baqueiro wrote that José María Barrera carved a cross into a tree next to a cenote and later made a small wooden cross that he said descended from heaven. Nelson Reed writes that a man from Xocen, Juan de la Cruz Puc, proclaimed that the unmovable stone cross from his home village had mysteriously traveled underground 100 kilometers and surfaced to bless a small mahogany cross that he had discovered at a cenote. He announced that it spoke the word of God. While some historians think that Juan de la Cruz Puc was a pseudonym for Venancio Puc, who became a principal leader of the movement, Victoria Bricker thinks that it was more likely Atanasio Puc, who served as secretary for the Cross. Bricker includes an entry in the diary of a Creole officer, Felipe de la Cámara Zavala, who described the church: "There was at one end of it, an altar which no one could approach except the person in charge of the three crosses. These were found on top of the altar, clothed in dress and petticoat; behind that altar there was a pit in which a barrel was placed which served as a resonating chamber, giving at once a hollow and cavernous sound. All this was hidden from the view of those who were in the main part of the Church." A man could speak from the barrel and dictate the wishes of God. Bricker 1981:108.

7. Farriss 1984:67.

8. But even the rebels were disturbed when their leaders became too bloodthirsty. It is difficult to argue with a leader who explains that God is telling him what to do, but the rebels did argue. Many people died as a result.

9. See Farriss 1984: Chapters 9 and 11. A theocratic-military society goes right back to Precolumbian times. "To the Maya, the idea of dividing the responsibility for human welfare between politicians and priests would have been incomprehensible. The kings were, above all, divine shamans who operated in both dimensions and through the power of their ritual performance kept both in balance, thus bringing prosperity to their domains." Schele and Freidel 1990:65.

The leaders of the Santa Cruz Maya spoke to God and brought God's word to their people. And God told them to make war.

10. Sullivan 2004:85. Although some authors use the term "Chan Santa Cruz," the Santa Cruz Maya don't accept it, because using the word *chan* (little) diminishes the importance of the cross—the size of the cross has nothing to do with its power.

11. The British settlement numbered less than 20,000. The British colony was scared to death of invasion and not equipped to defend against it. Dumond 1997:423.

A lot of Yucatecan Maya fled to Belize to escape the fighting. Alfonso Tzul is a Yucatecan Maya who grew up in San Antonio, Belize. His great-grandparents fled Yucatán during the Caste War. Alfonso speaks Spanish, Mayan, and English and has a degree in agronomy. He's a handsome and active man, recently retired from the Department of Agriculture, where he worked as a field extension officer and then as the administrator of the program. Now he's pursuing his roots by writing history, promoting the Maya Forest garden, and teaching the Mayan language in the school at San Antonio. He's been doing a lot of research in the government archives. One day, as we drove from Cayo to Belmopan, he told me about his family.

"The people who fled during the Caste War, like my grandparents who came to Belize, were called the Pacíficos [peaceful Indians, a group of Santa Cruz Maya who wanted to stop fighting]. I think that, to some extent, they were wiser than the other mazehual, because some of them were fighting the Spaniards [Mexicans] with machetes and sticks. How could you ever win a fight with machetes and sticks against people who have gunpowder? To me the Pacíficos realized that it would have been much better to strike some deal with the Spaniards rather than continue fighting them, so they laid down their arms. Naturally this enraged the other Maya who were laying down their lives for the cause, and they turned against their brothers.

TOP: Carlos Chan, museum director, with copy of *The Modern Maya: A Culture in Transition*, and Hilario Canul and José Domingo Kauil, at the entrance to the Museum of the Caste War. Tihosuco, Quintana Roo, 2001.
CENTER: Gremio procession to the shrine, Santa Cruz Tun Chuumuk Lu'um. Xocen, Yucatán, 1974.
BOTTOM: Altar for the Day of the Dead ceremony, Museum of the Caste War. Tihosuco, Quintana Roo, 2001.

"My grandfather was from Ma—í, Yucatán. My grandmother was from Icaiche, close to the Belize borde —her family had already escaped south— and she told me that the Santa Cruz Maya killed her mother and father and little brother. She escaped to Yok Creek, near Orange Walk, here in Belize, where a black man brought her up, and that's how she reached San Antonio, a motherless girl, and a descendant of the Pacíficos. My grandfather also reached San Antonio, after a number of sojourns in other villages, and that's how they met. My other grandparents died before I was born, and I only heard stories about them. They were also Pacíficos. I heard that my grandfather Diego Tzul went back to Yucatán around 1912."

"Did they ever go back before that?" I asked.

"The Maya life in those days must have been much simpler than we have it today, because my grandfather said they carried all their belongings on their back, which means a change of clothes and not much else. The way he described it was that they'd find a place to hide, to live, and they'd walk back to Yucatán and bring seed, little by little. If they didn't have it, they'd get it from a former neighbor. And one of the things you find in San Antonio is the palm for making straw hats. And I was told my grandfather brought that all the way from Yucatán. And I thought, how was it that my grandfather put that seed in his bag? He left his village on the shoulders of his grandfather. He was a small boy. So he went back after he settled in San Antonio and got the seeds and brought it back. He was a hat maker."

"And what would they eat when they were fleeing?"

"Roots and trees they found in the forest. One tree is called pumpkin tree. In April and May it blooms red, red, red. The pulp is soft and digestible. They also ate nuts and fruits, but it depended on the season. And that's what they ate in hard times," Alfonso told me.

"Now, I think that the only reason the Santa Cruz people lasted as long as they did is because the Spaniards realized that going against them in the forest was foolhardy. The Maya knew the forest and the Spanish didn't, so they decided to stop fighting all the time. Finally, in the twentieth century, when the Mexicans did arrive in Noh Cah Santa Cruz Balam Nah, they didn't find anybody. The Maya just dispersed into the forest. The Maya used the forest as a protection, as part of their strategy, which included living in small hamlets deep in the forest but in communication with each other. The Maya walked through the forest without a compass and went anywhere they wanted to go. My father and grandfather showed me how to do that.

"However, the British say that when they arrived here in Belize they found no Maya. Yet how come every account, from 1803 to right up to 1847, reports skirmishes with the Maya right along the Belize River, with people being killed and camps being pillaged? They even mention the Maya using bows and arrows.

"The British were like the Mexicans—the forest wasn't their home. They wondered where the Maya came from. The British didn't see any towns, but that's because the Maya were living in small communities. It was no big deal for a Maya to walk ten miles in the morning, do whatever he wanted such as hunting or working at his milpa, and then walk ten miles home again. So they were along the riverside, but back a way. And the British didn't venture much beyond a few miles from the riverbank. The Maya had been here all the while, giving the British trouble. At the time of the Caste War, more Maya started arriving. The people at Chichan-há near the border (who were attacked by their Santa Cruz neighbors and abandoned it and moved to Icaiche) made a treaty with Mexico and Yucatán that they weren't going to fight anymore. Now this angered the Santa Cruz people, who turned against them, so the Maya living near the border decided that the best thing to do was to move deeper into Belize. Many of them came down to live in San Pedro and San José and other villages near San Ignacio, Cayo. Suddenly these small hidden villages became big villages, and the British report counted 800 people living in San Pedro.

"But then the Pacíficos, who'd escaped both the Mexicans and the Santa Cruz Indians, realized that the British were now encroaching on their

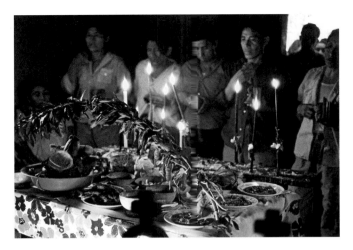

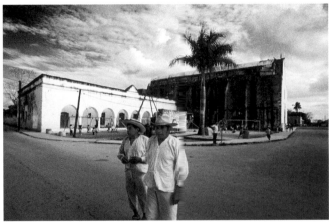

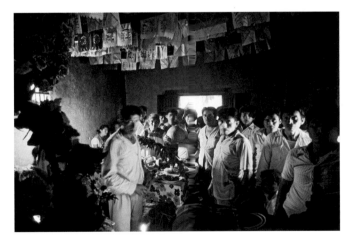

TOP: Group at the shrine with offerings during a gremio celebration, Santa Cruz Tun Chuumuk Lu'um. Xocen, Yucatán, 1974.
CENTER: Leaders from Tixcacal Guardia in front of the former Balam Nah, now a Roman Catholic church. Carrillo Puerto, Quintana Roo, 1974.
BOTTOM: Group at the shrine during a gremio, Santa Cruz Tun Chuumuk Lu'um. Xocen, Yucatán, 1974.

new land. They might have been called the Pacíficos, but they weren't afraid to fight. They attacked the mahogany camps and demanded that the British pay rent on the use of the land and pay a royalty on the trees that they were felling. The British didn't want to do that, so Marcos Canul, one of the Maya leaders, attacked a mahogany camp and carried off hostages and demanded that a ransom be paid for them. It was then that the British began to pay rent and royalties to the Maya.

"Then the British did a very interesting thing. They thought that there was a rift between many of the Pacíficos and Marcos Canul, so they gave arms to the Maya in San Pedro, who said that they'd fight against Canul. But it turned out there wasn't a rift, and the British simply armed the Maya.

"When they realized their mistake, the British went to San Pedro to see what was happening. When they arrived, only the *alcalde* [mayor] was in the village. They didn't know where the other men were, but they knew they were armed. The British returned with a larger force, but the Maya learned of their plans and attacked the British before they reached San Pedro, and the British retreated. Now the British had to show justice to the Maya, so they returned with more troops.

"The Maya again learned of their plans, so when the British arrived in San Pedro, they found it deserted. The British burned it down—all the buildings and all the surrounding villages too. But they didn't find anybody there. In retaliation the Maya, starting at one end of the river valley and working their way to the other end, burned every single British camp. The British deserted the river valley. This was in 1867, and the British didn't cut any more mahogany that year. They were afraid that the Maya were now going to move on Belize City and attack them. They were like the Yucatecans when they retreated to Mérida. The British realized their whole country was deserted and soon their economy would be in shambles. The British were more interested in working than fighting so they proclaimed an amnesty to the Maya. They appointed a fellow named Dolores Hernández to walk all the way to the Petén to announce to all the Maya scattered about that they could come back and nothing would happen, because the British wanted peace. I've researched this at the archives, and all of this is documented there. And within ten years, San Pedro and San José were once again bustling Maya villages."

"It sounds as if the British were much more practical than proud. By granting amnesty, a lot of fighting was avoided and a lot of lives were saved," I said.

"As a result of that proclamation the villages of Benque Viejo and Soccotz were reestablished, and San Antonio was founded in 1876, and then my grandparents met each other. Until 1985 everybody in my village of San Antonio spoke Mayan, and then things changed rapidly, and today most of the youngsters don't speak it any longer. Over the years, as peace prevailed over the region, the Maya of San Pedro and surrounding villages were slowly drifting into other population centers and became part of the mainstream society and the villages disappeared, until 1936, when only San José was left. And then the residents of San José were forcibly relocated to Orange Walk by the Belize Estate and Produce Company. Some of the people refused to go. They walked three days to Santa Familia near Bullet Tree and settled there."

12. "There had been no final victory, and there would be fighting for the rest of the century. But after 1855 it was considered a new thing, not a rebellion or a war but a struggle between sovereign powers, Mexico and Chan Santa Cruz. Of all the native revolts in America since the Arawaks used their wooden spears against the sailors of Columbus, this one alone had succeeded." Reed 2001:185–186.

13. During the Mexican Revolution, which consumed most of Mexico from 1910 to 1920, the Mexicans abandoned their war against the Maya. In 1915 the governor of Yucatán even delivered control of the area back to the Santa Cruz Maya and ordered dzul residents to move to Payo Obispo (now Chetumal)—which would become the new capital of Quintana Roo. Dumond 1997:426.

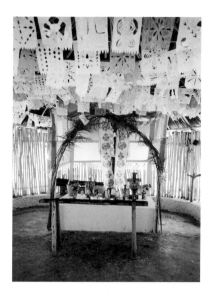

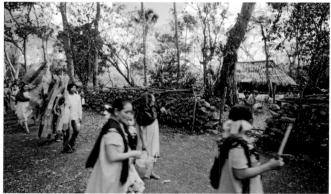

TOP: Interior of the Maya church. Yokdzonot, Yucatán, 2001.
CENTER: Gremio procession to the shrine, Santa Cruz Tun Chuumuk Lu'um. Xocen, Yucatán, 2003.
BOTTOM: Candles in front of the cross and altar, Santa Cruz Tun Chuumuk Lu'um. Xocen, Yucatán, 1971.

14. Bricker 1981:87.

15. Vandervort 2006:xv.

16. General May traveled to Mexico City and met with Venustiano Carranza, president of Mexico. Carranza confirmed May's authority over his territory and, for good measure, made him a general in the Mexican army. When General May opened up the forest to chicle collection and contact with the outside world, he must have walked a very fine line, incorporating his people into the commercial sphere while at the same time holding onto as much Maya autonomy as possible and avoiding assassination by jealous rivals or independence-minded traditionalists among the Santa Cruz Maya, not all of whom agreed with him. A dissident group seeking independence established Tixcacal Guardia and took the cross that formerly was at Noh Cah Santa Cruz Balam Nah.

Francisco Rosado May, great-grandson of General May, remembers Felipe Carrillo Puerto in the 1950s and 1960s and the large warehouses where blocks of chicle were stored before being shipped to Chetumal for export. He also remembers his great-grandfather saying that the one thing that he regretted was not knowing better "how the new system of work works"—that's how he said it in Mayan—meaning how the new economy functioned. Now everything was in pesos rather than in trade and barter. General May became a great advocate for education and told the Santa Cruz Maya that they had to study, that education was their future. In his footsteps, his great-grandson Francisco has fought for schools and bilingual education for the Maya and is the rector of Universidad Intercultural Maya de Quintana Roo.

17. Francisco Rosado May was a teenager when his namesake died in 1972, so he heard many stories growing up. His great-grandfather rose quickly in the ranks of the rebel Maya because he was such a good fighter and killed many Mexican soldiers. His great-grandfather told Francisco that one of the arguments the Yucatecans were using to gather support from Mexico City was that the Santa Cruz Maya were cannibals. The Maya decided to use this lie to their advantage. He said that they would take a dead soldier and boil him or cook him in a pib and make sure that the other Mexican soldiers would go by and see this. When you are undermanned and underarmed, psychological warfare is a very important weapon.

"One thing they did," Francisco said, "was use the chechen tree [also known as black poisonwood: *Metopium brownei*; it is part of the Anacardiaceae family, which includes cashew nut, mango, and pistachio but also poison ivy, poison oak, and poison sumac] because the resin burns your skin. My great-grandfather told me about a place near Chunyaxché, twenty kilometers south of Tulum, where there is a big patch of chechen growing there—just chechen, nothing else. And he'd lure the soldiers to the patch of chechen. Now before the soldiers arrived the Maya would chop the branches to get the resin really flowing. They developed several ruses to get the soldiers to chase them, but once they got to the chechen patch, the Maya would disappear, they would fade into the forest. Soon the soldiers couldn't move because of the burns and some would even be temporarily blinded. Just touching the tree can burn you." The old general would laugh and tell his great-grandson that the Mexican soldiers were easy prey and the Maya could go in and finish off the troops using just their machetes.

"I went to check it out," Francisco said, "and even though there has been some disturbance in the area, sure enough there was about a hectare of pure chechen growing there, right where he said it was. And history came alive for me. I pictured scenes with people running through here and then suffering from the burns and not being able to defend themselves. It was part of the war. It was a very brutal war."

18. An altercation took place in Dzula in 1933. Federal troops tried to arrest a Santa Cruz Indian, and the Maya fought back. Five Indians and two soldiers were killed. While the soldiers burned and looted Dzula, many of the villagers escaped to the capital Tixcacal Guardia (161 of them settled there). All the supporting villages sent armed men to Tixcacal Guardia to help in case the soldiers pursued the villagers. Villa Rojas 1945:33, 44, 48.

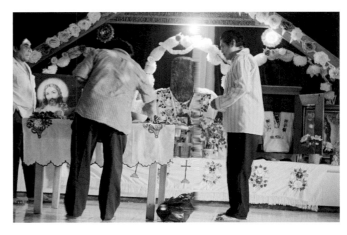

TOP: Gremio procession to the shrine, Santa Cruz Tun Chuumuk Lu'um. Xocen, Yucatán, 2003.

CENTER: Alfonso Dzib Nahuat praying at the altar with incense smoke rising, Santa Cruz Tun Chuumuk Lu'um. Xocen, Yucatán, 2003.

BOTTOM: Alfonso preparing the altar, Santa Cruz Tun Chuumuk Lu'um. Xocen, Yucatán, 2003.

19. In 1997, on the 150th anniversary of the beginning of the Caste War, a group of modern Maya wrote a letter to scholars attending an international conference in Mérida, asking them not to forget that the Maya still felt the war "in their own flesh, the 'soft' war, the war without arms, the war of hunger, of misery, and of injustices, the war without end." Reed 2001:360.

20. Charles and I investigated the use of this word *gavilán* in 2008, starting with the priostes of the church in Xocen. They told us that the Mayan word was *ch'uy*, which indeed is the Mayan word for a certain hawk, according to Cordomex. We asked why three crosses would collectively be called the Hawk of Christ or the Hawk of Three Persons. They couldn't tell us other than to confirm that the phrase is correct. When we asked others, they came up with possible explanations for its religious associations. Dario immediately, without prompting, invoked Cuauhtemoc to explain the gavilán's link to Precolumbian Mexico and went on to tell us that it was the eagle sitting on top of a cactus with a serpent in its mouth that is seen on Mexican coins (referring to the legend of how and where the Aztecs found their capital). Herculana suggested that the gavilán was the same hawk for which a milpero put aside an offering when he did his loh in the milpa to guard his crop. Like the gavilán, the crosses would guard Xocen. Celso suggested that the procession from the church to the home of the cargador out to the sacred cross and then back was like the gavilán circling in the sky, and that was why the procession of the three crosses was called Gavilán de Cristo.

21. The first performances of "Show and Dance in Xocen" was in Xocen itself, attracting hundreds of Maya from neighboring towns and villages as well as tourists and dzules from Valladolid. In 2002 they moved the show to a venue in Ticopo, on the outskirts of Mérida, where they played for the Meridians as well as tourists. The thirty performers and musicians from Xocen rode there every Saturday in a chartered bus and came back the same night.

22. Reed 2001:355–356.

23. Charles once met Paolo Freire, the Brazilian philosopher and educator theorist, and was delighted when he asserted: "Eating ice cream is a children's right, not a privilege." When we first arrived in Yucatán, corn had a value, and friends like Dario could afford to buy a popsicle for everyone in their family. Today he can't even buy ice cream for his two granddaughters. It would cost him a day and a half's wages.

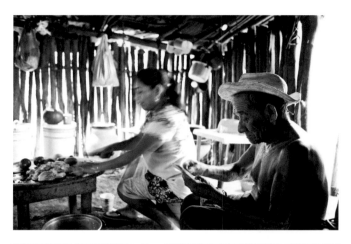

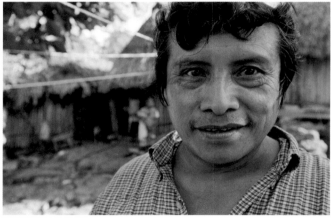

TOP: Rufina and Celso in their kitchen. Xocen, Yucatán, 2008.
BOTTOM: Alfonso Dzib Nahuat. Xocen, Yucatán, 2003.

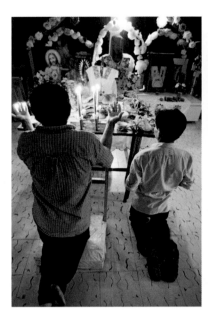 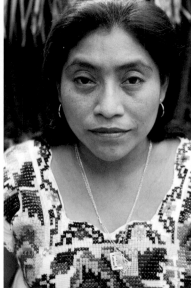 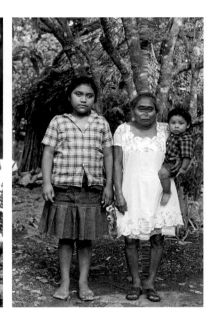

LEFT: Alfonso praying in front of the c oss, Santa Cruz Tun Chuumuk Lu'um. Xocen, Yucatán, 2003.
CENTER: Rufina. Xocen, Yucatán, 2003.
RIGHT: Victoria and María holding Lis Fernando, Victoria's brother. Xocen, Yucatán, 2008.

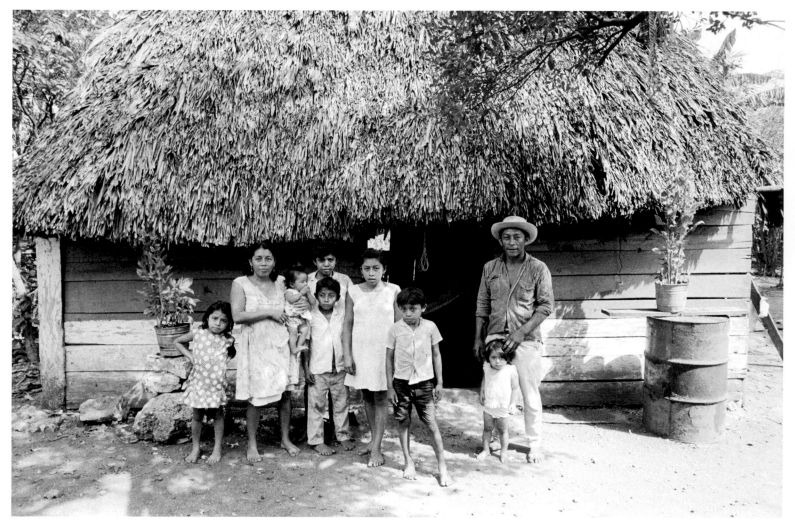

Pablo and Ofelia with their children in front of their house. Tulum, Quintana Roo, 1971.

On this day we left this island called Santa Cruz [Cozumel] and passed to the island of Yucatan, crossing fifteen miles of gulf. Arriving at the coast, we saw three large towns separated from each other by about two miles, and there could be seen in them many houses of stone, and very tall towers, and many houses of straw. We would have liked to enter these towns if the captain had permitted us to do so; but, he having forbidden it, we sailed that day and night along this coast, and the following day near sunset we saw very far away a town or village so large that the city of Seville might not seem larger or better; and there could be seen in it a very tall tower.
JUAN DIAZ, chronicler of the expedition led by Juan de Grijalva, 1518

I'm ready to kill pigs! I am ready for the fiesta!
AGAPITO EK, Tixcacal Guardia, 2004

Riviera Maya was named the No. 1 "up and coming" honeymoon destination in *Modern Bride* magazine's World's Best Honeymoon Destinations 2002 survey. Voted on by more than 3,000 ASTA [American Society of Travel Agents] members, the annual survey is the only one of its kind that asks agents about their favorite destinations to recommend to honeymooners. As part of the designation, the Riviera Maya will have the right to use the "World's Best Honeymoon" logo in advertising materials throughout 2003.
Press release, www.rivieramaya.com

VI The Santa Cruz Maya

An account of how Pablo Canche Balam and Marcelino Poot Ek introduced us to the sacred villages, talking crosses, fiestas, and celebrations of the Santa Cruz Maya; we witness the onslaught of development and tourism in their traditional lands and find a Talking Cross

Pablo Canche Balam is the most worldly of my Maya friends, even though his village was once so remote that a twentieth-century explorer referred to the area as a "lost world."[1] But as soon as a road reached Tulum in 1969, tourists started arriving to visit the nearby Maya ruin, a walled settlement perched on a cliff overlooking the aquamarine Caribbean Sea. The exquisite setting makes it the prettiest archaeological site in Mexico, if not the Americas. Miles of empty white beaches lined with coconut palms enhanced its popularity. Offshore the Meso-American Reef protected the waters and provided a rich habitat for marine life.[2] Tulum is now part of the Riviera Maya. More than a million tourists visit the archaeological site every year, many on day trips from Cancún, Playa del Carmen, and Cozumel.

Tulum Pueblo (inland and a few kilometers from the ruins) was one of the sacred villages of the Santa Cruz Maya, but they abandoned it for a short period near the beginning of the twentieth century. Pablo's family helped resettle it. His maternal grandfather, Dolores Balam, a renowned sacerdote in Yucatán, became the tatich of the Maya church in Tulum. He brought his grandson Pablo (born in Chichimilá on January 26, 1935) when he was a small child. Pablo remembers walking and not knowing where he was going. When he tired during the long days on the trail, his grandfather swatted him with stinging nettles so that he would learn to walk like a man. Dolores would also teach Pablo everything about the forest.

When Pablo married Ofelia Cámara Peraza in 1952, their families were two of only fourteen that lived in Tulum. Ofelia's parents, Juan Cámara and Victoria Peraza, had come from Mérida. Because Juan was "tranquil, humble, and learned in reading and writing," as Pablo's brother Nicassio explained, the few Santa Cruz Maya families living in Tulum invited this *nohoch* (big) *czul* into a leadership role. Juan planted several kilometers of coconuts on a stretch of coast just south of Tulum's ruins, shipping the copra (dried coconut meat) by boat around the peninsula to Mérida, where it was pressed into oil. He gave his new son-in-law land for his own coconut plantation. Soon Pablo had cleared, burned, and planted his first trees along the coast.

Pablo would walk along the shoreline whenever he had the chance, especially after storms, to collect planks of wood and whatever else washed onshore. In 1960 he used these planks to rebuild his house on the village plaza, across from the Maya church. The villagers had used similar planks to build their thatched-roof church. Tulum grew slowly as the children of the founding families got married, started their own families, and built their own houses. As Pablo's daughter Genoveva Canche Camara pointed out, "The founding families include Cámara, Canche, Pech, and Balam, and they are among the most common names of locals to this day."[3]

In 1958 the French adventurer Michel Peissel trekked the length of Quintana Roo. Pablo helped guide him for part of his journey. Peissel wrote in *The Lost World of Quintana Roo* that he found only ten houses in the village of Tulum, along with the Maya church where they worshipped. He included a photograph of a handsome young Pablo, whom he described as eager, intelligent, hospitable, at home in the jungle, and curious about the world, a description I found equally apt thirteen years later.

Pablo's curiosity led to experiences that his neighbors never shared, and his interaction with foreigners resulted in a series of collaborations.[4] In 1974 he played the title role of a mystic shaman in *Chac*, an impressionistic full-length movie by Chilean director Rolando Klein about a Maya village suffering a drought that needs a shaman to perform a rain ceremony. Pablo traveled to the highlands of Chiapas for the filming, and a year later Klein flew him to California to attend the movie's premiere. *Chac* has since become a cult classic. The same year Pablo started working with Richard Luxton, a writer from England. He would talk and explain his world, and Richard would ask questions and write their conversations. In this way the two of them authored *Mayan Dreamwalk*, published in the United States as *The Mystery of the Mayan Hieroglyphs*.

When I met Pablo in 1971, Tulum was still a small village of a few dozen houses. I'd tried to reach Tulum in 1967 when I walked from Chemax to Cobá, but Hurricane Beulah had flooded the jungle trails. Two years later I reached the ruins via the dirt road that work crews were extending south to Tulum from Puerto Juárez. I found the ancient city deserted, the white beaches empty. The waves were good waves, and

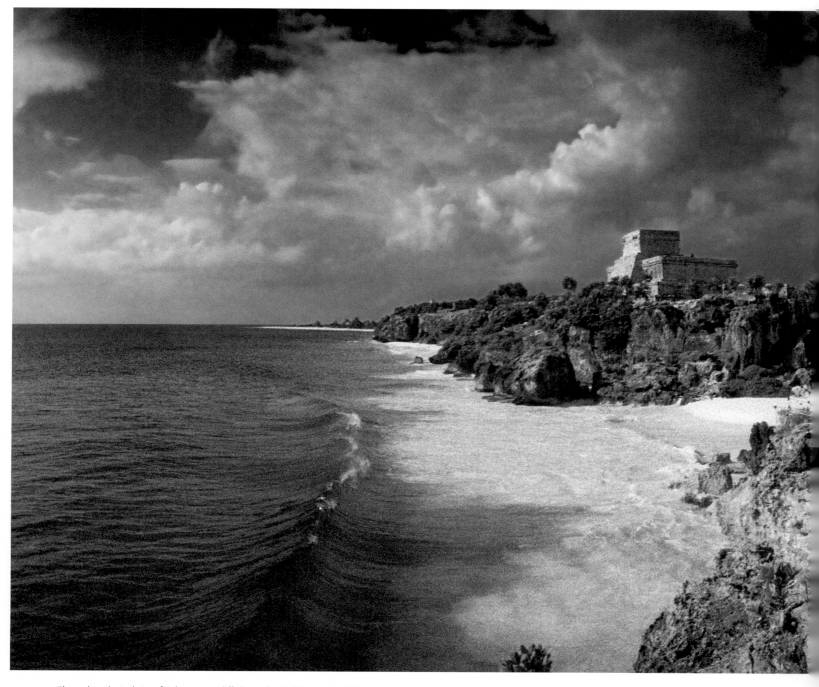

The archaeological site of Tulum, on a cliff above the Caribbean Sea. Tulum, Quintana Roo, 1987.

late in the afternoon I bodysurfed until dark beneath El Castillo, the Maya pyramid perched on the edge of the cliff overlooking the Caribbean.

Archaeologists once considered Tulum a walled city from the Postclassic period, but further investigation suggests that it was part of a much larger development that extended in both directions along the coast. Grijalva's expedition in 1518 described it as being as large and impressive as Seville. The area was a strategic Maya sea-trading center, and archaeologists suggest that the walled community of the present archaeological zone was the center for an elite group—probably merchants, especially honey vendors. Above some house and temple doorways is a depiction that was once thought to be a descending god but now appears to be a bee (a similar depiction is carved even today above the entrance to the wooden log beehives used for the native bee). Today's extensive development along the coast, including gated communities and highways heading west and up and down the coast, closely parallels what the ancient Maya had already done long before the conquistadores arrived. Archaeologists aren't sure when the Maya abandoned their many sites along the eastern coast, but the wave of epidemics that swept the Americas after contact with the Spanish certainly contributed to their disappearance.[5]

The abandoned ruins drew occasional explorers after Stephens and Catherwood opened the modern age of exploration with their visit in 1842. Despite its dreamlike location, few people visited the ruins before the 1970s because the region was not only roadless but also in rebel Santa Cruz Maya territory. When archaeologist Sylvanus Morley visited in 1922, for instance, a garrison of fifty or more well-armed Santa Cruz Maya from Chunpom met him. For the Santa Cruz Maya, Tulum was more than an archaeological site or a pretty place. It was one of their most sacred religious spaces, where the spirits of their forbears still lived. They celebrated religious rites in front of a wooden cross erected on an altar in a room at the top of El Castillo.[6]

Quintana Roo had been a blank spot on most maps since the conquest. The Spanish never occupied the eastern portion of the peninsula other than garrisoning a small fort at Bacalar (near present-day Chetumal), so there weren't any cities. At first the people who populated the forests of Quintana Roo were those who simply didn't want to be assimilated and runaway Maya fleeing colonial oppression. In the nineteenth century it became the home of the rebel Santa Cruz Maya, who fought from their jungle bases to establish a nation of their own.

Today it is hard to imagine just how forgotten and undeveloped the Territory of Quintana Roo was when I first visited in 1967. It was a territory because it lacked the 250,000 inhabitants needed for statehood. Dzules dominated the few small commercial centers on the coast. In 1969 Chetumal was the sleepy capital of the territory, with only 12,855 inhabitants; Cozumel had 7,562 residents and Isla Mujeres 3,949. But 70 percent of the population was Maya; most lived in small villages and farming hamlets in the interior.

Cancún didn't exist. The story that you hear of Cancún's beginning involves a computer search for the perfect location along Mexico's coastlines to build a resort that would rival Acapulco, at that time Mexico's leading tourist destination. All sorts of variables were fed into the computer. Three of the most important were beautiful beaches, cheap labor, and undeveloped land, preferably in an unpopulated area perceived as a tabula rasa on which to plan and build a resort city.[7] Cancún was chosen, and the Mexican government's introduction of tourism as a viable industry in this otherwise "worthless" environment was the catalyst for change on a scale unseen since the conquest. Nothing this monumental had been undertaken along the Caribbean coast since the Maya built their temples, pyramids, cities, and roads a thousand years earlier. When the government started to appropriate their territory for development schemes at the end of the 1960s, the Santa Cruz Maya had no idea how much their lives were about to change. The Maya believe that history is cyclical, and what was about to occur paralleled the Spanish conquest in the sixteenth century. By not realizing the strength of their numbers and joining together, the Maya would lose a lot of their land and autonomy.

Forty years later the demographics of Quintana Roo have reversed. Now 70 percent of the inhabitants are dzules and the native Maya are the minority. The Riviera Maya, an area stretching from just south of Cancún to Tulum, generates billions of dollars annually in tourist revenue. Cozumel has become a top destination for cruise ships. Land values along the coast are as high as any in Mexico. Quintana Roo is now the richest state in the country.

Since there weren't any hotels in Tulum when the road arrived, the first travelers camped along the beaches. Pablo quickly saw an opportunity to earn money, so he built some cabañas at Dzibaktun, his coconut plantation. He offered people a place to sleep in a hammock next to the Caribbean as well as meals, which often included fish that he'd caught that day. Others, including Pablo's half-brother Martín, turned their village houses into stores to capitalize on tourists looking for supplies.

Hilario, Charles, and I all met Pablo independently in 1971. We would spend hours with him at his house on the plaza, at his ranch at the beach, or out at his milpa in the forest and accompany him hunting at night. Like all our Maya friends, Pablo found time to answer our questions and teach us. After I mentioned that I wanted to spend a rainy season in the Maya forest with a chiclero, Pablo invited me to stay at his chiclero camp (see Chapter III).

When Hilario and I stayed in the village we asked for permission to hang our hammocks in the guardhouse, a long thatched-roof building with half walls where villagers often

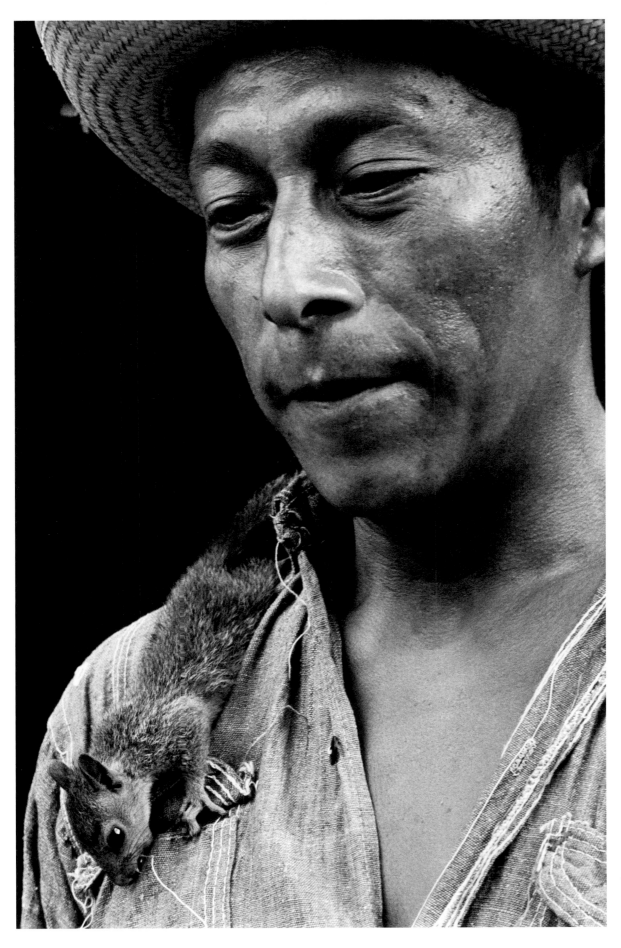

Pablo Canche Balam.
Tulum, Quintana Roo, 1971.

225

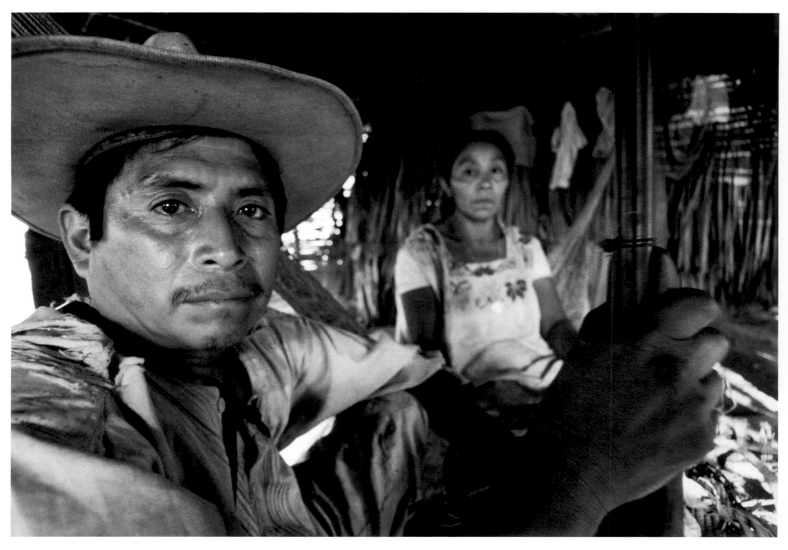

Comandante Marcelino Poot Ek and Isabela Yam Pech in their home. Tixcacal Guardia, Quintana Roo, 1974.

gathered.[8] In front was the Maya church. From the outside you'd never know that it was a house of worship. It looked like many other buildings constructed along the coast, with a raised cement floor, painted wooden plank walls, and a guano roof. We were to discover that, like all the Santa Cruz Maya churches, it was aligned so that the priest and supplicants faced east when they stood in front of the altar.[9] The main doors opened at the west end facing the guardhouse. The church had no windows. People could bring in food and other offerings through its side doors.

Visitors had to remove their shoes or sandals before entering the church. A guard at the doorway enforced the rule and had at his side a *santa vara*, the traditional whip made from a vine. Inside the church it was cool and dark. Often a second guard, also armed with a switch, sat at the entrance to the Gloria (sanctum), with a half-wall dividing it from the main gallery. Flickering candles cast light and shadows. Two rustic candle stands, with a base made from a single limb cut so that three protruding branches formed the legs, stood in front of the altar. We would light our candles then drip pools of hot wax so that we could stick them upright on the stand.

The altar was covered with an embroidered cloth between two sheets of plastic. A large wooden cross stood at the center of the altar; its arms were covered with a sudario in deference to its feminine gender. The cross was the physical presence of God. Flanking it were smaller crosses and cases holding plaster or wooden saints and plastic and real flowers. Penitents lit their candles then walked or crawled on their knees the length of the altar. In front of each cross and saint they made the sign of the cross, kissed their thumbs, and bowed their heads. Some did this once; others did it repeatedly. Some said their prayers out loud, while others whispered. For each it was an intensely personal moment.

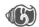

When Pablo invited Hilario to light some candles, Hilario had no idea what this would lead to. "When we started out I didn't even know where we were going," he told me. "We took this long walk through the jungle. We walked for several hours, into the evening, and it got dark. When we emerged from the trail into a village, I saw all of these open fires burning in the plaza, with hundreds of people gathered around preparing food in large cauldrons. It was unlike anything I'd ever seen in Yucatán. I discovered that Pablo had brought me to a fiesta in the Santa Cruz Maya sacred village of Chunpom." It was the first of many fiestas that Hilario, and later Charles and I, would attend. Hilario wanted us to join him immediately, but I wasn't able to return to Yucatán until the end of 1973 and Charles in April 1974.

Hilario had also met Marcelino Poot Ek, who quickly warmed to the Mayan-speaking American who'd married a Maya. Hilario had invited Marcelino to his home in Chichimilá, and they'd walked to Xocen to light their candles at the Cross of the Center of the Earth. Marcelino was *comandante* (secular leader) of Tixcacal Guardia, the most recent of the

sacred villages. It was founded in 1929 by a group of Santa Cruz Maya who split from other rebels in and around their former capital, taking (some would say stealing) that shrine center's sacred cross with them. They wanted sanctuary and independence from the soldiers and outsiders who were increasingly controlling the Santa Cruz Maya region.

The 700 Maya who made this move began calling themselves Los Separados (Separatists) and looked down on their less conservative kin. They chose an isolated area northwest of Carrillo Puerto that encompassed approximately 625 square miles and founded nine satellite villages to support their new capital. They built a thatched church on new holy ground to enshrine La Santísima, the sacred cross they'd brought, and barracks for their guards to defend it. Every married man was obligated to perform service to the cross, which included guarding it as well as daily maintenance while he was on duty.

Los Separados were the most determined to isolate themselves and retain their autonomy. They were hostile to outside influence and practiced passive resistance if anyone passed through their territory. They shunned strangers, wouldn't feed them, and wouldn't let the occasional traveling merchant who was allowed to stay spend much more than one night. Anthropologists were interested in them, of course, as they represented the most conservative of the Maya.

In 1931 the ethnographers Robert Redfield and Alfonso Villa Rojas visited the territory briefly. Villa Rojas reconnoitered the area more extensively the following year and chose it for further research. For his studies, Villa Rojas returned in the role of a traveling merchant, accompanied by a muleteer and three mules laden with merchandise. During his stay, he told the rebel leaders that Americans were working at Chichén Itzá. Acting on his recommendation to visit them, they sent several men to investigate, out of belief in a prophecy (written in the ruins of Tulum) that the Maya and Americans would join together to defeat the Mexicans.[10] Thus began a relationship between the rebels and the archaeologist Sylvanus Morley that Paul Sullivan recounts in fascinating detail in *Unfinished Conversations*. After an extraordinary exchange of letters between the rebels and Morley, the Maya, who were hoping to gain an arms-supply ally in Morley, allowed Villa Rojas to return for ten months in 1935 and 1936. This resulted in his influential work *The Maya of East Central Quintana Roo* (1945). Making contact with Morley and allowing Villa Rojas to live among them was a radical step for the rebels. Only a few years earlier, associating with whites—along with murder and witchcraft—was a crime punishable by death.[11]

Just over a generation later Hilario and I drove into Tixcacal Guardia in early March 1974, on a rough new road that the government had cut through the jungle. It was wide but uneven, and we bumped over the rocks. The few streets in the village were essentially footpaths bearing the marks of sandal soles and bicycle tires, as none of the villagers owned a vehicle.

Like most mazehual'ob, Marcelino didn't stop what he'd

Maya bullfight during a fiesta, with the man on the right playing the role of the bull. Tulum, Quintana Roo, 1974.

been doing to entertain us when we arrived. He'd just returned from his milpa with a load of dried ears of corn that now lay in a large pile on the hard-packed earth floor of his house. He pulled down a hammock for us to sit in and talked while he shucked corn and his wife, Isabela Yam Pech, made tortillas on the comal over the cooking fire. He wore homemade traditional clothes that I'd previously seen only in photographs taken in the 1930s by Villa Rojas and Morley. His white baggy pants, fastened with a drawstring and without pockets, came down to his knees, with two cutouts near the waist in the back. His long-sleeved white shirt had vertical pleats and a row of buttons that were decorative except for a few where the shirt opened at the neck. It had two pockets at the bottom, similar to a guayabera.[12] Isabela's huipil was also distinct from others in Yucatán, hand-embroidered with a cross-stitch known as *xok chuy* (*hilo contado*) in a local Tixcacal Guardia style that incorporated more broad geometric designs than the flowery, often machine-sewn ones that I'd seen in Yucatecan villages.

I watched through the pole walls as an older man approached the house. He wore the same style of clothes as our host. When he reached the doorway, he waited until Marcelino invited him in. Hilario introduced me to Roque Dzul, the Nohoch Tata (literally "Great Father," the high priest of the church). Don Roque pulled down another hammock from the rafters and joined the conversation, but a few minutes

later we asked his permission to light candles. When he nodded yes, we walked over to the church.

Four crosses, set at intercardinal points of the compass about fifty meters from each other, protected the church and the *popol nah* (community house) from evil winds and other dangerous influences. Nearby were the barracks for men performing their guard service, a responsibility that rotated among the villages so that there was always someone on duty to protect the cross. During fiestas the barracks would overflow with village delegations and whole families of pilgrims, with hammocks swinging from every rafter.

We removed our sandals at the entrance to the thatched-roof church and walked barefoot on the tile floor, which felt cool in the midday heat. The inside walls were plastered and painted a pastel blue and green, decorated with freehand drawings of crosses, flowers, and vines. Two bass drums hung from a crossbeam. The half-wall that separated the Gloria from the main gallery consisted of a series of solid arches topped with crosses, with an arched entrance in the middle. "Noca Santa Cruz XBalamNa" (Great Town of the Holy Cross, House of the Jaguar) was inscribed on it. Outside the sanctum the tiles had colored floral patterns, but inside they were solid blue. The altar was covered with embroidered cloth, and the crosses were draped in sudarios.[13] We lit our candles, placing them on a rough-hewn wooden stand, and said private prayers. Afterward we lingered in the

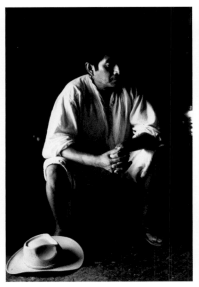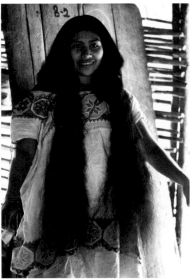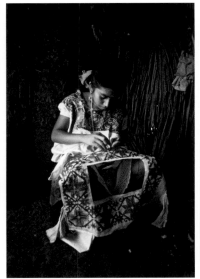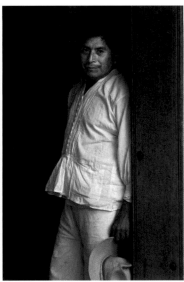

FROM LEFT: Marcelino Poot Ek; Emilia Poot Yam, Marcelino's daughter; Emilia sewing, Tixcacal Guardia, Quintana Roo, 1974. Marcelino visiting the Roman Catholic church, the former Balam Nah, Carrillo Puerto, Quintana Roo, 1974.

church, sitting on a bench and leaning against the wall, the plaster cool on our backs.

A week later Hilario and I picked up Roque, Marcelino, and his son to go to the fiesta in Tulum. The road south from Chichimilá to Carrillo Puerto and then up to Tulum wasn't paved and was in miserable shape. It was a modern version of the ancient Maya sacbe and similarly constructed, with a roadbed of rocks topped with saskab. Every year the road was supposed to be graded and resurfaced after the rainy season, but it hadn't been. The storms had worn away the soft earth in many places, exposing the rocks. Driving was exhausting because I needed to pay such close attention to the bone-jarring potholes. Traffic was light, so I could drive on either side of the road or right down the middle and found some stretches that weren't too bad. But it seemed that as soon as I'd speed up I'd hit a section of potholes so thick that there was no avoiding them. I'd have to swerve and jam on my brakes. It made for an uncomfortable ride and interrupted conversations.

We arrived in Tulum a few hours after dark and parked in front of Pablo's house. We got out, stretched, and rubbed assorted sore spots. Ofelia welcomed us and told us that Pablo was still in San Cristóbal filming *Chac*. We walked across the street to the church and added our shoes to the stack at the entrance. A group of musicians sat on benches in the main gallery—three violinists, who held their instruments at mid-chest rather than tucked under their chins; two trumpeters; and a snare and a bass drummer, who rested their instru-

ments on the floor. They played *mayapax* (Maya music), a repetitive, trancelike music that struck a casual listener as having no beginning or end and few special passages. Based on seventeenth-century Spanish music, it had clearly evolved and undergone a New World transformation. An elderly man who sat in the corner underneath two bells suspended from the roof added to the trance-inducing nature of the music. Using ropes connected to the clappers, he kept up a quick, steady rhythm, ringing one bell in 3/4 time and the other irregularly.

"Traditionally there are two violinists, a snare drum, and a bass drum, and sometimes a trumpet," Hilario explained. "But that can change. The music sounds very monotonous and repetitive at first, but I discovered that there are three basic categories—prayer music, dance music, and bullfight music. The Maya refer to them as *aires*. You need an ear for it—otherwise they sound indistinguishable. The prayer music is played while we bring in the offerings of food to the Cross. The musicians are part of the procession, and they play while walking with everyone and then continue playing during prayers in the church. The bullfight music is played in the afternoons for the bullfight, and the dance music is played at night. During the ceremonies, the musicians often put in seventeen-, eighteen-, or even twenty-hour days, when they have to be around for all the different events. They need to be careful not to get too drunk or to fall asleep. It is hard work, and they get paid for it." He added: "Not very much, but they get paid."[14]

Outside the church a full moon bathed the warm night in a soft light that made the women in their huipiles seem to glow. We joined hundreds of people in yards near the church

preparing food for the next day. A group of men, resting between work details, invited us to have a drink with them. After finishing a beer we took our turn grinding corn. We found it hard, because the grinders were positioned for the shorter Maya. We had to stoop to work; when we joked about it, they offered copitas of rum to lessen our back pain.

A pilgrim from the village of Pom handed out cigars made from native tobacco. The cigar was mild, and we relaxed, watching our smoke in the moonlight. For many Maya smoking is a social and communal act rather than an addiction, ritually offered during public activities such as sacred fiestas and church services but also in private rituals, such as a baptism, or when visiting the father of the young woman that your son wants to marry. It is a small pleasure that is shared.

Hilario decided that we needed music. The musicians had gone to bed because they were exhausted, so he went and got his tape recorder and a recording of a group playing in the church at Tixcacal Guardia. The music put everyone in a festive mood. Some men started to dance, and women came over to listen. It was the first time they'd ever heard a recording of mayapax.

There was no distinction between participant and spectator at the sacred fiesta—everyone was both. It was a time to eat and drink, be foolish, boast, get drunk, get sick, dance, be happy or sad, renew friendships, extend and affirm social bonds beyond the family, proclaim unity, and above all pray to God and thank Him for life in all its manifest forms.

Each day of the fiesta had a *nohoch kuch* (big load carrier). Usually a wealthier member of the community, the kuch was responsible for providing food and drink for everyone. He would commit to his volunteer service at least a year in advance and solicit the help of relatives and friends. Everyone in attendance contributed something or shared in the labor. All people of good faith were welcome, and the feast was free.

This ceremonial preparation, blessing, and distribution of food to everyone in attendance is known as *matan* (offering, gift) and is central to the Maya faith, not just with the Santa Cruz Maya but also throughout the peninsula. This traces back to Precolumbian times, when a duty of the nobility was to feed the gods and the feast was the chief element of the Maya liturgy (this is what Dario and his neighbors did in Chichimilá when they performed their Ch'a Chaak, as described in Chapter I).[15]

Each morning the food was taken to the church to be blessed and prayers were said. The food was harmoniously arranged on the altar and offered to the Saintly Cross and all of the deities. After they had spiritually feasted, it was removed from the church and distributed to everyone at the fiesta.

Matan combined the tradition of ritually sustaining the gods with food with community responsibility—you are your brother's keeper, so no one goes hungry. For many it might have been one of the few times of the year when they enjoyed meat.[16] The sacred feast had to be worthy of the gods and saints; because it was such a treat, it was a rich and joyous time.

The next morning one of the guardias suggested that I could photograph inside the church when the food was brought in and blessed. When I asked permission, I was told that I could. When I pulled out my tripod, however, an elderly leader who followed the old tradition of wearing an earring in his left ear changed his mind. I put my camera away, but I wanted to photograph as much as I could because I knew there was scant visual documentation of the Santa Cruz Maya. Although they frequently had rules against photography, they often gave me permission if I asked.

In 1974 *National Geographic* was preparing a big story on the Maya. I was one of several photographers to work on the project. A couple of months earlier my editor, Jon Schneeberger, had told me that they were looking for contemporary situations that could show the continuity between ancient and modern Maya. Archaeologists and anthropologists sometimes write that modern Maya continue traditions that are thousands of years old. I told my editor about the Santa Cruz Maya and their sacred villages. Although the magazine had published numerous articles on the Maya, it had never covered the Santa Cruz Maya. The only recent photographs from Tixcacal Guardia and Chunpom had been published in *Argosy* magazine when writers and adventurers Milt Machlin and Bob Marx had been allowed to photograph in the church during their search for ancient Maya codices.[17] I explained to my editor that to gain permission to photograph we'd need to give a donation to the village, such as violins for the musicians or a large cauldron for preparing communal feasts. Without making a significant contribution to the church, I felt that I was limited in what I could photograph.[18]

After the church service and feast, Marcelino and Roque wanted to go to the beach. Fifteen people, including the musicians, squeezed into my truck. We drove to Dzibaktun, Pablo's ranch and coconut plantation. They rolled up their pants legs and waded fully clothed into the Caribbean. Splashing and getting sand between their toes, they looked out across the sea to the horizon where the sun is born each morning. Afterward they gathered coconuts to take back to their villages, some to plant and others to eat.

We stopped at the nearby ruins. Villa Rojas had written that members of Tixcacal Guardia made pilgrimages to Tulum because they felt that the spirit of the ancient Maya resided within the ruins. I myself had found candles in front of altars and stelae when I'd first visited Tulum and Cobá. On this day we didn't light any candles. I watched Marcelino and Roque walk around looking at the temples and I wondered how they saw the site. Did they still consider it a place of worship and feel the spirit of the ancient Maya? Or did sharing the site with thousands of tourists diminish its sacredness? These were Western questions, ones that I didn't feel I could ask without perhaps offering a bottle of rum to facilitate the process. Instead we walked soberly around as they looked inside the buildings.

When we returned to Tixcacal Guardia, Marcelino and Roque invited us to return the following weekend. They would be celebrating a loh for the milpa. We accepted their invitation and arrived the following Saturday. We helped the men from Tixcacal Guardia and satellite villages dig a pib and bake ceremonial corn breads. When the breads were done, they removed them from the oven, unwrapped them from the leaves they'd been cooked in, and laid the sacred breads on more leaves spread on the large concrete platform in front of the church doors. Then they placed a hard-boiled egg and a piece of chicken on each bread, and the offerings were blessed. Afterward the bread was broken up and added to corn gruel. Everyone was served a gourd of the sopa to eat. No one objected to my photographing them over the course of the celebration, but General Juan Bautista Poot, from Yaxley, reminded me not to shoot inside the church. During the afternoon a lot of people invited us to go with them to the fiesta at Chancah Veracruz, and we decided that we should go. We were being welcomed and invited to a lot of ceremonies and fiestas, so we saw this as an opportunity to visit all the sacred villages.

So two weeks later, on April 1, 1974, Hilario and I visited Chancah Veracruz. The Maya church was amazing. It was built on a stone outcrop, set higher than any other building in town, and looked as if it had been transported directly from the South Seas. The interior was cavernous compared to the other Maya churches, and the roof, containing more than 30,000 guanos, sailed into the heavens. It was the largest and most beautiful Maya church I'd seen. Instead of having a Gloria set off by walls, it had a cloth curtain that partly shielded the altar from the rest of the room. The altar was packed with saints and crosses, many presumably hostages captured during the Caste War, as the Maya believed that a town was powerless without its patron saint. Chancah had by far the greatest collection of saints of any of the sacred villages. Originally the amazing array had been sheltered in the church at Noh Cah Santa Cruz Balam Nah, but the Maya had brought them here before abandoning their city to advancing Mexican troops in 1901.[19]

We were given permission to hang our hammocks in the school outbuilding with the Tixcacal Guardia group. That evening nearly everyone danced in the church to a band of drums and violins playing mayapax. Hilario started the dancing, in his unofficial capacity as an auxiliary *chi'ik* (master of ceremonies); a drunk quickly joined in, with elaborate and overemphasized motions. With the ice broken, others got up to dance. Candles burning in front of the altar illuminated the room, and our shadows glided and jumped along the walls. The band played long into the night.

Everyone was in a good mood the next morning and gave us permission to photograph a church service. Don Ambrosio Cauich, the Nohoch Tata, gave his permission, as did the guardian on duty. They all consented. I heard later,

though, that once the ceremony began someone had second thoughts—and once he revoked his consent, everyone else did too. But no one said anything to me. Instead everyone smiled at me as I moved around during the service with my tripod and camera, trying not to make too much noise as I photographed.

When Hilario, Charles, and I returned to Chancah Veracruz a month later, no one mentioned the incident, even after I brought out a movie camera and filmed outside the church in the plaza. But the following year don Ambrosio took Hilario and Charles aside and explained that the other leaders in the village were upset that he had let someone photograph inside the church. He was in trouble, and the villagers were thinking of throwing him out of office. The story was that we'd already sold the photographs for a high price and were now very rich. The protesters acknowledged that we weren't the only ones who had photographed inside the church. Other visitors had done so in both Chancah and Tixcacal Guardia, they said, but not during a service.

Hilario and Charles spent the day assuring everyone that we hadn't sold the photographs, no one had gotten rich, and don Ambrosio had not personally profited either. It was impossible to explain to the villagers that the photos had little value except as documents of anthropological and historical importance. The one magazine that might have published such photos was *National Geographic*, and my editor had by now clearly stated that he didn't think the subject was interesting or important. How could you explain to the mazehual'ob that an editor wasn't interested in a picture of their church when that church was so important to them?

The experience has affected the way I shoot and approach stories. I was dismayed when I found out that Ambrosio might lose his position, but I also found out that he was embroiled in another scandal for allegedly pawning gold hanging from the necks of the saintly crosses. Hence the villagers deposed him as their leader. Even so, in a sacred situation, no matter where in the world I am I don't push it if someone says no. I've missed some great photographs because of this, but the potential for misunderstanding between cultures is always high. What I feel and think is important may have no bearing on their lives, but my actions can.

I've never published the photographs other than in my book. Tragically, the church doesn't even exist anymore. Two years later the Mexican government helped the villagers build a new church. They tore down the most beautiful of Maya churches and replaced it with a concrete box.

Charles returned to Yucatán in time to join us on a visit to Tixcacal Guardia on Good Friday April 12, 1974. We passed large crowds at village churches. In Tihosuco we had to stop as worshippers leaving the ruined seventeenth-century colonial Roman Catholic church after evening services swarmed across the road.

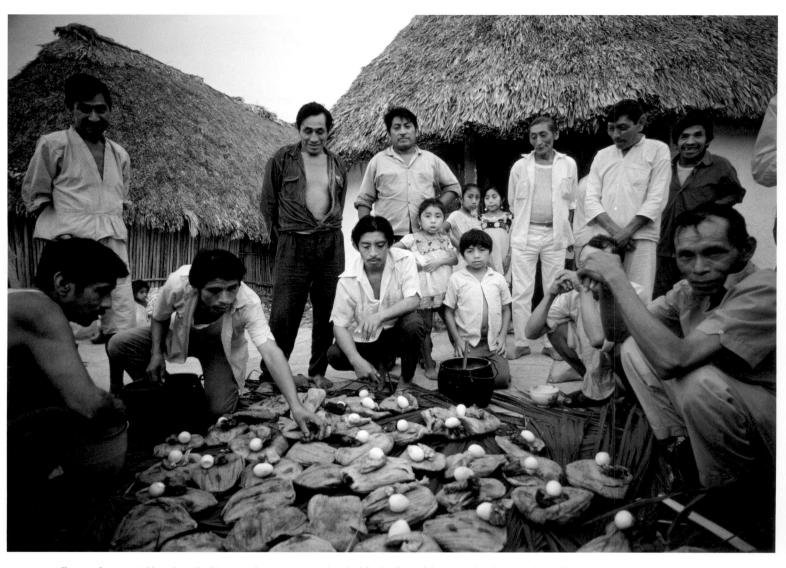

Offerings of ceremonial breads cooked in an earth oven, eggs, and cooked fowl in front of the Maya church. Tixcacal Guardia, Quintana Roo, 1974.

We wanted to attend a new fire ceremony (*suhuy k'ak'* or *tumben k'ak'*; literally "virgin fire" or "new fire"). The ritual dates to Precolumbian times when all the fires in villages and cities were put out once a year and a new fire was kindled. According to colonial chronicles and archaeologists, the ancient Maya not only put out their fires but also discarded plates, vessels, stools, mats, and old clothes. The rite assumed its greatest importance every fifty-two years, a measurement of time known as the Calendar Round. On those occasions whole households, buildings, temples, and pyramids would be refurbished or even destroyed and rebuilt to mark the advent of a new cycle. Now the ancient rebirth and renewal ritual was celebrated at Tixcacal Guardia at Easter.

The fire-making action is called *haxab k'ak'* (literally "twisting the fire"). Francisco Tamay, a villager who knew how to do it, joined Marcelino and Roque at 4 A.M. A few children showed up to watch and learn—quite a change from the report by Villa Rojas that all the married men in the village had participated in the 1930s.[20] No one spoke, for Marcelino had whispered that if you talked, the fire wouldn't start. Francisco began twirling a stick of *xkanan* (*Hamelia* spp.) between his hands, its point grinding into a small depression that he'd made in a short dry log of *chakah* (gumbolimbo, *Bursera simaruba*). Francisco couldn't make a spark, so Marcelino gave it a twirl and then Roque tried, but to no avail.

Francisco suggested that they use a longer fire stick. Marcelino borrowed my headlamp and returned to his house to find one he had stored for just this purpose. Francisco decided to replace the chakah wood with a dried stem of the large squash known as *ka* (*Cucurbita pepo*).

Marcelino twirled the new stick back and forth into the squash stem. Francisco crouched beside him and added small bits of native cotton (*pitz*). Francisco blew gently on the tiny embers that soon appeared, adding more cotton until they burst into flame. Marcelino immediately lit a candle from the new fire and entered the church, leaving his sandals at the entrance. His shadow followed him, dancing along the wall as he carried the virgin flame to light fresh candles at the altar.

We added kindling to the burning cotton then larger sticks. Once the fire was blazing we went into the church, lit our candles from the new flame, and placed them on the stand in front of the altar. Roosters were crowing from every quarter of the village, and dogs barked their own greetings to the dawn. It might have been like any other morning in a Maya village, but today I'd participated in a tradition that was thousands of years old that I'd only read about.

I knew how important fire was in a Maya household. At night, upon retiring to their hammocks, they would add a piece of hardwood to the kitchen fire to smolder all night. In the morning they would fan the smoldering embers and add quick-burning sticks to heat the breakfast atole. The Maya always kept a kitchen hearth fire burning unless they closed their house to move the whole family out to their milpa or to go on a trip. Charles asked Marcelino if everyone in the vil-

lage participated in this ritual of rebirth. He answered that he wasn't certain whether all the families had extinguished their fires. But we observed a steady stream of villagers coming to the church all morning with buckets and pots to carry coals from the new fire back to their homes, convincing us that all, or nearly all, had done so.

The only sacred village that we hadn't visited in the spring of 1974 was Chunpom.[21] That changed when a friend in Tixcacal Guardia invited us to their fiesta. Lorenzo Be had agreed to help one of the kuch'ob and in turn asked us.

Chunpom had a deserved reputation for being wild. Nancy Farriss argues that the death of Juan Bautista Vega, one of the last Caste War leaders, in 1969 might have signaled not only the end of the Caste War but also the end of the conquest of the Maya that the Spanish had begun more than four hundred years earlier. The villagers had threatened to attack the highway crew that was building the road through their forest that would connect Carrillo Puerto with Tulum. They called off their assault when they couldn't acquire modern rifles and reluctantly realized that armed conflict was no longer a viable option in defending their isolated autonomy. Even so, Mexican soldiers patrolled the highway until it was completed in 1971.[22]

At one point Juan Bautista Vega had actually asked the president of Mexico for a road to his village; but when the government did build a road it was to facilitate the army moving troops around the territory. When the government built a basketball court in the town plaza, everyone knew that it was a helipad, so the army could avoid using the narrow road where the Maya could easily ambush them.

Not long before we arrived in 1974, soldiers had moved through Chunpom, shooting pigs and chickens in a display of force. The Mexican government was nervous that a Maya uprising could disrupt its plans for developing the Caribbean coast into a tourist destination, so it periodically deployed troops to pacify the area, continuing a policy of intimidation and force that had been going on since General Bravo had captured Noh Cah Santa Cruz in 1901.[23]

These tactics could have tragic consequences—as we found when we interviewed a small, skinny mazehual in a jail cell in Chetumal.

"A group of soldiers came running through my village," he explained to us in Mayan. "They came out of nowhere, yelling in a foreign language [Spanish]. One of them approached me with his gun, and he looked so big. I was so scared! I feared for my life. I thought he was going to kill me. I didn't know what to do, so I swung my machete and killed him."

Charles, Hilario, and I arrived on April 30 for the nine-day fiesta in honor of the Day of the Holy Cross. We were able to drive in on a very rough road, the last segment primarily of rocks without saskab. I'd just had my cameras stolen in Mérida; but I'd brought along a 16 mm movie camera, which I'd never used, and a Nikonos underwater camera. We found

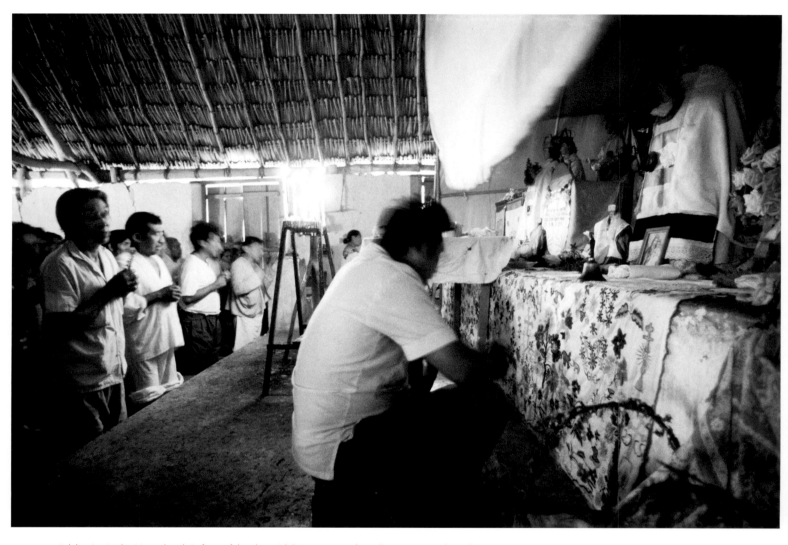

Celebration in the Maya church in front of the altar with hostage saints from the Caste War. Chancah Veracruz, Quintana Roo, 1974.

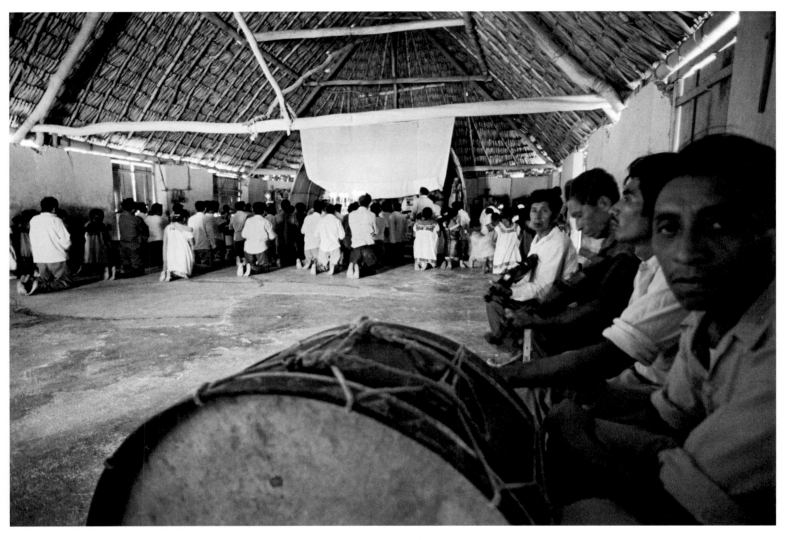

Musicians and pilgrims during a celebration in the Maya church. Chancah Veracruz, Quintana Roo, 1974.

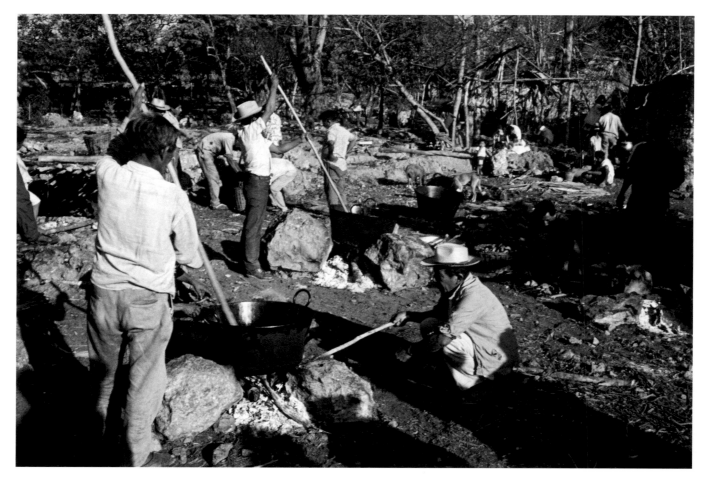

Men cooking in cauldrons over fires during a fiesta. Chunpom, Quintana Roo, 1974.

Lorenzo Be and his delegation from Tixcacal Guardia. All of us—his extended family and friends, including ourselves—shared a house and yard provided by a friend of his in Chunpom. We'd brought corn, candles, firecrackers, food, and bottles of rum as our contribution to his friend's responsibility for one of the feast days. After we hung up our hammocks, we asked what else we could do to help. He suggested that we go to the center to offer our labor.

The plaza was a large unarticulated open field of red earth and rock dominated by a great ceiba tree—the village really was a rustic forest outpost. Animals and people moved about beneath a brilliant blue sky and a scorchingly hot sun. Men carried heavy loads of corn and firewood, bent under their tumplines, while others herded pigs or carried live turkeys and chickens hung upside down from poles or just slung over their shoulders. Men with pack animals brought even greater loads of firewood and stacked them near cooking fires in the plaza. Others took turns grinding corn kernels in hand mills. Using six-foot-long poles, men and women stirred and cooked in large cauldrons, work that would go on day and night. The pilgrims and villagers worked amid a loud and joyous mix of conversations, whoops, shouts, and laughter. Many saw each other only at fiestas. In the shade

of the ceiba tree five women drew water from the plaza well and filled buckets. As a continuous parade of women carried them off, a full bucket in each hand, others returned with empty pails. A lot of water was needed for washing, cooking, and boiling cauldrons of corn. A work crew at the side of the plaza was busy constructing a bullring. They dug postholes, and set posts from timber that they'd cut in the forest. Then they added corral poles, wrapping them tight to the posts with vines. The men used their machetes to trim the poles and vines to the dimensions they needed. When they finished tying up the bullring they inspected the ground, tossing out the rocks lying inside.

At the north end of the plaza was the Maya church, the largest building in the village, with plastered walls and a thatched roof. A guardhouse stood next to it. Elsewhere around the plaza were traditional Maya houses and stone houses owned by the leading families in the village. Each house had a yard with trees and gardens and animals, bordered by rock walls. Rough lanes rather than roads or streets led into town and between the houses. It didn't look as if anyone owned a car or truck. Their only means of transport were horses and mules and the backs of the men, women, and children themselves.

Our first job was to help butcher eleven pigs. We joined about forty men—three or four to each pig. I helped hold one as a man thrust his knife into the heart of the pig. As the blood gushed out, another man rushed over with a bucket and jammed it against the struggling pig's chest to collect the blood as it screamed and thrashed in the dirt. We fought to hold it down. I looked around and saw that others were doing the same thing—a knife to the heart and a bucket jammed to the pig's chest. The blood was to make blood sausage. For a couple of minutes it was bedlam until all the pigs were dead. We were hot, and the blood and dust mixed with our sweat. The sun seemed harsher than ever—you could hardly see the flames of the fires. It was the end of the dry season, the hottest and most humid time of the year.

We singed the pigs' skins with burning palm fronds and scraped the hair off with a knife or rocks. Then men cut up the pigs. They fried their skins in big black cauldrons of boiling fat to make *chicharones* (cracklings) and hung the butchered pork from trees and temporary scaffolds. Dogs ran around, licking up the blood from the ground.

Groups of three or four women, wearing clean and brilliantly white huipiles and with bright ribbons in their hair, sat at low tables next to the cooking fires, patting out corn tortillas. They'd stop, take a corner of their sleeve to wipe away the sweat on their brow, and go back to patting out more tortillas, stacks and stacks of them.

People took breaks and leaned against the shadow side of rock walls. There was no breeze to dry our sweat. I decided that my break was a chance to light a candle and pray. I walked over to the church, took off my sandals, and entered through green double doors on the west side. The interior was dark and relatively cool and quiet. It was beautiful and simple inside—a long room with a partition at the far end for the Gloria. The walls were plastered and painted white. Heavy posts and beams held up the guano roof. The floor was laid with yellow and red tiles, merging into green and red ones near the altar. The partition separating the altar was a low wall with an arched entrance crowned with a cross. Benches and chairs lined the walls. Two large bronze bells hung from a pole, and two drums hung from posts. A mass of paper flowers, like a piñata, was suspended from the roof. The altar was covered with a blue plastic tablecloth printed with multicolored flowers. Several brightly colored and embroidered cloths added to the decoration. All the saints, shrines, and crosses were covered with cloth. Mirrors hung from the necks of the crosses.

I was alone until I heard music approaching. Then twenty young women came in carrying candles and bowls of food, followed by the musicians. These unmarried women, led by a matron, were the *vaqueras* (cowgirls), performing nine days of service to the Cross, with duties that included accompanying the daily procession of food offerings.

Once the food had been placed on the altar and blessed with prayer and music, the procession returned to the house of the nohoch kuch, where that day's feast would be distributed. A guard on duty brought me some of the food that had been blessed on the altar, including a small stack of tortillas, and I went outside to eat. I had to squint until my eyes adjusted to the blinding sun. It was so hot that everything looked burnt and brown. Normally the streets and plaza would be deserted at this time of day in this heat, but today pilgrims surrounded me, busy preparing for the next phase of praying, eating, drinking, dancing, bullfighting, and other rites. Although I later learned that each sacred fiesta has a well-planned sequence of events, I never figured it out, other than a broad understanding of what to expect. It was a twenty-four-hour experience. Over the next several days I found that I could work, pray, eat, drink, or sleep whenever I wanted to. Whenever I awakened, something would be going on. I noted some general benchmarks. The food would be blessed daily and distributed to all as part of the matan. Bullfights would be held in the afternoon and a dance in the evening.

The planting of the yaxche took place on the afternoon of the second day of the fiesta before the beginning of the daily bullfights on the third. This element has disappeared from village fiestas elsewhere in Yucatán. Twenty or thirty men go into the jungle and cut down a preselected tree. They carry it back on their shoulders, whooping and hollering as they ritually pass around bottles of rum. The rum animates and strengthens the young men: the tree is big and heavy, and cutting it and carrying it through the forest is hard work. When the men get close to the village they shoot off fireworks to announce their arrival. The musicians meet them at the outskirts, and together they march to the bullring where the tree will be planted amid music and fireworks.

Riding in the tree is a man shouting and raising a ruckus, playing the role of the *chi'ik*, named after the white-nosed coati, a mischievous animal related to the raccoon that is famous for stealing food from the milpa (the Maya sometimes keep them as pets). During the fiesta the chi'ik is both the master of ceremonies and also the jokester, akin to the coyote in the American Southwest.

There is a very good chance that the planting of the yaxche has its origins in Precolumbian times. "At first I assumed that they were planting a young ceiba, which is 'yaxche' in Mayan," Charles said, "because I knew the yaxche was the sacred tree of the ancient Maya cosmology—the great tree rooted in the underworld that reaches into the heavens, the tree of abundance. It's the tree that grows above cenotes that so many Maya villages are founded around. But in fact they were planting a zapote tree. I realized that in calling it 'yaxche' they were invoking a second meaning for the word, which is literally 'first tree' or 'green tree.' Later Linda Schele told me that the decipherment of the Maya glyph for erecting a stela was 'to plant a stone tree.' She thought that the Santa Cruz Maya planting of the yaxche could be analogous to the idea of Wakah-Chan—the World Axis rising through the multiple planes of the underworld, earth, and heavens—from ancient imagery."[24]

Hilario really got involved in the planting of the yaxche. "Everyone was drunk and running around," he said, "and this tree was particularly large and heavy. There were ropes

tied to the upper part, and slowly we started raising the tree into the hole that had been dug for it. 'Here we go—that's it, up a little more, watch out! Over there, hey, pull back on that side, hey, watch it now! Oh, too far over there, back, back! There, that's it, that's it, get the base into the hole, that's it, that's it, upright a little more, come on, we almost have it now . . .' Now of course fireworks are going off and there is a lot of yelling and explosions, so people have to scream to be heard above the noise.

"The men threw rocks into the hole around the tree trunk, the traditional Maya way of setting any post in the ground. You first jam the hole with rocks, pounding them down hard and tight, and then you throw in the dirt. I was on my hands and knees, and right next to me was a young guy who was very drunk and sweating profusely and was using his hands like a bulldozer, pushing the dirt into the hole. As he pushed, he talked to the earth, repeating, '*Santo luum* . . . Earth, earth, saintly earth,' and I joined in, 'Luum, luum, santo luum.' The timing and the situation were just right. I truly felt I understood the profound connection that these words held for him, and I felt them myself as we both pushed the earth into the hole."

The chi'ik was in the tree. The men shook it as they raised it, trying to knock him out. He stood up in its branches or sat on a limb, drinking rum from a flask and taunting the men planting the tree, just as a real white-nosed coati taunts a milpero while stealing food from a milpa. When the yaxche was planted, the chi'ik tossed handfuls of sikil seeds to signify that the tree had blossomed. To show that the tree had borne fruit, he placed fruits and vegetables from the milpa in its branches, such as bananas, *yucas* (cassavas, *Manihot esculenta*), macal, and camotes—foods that a coati likes. During the fiesta he might throw or carry the "fruits" down, with the vaqueras and children harassing him and stealing the food from him, just as in the milpa when the mama chi'ik gets food and then her kids steal it from her.

This was all done in good fun, because that was the point of the chi'ik. He was a trickster. His job was to loosen up the crowd. Wherever he went during the nine days of celebrations, he usually carried a gourd or bottle filled with rum, which he passed around freely. Another of his functions was to arrange the Vaquería, the jarana dance each night. It dates from colonial times when the Spanish had a fiesta and dance after the yearly cattle roundups at their haciendas. The young women were called vaqueras and the young men were called vaqueros.[25] Until recently nearly every fiesta in Yucatán featured at least one night of jarana. Over the centuries the jarana has metamorphosed from a dance originating in Spain into the traditional folk dance of the Yucatán. It is notated in either 6/8 or 3/4; when it is done well, the dancers execute their steps in consonance with the music. When you think of dancing, and especially dancing in Latin America, you might think of couples touching and twirling: salsa dancers spinning in one another's arms, tango dancers sinuously entwined as they glide across the dance floor, mambo

dancers moving suggestively in rhythm. However, jarana is danced standing apart. Partners don't touch or sometimes even look at each other.

Both dzules and Maya dance the jarana during fiestas. Even in the largest towns of Yucatán, the traditional clothing worn for the jarana is Maya dress. The women wear elaborately embroidered ternos made of fine cotton or silk or fine huipiles. The men wear Maya sandals, pressed white pants, and white shirts with a colored handkerchief in their right back pockets. Even the lyrics are often in Mayan.

In Chunpom the Maya women wore their nicest huipiles and the men wore their cleanest clothes. The dance was as much a religious ritual as a chance for the young people to see each other. But the young men and women suddenly became shy when the dance started. This is where the chi'ik has to work the hardest—to get the dancers relaxed and out on the dance floor. The chi'ik paid particular attention to the cowgirls, joking with them, offering them rum (which they might or might not accept), and otherwise uplifting their spirits. A successful dance needs young women, so he encouraged them to laugh, to drink, to dance, to enjoy the fiesta.

Everyone could enjoy the dance. After cooking feast food all day and night, the women welcomed the opportunity to dance with their husbands as well as relax with friends, whom they might see once a year, and talk about which boys were dancing with which girls. If the pairing surprised them, they had a lot to talk about. The men smoked cigarettes, drank, and rested.

The quick steps and tempo of the jarana often get a bit muddled by drinking—you see people executing small dance steps out of time with the music. Or someone may completely slow down and appear to be dancing underwater while his partner tries to remain serious until she cannot keep a straight face any longer. At that point the man is usually left to dance his delirious steps by himself, enjoying rhythms that no one else hears.

In the afternoons, beginning on the third day, a *pay wakax che* (fight the wooden bull) was held. The Santa Cruz Maya had adapted the Spanish bullfight to their own impoverished condition. Since the villagers couldn't afford to buy and kill bulls, they carved a bull's head from wood and mounted it on a burlap-covered frame, with suspender straps so a man could wear it. Once a man put it on, he would take on the mentality and movements of a wild bull. Sometimes a "bull" would escape from the ring and run through the plaza, knocking people over and creating havoc until it was roped and tied up. You couldn't just yell to the bull to stop being the bull—the man had to be captured before he could stop playing the part.

A bull costume was tied to a pole in the center of the ring. One of the men would step in and put it on. After the chi'ik had given him a couple slugs of rum, he was set loose amid a barrage of firecrackers. Other men were the bullfighters, waving cloths in front of the bull. The men traded places and

would carry on all afternoon through dusk. The spectators loved it, and another pay wakax che would be held the next day and every day after that, as long as the fiesta lasted.

"The pay wakax che is very popular among the young men," Hilario said. "You get all these young women coming out here after spending a year in the jungle and they are hot—their dress, their posture, their look, and the way they dance. It's all very proper, but they are hot. And the young guys want to show off, so they'll keep bullfighting until dark. They can get pretty wild. But I'm not afraid to go out and bullfight with them because everyone knows that I'm married. No one is going to pick on me."[26]

Drinking was an integral part of the celebration. Alcohol was dispensed ritually by the nohoch kuch during his day of preparations, by the chi'ik at the fiesta's ceremonial events, and by pilgrims who'd brought their own bottles. Many sips were accompanied by a toast to unity spoken in *chu'huk t'an* (sweet talk), when the speaker is positive in everything they say (highlighting strengths while ignoring weaknesses).

The ritual drinking was carrying on a Precolumbian tradition in which drunkenness was a necessary part of every ritual, as well documented by the Spanish. Farriss points out that publicly sanctioned drunkenness helped release tensions that could build up over the year and facilitated access to the supernatural.[27] I discussed this later with Allan Burns. "It isn't just the drinking (which isn't that constant) but the lack of sleep that probably induces people to an altered state," he said. "When I was at the May 1 ceremonies at Tixcacal, I remember talking with one of my neighbors, and his voice was lowered and the 'couplets' that are more pronounced in *uchben tzikbal* [ancient conversation] were loud and clear. At the time I thought that this is a bit like a possession, but a possession back to ritual Mayan of uchben tzikbal. The other thing I remember was the strong effect of the burning chiles in the air throughout Tixcacal. It burned my eyes, and the light smoke throughout the town added to the general odd atmosphere during the fiesta."

I was drinking with everyone else, but I'd just given up smoking. I would have loved a cigarette to go with the alcohol but refused them whenever they were offered to me. Anyone who has quit knows how hard it is to do.

I'd joined some men in carving a new bull's head for the bullfight. About twenty of us walked over to a side yard where several large rounds of cedar were stacked. We sat in the shade, avoiding the direct sun. After much discussion, one round was blocked out using a pencil to sketch an outline, and the men took turns shaping it with an axe. The first attempt failed. The wood split at an awkward angle, and another round had to be selected. We passed around a bottle of aguardiente, which rapidly evaporated. It was suggested that I buy a case of beer. When I returned I passed the bottles around. One of the men took out his cigarettes and offered me one. I took it and stuck it behind my ear, a common and polite enough practice when you weren't going to smoke it immediately.

"Let me light it for you," he said.

I raised my hand in a small salute and told him that I would smoke it later. The man staggered over and rested both of his arms on my shoulder. He leaned back to get a better look at me. He was very drunk.

"Smoke it," he demanded, breaking away. When I demurred, he grabbed the axe from the man carving the bull's head and advanced toward me, waving the axe.

"We're brothers," I blurted out. "This is a Santa Fiesta and we are all working together . . . " I didn't stop talking until he put down the axe. He came forward, and we embraced. We slapped each other on the back several times and hugged. Embarrassed, he handed me another cigarette—I stuck it behind my other ear—and we embraced again.

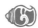

Within three months in 1974, we've visited the four Maya sacred villages that worshipped the Talking Cross, attending fiestas and ceremonies. There was one other shrine village with a Speaking Cross, San Antonio Muyil, but Mexican soldiers had overrun the town in the nineteenth century. Rumor had it that their cross still existed, but we certainly didn't hear about any current festivities related to it.

We tried to put what we'd found into perspective, comparing our experiences to what Morley and Villa Rojas had seen in the 1930s. The mazehual'ob were still understandably wary of outsiders, trying to retain their autonomy even as the Mexican government was working furiously to incorporate them into Mexican society through integration (colonists), intimidation (soldiers), and an aggressive road-building program within their forest territory. What the Maya leaders still controlled was their church and religion.[28]

We had found the churches in all four shrine villages to be very active. They held services for the local community that included the supporting satellite villages. Pilgrims filled the shrine villages during the major fiestas and celebrations. They continued to worship Kichkelem Yum, Beautiful God, as personified by the Santa Cruz, the Holy Cross. "This is a Maya church" we heard time and time again, distinct from those controlled by Rome.[29] They believed that their church put them closer to God than any other religion could. They had faith in the strength of the community and the value of community spirit and unity. This weaving of religion and community worked because their religion reflected their self-sufficiency while reaffirming their identity as Maya.

Their services were closely tied to the agricultural cycle and Christian calendar, crucial to the maintenance of the mazehual'ob way of life. They had a church that facilitated speaking with the rain god Chaak so that their crops were well watered. They spoke with the forest gods and saints to ensure that they weren't injured in their fields and that the animals didn't take too much from their fields before they harvested. Religious services functioned both to celebrate service to God and to further the social cohesion of the com-

munity. The church reflected a set of shared core values that were rarely challenged.[30]

While we truly enjoyed the social and spiritual feelings from our pilgrimages to the sacred fiestas, not to mention the good food and drink, it was very clear to our Maya hosts that we were also collecting ethnographic data and making photographs for an article or book. I wanted to document their religious practices, the glue that held contemporary Maya society together. Their religion was inextricably tied to how they saw themselves, so I wasn't surprised that they were protective and secretive about it and often couldn't agree on whether to give me permission to photograph. Some understood the historical value of photography while others didn't—or if they did, it still did not outweigh the principle of not consorting with outsiders, a strategy that had worked in the past. They also understood that they'd have no control over how and where the photos would be published. Everyone thought I'd make money.[31] I had no rebuttal for their arguments. I didn't push photographing inside the church or outside of it. I asked permission. If it was granted, I photographed; if it wasn't, I didn't. I was glad that it was a community decision, so we all shared responsibility.

Whenever we asked the Maya's permission to photograph, they'd ask us to help sponsor their service to the Cross. Indeed, sooner or later the Maya make similar requests to most outsiders who spend time with them. On many occasions we were asked by fellow pilgrims to contribute a few pesos to purchase a bottle of rum or corn or soft drinks or to provide transport for people or gear. As for the leaders, they hoped we might help with their *cargas* (obligations), which meant providing corn, pigs, rum, turkeys, chickens, firecrackers, and candles necessary for each day of the fiesta. Then there was the hardware that had to be fixed or replaced: the pailas for preparing quantities of feast food, violins for the musicians, bronze bells for the church, and indeed repairs and improvements to the churches themselves. Over the years we've given all of these as well as gifts of corn and pigs and money, becoming cargadores in our own way, contributors to the Maya church and its sacred communal feasts and fiestas.

Although Pablo never asked us for guns, many others did. As other anthropologists have noted, the Maya spoke of a prophecy that an American would come and help their struggle, although it was the British who actually supplied them with guns and ammunition for decades during the nineteenth century. Any American who spent time in the sacred villages and gained their confidence would be asked to help. The subtext of such requests for arms was often couched in vague, open-ended statements, perhaps to see if they would rise to the occasion. Conceivably, anyone so inclined could have reignited the Caste War. Just look at what happened twenty years later in Chiapas when Subcomandante Marcos helped the Maya form the Zapatista Army of National Liberation.[32]

Student protests, coups, and revolutions were occurring around the world in the 1960s and 1970s. Mexico's equivalent to Tiananmen Square or Kent State occurred in 1968, ten days before the opening of the Olympic Games, when police and soldiers in Mexico City killed hundreds of peaceful demonstrators, many of whom were students. The Tlatelolco Massacre was just the most visible of the government's vicious responses to growing unrest. It began an extended political crisis for Mexico. In addition, Mexico was afraid that Fidel Castro, at the time actively exporting revolution abroad, would arm and support the Maya—the road building along the coast was in part to protect the Caribbean shore from a Cuban invasion. Mexican armed forces patrolled the coast, looking for clandestine Cuban agents landing on deserted beaches.[33]

In 1974 Marcelino introduced Hilario and me to Paulino Yama in nearby Señor. He informed us that the British had brought his grandfather from China to Belize in 1866. When a hundred of these coolies escaped the terrible working conditions and fled north, the rebel Maya captured most of them. Eventually, some of the Chinese and their descendants were incorporated into the Santa Cruz Maya society, adding new knowledge and new blood to the isolated rebel culture.[34]

Paulino seemed genuinely pleased to meet us. He commented on how hot it was and suggested that we sit outside in his backyard in the shade. It was easy to talk to Paulino, who had many things he wanted to tell us. He spoke knowledgeably about current events. He said that his father had been born in Noh Cah Santa Cruz and that he and his father were brought up as Maya. In fact, we found out later that Paulino was a Santa Cruz Maya leader and comandante. He had also been one of the most vocal in insisting that the mazehual'ob pursue an alliance with Britain and the United States following the loss of their capital to the Mexican army. Toward that end, he'd traveled to Belize five times and had been a member of a delegation that trekked to Chichén Itzá to meet with the archaeologist Sylvanus Morley in the 1930s.[35]

Paulino pulled out a large photograph of Princess Margaret, looking very regal against a plush red background. For Paulino, the photograph represented a past savior who might again help the Maya. He told us that he had been given the poster while on a trip to Belize in 1957 and referred to Princess Margaret as the sister of the queen of England.[36] "The queen today should send us arms as Queen Victoria did, because the British and the Americans are the allies of the Maya." Perhaps, he suggested, we had connections too? Paulino and Marcelino looked expectantly at us. The conversation stopped.

Pablo was angry. Already the Maya had become a minority in their own town. They were losing their authority and their land to outsiders. Used to policing themselves and settling their own problems, they were annoyed that dzules were now making the policies. The government was taking communal land and giving it to colonists who were arriving dai-

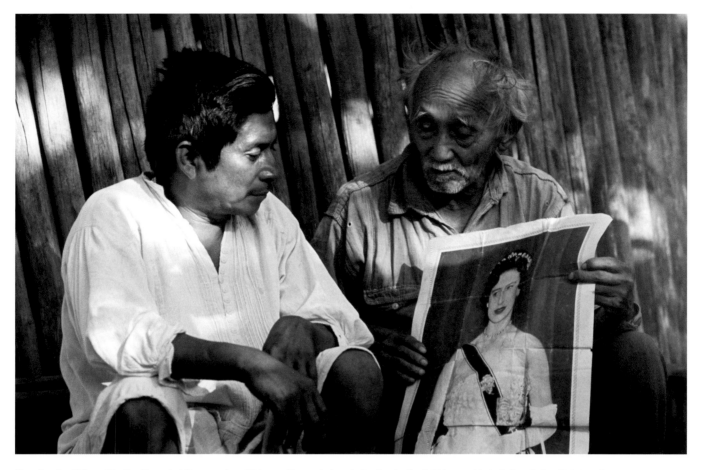

Marcelino Poot Ek and Paulino Yama holding a poster of Princess Margaret given to Paulino by the British on a trip to Belize. Señor, Quintana Roo, 1974.

ly. It was obvious that Mexico hoped to use them as a way to pacify an area where they'd never had much control. To add insult to injury, officials had the temerity to tell the Maya that they were better off than before.

I'd just arrived in Tulum to attend the annual fiesta in March 1976. Pablo had a litany of grievances that he proceeded to share with me. He was upset that dzules, especially Mexicans, were wandering in and out of the fiesta without knowing anything about Maya customs. On top of that, police and soldiers had descended on Tulum, ostensibly looking for drug use among the tourists camping at the beach. The villagers didn't consider it a coincidence that this show of force coincided with their fiesta.

Pablo couldn't believe how quickly things had changed in just the few years since the road had arrived in his tiny hamlet. Already the Maya church and plaza were no longer the center of Tulum. The government was bulldozing a new grid of roads to create Tulum Nuevo, which would have its own separate plaza and church. They were already becoming a Maya barrio of a Mexican town.[37] And then FONATUR (Fondo Nacional de Fomento al Turismo/Natural Trust for Tourism Development) was snatching up land along the coast for development, declaring kilometers of land south of the ruins, including Dzibaktun, Pablo's coconut plantation, to be "Fon-

do Legal" (property of the state).[38] Pablo was fighting them, but he felt powerless in a foreign system.[39]

"Our lives are spinning in different directions," he explained. "We're no longer a united community working for the same goals. Personally I'd like to resolve things. If the government takes my land, so be it. I just need to know what to teach my children—to fish and learn to work with the tourists or to go into the jungle and farm as our grandfathers did. In the meantime we must make petitions. Not just one, but many. If a governor sees a paper on his desk, he may not pay attention. But if next week he sees ten papers, then fifty, then a hundred, and the stack keeps growing larger, it doesn't matter how big a governor he is, he is going to have to attend to us.

"First they want to take my land and then they want me to pay taxes on it," Pablo griped. "It's the same suffering we endured when the Spanish made us pay tributes. We are not accustomed to so many people coming here and to the types of people. Thieves and even those who murder! We are forced to walk a path with others now, and we must watch out—there was a group of colonists brought in from the north. They were used to the desert and didn't even know how to farm and what to eat, so they stole from our milpas—our corn, our squash, and our food.

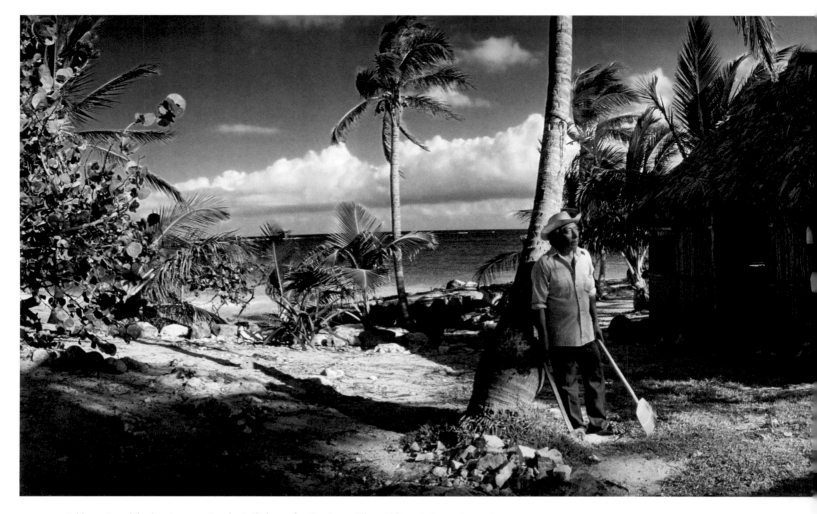

Pablo resting while cleaning up at Rancho Dzibaktun after Hurricane Gilbert. Tulum, Quintana Roo, 1988.

"When they built the road from Tulum to Cobá, men from Mérida hunted at night with powerful guns and bright lights on their trucks. They'd shoot five or six deer each evening and a lot of wild turkeys. They'd sell the meat in Mérida, or worse, leave the meat and take only the skins for trophies. Now there's no game. If we want to hunt we have to go far into the jungle. It disrupts our way of life."[40]

On the other hand, Pablo readily acknowledged that the opening of roads had brought material benefits. *Hay trabajo, hay dinero,* he answered when I asked about the rapid development. "There's work, there's money." Many Maya perceived their standard of living improving. They could earn cash to buy or at least put a down payment on radios, televisions, cassette players, even cars. Besides, as the younger Maya said, the work was easier than farming. More importantly, the work appeared steady and secure. The older Maya knew only too well how harsh the life of a subsistence farmer could be. Periodic catastrophic famines caused by droughts, plagues, or hurricanes and famine-related epidemics had annihilated the Maya since the Spanish conquest. It's little wonder that many Maya found the security of a regular job appealing. Even so, Pablo himself was spending more and

more time at Angelita. He considered the forest his escape. He referred to Angelita as a place where he could retreat if he had to, away from the intrusive authority of the new Mexican way of life.

Compared to the rapid changes occurring in Tulum, the impact of Quintana Roo's economic development was much less visible and dramatic in the other sacred villages. But the roads that had recently reached each sacred village would have a profound effect. Once opened, the village absorbed elements of the outside world. Perhaps you could call it passive incursion, because the road (and later electricity and, with it, television) brought in incremental changes. Without any further government action, the Santa Cruz Maya were having to adapt to the new mix of tradition and modernity, sacred and secular.

Hurricane Gilbert devastated Yucatán in 1988. When Charles and I sponsored a benefit in Santa Barbara for Gilbert's victims, we decided that most of the money should go to Santa Cruz Maya villagers, who were least likely to receive re-

church. I was in time for breakfast. One guard came in with hot tortillas wrapped in a cloth and two cans of sardines in tomato sauce, so I walked over to a nearby store and purchased two more cans of sardines and enough soft drinks for everyone. The guard opened the cans with his machete and poured the sardines into a bowl, found several chiles to add to the meal, then spread the cloth holding the tortillas out on the floor. Nine of us squatted to eat, tearing off bits of the chiles to spice up the meal.

I'd traveled all night and hadn't slept, so Pablo offered me a hut behind his house that was quiet and calm where I could hang my hammock. Two of Pablo's daughters and their children were gathered around a table in the backyard preparing tamales for Despedida de los Difuntos (Farewell to the Deceased), ending a weeklong celebration of the days of the dead begun on November 1, All Saints Day. After a week the souls return to the place where they dwell. The women patted out corn-dough tamales for the going-away celebration and filled them with shredded chicken, tomatoes, and the pungent herb epazote before wrapping the rectangular cakes in banana leaves and cooking them in a pib. This kind of earth-oven baked tamale is traditionally prepared for the dead because it travels well and can keep for days, good qualities for offerings to the spirits of the deceased for their journey. After chatting briefly, I went into the hut and hung up my hammock. The morning was alive with sounds. Chickens pecked around the yard while a rooster crowed and birds sang from trees and rooftops. A cool breeze from the ocean a couple of kilometers away rustled the guanos of the thatch roof. Children played outside, their sandals slapping against the soles of their feet as they ran by. I dozed off.

That afternoon I heard about the big events of 1988. First, Tulum's sacred cross had returned from Tixcacal Guardia, along with its guardian, Juan El.[41] The other big news was that Gilbert had caused limited harm to their church because the Maya had opened all the doors when the hurricane struck. The damage it suffered was nothing compared to what happened to the Roman Catholic church in Tulum Nuevo—its concrete roof was blown off. The Maya saw this as a sign that God still favored them.

Charles and I walked over to look at the Roman Catholic church, completed the year before on the "new" city's plaza. Only two walls were left standing. Goats were grazing between the remaining pews. This was so odd that we mentioned it when we got back to the guardia. One of the guards laughed, but Pablo cut him short. "No one should laugh," he admonished the guard. "It only invites trouble."

The Maya plaza had sustained some damage too. A large pine that long dominated the plaza had listed dangerously and therefore was cut down. And the palm roof of the Maya church had been damaged. Pablo told us that the villagers were discussing replacing it with tarpaper or concrete. Charles and I offered to fund the purchase of guanos for a new roof. Pablo and the village leaders considered our offer—how many guanos were needed, how much it would cost, who would do the work—and in the end agreed.

lief from other sources. We knew that donations of corn and cash to the Maya church could alleviate some of the hardship and at the same time honor the church and its distribution system that was already in place. Our friend Mario Escalante, a dzul hotel owner in Valladolid, was mounting his own relief effort but having trouble enlisting others to help. He used our efforts as an example to raise more money: if people were coming from so far away, he told his fellow businessmen in Valladolid, surely they would contribute something too.

Mario drove Charles to Chemax, where Hurricane Gilbert had spared some harvests, to purchase corn. After filling his truck with 50-kilo sacks, they continued on to Tulum. When they approached the church, the guardian asked Mario why he was there. "You know how it feels," he told me later. "It's their church and I'm an outsider. They're suspicious. That's why they have a guard. I didn't know the formalities of what to do, so I just blurted out, 'I've brought corn.' The guard's attitude immediately changed, and he broke into a smile. 'I'll help you carry it,' he offered."

I arrived early the following morning, November 8. Pablo was on duty, resting in the guardhouse in front of the

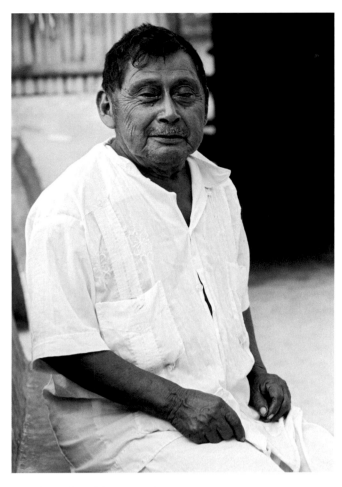

Juan Ek, Guardian of the Cross. Tulum, Quintana Roo, 1988.

That evening villagers placed lit candles along the rock walls of their yards so that the dead could find their way. Nearly every door and window of houses along the street was open—anyone walking by could see the altars on tables inside each house that honored the dead. The tables were covered with flowers (especially marigolds), fruits, vegetables, jícaras of food and drink, bottles of soft drinks, beer, and rum, tamales wrapped in banana leaves, photographs of the deceased, and pictures of Jesus, the Virgin of Guadalupe, and various patron saints. Candles illuminated the altars, and copal incense burned in censers.

Next to the church on a basketball court teenagers were shouting and playing. I watched a tall Mexican girl make a string of shots from more than twenty feet out. Even the boys who were pretending to ignore her were impressed. All the stores around the plaza were open, most with televisions or radios playing, adding to the cacophony. A couple of cars parked alongside the plaza bore foreign license plates. One group included four Japanese men who struggled in English, which was translated by a German who struggled in Spanish. They left in an Olds Cutlass with Kentucky license plates.

Everyone ignored the Maya church in the middle of this

bustle. It had evolved in the seventeen years since I'd lit my first candles here. The wood planks had been replaced with concrete block walls, and now a partition separated the Gloria from the main room. I thought of the churches in Mexico that created a human space of soaring ceilings, rich imagery, and decoration to represent the heavens and earth. They invited the congregation to worship and pray. Everyone had access to God. You raise your eyes to the heavens, and often there is a large cross above the altar. The altarpiece is an artistic testament to God's power and glory and the focus of the richest display of wealth: paintings, gold leaf, carvings, elaborate niches. Windows let in light, sometimes of stained glass, which adds an ethereal kaleidoscope of rainbow colors dancing on the floor and walls as the sun moves. It is light, mysterious, and holy.

What a contrast to the Maya churches in the sacred villages. I thought of the ancient Maya temples that also encompassed heaven and earth. But the congregation remained outside, at the base of the pyramids and temples. The inner sanctum was reserved for the high priests and royalty. Today the Santa Cruz Maya allow their congregation inside, but they continue a tradition of secrecy. The crosses and altar are not on display when you enter their churches—they are in the Gloria, hidden or shielded by a wall or curtain, and a guard protects their sanctity. The churches have no windows. Instead you are in a dark enclosed space lit with flickering candles. When you enter the inner shrine to pay homage, it is like going into a cave; even then the crosses on the altar are shrouded and often hidden in deep shadows. It is dark, mysterious, and holy.

It could be that the Santa Cruz Maya are continuing a Precolumbian tradition. But they might also have a very practical reason for secrecy today. Since the conquest, and more recently since the beginning of the Caste War, the Maya have been under siege. And they may feel that the most valuable thing they have is their faith and that they need to protect it.

Charles and I entered the Maya church. A man doing his guard duty, who was also a *rezador* (prayer man), began to recite prayers as he knelt in front of the altar. He was hard of hearing, so people had to yell the names of the dead into his ear several times for him to pray for them. Musicians played trancelike aires, a prioste rang a bell, and the church filled with worshippers. We went into the Gloria to light our candles. Sixty Maya, mostly women and children, were packed in, kneeling before the crosses on the altar that spanned the room. Herbs (especially sweet basil) and other offerings for the Day of the Dead adorned the altar.

When a man who'd been drinking came in and saw us, he started waving his arms and shouting about why two dzules were in their church. The guards calmed him down and explained that we were respectful, but not before we wondered if they would take the easy way out and ask us to leave. We

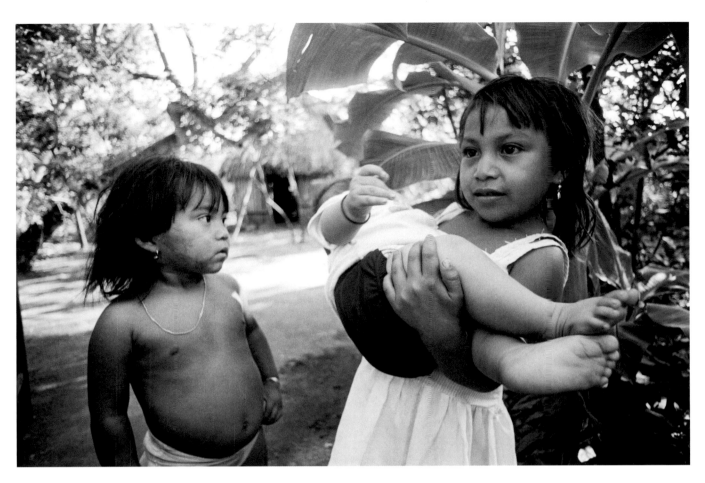

Pablo's grandchildren in his yard. Tulum, Quintana Roo, 1988.

replied directly to the drunk with calming words that included friend, brother, Ha'hal Dios (True God), and Santa Cruz. Hearing Charles speak Mayan pacified him to a surprising extent.

The man's outburst reminded us that, even though we'd immersed ourselves in mazehual life and on this occasion brought corn and money that we'd raised from the hurricane benefit and given to the church, some people still didn't differentiate between outsiders and viewed any dzul with suspicion. The Maya church was theirs. It was one of the last areas where they maintained control. Being a photographer made it worse. Sometimes passion and sheer frustration, combined with alcohol and aggression, created anxious scenes.

Juan Xim was an influential man within the Tulum mazehual community. The villagers knew that he drank too much but nonetheless respected him, as he voiced what many were too timid to say. Each year he would police the fiestas drunkenly and rail menacingly against outsiders. In the morning he'd seen my camera when we were sitting with the guards in the guardia. Afterward he accused Pablo of dereliction of his guard duties for letting someone photograph inside the church. Juan said that he was going to get the police.

Pablo was upset that a drunk was telling him what to do and spreading lies—I hadn't photographed inside the church—but he couldn't help but be annoyed that our presence created these situations. Pablo was a bridge between the mazehual'ob and dzul'ob, which often complicated his life.

Even so Pablo decided to accompany Charles, Hilario, and me to distribute relief aid to Chunpom, Tixcacal Guardia, and Chancah Veracruz. As a recognized wise man among the Santa Cruz Maya and a religious leader in Tulum, he welcomed the opportunity to keep in contact with the three other shrine villages, interchanges that normally occurred only during pilgrimages to attend fiestas. And Pablo was curious to see firsthand what Hurricane Gilbert had done elsewhere.

We arrived in Chunpom at midnight. Two men in the guardia were next to the church. They treated us as pilgrims, inviting us in to hang our hammocks. In the cold before dawn, they arose to light candles in the church. They rang the smaller high-pitched bell rapidly; the large one they rang slowly. Together they sounded like a locomotive approaching a crossing guard. We lit our candles and sat down with the guards as the patron of the church arrived to say his prayers. One guard said that his father, don Secundino, had been the tatich of the church until he passed away. We told

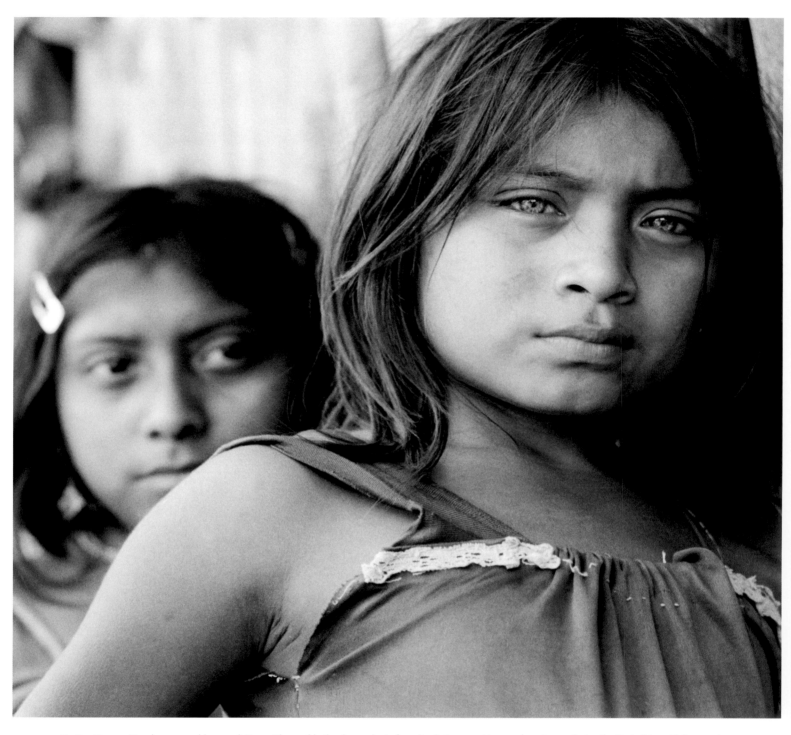

Martina Manzon Tuyub, a young blue-eyed Maya girl, possibly the descendant of a union between a Maya and a prisoner during the Caste War, with her cousin, Patricia Manzon. Rancho San Antonio Nuevo, Quintana Roo, 1988.

him that we'd met his father briefly during the fiesta in 1974. The guard also mentioned that he'd recently made a pilgrimage to Xocen to light his candles. The other guardian added that the Saintly Cross of the Center of the Earth was as old as Jesus Christ. I asked how many people came to the Maya church. Of the 400 people who lived in Chunpom, he said, 396 attended. The other 4 were Protestant Evangelists from Carrillo Puerto who had yet to succeed in converting anyone. He added that all the villagers wished that they'd leave.

When we learned that Gilbert had destroyed many of their milpas we presented a donation of money to Chunpom's church, which the tatich received with formality. Then the guardians helped us carry sacks of corn into the church. I went outside at dawn and noticed some changes to Chunpom in the fourteen years since I'd last visited. Electricity had brought television antennas, and a big water tower now stood near the entrance to town. No one used the well underneath the ceiba tree in the central plaza anymore, which had always been a hub of activity where women would gather, laughing and talking as they pulled up buckets of water. But even as I thought this, a barefoot woman in a huipil came out with a coiled rope and pails and drew water from the well as the sun came up. Four young girls came running across the plaza chasing a dog. A group of men and boys walked up to the church. It was still cold, and we sat on rocks and soaked in the warmth of the sun. For a while no one said anything, each in our own private reverie. As I warmed up I looked around and started laughing. I commented that we were like iguanas, each on our own rock in the sun, and the others started laughing too. It broke the ice. Everyone wanted to know about our donation of corn and money. I told them that my neighbors had made this possible and showed them photographs from the donation event. They examined them as if they were anthropologists discussing a strange and interesting culture. It was hard for them to understand how complete strangers from such a distance would help them, yet at the same time they were thrilled that we had. They hadn't anticipated any help, and indeed the government had fully met their expectations.

Leaving Chunpom, we took a new dirt track through the forest toward Tixcacal Guardia. At the remote ranch of San Antonio Nuevo, we met a whole family of Maya girls with blue eyes. We could only surmise that they were descended from hostages taken during the Caste War. We reached Tixcacal Guardia after dark and saw a group of men standing in the street as we drove up, Marcelino among them. He greeted us like old friends, shaking hands and inviting us to his home. I was surprised by his handshake. I expected the typical Maya soft handshake, but Marcelino gripped our hands firmly. He now had a shock of white hair in front that contrasted with his otherwise black hair and looked very contemporary and fashionable.

Marcelino's house was full of people because several of his daughters were visiting. He'd added a cement floor that was now crawling with grandchildren. Electricity had ar-

rived, and a single bare lightbulb hung from a beam, below roof palms blackened by years of smoke from cooking fires. Now cold beer was available from one of two stores, so we sent Marcelino's son for some bottles to clear the dust from our throats. Marcelino was pleased to see Pablo. Over beers, he told us that he wasn't getting along with the new Nohoch Tata of the church who had taken over when Roque Dzul died. We commiserated with Marcelino for his loss, and I gave him some photos that I'd brought down, which included several of his close friend.

Marcelino brought out a violin we'd given him years before. The neck was broken, and the violin was in a sorry state. He explained that he had been carrying it one rainy day when he slipped in the mud. Could we fix it? We had to tell him that it looked irreparable. Charles showed Marcelino the violin that he'd bought just that morning in Chunpom from don Us (Eusebio Dzul), an old master violinmaker who carved his instruments from local woods. It didn't have any strings, so Marcelino removed these from his broken violin to test it. He tuned it then brought out his other good violin, handed it to me, and offered to teach me how to play mayapax. He showed me the fingering. Mimicking Marcelino, I held my violin out from my chest rather than tucking it underneath my chin. I'd studied violin when I was in elementary school but hadn't touched one since. Marcelino was very kind when he said that I showed promise. If nothing else, his style made it easier to play while sitting in a hammock. When I demonstrated to Charles what I'd learned, he was soon playing as well as I did. Pablo was enjoying this and settled comfortably back into his hammock. He told Marcelino that he appreciated that they could talk and not be interrupted by a television, which was becoming ubiquitous in Maya villages all over Yucatán. Neither man owned one, and they were proud of it. They began the evening sitting in two different hammocks and ended sharing the same one. They agreed that they should get together again, so Pablo invited Marcelino to Tulum the following month to pray to the Virgin of Guadalupe on December 12.

We slept in the same guardia building we'd stayed in on the night of the new fire ceremony. We woke up to the laughter of men in an adjacent guardia. They were from Señor, including one of Paulino Yama's sons, and they offered us a breakfast drink of warm atole. Afterward we walked over to the church to light our candles. I saw that a road now passed through the center of the shrine village along with concrete power poles and electrical lines, horribly compromising the symmetry and beauty of the plaza. They were as out of place as power lines and a road across the White House lawn.

Villa Rojas, who visited Tixcacal Guardia only three years after it was founded, wrote that it had been built as a sanctuary for the Cross, a shrine center no one was actually going to live there.[42] Indeed, its very name "Guardia" indicated its purpose as a sanctuary. He found the rule had been relaxed, however, and it had become the largest village in the area, with over two hundred inhabitants. Even so, the villagers

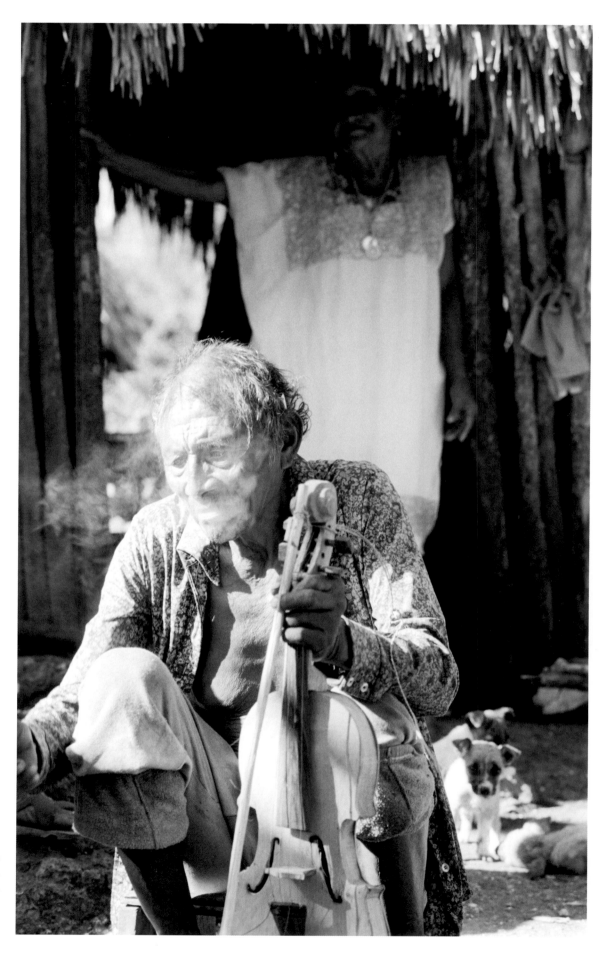

Eusebio Dzul, violin maker, and his wife Mónica. Chunpom, Quintana Roo, 1988.

wouldn't allow horses, mules, or cattle because they didn't want their sanctuary soiled with excrement.[43]

Pablo seemed to enjoy watching as we pilgrimaged from shrine village to shrine village, giving away food and money. It was a sign of his character that he didn't try to control the situation. He never questioned our choice of the people to whom we gave donations or told us to give to one person rather than another. He never requested that we give money to his family or any of his friends. When we helped someone, he'd catch our eye and nod his head approvingly. We gave to the people in need we encountered, including people who had offered us kindness in the past. And we gave the largest sums to the Maya churches, whose communal projects benefited everyone.

Pablo and I sat in the back of Hilario's truck as we drove to Chancah Veracruz. He told me that he enjoyed traveling. "I don't know how long we can exist in Tulum," he explained. "If things get worse I'm prepared to move to Angelita or even deeper into the jungle. I've already picked a spot." Pablo smiled as he surveyed the countryside. "But I'm looking to see if there is better land."

Chancah Veracruz is located in an area with some of the richest natural vegetation in Quintana Roo, though most of the largest trees have been logged. In the mid-1930s the federal government under President Lázaro Cárdenas divided the area into several ejidos, which had the effect of disrupting the original Maya social and territorial unity and making it difficult for Chancah Veracruz to continue as the shrine village of the region. When the road reached their village, many villagers left for paying jobs elsewhere and sent their children to state-sponsored boarding schools in the territorial capital of Chetumal. Few of them, once educated, returned to their village.

My favorite church had been replaced, but I wasn't prepared for what I found. The previous church had been beautiful, a long, tall, thatch-roof building with the grace of a sailing ship. The new one was built more like a cement-block fortress, squat and ugly. A plaque recorded that the church was built, with help from the Mexican government, from June to December 1976 and was dedicated on May 12, 1977.

The church was locked when we arrived, with no guardian on duty. In fact, Chancah Veracruz didn't have a guardhouse next to the church. A man in the plaza that we'd met the day before in X-Hazil recognized us. After ten minutes, word of our arrival reached the *capitán* (captain of the church guard) of Chancah, who opened the church for us. Charles and Hilario explained our relief mission while I carried in the sacks of corn we'd brought for the village. The church was very hot and musty, so they opened all the doors to air it out. I laid down a sack of corn and looked around. The room had a flat ceiling supported by exposed concrete beams. I could see where windows had been built, but they were bricked up. Some Mexican tissue paper decorations with stencil-cut

designs of birds, flowers, cactus, and animals were draped from the ceiling, a gift from the governor. The wall separating the Gloria from the rest of the church was low, and a large plastic green curtain suspended from the ceiling forced everyone to duck before going in.

Pablo, Charles, Hilario, and I entered, lit candles, and passed before the altar, which extended almost the width of the back wall. Surprisingly, a large Jesus Christ on the cross towered over us—exactly the sort of crucifix you'd expect in a Roman Catholic church. We'd never seen this at any of the other sacred villages. Beneath the cross the altar was overflowing with saints, icons, crosses, herbs, plastic tablecloths, embroidered cloths, and plastic flowers. A few icons were draped in cloth, but otherwise the crosses and saints were not hidden under shrouds. All the saints wore garments. Perhaps they were supposed to be robes, but they all looked like dresses. A couple of bearded saints looked like Venetian gondoliers in jaunty blue-and-white striped outfits with straw boaters on their heads. The saints carried sweet basil that someone had recently picked.

When I asked Faustino Santa Cruz, the capitán, how many saints they had, he answered more than thirty. He told me that earlier in the year a man from Tixcacal Guardia had insisted that since Chancah had so many they should give them a saint for their church, but he quickly repented when his house was the only one damaged by Hurricane Gilbert. We'd heard the story already but listened as Faustino told it. He said that seventy families lived in Chancah. Counting the villagers in satellite villages, more than four hundred people used the church. Faustino emphasized that all the mazehual'ob were united, pointing out that there weren't any Evangelicals, Mormons, or others in the area. *Somos muy católicos, muy cristianos,* he repeated. "We are very Catholic, very Christian." We heard this at all the sacred villages.

Little chairs placed at either end of the altar intrigued me. They were child-sized and adorned with handkerchiefs and other decorations. Little arches made from jungle vines rose over the backs of the chairs; they looked ceremonial rather than being for use by the congregation or the guards. I asked Faustino about them. He answered that it was customary to include them. "They're for saints who want to come to visit. The saints come in on the wind and we can't see them. But just as we have benches, the saints should be comfortable too."[44]

I then asked Faustino why the crosses wore sudarios. He said that it was the custom and wouldn't elaborate. I'd once asked the same question of Juan Ek, the guardian of the cross in Tulum. "Would a king appear naked?" he replied incredulously.[45]

I'm getting used to finding something unexpected when I return to Tulum. In 1993 it was Colombian drug baron Pablo Escobar building a multimillion-dollar house on the beach.[46] In the spring of 2004 it was two signs placed by the Mexican

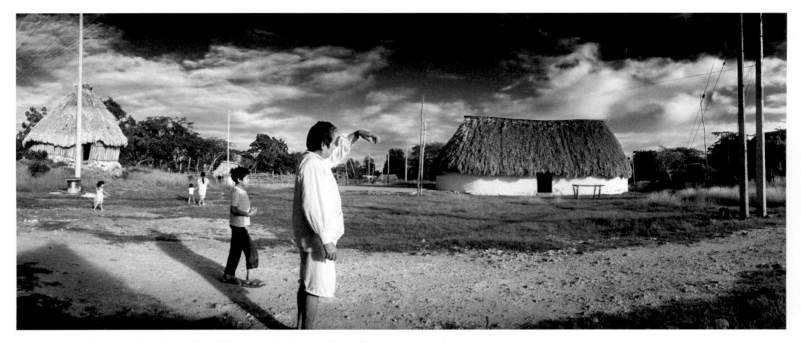

Marcelino Poot Ek standing in front of the Maya church. Tixcacal Guardia, Quintana Roo, 1988.

government in front of the Maya church in Tulum. One sign declared the plaza a "Centro Ceremonial Maya" (Maya Ceremonial Center). The other had a map and legend that showed (incorrectly) where the church, guardia, and other buildings were located. The signs were similar to what I'd find at an archaeological site or a zoo. It would have been one thing for the government to recognize the Santa Cruz Maya as the self-governing, semiautonomous cultural entity that they once were and still strive to be, but the signs were patronizing. I wondered what the government had promised or given of such value that the church leaders had allowed this and whether the sacred precincts of the other sacred villages, not as inundated by dzules as Tulum, had been similarly signed and designated.

It was a question that we could quickly answer, because Charles and I had already planned to revisit Chunpom and Tixcacal Guardia. Pablo, for his own reasons, decided to join us. He told us that he hadn't been to Chunpom's fiesta in years and hadn't been back to Tixcacal Guardia since we'd visited together in 1988.

For a change, we left Tulum early and were soon in Chunpom. We could see that it had changed dramatically. The great open plaza, which had functioned as a sacred space where the faithful would assemble, no longer existed. Instead it was broken up by paved streets and sidewalks and a park of overgrown weeds. The large ceiba tree, the axis mundi of the Maya cosmos, still presided over the plaza, but now all that revolved around it was a traveling salesman in his Volkswagen bug selling used clothing. He had a loudspeaker attached to his roof, and his amplified voice echoed off the walls of the buildings as he drove around the plaza. There was a government sign again, at the entrance to the plaza,

designating Chunpom as a "Centro Ceremonial Maya," with a map showing the important buildings.

Architecturally the church no longer extended its influence out into the plaza. It looked like a fort, stuck on a corner behind fences and walls. When we went to light our candles, we found at the entrance gate another government sign: "Iglesia" (church). The church was locked. We asked a couple of boys playing in the gallery between the guardhouse and the church who could open the doors.

Pablo was surprised when they told us that the guardian was away on a trip and only he had a key. "They shouldn't close the church," he said. "We've come as pilgrims to pray and the church is closed. Why isn't anyone on guard duty?" As we talked to the boys, a man walked up and wanted to know why we were there. He was protective and curious but not unfriendly. Pablo introduced himself, telling him that he was from Tulum, and introduced us as those who had given corn and money to the church on our last visit following Hurricane Gilbert.

The man shook hands and corroborated what the boys had told us. At that we decided to leave our candles and names with the eldest boy and asked him to give them to the Maya priest to light on our behalf. We walked across the street to the plaza. The well in the shade of the ceiba, once the hub of social activity, was now full of trash. Evidently people no longer came to fetch water when they could get it from a faucet. Above us in the branches of the ceiba were a generous assortment of air plants and orchids. I was pointing one out when a group of teenaged schoolboys cut across the plaza. As they passed, one boy said to his schoolmates in Spanish loud enough that we could hear, "A Maya who sells his religion."

Maya church and guardhouse. Tulum, Quintana Roo, 2001.

"He thinks I'm making money bringing you here," Pablo said, stung by the remark. "He doesn't know how long you've been here and what you've done for the town and the church, especially after the hurricane." To have a schoolboy question Pablo's devotion was uncomfortable. In the painful silence he suggested that we buy some cold beers and leave. It only took a minute to arrange this.

It was hot. We rolled our car windows down as we left the village. The air was refreshing. To break the silence, I tried talking to Pablo about names and terms used to clarify Maya identity. I began by asking him what the term "Cruz'ob" (usually written "Cruzob") meant to him. It was a designation that Nelson Reed made up to identify the Santa Cruz Maya when he wrote *The Caste War of Yucatán*, to differentiate them from other Maya in Yucatán.

"It means 'many crosses,'" Pablo replied, citing the literal translation of the word "Cruz" with the plural Mayan suffix -'ob.

I told him that I'd seen the term "Cruzob" used by anthropologists, politicians, and lately even local Maya to designate the Maya of the sacred villages, but I wanted to know how he referred to himself.[47] Did he ever use this term?

I glanced over as I drove and saw that Pablo was angry. I realized that I might be able to ask Pablo what he called foreigners and what he called the Mexicans, but he was making it clear that I should not ask him who *he* and his neighbors were—a silly and obvious question that didn't deserve a response. Pablo was forthcoming with almost everything, but some questions annoyed the hell out of him. "Me? I'm Maya," he finally said.

Charles changed the subject by asking what Pablo intended to plant in his milpa this year. "Corn, squash, beans, chiles," he recited, "and maybe some new fruit trees. The fruit trees attract birds, especially chachalacas [*Ortalis vetula*] and toucans, and they'll eat some of your fruit. But they also shit seeds from other fruits, and then a year later I'm surprised by what sprouts in my garden. The birds help me plant."

"Hmmm," I said. "Wouldn't it be something if we could farm like birds? Spend our time eating and defecating and later: a harvest!"

Pablo laughed. It was the first time he'd smiled since the boy's remark. "You know what surprises me?" he asked. "How quickly we can turn cold beer into warm water. Can you stop for a moment?"

Marcelino didn't answer when we knocked on his door. When we knocked again, a child poked his head out the window. He looked at us for a moment then opened the door without saying anything. He then explained that his grandfather wasn't feeling well. We saw both Marcelino and Isabela in their hammocks. She got up to greet us, while he waved feebly. He shook our hands then invited us to sit down on stools that Isabela set out for us.

It was a warm day. Marcelino mentioned that it hadn't rained in months. Even with the doors open, the breeze didn't pass through, so we were bathed in sweat. A rooster crowed in the front yard as two others answered behind the house. In syncopation, others around the village chimed in. Someone in a neighboring house turned on a radio station playing cumbia but not too loudly—it became background music to a tropical afternoon. The beginning of a breeze rustled the guanos in the roof.

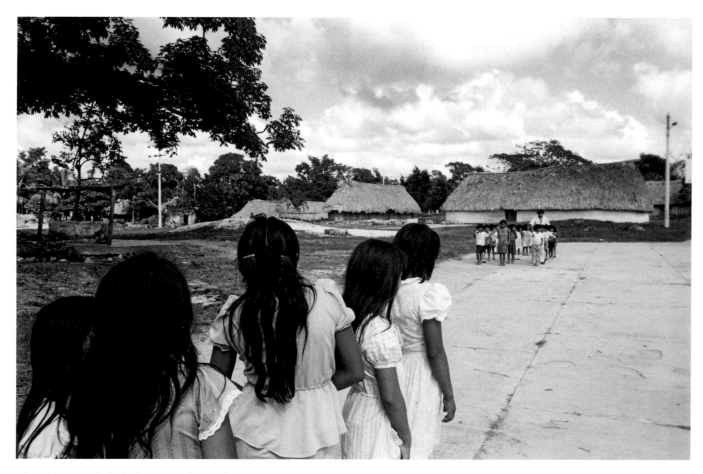

Schoolchildren on the basketball court in front of the Maya church and guardhouse. Chunpom, Quintana Roo, 1988.

Marcelino asked if we'd seen the orange trees as we drove in. When we nodded he complained that it was another government project to help the Maya that was underfunded and not well thought out. Each family had been allocated a mecate of the orchard, but no one was earning anything. The villagers had no vehicles to deliver their crop and no help in marketing their produce. Some had tried on their own to sell on street corners in Carrillo Puerto and others had gone as far as Tulum, but without a vehicle they could only sell what they could haul on the bus. They could hire a taxi or truck, but that meant more expense and then they still had to sell the oranges. Several families had tried to make a go of it but lost money, so most villagers, after picking fruit for themselves, let the oranges rot in the field. As usual, the problem was marketing and distribution. It reminded me of an earlier government program that had encouraged the Maya to grow habanero chiles. The farmers had harvested tons and tons of the wonderful habaneros only to find that no one had thought of a marketing plan, so all over Yucatán chiles rotted in the fields.

Marcelino asked us if we'd also seen the greenhouses as we came into town. They were raising tomatoes, he told us,

and provided some income for villagers. But this was yet another unfinished project. Greenhouse production requires special skills, training, and technology—without them, it fails. Most money for the project was spent in Carrillo Puerto, some of whose inhabitants were sent to study in Israel and Europe. Because of the training, the greenhouses in Carrillo Puerto were a success story. But no one was getting any training in Tixcacal Guardia. Marcelino complained that inefficient programs were introduced with fanfare each election cycle, only to fail soon afterward. For a program to work, training was needed as well as economic loans that allowed the Maya to compete in the peninsular economy. Hotels, restaurants, and residents also needed an incentive to buy locally because so much is shipped in from the United States. But the Maya got half-measures that didn't allow for their input. This was one reason why young people had to leave their villages to find work.[48]

I'd brought photographs. Marcelino laughed as soon as he saw the first, a picture of himself when he was heavier and healthier. "That's when my hair was black," he said. "Now I'm a *sac pol*—a white head."

"Huhhh," Pablo said as we looked at thirty years of photo-

LEFT: Maya church and guardhouse, Chunpom, Quintana Roo, 2004. RIGHT: Maya church and guardhouse, with a newly erected fence, Tixcacal Guardia, Quintana Roo, 2004.

graphs. "Tomorrow or the next day all of us will die, and the ones of us who remain are the ones who have had their photos taken by don Macduff. Each year this unknown person passed through, and now he leaves these photographs and his book that shows our grandfathers, our fathers, our brothers, and our children."

"Aha, that's true," Marcelino and Isabela said, nodding their heads. They had already seen many of the photographs, but on my last visit they'd told me that the tropical heat and humidity had destroyed most of them. So this time Charles and I'd put these pictures in frames with glass, hoping that they would last longer. Isabela selected the ones that she wanted and placed them beside her in her hammock. She gave me back a photograph of her sister. "You should give this to Martina yourself," Isabela said. "She lives nearby. She married the son of Juan Ek [guardian of Tulum's cross]. And now he's the Nohoch Tata of the cross here in Tixcacal Guardia."

The music from across the street stopped, and suddenly we could hear birds outside. This reminded Pablo of the doves that came back every year. He told us how they'd build their nests, have babies, fly off, and come back the following year. But now that Tulum was noisier, with traffic, radios, stereos, and televisions, he sometimes didn't know if the birds were there anymore. He liked it when it was quiet and he could lie in his hammock and hear the doves and his grandchildren playing outside.

Pablo asked the local price of corn. Then he asked about the price of beans. Once he and Marcelino had determined that the prices were the same in each of their villages and how hard it was for a farmer to make a living at those prices, they talked about the church. Marcelino proudly told us that they'd rebuilt their church and suggested that we take a look. In addition, about thirty young men were learning to do service. He was very pleased at this, and Pablo was impressed.

Every time I visited Isabela asked me if I wanted to buy a jar of ground habanero powder and I'd purchase a few. She brought out a jar; I bought it and offered to buy more. She shook her head. "No, this is the only one. You know, to do this, I have to dry the habanero chiles and grind them. It stings, it stings!" she cried out. "I have to do it outside. I'm sweating and grinding and my eyes water as if it is a hot sun making me sweat. It burns my whole body. You have to be careful what you touch. It's a lot of work. I do this to make a little bit of money. I have to go to Carrillo to sell it, but the trip is now so expensive. Everything is now so expensive. Sometimes I just sit down and cry."

There was a new fence around the church and popol nah.[49] While Charles and Pablo walked in through a gate, I stopped to read the sign near the entrance. It was hand-lettered, different from the ones at Tulum and Chunpom. It said: "Church and general barracks were remodeled with the collaboration of Maya priests and the interested parties of this ceremonial center and without support from any municipal or state authority. *La Unión hace la fuerza* [Unity creates strength]." So Tixcacal Guardia had refused to let the Mexican government come in and put up its signs. Pablo came back and looked at the sign too. "We came here to light candles," he said curtly. "I don't want to talk politics."

The mazehual'ob had done a beautiful job of remodeling their church. The interior was bright and clean. They'd painted the walls white, with a meter-high band of blue around the base. They'd completely reroofed the church, and the scent of freshly cut guanos filled the building. It's a wonderful smell that brings back memories to anyone who has lived in rural Yucatán. They'd also built a new altar and candle stand out of concrete. The tiles on the altar were shaded

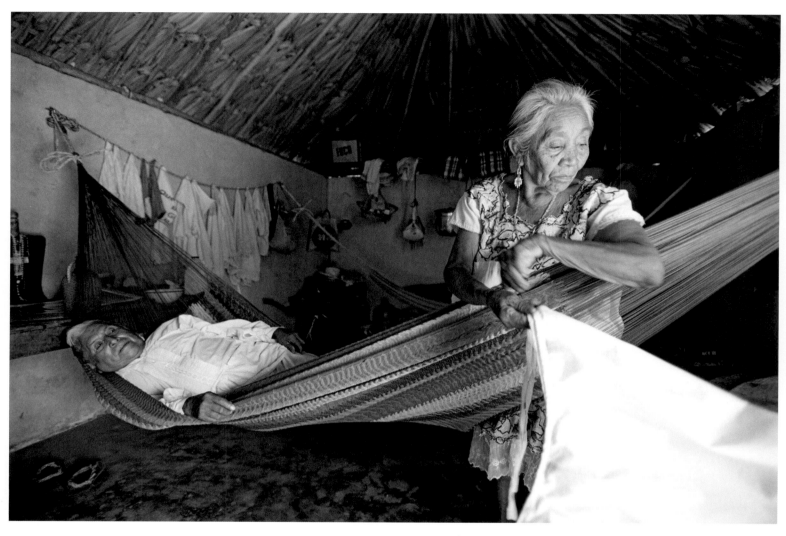

Marcelino and Isabela. Tixcacal Guardia, Quintana Roo, 2001.

white to powder blue to blue. Above the altar was an arched cloth canopy. The wall behind the altar was painted orange. Three bells hung by chains from a beam at the back of the church. We lit our candles and offered our prayers.

When we knocked on the door of Martina's house, her husband Agapito answered. Pablo presented himself as Pablo from Tulum and introduced us, as he'd done in Chunpom, as those who'd brought corn and money for the church following Hurricane Gilbert in 1988. When we told Agapito that we'd brought a photograph of his wife, he asked to see it. He studied it a moment. "That's not my wife," he said and began to hand it over.

I asked him to show it to Martina, and he took it to the kitchen out back. When he returned, he looked a little sheepish. "Yes, it is her," he said, inviting us in. When Martina came into the room and joined us, we asked Agapito who she was. He started to say that she was his wife until he realized that we were teasing him. As we were joking, a breeze rustled the leaves on the trees outside. Pablo said that it reminded him of his milpa. This started a conversation about how to plant onions, how good *hierba santa* (*Piper auritum*) smelled when eaten with tamales, and a comparison of the price of beans in Tixcacal Guardia and Tulum—a conversation we heard whenever Maya farmers got together. When Pablo asked Agapito if he would sell him some heirloom corn seed, Agapito replied that he would give him some. Pablo told them how he'd plant that seed in his milpa at Angelita and went on to speak of the rich soil and the tall forests near the border of Belize that he'd seen with us on our visit to Diego. "There's room to live there, among the monkeys. Hoo, hoo, hoo," he mimicked.

For the next few hours Pablo and Agapito talked state business. One item was the sale of beer that brought in revenue during the sacred fiestas—it was currently a source of dispute in Tixcacal Guardia. As they continued talking, Charles looked over at me. "The Maya in the sacred villages may be somewhat autonomous, but look at what their leaders are reduced to—begging the bureaucracy for fairness and attention and fighting over the little bit of money they get from their fiestas' liquor concessions—the only little pot of money that they, and not the Mexican politicians, control. The annual fiesta is one thing they've celebrated continuously since the conquest," Charles said. "It's culturally reaffirming, and it's theirs. In my opinion, one of the main causes of the Caste War was that dzul political structure changed the rules of the game after Mexican independence. The local Maya caciques could no longer earn as much as before for the administrative fees that they enriched themselves with and, as nohoch kuch'ob, used to finance these fiestas. Remember that it was the caciques who plotted against the government. It was the execution of the cacique of Chichimilá that started the war. Of course, once it was unleashed, the bigger problem of getting rid of the oppressor and gaining true autonomy became the sustaining issue."

A problem in everyone's thoughts was the imminent death of Marcelino. He'd been comandante for so many years

that there would certainly be competition to succeed him.[50] When his longtime friend and co-leader Roque had died, the transition had not gone smoothly. Agapito had ultimately emerged as the new Nohoch Tatich, but only after another had first been selected and subsequently deposed, accused of stealing the cross.

Agapito told us the story. His predecessor, don Isidro, had been don Roque's secretary. When Roque became ill, Isidro took over his duties as the guardian of the cross. Before he died, Roque had a vision that Isidro had stolen the cross and moved it to his house and told Marcelino and other leaders.

At this point, Charles and I asked: why wouldn't everyone already know that it was missing? Wouldn't there be an empty place on the altar? The answer was no. Agapito explained that only the guardian saw the cross. All the crosses that we saw on the altar were not the most sacred cross. Therefore there was no empirical proof that the cross had been stolen. This was a real problem, because it was a dying man's word against the word of the new Nohoch Tatich. The villagers didn't know what to do.

When Charles and I asked again if no one else got to see the cross, Agapito told us that a portion of the most saintly cross might be exposed during a fiesta. As he said this he made a motion as if pulling slivers from his little finger. "Only a little peek," he emphasized.

The truth came out when villagers discovered Isidro trying to leave Tixcacal Guardia in a taxi with the cross. They were so angry that they were ready to kill him, but they let him live when he returned their cross.

"But for the grace of God," Pablo said, "Tixcacal Guardia almost had a disaster."

We all nodded our heads. The conversation switched to current events, and we agreed that everything was changing. "Huhhh," Pablo said. "It is sad when a son forgets what his father has taught him. We see this all the time—a day comes when the son says to his father, 'Let's sell your land.' And the son spends the money and is left without property because he didn't appreciate the earth. How can you not appreciate the earth?" He shook his head. "I can't understand it."

Agapito concurred. They talked about how hard it was to keep the young men in the village. Farming couldn't offer the same benefits it used to. As we were talking, a pig appeared at the door and came inside. Pablo started laughing. Agapito shooed it out and started laughing too.

We'd planned to visit Chancah Veracruz, but Pablo advised against it. Both Marcelino and Agapito had mentioned problems there. Still bothered by finding the church locked in Chunpom, Pablo didn't want to have it happen again in Chancah, particularly since we'd be arriving long after dark. Instead we decided to turn north and drive to Xocen to light candles at the Cross of the Center of the Earth. We would spend the night in Chichimilá.

Dario gave us each a big hug and a kiss when we arrived at

11 P.M. Herculana was in her hammock and wanted to give us a hug; we bent down so she didn't have to get up. Even at that late hour Dario and Pablo, like farmers everywhere, started talking about their milpas. Both had farmed their current milpa for more than thirty years.[51] Pablo still didn't have his papers for Dzibaktun, his coconut plantation along the beach, or Angelita, his milpa. He wanted to pass his land on to his children. He told Dario that he was caught in a bureaucratic nightmare. "I've spent fifty years working, improving my land. If I was an employee, I would have now earned my retirement. Yep, fifty years of service, but I don't get to retire." He chortled. "And when I die, they are going to employ me in another place."

Pablo and Dario discussed the dangerous work they'd done over the years. Dario had dug wells and worked with dynamite. Pablo had been a chiclero climbing and hanging off trees, swinging his sharp machete. They both admitted that at a certain point they had decided, "I've come this far without a serious accident. Thank God that I'm still alive and healthy. Now it's time to do something else."

The next morning at dawn, as Dario left for his milpa, Pablo, Charles, and I drove to Xocen and stopped to visit Celso. Pablo and Celso immediately started talking about farming, festivals, and rain. Celso told us that he'd sponsored a ceremony at his house on May 3. He'd hired musicians and prepared a feast. He laughed and clapped his hands when he said that it rained and everyone got wet. Pablo and Celso compared the fiestas in Xocen and Tulum—what ceremonies were celebrated, how many pigs were necessary, how many pailas of food they prepared.

"Boy, killing the pigs, it is so bloody, you don't even notice that your pants are soaked with blood," Celso said, stabbing the air. He told stories as if he was drawing in space. "When you put in your knife it just comes spilling out."

"And always make sure they take the chicharones to the church," Pablo said. "We're still doing it the same way as our grandfathers did it. Everyone is fed. No one pays to eat."

"You can dance even if you are drunk," Celso added.

"Yes, until you fall down," Pablo agreed in his sardonic way.

"If you fall down," Celso said, "they'll pick you up and you can keep dancing." They both laughed and nodded in agreement. "The fiesta is celebrated every year to give us a moment or two of diversion," Celso added, "and to remind us that another year has passed."

Their religion defined them. They contributed to their church because their faith was integral to their community. It was how they spent their free time and energy. They loved talking about the last ceremony and the preparations for the next one.

Over a breakfast of scrambled eggs and tortillas, Celso and Pablo discussed the cultures and folkloric traditions of different Indian groups in Mexico. Both men were informed by their travels. Celso told Pablo how he'd worked as a musician every weekend for thirteen years now and had met other folkloric groups at performances. He felt it had broad-

ened his appreciation of Mexico's musical offerings and he'd also learned what other campesinos were thinking by talking with everyone. Musicians, writers, and artists make the best cultural ambassadors.

Pablo in turn told Celso about Chiapas, where he had filmed *Chac*. He said that the Lacandon Indians who lived there spoke beautiful Yucatecan Mayan. He added that, although it sometimes might seem to get chilly when a norte was blowing here in Yucatán, in the mountains of Chiapas it got downright cold!

Celso mentioned that he'd recently trapped a pocket gopher in his yard, Pablo turned to us. *Tak u ta' ka hantik!* he said. "You even eat the shit!" We started laughing, because we heard this phrase every time anyone mentioned a gopher. It referred to the Maya practice of simply skewering and roasting the gopher over a fire—singeing and scraping off the hair, of course, but indeed eating all the rest of it.

Celso nodded in agreement. *Hach kiv!* he added. "How delicious!"

The two priostes at the shrine of the Cross of the Center of the Earth said little when we introduced ourselves, even though the village's comisario had threatened to arrest us when Charles and I had been there just a few months earlier. They might not have recognized us or possibly were simply staying out of secular politics. Either way we didn't press the point. Pablo told them that he was from Tulum. I'd observed that he introduced himself as Pablo from Tulum wherever we went. Upon hearing this everyone knew that he was a Santa Cruz Maya. Thus Pablo had answered my question of how he referred to himself. He used geography rather than an ethnic term.

We went inside to light our candles and say our prayers. Someone had added a string of blinking Christmas tree lights to the altar decorations, which included a computer chip that continuously played Christmas songs. I couldn't hear the cicadas any longer. As we were leaving, Pablo asked the priostes if we could snap a photograph as a *recuerdo* (remembrance) of our pilgrimage. I hadn't asked him to ask for me—he did it on his own. He had an idea of what I needed to document this book and took it upon himself to act as an intermediary.

The priostes answered yes but had changed their minds by the time I came back from the car with my camera. I told Pablo that it was fine. The morning was already growing warm, so I gave the priostes ten dollars for soft drinks and we said our good-byes.

As we drove off, Pablo shook his head. He was disturbed by the priostes' reaction to photography. Everyone, he said, now treasured photographic memories. Living in Tulum at the intersection of contemporary Maya culture and tourism had shown him that. Furthermore, he added, the photographs we sought to take were memories of his people and their culture.

When we got back to Chichimilá, it took a while to say good-bye to Dario and Herculana. They walked with us out to the car as we were leaving and gave us big hugs. They stood and waved as we turned around and drove away. "There is just one more stop," I told Pablo.

I had to say hello to my comadre. Pablo knew Veva and her family from our season collecting chicle thirty years earlier but had not seen them since. When we pulled up, Alicia came to the door; as soon as she saw us, she called everyone to come outside. Family surrounded us. Veva gave me a hug. I told Pablo that I hated short visits, but it would be worse to come and go without saying hello at all.

Leaving was hard: there was always one more story or the little moment when you just sit and hold someone's hand. Leaving required kisses, hugs, and some tears. Everyone gathered around the car and waved good-bye when we left. We waved back, and I tooted the car horn. As I looked in the rear-view mirror, they were still waving, standing at the edge of the road. I saw that Pablo had turned around and was watching them too.

After passing through Valladolid we sped toward Quintana Roo on the narrow trans-peninsular highway. Out of the blue Pablo mentioned that the sacred Talking Cross of San Antonio Muyil was in Nuevo Xcan, a town on the border of Yucatán and Quintana Roo. I couldn't have been more surprised. I knew that San Antonio had been an important wartime shrine village northwest of Tulum that was overrun and burned by soldiers in the nineteenth century and abandoned. I'd read accounts of the Santa Cruz Maya by Victoria Bricker, Don Dumond, Nancy Farriss, Nelson Reed, and Paul Sullivan, but no one had mentioned that San Antonio's cross had been moved to Nuevo Xcan. As far as I knew, this was the first confirmation that the cross had survived and was still worshipped. We had set out on this trip to light our candles at shrines to the Santa Cruz Maya crosses. When we didn't visit Chancah Veracruz, Pablo suggested that we visit another of the sacred cross villages.

"In the old days, from Akumal you walked west into the forest and then a little north to get to San Antonio Muyil," Pablo explained. "Jorge Aguilar carried the Santa Cruz to Xcan. That was many, many years ago. I met him when I was very young and he was very old with white hair. Don Jorge moved to Xcan and there he died. He left the Saintly Cross in the hands of those who would continue to attend to it. Some of us in Tulum know very well that the cross of theirs is the compañero of the cross we have in Tulum and the cross that is in Chunpom."

When we got to Nuevo Xcan, Pablo directed us to a church a block off the highway. It was built of masonry, with a tin roof. The front was painted blue with a white gable and a blue cross centered above the turquoise double-door entrance. No one was around. The church was unlocked, however, and we entered. The interior was pale yellow. Spaced along the walls were matted and framed Italian postcards of colored engravings of the Stations of the Cross. Three ceiling fans hung from the roof beams. Near the chancel were double doors opposite each other that were open to allow for air and light. We'd brought our candles and walked down the center aisle, past eight rows of benches.

Centered behind the altar on a shelf eight feet up were the Saintly Crosses of San Antonio Muyil, a large one and two small ones. Each was covered with a sudario. They weren't hidden but right out in plain view. But if you didn't know what you were looking at, they would have been lost among all the other crosses, virgins, saints, reliquaries, and wreaths that decorated the inside of this church, many of which were larger and more elaborate. We learned that a Roman Catholic priest in Kantunilkin visited the church every Saturday. The Saintly Cross was now integrated into a community church. I knew I had to come back.

We took the narrow road that led from Nuevo Xcan to Cobá and Tulum. It was in relatively good shape, there wasn't much traffic, and we made good time. Pablo stared out of the window, looking at the buildings in the curtain of vegetation rushing by. We made a detour to visit Pac Chen, a village that was working with Alltournative, a tour company based in Playa del Carmen; Pablo was intrigued when we told him that the entire village made a living cooperatively working in ecotourism. We arrived after sunset and walked down to the lagoon. All the canoes that the tourists paddled around by day were pulled up on the shore. We sat down on the dock and enjoyed the view of the lagoon and the slight breeze blowing across. It was a simple but sublime pleasure after a hot day. As we talked about ecotourism, a full moon began to rise above the forest canopy and its twin appeared on the lagoon surface.

"*Muy tranquilo* [it's very peaceful]," Pablo said. "Hmmm. There is a lagoon near Tulum that's full of crocodiles. At night when you turn on your flashlight it's as if you are in a roomful of cats—eyes shining back everywhere around you. And you can tell the size of each crocodile from its eyes. You look to see how wide apart they are." He held up three fingers. "If they are only this far apart they're about five feet long." Pablo spread his hands. "If their eyes are this far apart, they're nine feet long. Tourists might be interested in that, wouldn't they? Hmmm." He nodded his head.

The breeze ruffled the surface of the water, and the reflection of the moon skittered on the tiny waves.

"You guys left some sad hearts where we visited," Pablo suddenly said. "Wherever we arrived, nobody wanted you to leave."

"We didn't want to leave either. We've all been friends for a long time."

"They really like you," he repeated. "They really didn't want you to leave. ¿Pero, que más? [Well, what more?] They are in their pueblo and we have to return to ours."

An owl swooped low across the road. For a moment its wings were brilliant in our headlights. Other night birds were flitting shapes in the moonlight. We drove toward Tulum, slow-

ing for the speed bumps at the entrance and exit of each village that straddled the highway. A mother pig and her piglets walked slowly across the road at one.

"Are you going to kill a pig?" Charles said.

"Huh? Pig?" Pablo asked surprised. "I don't have any pigs."

"For the fiesta," Charles explained. "You said you were a cargador."

"Oh, for the fiesta! Well, yes, others might offer a pig or half a pig for the feast." Pablo said. "But what I'm responsible for is the *misa* [mass] before the fiesta. I'm going to offer a little bit of chicken, because it is a prayer that I'm going to do. And then eight days later is the start of the fiesta."

"Do you have to organize this?"

"Of course I do. But I can't do it alone. What if there is no one to help me? I have to talk with others, like you and Macduff—I'm using you two as an example so that you will understand. Perhaps six months before my misa I'll advise you. 'You know, have you thought about the little something you are going to prepare for the service we are offering?' I'm not going to ask you, 'Give me a hundred kilos of corn and give me two pigs.' No, you are going to think, in good faith, of what you can offer. As far as the feast food for the church goes, my task is to fill the bowls before the saints on the altar. I'll do that with chicken. If one of my *segundo cargadores* [primary helpers of the sponsor] happens to donate a pig, I'll have to figure out how to cook it. If it's a whole pig, I'll need two cauldrons. If it's half a pig, I'll need one. If it is just a little, I'll prepare pork and beans. Hmmm, good," Pablo said.

"Hmmm," Charles and I echoed. It seemed that whenever we talked with Pablo the conversation would come around to food.

"Regarding rum," Pablo continued, "if someone wants to offer some, fine. If not, fine. A little beer, a little rum, a little beer, a little rum—in moderation, of course. That is what you have to add to the festivities. If you drink too much, fine, but I know that after a while you will be drunk. Then you won't be able to do anything—you won't even be able to get your chicharones!" He laughed. "Instead you'll fall into the cauldron of hot lard!

"Once the saints receive their food, I'm done. It's in the hands of my daughters to give the food away to those that show up, until it is all gone. I say to my daughters, 'I'm going now. I'm tired. I've done my job.'"

The moon was very bright, and the forest leaves reflected silver. When I turned off the car headlights, the roadway was a shimmering ribbon. I drove by moonlight until another car approached. After the car passed, I again turned off our headlights. Pablo noted our progress on the highway. "*La cucaracha, la cucaracha, estamos cerca de Tulum* [we're getting closer to Tulum] . . . " he sang, making up verses. "Hmmm," Pablo said. "A beautiful moon to walk on the beach."

When we dropped Pablo off, he said, "Tomorrow we should all go to my milpa. I saw how interested you were in Dario's farm. You should see mine."

Pablo brought along his four-year-old granddaughter Victoria Ofelia when we picked him up in the morning. She

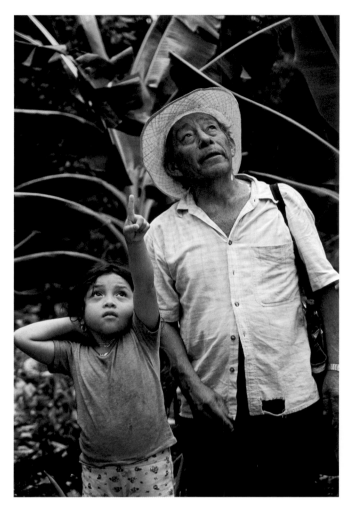

Pablo with his granddaughter Victoria. Tulum, Quintana Roo, 2004.

lived a few meters away in a house that Pablo's son Ricardo had built on the family plot in Tulum. She held her grandfather's hand as we walked around Angelita. Pablo told us that she'd missed him while he was traveling with us. We listened to the frogs and looked at the fish in the cenote. Pablo mentioned that he'd seen a terciopelo there. He'd sadly watched the pit viper swim around, its tongue flicking rapidly, before he killed it. He regularly made offerings to the cenote and to the sky to protect his milpa, but he was checking again this morning to make sure there weren't any other snakes. He didn't want a snake to bite one of the scuba divers who paid a fee to explore his cenote. "Here in the forest where I make my living, I live with the monkeys, with the peccary, the coati, the paca, with all the animals of the forest except the snake. The snake is not my friend," he said.

"The animals eat the fruit of the forest," Pablo continued. "There are many fruit trees that grow wild. When the tender fruits begin to fall, the animals never leave the trees alone. Day and night they come by to gather what is falling. I remember when this was high forest. When all the big trees were bearing—it was amazing!—this forest was dense

with fruit. But the forest floor was clean, as if swept with a broom." He chuckled, making a sweeping gesture with his hand. "That was the work of all the animals who gathered the fruit where it fell."

"What about the jaguars?" I asked. "Do they still live here?"

"Hmmm, the jaguar. He stays away. But he watches. If he's not scared, he will watch you pass with your flashlight. If he thinks you are about to see him, he closes his eyes so that you cannot see the reflection. He waits until you pass. Then he opens his eyes little by little. Hmmm," Pablo said in his low gravelly voice, nodding his head slowly. "That's what my friend the jaguar does."

As we walked around his farm, Pablo pointed out details to Victoria, patiently and slowly passing along his knowledge. The morning was hot, and Pablo found a log we could sit on in the shade. He peeled and cut up a ripe mango he'd picked and handed Victoria a slice. The juice spilled from her lips. Pablo cleaned her face. She looked up at her grandfather, moved closer, and put her head in his lap. He stroked her hair and suggested that we head back to Tulum so she could take a nap.

On the way back Pablo talked about the Maya church. "We're losing the younger generation, they aren't coming," he said. "What are we going to do? Hit them? No way. God will castigate them when their time comes."

"What will you do?" I asked. It was clear that community meant everything to Pablo, and he worried about the survival of his church.

"It's getting hard to put on a ceremony because you need people who know how to do things. You can't ask them to do jobs they don't know how to do. We have a lot of new people moving to Tulum. Some are very religious, but not Maya religion. Many people come to our fiestas now just to get drunk and don't offer anything positive."

I needed help understanding what was going on politically in the shrine villages and what the Mexican government was up to. It was hard not to be cynical about the new signs in front of the churches in Tulum and Chunpom. But before jumping to any conclusions, I consulted Francisco Rosado May, whose great-grandfather Francisco May had been in leadership battles of his own—indeed, the group that founded Tixcacal Guardia had rejected his rule and stolen his cross. He was one of the few leaders who died a natural death.

"Of course the government is up to no good," Francisco said matter-of-factly. "It's in their best interest to foment dissension within the leadership of the shrine villages. In the early 1970s, when the Territory of Quintana Roo became a state, the Maya were 70 percent of the population. Cancún was being built at the time. The politicians worried that if the Maya realized how powerful they were as a voting block, they could really disrupt their agenda. They could

have demanded jobs, schools, medical care, anything. So the emerging state government became very adept at co-opting any Maya leader who appeared. The government built houses for some of the church leaders, and of course this caused problems. Now that the church actually had money, power struggles broke out over who would run it. Different factions aligned themselves with PRI and PRD (Partido de la Revolución Democrática/Party of the Democratic Revolution), two of the Mexican political parties. That divided the community, which is exactly what the government wanted. You saw how the government is putting up their Maya Ceremonial Center signs—a little money and now they are partners with the church. It's more of the same."

Francisco added: "But the Santa Cruz Maya aren't completely without resources. In 1994 as soon as the Zapatistas appeared, your friend Marcelino let it be known that the people of Tixcacal Guardia sympathized with the rebel Chiapas Maya. That's all he said. Nothing more. One sentence. Almost within hours, truckloads of gifts for the church came rolling into town—and not just to Tixcacal Guardia but to the other shrine villages too. Both the state and federal government reacted very quickly. Consequently you didn't see Zapatistas appearing on the Riviera Maya."

Hilario called in October (2004) with the sad news that don Marcelino had died.

Anthropologists from the time of Redfield and Villa Rojas have drawn a distinction between Maya villagers living in Yucatán and those in Quintana Roo. When we first arrived, even the Maya themselves distinguished between those living in the villages at the frontier of dzul control and the Santa Cruz Maya farther to the south. But the isolation of the Santa Cruz Maya, which had made them the object of ethnographers' curiosity, disappeared with roads, economic development, and thirty-five years of state and federal government intervention. It was becoming increasingly hard to call one place more isolated or "authentic" than another. The traditions tucked away in the villages on the frontier had evolved in their own adaptive ways, just as those to the south had done. Even though there is a difference between the Santa Cruz Maya area that includes Tulum, Chunpom, Chancah Veracruz, and Tixcacal Guardia and the area that includes Xocen, Kanxoc, Tixhualatun, and even Chichimilá around Valladolid and Nuevo Xcan in the northeast, they all share a tradition of worshipping the sacred Maya crosses that the Santa Cruz Maya believe are related.[52]

I was intrigued with the cross in Nuevo Xcan. While the other Talking Crosses were worshipped and guarded by the Maya in shrine villages, with their own priests conducting services, we'd found the church in Nuevo Xcan empty and unlocked, with a Roman Catholic priest conducting the

weekly services. The priest must have known about the Talking Cross. It reminded me how the Maya were able to carry on their ceremonies after the conquest under the guise of Roman Catholicism, at times with the tacit approval of the Roman Catholic priests, even as the Spanish were smashing their idols.

When Charles and I revisited Nuevo Xcan in late April of 2005, we found the front doors of the church open. Two young women were sweeping up rice from a wedding and changing the flowers on the altar. When they saw that we had brought candles to light, one of the girls volunteered that the church had one of the three original *cruces parlantes* (talking crosses). "The other ones are in Carrillo and Chan Santa Cruz," she said. "They say that this is the one that bled from the trunk when they cut it from the tree. Back in the time when there was fighting, families brought the cross here from somewhere south."

Though the details of their history were flawed, as Carrillo Puerto and Chan Santa Cruz (Noh Cah Santa Cruz) were actually the same place, we were curious about their knowledge. Charles asked if they'd learned this in school, but they shook their heads. Their father had told them. He was the *encargado* or prioste of the church. The girls, introducing themselves as Genny and Sandra, recommended that we come back the following week to witness the gremio celebrations that would continue through May 3—the Day of the Cross. We could eat relleno negro and talk to their father. He could answer more of our questions.

When we returned on Saturday, April 30, we passed women in the streets carrying plates and bowls of food. Outside the church, other women welcomed us with a plate of fresh chicharones and a stack of tortillas. "Our Saintly Cross is one of the three Talking Crosses," said one. A gold tooth shone as she smiled.

"The other two are in Tulum and Carrillo," another with a silver tooth added. "They say that one day the three crosses will reunite."

"What will happen then?"

They looked at each other. "That's just what they say. We don't know."

As we left the church Genny and Sandra pedaled by on their bikes and stopped when they recognized us. They told us that their father was selling food at the eastern entrance to town, at a wide spot in the road in front of a beer distributor, and we should go ask him about the history of the cross.

Juan Bautista Poot Loria had a tricycle set up as a food stand in the parking lot. Eight women were also selling snack food from plastic pails and aluminum pots. He talked while he sold his *polcanes* (cornmeal dumplings with black-eyed peas).[53] He also had an ice chest with cold soft drinks, though most customers were buying beers from the store. Taxis from Cancún, Mérida, Valladolid, Tekom, Chemax, Tixpeual, Kanxoc, Chichimilá, Dzitnup, and many other towns and villages came pouring through, stuffed with men who had just gotten off work in Cancún or along the Riviera Maya

and were heading back to their villages for their day and a half off. They stopped briefly for something to eat and drink then drove off.

"I work here every Saturday from noon to six," Juan explained. "I'm a milpero, and this is my opportunity to earn some cash." He said he was fifty-five; he'd moved to Nuevo Xcan when he was seven. "New" Xcan was founded when the government settled the border between the state of Yucatán and the territory of Quintana Roo. The new border placed Xcan just inside Yucatán. Many villagers wanted to remain in Quintana Roo, so they built a new village across the border. There was only one Talking Cross, however, and it couldn't be divided. Its patron took it with him to Nuevo Xcan. When one of the Xcan faction protested, pulled out his machete, and tried to chop the cross in two (Juan told us that we could still see the marks), his blow glanced off and his machete hit his knee, cutting him badly. That stopped anyone else from trying to take back the cross.[54] Juan explained that about 80 percent of the men in Nuevo Xcan were milperos like himself, and they still conducted Ch'a Chaak rain ceremonies. Nuevo Xcan had no h'men, so they had to bring one in from another village. It was something that they needed to do as a group, which took a lot of organization and work. Because of that, they had last celebrated Ch'a Chaak in their village three years ago. Nevertheless, many farmers continued to perform individual ceremonies in their milpas.[55]

"How do worshippers navigate between Maya belief and the church?" Charles asked.

"You mean the Roman Catholic Church?" Juan asked, clarifying his question. When Charles nodded yes, he continued: "The padre permits traditional Maya rites in the church. He accepts them as long as they aren't held when he's scheduled his services and sermons. A lot of what I have to do as a prioste is schedule events and keep everyone happy." Juan adjusted the umbrella he had over his tricycle to keep his food in shade as the sun lowered in the sky.

"Our traditional offerings I put in front of the altar to God for Him to partake spiritually, but I tell the people to give them away outside the church, in the corridor, because you can't distribute and eat them inside. That is the padre's rule. His message comes from Rome. But as Maya, we want autonomy. And the padre accepts this. We must all accept each other's beliefs in our own way."

Another taxi came, and Juan got an order for eight polcanes. One of the pretty young women selling *panuchos* (fried tortillas with black bean sauce and shredded meat and red onions) came over and asked Juan for change. She'd dressed up for her Saturday afternoon of food sales in the parking lot; she wore a red dress, high heels, gold earrings, and a gold necklace. Her jet-black hair was pulled back in a blue hair band and her smile was bright with lipstick. Juan introduced her as the daughter of his compadre. After her customer left we started talking. She told us that she was married, with a year-old baby. Her husband worked as a welder in Playa del Carmen, and she worked at a hotel on the Riviera Maya. She

commuted every weekday from Nuevo Xcan, two hours in each direction. Her family took care of their baby while she worked. "I miss not seeing my child," she said. "But we have dreams, and this is the only way we can make any money."

Before we left I asked Juan if he could arrange a rezo for my father, who was fighting melanoma cancer, and how much the service would cost.

"I can't take money to say a prayer for your father," Juan said. "We will do that with pleasure. I hope that your father lives a long life."

The Day of the Holy Cross has its origins in the discovery of the cross on which Jesus was crucified, by a group of Christian pilgrims to Jerusalem in AD 326. May 3 commemorates this event, which is also known as the Feast of the Cross or the Feast of the Exaltation of the Cross or, most recently, the Triumph of the Cross. The festival melded seamlessly with earlier fertility and agricultural rites celebrating spring and the beginning of summer in Europe and around the Mediterranean.

Today in Yucatán May 3 heralds the advent of the rainy season to such a degree that many expect rains that very day. Maya farmers have burnt their fields in anticipation and are ready to plant. For the Santa Cruz Maya, the day of the Holy Cross is a much more important celebration than Christmas or Easter.

It had been years since Charles and I were on the peninsula for the Day of the Cross. We wanted to return to Chunpom to compare the 1974 celebration we'd participated in with what we'd find in 2005. We also wanted to visit Xocen and Nuevo Xcan. There were three villages with Saintly Crosses but only two of us. We decided to split up. Charles left for Chunpom while I went to Nuevo Xcan, whose celebration we hadn't seen documented. We invited Pablo, but he had his own duties in Tulum. He told us that he wanted our report when we got back.

Juan was outside the front doors of the church in Nuevo Xcan when I arrived. It was hot, with not a cloud in the brilliant blue sky. He motioned me inside. The gremio was celebrating its prayer service, and the congregation was responding to the woman who led the prayers. In front of the main altar was a table with four gourds of relleno negro, four stacks of tortillas, and four gourds containing sakah. A low stand held a long row of burning candles that flickered in the heat.

"Go get your cameras," Juan urged. When I set up at the rear of the church, Juan told me to move to the chancel so that I could photograph from the altar. "It's a better shot," he told me. "From there you can see everyone's faces." At the end of the service we moved outside to the gallery. Three women passed out tortillas and ladled relleno negro from a paila into the containers that all the worshippers had brought to collect their food. Juan told me to get ready, as the pro-

cession would soon begin. Women picked up banners that had leaned against the walls of the church and walked out through the front doors. The banners were embroidered or painted on velvet and other heavy fabric and decorated with fringe and tassels. Some were hung individually on poles, while larger ones had to be unfurled and carried by two people. Everyone was sweating under the hot sun. Beads of perspiration gathered on our upper lips.

When the procession reached the Mérida–Cancún highway, a policeman stopped the traffic. After a couple of blocks we turned off the main highway onto the road to Cobá and reached the house where the gremio had prepared the relleno. We were met by three women with trays full of plastic cups of cold Pepsi-Cola.

"Do you think it's going to rain?" I overheard a woman ask another, as they both wiped sweat from their brows and finished their cold drinks.

"We certainly need it."

"That's why we pray."

I walked back to the church with Juan and several women. I wanted to photograph, but Juan insisted that I eat first, and the women gave me a bowl of relleno negro and a stack of hot handmade tortillas. Everyone waited for me to take a bite.

Hach ki'! I said. "It's delicious."

Mix pap? they asked. "Not too spicy?"

Ma', I said. "No. It's very delicious! *Hach ki'!*"

They laughed and agreed that the relleno was not too spicy. Juan and the women left to bathe before the priest arrived to give his service, leaving me with another man who'd arrived on his tricycle with a block of ice that he added to a large pail of atole in the gallery. The man introduced himself as Venunciano Dzul Cahuich. We were the only ones there, and he asked if I could help him prepare the crosses for the church service and the procession.

I felt privileged handling the Saintly Cross, but at the same time it felt strange. As I'd learned from don Agapito in Tixcacal Guardia, the holy cross is kept hidden, guarded by the Nohoch Tatich. Most Santa Cruz Maya never see their own cross. Here we were, however, placing the adored Talking Cross on a specially constructed flat wooden platform. Two parallel arms stuck out from the front and back of the platform, so four men could carry it during the procession. The large cross was centered on it, held in place by molding, flanked by its two smaller companions. We added two vases of flowers.[56]

Venunciano brought out a spool of blue thread, and we tied down the vases and a bouquet of flowers at the base of the larger cross. He showed me where the machete blow had struck. They'd painted over the small missing chunk so that it hardly showed.

"The man who did that died," he told me. "His blow

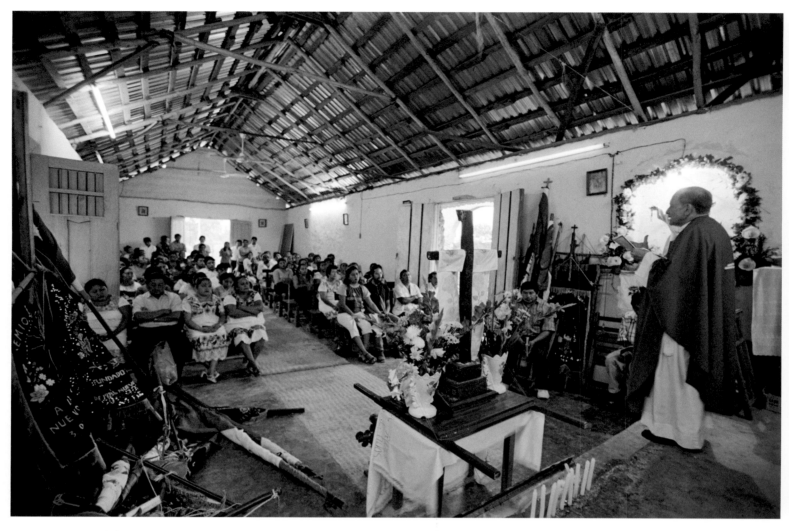

Roman Catholic service on the Day of the Cross with the Talking Cross in the foreground. Nuevo Xcan, Quintana Roo, 2005.

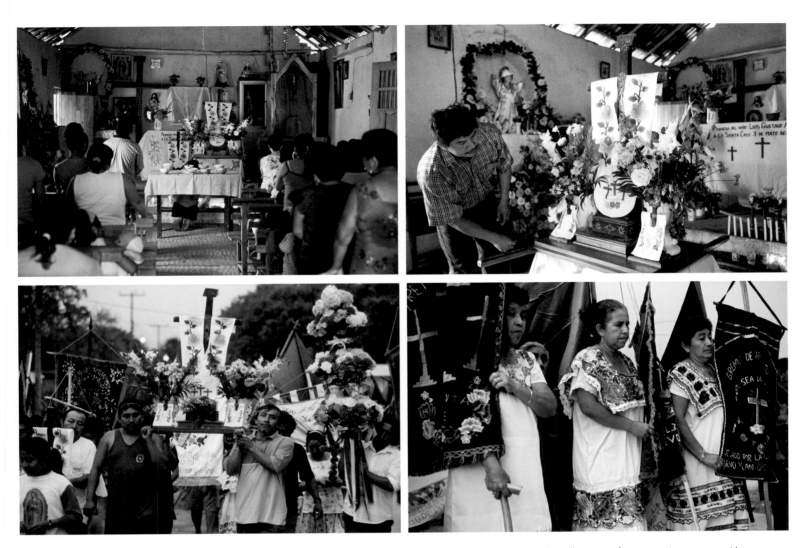

CLOCKWISE FROM TOP LEFT: Maya service on the Day of the Cross with the Talking Cross on the altar; preparing the Talking Cross for a procession; women with procession banners; a procession with the Talking Cross on the Cancún highway on the Day of the Cross, Nuevo Xcan, Quintana Roo, 2005.

glanced off the cross and cut his knee. We shouldn't fight over the cross. We venerate it because it's powerful, and because our ancestors gave it to us so we have protection."

Once Venunciano was convinced that the crosses were safe to carry, we needed to move the pews and straighten up the church. Preparing the church for a service reminded me of when I was an acolyte and helped my father. The wind had picked up, and swirls of air carried trash in through the open doors. With each gust the tin roof clattered as if it was going to blow off—two sheets of roofing that overhung the eaves at the back corner of the church had been bent by storms, and now the wind worried them noisily. A few clouds were scuttering across the sky.

"It's the priest," Venunciano whispered conspiratorially when we heard a car park outside. "Don't tell him about the earlier service and the relleno on the altar." The padre walked in, head down, hunched against the wind, which was now blowing very hard. He seemed frail and very human. Father Pablo López Martínez smiled when Venunciano introduced us and without hesitation gave his permission for me to photograph from any place I wanted. He seemed tired as he walked behind the altar to prepare for the service. His assistant went outside to ring the church bell. Clouds were rapidly filling the sky, shifting in color from white to Payne's grey to black.

"Here they come," Juan said, arriving back at the church and pointing to the gremio procession moving toward us on the highway. As they turned the corner to come to the church, the first fat raindrops splattered. They all sped up to get out of the rain, smiling as they crowded into the church. The raindrops on the tin roof quickly drowned out the priest as he began the service. The congregation got their cues from the movements of Father Pablo as the service continued through communion. There was a bright flash and crash of thunder as a lightning bolt struck nearby and the lights in the church went out. The roar of the wind and the rain on the roof were incessant, even as the lightning and thunder moved farther away. Ironically, I'd been worried that the click of my camera would be a distraction.

At the end of the service Father Pablo waited ten minutes for the rain to abate. When it didn't he dashed out to his truck and drove off, already late to his next service. There was no question among the congregants that this had been a rain ceremony—or rather a service affirming the rain. Chaak and God were rewarding piety.

Juan wanted to know what I thought of Father Pablo. I said that he looked very tired.

"He had a service in Cobá this morning then here," he said. "Now he's on his way to another village, then he has an evening service in Kantunilkin. He is the priest to over thirty communities. He's overworked. He's been here for more than thirty years. Everyone likes him."

After twenty minutes Juan spoke to the congregation. When he was finished, he turned and asked if I would say a few words too. I stood near the altar and had to shout when

the members in the back said that they couldn't hear me. I told them how impressed I was by their faith and their working together as a community and that I was grateful they so generously welcomed me. *Hats'uts'*, I told them. "How beautiful."

The rain thrilled everyone, and no one was bothered by the delay it caused. They had prayed for rain. It was raining! Their prayers had been answered. People introduced themselves and asked me questions. When we could hear each other without yelling, we realized that the rain had stopped. We went outside, some carrying the banners of the gremios, and fell in behind the four men carrying the Saintly Cross on its platform. We walked counterclockwise around the plaza, snaking around large puddles, and again the police shut down the Cancún–Mérida highway for us. As we neared the church it started raining again, and the rain made us grin.

When I got back to Tulum, I visited Pablo to give him my report. The street in front of both his house and the church was flooded. The sky was dark with the storm. I told Pablo that this first big storm of the rainy season was regionwide and had knocked down trees on the road, especially between Cobá and Tulum, and that I'd seen a car that had gone off the road where a tree had fallen. The driver had probably put on his brakes and skidded off—the first rain is always the slipperiest because of the buildup of oil and grease on the road during the dry months.

Pablo asked me if I wanted something to eat. I told him that I was full after eating relleno negro. At that he grinned and told me how lucky I was. I told him it was good to see a community that had faith, and Pablo reminded me that they had a sacred and powerful cross, like the one in Tulum.

On the wall a gecko chased an insect. Pablo said that in his house geckos had appeared a couple of years after the last hurricane; he thought maybe the wind had picked some up from another place and dropped them in Tulum. They'd quickly multiplied, or maybe it was just one pregnant mother. He didn't know. I told Pablo that I'd once found a small fish swimming in an air plant up in a tree in a cloud forest in Oaxaca, thousands of feet above the sea. I thought maybe a waterspout had picked it up from the sea or a bird had dropped it. "God does these things to confuse us and keep us honest," Pablo suggested.

It had also rained hard in Chunpom. The rain came just before dawn on the morning of May 3 after a full night of dancing to mayapax at the church. It dripped off the gallery's thatched roof onto those sitting on the edges of the dance floor. And as in Nuevo Xcan, everyone was grinning.

"About sixteen vaqueras danced," Charles told me when we reunited at Pablo's house. "Some seemed really young, like eleven or twelve years old." It was something we'd noticed over the years. The median age of the girls who served as vaqueras in the shrine village fiestas was growing young-

er. Many older teenagers, rather than dance to mayapax in the church gallery, waited for the amplified Mexican bands.

"There were some older girls who danced mayapax," continued Charles. "But none wore their huipiles. Only the younger ones did, and when they come of age at their quinceañera I'm sure they'll abandon their huipil for Western dress too. It's the new custom."

Charles told me that the electricity had been knocked out early in the night, as Chaak thundered in the distance hours before the rains came. "So the cumbia dance on the basketball court was canceled," he said. "It was kind of cool because it was so dark—no electricity, and no stars because of rain clouds. The church dance was lit by candlelight. It was just as we remembered it."

Charles contrasted the happiness felt by those dancing at the church, who welcomed the rain when it came, grinning and getting wet and toasting it with rum dispensed by the chi'ik, with the disappointment that the people who had wanted to go to the cumbia dance must have felt. "To me it's symbolic of the move away from an agrarian society where everyone depends upon the rain—welcomes it, even prays for it—to a commercial economy where wages are earned and your food and pleasures are purchased, and rain gets in the way of those pleasures."

Early every morning, Charles reported, buses from Hotel Príncipe Maya picked up laborers in Chunpom for a day of work on the Maya Riviera. "There were several of them, sent by the hotel, with big, bright hotel logos on the sides. They must have picked up two hundred people or more," he informed us.

"During the fiesta?" I asked. "But everyone gets off for their fiesta."

"Not anymore," he said. "The workers didn't get a day off, much less a week. Bussed to work in the morning and bussed back home each night. Most were young men and women. I talked to a farmer about it. He said that because his children went to school they can do work in a hotel instead of a milpa. He said it matter-of-factly. He didn't seem particularly bothered."

Charles had spoken to the Nohoch Tata, who said that he could hang his hammock in the guardia next to the church. Charles was sad that food preparation had been shunted away from the open plaza to a small yard a half-block from the church. It apparently served as a community yard for just such feast preparations. Two visiting kuch'ob from a responding village—one of whom was a very old, respected tatich—had set up there with their families and been responsible for two of the nine days of activities. A couple of dozen men and women and older children worked day and night in revolving shifts, boiling and grinding the corn and butchering the pigs and hanging the meat on lines. The villagers walked in a procession every day to bring an offering of food to the church then returned to the community yard to distribute the communal feast.

Charles had run into a friend as he helped butcher a pig.

Ismael was from Chunpom, but his father, a respected hierbatero, had moved his family to Chunyaxché, thirty kilometers away. Charles and I knew them from their work as tour guides in Sian Ka'an Biosphere. Ismael, in his early twenties, was on his way to becoming an expert ornithologist. "Pretty strange, huh?" Ismael said to Charles in English as he fingered the cell phone in his pocket. "Pretty strange to see all of us young Maya in Nike T-shirts, gutting the pigs!"

At times, Charles told me, there were scant indications in the central plaza that the holiest of Maya celebrations was taking place in Chunpom. A driver passing through might not even have noticed. But many if not all of the fiesta activities we'd witnessed a few decades before were still taking place. "They are more tucked away now," he said. "Future anthropologists are going to have to look a little harder to find what's Maya amid the dzul influences."

Charles continued: "However, the planting of the yaxche was as wild and public as I remembered it. They shot off fireworks to announce they were bringing it in. When it was time to plant the yaxche, the chi'ik whooped and shouted as loud as he could, 'Vaqueras! Vaqueras!' to summon the girls to come so he could throw seil seeds at them and taunt them from his perch in the tree."

One change that Charles couldn't help notice was that a few families of pilgrims arrived by cars and stayed only long enough to light their candles. "I asked a lady why her family had come and she said, in Spanish, that the Cross was very powerful. She sent her two sons into the church. Teenaged boys, dressed nicely, in button-up shirts that they'd wear if they were going to, well, church. She'd given them candles and the fee for a prayer to the Cross. So the two boys asked for the tatich. The boys were of Maya descent, but they kind of stood out, as we do. They looked and acted like dzules. They were finally directed to the Nohoch Tata and spoke to him in Spanish. 'Our mother sent us to ask for a prayer, here are the candles, here's the money.'

"'We don't understand Spanish here,' the Nohoch Tata replied in Spanish, although of course he did. 'Speak to me in Mayan,' he scolded."

Pablo laughed when he heard this. "The Nohoch Tata is still carrying on the traditions," he said. "They are making sure the kids speak Mayan."

One evening, during a week when Pablo had no guard duty, we invited him to eat. We walked to one of the many restaurants, run by colonists, that now cater to the thousands of colonists living in Tulum and the tens of thousands of visitors who pass through each month. Pablo seldom ate there or anywhere else along the main street, even though it was just a few blocks from his house. Nearly all his needs were met around the Maya plaza where he lives. Indeed, it was the first time in over three decades of friendship that either Charles or I had ever walked with Pablo anywhere along the

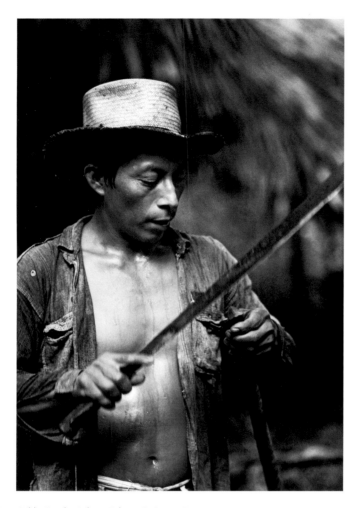

Pablo Canche Balam. Tulum, Quintana Roo, 1971.

commercial strip that today defines Tulum to those passing through.

Lightning lit up the sky, and Charles counted the seconds out loud before we heard the thunder. *Tan kilba Chaak,* Pablo said. "Chaak is thundering."

Pablo pointed out new construction: foundations that showed the footprint of what would become new offices, new stores, and new houses. When we got to the highway, just remodeled again with landscaped dividers and new brick sidewalks, he couldn't contain his displeasure. "You'd think we were in Mérida," he muttered, shaking his head.

We stopped at an open-fronted taco restaurant with a vertical spit of roasting pork and tables and chairs on the sidewalk. We sat outside and ate *tacos al pastor* (tacos shepherd style), a tasty *antojito* (snack) typical of central Mexico. They were good. Pablo ordered an *horchata* (a sweet rice drink) instead of a beer. By way of explanation, he told us that he'd been to the doctor recently. It was hard to hear, as a jukebox inside blared a mediocre ranchera.

"There's nothing natural here anymore," Pablo shouted.

"Too much noise in the morning, too much noise in the day, and horrible noise at night." He shook his head. "I'm going to my milpa. I have another type of music there." He laughed impishly. "The music starts at five A.M. when the chachalacas start singing."

"Ahh," I agreed. "The concert of the forest. I enjoy its rhythm too."

A huge flash split the night, and the thunder was simultaneous. The lightning knocked out the power for a moment. Then it came back on.

"The only time things are natural anymore," Pablo said, "is when the electricity goes out."

As we walked back to his home we passed a real estate office. We glanced at the ads printed out on a laser printer and taped to the window. Most were for beachfront property—none of which was owned by a Maya—with photos and glowing descriptions of each "dream house." They each had a selling price of over a million dollars, a figure that mocked the Maya and their dreams.

Se perdiereron los tulumeros, Pablo commented quietly. "The locals lost."

In 2008 Genoveva, Pablo's daughter, told Charles and me that her father was dedicating the rest of his life to the Maya church. After consulting a h'men in Chunyaxché, Pablo was meeting with other Santa Cruz Maya leaders to talk about the lack of support and attendance among the younger generation and the crisis they were facing. There was talk, Genoveva said, that Pablo would become a *sacerdote* (priest).

When we went to light our candles in the church, we found Pablo reciting a prayer in the Gloria. Afterward we walked across the street to his house to talk. But an Evangelical neighbor was holding an amplified service across the street, every word reverberating through the neighborhood. Some of Pablo's neighbors had turned up their televisions and radios to provide a wall of sound to drown out the service. We had to yell to hear each other. Pablo told us that he had to endure this for several hours every night. I thought back to when Pablo had told me that he loved to hear the sound of doves and birds nesting outside his house.

When we left, Charles and I stopped in front of the Evangelical, who was playing an organ and singing into a microphone. He'd been on the same deafening song for over twenty minutes. An open doorway invited us in, and we could see a room full of chairs. But there was only one person. Hallelujah, brother!

A few days before, Agapito Ek, the Nohoch Tatich of the sacred cross in Tixcacal Guardia, had told us just how serious the problem had become in Tulum. They were considering suspending the annual fiesta altogether because there was no longer any land left around the church where they could kill their pigs and prepare their meals. The economic and social pressures of a modern Mexicanized Tulum were

forcing the Santa Cruz Maya from one of their traditional sacred centers. If this news stunned and saddened us, I could only wonder how Pablo felt.

We saw Pablo again a week later, while he was performing his guard duty. We'd bought candles and walked over to the church at 10 P.M. The plaza was lively. Kids were playing, and men and women were standing around; it was still too hot for anyone to go to sleep, even in their hammocks. Teenagers were playing an energetic and loud volleyball game on the basketball court right outside the church fence.

Pablo was sitting on a bench in the covered corridor between the church and the guardhouse. We greeted him formally, and he introduced us to the other guards before we took off our shoes and went inside to light our candles and pray. On the altar were fresh sprigs of *ruda* (rue, *Ruta chalepensis*) and basil. More than thirty other candles were already burning brightly, and the inner sanctum was hot. Maybe because of the humidity it seemed even more cavelike inside than usual. I prayed for the health of my friends, too many of whom had fallen sick with life-threatening diseases even though they were still young.

Pablo was in a grumpy mood when I got back outside. He was complaining how kids didn't know how to work anymore; you measured a man by the work he could do, and kids these days didn't even know how to sweat. As Pablo was talking, a young Maya came up to him and asked if he could buy some rue; his daughter was sick, and he needed the herb for medicine. Pablo pointed to new planters along the fence in which rue and basil were growing and told the man that the plants were for the use of the church. He couldn't give him or sell him any. As the man walked away, Pablo shook his head. "Why don't they plant their own? Nobody grows herbs or gardens anymore."

As he went on, I thought about how the older generation always complains about the younger generation—it must be programmed into our genes. But I sensed that Pablo was really bemoaning the bigger changes: the Maya were losing Tulum to outsiders, many kids were no longer speaking Mayan or attending the Maya church, and young men not only were not making milpas but weren't even planting home gardens anymore. Few were volunteering for guard service. Pablo had long been cynical, but he had also been reasonably optimistic. He was quite aware of the bigger picture. Now that he wasn't drinking or smoking anymore, he had nothing to alleviate the pain of what he saw and what he felt for the future.

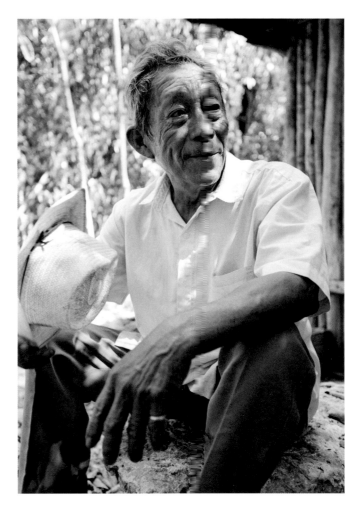

Pablo Canche Balam. Tulum, Quintana Roo, 2001.

NOTES

1. Peissel 1963.

2. The second longest barrier reef in the world runs the length of Quintana Roo and extends south to Belize and Honduras. The coastline includes beaches, lagoons, mangroves, rocky shoreline, and dense forest. It is a complex and fragile system. The biodiversity found in the reef system offshore and in the sea is even more diverse than on land. It is fitting that even the land once came from the sea—the peninsula once was an ocean bed.

The Gulf Stream passes by, day in and day out, at a steady 4–5 knots. The continental shelf falls off sharply right along the coast, with a deep trench between the nearby island of Cozumel and the coast.

Protecting the land from the forces of wind and waves is the reef. Inside the reef sea grasses grow in underwater meadows. Among the grasses live sea cucumbers and sea slugs, urchins, snails, sea stars, shrimp, crabs, octopods, squid, conch, pen shells, and juvenile fish that will move to the reef when they become larger. The leaves have fringed blades that absorb the current, which then allows sediment to settle to the ocean floor. The grasses strain the muck to clear the water. The sea-grass meadows are important to the life of the coral reef and also to the health of the beach. Blades of sea grass break off and are washed ashore. The leaves build up along the high-tide line and serve as a buffer against the waves, a natural breakwater. The sea grasses break down and get mixed with the sand and help aerate it and add nutrients. The aeration helps the sand crabs, the natural environmental janitors who clean the beach of edible trash. The developers and hotels that sweep and rake their beaches are interrupting a valuable part of the complex system. This frequently leads to loss of beach and sand; in the end, they often build unnatural breakwaters.

Behind the sand are the low coastal dunes, anchored by low-growing halophytes—plants that can withstand huge amounts of salt and constant buffeting from the wind as well as survive in sand. The plants stabilize the dunes. Behind the dunes begins the dense forest jungle. Coconut palms and sea grapes, a tree with edible fruit and broad waxy leaves, can live between the high-tide line and on up into the forest. Although coconut plantations were established along the coast, many palm trees sprouted from shells that floated in, pushed by waves and current, and grew where they washed up.

The coastal dunes are very important. Replace the word "dune" with "dam" and you have a better idea of how they function. The problem with many of the developments along the coast is that they build on the dunes; killing or removing the halophytes results in erosion that destroys the dunes. Developers have bulldozed and cleared the habitat and species that live there and removed and filled in mangrove swamps.

The mangroves and mangrove swamps along the coast and in depressions in the coastal area are very important to the health of the reef. They provide nutrients that flow out to the reefs with the tides and through the underground river system. When the developers destroy the mangroves, the mangroves no longer feed the reef, which was the attraction for building the hotel in the first place. They are condemning their hotels to a short lifespan.

The reef is an oasis in an oceanic desert. The incredible blue color of the water is a result of the absence of plant life on the ocean floor and the reflection of the sun and sky off the white sand through the clear waters. The beautiful white sand is a combination of crumbled coral and skeletons of calcareous algae that deposit calcium carbonate in their tissue. The reef needs the nutrients and help provided by the sea grasses and the mangroves. The water table along the coast is very shallow, so the sea is polluted if waste treatment is poor or nonexistent. Algae growth from waste can cover the coral and kill it. The pollution also enters the drinking water that everyone uses. The water is so crystal clear that the pollution immediately becomes visible.

Maya ruins are found along the length of the Quintana Roo coast. The Maya were great traders and paddled large seafaring canoes. At some plac-

TOP: Comandante Marcelino Poot Ek visiting the archaeological site. Tulum, Quintana Roo, 1974.
CENTER: Bodysurfing beneath El Castillo. Tulum, Quintana Roo, 1969.
BOTTOM: Children playing in the guardhouse in front of the Maya church. Tulum, Quintana Roo, 1971.

es in the ocean the sweet water from the underground rivers on the peninsula bubbles to the surface, providing good drinking water in the ocean without having to land. Hilario, Charles, and I have found several and swum through them. Like any healthy river emptying into the sea, it attracts marine life because of the nutrients it brings.

To learn more, Charles and I went diving with Ramón Carlos Aguayo, who was working at Maroma Resort and Spa and offered to show us the reef system.

"The energy here is incredible," Ramón told us. "The Cozumel Channel is a deep trench—it is like the Grand Canyon—deep and magnificent. It is wider at the south end, and it gets narrower, like a funnel, here at the north end. The current is stronger here and more unpredictable. It's like a river. When it smashes against the wall of the canyons, it creates an amazing upwelling that brings an abundance of nutrients and gives life to the coral, sponges, sea anemones, shellfish, fish, and turtles."

I knew exactly what he was talking about. When I was working as a whitewater river guide, one of the rivers I ran was the wild and scenic section of the Rogue River in southern Oregon. My father's family had come out on the Oregon Trail and settled in this area, and there is an Everton Riffle where the family farm had been near Grants Pass. The Rogue River is a beautiful trip that features a lot more scenery than whitewater rapids. At one spot at Coffee Pot in Mule Creek Canyon the river is suddenly forced between the narrow confines of a canyon wall, however, and in places the river is only fifteen feet wide, creating extreme hydraulics. It can be a wild ride where an upwelling will lift your boat up and twirl you around and push you forward, or backward, or sideways. You must constantly adjust so that you don't smash against the canyon walls. It resembles coffee percolating—hence its name. When two boats are near each other, one can be a foot higher than the other.

When they first sailed these waters, the Spanish named the point for the whirlpools (*maromas*) they encountered. Because of the current and the depth, we would do a drift dive. Rodrigo Sosa Cantillo, a young fisherman and boatbuilder from Dzilam Bravo, a coastal fishing village in Yucatán, was the captain for our boat. His job was to follow our bubbles so that he would be there when we surfaced at the end of the dive. The reef at Punta Maroma is only a few hundred yards off the coast, and the Yucatán plate ends just beyond that. We put on our masks, fins, and tanks and fell backward into the water then descended to 110 feet. Water filters out the red from the color spectrum, and everything around us was blue, a vast, deep blue sea. If you dive around the reef you see the sea fans and soft corals and anemones waving back and forth, affected by the current, tide, and waves. But here on the canyon wall the current was bending all the organisms one way, just as a strong onshore wind bends and ultimately shapes trees along a coastline. We didn't have to swim much at all because the current swept us along.

I drifted along with a group of fan fish, with big fat lips. The ocean floor kept dropping off. At a depth of 130 feet Ramón found an overhang and swam underneath it. He motioned for Charles and me to follow him in. It was dark, and it took a moment for my eyes to adjust. The floor of fine white sand angled up to meet the roof at the back, but Ramón pointed to something that was hidden behind a sand berm. I followed him farther in and discovered a sleeping nurse shark a few feet in front of me, lying motionless in the sand.

Years ago, just up the coast at Isla Mujeres, a free-diver nicknamed Valvula was amazed to find reef sharks sleeping in caves—they weren't known to be able to sleep, and it was only the combination of nutrients and a strong current that allowed them to do this. He showed them to Ramón Bravo, who photographed them for *National Geographic*, and later Jacques Cousteau came and saw them. Today you can't see them anymore—they've been fished out and killed.

As we left the nurse shark, the current suddenly buffeted us. We could see each others' bubbles go down, sideways, up and down and around, rather than normally rising straight up.

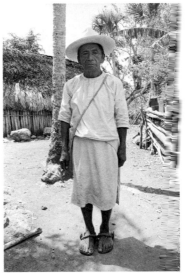
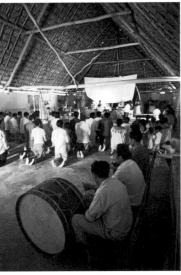

TOP: Cross and altar set up outside the church at night during a fiesta. Tulum, Quintana Roo, 1974.
BOTTOM LEFT: Tomás Che wearing a *k-lantera*, common dress for Maya men until the 1970s. Chichimilá, Yucatán, 1971.
BOTTOM RIGHT: Musicians in the church during a service. Chancah Veracruz, Quintana Roo, 1974.

"All that water that is caught in the upwelling is recirculating," Ramón later explained. "The water rushes over the edge into the trench like a waterfall, and we were on the edge of that. That is why we had to work to move away from the edge."

As soon as we did, we swam up on a loggerhead turtle that was nibbling on a sponge at 150 feet. Soon the turtles would gather off the reef to mate and the females would be laying their eggs on the sandy beaches. We wanted to go closer, but we'd used up a lot of our air fighting the recirculating currents and still had to decompress before we could surface.

3. Florentino Pech married Florencia Balam, Pablo's mother, and was her second husband. Juan Canche Ay, Pablo's half-brother, remembers that the patriarchs of the founding families of Tulum were Dolores Balam (Pablo's grandfather), Gollo Catzin, Juan Camara (Ofelia's father and Pablo's father-in-law), Silverio Chim, and Melín Borges. Their family homes are still near the Maya church and plaza. According to Juan Canche, the successive Nohoch Tatich'ob of Tulum's Maya church began with Pablo's grandfather, don Dolo, who was followed by Gollo Catzin, Silverio Chim, Juan Ek, and Moisés Chim Hoyil in 2008.

During the Caste War in the nineteenth century, María Uicab, called the queen or patron saint by the Santa Cruz Maya, protected Tulum's cross. Even though she was carrying on an ancient Maya tradition that included women as priests and rulers, the queen was unique—there are no references to the Cult of the Cross under the direction of a woman at any of the other shrine centers. Villa Rojas 1945:24.

4. Some researchers doubted Pablo's information precisely because of his contact with the outside world. One archaeologist confided to me that she questioned whether Pablo had heard the story of the Hero Twins (chronicled in the Precolumbian narrative Popol Vuh) from his grandfather or had learned it while filming *Chac*. When I asked Pablo, he was interested in the question. He said that he had heard the story as a youngster and been reminded of it when filming. The film had awakened an interest in his past. In fact, the Maya have always been influenced by the cultures that have intersected with their world. Pablo was able to bridge both worlds and judge the value in each.

5. Scott Fedick told me that at places such as Calica and Punta Venado, before they were destroyed by new construction, INAH did extensive mapping of the settlement and some test excavations in the area that was going to be ripped up, and reported just solid settlement, including what appeared to be numerous structures for apiaries.

Pablo Canche also remembers a lot of archaeological evidence along the coast of Tulum before the road changed everything.

6. Morley, returning to Tulum by boat in 1922, "walked up from the beach and pushed through the palmetto bush to the inner enclosure [of the site] . . . a most pleasant surprise awaited us. It had been largely and recently cleared and the Castillo stood up wonderfully clear. Climbing thereunto first another surprise awaited us. It had been nicely swept and in the inner chamber on the bench at the back stood a small wooden cross, perhaps 16 or 18 inches high, painted blue with some figures on it. The cross was garbed in a miniature embroidered frock similar in cut to those worn by Maya women (i.e., \'ipil), and in front of the stone on which it stood Morley found white, yellow, and pink candle drippings." Sullivan 1989:22.

Groups from Tixcacal Guardia made pilgrimages to Tulum because they believed that the spirits of the ancient Maya resided within its walls. They placed offerings in front of a cross at El Castillo. Villa Rojas 1945:5, 45.

"I saw a Talking Cross inside the Castillo at Tulum as late as 1948." Coe 2005:250.

7. The second choice was Sian Ka'an, which is now a protected Biosphere Reserve. One reason they built Cancún is that the freshwater aquifer nearby is at least 120 meters thick, the thickest known on the Yucatán Peninsula.

8. When I first arrived, the building served more as a community center—it was only later, after the influx of outsiders, that guards were on constant duty. Villa Rojas, speaking of a similar structure at another shrine

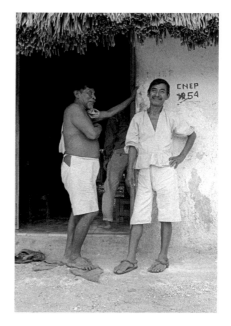

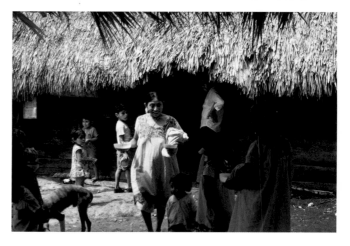

TOP: Roque Dzul, the Nohoch Tata, and General Juan Bautista Poot in front of the Maya church. Tixcacal Guardia, Quintana Roo, 1974.
CENTER: New fire ceremony in front of the Maya church. Tixcacal Guardia, Quintana Roo, 1974.
BOTTOM: Woman carrying communal food during a fiesta in which everyone is fed. Tulum, Quintana Roo, 1974.

village, suggests that it may correspond to a popol nah in the Precolumbian Maya villages. "According to the *Motul Dictionary* this was 'a community house, wherein they assembled to discuss affairs of the common weal and where they were accustomed to dance in the village festivals.'" Villa Rojas 1945:43.

9. The Maya believe that the east is the most important cardinal point and the most powerful because it is the preferred domain of the gods, including even God. They also believe that their ancestors are in hiding in the east "awaiting the moment when they may return to their land and resume their ancient grandeur." Villa Rojas 1945:155.

10. Sullivan 1989:48.

11. Villa Rojas 1945:25. Since that time, the villagers have dealt with other anthropologists and a few Mexican government officials. To the Santa Cruz Maya, Mexico was—and to a great extent still is today—a foreign country and even Yucatecans were considered foreigners. They were friendlier to the few British and Americans they met because they hoped that they might help with weapons in the fight against Mexico.

12. In other parts of Yucatán some older men wore another type of traditional dress that was disappearing with their generation: short pants and a saronglike wrap of cloth around the waist that was often white with blue stripes, called a *delantera*.

13. Allan Burns suggests that if the Speaking Cross is interpreted as a cultural idea, it's more than just a material object—it can take the form of many things: everything from people to pieces of wood to paper with writing on it. In that sense, if we believe that God is really in all of us, then God should be in everything. Burns 1983:73.

14. Hilario feels that the aires give a hint of what Precolumbian Maya ritual music may have sounded like. It was pentatonic (with five tones). We know some of their instruments: clay flutes and ocarinas, conch shells used as trumpets, turtle-shell drums, and a large hollow log known as a *tunkul* that the Maya still play today. At Chichén Itzá there is a pile of stones near the Venus platform. The stones are of similar shape, round like a column, but of different lengths. A guide told me to strike one with another rock. It sang. I struck another and got another note. I struck several, and it was like playing a marimba.

When Hilario was recording a mayapax in Tixcacal Guardia, General Juan Bautista Poot, from the nearby supporting village of Yaxley, came up to him and asked him what he was doing. The general wore an earring in his left ear (like many of the previous generation of rebel Maya). Hilario knew that the general could destroy his Tandberg tape recorder and have him thrown out, so he anxiously answered that he wanted to preserve the music so it wouldn't be lost. He held his breath as the general stared hard at him. "If our music is lost," the general finally said, "it is the end of the world."

15. See Fariss 1984: Chapter 11. "*Mantan* is a term meaning offering or gift, and is most commonly used by the natives to refer to the offering of food at the conclusion of certain ceremonies, both pagan and Catholic, public and private." Villa Rojas 1945:118.

16. Bone analysis indicates that the Precolumbian Maya ate a lot more meat than contemporary Maya. Rural Maya today are poor. Game is scarce, and domestic animals are more often sold for cash than eaten.

17. In the mid-1990s I worked on a book with Linda Schele, Peter Mathews, and Justin Kerr, which became *The Code of Kings*. Peter, Linda, and I spent several weeks in Yucatán over a period of a few trips, and then Linda and I traveled together to Guatemala to complete the book.

Whenever I got a phone call from Linda I knew immediately who was calling. She had an unmistakable southern twang and such an effusive and ebullient nature that the words and sentences tumbled out in a joyful cascade. One time she called to say that she had just returned from Yucatán and something so special had happened that she just had to tell me. She and Nikolai Grube were working around Tixcacal Guardia, and they'd asked if anyone had treasures—any books that were valuable. They are two of the greatest epigraphers and scholars of the Maya, and it is every Mayanist's

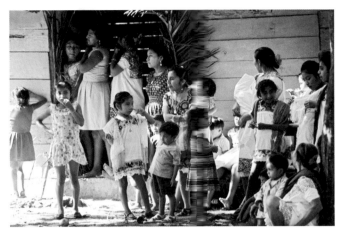

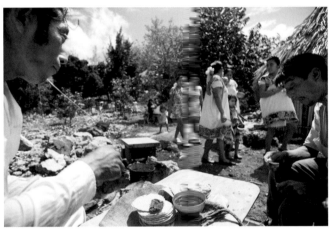

TOP: Women in front of the Maya church. Tulum, Quintana Roo, 1974.
CENTER: Men eating a communal meal as women return from the Maya church. Tulum, Quintana Roo, 1974.
BOTTOM: Wooden bull, tied up in the corral before the bullfight during a fiesta. Tulum, Quintana Roo, 1974.

dream to discover an original Precolumbian text. Only a few codices survive today, but there is always hope.

Linda said that one man finally volunteered that he had a treasure. He said that he was willing to show it to them. They followed him to his house, and he invited them inside. It was a typical Maya home with an earthen floor, pole walls, and a thatch roof. Above, resting on the crossbeams, were several planks that served as a storage shelf. There was a chest on the shelf, and the man brought it down. When he opened it, they could see a bundle inside, wrapped in cloth. Now at this point, Linda told me, she and Nikolai were getting pretty excited. The man carefully unwrapped the cloth, and as it fell away it revealed a copy of *The Modern Maya: A Culture in Transition.*

"That was his treasure, Macduff. A copy of your book! I just had to tell you this because if I ever had a book treasured like this, I could just die and go to heaven!"

Anyone else would have been sorely disappointed, but Linda couldn't wait to tell me. Her books have been wildly popular, but she always seemed to find the time and joy to pass along a compliment or to give credit to someone. She inspired people of all backgrounds and persuasions to believe that their particular insight and expertise might help lead to a new discovery.

One of the projects that Linda and Nikolai were working on was offering hieroglyphic workshops in Yucatán and Guatemala, teaching the Maya how to read their own history in their own language. Linda died too young and too early from pancreatic cancer in 1998.

18. Jon Schneeberger told me to keep working on the story and he'd get back to me. I knew that I needed to get to Pan Am's offices in Mérida to send my next batch of film to Washington so that he could see what I was being allowed to photograph.

We communicated by letter and phone. To call Jon, I needed to go to Valladolid or Mérida, where there were offices for making long-distance calls. I would give the operator the number to call, and she would contact an international operator who then talked to an operator in the United States. It sometimes took hours, and I often had to reserve a day for the call. For that reason most of my contact with Jon was by mail, which meant that a reply could take weeks.

19. Don Dumond points out that at least ten years before the army arrived the major annual religious festival was taking place in Chan Cah Vera Cruz (Little Settlement of the True Cross) rather than in Noh Cah Santa Cruz Balam Nah, which may explain the preponderance of saints in Chancah. He believes that this indicates that the center had already been moved. Dumond 1997:376.

20. Villa Rojas 1945:122.

21. Don Dumond notes that in regard to map designations "very modern local usage tends to alter Mayan words to conform to Spanish expectations (as, by changing Chunpom to Chumpón), thus I have retained here a number of nineteenth-century spellings, especially when there is clear precedent in the anthropological or historical literature to do so." Dumond 1997:xv–xvi.

The changes in the names of towns and other Maya words (see street names in Cancún, for instance) reflect how poorly government officials understand Mayan and how little they are willing to learn. In the case of Chunpom the locals have a history of destroying the signs posted at the turnoff from the Tulum–Carrillo Puerto highway, because (a) they did not want dzules visiting their town and (b) the name was always misspelled.

Linda Schele used "Yukatan" for "Yucatán" and "Koba" for "Cobá." Michael Coe also uses "Koba." But this is confusing to the layperson who is looking for place-names on a map unless everyone accepts the revised spelling.

22. Farriss 1984:19. Other Maya leaders from the active period of the Caste War who died afterward include General Francisco May, who passed away in 1972 in Carrillo Puerto, and Paulino Yama from Señor.

23. Francisco Rosado May remembers that in the 1950s, 1960s, and early 1970s the army soldiers stationed in Carrillo Puerto started conflicts with the local Maya—fistfights and even shootings—every day, although

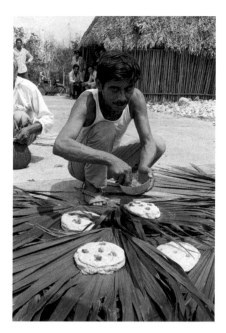

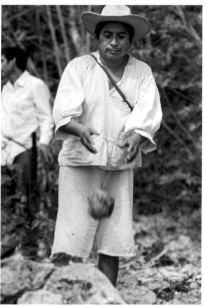

TOP: Man preparing ceremonial breads to be cooked in the earth oven. Tixcacal Guardia, Quintana Roo, 1974.

BOTTOM: Marcelino dropping a rock into the earth oven. Tixcacal Guardia, Quintana Roo, 1974.

residents. Even George Washington started distilling whiskey at Mount Vernon and produced 11,000 gallons in 1799, worth a small fortune.

"Throughout the colonial period," writes Tom Standage (2005:127), "spirits provided an escape from hardship—both the self-imposed kind experienced by the European colonists and the far greater hardships they imposed on African slaves and indigenous peoples. For as well as using spirits to purchase, subdue, and control slaves, European colonists in the Americas deliberately exploited the local Indians' enthusiasm for distilled drinks as a means of subjugation." Many Mesoamerican cultures used mushrooms, peyote, fermented drinks, and other natural substances as well as distilled spirits to converse with the other side. John Lilly told me that he surmised that only moderate amounts were ingested in many of the ritual ceremonies, just enough to reach that other state. Some anthropologists speculate that, when so many of the native priests and curanderos were killed by the Spanish or by the diseases they brought, the survivors—who hadn't been trained but knew something from observation—continued to use the intoxicants in an attempt to carry on religious traditions. Knowing just a little, they would take a lot, looking for "a state"; such excessive drinking is not uncommon at religious celebrations throughout Mesoamerica today.

We can imagine the Spanish friars' displeasure with the excesses of Mesoamerican religious ritual when they attempted to convert the Maya to Christianity after the conquest. Then again, it was the friars who planted vineyards when they built their missions and whose sacrament of Holy Communion symbolized the body and blood of Christ. In Mexico the Spanish encouraged the Indians to overindulge themselves so that they would become dependent on the colonial powers for distilled spirits, and laws forbidding sale of alcohol to Indians were widely ignored. They distilled pulque into the much more potent mescal and produced cheap aguardiente and rum from sugarcane. Not surprisingly, those who controlled the sale of alcohol in Maya villages in the twentieth century—be they mazehual caciques or dzul concessionaires—enjoyed both political and economic power.

28. Villagers sometimes viewed outsiders, including us, with fierce suspicion. Hilario, Charles, and I experienced the techniques that they adopted to shun outsiders, such as not talking or selling food to us. Parents would hustle children inside their homes, where they'd peer out through pole walls. More than once, particularly when we showed up not at fiesta time, we were greeted with stones thrown at our car as we entered a shrine village until we formally established our presence before the authorities of the town.

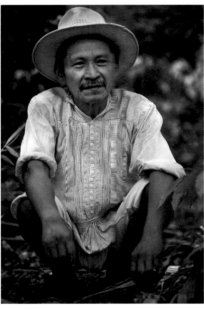

Charles learned firsthand about the importance of being formal. "I'd moved to Tulum in 1975, and for a year tended the cocal of Pablo's mother-in-law, doña Victoria. During the hot, flat, calm days of summer, Pablo taught me how to catch stingrays. He fashioned me a harpoon from rebar and we'd walk along the bluffs south of the ruins where we had a good view of the shallows of the clear Caribbean water where the stingrays liked to lie camouflaged in the sand. I would wade waist deep in the water and spear the rays. The Maya don't eat ray meat, as it is black and mushy. But its skin is like sandpaper and is prized by the Maya women, who use it to scrub their tortilla tables and furniture. Pablo showed me how to make two slits on the belly, like a cross, and how to pull back the skin using a wooden wedge. I'd wrap the stingray skin around the trunk of a coconut palm and go on my way. When I finished fishing for the day, I'd walk back along the beach, gathering the skins off the trunks. I'd hang them on a line between two coconut trees back at the cocal, and let them dry for a few days and flatten them. Then I'd cut them into squares.

"I also caught sharks. I'd chum the water and when the sharks started feeding, I'd throw in a large hook attached to a length of chain. On a good day I could land several sharks. Having no ice or refrigeration, I'd spend the evening skinning the sharks, filleting the meat into thin boneless slabs, and then salt them and hang them to dry for a few days in the wind and

TOP: New Maya church, Chancah Veracruz, Quintana Roo, 1988.
BOTTOM: Man from Yaxle attending a ceremony at Tixcacal Guardia, Quintana Roo, 1974.

tropical sun. I'd sell the dried meat to the Santa Cruz Maya in jungle villages southwest of Tulum, along with my squares of stingray skin."

Charles recalls: "No one would talk to me the first time I walked into Chunpom by myself. I was walking in on the new road when I met up with a farmer coming home from his field and tried to engage him in friendly conversation. He was polite, but extremely reticent to talk. He even seemed fearful. I kept on trying to converse with him in Mayan and quickly found out that he wouldn't, or couldn't, speak to me until I asked permission of the town leaders to visit. I realized then that there was a protocol and formality to visiting the Santa Cruz Maya. It's kind of like visiting a new country where you first have to go through immigration and explain the purpose of your visit. I walked on into town—well ahead of him so he would not have to answer any questions from his townspeople about his relations with me—and went straight to the leader of the village, who I believe was don Secundino at that time.

"Once I'd presented myself to the village authority and asked permission to peddle my wares, the ice was broken. Everyone began joking with me, both men and women. They wanted to see what I had for sale. Word spread, and I was sent from one house to another. I quickly ran out of the fish but had plenty of stingray skin to sell, as I'd cut it into little squares. All the women clamored after these because they were rough and better than sandpaper. I sold all the squares of it I had, for two pesos each, but the best thing was that I got to practice speaking Mayan—they speak really good Mayan in Chunpom, with very few Spanish words—and they fed me some delicious Maya home cooking!"

29. A Roman Catholic priest came to Tixcacal Guardia while Agapito Ek, the new Nohoch Tatich of the church, was conducting a service. The priest asked Agapito to stop so that he could perform his own service. Agapito told the priest that he couldn't just stop, but the priest was welcome to stay for the service. The priest was so upset that he left and never returned.

In Yaxley, for Easter, the villagers decorated their church with *ts'iits'il che'* (*Gymnopodium* spp.), a beautiful flower at that time of year. When the Roman Catholic priest and his two helpers arrived, they started taking the flowers down. The villagers said "No!" and they almost came to blows. The priest left. Since the priest considers it his church, he's been back, but the villagers continue to use the church for their Maya services when he isn't there.

30. Often the political-religious hierarchy leadership is kept within elite families. However, someone else in the community can succeed. This was especially true during the fighting, when military commanders earned their title in action. The Santa Cruz Maya retained a strong social cohesion and a system of authority based on military defense and religious conviction, following a Precolumbian tradition that had served the Maya for millennia.

The churches in the shrine villages were usually open twenty-four hours a day, every day of the year, with guardians on duty. Each shrine village and its supporting villages worked out schedules of guard duty, with guardians performing their service for a week at a time. We came to know a cadre of churchgoers, especially leaders, who made pilgrimages to one or all of the other shrine village fiestas. They welcomed us to their fiestas and accepted us as pilgrims. After all, this was Ha'hal Dios (True God) that we were celebrating.

I was raised to believe that God could be worshipped in many different ways and I found the mazehual'ob to be honest in their worship. Charles says that he came to understand the value of religion while living with the Maya. The Maya church impressed him with its close proximity to nature and its power of ritual, and this helped him realize the importance of religious ritual to all peoples. Hilario was a spiritual man, married and immersed as he was in Maya culture, who likewise embraced its religion. He did this for no other gain than to satisfy his own spiritual needs and the universal need to be part of a larger whole, though he came to benefit by becoming known as an expert on the region, if somewhat eccentric, after nearly forty years in Yucatán.

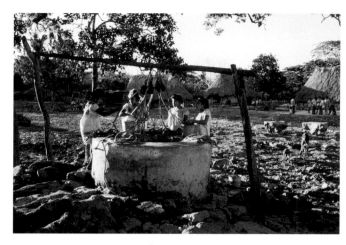

TOP: Women at the well during a fiesta. Chunpom, Quintana Roo, 1974.
BOTTOM: Men preparing the corral for bullfights during a fiesta, tossing out rocks. Chunpom, Quintana Roo, 1974.

31. Paul Sullivan discusses this in *Unfinished Conversations.* "Villa's ethnography of the Maya of central Quintana Roo was first published, in English, in 1945. Not until 1978 did a Spanish-language translation appear, and then it was distributed only from a single bookstore in Mexico City. To this day precious few copies have made it to Quintana Roo, and Mayas are only now circulating rumors of its existence. However, other recent books that include photos taken by Frances Rhoads Morley are more readily available, such as the Spanish-language edition of Nelson Reed's history of the Caste War. Few Mayas around Xcacal Guardia can actually read that book, but some of them own copies and by its photos discern that the book tells of 'ancient' leaders and their subsided war. These books are very expensive by local standards, and so Mayas conclude that the manufacture and marketing of books is far more lucrative a labor than the slash-and-burn corn farming, forest hunting and gathering, and the kinds of wage-earning employment they are limited to. These Mayas suspect they have been hoodwinked in the commerce of information, photos, and books, *their* livelihood growing ever more precarious and difficult despite having time and again cooperated with the rich foreigners who came to write about them. They suspect us of having conned them (or 'screwed them') out of their inheritances.

"Some Mayas today consider it foolhardy, even negligent toward their dependents, not to obtain proper compensation for the information they can give us. Abandoning the circuitousness of past courtly forms of dialogue, they adopt instead a salesman's rhetoric, aggrandizing the quality of their wares, casting aspersions upon the wares of competitors, and making their best pitch for a transaction to be consummated not eventually and in the collective interest of 'their people,' but here and now and in private. Talk of war, deities, history, leadership, and more, talk once offered up in expectation of an ultimate return in the form of commodities of war, has become a commodity offered in return for payment in the currency of contemporary Maya sustenance, which is to say, cash for food, medicine, and other necessities of every life." Sullivan 1989:198–199 (original emphasis).

32. In the 1950s, while researching *The Caste War of Yucatán,* Nelson Reed had visited the shrine village of Chancah Veracruz and met the village leader, who informed him of a prophecy that a North American would come to ask questions and inspect the villages. He told Reed that he couldn't shop any longer in Belize. "It is one thing to read of cults and prophecies in books, to accept the fact that they are believed by people in a remote country, to accept what is out of our own experience as we accept so much that is printed; it is another matter to find yourself playing a role in such a belief . . . I asked what sort of goods he wanted to buy in Belize. 'Carabines,' he said, and the word needed no translation." Reed 2001:346; see also Sullivan 1989.

33. See Chapter III, note 2. Mérida had the second largest CIA station in Mexico, largely dedicated to monitoring Cuba as well as Cubans in Mexico.

34. Nelson Reed (2001:265) notes that four of the Chinese workers made it all the way to Mérida, where they opened a laundry. Dumond (1997:514) writes that the Chinese, who initially had been enslaved by the Maya leaders of the time, had "graduated from the status of laborers to that of wandering peddlers who provided most of the commercial needs of the *masewalob* and had largely cornered the export pig market. Resentment of them was strong; by one account most of them lived in a small village about fifteen kilometers from Noh Cah Santa Cruz, but unlike ordinary *masewalob* they were required to pay an annual tax of two kegs of powder per person."

35. Now an old man, Paulino informed us that his village was named after him. He said that he'd settled here many years ago and during those times people often didn't give out names. People referred to him simply as "El Señor," a term of respect, and his ranch became known as "El Señor's Place" until it was shortened to "Señor." In the 1930s he'd ridiculed and opposed the schemes of the Mexican government to place schoolteachers in the mazehual villages and warned Villa Rojas that they were prepared to fight if the Mexican government interfered in their affairs. In fact,

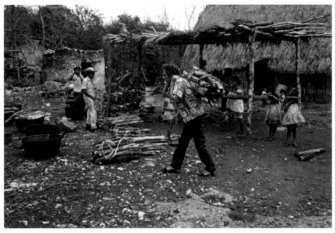

TOP: Woman at the well in front of the Maya church. Chunpom, Quintana Roo, 1988.
BOTTOM: Charles bringing in a load of firewood during a fiesta. Chunpom, Quintana Roo, 1974.

Paulino had been practicing shooting down high-flying buzzards in case the Mexican government sent airplanes. Sullivan 1989:43.

When I met Paulino in 1974, he was very talkative and outgoing. He was used to having his conversation recorded and would start right in when we appeared. He'd had a lifetime of talking with foreigners. Paulino began talking with Villa Rojas and Morley in the 1930s and then with assorted agents and dignitaries in Belize. He mentioned that Allan Burns, an anthropologist from the University of Washington, had recently lived next door to him. Allan had very rapidly learned to speak Mayan, Paulino said, and had promised and delivered wonderful photographs, some of which he proudly showed us. Years later Allan told me that Paulino would show up at dawn every morning with a jícara of atole. While Allan was drinking it, Paulino would look around, anxious to tell stories, and ask where the tape recorder and microphone were. His stories are featured in the wonderful book *An Epoch of Miracles: Oral Literature of the Yucatec Maya* (Burns 1983).

Allan also conversed with Marcelino. "The Maya tell me that they dream for very practical reasons: to learn things, to know what's going to happen, things like that," Allan explained. "It is all very straightforward and not thought of as 'mystical' or anything. I'd met Marcelino a couple of times and then out of the blue he showed up at my house. I was living next door to Paulino. We sat around and talked for a while. Finally I asked him why he was in Señor. 'Well,' he said, 'I dreamt that you wanted to ask me something last night, so I came by to hear what it was.' I was pretty shocked because just the day before I'd mentioned to a friend that I wanted to record some mayapax! So I told Marcelino that I wanted to record his violin playing, and he said 'yes.' A few days later I went to Tixcacal Guardia to record him."

Allan told me that his Maya neighbors, following the events of the Vietnam War, suggested to him that the United States should support them in their struggle against Mexico rather than support the South Vietnamese, because the Maya would be much better allies. One day a Maya elder, a respected leader in his village, took Allan out to his milpa to a shed where he stored his corn. He started excavating the floor until he found an oilcloth. The man carefully worked around it until he could pull it out and unwrap it. As the cloth fell away, Allan saw that he had buried an ancient muzzle-loading rifle. "The man had cataracts and could hardly see," Allan said, "and when he started waving the rifle around, I could only think, 'What if it was loaded?' I pushed the muzzle away so that it wasn't pointed toward me and he sighted along the barrel, mentioning how good it would be to shoot some of the damn Mexicans again."

36. Paulino was part of a delegation of Santa Cruz Maya that traveled to Belize in 1957 to meet Princess Margaret, "reiterating to her their unbreakable loyalty, since she was 'the sister of Her Majesty.'" Sullivan 1989:232.

37. See Juárez 2002.

38. When Miguel Alemán, president of Mexico from 1946 to 1952, died in 1983, his obituary in *Time* magazine commented that his presidency was noted for its corruption and the millions he'd made from his landholdings in Acapulco. He was Mexico's first president to see the potential in developing a tourism resort, especially after he and his cronies had bought up the land. He turned a sleepy port into a playground for the jet set and in the process became fabulously wealthy. After his presidency he continued to funnel money into Acapulco as head of Mexico's department of tourism. "Alemán thus left an enduring model: tourism as a vehicle for personal wealth, political payoffs, kickbacks and related forms of corruption." Saragoza 2004:40.

Luis Echeverría, president of Mexico from 1970 to 1976, followed by developing Cancún and set new parameters. Coincidentally a lot of the land around Cancún ended up in his wife's name. A friend of ours from Mérida, a working-class mechanic who was hired in the 1970s to install air-conditioning systems in some of the first exclusive homes built along the coast, put it succinctly: "The bankers and politicians flew over in their private planes, divvying up the coast among themselves—'this piece for you, this piece for me.'"

It was one thing to steal the land from the Maya. It was another to

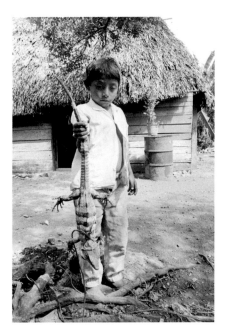

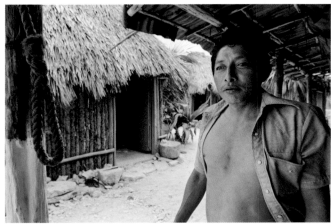

TOP: Pablo's son Fidel with his iguana. Tulum, Quintana Roo, 1971.
BOTTOM: Fidel at Rancho Dzibaktun. Tulum, Quintana Roo, 2001.

appropriate it from the landowners of Mérida, Cozumel, and Mexico City. When Quintana Roo became a state in 1974, the government told all of the landowners that they'd have to legitimize their titles to their land. They said it was merely a formality associated with changing from a federal territory to a state. The landowners wouldn't lose their land, but the new state government needed to assess their property and would charge a token fee. Upon paying the fee the landowners would get their new deed immediately.

One property owner I met told me that his token fee amounted to a million dollars. He was able to bring the fee down to $250,000, but it took fourteen years to get his new deed to his property. Pablo Bush Romero, a businessman and explorer, founded Akumal originally as a base for exploring underwater wrecks along the Caribbean coast. It later became a hotel and dive center and then a resort community. He owned seventeen kilometers of beachfront land along the Caribbean coast that included Akumal, Xelha, and Chemuyil. As a businessman who understood what the government was doing, he didn't even try to come up with the supposed token fee. Instead he traded two-thirds of his property for a deed. As an environmentally conscious sportsman, he tried to make sure that some of the best land was put into a land trust so that it would be protected and preserved for eternity. Eternity has a short life span when an administration can change any law. Land deeded to the government for conservation often becomes a pot for all of them to steal from until it is empty. "I promised to love you forever," sings bluesman Robert Cray; "it's just forever ran out of time" ("Far Away," in *Shoulda Been Home*).

Then the taxes started—sooner or later, everyone I met in Quintana Roo complained about taxes, whether they were Maya living in a traditional guano-roofed house or hotel owners on the Riviera Maya. They were all feeling the burden. There were property taxes, a maritime tax for those who owned land along the coast, and other taxes that no one had heard of before.

"I can't believe that they can give you these bills with a straight face," an acquaintance in Tulum told me in 2001. "I just received a tax that I'd never heard of, that shouldn't even exist, for $600,000. A few years ago I would have wet my pants if I'd gotten this bill. I would have been scared if they'd asked for $5,000 because I might have been able to pay that. But once you get up into the hundreds of thousands of dollars, it's laughable. It is so ridiculous I can't take it seriously. It's more than the property is worth."

A hotel owner along the Riviera Maya told me that in 2004 the government increased coastal property tax by 1,000 percent. "Even if our business is wildly successful we will never be able to pay this. It would bankrupt us within a few years. The tax reflects the maximum amount of hotel rooms that could be put on the property regardless of design, landscaping, and any thought of esthetics or ecology. They want to tax the mangrove swamp we set aside as if it was beachfront property. We were saving this land for ecological reasons, but we are being taxed as if it has rooms on it. It is crazy. Their greed will ruin this coast. They are asking us to abandon all our environmental policies." He added: "And this will continue until we have laws that everyone respects and that won't change with each new administration. In the meantime we are fighting the new taxes. They have to realize that it's not good business if they tax us out of business." He shook his head. "The best friend of corruption is regulation."

39. Francisco Rosado May explained to me that Quintana Roo passed legislation that recognized the local judges (*jueces tradicionales*), who make sure that the law is obeyed in the local communities. It is the most advanced law in Mexico. The ruling of a juez tradicional has the same weight as any other ruling. This is the only state where this is true, written by law. However, it hasn't been exercised enough for people to feel more empowered. Technically they even have the authority to arrest the state governor if they feel that they need to. Or they could fight the land takeovers. Even though the law says that they have the power, the Maya lack the confidence and money to pursue justice.

40. Eugene Anderson and Felix Medina Tzuc state that until recently

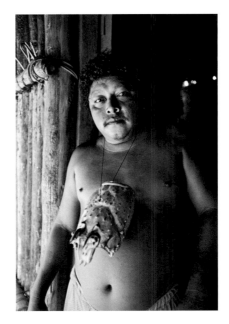

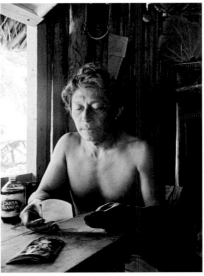

TOP: Pablo's son Ricardo, a fisherman, with a lobster carapace around his neck. Tulum, Quintana Roo, 2004.
BOTTOM: Pablo at Rancho Dzibaktun, looking at photographs that I brought him. Tulum, Quintana Roo, 1980.

Quintana Roo was a hunter's paradise and suggest that the agricultural practices of the Maya contributed to the abundance of game. They quote Gabriel Salazar, an early Spanish visitor to Yucatán, describing "an infinite number of game in all the land." Anderson and Medina Tzuc 2005:8, 63.

41. I was curious why Tulum's cross had returned from Tixcacal Guardia after so many years. Pablo suggested that I talk with Juan Ek, its guardian. He was an elderly man who occasionally rambled when he talked. "Before, the Cross used to speak, but not anymore. Still, the Cross and God are related. It's like when you have a problem. First you go to the mayor, who might refer you to Carrillo Puerto, and then to the governor in Chetumal, and then maybe to the president of the Republic of Mexico in Mexico City. The Cross serves the same purpose. To talk to God you need to ask the Cross."

Juan knew about the governor and president and the chain of command. He had been part of a twenty-two-member delegation of mazehual'ob invited to Mexico City to meet President Miguel de la Madrid. He told us that they'd been bussed to the capital, where they stayed just long enough to be photographed with the president and local party leaders from Quintana Roo. Juan and the other mazehual leaders were appalled when they were asked to pay for a copy of the photo. Then they were placed on another bus for the twenty-four-hour nonstop ride back to their villages. Although they'd had the opportunity to talk to the president, they felt that they'd been used for political propaganda.

Juan didn't mention it, but Pablo told us that Juan had brought his wife along on the trip. She was a real jungle woman who had no experience in cities, let alone the largest one in the world. She was struck and killed by a vehicle when she tried to cross a street. I could only imagine Juan's grief on the long bus ride back to his village.

Juan Ek never answered my question about why he'd brought the cross back to Tulum. It was his son, Agapito Ek Pat, the new Nohoch Tatich of Tixcacal Guardia, who told us twenty years later, when Charles and I visited him in August 2008. Juan Ek had been born in Tulum. His father, Crisanto Ek, was the guardian of Tulum's cross. When Juan's father died, Juan succeeded him as the guardian of the cross. He was still a young man, however, so he shared his duties with José Cauich of Cocoyol (a village about twenty-four kilometers north of Chunpom). Juan moved Tulum's cross to Cocoyol and married a woman there, and Agapito was born soon after. When Juan's wife died, he moved to Tixcacal Guardia to marry his second wife, bringing Tulum's cross with him. And when she died on that fateful journey to Mexico City, Juan moved back to Tulum to marry a woman there. That is how Juan brought Tulum's most holy cross home. If Juan had originally found a wife in Tulum, the cross would have come home much sooner.

42. Charles questions the idea that no one was supposed to live there and wonders whether this might have been an archaeological notion that Villa Rojas projected; the belief at the time was that the Precolumbian Maya had "ceremonial centers" where no one lived. The main proponent of this theory was Sylvanus Morley, the mentor of Villa Rojas, who was excavating at Chichén Itzá.

43. Villa Rojas 1945:43.

44. "It's also for the children to sit on," Francisco Rosado May told me, "so the children are aware that there is this God, that there is this power, that there is something to respect, and so that they are comfortable while learning the traditions of the church."

Villa Rojas (1945:128) suggests that a chair could be a literal sacred symbol of divinity representing the Holy Seat or "Seat of the Lord," on which God is seated in heaven.

45. Years later Francisco Rosado May, whose compadre was head of the church in Chancah, provided another answer. "I've come to the conclusion," he explained, "that the Maya adopted the cross because they were already familiar with the symbol. But they wanted to keep their own beliefs too and put their own imprint on the religion while appearing to embrace it.

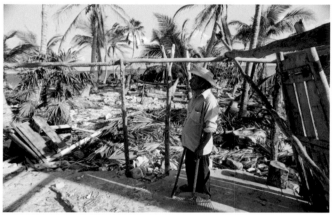

TOP: Roman Catholic church after Hurricane Gilbert. Tulum, Quintana Roo, 1988.
BOTTOM: Pablo cleaning up after Hurricane Gilbert at Rancho Dzibaktun. Tulum, Quintana Roo, 1988.

I realized this one day when one of the sacerdotes in Tulum said to me, 'Today is the day of San Sebastián, so we dress the cross like this. Next week will be the next saint's day, and we'll dress the cross that way.' And I understood that the design of the embroidery had a special meaning—it meant for them which saint they were celebrating."

"So they weren't putting figures on the altar?" I asked.

"The original Maya church had only the cross. No saints. No virgins."

"So the cross stood for everything, and the vestments denoted the special days?"

"Exactly," Francisco replied. "A term for cross in Maya is *Ki'ichelem Yum*, and one way to translate this would be that you have compassion for something so fragile, a delicate god. It's always a baby, and for many of them the baby Jesus Christ is also the cross. It's not the adult Jesus Christ. You never see a cross with Jesus crucified on it in a Maya church [at the time of my conversation with Francisco, the Maya of Chancah Veracruz had already removed the crucifix from the church, which had been a gift from the government]. No, just the cross and the huipil [sudario] on it."

"I think that there was a constant internal dilemma," Francisco said. "'I am a Maya, I'm conscious of my origin, but I have this overwhelming religion on top of me now. And I'm wondering if this foreign religion is more powerful than my own gods. How can I solve this contradiction? I adopt it, but I don't show everything.'"

"So only the initiated understood the embroidery designs?"

"Yes. Now over the years powerful people in the community have commissioned special huipiles for the cross to show their patronage, but those huipiles are never used for traditional days of the cross."

46. In the early 1990s builders started work on a large walled compound on the beach a few miles south of the ruins at Tulum. The owner was influential enough to reroute the sandy coastal road running south to Sian Ka'an and Boca Paila around the property. Power lines were brought through the jungle to the property, without offering service to any neighbors, even though the poles and wires crossed everyone's property. The word was that an ex-president of Mexico was the owner. When people searched the records they found that the title of the house was in the name of Adriana Salinas de Gortari, the sister of the president. Casa Magna had a heliport, underground rooms, and windows of bulletproof glass. The owner turned out to be Pablo Escobar, the Colombian drug lord. Work stopped on Escobar's house when he was killed.

Two years later, in October 1995, Hurricane Roxanne hit the coast of Yucatán and knocked down the power lines, leaving them sparking and dangerously snaking across the ground. Local authorities in Tulum called the Federal Electricity Commission and told it to clean up the mess before someone was electrocuted. The commission replied that it didn't have any lines there. The seven kilometers of towers and high-tension lines didn't exist. The director invited anyone to look at his maps, which clearly showed that they didn't exist. Seven years later the phantom posts and line still remained. It was amazing that something that didn't exist could be so unsightly. Following Escobar's death, Casa Magna was put up for sale and Mexican soldiers guarded it and patrolled the beach in front. In 2005 Amansala Eco Chic Resort finished renovating it and brought in Tibetan monk Palden Gyatso to spiritually cleanse and bless the house. You could rent it (including meals, housekeepers, private chef, groundskeeper, and concierge service, for up to sixteen guests), starting at only $26,000 a week (plus tax and gratuities), depending on the season. It had become a very hip place for weddings, especially among New Yorkers. In 2011, Casa Magna was again for sale for only $17 million.

Consider this rumor. President Salinas de Gortari needed an international loan for Mexico during the economic crisis in the early 1990s. International inspectors were about to arrive, and the government banks didn't have enough money to secure the loan. Mexico needed to show that its banks were solvent, but the wealthy Mexicans who could have sustained the system had their money in overseas accounts—they had lost so much

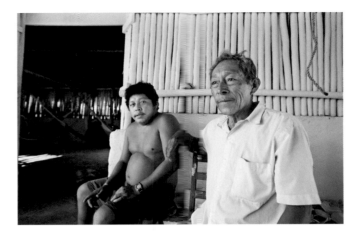

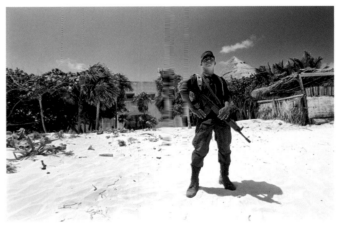

TOP: Pablo and his son Ricardo on guard duty at the Maya church. Tulum, Quintana Roo, 2001.

BOTTOM: Soldier guarding the house on the beach built by Colombian drug lord Pablo Escobar. Tulum, Quintana Roo, 2001.

when Mexico devalued its currency in the 1980s that they weren't going to let that happen again. Salinas called the major drug-trafficker families and said to them, in effect: deposit your money and I won't touch you. The drug traffickers deposited billions, Mexico got its loan, and Salinas kept his promise. Whether or not this story is true, many Mexicans believe it. It didn't help that Salinas left office amid a growing scandal that involved his brother and close colleagues and the drug cartels and their increasing influence over the Mexican government.

It is hard not to be cynical. In the late twentieth century Mexico set aside several nature reserves that are conveniently near a frontier: Sian Ka'an in Quintana Roo, along the Caribbean; El Cielo Biosphere Reserve, in Tamaulipas near Texas on the Gulf side; and Reserva de Biosfera El Vizcaíno in Baja California, near California and Arizona (the largest reserve in the world, with more than six million acres of uninhabited islands, deserts, and forest).

There are persistent rumors that drug runners use these ecological preserves for drops. The locals in Sian Ka'an joked that the government was using the area as a bombing range, because the drug traffickers were dropping packages of marijuana and cocaine from the sky almost daily. The reserves were perfect places for illegal activities because few people lived there and the public perception was that the government provided protection and security. The locals were naturally curious and observant, especially when they found bales of marijuana and packages of cocaine floating up on the beach or hanging from trees in the mangroves.

The Maya were beachcombers long before roads and tourists, sometimes coming from inland villages to collect what had drifted in. Pablo told us that one time he discovered a huge canoe washed up after a hurricane. It was carved from a single tree trunk, large enough for twelve people to paddle. Pablo imagined that it was similar to a Precolumbian Maya canoe. He wondered if it came from Belize or Honduras, or even Nicaragua, but he didn't know. Pablo rigged a sail and utilized it in his daily work. He fished from his canoe. He sailed it down to Boca Paila, transporting the workers hired to chop the weeds at the coconut plantation. Used to walking on foot, Pablo was suddenly a sea captain. He proudly told us that he'd even taken his mother-in-law and family on a trip. His seafaring days ended when he beached one day at Kapechen, in what is now the Sian Ka'an Biosphere, and someone stole the canoe while he was off working.

When Pablo told this to younger people in Tulum, they didn't believe him. Times had changed so much that it was a story from another era. Today they find cigarette boats, the sleek powerful racing boats favored by smugglers, abandoned on the beach or intentionally sunk in the shallows offshore by Colombian drug runners. The Colombians make such huge profits that ditching an expensive boat is just one of the costs of doing business. Tourists on the beaches of Tulum were surprised to see a half-submerged boat float by on the current. The crew members had botched scuttling it after making their drop, and the trapped air kept it bobbing along the surface.

In November 2001 I followed newspaper coverage of five Colombians stopped offshore by the Mexican navy when they discovered 1,500 kilos of cocaine on their ship. The Colombians were arrested and jailed in Cozumel. Almost immediately a prominent lawyer came from Chetumal to represent them. Within a few days a judge ruled that the Colombians could be prosecuted for possession but that there was no proof of intent to sell—the 1,500 kilos of cocaine could have been for their personal consumption. A few days later I read that the Colombians weren't even charged with possession—they were simply deported for violating immigration laws. I wondered what Dario thought of this. He'd spent five and a half years in prison on trumped-up charges to please U.S. law enforcement officers. It is no wonder that the Mexicans are so cynical about their police, judges, and politicians.

47. Charles and I visited Moisés Chim Hoyil, the new Maya priest in Tulum. He showed us a publication from Carrillo Puerto written primarily by Maya for Maya that used "Cruzob" as a designation for themselves.

TOP: Government sign in front of the Maya church. Tulum, Quintana Roo, 2004.
BOTTOM: Government sign in front of the Maya church. Chunpom, Quintana Roo, 2004.

48. Eugene Anderson (Anderson et al. 2005:4) observed a number of projects while doing his research in Chunhuhub near Carrillo Puerto. He found that many schemes were genuinely good and valuable but "absurdly wrong for the situation . . . I have often said that for every bad thing done by bad people being bad, there are a hundred bad things done by good people being stupid." He found one program "so ill-advised as to border on the insane" (Anderson et al. 2005:68).

Anderson (Anderson et al. 2005:209–211) believes the biggest problem is lack of accountability. No one suffers the consequence for devising and implementing bad plans, and none of the planners have to prove that their scheme will actually work. "They [Maya] know that many a plan is merely an election-year device, and many another is well intentioned but quite irrelevant to reality . . . One realizes that bad planning, bad execution, bad English teaching, bad marketing, and many other small-scale local bads are the ways that the systemic flaws in the world economy translate to the local level."

49. Tulum, Chunpom, and Tixcacal Guardia had constructed permanent corrals for the bullfights held during the fiestas (rather than constructing an impermanent one each year). When Nikolai Grube showed Linda Schele a diagram of the center of Tixcacal Guardia (after the addition of the corral), "they both realized that it reproduced in detail the pattern of the East Court at Copan. There Temple 22 and Structure 22a, the Yax-Hal-Witz and the Popol Nah, correspond to the Iglesia at Tixkakal with its sanctuary holding the Talking Cross and the sacred books, and the Tixkakal Council House. In front of the building at Copan sat a huge dance platform and a sunken court marked as a false ballcourt where sacrifice took place. A large dance platform also sits in front of the Iglesia and the Popol Nah at Tixkakal. The Ballcourt at Copan has its counterpart in the bullring, for although the game has changed, the purpose and the end result—sacrifice for the sanctification of ritual—is the same." Freidel, Schele, and Parker 1993:168.

50. "Who knows how things are going to go for don Marcelino," Pablo told us. "He wants a change of governors because he doesn't like the current governor, Joaquín Hendricks. So now Hendricks is going around Marcelino, telling the Tixcacaleños that he's going to help them. They're crazy to believe him, those guys." He shook his head. "Don't they remember that everybody says they are going to help us when they are campaigning? 'We are going to help you, we are going to help you.' So you'd think we'd get some help, wouldn't you?

"Now Marcelino is really sick and is going to die soon. But let me tell you what he told me. The politicians invited him to Cancún and also to Chetumal. When he was in Cancún, the mayor told him, 'You're sick, don't drink.' But right after that he served him cocktails. And in Chetumal the governor told him, 'You're sick, don't drink.' Then, just as in Cancún, they invited him to drink with them. It was on that trip that he got sick, the sickness that he's going to die from. When they found out how sick he was, they said, 'We told you, sir, not to drink.' They gave him a little bit of medicine, and now he is worse for it. But you know what really bothers me is that they treated him like a disobedient child. How is that? He is an elder, a mature man!"

"There were more reports and more stories about political intrigues among officers affiliated with (or formerly affiliated with) Xcacal Guardia," Paul Sullivan wrote me, "and many different explanations of their cause, including meddling by municipal and state officials. Over time, I guess, and in the process of doing research on Santa Cruz leadership struggles for my Xuxub book, I came to the conclusion that such conflicts have always been one element of how autonomous Maya rebels governed themselves. Why? Because leadership is for life—you can't just get rid of officers who grow more cantankerous with age, or who turn to advancing their own private/family interests at the expense of the larger group. Because the Maya polity is diffuse, population spread among many small communities in which each household sustains itself, all making for a certain ambivalence towards central authority, even if that authority is Maya. Because contact with outsiders (however near or far away they are) has always been potentially

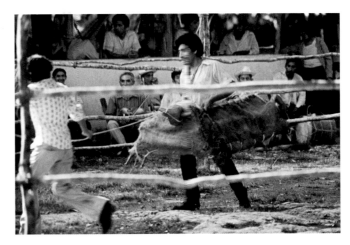

TOP: Maya bullfight during a fiesta. Tulum, Quintana Roo, 1974.
CENTER: Escaped bull running down the street during the Maya bullfight at a fiesta. Tulum, Quintana Roo, 1974.
BOTTOM: Martina Manzon Tuyub, holding a photo of herself taken in 1988. Kankabdzonot, Quintana Roo. 2011.

rewarding and yet fraught with danger—hence the perennial suspicion that someone among the leadership has sold out to outsiders. And so on and so forth."

51. This says a lot about how sustainable their system of farming is. Conventional wisdom suggests that they could only use a farm for a few years before having to start another field. You can't farm the same land unless the agroforestry system is appropriate.

52. These were the most Maya areas of the peninsula. Over and over we heard "Ha'hal Dios" (True God), "Kichkelem Yum" (Beautiful God), and "Santa Cruz." Their fiestas were a celebration of community and thanks to God for all He provides, however meager, in this poor life. Both Xocen and the sacred villages had celebrations that often lasted a week and had a kuch to arrange food, a band, fireworks, and drink each day. At Xocen you could wear shoes at the shrine, although we were told: "Our ancestors, when they prayed here, took off their shoes and crawled on their knees to the cross." At the sacred villages you had to remove your shoes or sandals before entering the church. In the early twentieth century, after the Mexican army had desecrated Noh Cah Santa Cruz Balam Nah, the Santa Cruz Maya began the custom of taking their sandals off before entering the church because the cowhide soles and the soil tracked in were a pollutant, a thing of the devil. This was the inspiration of Lt. Desiderio Kooch Huá, who assigned a punishment of twenty-five lashes for an infraction of this new rule. While drunk, Kooch himself forgot to take his sandals off and was whipped. Reed 2001:311.

A band with a trombone, trumpet, saxophone, and drum provided the music at Xocen. In the sacred villages the musicians played violins and drums, often homemade, and sometimes trumpets. At Xocen they celebrated with pieces of chicken on the altar and loaves of noh wah. At the sacred villages they used a chicken egg and noh wah. In both areas the food, after being spiritually partaken, is distributed freely to the worshippers. Xocen is still considered a holy Maya shrine center by the mazehual'ob, and both areas mix Maya and Roman Catholic ritual and have uniquely adapted the ceremonies over the last hundred and fifty years.

Other religious festivals in the north and west of Yucatán, such as at Izamal and Tizimín, attract their own pilgrims from that more Hispanicized part of the peninsula and are commercial. These fiestas are for the faithful as long as they bring along their wallets. They also attract the not so faithful who want to party and enjoy the carnival rides and dances. The beer distributors and merchants have hijacked or rather kidnapped the chi'ik. Everything costs money, from food and drink to admission to the dances. In that sense, the sacred had become secular and the Santa Cruz Maya in Quintana Roo and those in the villages responding to Xocen were certainly the most Christian.

53. "Maya *pool kaan*, 'snake-head,' with a Spanish plural! The name comes from the resemblance between the opened-up dumplings and a snake's head with mouth open." Anderson 2008:50.

54. When villagers fled San Antonio Muyil many first went to Pak Chen and then later moved to Xcan. Although the church in San Antonio Muyil had several crosses, they only brought the Speaking Cross and the two small crosses that now stand on either side of it in Nuevo Xcan. Someone had to carry them, which is why they chose the smaller ones.

Antonio Dzul, the grandson of one of the founders of the church when they moved from Xcan to Nuevo Xcan, is still alive. Nuevo Xcan family founders (those who moved the cross from Xcan to Nuevo Xcan in 1953) include Mariano Aguilar (probably related to Jorge Aguilar, who carried the cross from San Antonio to Xcan, according to Pablo), Juan Dzul, Eugenio May, and Panfilo Camaal. The first prioste was Pablito Cupul, the next was Alfredo Aguilar (nephew of Mariano), and the third was Ernesto Pumul, whose parents were also founders. The fourth prioste was someone sent by the church from Mérida to teach Juan Bautista Poot Loria his duties, and that's when Juan took over.

55. "There are those who offer sakah, but they do it alone," Juan said. "I do it my own way. I feel the cross is my intermediary. I light a candle

TOP: Agapito Ek and Martina Yam Pech. Tixcacal Guardia, Quintana Roo, 2008.
BOTTOM: Agapito Ek, the Nohoch Tata. Tixcacal Guardia, Quintana Roo, 2008.

in front of the cross before I start cutting the forest and then again after burning, when I'm ready to plant. Upon planting I invent my own prayer, all alone, on my knees, in the milpa. I ask for the favor of Chaak, and the wind gods, and the forest gods, and the gods of the animals. And any other gods that God knows. I actually say that because only God knows how many gods there are, and I put my fate in His hands. I'm simply the instrument of His work. Then I come back and light a candle before the cross. At the harvest I pay the padre for a prayer, and at the same time I buy a young chicken—not a big one—and I prepare a meal for the saints in my house. I make atole with the new corn and offer it to my saint before I eat. That is my offering and my thanks."

56. The Speaking Cross was painted green with a thin red outline along its edges and had a painted depiction of Jesus hanging on it. Beside it were two identical smaller green crosses, with a heart and a ladder painted on them. The Speaking Cross and the two smaller ones wore red crowns with the letters "INRI." All three crosses were set in three-tiered pyramidal wooden bases. The first and third levels were red, the middle one green with white floral patterns that had aged to a cream color.

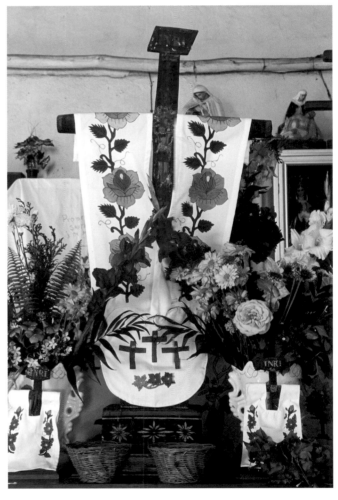

TOP: Juan Bautista Poot Loria standing next to a Maya Talking Cross in the Roman Catholic church. Nuevo Xcan, Quintana Roo, 2005.
BOTTOM: Maya Talking Cross in the Roman Catholic church. Nuevo Xcan, Quintana Roo, 2005.

285

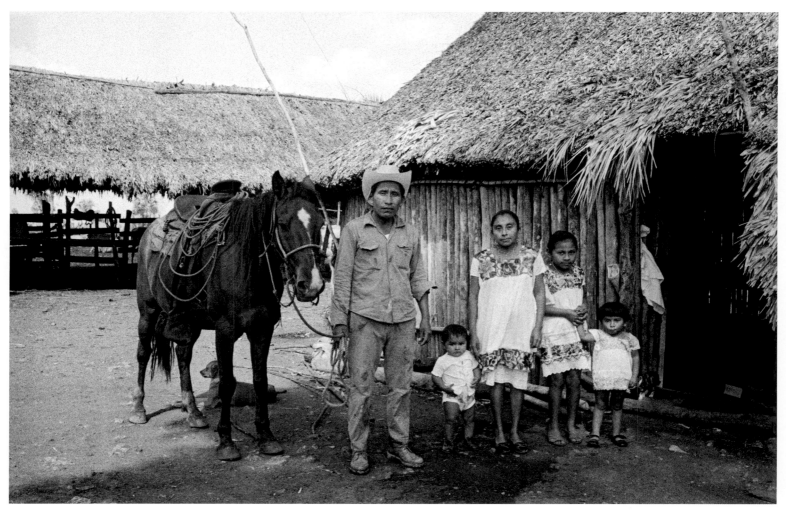

Eleuterio Noh Cen and Juliana Caamal with their children, Julián, Faustina, and Paolina. Rancho Tunkas, Yucatán, 1976.

The estancias of early and mid-colonial Yucatán were simple institutions. Stock-raising was not labor-intensive, and most ranches employed only a few permanent workers, typically a steward, called a mayoral, and a few cowboys, or vaqueros.
ROBERT W. PATCH, *Maya and Spaniard in Yucatán, 1648–1812*

VII Cowboys: Corn to Cattle to Corn

An account of Eleuterio Noh Ceh, a corn farmer who became a cowboy and then returned to corn farming, whose children abandoned farming to find work in maquiladoras, making Maidenform bras and Jordache jeans, until the manufacturers found cheaper labor elsewhere

I never thought I'd find Eleut crippled and his wife dead. Their life had seemed so idyllic. I'd met them through Manuel Solís, an acquaintance whose family owned a ranch north of Valladolid, near Tizimín. When I told him I was interested in visiting his ranch, he initially agreed to take me. He suggested that we meet at a bar to discuss the details. Manuel arrived an hour late. He apologized by boasting that he'd just gotten up after dancing until dawn with an American woman he'd met. Valladolid was celebrating its annual Feria de Candelaria. He wanted to know if I was serious about going then tried to talk me out of it. Manuel didn't really want to leave town to go to the ranch. Finally he agreed to pick me up at 5:30 the next morning.

We left the bar to go to the bullfights. It was the hour of the aficionado, when anyone could enter. You could use anything as a cape—your shirt, an apron, a towel, or a flour sack. Some men tried to ride the bull. Some pulled the bull's tail. Others acted as if they were serious bullfighters, but they had to contend with all the other amateurs. I entered the ring with my camera and ran around taking pictures. A watermelon vendor, thinking the bull was distracted, tried taking a shortcut. The crowd was delighted when the bull chased him and crumpled the man's tray with its horns.

Manuel arrived an hour late. He sat behind the wheel of a stake-bed truck loaded with supplies and ranch hands who had attended the fiesta and were now returning to the ranch. I said good morning, and they smiled when they recognized me from the bullfight the day before. I rode up in the cab, and Manuel introduced me to Eleuterio Noh Cen, the ranch foreman, and his wife, Juliana Caamal, who held their three-week-old baby in her lap. I tried talking with Eleut, but Manuel usually answered for him and pestered me to give them all English lessons so that he could converse with the American woman he'd danced with.

We drove in fog past Tizimín to the place where the pavement ended. We passed through forest and then wide-open stretches of savannas, with fewer and fewer pockets of trees. Wooden gates announced the entrance to Rancho Tunkas. Fruit trees flanked a long driveway that led to a group of thatch-roofed buildings clustered around corrals and holding pens. Orange and lemon trees grew near the houses. Once we'd unloaded the truck, Manuel said that he wanted to leave and get back to the fiesta in Valladolid. He really didn't believe I intended to stay. He told me he was sure I would regret staying and would hold him responsible. But once I hung up my hammock, he saw that I was serious and ordered Eleut to provide me with a horse and see that I ate well.

As soon as Manuel left, Eleut and I saddled up and rode along a dusty path between stretches of fenced pasture. We talked about the fiesta in Valladolid, the ranch, and how he'd become a vaquero.

"I was born in Ebtun [a village just west of Valladolid] in 1944," Eleut told me. "As I grew up, I helped my father in his milpa. Then I had my own. But after I got married, more and more cars and trucks started passing by on the highway. They disturbed my sleep. Sometimes I'd lie awake all night, unable to rest just because of the traffic. So I said to my wife, '*Querida* [darling], we can't stay here any longer. Tomorrow I will go to Valladolid to look for work.'

"'What will you do?' she asked me. 'What type of work will you seek?'

"'I don't know,' I answered her, 'but I trust God will help me.'

"The very first man I met in Valladolid was Manuel's father, don Cristóbal Solís. He asked if I knew anything about cattle. I told him no. He said that would be all right because there was other work on his ranch. He warned me that many workers had quit because they grew restless from the quiet. 'My ranch is very rustic,' he told me."

Eleut continued: "I was overjoyed to hear this. We moved here to the ranch. I cleared land and planted fields of corn, squash, and beans. Don Cristóbal noticed how hard I worked and told his ranch foreman to teach me about cattle and horses. I didn't know it, but don Cristóbal was dissatisfied with the way his foreman treated the animals. I learned quickly, and within a year he made me foreman."

"You must have worked really hard."

"I like the ranch. My only disappointment is that my two oldest sons have to live with my in-laws in Ebtun to study because there aren't any schools nearby. But they return every summer. We still have four children here with us."

Spur worn by Serbulo Ay. Chichimilá, Yucatán, 1976.

"Do you leave the ranch often?"

"Maybe once a year, sometimes twice. We always go to the fiesta in Valladolid, and we visit our families in Ebtun. But if we're away from the ranch for more than a few days, the children start crying at night." Eleut started to grin. "The noise of the village disturbs them."

As we rode, Eleut told me more about the operation. Cristóbal had started the ranch in 1961. It was sixteen square kilometers, four kilometers to a side. Eustaquio Noh, from Chemax, helped as a ranch hand, and another dozen men worked in the fields. Each year more forest was cleared. First the ranch was planted with corn, beans, and squash. After two years it was seeded with grass to provide more pasture. The ranch used the food for the workers and animals.

Cristóbal raised white Brahmas and several Swiss cows and Holsteins to supply the ranch with milk. These were born to Brahma cows through artificial insemination. Cristóbal and Eleut were always improving their cattle. They sold the two-year-old steers at the end of the rainy season when the cattle were fat and healthy. Two months earlier, in December 1975, they'd sold over 200 steers, averaging between 400 and 500 kilos each, for $0.76 a kilo in Tizimín, receiving about $70,000.

The ranch was located on the flat and salty coastal plain that stretches along the north coast of Yucatán. Although the tropics are among the most fragile and diverse ecosystems, Mexico offered subsidies to promote the conversion of such "economically unproductive" forestland to cattle production. Mexico is one of the most biodiverse countries in the world, but it has the second highest deforestation rate in the world.[1] Roughly 90 percent of Mexico's forest in the lowland humid tropics had been razed by 1970, often through programs to convert forest to grazing land.[2] This not only destroyed the habitat but also changed the weather. Much of the air's moisture, which can turn into rain, comes from the transpiration of the forest.[3]

I shifted in my hammock when I woke. It was still dark, but I tried looking through the pole walls to see any movement outside or if anyone had stoked a cooking fire. Someone switched on a transistor radio in an adjoining house. Syllables rolled smoothly off the Honduran announcer's tongue as he tried waking all Central America with his patter. He boasted 50,000 watts of *potencia* (power). As the volume went up with an advertisement, the dogs started barking and a rooster joined in. I put on my hat and dressed quickly. The announcer came back on and dedicated a fast *ritmo tropical* (tropical rhythm) to all the truck drivers who hadn't slept that night, followed by a lively Colombian cumbia. The music seemed all the louder because the ranch had been so quiet. There was no traffic, no television, no telephones, no machines, no hum or buzz from electrical lines.

When I opened the door, several pigs snorted in surprise. They scrambled away in the darkness, bouncing off each other and squealing. I met Eleut near the cattle pens. We spoke softly to our horses as we saddled them, using gunnysacks for saddle blankets. I could feel my horse react to the sounds around us. He rubbed his head against my shoulder, and I scratched around his ears and throat.

Eleut invited me for coffee, and I followed him to his house. As soon as we walked in, one of his daughters ran over and hugged his legs. Eleut scooped her up and swung her into the air. He carried her over to look at his tiny son lying asleep in a hammock. Juliana lit a candle from her cooking fire and placed it on the table. She gave me a cup of coffee and pan dulce, still fresh from a bakery in Valladolid. Juliana and I shyly exchanged good mornings, and she looked proudly at her husband. They smiled at each other in a way that made me feel as if I was intruding, so I drank my coffee and went out to the horses. I'd noticed that Juliana always seemed to be smiling when Eleut was in the room. It was easy to notice because her smile glowed: her upper front teeth were gold.

We rode out on the savanna to round up the herd. A low fog muffled our movements. It felt very private and still. We sat in our saddles, synced to the movement of our horses, riding in silence until a mist-colored Brahma cow streaked by. Our horses shied violently, but it happened so quickly that we had to ask each other if we'd seen it.

Sunrise brought light and color. The sun rose a warm yellow, diffused by the fog. A flock of parrots shrieked, flying up from treetops and circling before heading off, chattering away. We came to a large fenced pasture of low rolling hills covered with belly-high grass and palm trees. Although the ranch was sixteen kilometers from the ocean, the land was barely above sea level, and all the *aguadas* (natural watering holes) were salty. Every morning Eleut herded the cattle into corrals near the ranch houses, where windmills pumped fresh water from wells into watering troughs. We spread out to round up the cattle that were grazing in small bunches. The cattle were used to the daily roundup, and most of them started moving as soon as they saw us.

The mist burned off as we worked. We prodded a few of the slower bunches with whoops and shouts and chased them in the right direction. Eustaquio joined us with cattle he'd rounded up from another pasture. As they all lined out, we followed. It was already getting hot and humid, and 3,200 hooves raised enough dust to stick to our sweat. The magic of early morning was gone.

By 9 A.M. we had the herd in the corral and had checked the water level of the troughs. The cattle milled around, and a few fights broke out until the proper bovine order was reached. Most lay down to wait out the heat of the day, while a few nuzzled each other.

As we left the corral a loose herd of hogs ran to greet us, grunting and squealing with anticipation. They followed Eleut to a storage hut where squash was piled high within a bin. We cut the squash in halves and pulled out the stringy seeds, which Eleut would dry and plant. We threw the rest to the pigs.

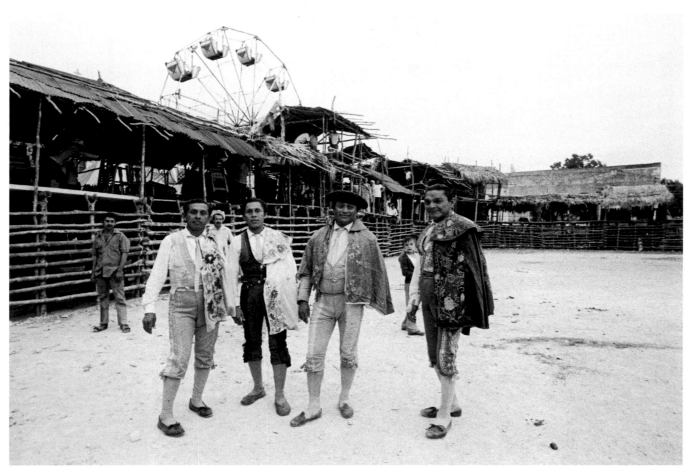

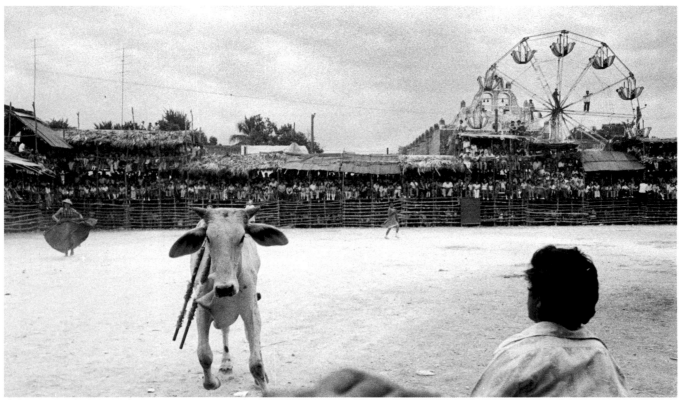

TOP: Yucatecan bullfighters in the ring before a bullfight during the Feria de Candelaria. Valladolid, Yucatán, 1976.
BOTTOM: In the bullring during the Feria de Candelaria. Valladolid, Yucatán, 1976.

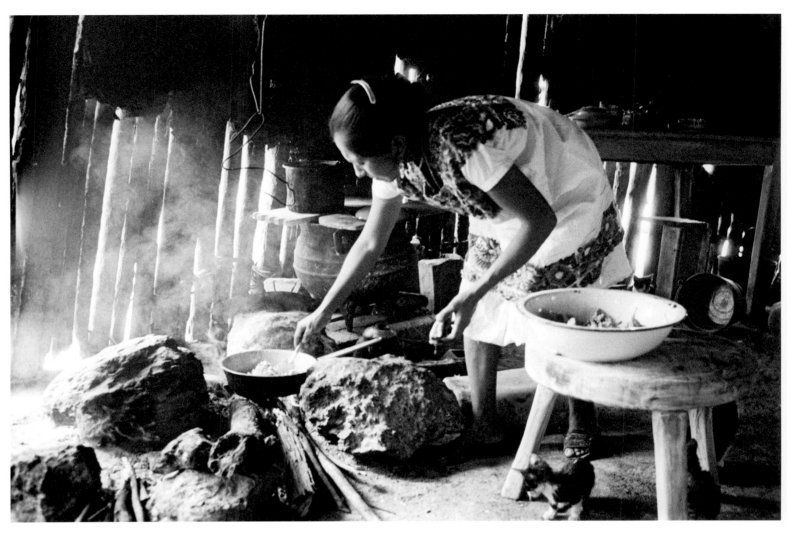

Juliana in her kitchen, with a kitten. Rancho Tunkas, Yucatán, 1976.

Eleut invited me for breakfast. Juliana was shoving soaked kernels of corn into the gas-powered corn mill in the center of their house. Chickens, turkeys, hogs, ducks, cats, dogs, and a pet Brahma calf formed a hungry circle around her, waiting for bits of corn to fall to the ground. Juliana smiled as soon as she saw Eleut and shut off the mill. Eleut shooed the animals away, and his children laughed and helped chase the chickens.

After breakfast it was time to bathe the herd in an antitick solution, a task that Eleut performed every fortnight. We soon wore a film of red dust as we put all eight hundred cattle into one corral and worked them on foot. They were shades of black, white, tan, coffee, red, sienna, umber, blue, and gray. The loose skin on their chests flapped back and forth, and their large ears looked like tropical flowers. Eleut, who wore red pants, a pink shirt, and a green baseball cap, looked like a tropical blossom himself. We broke off twenty head at a time from the herd and moved them to a pen that ended with a chute leading to a thirty-foot-long bathing trough that was six feet deep at one end and tapered up at the other. The cattle would get properly soaked before climbing out.

The herd didn't appreciate that we'd prepared a bath. The cattle bellowed and ran at us, and we'd yell at them in Mayan, Spanish, and English, waving our hands and turning them with a pole when they got too close. Most of this was bluff, but we had to climb the corral fence and start all over again when they didn't stop. The cattle seemed bewildered by the bother and noise, even though they'd done this all their lives. The steers would bellow, jump in, and hold their heads high as they swam across. After they clambered out, we kept them in a concrete pen whose floor was sloped so that the tick solution drained back into the trough. After a few minutes we turned them out to an adjoining corral.

Sometimes a calf wouldn't swim when it jumped into the bath. Eleut would quickly close off the chute so that another animal didn't jump on top, then grab the calf by the ear and pull it to the shallow end. Once it felt the bottom it would try standing up, legs buckling, shake itself like a dog, and run to join its mother.

Our work went relatively smoothly for over two hours until one angry steer didn't want to take a bath at all. He snorted, tossed his horns and head angrily, then charged us, trying to get back to the main herd. We were running toward him to close off his escape when he wheeled and crashed through the fence—the only part that was barbed wire. He left a gaping hole that the other steers could follow him through.

Eleut wasn't happy. Not only did he have to repair the fence without letting any more of the herd out, but he also had to round up the cattle that had escaped and doctor their nicks and scratches.

"Does it bother you working cattle on foot?" I asked.

"No," he answered. "I'm not afraid."

"Why aren't we using horses to do this?"

"I've never done it that way. But," he added, "maybe we should."

Eleut was typical of the Maya I'd met in that virtually all of his learning came through experience rather than from books and schooling. He was able to learn quickly what he was shown. He could make rapid transitions because he was confident and not easily awed. But he was raised a farmer, not a cowboy.

Each evening after I'd taken my bath from a bucket of hot water, I'd meet Eleut outside his house. We would smell of soap and talcum powder. Leaning back against the pole walls, we'd watch the palm trees lose their outline against the coming night. Eustaquio and the other ranch hands would drop by and join us, grabbing rough-hewn benches to sit on. We passed out cigarettes and blew smoke at the mosquitoes hanging around our heads.

This was a time for Eleut to get reports from his ranch hands and review the day's activities. Juliana was inside making tortillas for supper. I could hear her pat them flat and put them on the comal. And the scent of black beans boiling on the fire always made me hungry.

One evening Cristóbal visited the ranch and sat with us. He was deaf, so we had to yell in his ear. He told Eleut to put cement floors in the hog pens to keep them cleaner and to start feeding the hogs a special corn diet. Even as he spoke of the improvements, he stressed that he wanted the ranch to remain rustic.

"Do you like my ranch?" Cristóbal asked me.

"It's very nice," I yelled.

He smiled wistfully. "I wish my sons felt the same way. I can't get them to spend even a night here. Manuel can't bear to leave Valladolid for more than a day, unless it's to go to a bigger town. That's no good. He drinks too much. Can't you show him how wonderful this is? He respects you because you're an American."

"He thinks I'm crazy to stay out here," I shouted. "He jokes about the cold beers and the women I'm missing. If he found a girlfriend who loved country living, he might be more sympathetic to it."

"His wife likes the city too," Cristóbal said.

"Huhhh," I said, finding out for the first time that Manuel was married. He'd never mentioned or acted like it.

After Cristóbal left, one of the workers kept looking at me and finally spoke. "Is Castro really tall?" he asked.

"I think he's about my size," I told him, realizing that at six feet I was very tall compared to the Maya sitting around me, although I didn't consider myself tall.

"Huhhh," he said. He tilted his head and thought for a moment. "Well, then, he must be very fat, no?"

"Not at all," I said. "He's in good shape."

"Ahh, you mean like Charles Atlas?" another ranch hand said.

"Yes, like Charles Atlas," the first man repeated. They knew of Charles Atlas from advertisements on the back page of Mexican comic books.

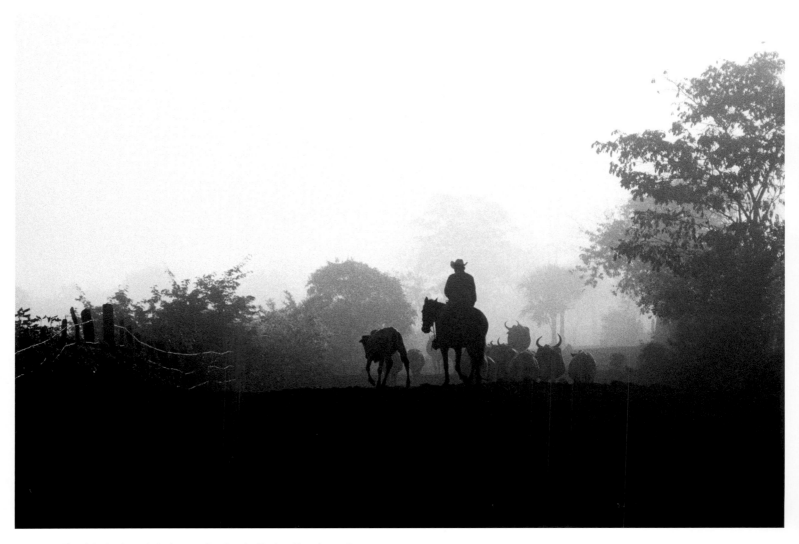

Eleut bringing in cattle in the morning. Rancho Tunkas, Yucatán, 1976.

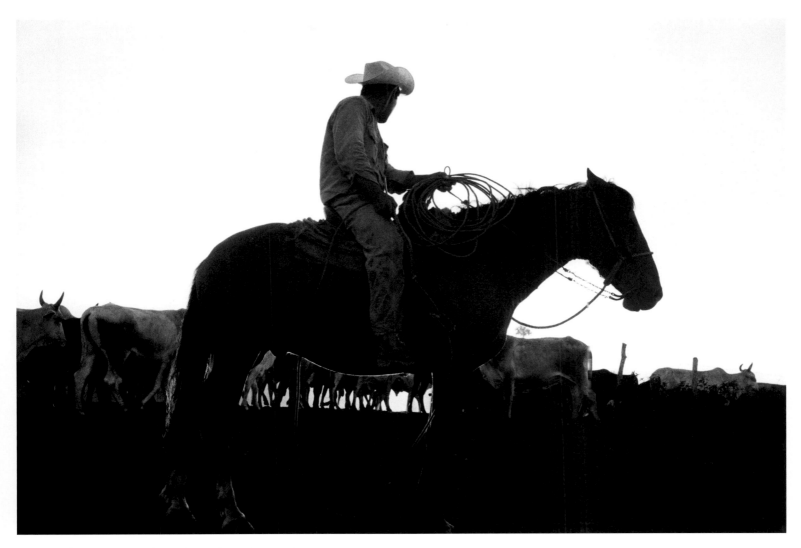

Eleut turning out cattle at night. Rancho Tunkas, Yucatán, 1976.

Eleut working cattle on foot in the corral. Rancho Tunkas, Yucatán, 1976.

"No, not really," I said. "Why do you ask? What do you want to know?"

The ranch hand puffed on a cigarette and blew out the smoke quickly.

"I was lied to," he said. "When I was in Valladolid a man told me that Castro was *el hombre más grande del mundo*—the biggest man in the world."

"Your friend meant it as a figure of speech. He must have respected him. It's an expression," I said.

"Huhhh," the ranch hand mumbled. No one said anything. They all looked away and slapped at mosquitoes. An eight-foot-tall muscled giant would've been much more interesting to talk about than some dumb figure of speech.

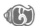

When I visited Eleut and Juliana four years later, they still seemed very happy with their rustic ranch life. Eleut had continued to improve the ranch, but very little had changed; Manuel didn't want to spend a night. I didn't see Eleut again until July 1988. I'd wanted Andy Johnson and Mary Heebner, my wife-to-be, to meet Eleut and Juliana and enjoy life on a Yucatecan cattle ranch.

When we arrived in Valladolid, I went to look for Manuel to make arrangements to visit his family's ranch. His acquaintances told me that Manuel drank as much as ever but didn't bother to pay for his drinks now that his brother was involved in politics. I also learned that his father had died.

I visited early in the evening, just after a summer rainstorm passed. When I knocked on Manuel's door I stepped on a mass of red ants, disturbed by the rain, that were swarming the sidewalk.

Manuel's wife answered and called him to the door. He didn't introduce me or invite me in, and he too stepped on the ants when he came outside. He was wearing tennis shorts and shoes. We stood in the street, slapping at the stinging ants. Truck after truck bound for Cancún rumbled by, forcing us to shout above the traffic. Manuel was my only acquaintance in Yucatán who hadn't immediately invited me into his home. He looked at me and started laughing.

"You remember the time we went to the dance in Chichimilá? You went off with your Maya compadres while I went off with that girl I'd brought and forgot to give you a ride back to town." He laughed again and hit me on the arm. "At four in the morning you had to walk all the way back to Valladolid."

I told him that I wanted to visit Eleut and Juliana. Manuel told me that Eleut had quit and returned to Ebtun. I knew he was lying when he said that Eleut had tired of the rustic living.

Although Ebtun is small, it took a while to locate Eleut. The villagers were hesitant to direct a dzul to a neighbor's home. While talking with them I found out that Juliana had died. I also found out that Eleut wasn't home. He was living on a ranch somewhere near Kaua, another village twenty kilometers to the west. But his daughter would be back tomorrow and could tell me where.

Not only did Eleut's daughter Paolina show up but also his son Mario. He was home from Cancún for the weekend, and together they offered to show us where their father was working. We bought fresh bread and soft drinks as a treat and drove to Kaua. Near the village a dirt road into the forest got worse—a lonely track that took us farther into the bush. At each fork they gave me new directions. Mary, who was just getting used to my excursions, asked where we were going.

An hour later we arrived at the ranch as fat raindrops spattered our windshield. We scrambled out and ran toward the house on top of a small hill. Eleut came to the door and broke into a big grin when he saw his children—normally they couldn't get out to the ranch on weekends.

Eleut introduced us to his mother, Esperanza, who'd come to live with him. As the storm moved on, we went outside to see the farm where he raised corn but no cattle. On another small rise were several other thatched huts with open sides and a windmill spinning in the wind. As we walked, I mentioned that I'd seen Manuel.

"What did he say?" Eleut asked.

"Nothing really. How come you quit? You and Juliana were so happy."

"I haven't worked for Manuel for three years," he said. "But I didn't quit. A horse fell on me. It crushed my foot." He shrugged.

"When my dad was hurt," Mario said, "Manuel dumped him at our home and drove away. He exploited my father for eighteen years then abandoned him. What kind of man would do that?"

"He didn't pay your medical expenses?"

"The doctors didn't think I'd walk again—I spent a year confined to my hammock. Manuel abandoned me. If it weren't for my sons finding work, I wouldn't have survived."

"They didn't give you anything?"

"Nothing," Eleut said emphatically. "When I started they had 200 cattle, and I built the herd up to 1,500 head. Same with the pastures; I increased them from two to thirty. I had fifty people working for me, and we planted 3,000 mecates of corn, beans, and squash. I never finished working until 10 P.M. at night. Don Cristóbal told me several times that he wished to give me a portion of the cattle. I was always told they would look after me."

"Did your accident happen after don Cristóbal died?"

"No, he was still alive."

"Maybe his sons didn't tell him. He was very old."

"I heard that when don Cristóbal was dying he sent for me, but his sons didn't tell me until after he died," Eleut said. "Juliana died also."

"I'm very sorry. I just found out. What happened?"

"She was sick, so I brought her a Valladolid doctor. I was taking care of her, but Manuel told me I had to go back to the ranch—he said that they couldn't get along without me. I went back because he promised to look after Juliana. But he didn't, and she died."

I was horrified. What kind of person could be so cavalier with another person's life? And then, to add insult to injury,

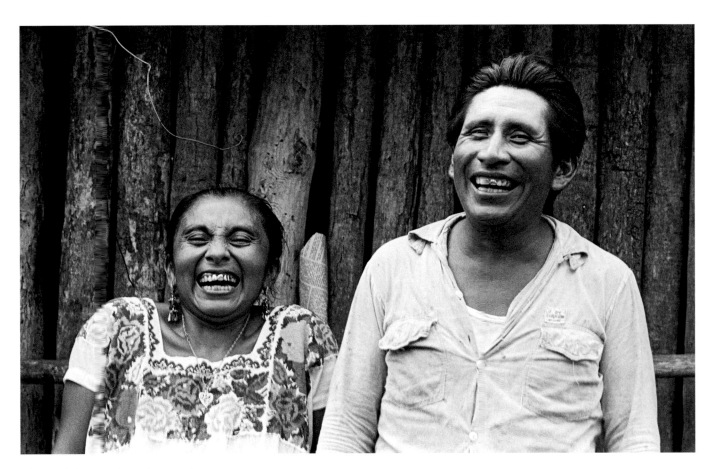

Juliana and Eleut, Rancho Tunkas, Yucatán, 1976.

fire Eleut when he got hurt? *¡Jueputa!* I finally said. "Sonofa-bitch!"

"Yes," Eleut agreed.

Once he could walk again, Eleut had found work in Can-cún, but he didn't enjoy living there. Sometimes, he said in amazement, the restaurants didn't even serve tortillas with a meal. Eleut returned to Ebtun. His uncle, who had a res-taurant in Valladolid, had just bought this ranch. Eleut began making improvements. He raised pigs, chickens, turkeys, and a large field of corn. He showed us the spotless cement-floored thatch-roofed pens where he kept his pigs.

Back at the ranch house, Eleut offered us some coconut milk from trees on the ranch. We sat near the door, watching the falling rain. It came off the roof in sheets, and the wind whipped it around before it fell to the ground.

"When I first moved here, we had a real problem," Eleut began. "A lot of the pigs and chickens died. So my uncle brought a h'men from Ebtun to perform a loh. Don Nicolás set up his altar underneath the big tree in front of the house. He brought balche' that had fermented for three days, and we bought him four bottles of *anís* [anise liquor], candles, dried chiles—everything he needed. We killed four turkeys and four chickens and my mother boiled them to make a broth. My uncle and his sons came, and we prepared an earth oven and baked the ceremonial breads.

"Don Nicolás started the ceremony about dusk. He walked around the ranch burning chiles at the crosses. He had little packages tied up and buried them at each cross."

"How many crosses are there?"

"Nine. Two for each direction, and one here at the ranch house. He poured a little anís on each cross and we drank some too. We lit candles and went around nine times. About 10 P.M. we opened the oven and made a sopa, mixing the bread, meat, and broth.

"Don Nicolás prayed at his altar and worked with a crystal ball in front of a candle. He used thirteen pieces of corn to see if the spirits and God accepted the feast. He prayed until about two in the morning. Since then we haven't had a sin-gle pig die. That was two years ago. He said this was an old ranch and we needed to perform a loh at least every five or six years."

"What about the alux'ob?" I asked Eleut, referring to the legendary little people that the Maya believe live in the for-est. "Do you have any here?"

"It's hard to say," Eleut answered, "but before you harvest and eat the products of your milpa, you need to bring some pozole for the alux'ob; otherwise when you eat your harvest, you'll get diarrhea. When a farmer has a wonderful year and harvests everything he planted, and the birds and the ani-mals don't bother his milpa, the alux'ob must have helped.

If you want the alux'ob to be your friends and protect your milpa, you make them a little altar, a small raised platform. Some farmers place little clay idols on their altars."

"And the alux'ob are always helpful?"

"No, not always. But there are ways to deal with them. Maybe you think they bring you bad luck. Or you stop farming, or you need to move—you have to do something because you can't leave an alux and you can't destroy it. So you construct some poles above its altar," he said, gesturing as if he was tying poles together. "And you use split vines to hang a large rock over the alux. The rock is big and heavy. When the vine rots, it falls and crushes the alux. And you aren't guilty because you didn't crush it yourself. It was an accident."[4]

"Huhhh," I said. "I'll have to remember that."

Rancho Bok Chen reminded me of Yucatán when I first came in 1967. There was no electricity, and the thatched houses at the ranchos we'd passed coming in didn't have locks. Some doors were not even solid but woven from jungle vine and sticks as in the old days. It was still raining when we left in the evening, but our rented Volkswagen had no problem negotiating the mud and ruts.

Mario had been polite but reserved when he offered to take me to the ranch. He opened up once he realized I wasn't going to ridicule his father. It was obvious that he enjoyed the ranch, so I asked if he planned to work there.

"No," he said. "I'm accustomed to Cancún. I get bored when I return to my village on weekends, unless my friends are around. There's nothing happening in Ebtun. In Cancún, there's always something to do. I like it."

Three months later I returned to the ranch with Charles and Hilario. Eleut told us he'd been in the ranch house with a daughter and two sons when Hurricane Gilbert struck. He was listening to the winds twist his windmill into a corkscrew when the house collapsed on top of them. He took his children and fled to a cave three hundred meters away to wait out the storm. The cave almost flooded and wasn't comfortable, but they were safe. A month later Eleut had already rebuilt his home and was able to laugh at their predicament while showing us the high-water mark in the cave. We spent an hour surveying the hurricane damage, but finally he told us that he'd lost his whole harvest.

When we gave Eleut half a million pesos ($200) of the money we'd raised for hurricane relief, I felt like the character in the TV show *The Millionaire* who went around knocking on doors and handing out money. Except everyone needed much more help than we could give.

A few years later Eleut moved back to Ebtun to farm ejido land. In 1996, twelve years after Juliana died, he married Victoria Noh Cen, a single woman he'd known for many years. She'd lived on the road to Cuncunul, which he passed every time he went to his new milpa.

Eleut's six children lived in Ebtun; several had houses on his property. One son was a mason; another was employed at the power station on the outskirts of Valladolid. His two other sons and one daughter worked at maquiladoras in Valladolid. His remaining daughter was a housewife, raising four children.

Charles and I visited Eleut in 2001. He was living in a traditional Maya house set behind his daughter's block house, with walls of closely spaced vertical poles, a thatched roof, and a raised concrete floor. Instead of hammocks, Eleut had furnished it with two plastic-covered stuffed chairs and a sofa. It was hot, and we sank into our chairs; unlike a hammock, no air flowed around our bodies.

It wasn't long before conversation turned to his milpa. Eleut said that he'd already burned and now he was waiting for the first rains to come so that he could plant his seeds. Like farmers everywhere, Eleut remembered dates and seasons. He can tell you when he planted his field two years ago, when he harvested last year, and when he will plant this coming year.

Eleut's farm was twelve kilometers away, between Cuncunul and Kaua. He had to take a bus and then walk a kilometer into what he said was the only high forest nearby. He and other local farmers were planning their Ch'a Chaak. When I asked if there was a local h'men to lead the ceremony, Eleut replied no. Alejandro Noh, the last of Ebtun's h'men'ob, had recently died. Now the h'men came from Kaua, where a few younger men were learning to be curanderos.

This was encouraging news. Too often we were seeing the culture die right around us. When we'd first come to Yucatán it seemed there were h'men'ob in every town and many Ch'a Chaak ceremonies every year. Ebtun had been famous for its many h'men'ob. But twenty years later a lot of the curanderos had passed away, and younger men weren't taking their places. Because of disappearing forested lands, the option of wage labor, and the NAFTA-driven drop in prices for corn, few Mayas were becoming farmers, and even fewer were becoming h'men'ob.

Nonetheless, Eleut and his children still grew or raised most of their own food. Eleut had an irrigated truck farm next to his house, with two cows and eight pigs. He also had a noisy flock of free-range chickens and turkeys. All of his sons had raised corn and vegetables in their milpas on ejido land, although they paid others to work it for them.

I visited Eleut seven months later while Yucatán was still feeling the effects of Hurricane Michelle. Heavy storm clouds darkened the sky, and the light was brittle. Eleut spoke in a low, pleasant voice, choosing his words carefully. I speak slowly myself, and the pace of the day slowed to our conversation. He'd just returned from his milpa. He'd lost at least half of his crop because it had not rained enough at first and then the hurricane came and brought too much rain. He also told me that he'd been sick and a doctor told him that it was

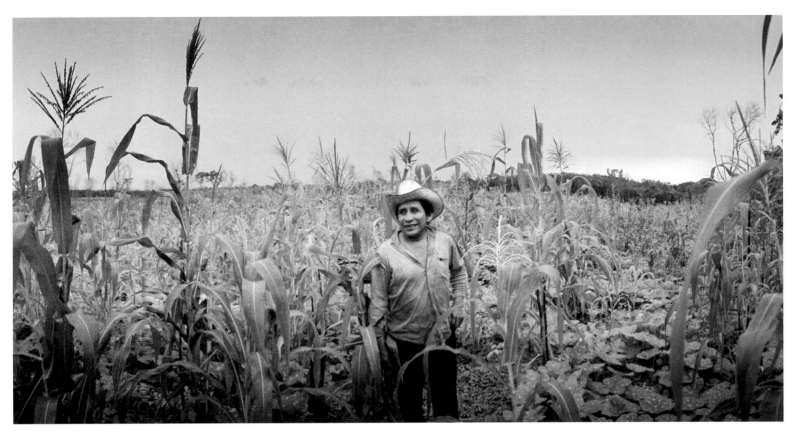

Eleut showing off his cornfield in a rainstorm one month before Hurricane Gilbert destroyed it. Rancho Bok Chen, Yucatán, 1988.

his pancreas. When I asked him if he was diabetic, he said he didn't know yet. But his illness had kept him from his milpa and made him feel unwell.

Two sons joined us. Julián had quit school to support his father when he'd been injured, but he'd just finished earning his equivalency for both his primary and secondary education while still working full-time as an assistant chemist, monitoring the cooling pumps at the electrical plant in Valladolid. His employers had encouraged him to go back to school so that he could advance.

Mario told me that he worked at a maquiladora in Valladolid and made Maidenform bras. His employer wasn't as supportive as his brother's. Mario received such a paltry salary that he couldn't save anything, although he received certain health care benefits. He and his co-workers were finding out that the maquiladoras would never pay more than minimum wage and offered no place for advancement. None of them got hired as management in the maquiladoras, because they didn't have the education and the training.

The maquiladoras depended on cheap labor, which in a global economy meant that laborers in Mexico were competing against laborers in Indonesia, China, Honduras—anyplace where labor was cheap, with sufficient infrastructure for shipping and production. World Trade Organization (WTO) agreements had spurred industry in many countries,

and manufacturing in Mexico wasn't as attractive as it once had been.[5]

One problem is that Mexicans themselves often invest abroad rather than at home. Mexico is competing with countries that put a premium on education to produce engineers, technicians, and scientists. Mexico's education system is woefully lacking, especially in rural areas. Indigenous students in particular are marginalized before they even look for work.[6] So instead of providing better education, health care, and business opportunities, the government chose to turn southern Mexico into one big sweatshop and free trade zone.[7]

It wasn't an accident that NAFTA forced 2.8 million Mexican farmers off their fields when they couldn't compete with subsidized corn and food coming from the United States.[8] That was planned by economists who wanted to establish the conditions for capital accumulation. But they failed to create the jobs when other countries offered better infrastructure and even cheaper labor, and Mexico lost four times as many farm jobs as it gained in export-manufacturing jobs. They sacrificed the farmers for nothing and destroyed a millennium of agricultural knowledge and a tradition of sustainable continuity for a one-time profit, leaving no seeds for the future.

Is it surprising that some of the farmers came to the Unit-

Eleut and Victoria at Julián's house. Ebtun, Yucatán, 2003.

ed States to look for work?[9] It is hypocritical when U.S. politicians complain about illegal immigration without taking any responsibility for it. "It's really unconscionable that there is no discussion of the American fingerprints on this," says Jeff Faux, founding president of the Economic Policy Institute and author of *The Global Class War*. "There is a lot of winking and nodding going on . . . because it's their [U.S. politicians'] business constituents that supported (NAFTA) and that are enjoying the benefits" of low-wage immigrant labor. Pamela Starr, a Latin American analyst for Eurasia Group, suggests that it is time for the United States "to get real" with its trade and immigration policies toward Mexico and that it is disingenuous and unfair for the United States to protect its own agribusiness farmers with fat subsidies while demanding that small Mexican growers compete with them head-to-head. "An essential part of any migration program designed to reduce the flow (of illegal immigrants) needs to have U.S. efforts to help Mexico develop its own economy. The U.S. has two options. It can import Mexican goods or it can import Mexican workers."[10]

One way to stop the influx of undocumented immigrants would be to provide training and business loans to villagers without the need for collateral. Most Mexicans are excluded from bank loans because they lack collateral and can't afford annual interest rates that can top 70 percent. For many, a pawnshop is the only alternative. Mexico's middle class is also woefully underfunded, guaranteeing that too few jobs are generated within Mexico.[11]

Mexico's business and political leaders have failed to create jobs, failed to modernize, and failed to reform a system that benefits the rich and penalizes the poor. The result, according to Denise Dresser, a professor at the Instituto Tecnológico Autónomo de México, is "an economy that doesn't grow enough, a business elite that doesn't compete enough,

an economic model that concentrates wealth and doesn't redistribute enough of it and 50 million Mexicans living on less than $4 a day."[12]

When Hurricane Isadora destroyed Eleut's harvest in September 2002, it left him and his wife with nothing to show for a season of hard work. Eleut had to resort to cutting and selling firewood every day to survive, even though his kids pitched in to help. The government provided little relief—its response was to give away out-of-date cans of food. Eleut was resigned to the way in which the government treated the Maya. He'd learned that there was no safety net for poor people.

Charles and I visited Eleut several months later. He was out cutting firewood, so his son Julián invited us next door. He'd saved his money and built a house of cement block. He'd plastered it both inside and out and painted it and was justifiably proud of what he'd accomplished. As soon as we sat down, he went to his fridge and offered us cold fruit juice. He told us he was still working with the electric company and that he had a good salary and a good contract with health services.

"We have a health clinic here in Ebtun, and the union makes sure we get excellent care—the level of service they provide depends on who you know. If they consider you important, you'll get X-rays, good diagnosis, and medicines. If they think that you are just a poor person, you'll get some pills and be told to come back in fifteen days."

Julián wiped the sweat from his face and offered to refill our glasses. "Have you noticed because of global warming the weather patterns are changing? Before, it was easier being a farmer. We knew when to burn, when to plant, when the rains should come. But now the uncertainty of predicting the weather is discouraging. I feel very lucky to have found a job that pays regularly, and because of that the hurricane didn't hurt me as it did my father.

"I'm one of about twenty younger men in Ebtun still with a milpa, but all of us contract someone else to do the work.[13] I'm lucky that my dad supervises the work in my milpa—since he's already out there, he can check on mine too. A lot of our neighbors still raise animals and gardens as we do. We can sell tomatoes, herbs, radishes, and lettuce—anything that can be irrigated. Because of that we're already eating food planted after the hurricane. I think one thing that defines being Maya is living from what the earth gives. We have our Maya diet, and it doesn't include processed or canned food. We prepare our food. Between our farms, the maquiladoras, and other work our village is doing okay."

But a few years later two of the three maquiladoras in Valladolid relocated abroad and left 1,600 employees without work. A few of Julián's neighbors had found work locally or were still looking, but many ended up working in Cancún or along the Riviera Maya as maids, kitchen staff, waiters, bellboys, gardeners, and the like. The hotels were sending their

Eleut and Victoria with their extended family: Elsie Noh, María Angelita Noh holding her daughter Claudia Paolo, Julián Noh (Eleut's brother), Esperanza Cen (Eleut's mother), Eleut, Julián Noh Caamal (Eleut's son), Victoria, Demetrio Un Un, and Faustina Noh Caamal. Ebtun, Yucatán, 2005.

own proprietary buses every day deep into the heart of Yucatán, transporting villagers to and from the Caribbean coast. It was quite a commute. They would typically awaken in their villages at 3 A.M., catch a bus at 4:15 A.M., ride for two and a half hours, work from 7 A.M. to 4 P.M., then ride two and a half hours back home to eat and sleep and see their family. They repeated this six days a week and didn't get paid for their commute. Usually both parents had to work to support a family.

This was life circa 2008 in a former community of Maya farmers. Julián believed that only 10 percent of the men in Ebtun now worked milpas, down from 80 percent in just one generation. In a year such as 2008, when the rains didn't come and the sun withered the crops in the fields, villagers considered themselves lucky if they had another job.

But changing from being milperos to becoming salaried workers had its own problems. Villagers were learning that the tourism industry could be just as affected by weather and events. When the price of oil rose in 2008, so did the cost of air travel. Tourism dropped off, and hotel occupancy fell. The drug wars and violence in Mexico also affected tourism. Yucatán had been considered safe, but then the Gulf Cartel assassinated the police chief of Playa del Carmen right in front of his house in broad daylight and twelve mutilated and decapitated bodies were dumped outside of Mérida in the same month. And if that wasn't bad enough, everyone knew that it was just a matter of time before the next big hurricane smacked the peninsula, damaging the hotels and restaurants built too close to the water and putting hundreds of thousands out of work.

NOTES

1. Anderson et al. 2005: 12.

2. Rzedowski 1978.

3. "Because of the high leaf area of the forest, transpiration rates can exceed the rates of water loss from open pans. As one moves inland, greater amounts of water in the atmosphere continue to come from vegetation, not from the ocean . . . This process has clearly been demonstrated in the Amazon basin. This is also apparent in weather satellite images and in precipitation patterns in the Yucatán." Allen and Rincón 2003:22.

4. Paul Sullivan told me that "Yucatec Mayan, in addition to having the familiar 'voices' we call 'active' (John hit Bill) and 'passive' (Bill was hit by John), has a third voice sometimes called 'middle,' sometimes called 'antipassive' (Bill came to be hit). Both active and passive voices invoke or imply the existence of an agent. Antipassive voice in Maya denies the existence of an agent. Stuff just happens. So by simply altering the verb form for 'break' you could say in Mayan: He broke the alux. Or: The alux was broken (by someone). Or: The alux came to be in a broken state (because that's just what these things do over time)."

5. When worldwide textile quotas ended in 2005, many countries in Latin America lost jobs to countries in Asia because they offered better infrastructure as well as a large supply of cheap labor. Mexico's inability to improve its infrastructure, to a large degree the fault of the PRI political party that ran the country inefficiently and used people's poverty and vulnerability for its own political benefit, will cause the loss of a lot of jobs. It is ironic that it was Mexico that lobbied the WTO to do away with the quota system, thinking that it could get even more work. Iritani and Dickerson 2005.

6. The World Bank, in its report "Indigenous Peoples, Poverty and Human Development in Latin America: 1994–2004," found that the incidence of extreme poverty in 2002 was 4.5 times higher in predominantly indigenous municipalities than in nonindigenous municipalities, up from a ratio of 3.7 times a decade earlier (http://go.worldbank.org/IY5XAU9800).

7. Vicente Fox, the Coca-Cola executive turned president of Mexico, promoted a plan in conjunction with the Inter-American Development Bank to deal with the poverty from Mexico all the way south to Panama. Plan Puebla-Panama (PPP) would essentially turn the area into a massive free trade zone, leaving indigenous people to work in maquiladoras with no hope of ever bettering themselves or earning adequate wages.

8. Dickerson 2006.

9. Thousands of young men in Yucatán went to the United States illegally. An estimated 60,000 Yucatecans crossed in 2003. They sent home $52 million—a pittance of the $24 billion in remittance to all of Mexico. Many Yucatecans make less than $2,000 a year.

10. Dickerson 2006.

11. The classic example of how microcredit works is the Grameen Bank in Bangladesh. Begun as a research project in 1976 by Professor Muhammad Yunus, the bank has had tremendous success with poor villagers who had been kept outside the normal business and banking circles because they were considered too poor. Yunus felt that if he could extend microcredit on terms and conditions that were appropriate and reasonable, "these millions of small people with their millions of small pursuits can add up to create the biggest development wonder" (www.grameen-info.org). By July 2004 the Grameen Bank had 3.7 million borrowers (96 percent women) and had been studied and documented by many, including the World Bank. In 2006 Yunus won the Nobel Peace Prize for his pioneering work. Today other programs, primarily run by NGOs (nongovernmental organizations), are based on the successful model of the Grameen Bank.

Pro Mujer, based in the United States, helps some of Latin America's poorest women through micro-lending, business training, and health-care support. It typically lends $150, and its success is reflected in a default rate on the loans of only 1.1 percent. Another example is FINCA (Foundation for

TOP: Eleut with his son Mario, nephew José, and daughter Paolina. Rancho Bok Chen, Yucatán, 1988.
BOTTOM: Tick bath. Rancho Tunkas, Yucatán, 1976.

International Community Assistance), which has over 64,000 clients borrowing from it in Mexico.

12. Dresser 2006.

13. Julián told me they were able to hire someone because of Procampo (Program for Direct Assistance in Agriculture). At the onset of NAFTA, the government created a program to assist farmers who wouldn't be able to compete with U.S. and Canadian exports. Farmers were paid approximately $67 (U.S.) per hectare that they planted. Out of the 112 farmers in Ebtun, 105 had signed up for Procampo. The payment covers the cost of clearing the land. The rest of the work is on their own. But Julián admitted that even with the subsidy it didn't pay to be a farmer and predicted that fewer and fewer would do it.

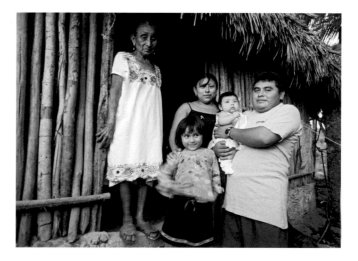

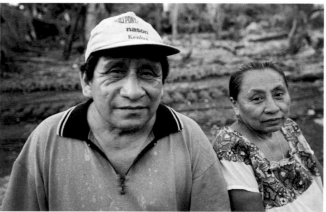

TOP: Julián with his grandmother, wife, and family. Ebtun, Yucatán, 2003.
BOTTOM: Eleut and Victoria. Ebtun, Yucatán, 2003.

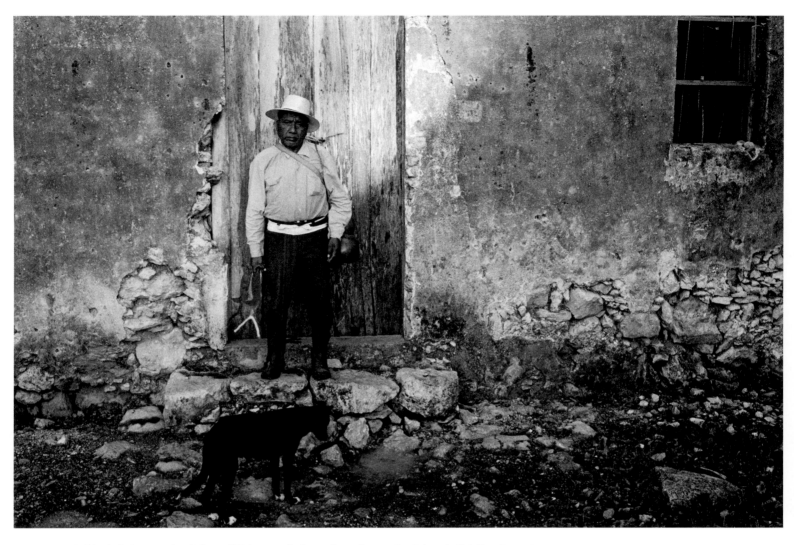

Jesús (Chucho) López Martínez in front of his house as he leaves for work at sunrise. Ruinas de Aké, Yucatán, 1976.

All the state is for henequen, and outside of it is nothing.
SERAPIO BAQUEIRO, 1881

It is said that our indigenous ancestors, Mayas and Aztecs, made human sacrifices to their gods. It occurs to me to ask: How many humans have been sacrificed to the gods of Capital in the last five hundred years?
RIGOBERTA MENCHÚ, Maya Nobel Peace Prize winner, 1992

VIII Henequen: The Dangers of a Monoculture

An account of Jesús López Martínez, a henequen worker, and the henequen industry, which failed to remain competitive in a world economy, and the consequences of a monocrop

I didn't know anyone when I first visited Ruinas de Aké in 1976. There weren't any hotels, guesthouses, or restaurants in the village. Everyone I asked suggested that I stay with don Chucho—he'd once put up another stranger. With a group of boys running ahead yelling out his name, I followed them down a dusty street to a row of stone buildings.

"Don Chucho!" they hollered as they knocked on his door. Soon enough a gray-haired man came to the doorway. He looked out at the chattering boys and was about to shut his door when he saw me. "He's looking for a place to stay," they shouted. He didn't smile but opened the door farther, held out his hand, and said, "Jesús López Martínez at your service. Everyone calls me Chucho."

We shook hands, and he motioned me inside. He pointed to the end of his one room and told me that I could hang my hammock on hooks set in the stone wall. A rain shower began falling, doing nothing to decrease the heat but leaving the air smelling of wet dust. The crowd of boys and curious neighbors drifted away. Chucho stood by the doorway staring outside, and wondered what to say.

"Have you come to photograph the ruins?" Chucho asked.

"I'm more interested in taking pictures of the *henequeneros* [people who work in the henequen industry]."

"Huhhh," he said. "You came to the right place. Everyone here is a henequenero. There's nothing else."

The village existed solely to cultivate and process henequen, an agave whose fiber is used for making binder twine, rope, and textiles

As the uninvited guest I felt awkward. I wanted to find out what his daily routine was so that I wouldn't be too much of an imposition. Chucho shuffled around his room, intent on what he was doing. Our conversation had long pauses. He told me that he was happy to have a visitor because I might add a new perspective to his problems. There were things he wanted to talk about, he said, because he was no longer happy.

I didn't know how to answer, so I asked how I could help with food. Chucho said that he already had a pot of black beans and tortillas but I could buy some eggs. He added that he liked Pepsi-Cola.

We walked to the village store, where I bought the eggs and three one-liter bottles of Pepsi, which Chucho said was better than Coca-Cola.

The village had an enormous bare central plaza. The entire south side was taken up by a Victorian building housing the rasping machine for the henequen crop. The north end was open save for a few buildings, the west side was defined by village homes, and on the east were some houses, a church built upon a Precolumbian mound, and the elegant home of the hacienda owner, set back behind a fence.

Chucho invited me to see the ruins that give Ruinas de Aké its name. We didn't have far to walk. Just beyond the south end of the plaza was an unexcavated mound, with a wooden cross planted on top. Farther east we found an ancient plaza, where a solitary weathered stela stood. On the north end a large platform was crowned with three rows of twelve columns, each made of large drum-shaped stones stacked as high as sixteen feet. We walked to the top on a wide stairway as long as the base and made of huge stone blocks more than four feet long. The modern village is built from stones taken from the ruins; the stairway and columns were possibly spared because they were so big and heavy.

We climbed on top to see the view. In the west, beyond fields of henequen that extended to the horizon, black slanting rain fell heavily toward Mérida. Lightning jumped within the dark clouds, but we couldn't hear the thunder. Along the southwest side of the plaza were other unexcavated mounds, and the swells in the scrub forest at the south end of the plaza indicated more mounds that once had been temples and buildings. To the east rose the pyramids in Izamal.

The steam-powered rasping machine starting up broke the quiet. Then we heard the drive belts engage and the henequen leaves being fed into the machine—a heavy thud-thud-thud as steady and monotonous as a heartbeat. The clatter of the machinery reverberated around the ancient plaza.

"They're running it day and night to catch up," Chucho explained. "The machine has been breaking down."

The rasping machine indeed broke down later, while we were sleeping, and the silence woke us. I heard Chucho rummage in the dark before he lit a candle, standing it on the damp dirt floor. Chucho squinted while pushing himself into his hammock then rocked back and forth, watching the flickering flame.

I pulled my blanket tighter around me, shivering from the damp cold. The room was musty with the smell of wet limestone.

Buenos días, I said. "Good morning."

His hammock ropes creaked. Chucho acknowledged me with a nod, and I wondered if he was getting up soon. I wished that he liked small talk just a bit more.

When the steam engine started a few minutes later, Chucho sat up and adjusted the clothes he'd slept in. He then stood up and knotted a piece of twine around his waist for a belt. He sat down again and stared off into the dark room. "Morning," he finally said, pulling his blanket tighter around his shoulders. "I'll heat some water."

Chucho slipped on his sandals and shuffled over to the hearth with his candle. He soon had a fire going. I got up and put my hands over the flames to warm them. A broken guitar hung on one wall. Tacked into the mortar was a faded photograph of a group of musicians. Our hammocks hung at the other end of the room, along with a trunk where Chucho kept his clothes. Except for a few cooking utensils, several clay water jugs, a pail, and his tools, that was it.

Chucho made us a hot drink with an inexpensive coffee substitute prepared from ground corn.

"We'll eat when we get back from the fields. If it's all right with you."

"Huhhh," I said.

"Huhhh." He gazed at the fire.

When we left for the fields Chucho's rib-thin black dog ran circles around us and jumped with excitement. In near-darkness we slipped on rocks and weeds slick with dew. Stray dogs growled from empty houses that smelled of dank stone and garbage. We heard the muffled voices of families waking up. Candlelight escaped from shuttered windows and cracks in stone walls. A transistor radio competed with the noise of the rasping machine.

At the plaza, through a wide doorway, we entered the long building housing the *desfibradora* (a fiber-removing or rasping machine). Weak bulbs dangled from the high ceiling, supplying more shadows than illumination. Giant drive belts slapped the air, transferring power from the steam engine in the next room to the rasping machine on an overhead platform. The room shook with each thud. Workers threw bundles of leaves on a vertical conveyor that carried them to men who untied the bundles and rapidly spread the spiny leaves on another belt leading to the desfibradora. The machine made a thumping sound as the leaves passed through, the fiber burnishing the copper and brass parts that shone even in the dim light.

One of the workers beneath the platform was monitoring the stream of water and plant waste plopping into small hopper railcars from above. The man complained about the

Chucho sitting at his table, waiting for water to boil on his fire. Ruinas de Aké, Yucatán, 1976.

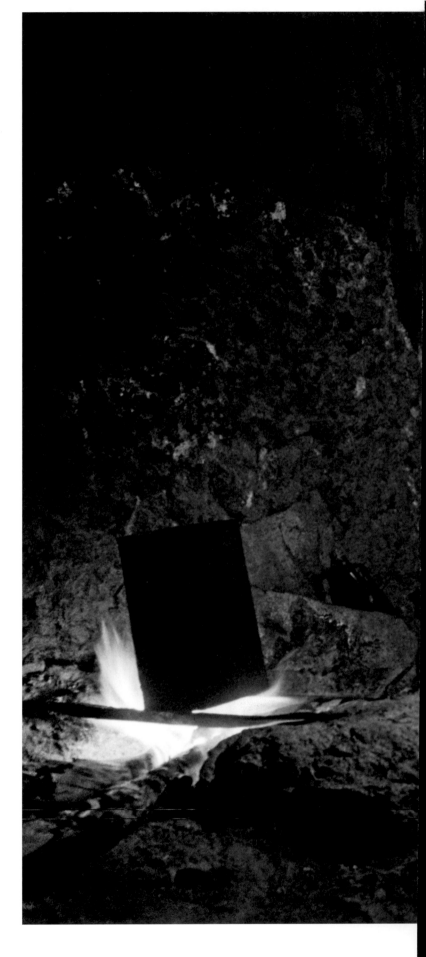

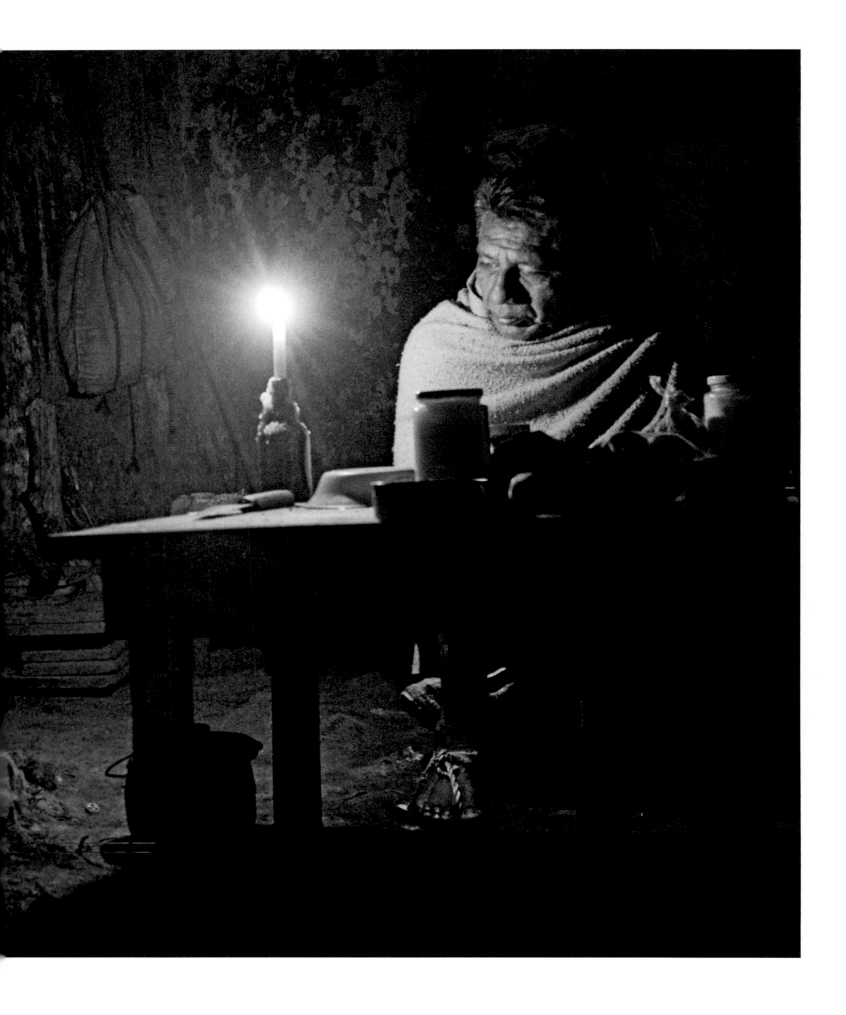

309

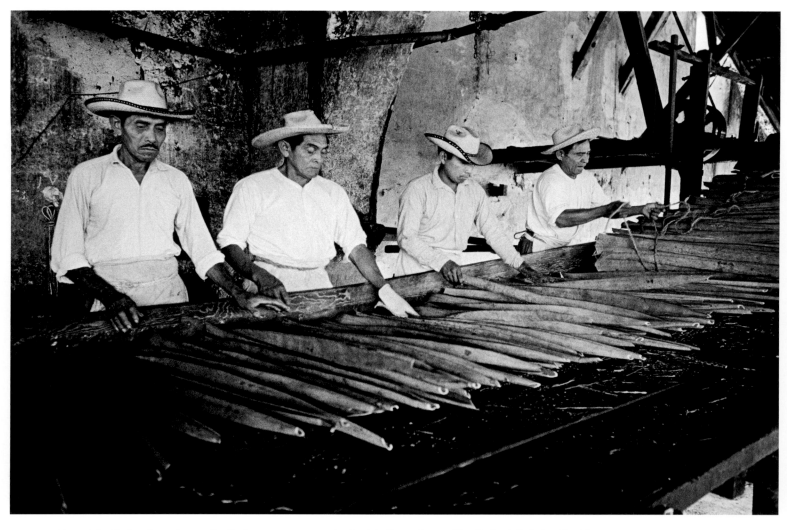

Men untying the bundles and separating the leaves on a conveyor leading into the rasping machine. Hacienda Holactun, Yucatán, 1971.

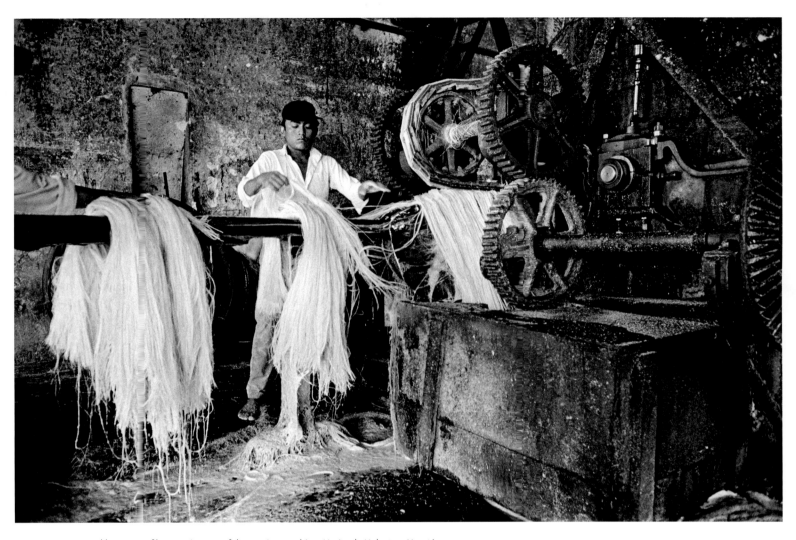

Processed henequén fiber coming out of the rasping machine. Hacienda Holactun, Yucatán, 1971.

breakdowns, having to work day and night to make up for them, and having to fix machinery when the ejido didn't have money to buy new parts. Chucho nodded in agreement. Because of the noise they had to yell into each other's ears. Puddles of water, sludge, oil, and grease pooled on the dirt floor along with the bright chartreuse plant waste.

We followed a mule pulling a train of railcars that was headed out to a dump, the wheels jogging back and forth on the Decauville narrow-gauge track that was put together in sections like a toy train.[1] They were now dumping the plant wastes in the ancient plaza.

Past the ruins we'd seen yesterday evening, sheep grazed on an ancient mound. From the end of the plaza we looked back at the rows of columns atop the ruins, burning red in the dawn.

"I like the early morning," Chucho said. He led me along a sacbe, an ancient Maya road that had connected Aké with Izamal. Heavily overgrown with weeds, it now disappeared into a henequen field.

Chucho stopped in a field and began weeding. I couldn't see any other workers. He worked methodically, swinging his machete low and level with the ground in short arcs. He cleared an area and stacked the weeds. Around the henequen plants he used his coa, propping up the plants' lower leaves with a splayed-end stick. The spiny henequen leaves narrowed to green spears tipped with black needles. The sun was soon hot in the open field, and there wasn't any shade. Chucho wiped sweat from his forehead and inspected his cleared aisle.

"The old days were bad. We were treated poorly," he told me. "But we took pride in our work. We kept these fields clear, and between the rows you found only grass. Today, well, just look." He pointed to the different spines, stickers, and weeds heaped in his piles. His expression tightened. "The others laugh at me when I clear my section well."

"Who's in charge? Doesn't anyone care?"

"We're all in charge. That's the problem. The government gave us the fields, and we're all part of the ejido. To make a decision we all have to agree, and in the meantime some men work hard and others don't. I don't even like talking about it," he grumbled. "It just makes me mad."

Chucho swung at the weeds with his machete. "We have the fields," he added angrily, "but no one taught us how to run them. And little by little, the work sinks to the level of the laziest worker. Do you see the problem?"

"But you understand the problem. Can't you do something about it?"

"Maybe before, but not anymore," he said, shaking his head. "I'm too old. The easiest way would be to leave, look for work elsewhere, but I can't do that. I could get a job as a night watchman in Cancún, but my mother lives here and she wants to stay. What if I went away and she died and I didn't know it? So I can't leave. I am a widower, so I married another woman. She's working in Mérida because I can't even make enough money to support her."

"How often do you get to see her?"

"I don't, at least not much." Chucho looked at me intently. "I guess the best solution would be if twenty of us could work together, people I know and respect. Hard workers. And we'd want to see our profits, not be exploited from all sides. But there's a problem working with a lot of people. We have good ideas, but we need education and someone with courage and strength. We're promised many things. It always seems the same. Previously, the *patrón* [boss/owner] exploited us. Now it's the bank. There's little difference. Both are enemies of the worker.

"When I was younger, I went to see the patrón in Mérida and asked him for higher wages and health protection. The patrón refused to help. At that time, if a worker was hurt or sick, the patrón did nothing for the man or his family. Finally I told him, 'You're rich from our work and you bathe in the sweat of your workers.' He had me thrown out. Today there's insurance and they say we'll get medical help, but not yet."

Chucho laughed at the memory, and I saw he had a nice smile.

"What happened then?"

"The patrón came out to the hacienda later that year and gave us a little speech. He told us the poor people were better off than he was. His life, he said, was full of terrible worries. His life was weighted with responsibilities. He told us we were healthier, we ate fresher food, our lives were free from stress. But when I asked him to trade places with me—well, he refused, of course, and I told him, 'You need us more than we need you. Without our work, you'd starve! You couldn't live!'"

Chucho laughed again. His face was transformed.

"You must have been his favorite."

"He remembered me, that was clear. I had to leave for a while. I worked as a dynamiter on a highway crew, but I came back."

"And he didn't bother you?"

"I got the worst jobs."

"You had a lot of courage to speak out against the patrón. Why not speak out now?"

"I'm getting old. I'm just a poor old man. What we need . . . " Chucho turned away and looked at the ground. I waited. Soon too much time had elapsed for him to finish. He stared at his hands, studying rough fingers cut by work. With his teeth he pulled a thorn from a callus. It started bleeding, and he sucked on it. He ignored me then pulled a file from his back pocket. Putting his machete to his knee, he pushed the file at an angle against the blade. Metal grated on metal, as shiny flakes gathered on his trouser leg.

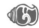

Succulent plants store water in juicy leaves, stems, or roots and can grow under harsh conditions. The best-known of this family are agave, aloe, cactus, and yucca. The ancient Maya cultivated henequen (*Agave fourcroydes*) for the fiber in its leaves and used it to make an infinite number of things. Even today the Maya in rural areas utilize it for making their

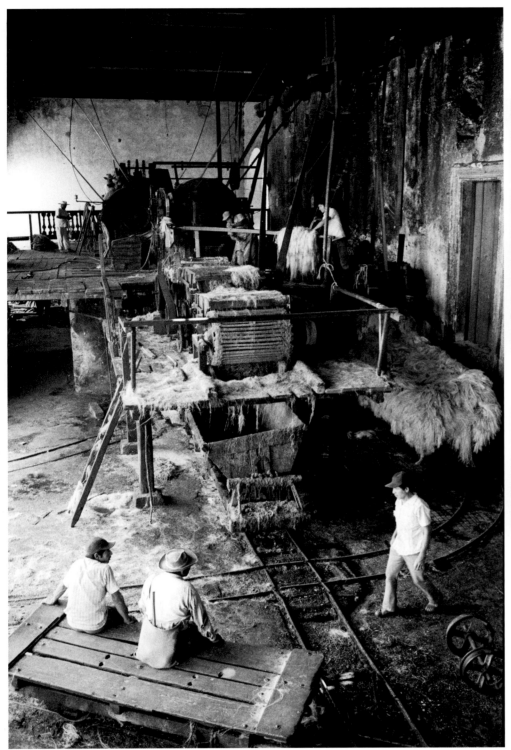

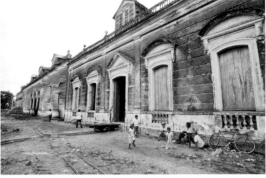

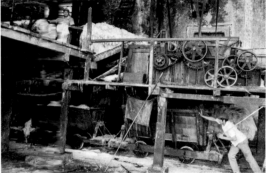

The building erected in 1912 that houses the rasping machine. Ruinas de Aké, Yucatán, 1976.

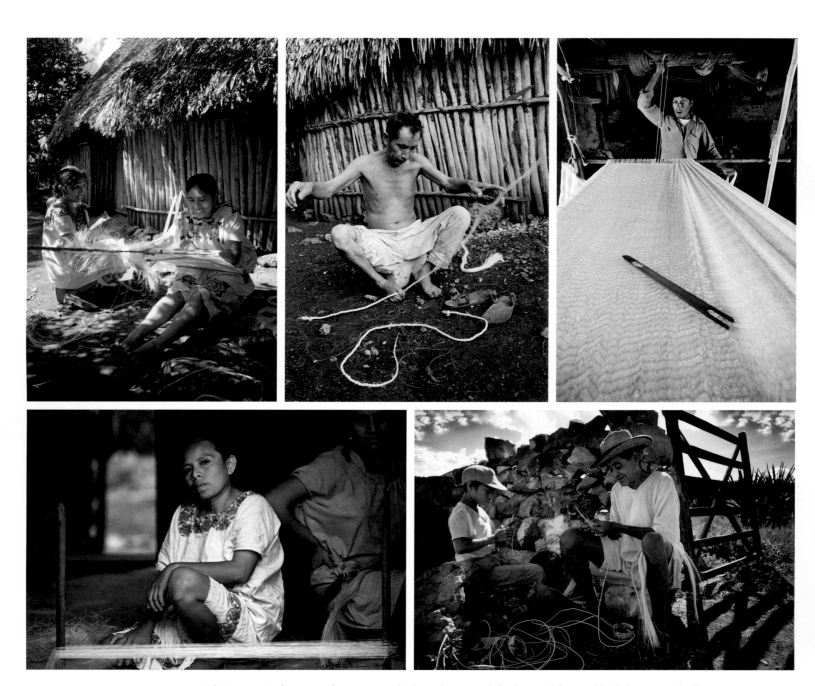

CLOCKWISE FROM TOP LEFT: Sylveria Poot Canche weaving henequen on a backstrap loom outside her house while a neighbor helps prepare the fiber, Tixhualatun, Yucatán, 1971. Francisco Puc Poot making rope from henequen fibers in front of his home, using his toes as a third hand (the rope is for his sandals, lying unfinished near his left foot), Chichimilá, Yucatán, 1971. Dario weaving a hammock from henequen fibers, Chichimilá, Yucatán, 1976. A man and his grandson at the gate to a henequen field, making twine from henequen fibers to hang kitchen holders for gourd cups, Sahcaba, Yucatán, 1971. Martina Martinliana Pol Dzul weaving a sabukan from henequen fiber while her mother prepares a loom, Holcaba, Yucatán, 1971.

sandals, tools, household utensils, rope, bags, and hammocks, although its usage has been quickly disappearing since the mid-1970s because synthetic products are cheap and ubiquitous.

The Spanish colonial haciendas raised cattle and grew primarily corn but also sugarcane, tobacco, and henequen. They produced rope from the henequen, selling small amounts to the Spanish merchant marine. After Mexico's independence from Spain, the henequen industry slowly grew. As it became more profitable the *hacendados* (hacienda owners) needed more workers to clear and plant more fields.

Henequen's value increased when Cyrus McCormick's mechanical reaper mechanized American farming, creating a vast market for binder twine. The hacendados cleared and planted large areas. Their fields encompassed nearly the entire northwest Yucatán Peninsula. They had a virtual monopoly on the world's production of henequen, and exports increased at a dramatic rate. By the end of the century it was estimated that fully seven-eighths of Yucatecans were involved in henequen cultivating, processing, or marketing.[2]

Just as denim fabric got its name from "de Nimes," the city it was from, processed henequen became known as "Sisal" for the port in Yucatán from which it was shipped.[3] By 1900 Yucatán was exporting 81 million kilos of sisal annually. Business was so good that from 1880 to the end of World War I Yucatán became the wealthiest state in Mexico.

Both expansion and profitability depended on cheap labor, so the henequen barons forced the Maya to work on their haciendas under the supervision of armed guards. The conditions were some of the most oppressive in the Mexican republic.[4] The hacendados devised a self-perpetuating system of debt peonage that destroyed the old ways of self-sustaining Maya agricultural villages. They used debt as a mechanism of social control and made a fortune at the expense of the Maya.[5] The landowners became so powerful that national laws meant nothing on their property—like feudal lords, they exercised the power of life and death over their subjects. Of the three hundred families that dominated the region, thirty or forty families, primarily of Spanish lineage, emerged as the most important. They became known as the *casta divina* (divine caste).[6]

This continued until the Mexican Revolution. In 1915 General Salvador Alvarado, the newly appointed governor of Yucatán, freed sixty thousand Maya and their families from the debt law, ending centuries of slavery. Though the Maya were now free, they had no money, land, or education. Essentially their situation hadn't changed, and conditions worsened. The price of henequen plummeted at the end of World War I. Yucatán's world monopoly on henequen was broken when new sisal plantations in British Africa and Java produced plants with longer fibers of greater tensile strength. By 1930 the other locales in the world were supplying more fiber than Yucatán. The Great Depression only exacerbated the situation. Certainly by this time everyone should have realized that a monoculture was no longer economically sustainable for Yucatán. They needed to diversify.

However, that was not to be the case. In 1937 President Lázaro Cárdenas expropriated the lands of many haciendas and gave them to the Maya as ejidos to be owned and run by the workers. It was the largest single episode of agrarian reform ever carried out in Mexico.[7] Cárdenas tried to right many wrongs, but it was a fiasco from the beginning. The land was haphazardly redistributed, so few ejidos could start as working henequen plantations. Many owners overcut their fields before the Maya took them over, leaving them unprofitable for years. The most egregious mistake was allowing the hacendados to keep a 150-hectare nucleus around the main buildings that included the rasping machines and allowing the hacendados to set the rate for processing the henequen. Not surprisingly, they charged the Maya exorbitant rates. The hacendados still controlled the industry, but they now had even less responsibility.

The unskilled and uneducated Maya had no administrative skills, no rasping machines, and no money. So the federal government eventually took over the industry, more to minimize social discontent than to compete in the global economy. It decided where to plant and process and set the price paid the workers. The Maya continued to do the work; the hacendados and the government received 90 percent of the revenues.[8]

What began as an economic bonanza for a few favored families ended up a social and environmental disaster for all. Yucatán's dependence on a monoculture became a huge liability. The collapsing henequen industry was badly run and employed too many poorly paid people. Forty years after the Cárdenas attempt to reform the industry, President José López Portillo, during a visit to Yucatán in 1977, commented that what had begun as a redistribution of wealth had become a distribution of misery.[9]

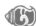

In the days that passed Chucho didn't say much, explaining that he was depressed and tired. He told me that he used to drink but couldn't even afford that any longer. He did promise that we'd go for a swim at his favorite cenote, where the water was perfect.

One hot afternoon he decided that it was time for that swim. The path to the cenote led through a vast field of young henequen plants no more than two feet high. Very little moved in the heat except what we stirred up—a constant flik-flik of grasshoppers jumping and a group of ground doves that scurried before us. A breeze pushed the air uncomfortably against us as rows of biscuit-shaped clouds scudded across the sky.

We walked along steadily, and I was surprised when Chucho told me that we were near a cenote. There wasn't any telltale sign, such as a ceiba tree, a large opening, or a depression. Chucho pointed out a small hole hidden in the rocky soil between henequen plants and a few spiny nopal cacti.

Through the hole I saw a pile of stones ten feet below. I

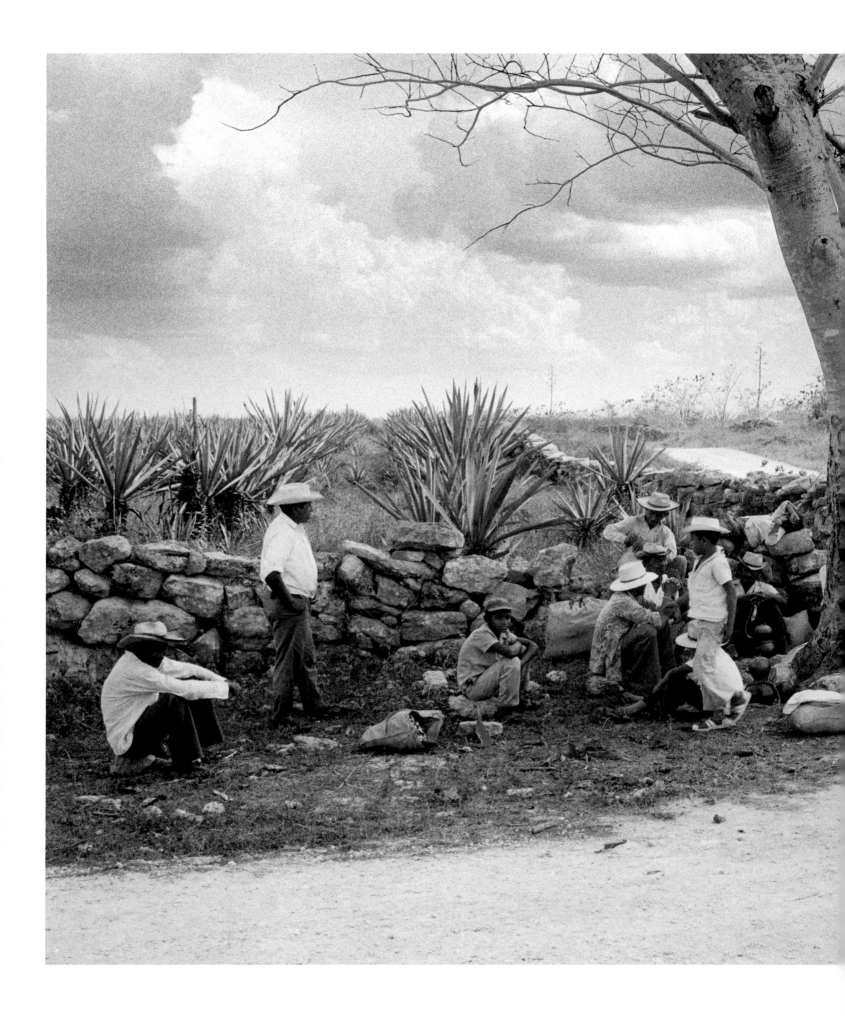

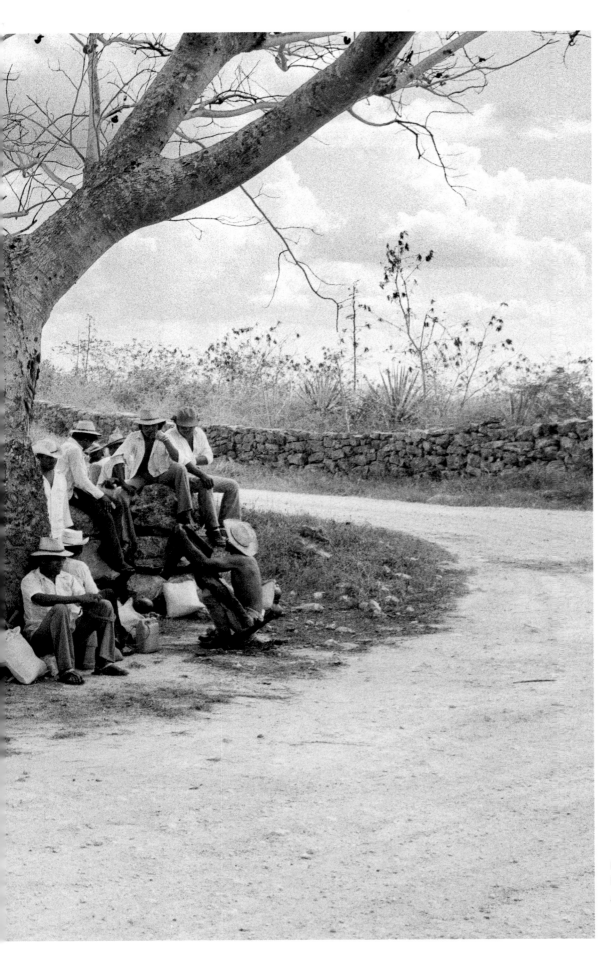

Henequeneros waiting for transportation home after working in the fields. Ruinas de Aké, Yucatán, 1976.

Boy holding a henequen plant ready to plant. Hacienda Holactun, Yucatán, 1971.

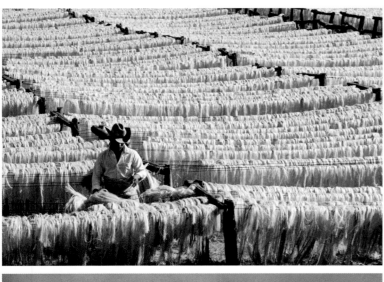
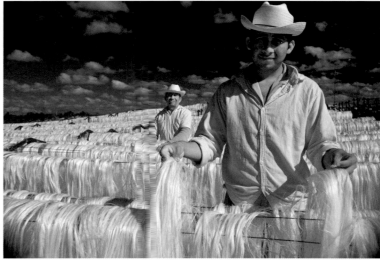
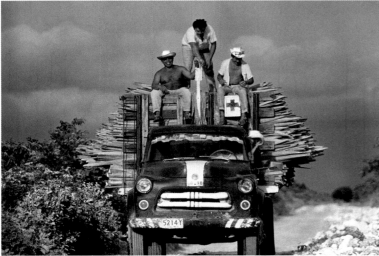
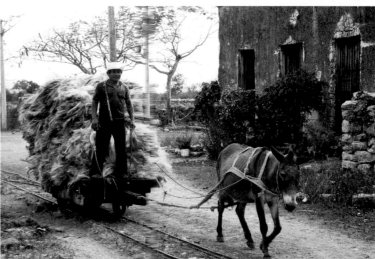

CLOCKWISE FROM TOP LEFT: A henequenero hanging henequen fiber out on drying racks; henequeneros hanging henequen fiber on drying racks after it has passed through the rasping machine, Hacienda Holactun, Yucatán, 1971. A henequenero bringing dried fiber back from the drying racks, Ruinas de Aké, Yucatán, 1990. A truck loaded with henequen leaves heading toward a rasping machine, Sinanche, Yucatán, 1971.

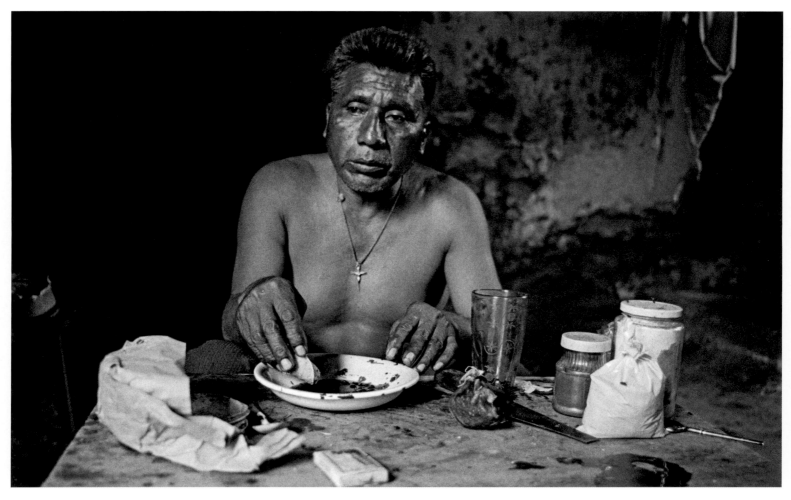

Chucho eating lunch in his room. Ruinas de Aké, Yucatán, 1976.

wondered about rattlesnakes. Chucho led me down the shaft into a cramped cavern with a cenote that disappeared into darkness. The water was gray underneath a film of dust. Chucho proudly swept his hand across the scene. I knew that I was supposed to marvel at the spectacle, but I found it disappointing. It wasn't anything compared to some of the cenotes I had visited. But we were both sweating profusely, and I was happy to go swimming.

"It's very pretty," I said, trying to sound cheerful. "You must have a lot of memories here."

He nodded then took off his shirt, spreading it on a rock in a shaft of sunlight so that the sweat could dry out. We weren't ready to swim yet. We needed to cool off before jumping in. Moving to the water's edge, Chucho crouched on the narrow sandy beach and dipped his hand, brushing away some dust.

"I was only five when I first came here," Chucho reminisced. "I was born in Maxcanu [a town southeast of Mérida] in 1921, but I've lived here ever since. In those days there was still some forest left. I used to fetch water for my father when he was burning trees for charcoal. I learned how to swim here. All the boys in the village would come here to play. It was really something then." He smiled sadly. "Not too many people come here anymore. That's why there's a lot of dust here now."

"How old were you when you started working in the fields?"

"Nine when I started working full-time," Chucho said. "My father was sick, and there was no way my family could eat without my working. It didn't seem that bad. After work, we'd come here every day, all of us my age. We'd swim and play tag and other games, and we knew every part of this cenote." He indicated the back of the low-ceilinged cave, hidden in darkness.

"Back there is a rock that's hollow. It rings like a bell if you knock on it!" Chucho picked up a stone and threw it in the water, scattering the dust. Following his example, I threw some rocks too. Light reflections from the disturbed water danced on the ceiling.

"You see how clear the water really is?" he said happily. "There are even fish."

Silver fish glided over the rocky bottom. I couldn't tell how deep it was.

"When we came here after work," Chucho continued, "we'd all leave together at the same time. Nobody could leave early. If someone tried, we'd hit them with a glob of mud." He laughed. "Well, they couldn't leave covered with mud, could they? Of course not! They'd have to jump back in. Later, as we got older, we brought our girlfriends and sat around the water, playing our guitars and singing. The music echoed through the cave. It was beautiful, especially at night."

"Did you sing and play?"

"For years I played guitar. I even had a seven-man band. We performed for parties and dances all around. That was another time, and now my guitar is broken. Look!" Chucho indicated the opening. "It's raining."

Raindrops sparkled coming down the shaft of sunlight. The afternoon shower increased the humidity in the cave, making us feel even hotter than before. We stripped to our shorts, and Chucho dove into the water. He swam to the center, pushing the dust in front of him and into the corners. He started splashing, burying the dust beneath the waves.

"Come on in," he said.

I dove in and swam to the back of the cave, searching for the bell stalagmite. Once my eyes adjusted to the dark I thought I found it growing from the water, shiny and slippery, almost like ice. I looked for Chucho.

He'd swum over to the beach for the bar of soap he'd brought. He was lathering up, covering his whole body in suds. Chucho discovered me watching him and threw the bar into the middle of his cenote. He grinned and dove in after it. I was delighted to see him look so happy.

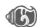

Two kids from next door came over with a plate of barbecued iguana. They'd shot it that morning with slingshots. We thanked them and added the meat to our lunch of beans, eggs, tortillas, and Pepsi.

When the boys left, Chucho said. "Look at that! People even eat iguana. Things have changed—there's so little game around. Not like before."

"At least," I said, trying to be positive, "it tastes very good."

"Huhhh," he said, picking up the day's paper. It was delivered every day from the capital by the morning bus. As a young man, Chucho had somehow learned to read with little formal education and was remarkably concerned about keeping abreast of national and world events. But reading the news reinforced his feelings that times were bad.

I ate my lunch in silence. The eggs were cooked in too much lard for my taste, but I couldn't tell him that. I didn't want to add another complaint. I wondered why his wife had left and if he ever saw her.

"Look at this," Chucho said, glancing up from his paper. He pointed to a picture of López Portillo, the PRI party presidential candidate who was campaigning in Yucatán. "Another politician, another promise, and my community is falling apart. My neighbors buy televisions on credit and dream of leaving their village. How do we know what to do? We're told this, we're told that. When they call something progress, it always means a new hardship, doesn't it? Some suggest that we should vote for the Communists, but I distrust them just as much as the PRI."

I nodded in agreement. Like most of my friends in Yucatán, Chucho had had a very hard life. I felt incapable of cheering him up. I finished my bowl of beans instead.

"I'm sorry," he said noticing that my plate was empty. He spooned out more beans from the pot on the fire and poured the leftover pig fat on them. It was a special favor, as he enjoyed it so very much himself.

After lunch I took down my hammock and put it in my

CLOCKWISE FROM ABOVE LEFT: Chucho preparing a cooking fire for lunch; walking in the village; reading his newspaper at lunch; watching television at his neighbors' house, Ruinas de Aké, Yucatán, 1976.

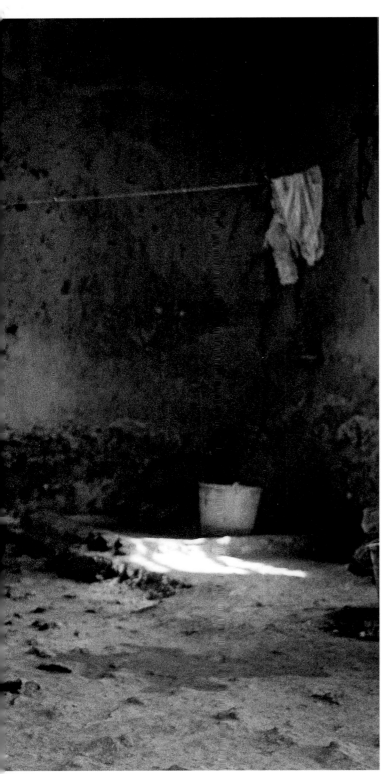

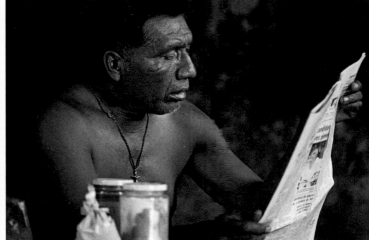

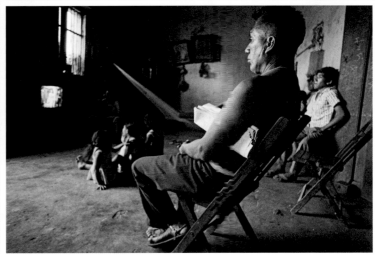

mochila (bag) as Chucho watched. I thanked him for my stay in his home and for the meals we'd shared.

"You know," he said, "I'm alone here. If any of your countrymen would like a place to stay, I'd enjoy very much talking with them. They can stay here. We can share our meals and talk."

"I'll tell them," I promised.

I shouldered my sabukan and mochila and headed for Tahmek, twelve kilometers away. At the outskirts of town I looked back. Chucho stood in the bright, empty street, the saddest man I knew in Yucatán. We waved. I turned and started walking, feeling alone under the hot sun, between rows and rows of henequen and deserted ruins.

Four years later I went back to see Chucho, bringing along my son and some friends. His old house was empty. His neighbors told me that he'd moved a few blocks away. They said that he was living near the plaza with his wife.

I found a house with flowers growing in window boxes. I asked the woman who answered the door if Chucho lived there. She called his name, and when he saw me he broke into a huge grin. He gave me a big hug. He proudly introduced his wife Heliodora.

"I've told my wife I had a friend from the United States. And now a whole carful shows up! She thought I was making you up, I've talked about you so many times. She said I was probably so depressed that I was inventing friends."

Heliodora nodded. "Because of his smoking and drinking, I left him for seven years," she confided. "We'd only been married two years when I left, but once he gave up his bad habits, well, we've been together ever since."

I gave him an album of photos from my last visit. He sat in a hammock and turned each page, explaining to her all the things we'd done. "This is wonderful," he said, laughing at the memories.

I brought in several liter bottles of Pepsi, and Chucho laughed again. He brought out his mended guitar and sat close to Heliodora. They sang duets for us, looking into each other's eyes. It was wonderful to see Chucho smile and enjoy the day.

"He should never have given up playing music," she said. He smiled again. "Who knows how many guitars he broke when he was drinking."

"I'm making 5,750 pesos every fifteen days [$11.50 U.S.]," Chucho told me in 1986. "Let me tell you how expensive everything is. A kilo of corn costs 59 pesos. A kilo of chicken costs 580 pesos. A soft drink costs 55 pesos. An egg costs 25 pesos, and a kilo of lard for cooking costs 800 pesos. Five thousand pesos doesn't buy much. A little here, a little there, and it is gone. There are men working beside me with four or five children. In all honesty, how can a family survive?"

I shook my head.

"You read the paper and the politicians tell us the economy is faltering right now and it's necessary to tighten our belts. Our belts have always been tight. Our village is dying of hunger, but the politicians are eating well. If only they learned a lesson from Marcos"—Chucho had been following the events in the Philippines leading to that leader's downfall—"because we're even worse off now than when you first visited."

"So what can you do?"

"Not much. There are experiments to replace henequen with other crops or even forests of hardwoods. In fact there's no new work. The government talks about development then we're told that there isn't any credit. We've proposed some projects here on our ejido, but the government and the bank haven't accepted them. You want to know how crazy things are? A worker at the Cordomex factory makes 2,500 pesos a day [$5 U.S.]. In three days they've made more than we do in fifteen."

That night Chucho and Heliodora went to church, something they now did every night. Like many Roman Catholic churches in Yucatán it was built on a former Maya temple. Chucho accompanied the hymns with his guitar. Scaffolding was set up inside, and villagers had donated enough to refurbish half the church. Contributions were small, and they didn't know when the work would be finished.

In 1988 Chucho retired with a pension that paid him less than $15 a month. Not surprisingly there was no work in Ruinas de Aké to augment his pension. Heliodora had two daughters living in Ruinas de Aké and a son in Mérida, so she and Chucho went to live with her son so that Chucho could work as a night watchman at Restaurant Le Gourmet, a fancy French eatery in Mérida. He earned $80 a month working from 11 P.M. to 7 A.M. six days a week.

I found them in Ruinas de Aké in October 1988. They were repairing damage to their house after Hurricane Gilbert. The wind had ripped down the wooden shutters and knocked over many trees. Across the plaza, Gilbert had toppled the bell tower of the church; masonry was still scattered on the mound. The hurricane's destruction lay everywhere, and no one in the village had money for repairs.

A week later the UCSB students arrived in Yucatán, and I introduced them to my friends. Although Charles and I had a discretionary fund to help hurricane victims from the benefit that we'd thrown in Santa Barbara, one student decided on the spot to give Chucho a generous donation. We opened an account for him. Chucho couldn't contain his excitement as we walked back from the bank. He almost jumped and clicked his heels. When I visited a month later he brought out a guitar that he'd just bought and played me a song. Heliodora leaned over to me and whispered loudly, "This is the way he impresses the girls."

The following year, in May 1989, I received a letter from

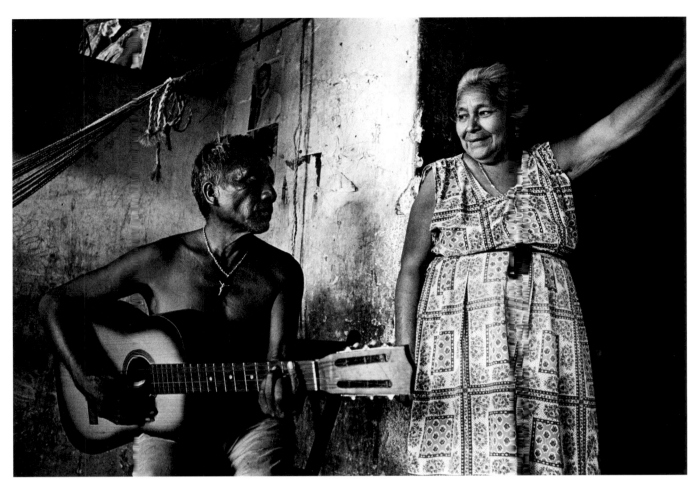

Chucho serenading Heliodora in their house. Ruinas de Aké, Yucatán, 1980.

Chucho telling me that his condition was grave and that he and Heliodora had returned to Ruinas de Aké. He said he hoped that I could get back to Yucatán soon. Praying that he wasn't dying, I wrote him that I couldn't come right away, that I was getting married in August and would honeymoon in Yucatán so they could meet Mary.

It wasn't until March 1990 that we actually visited. They were living in Ruinas de Aké, but Chucho still worked in Mérida as a night watchman, now for a department store. He spent sixteen hours six nights a week commuting and working, earning $4 a night. He'd been able to keep almost $400 in his bank account, and the monthly interest helped them get by—enough to repair the damage on their house slowly and buy a small black-and-white television.

We'd sent an invitation so they knew the wedding date, and it inspired Chucho to prepare a party for us. He and Heliodora killed a twenty-pound turkey, baked it, then waited for us to show up for our honeymoon. They waited for us all day and into the night.

There was no way we could apologize sufficiently for this. Chucho was a perfect gentleman. He got out his guitar and sang us love songs. Mary smiled and cried and kept asking for one more.

They were gracious enough to laugh with us as we explained that we were still on our honeymoon and hoped that it would never end. We said we felt terrible that we'd missed our own party. Chucho and Heliodora told us that we'd missed a great meal.

In 1991 the federal government finally quit the henequen business, though there was still a market for binder twine, rope, gunnysacks, and other products. Henequen production was 140,000 tons in 1960, 73,000 tons in 1970, and 35,000 tons in 1990. What saved Yucatán from major economic and political crisis was tourism. The men could find work in Cancún and along the Caribbean coast. But it came at a price—for a man to see his family, he had to return to his village on weekends.

One of the problems in revitalizing the henequen zone is that most Mexican government planners still want to replace henequen with another monocrop, an idea that is bound to fail.[10] Politicians further doomed any scheme because they only championed short-term projects—just as they didn't see any political reason to continue programs that would

Chucho underneath the village
church bell tower. Ruinas de
Aké, Yucatán, 1980.

bring credit to their predecessors, they also knew that their successors would do the same. So there are no serious government programs to reverse the environmental and social degradation to an area that Stephens described in *Incidents of Travel in Yucatan* in 1842 as a great wooded plain with thick woods.[11]

As for social services, during President Luis Echeverría's six-year term in the 1970s the government modified the Social Security Law to allow the henequen workers and their immediate families finally to receive the medical services they'd long been promised. Everyone who worked was eligible for Social Security. All that was required was an employer to pay into the system. As the government hadn't paid into the system, the henequeneros weren't eligible.

In the 1970s the rise of Mexico's oil wealth led to hospitals and clinics throughout the country. A decade later, when Mexico faced an economic crisis and devaluation, the government cut back benefits under a program of decentralization and passed the costs of health and education to the state governments. Because the towns in the henequen zone were left with mainly women, children, and seniors, they lost most social services.

The only new work came about in the 1990s with the conversion of some of the old haciendas into luxury country hotels, subsidized in part by government agencies and programs. Work at the hotels was the only new local employment available to the villagers.

I immediately agreed when the *Los Angeles Times* asked me to photograph Hacienda Katanchel, one of these former henequen plantations turned luxury hotel. As soon as I arrived, I got a ride over to nearby Ruinas de Aké.

Heliodora came to the door and I knew by her expression that Chucho had died. She told me how it had happened. One day on his way to work as a night watchman in Mérida Chucho had fallen and wasn't able to get back up. He may have suffered a concussion or perhaps a stroke. People thought he was a drunk and walked around him. A kid robbed him, and no one tried to stop it. Chucho lay in the street for hours before someone finally came to his assistance. He managed to stagger back to his home in Ruinas de Aké with a big bruise on his face from his fall. He got into his hammock and died a few days later, on March 25, 1995.

I cried when Heliodora told me this. It seemed so unfair. Chucho had fought his whole life for dignity and respect and to be robbed of that as he lay dying seemed the most grievous of life's injustices.

Mary and I returned to Yucatán in July 2002. We flew into Mérida and picked up a rental car. Even though the rainy season had started, it was hot. The heat reflected off city buildings, and the blast of hot air could buckle your knees. I have friends, both American and Mexican, who complain that the heat in Mérida is the worst they've ever suffered. As we drove out of town I leaned forward in my seat so the air coming in

Chucho and Heliodora inside their home. They placed our wedding photo below their altar. Ruinas de Aké, Yucatán, 1990.

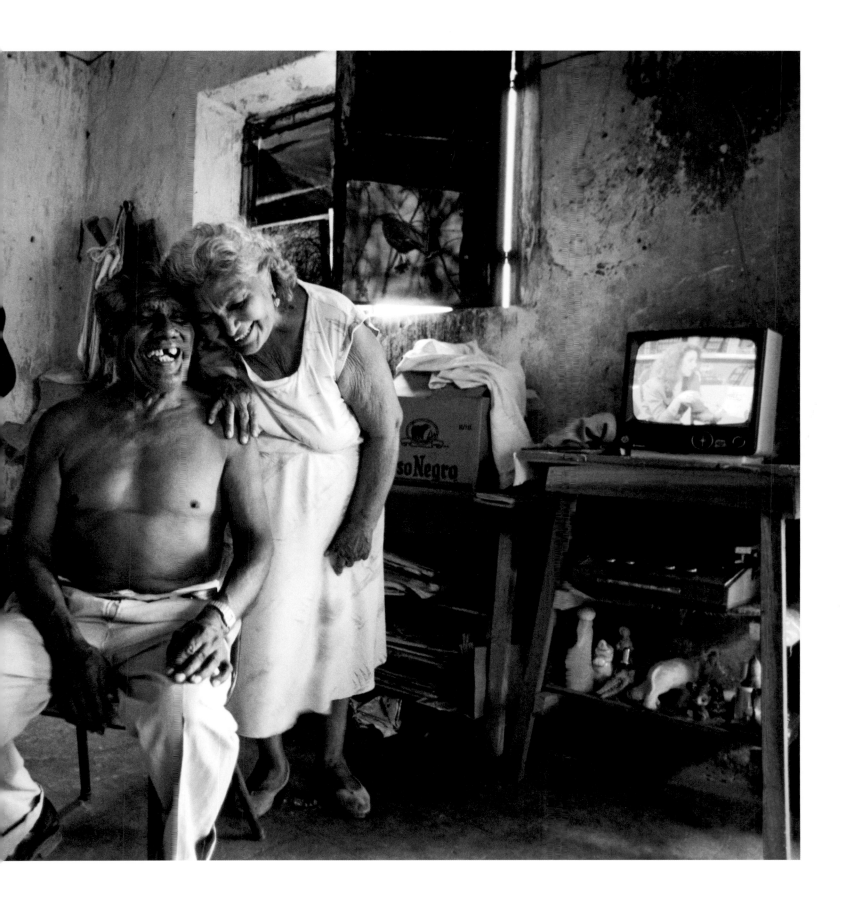

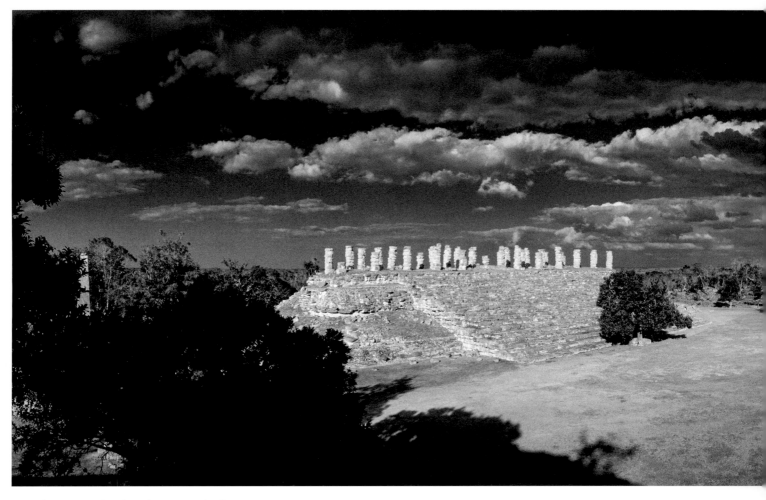

Pyramid at a Maya archaeological site. Ruinas de Aké, Yucatán, 1987.

through the windows could dry the sweat running down my back. I was sweating faster than I was drying.

We took back roads barely wider than our car. The rains had transformed the world into a tunnel of green that hugged the car and spilled into the roadway. The heat fueled its growth; you could almost feel the vegetation reaching out and stretching. The trees were so full of leaves that we rarely saw the sky, and the light was tinged a yellowish-green, as though we were underwater. Thousands of butterflies—pale yellow, light green, yellow orange, and white—fluttered through the forest like confetti, attracted by the water puddled on the road.

This all changed when we reached the turnoff to Ruinas de Aké. Weed-choked fields of henequen replaced the forest, and the verge was littered with trash. There was so much garbage that it looked as if we were entering a municipal dump rather than a village. Not long ago nearly everything the Maya used would decompose. Wrap a tamale in a banana leaf and you could toss the wrapper. If you ate a piece of fruit you could toss the peel. Men carried their water in a gourd. Families guarded their empty bottles to avoid forfeiting their

deposit. But today's wrappers and containers are made from plastic, glass, and metals, and bottles are no deposit/no return.

We only saw women and children in the village. It was strange not to see men. Although a few remained to grow henequen and run the rasping machine, almost all the other men were working in Cancún or Mérida. Heliodora greeted us with a hug and a kiss, and soon her two daughters Dorita and Betty appeared, followed by grandchildren and neighborhood kids.

They were so pleased to see Mary. On a prior visit they'd chided me for not bringing her along. They invited her inside and offered us the hammock to sit in as they brought up chairs, asking about Mary's daughter Sienna, whom they'd met in 1991. Mary told them that Sienna was now married and that her studies had taken her to Mustang, Nepal, and Tibet. It was difficult to explain the Himalayas to people who'd spent their entire lives on a flat peninsula in the tropics. But Mary was too proud of our daughter not to try. She told them that Sienna lived in mountains higher than the rain clouds. She tried to tell them how far Tibet was from Yucatán. "*Lejos,*

muy lejos—very far away," she said, flinging her arms as wide as possible. The kids broke into laughter.

Because of the hot weather we moved outside and sat in chairs and on rocks in front of the house. Heliodora's grandkids asked me if I'd brought another copy of *The Modern Maya: A Culture in Transition*. Heliodora's copy was with her son in Mérida. They wanted to see it again because, they said, it was their history. When I brought out a copy, the kids pored over it for hours as if it was a family scrapbook, recognizing relatives and neighbors and comparing their lives with the lives of others on the peninsula. I saw this everywhere I left copies of the book.

In Heliodora's room was a bale of clothing that her son had brought. He was able to buy used clothes cheaply by the bale, and then Heliodora and Dorita sold them to their neighbors. It provided them with a little cash. Dorita worked twice a week for the village government doing whatever was necessary, including helping to keep the peace. The police in the nearby town of Tixkokob had installed a two-way radio, and Dorita called for a police response when there was a problem in the village. I asked her what kinds of incidents she'd

have to report. She said most of them occurred on the weekends, when the men came back from working on the Caribbean coast. If they started drinking it could lead to fighting, domestic abuse, or just urinating in front of others.

Hurricane Isadora swept across Yucatán in September 2002. I returned to Ruinas de Aké in February 2003. Charles and I found Heliodora's door padlocked. None of her neighbors answered either, so we walked over to the desfibradora plant. Isadora had done more damage than Gilbert had. The hurricane had torn off the roof of the large building as well as architectural details and pediments. Stone walls once two stories high had been blown down, roofs and doors and windows torn off. Machinery had been crushed, outbuildings and houses had been destroyed, and the buildings had jagged cracks. The steam engine that powered the machinery had been crushed when the roof collapsed. The weight had snapped the steel beams holding up the floor, and everything had crashed into the basement. The ruin of the henequen industry was no longer a metaphor.

A man walked up, introduced himself as Teo, and asked if we wanted to tour the rope-making factory now in another building. They didn't charge much, he said, and other tourists liked the tour, though he conceded that few came. I told Teo that I was looking for Heliodora. The smile on his face disappeared.

"She's dying," Teo told me. "She is my mother-in-law's mother. They took her to the hospital yesterday. If you wait for the four o'clock bus from Tixkokob, you might find out how she is."

I told Teo I'd wait. Charles's fifteen-year-old daughter Djamila was with us, so we agreed to take the tour. It was confined to a building where sisal was twisted into rope. The business employed fifteen men. The air was full of henequen dust, and all the workers wore masks or bandanas. I didn't want to stay, so I walked a block over to the ruins and the ancient plaza. Archaeologists had recently cleared brush and trees from more structures around the main plaza, so it was easier to see how large a site Aké really was.

I remembered when Chucho and I had walked here years before, talking about his dreams and the tribulations of his life. I prayed that Heliodora would be okay, but at the same time I dreaded the news that the bus would probably bring. I thought of how depressed Chucho had been when I first visited. He'd understood how the henequeneros were exploited and abandoned. What kind of malaise had gripped Yucatán's leaders to allow their region to become this depressed, exhausted wasteland? They'd known for nearly a century that henequen was no longer sustainable. I remembered something that Alejandra García Quintanilla, professor at the Universidad Autónoma de Yucatán, had told me. She'd once observed a sacred sakab ceremony in a field of henequen, to prevent bad winds that can kill. "You can't help but notice

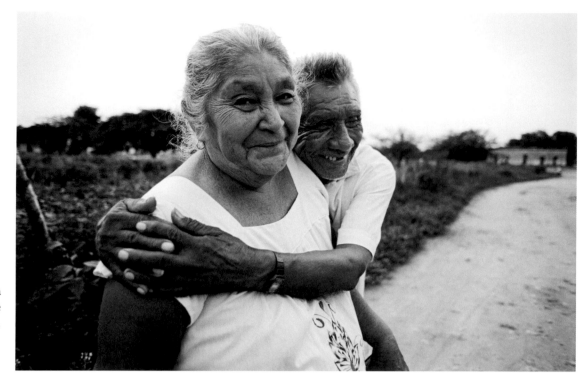

Chucho and Heliodora on the plaza. Ruinas de Aké, Yucatán, 1992.

the difference," she said. "A sakah in a milpa is for a good harvest, but here in the henequen zone it's to prevent death."

I climbed one of the recently cleared mounds and looked out over the fields of henequen. A wind moved a storm across the sky and blew shadows across the fields. I stayed in the ruins past closing, and no one asked me to leave. Finally, close to six o'clock, I joined Charles and Djamila on top of the large platform with the columns. I wanted to put off walking back into town as long as possible. Teo found us sitting on the ruin.

"Heliodora is okay," he shouted. "She's at her daughter Betty's house."

I hurried down the steps and into town.

Dorita and Betty and her young daughter Verónica all talked at once as soon as they saw me. Heliodora was lying in a hammock in front of a TV tuned to a variety show. Christmas lights were hung around the TV and blinked happily on and off. She tried to rise, but I went over to the hammock and held her hand. Her daughters told me that Heliodora had been vomiting blood and probably had gastritis. An ambulance had taken her to the emergency ward in Tixkokob, but the doctor had sent her to a specialist in Motul. Dorita had spent the night with her, and after a while she was released. Heliodora didn't want to talk about her illness: she wanted to tell me about Isadora.

"It took my roof," she said. "It was a terrible storm."

"All the roofs were flying off and making a huge noise. Never in my life have I heard a sound like that day," Betty told me.

"It was so noisy," Veronica said. "The wind shook our house."

"All the photographs you just brought down last time," Dorita added. "We lost everything."

Finally they slowed down enough to speak one at a time. Isadora had struck in the morning with brutal force. Heliodora and Dorita lost their roof and everything inside their house. Betty lost the roof over her kitchen, and her antique wood cabinets were soaked with rain. Anything that could absorb water was lost. Betty and her husband had stretched a tarp over the kitchen until they could repair their roof, which they thought might take months or even years.

Heliodora had first stayed with her son in Mérida but returned to stay with her daughter. Betty took me outside to show me more of what Isadora had done. It was getting dark and the gloaming hid some of the damage, but I could see the night sky through the gaping holes and missing roofs on buildings. There weren't many people on the streets. Ruinas de Aké seemed like a ghost town.

I asked Heliodora how she was feeling. She lay back in her hammock and tried to smile. She told me she was okay. She motioned around her. Veronica was chatting happily, the Christmas lights were blinking, Betty was talking with her husband who'd just returned from work, and Dorita was busy talking with Charles and Djamila.

Heliodora was being kind. She knew that I had to leave and didn't want me to worry. I gave her a kiss and told her she was looking good. She asked when Mary was coming to visit. I told her soon and hoped it was true.

1. The track was named after Frenchman Paul Decauville, who designed rolling stock and ready-made sections of light narrow-gauge tracks that came to be used on plantations worldwide. Because his design incorporated steel sleepers attached to the track, lines could quickly be laid out and changed. The rail cars could be pulled by animals or small steam engines.

2. Joseph 1986:32.

3. Each bale of henequen was stamped "Sisal." Ironically, what is now called sisal is a different species, *Agave sisalana* Perrine. The fiber from both plants is called sisal or sisal hemp in English. Henequen is a coarser fiber than sisal and not as strong. Colunga-García Marín 2003:439.

4. As "Friedrich Katz persuasively argues in his comparative regional study of labor conditions on Porfirian estates, on the whole, social relations on Yucatán's henequen plantations were among the most oppressive in the tropical southeast, a region that maintained the most onerous labor regime in the Mexican republic." Joseph 1986:62.

Whether the Maya were slaves or debt peons is the subject of controversy. Joseph (1986:59) cites John Turner's "chilling indictment of Yucatecan slavery in *Barbarous Mexico*."

5. "The theory behind the land and debt laws was that the Maya must become participating citizens. Theirs [hacendados'] was a conscious plan to destroy the old ways of the self-sustaining villages and replace them with rules of economic cooperation and progress. When philosophy and greed combine, their strength is hard to contest." Reed 2001:13.

A census of the l880s listed a third of the population as indebted servants—all were Maya. Forced from their farms and into work in the henequen fields, the Maya were dependent upon the landowners. The hacendados were able to accomplish this by taking the ejidos, the common land granted to the Maya, and turning it into their private property. Although this was illegal, no one came to the defense of the Maya—not when the economic prosperity benefited the men making and enforcing the laws. Violations didn't come under scrutiny. In fact, instead of protecting the Maya, the government passed a law in 1880 that gave plantation mayordomos legal powers to watch and punish servants.

The Maya had created the greatest civilization in the Americas based on sophisticated agroforestry techniques. Now Yucatán had to import food.

The henequen boom followed a cycle of death among the Maya. The Caste War of Yucatán had uprooted or killed hundreds of thousands. Epidemics had killed many, and a plague of locusts had destroyed their crops. The Maya were spiritually broken, and historians argue that this is the only reason they worked in the henequen zone, under such horrible conditions, without rebelling. See Rivero 2003:577; and Brannon and Baklanoff 1987.

Paul Sullivan (2004: Chapter 7) tells a chilling and horrifying story about a henequen hacienda owner of limitless cruelty and violence.

6. Seriously, what kind of people have the hubris to call themselves the divine caste? See Joseph 1988:51, 53, 56–57, 62 (etc.).

7. Joseph 1986:125.

8. The expropriation was meant to re-create the ejidos that the Maya had lost a hundred years before. But the Maya of the henequen zone had little control over their newly acquired land and would lose it if they stopped producing henequen.

Henequen is first raised in intensive fields and then transplanted after a year or two. At seven years the first leaves can be cut, but the plant is not really ready for production until it is twelve years old. It is at its peak from twelve to twenty years; after that, it declines in yield to a point where the fields are burned and the cycle begins again. Ideally there is a fallow period before new plants are introduced. It is important to have new plants as well as mature plants, in well-distributed stages. At least half the land needs to be kept in nonproductive and low-yield stages for a steady yearly yield.

"The crisis that enveloped the henequen industry was significant in several respects. Operating outside the discipline of the market system

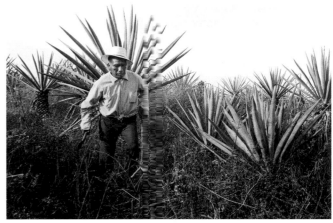

TOP: Chucho clearing weeds around henequen plants. Ruinas de Aké, Yucatán, 1976.
BOTTOM: Chucho walking in a field that needs clearing. Ruinas de Aké, Yucatán, 1976.

and without the benefit of serious efforts to coordinate production and planning, the industry drifted like a rudderless ship. The federal entities charged with administering the industry were, as Mexicans are fond of saying, 'barriles sin fondo'—bottomless wells into which billions of pesos flowed with little apparent lasting benefit for the 57,000 henequen farm workers and their families." Brannon and Baklanoff 1987:5.

The party leaders wanted the workers dependent on them—they didn't want an economically independent peasantry that wouldn't always vote for them. The corruption-ridden and inefficient production structure was the outcome of more than forty years of manipulative, as opposed to participative, politics. Since the Maya on the newly formed ejidos didn't own a specific piece of land (it was communal), they couldn't legally transfer or mortgage it, which meant that they had no incentive or means to improve it. (This changed in 1993 when article 27 of the Mexican Constitution allowed ejido land to be sold and divided in order to comply with NAFTA regulations.) Nor could they make their own decisions on what they wanted to plant or produce—that was done by the federal government. They had to sell the henequen to the federal government, which set the price. The revolutionary promise of land reform in Yucatán meant that the henequeneros had the right to backbreaking unskilled work that didn't even provide subsistence for their families. Agrarian reform in Yucatán restricted rather than promoted growth and opportunities. The system hadn't changed the workers' dependence on their master: now the federal government rather than the hacendados. "To view the structure of production today as substantially better than that of the plantation era," conclude Jeffery Brannon and Eric Baklanoff (1987:186-187), "is to have fallen victim to revolutionary rhetoric and to ignore reality."

In the 1960s the federal government formed Cordomex to oversee the henequen industry. It built new rasping plants and tried to expand the market by building processing plants that produced binder twine, rope, gunnysacks and cloth, padding for upholstery, and carpets and tapestries. But it was too little, too late. Technology was changing. Plastics and synthetic fibers entered and dominated the market.

By 1976 an unpublished internal U.S. government economic report stated: "The outlook for both raw and processed henequen production and exports is rather dim at this stage . . . the domestic henequen industry is faced with an excess of labor and high support prices to producers paid both by Cordomex and [by] the official loan bank in Yucatán, making it necessary for the state government to absorb substantial subsidy losses. Some government sources feel that the industry requires a drastic cutback in both area and in producers, currently numbering 75,000 versus only 25,000 producers actually required to keep up the crop production. The widely announced release of 21 henequen rasping plants to the ejido sector has not yet materialized and will be difficult to implement inasmuch as the latter is rather unskilled both technically and administratively and will require considerable guidance from the Secretariat of Agrarian Reform. Hence, for all practical purposes, these plants continue in the hands of their former owners."

9. Brannon and Baklanoff 1987:185.

10. "The worst bane of the peninsula has been the search for the single quick fix. Monocropping is bad almost anywhere in the world, but nowhere more so than in the Yucatán Peninsula . . . Poor soils, a climate conducive to pests, isolation, and relatively apathetic investors have generally guaranteed that the peninsula was the first to suffer all the ills of monocropping, and often the last to reap any benefits. The henequen growers lost out to foreign competitors even before nylon wrecked the henequen market for good." Anderson et al. 2005:83.

11. "In the peninsula, short-term successes, most notably the famous henequen boom of the late nineteenth and early twentieth centuries, have blinded Mexican and international planners to the long-term unsustainability of monocrop agriculture." Anderson et al. 2005:127. When tequila

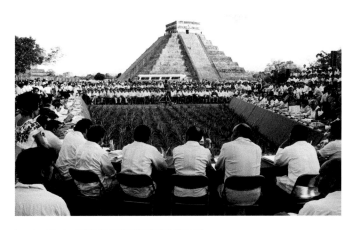

TOP: PRI presidential candidate José López Portillo (*third from right*) campaigning at Chichén Itzá in March 1976, with henequen plants temporarily planted in front of El Castillo. Chichén Itzá, Yucatán, 1976.
BOTTOM: Statue of General Salvador Alvarado in front of a Cordomex plant, getting a cleaning before the visit of the governor of Iowa, sister state of Yucatán. Mérida, Yucatán, 1971.

became very popular, there was a period when producers raised prices and sold everything they could produce. In the early 2000s entrepreneurs were selling the *pina* (pineapple) of the henequen to distilleries in Jalisco, but the government put a stop to it. Tequila is supposed to be distilled from the blue agave grown there. So local businessmen, planning to take advantage of the liquor's popularity, built a distillery in nearby Izamal. Henequen was again going to make the region rich. But they didn't advertise or promote it, and the liquor (named Sisal) didn't compare favorably to tequila.

TOP: Heliodora with her daughters Dorita and Betty. Ruinas de Aké, Yucatán, 2001.
BOTTOM: Francisco Puc Poot rasping a henequen leaf by hand. Many village Maya grow henequen plants in their yards to satisfy their needs. Chichimilá, Yucatán, 1971.

Schoolchildren. Tihosuco, Quintana Roo, 1971.

Epilogue

I wrote this book to tell the stories of Dario and Herculana, Diego and Margarita, Cornelio and Veva, Alicia and Juan, Celso and María, Pablo and Ofelia, Marcelino and Isabel, Eleut and Juliana, and Chucho and Heliodora and those of their family and friends and neighbors. For forty years I have been visiting Mexico, a country that I love. I've been told over and over again that Mexico will never become a modern country as long as there are Indians who haven't been assimilated into the national economy and culture. By this they mean that Indians need to lose their cultural identity. But if Mexico indeed wants its Indians to become part of the Mexican nation, it can begin by appreciating and respecting them. How can a country that earns billions of dollars every year by exploiting the Maya—their name, their history, their archaeological sites, and their land—punish the modern Maya for being Maya or punish the many other Indians in Mexico? Mexico's wealth is its diversity of cultures and the tremendous promise of its indigenous peoples. Until it embraces these, Mexico will never realize its potential as a great nation.

I still can't get over the racism I've witnessed while living in Yucatán. It permeates life in Mexico, with antecedents rooted in the Spanish conquest. From the very beginning the Spanish exploited and discriminated against Indians, whom they did not see as their equals.[1] Spaniards, no matter what their rank or intelligence, were always superior to Indians, and "almost any Spaniard could physically abuse any Indian with impunity."[2] The Spanish also lowered the status of women, who had carried out important roles in Maya religion and had political power. The Spanish clergy and secular authorities couldn't conceive of women in power, so none were appointed.[3]

This belief in the inferiority of Indians remains so pervasive in Mexican society that many Mexicans are genuinely surprised if you suggest that they are racist. But in May 2005 the Mexican government released a survey on discrimination. Josefina Vásquez Mota, Mexico's minister of social development, found the results to be a "crude, painful and startling" picture of Mexican reality. For example, 40 percent of the Mexicans surveyed said that they wouldn't want to live next to an Indian community. Citing the survey, Ginger Thompson wrote in the *New York Times:* "Mexico's 10 million Indians are not only last in almost every social indicator, including levels of literacy, infant mortality, employment and access to basic services. They still appear on television mostly as maids and gardeners."[4]

I've met many Mexicans who deplore the way Indians are treated and don't accept the racism in their society. Mario Escalante, a business leader in Valladolid, is a friend; Charles and I often sat with Mario under the gallery around the courtyard of the colonial house where he was born. Mario turned his ancestral home on the plaza in the center of the historic district into El Mesón del Marqués, Valladolid's best hotel. He kept the original colonial structure and added onto it, rather than tearing it down and putting up a modern building (as some neighbors had). A red cedar has grown tall and grand, and Mario cut a hole in the roof for the tree to grow through. His excellent restaurant features regional cooking, including some of the best Maya cuisine.

One evening over *czotobilchay* (tamales with chaya, ground squash seeds, and hard-boiled eggs) we were discussing the Zapatistas, as was most of Mexico in 2001. Comandanta Esther, an indigenous Maya commander, had recently addressed the Mexican congress on national television.

"Everyone in Mexico watched," Mario said. "I couldn't believe that an Indian woman was on television. Esther was eloquent. All that she asked for was for the indigenous to be treated with respect. She started out speaking so much like a Maya, as you guys know very respectful. She said that it was symbolic that a woman would have the first word."

Mario paused before he continued. "I remember what she said because we all know it is true. She reminded us of the scorn that indigenous women endure because of their dress, their customs, and their poverty. She spoke on behalf of all indigenous women about how hard it is to watch her husband come home from the fields and the coffee and sugar plantations with a weakened body, yet not enough money to feed their children. She spoke of watching her children die, barefoot, with no food or medicine."

Mario confessed: "I started crying. The truth of what she said was so obvious. No one in Mexico should be treated like that."

He leaned forward in his chair and began speaking slow-

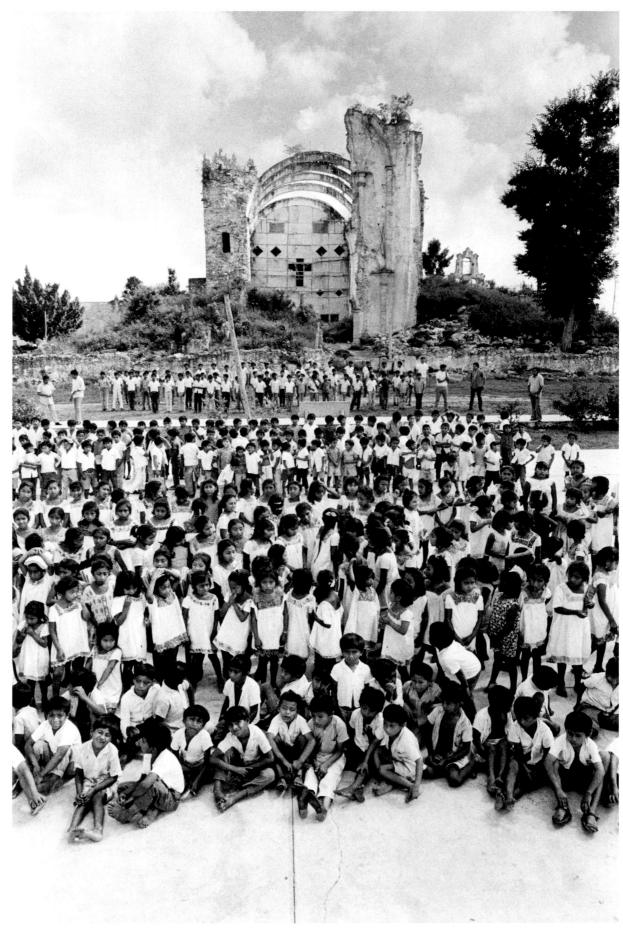

Students and faculty in front of a church damaged in the nineteenth century during the Caste War of Yucatán. Tihosuco, Quintana Roo, 1971.

er and more forcefully, as if he himself was making that speech. "She told us what kind of nation the Zapatistas, and all indigenous people, want Mexico to be—one where the indigenous will be respected. A Mexico where being different is not a reason for death, jail, persecution, mockery, humiliation, or racism. A Mexico where our differences form a united nation, not an unfair colony. Where we rise above our differences to acknowledge what we have in common—that is, being Mexican."

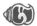

The changes that I've witnessed over the last four decades have been tumultuous. Over their 3,000 years of continued cultural traditions the Maya have shown an ability to adapt and evolve. They survived the Spanish conquest and the Caste War of Yucatán. I remain optimistic that the Maya will continue to survive and keep their traditions and culture. Ironically, it might be tourism that could enable Maya economic and cultural survival. But today there aren't many examples to back my optimism. In Chunyaxché the Maya (with the help and guidance of Amigos de Sian Ka'an, an NGO) have formed a guide co-op to lead tours into the Sian Ka'an Biosphere. It is a moderately successful operation, in which the villagers are the owners. Another example is Alltournative, a private tour operator based in Playa del Carmen. It offers a "Maya Encounter" trip and work in conjunction with three villages near Cobá. The enterprise is envisioned as an ecotourism business that helps the social and economic development of the region. The villagers have enough work to live at home rather than having to seek jobs in Cancún and the Riviera Maya. They are discovering that their Maya culture and traditions are what tourists come to see—that conserving their culture has a long-term economic value.

For tourism to help the Maya, they have to be the owners and operators. A major obstacle to any community development project that seeks government funding is the bureaucracy and mountains of paperwork necessary to submit a proposal. It's a daunting task which ensures that very little money ever gets invested in village projects unless they have help from a nongovernmental outsider familiar with the economic and bureaucratic labyrinth. And the reality is that communities need education and training programs to become aware of international standards and the market they are competing in. They have high expectations, but I've seen failure after failure. I'm disappointed that an industry which generates billions of dollars a year in Quintana Roo doesn't have successful examples of villages working directly in tourism or a comprehensive training program for the Maya.

But the reason I am still optimistic is Francisco Rosado May. Francisco is a mazehual born and raised in Carrillo Puerto. He studied hard and did well in school. His teachers encouraged him, and he earned a government fellowship to go to high school in Chetumal and then college in Tabasco. There he studied agricultural engineering and received his master's degree in tropical ecology, studying with Stephen Gliessman, a visiting professor of agroecology who inspired him to pursue his doctorate at the University of California at Santa Cruz. He was the first Santa Cruz Maya to attend Santa Cruz, a coincidence that was not lost on him.

"Education," Francisco told me. "That is what is important if the Maya are going to succeed in this new world. And education will also lead to self-respect." Francisco was discriminated against in Mexico because of his skin color and indigenous background which affected how he thought about himself and his people. Even though he was the great-grandson of the last rebel Maya general, he'd hardly talked to anyone about his Maya heritage until he came to California for his postgraduate studies. There he met other students, particularly Native Americans, who were proud of their origins. It changed his life—he understood for the first time that he could be proud of who he was and could openly talk about being Maya. He wanted to do something that would make a change. Quintana Roo was the only state in Mexico that didn't have a university and in 1991 Francisco became a founding faculty member of the University of Quintana Roo (UQROO). Later he became the president of the university. During his term he led a team that positioned UQROO within the top three best public universities in Mexico, based on external evaluation of quality in teaching and administration.

In 2007 Francisco became president of the newly created Universidad Intercultural Maya de Quintana Roo, only the tenth intercultural university in Mexico. The university had been Francisco's dream. He'd worked hard with the governor of Quintana Roo and the Mexican government to establish it. I visited him in February 2007, as he was busy interviewing faculty, supervising construction, and designing the courses.

"I want to have a h'men and a scientist teach a class together," Francisco explained. "Have the whole university run this way, with a rigorous academic standard so that we are the equivalent of any other institute of higher learning. Intercultural education offers such a great opportunity—it permits a condition to create new knowledge based on our history and cultural heritage. This is true for any indigenous culture. The way that you process and construct knowledge at home can be very different than the way that you are taught in school. It's often too linear and inflexible at school. There is a real conflict that's transformed into a lack of self-confidence because from a young age you're made to feel dumb, and when you are older you aren't capable of catching up.

"The Maya were performing complex mathematics before the Europeans showed up. We built great cities and explored the heavens. Western mathematics uses the decimal system, and ours is vigesimal. There is a way to integrate the two systems without ignoring either or saying that one is right and the other is wrong. NASA [National Aeronautics and Space Administration] has a project to study Maya mathematics. That's something Mexico should be doing!

"When my great-grandfather overheard foreigners referring to the collapse of the Maya civilization, he told me that

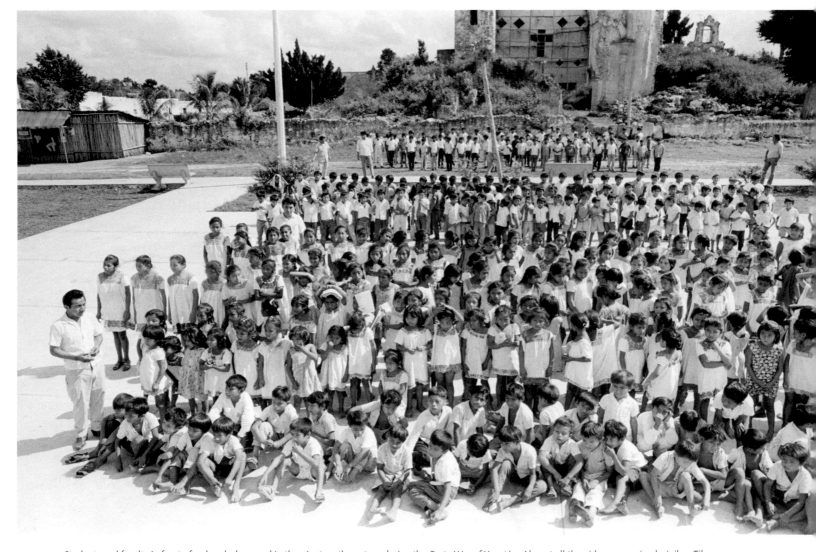

Students and faculty in front of a church damaged in the nineteenth century during the Caste War of Yucatán. Almost all the girls are wearing huipiles. Tihosuco, Quintana Roo, 1971.

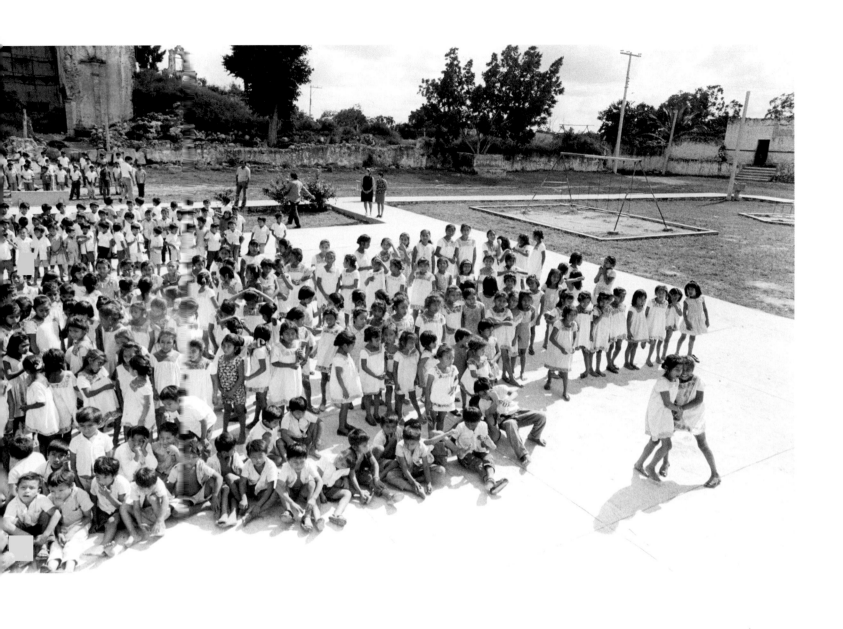

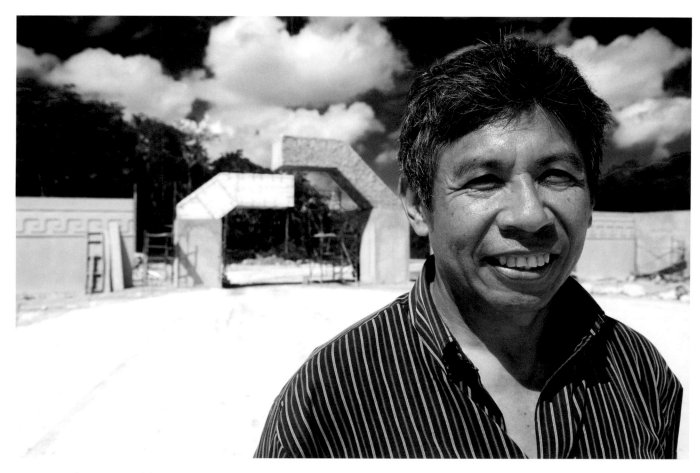

Francisco Rosado May, rector of the Universidad Intercultural Maya de Quintana Roo. José María Morelos, Quintana Roo, 2008.

there hadn't been a collapse. Our culture evolved in cycles, he told me, and when the Spanish conquistadors coincidentally arrived at the end of a cycle we didn't have the opportunity to move to the next level. Three hundred years later the Caste War was an attempt to create conditions for a new cycle to develop. We tried to reinvent our society and religion to bring back our culture.

"My great-grandfather used to say to me, 'Francisco, if there is something you have to do in this life, it's to go to school and do well. That is the reason I signed an agreement with the federal government in 1918—I demanded that they provide an education for my people.' He had it in his mind that education was what we needed."

"So your great-grandfather was optimistic?"

"Yes, of course, although he also had a sharpened machete next to him!" Francisco said, laughing. "Education and self-confidence will be our weapons. The Zapatistas were able to make some changes, but not enough. Education is a way to bring alternatives, to provide options to people who aren't used to having them. Intercultural education is important because it provides the bridge for indigenous students to learn. If we can build their confidence, maybe they will ef-

fect change. Maybe they'll find that applying for international funds is more effective than waiting on local banks and the government to address the problem. They might come up with solutions. I really believe that education can play an important role in making needed changes in our society. We Maya have shown such resilience, for so many years, that I think that we can still do it."

Francisco was still excited when we talked in 2010. "After two and a half years we have nearly five hundred students, and the breakdown is exactly what we were hoping for. Ninety-five percent are Maya, primarily from eighty communities in Quintana Roo and Yucatán, and they're the first of their families to attend a university—the largest group of Maya college students in postconquest history. While we promote their language and culture, the school demands that they master Maya, Spanish, and English, and they're getting an education that makes them as competitive as any other university graduate. When you realize how poorly prepared some of our students are because of the rural education system, this is a real triumph on their part. Our students are really working hard!"

As Dario would say, *Hats'uts'!*

NOTES

1. "They shared with the rest of the European colonizing groups the unswerving conviction of their own cultural superiority. To be fully civilized one must be Christian—Catholic of course—and preferably Spanish. A conviction of cultural superiority may be necessary for the success of any colonizing endeavor. To believe otherwise might weaken the nerve, blur the boundaries between rulers and ruled, and eventually undermine the ties binding colonist to the distant metropolitan center." Farriss 1984:90–91.

2. Farriss 1984:44. "During the decades following the conquest colonial society had been hardening into a system of castes that reduced all social complexities to the simple principle that Spaniards, no matter what their social status, were to be masters in the larger colonial schema; Indians, regardless of hereditary rank and status within their own society, were to be servants." Farriss 1984:99.

"The Maya had every reason to consider these intruders a thorough nuisance. No matter how lowly in station, most non-Indians considered themselves entitled to deference, food, and transport from the Indians." Farriss 1984:212.

3. "One of the tragedies of European colonialism in America was the transformation of great civilizations into peasantries . . . To the Maya was assigned the role of a peasantry, that is, members of rural communities producing the goods required for the survival of the higher social classes, which in Yucatán were composed of mixed-race people and Spaniards. The Indians, then, made up a part, but only a part, of a larger society. As a result, cultural expression ceased to be the product of a variety of classes, and instead became associated only with the peasantry. Maya culture became peasant culture.' Patch 1993:67; see also Patch 1993:24–25.

4. Thompson 2005

5. When the Maya archaeological sites were rediscovered in the nineteenth century, many Westerners weren't about to credit a major civilization to people who lived in the jungle—only savages lived there. They believed that civilizations came from more temperate zones, so they speculated that these mysterious "lost ruins" were built by everyone from the Phoenicians, Greeks, Egyptians, Scandinavians, Lost Tribes of Israel, or survivors of the lost continents of Atlantis and Mu to extraterrestrials who arrived by spaceship. Ever since there has been a lunatic fringe attracted to Maya archaeology. See Wauchope 1962.

TOP: Alina Ballote Blanco, English teacher, native of José María Morelos, in her classroom at Universidad Intercultural Maya de Quintana Roo. José María Morelos, Quintana Roo. 2008.

BOTTOM: Students at Universidad Intercultural Maya with local community members who worked together to collect recipes for a gastronomic project. La Presumida, Quintana Roo. 2011.

Glossary

"In Maya studies, spelling has always been a problem," wrote Linda Schele and Peter Mathews in *The Code of Kings*, a book we worked on together. How do you suggest sounds that don't exist in your own language? Over the centuries, many different conventions have been devised. "Modern scholars have continued to add their own orthographies to the resulting hodgepodge so that the same word appears in many different spellings causing confusion among scholars and interested readers alike." In 1980 the *Diccionario Maya Cordemex* was first published in Mérida, Yucatán, but its attempt to standardize orthography hasn't been universally accepted. However, until something better comes out, I have generally used it for spelling.

Adding the suffix -*'ob* to a Mayan noun makes it plural. As John Montgomery points out in his *Maya (Yucatec) Dictionary & Phrasebook,* however, there are exceptions. *Wah,* the word for tortilla, never takes the plural suffix. And as a rule nouns are rarely pluralized after numbers and quantifiers. Mayan orthography is only now being worked out, so earlier texts used -*ob* rather than -*'ob* as the plural. To complicate this, the Spanish -*es* is sometimes added to make the plural rather than the Mayan -*'ob*/-*ob*. An example in general use would be *sacbe/sacbes* for the Precolumbian roads the Maya built and *dzul/dzules,* the word for anyone not Maya.

aguardiente: firewater (literally "burning water"); in Yucatán it means a cheap cane-based alcohol

ahkin: the Maya chief priest (literally "sun king")

bakche': a husking tool traditionally made from a deer horn but now more likely made of hardwood

balche': the sacred wine made from water, honey, and the bark of the balche tree, which ferments quickly into an intoxicating drink that is both emetic and purgative

batea: a washtub hollowed from a single piece of wood

cacique: a village chief

cargador: the sponsor for a day during a fiesta, whose duties include feeding everyone

cenote: a sinkhole or natural well

Ch'a Chaak: a ceremony to petition the rain god Chaak

chi'ch': rock and gravel mounds (probably agricultural features that acted as a mulch to hold moisture in the soil)

chi'ik: both the master of ceremonies during a fiesta and a jokester; named after the white-nosed coati, a mischievous animal famous for stealing food from the milpa but sometimes kept as a pet

Chilam Balam: Book of the Prophet Balam; books written in Mayan during the colonial period using European script

coa: a hook-shaped knife with a long handle

dzul: anyone not Maya, including people of mixed blood who are Mexican in outlook

hats'uts': beautiful, nice, very good

hierbatero or **hierbero:** an herbalist, herb doctor

h'men: a Maya lay priest or medicine man who conducts Maya religious ceremonies and performs the function of a spiritual doctor

huipil: a commodious dress shaped in the form of a billowing "T," brightened by an embroidered bouquet of flowers and designs across the bodice and hem

k'aanche': a raised garden bed made from lashed poles for growing plants to keep animals from reaching them

k'anche': a wooden sitting stool

kuch: a load carrier, the person responsible for providing food and drink for everyone on each day of the fiesta; *nohoch kuch* means big load carrier

lek: a bowl or container made from bottle gourd (*Lagenaria siceraria*)

luch: a cup or bowl made from a gourd of the calabash tree (*Crescentia cujete*)

maquiladora: a large factory where raw materials imported from abroad are turned into something useful and then exported back out of the country

matan: an offering or gift, referring to the ceremonial preparation of food, its blessing, and its distribution to everyone in attendance

mayapax: Maya music, traditionally played by two violinists, a snare drum, a bass drum, and sometimes a trumpet

mazehual: the Maya, the people of the land

mecapal: a tumpline used for carrying loads

mecate: 20 linear meters or 20 meters squared (in Yucatán usage)

milpa: a farm

Nohoch Tata: literally "Great Father," the high priest of the church

oksik sakah: to offer sakah, a simple ceremony that a farmer performs in the milpa

pay wakax che: literally "fight the wooden bull," the Maya bullfight, in which a man puts on a bull costume and acts like a wild bull

pet kot: a circular wall of stones (the term usually refers to small patches of tall forest planted by the Maya to concentrate and protect useful plants)

pib: an earth oven

pibil: baked (in an earth oven)

pibil nah: ears of corn roasted in an earth oven

popol nah: the community house

prioste: a sacristan

quinceañera: a fifteenth birthday party for a girl

sabukan: a carrying bag made locally of native sisal on a back-strap loom

sacbe: a road (literally "white road")

sakah: a sacred corn drink of the Yucatecan Maya offered to the gods by a h'men or farmer during ceremonies

sakan: corn dough or masa

Santa Cruz Tun Chuumuk Lu'um: Saintly Cross of the Center of the Earth, located in Xocen, Yucatán

saskab: calcareous white marl

solar: a yard around a Maya house

sudario: an embroidered cloth (similar to a huipil) draped over the arms of a cross

suhuy k'ak': literally "virgin fire," referring to the new fire ceremony (also called *tumben k'ak'*, new fire)

suum: rope

tatich: the patron of the cross

terno: a richly embroidered three-piece dress ensemble based on the huipil

tumben k'ak': literally "new fire," referring to new fire ceremony (also called *suhuy k'ak'*)

wach: an outsider (like *dzul*), a term often used for soldiers

wah: corn bread

Suggested Reading

Allen, Michael F., and Emmanuel Rincón. 2003. The Changing Global Environment and the Lowland Maya: Past Patterns and Current Dynamics. In *The Lowland Maya Area: Three Millennia at the Human-Wildland Interface,* ed. Arturo Gómez-Pompa, Michael F. Allen, Scott L. Fedick, and Juan J. Jiménez-Osornio, 13–29. New York: Food Products Press.

Anderson, E. N. 2008. *Mayaland Cuisine.* Lulu Publishing (online).

Anderson, E. N., Aurora Dzib Xihum de Cen, Felix Medina Tzuc, and Pastor Valdez Chale. 2005. *Political Ecology in a Yucatec Maya Community.* Tucson: University of Arizona Press.

Anderson, E. N., and Felix Medina Tzuc. 2005. *Animals and the Maya in Southeast Mexico.* Tucson: University of Arizona Press.

Atran, Scott. 1993. Itza Maya Tropical Agro-Forestry. *Current Anthropology* 34(5): 633–700.

Atran, Scott, Douglas Medin, and Norbert Ross. 2004. Evolution and Devolution of Knowledge: A Tale of Two Biologies. *Journal of the Royal Anthropological Institute* 10(2): 395–420.

Bainbridge, David A., and Arturo Gómez-Pompa. 1995. Tropical Forestry as If People Mattered. In *Tropical Forests: Management and Ecology,* ed. Ariel E. Lugo and Carol Lowe, 408–422. New York: Springer-Verlag.

Barrera Vásquez, Alfredo. 1980. *Diccionario Maya Cordemex.* Mérida: Ediciones Cordemex.

Bartolomé, Miguel Alberto, and Alicia Mabel Barabas. 1981. *La resistencia maya: Relaciones interétnicas en el Oriente de la Península de Yucatán.* Colección Científica, 53. Mexico City: Instituto Nacional de Antropología e Historia.

Berry, Wendell. 2009. Preface. In Masanobu Fukuoka, *The One-Straw Revolution: An Introduction to Natural Farming,* xi–xv. New York: New York Review of Books.

Blom, Frans, and Oliver La Farge. 1926. *Tribes and Temples: A Record of the Expedition to Middle America Conducted by the Tulane University of Lousiana in 1925.* 2 vols. New Orleans: Tulane University of Louisiana.

Blow, Charles M. 2011. Drug Bust. *New York Times,* June 11, A19.

Brannon, Jeffery, and Eric N. Baklanoff. 1987. *Agrarian Reform and Public Enterprise in Mexico: The Political Economy of Yucatán's Henequen Industry.* Tuscaloosa: University of Alabama Press.

Brannon, Jeffery, and Gilbert M. Joseph, eds. 1991. *Land, Labor and Capital in Modern Yucatán.* Tuscaloosa: University of Alabama Press.

Bricker, Victoria R. 1981. *The Indian Christ, The Indian King: The Historical Substrate of Maya Myth and Ritual.* Austin: University of Texas Press.

Bunson, Margaret R., and Stephen M. Bunson. 1996. *Encyclopedia of Ancient Mesoamerica.* New York: Facts on File.

Burns, Allan F. 1983. *An Epoch of Miracles: Oral Literature of the Yucatec Maya.* Austin: University of Texas Press.

Campbell, David G., Anabel Ford, Karen Lowell, Jay Walker, Jeffrey K. Lake, Constanza Ocampo-Raeder, Andrew Townesmith, and Michael Balick. 2006. The Feral Forests of the Eastern Petén. In *Time and Complexity in Historical Ecology: Studies in the Neotropical Lowlands,* ed. Clark Erickson and William Baleé, 21–55. New York: Columbia University Press.

Castelló Yturbide, Teresa. 1987. *Presencia de la comida prehispánica.* Mexico City: Banamex.

Chase, Diane Z., and Arlen F. Chase. 2004. Hermeneutics, Transitions, and Transformations in Classic to Postclassic Maya Society. In *The Terminal Classic in the Maya Lowlands: Collapse, Transition, and Transformation,* ed. Arthur Demarest, Prudence M. Rice, and Don S. Rice, 12–27. Boulder: University Press of Colorado.

Clendinnen, Inga. 2003. *Ambivalent Conquests: Maya and Spaniard in Yucatan, 1517–1570.* 2nd ed. Cambridge: Cambridge University Press.

Coe, Michael. 2004. Gods of the Scribes & Artists. In *Courtly Art of the Ancient Maya* by Mary Miller and Simon Martin, 239–241. London/New York, Thames & Hudson.

———. 2005. *The Maya.* 7th ed. London/New York: Thames & Hudson.

Coe, Michael, and Justin Kerr. 1998. *The Art of the Maya Scribe.* New York: Abrams.

Colunga-García Marín, Patricia. 2003. The Domestication of Henequen. In *The Lowland Maya Area: Three Millennia at the Human-Wildland Interface,* ed. Arturo Gómez-

Pompa, Michael F. Allen, Scott L. Fedick, and Juan J. Jiménez-Osornio, 439–446. New York: Food Products Press.

Demarest, Arthur. 2004. *The Rise and Fall of a Rainforest Civilization*. Cambridge: Cambridge University Press.

Demarest, Arthur A., Prudence M. Rice, and Don S. Rice. 2004a. The Terminal Classic in the Maya Lowlands: Assessing Collapses, Terminations, and Transformations. In *The Terminal Classic in the Maya Lowlands: Collapse, Transition, and Transformation,* ed. Arthur A. Demarest, Prudence M. Rice, and Don S. Rice, 545–572. Boulder: University Press of Colorado.

———, eds. 2004b. *The Terminal Classic in the Maya Lowlands: Collapse, Transition, and Transformation.* Boulder: University Press of Colorado.

Diamond, Jared. 2005. *Collapse: How Societies Choose to Fail or Succeed.* New York: Viking.

Díaz del Castillo, Bernal. 1956. *The Discovery and Conquest of Mexico.* New York: Farrar, Straus & Cudahy.

Dickerson, Marla. 2006. Placing Blame for Mexico's Ills. *Los Angeles Times,* July 1, C1.

Dobyns, H. F. 1966. Estimating Aboriginal American Population: An Appraisal of Techniques with a New Hemispheric Estimate. *Current Anthropology* 7: 395–416.

Dowie, Mark. 2005. Conservation Refugees—When Protecting Nature Means Kicking People Out. *Orion Magazine* (Great Barrington) 24(26): 16–27.

Dresser, Denise. 2006. They Hate Him, But They Made Him. *Los Angeles Times,* June 26, B11.

Dumond, Don E. 1997. *The Machete and the Cross: Campesino Rebellion in Yucatan.* Lincoln: University of Nebraska Press.

Everton, Macduff. 1991. *The Modern Maya: A Culture in Transition.* Albuquerque: University of New Mexico Press.

Farriss, Nancy. 1984. *Maya Society under Colonial Rule: The Collective Enterprise of Survival.* Princeton: Princeton University Press.

Faust, Betty Bernice. 1998. *Mexican Rural Development and The Plumed Serpent.* Westport: Bergin & Garvey.

Fedick, Scott L. 1989. The Economics of Agricultural Land Use and Settlement in the Upper Belize River Valley. In *Prehistoric Maya Economies of Belize,* ed. Patricia A. McAnany and Barry L. Isaac, 215–254. Greenwich: JAI Press.

———, ed. 1996. *The Managed Mosaic: Ancient Maya Agriculture and Resource Use.* Salt Lake City: University of Utah Press.

———. 1998. Ancient Maya Use of Wetlands in Northern Quintana Roo, Mexico. In *Hidden Dimensions: The Cultural Significance of Wetland Archaeology,* ed. Kathryn Bernick, 107–129. Vancouver: University of British Columbia Press.

———. 2003. In Search of the Maya Forest. In *In Search of the Rain Forest,* ed. Candace Slater, 133–164. Durham/London: Duke University Press.

———. 2010. The Maya Forest: Destroyed or Cultivated by the Ancient Maya. *Proceedings of the National Academy of Sciences* 107(3): 953–954.

Fedick, Scott L., María de Lourdes Flores Delgadillo, Sergey Sedov, Elizabeth Solleiro Rebolledo, and Servio Palacios Mayorga. 2008. Adaptation of Maya Homegardens by "Container Gardening" in Limestone Bedrock Cavities. *Journal of Ethnobiology* 28(2): 290–304.

Fedick, Scott L., and Anabel Ford. 1990. The Prehistoric Agricultural Landscape of the Central Maya Lowlands: An Examination of Local Variability in a Regional Context. *World Archaeology* 22: 18–33.

Fields, Virginia M., and Dorie Reents-Budet. 2005. *Lords of Creation: The Origins of Sacred Maya Kingship.* London: Scala Publishers Ltd/Los Angeles: Los Angeles County Museum of Art.

Ford, Anabel. 2008. Dominant Plants of the Maya Forest and Gardens of El Pilar: Implications for Paleoenvironmental Reconstructions. *Journal of Ethnobiology* 28(2): 179–199.

———. 2009. Origins of the Maya Forest Garden: Maya Resource Management. *Journal of Ethnobiology* 29(2): 213–236.

Ford, Anabel, Keith C. Clarke, and Gary Raines. 2009. Modeling Settlement Patterns of the Late Classic Maya with Bayesian Methods and GIS. *Annals of the Association of American Geographers* 28: 179–199.

Ford, Anabel, and Kitty F. Emery. 2008. Exploring the Legacy of the Maya Forest. *Journal of Ethnobiology* 28(2): 147–153.

Ford, Anabel, and Ronald Nigh. 2009. Origins of the Maya Forest Garden: Maya Resource Management. *Journal of Ethnobiology* 29(2) (Fall/Winter): 213–236.

———. 2011. Resilience and Adaptive Management: Climate Change in the Ancient Maya Forest. In *The Great Maya Droughts in Cultural Context,* ed. Gyles Iannone. Boulder: University Press of Colorado. In press.

Foster, Lynn. 2002. *Handbook to Life in the Ancient Maya World.* New York: Facts on File Library.

Freidel, David, Linda Schele, and Joy Parker. 1993. *Maya Cosmos: Three Thousand Years on the Shaman's Path.* New York: William Morrow.

Fuentes, Carlos. 1992. *The Buried Mirror: Reflections on Spain and the New World.* Boston: Houghton Mifflin Company.

———. 1996. *A New Time for Mexico.* New York: Farrar, Straus & Giroux.

García Quintanilla, Alejandra. 2000. El dilema de Ah Kimsah K'ax, "El Que Mata al Monte": Significados del monte entre los mayas milperos de Yucatán. *Mesoamérica* 21(39): 255–286.

Gliessman, Steve, Amador Alarcón, Francisco Rosado-May, and B. L. Turner. 1985. Ancient Raised Field Agriculture in the Maya Lowlands of Southeastern Mexico. In *Prehistoric Intensive Agriculture in the Tropics,* ed. I. S. Farrington, 97–111. BAR International Series 232. Oxford: BAR.

Gómez-Pompa, Arturo. 1987. Tropical Deforestation and Maya Silviculture: An Ecological Paradox. *Tulane Studies in Zoology and Botany* 26: 19–37.

Gómez-Pompa, Arturo, Michael F. Allen, Scott L. Fedick, and

Juan J. Jiménez-Osornio, eds. 2003. *The Lowland Maya Area: Three Millennia at the Human-Wildland Interface.* New York: Food Products Press.

Gómez-Pompa, Arturo, and Andrea Kaus. 1987. The Conservation of Resources by Traditional Cultures in the Tropics. Paper presented at the World Wilderness Congress, Estes Park, Colorado.

———. 1990. Traditional Management of Tropical Forests in Mexico. In *Alternatives to Deforestation: Steps towards Sustainable Use of the Amazon Rainforest,* ed. Anthony Anderson, 45–54. New York: Columbia University Press.

Gómez-Pompa, Arturo, Andrea Kaus, Juan J. Jiménez-Osornio, David A. Bainbridge, and Veronique M. Rorive. 1993. Mexico. In *Sustainable Agriculture and the Environment in the Humid Tropics,* comp. National Research Council, 483–548. Washington, D.C.: National Academies Press.

Gómez-Pompa, Arturo, José Salvado Flores, and Victoria Sosa. 1987. The "Pet Kot": A Man-Made Tropical Forest of the Maya. *Interciencia* 12: 10–15.

Graham, Alistair, and Peter Beard. 1973. *Eyelids of Morning.* New York: New York Graphic Society.

Grube, Nikolai, ed. 2001. *Maya Divine Kings of the Rain Forest.* Cologne: Könemann.

Hamman, Cherry. 1993. *Mayan Cooking: Recipes from the Sun Kingdoms of Mexico.* New York: Hippocrene Books.

Hartig, Helga-Marie. 1979. *Las Aves de Yucatan/The Birds of Yucatan.* Mérida: Fondo Editorial de Yucatán.

Hervik, Peter. 1999 *Mayan People within and beyond Boundaries: Social Categories and Lived Identity in Yucatán.* Amsterdam: Harwood Academic Publishers.

Hodell, David A., Flavio S. Anselmetti, Daniel Ariztegui, Mark Brenner, Jason H. Curtis, Adrian Gilli, Dustin A. Grzesik, Thomas J. Guilderson, Andreas D. Müller, Mark B. Bush, Alexander Correa-Metrio, Jaime Escobar, and Steffen Kutterolf. 2008. AN 85-ka Record of Climate Change in Lowland Central America. *Quaternary Science Reviews* 27: 1152–1165.

Hollmann, Ralf. 2008. *NotTheNews Yucatan Dictionary: A Handy Guide to Understanding Spanish in the Yucatan.* Lulu n Me (online).

Houston, Stephen D. Symbolic Sweatbands of the Maya: Architectural Meaning in the Cross Group at Palenque, Mexico. *Latin American Antiquity* (7)2:132–151.

Huxley, Matthew, and Cornell Capa. 1964. *Farewell to Eden.* New York: Harper & Row.

Iannone, Gyles, ed. 2011. *The Great Maya Droughts in Cultural Context.* Boulder: University Press of Colorado. In press.

Irigoyen, Renan. 1973. *Calendario de fiestas tradicionales de Yucatan.* Mérida: Ediciones del Gobierno del Estado.

Iritani, Evelyn, and Marla Dickerson. 2005. A World Unravels: Clothes Will Cost Less. *Los Angeles Times,* January 16, C1.

Islebe, Gerald A., Henry Hooghiemstra, Mark Brenner, Jason H. Curtis, and David A. Hodell. 1996. A Holocene Vegetation History from Lowland Guatemala. *Holocene* 6: 265–271.

Iyer, Pico. 2000. *The Global Soul: Jet Lag, Shopping Malls, and the Search for Home.* New York: Knopf.

Jiménez-Osornio, Juan J., and Arturo Gómez-Pompa. 1989. Human Role in Shaping of the Flora in a Wetland Community, the Chinampa. Paper presented at the International Conference on Wetlands, Leiden, Netherlands.

Jones, Grant. 1977. *Anthropology and History in Yucatán.* Austin: University of Texas Press.

———. 1998. *The Conquest of the Last Maya Kingdom.* Palo Alto: Stanford University Press.

Joseph, Gilbert M. 1986. *Rediscovering the Past at Mexico's Periphery: Essays on the History of Modern Yucatán.* Tuscaloosa: University of Alabama Press.

———. 1988. *Revolution from Without: Yucatán, Mexico, and the United States, 1880–1924.* Durham: Duke University Press.

Juárez, Ana. 2002. Ongoing Struggles: Mayas and Immigrants in Tourist Era Tulum. *Journal of Latin American Anthropology* 7(1) (January): 34–67.

Kimball, Charles. 2002. *When Religion Becomes Evil.* New York: HarperSanFrancisco.

Kristof, Nicholas. 2009. Drugs Won the War. *New York Times,* June 14, WK10.

Kunow, Marianna Appel. 2003. *Maya Medicine: Traditional Healing in Yucatán.* Albuquerque: University of New Mexico Press.

Lattin, Don. 2003. Just Which Commandments Are the 10 Commandments? *San Francisco Chronicle,* August 26, A2.

Laughlin, Robert. 1975. *The Great Tzotzil Dictionary of San Lorenzo Zinacantán.* Washington, D.C.: Smithsonian Institution Press.

Lawler, Andrew. 2010. Collapse? What Collapse? Societal Change Revisited. *Science* 330 (November 12): 907–909.

Lee, Julian C. 1996. *The Amphibians and Reptiles of the Yucatán Peninsula.* Ithaca: Cornell University Press.

———. 2000. *A Field Guide to the Amphibians and Reptiles of the Maya World.* Ithaca: Cornell University Press.

Love, Bruce. 2004. *Maya Culture of Yucatan Today.* Mérida: Editorial Dante.

Luxton, Richard, and Pablo Balam. 1981. *The Mystery of the Mayan Hieroglyphs.* New York: Harper & Row.

Mann, Charles. 2005. *1491.* New York: Knopf.

Martin, Simon. 2003. In Line of the Founder: A View of Dynastic Politics at Tikal. In *Tikal: Dynasties, Foreigners, and Affairs of State,* ed. Jeremy Sabloff, 3–45. Santa Fe: School of American Research Press.

Martin, Simon, and Nikolai Grube. 2000. *Chronicle of the Maya Kings and Queens.* London/New York: Thames & Hudson.

Martínez, Maximino. 1979. *Catálogo de nombres vulgares y científicos de plantas mexicanas.* Mexico City: Fondo de Cultura Económica.

Martínez, Nurit. 2006. Disparidad en gasto educativo margina a niños indígenas. *El Universal* (Mexico City), September 25 (http://www.eluniversal.com.mx/nacion/143447.html).

Masson, Marilyn A., and Shirley Boteler Mock. 2004. Ceramics and Settlement Patterns at Terminal Classic–Period Lagoon Sites in Northeastern Belize. In *The Terminal Classic in the Maya Lowlands: Collapse, Transition, and Transformation,* ed. Arthur A. Demarest, Prudence M. Rice, and Don S. Rice, 367–401. Boulder: University Press of Colorado.

Mathews, Jennifer P., and Bethany A. Morrison. 2006. *Lifeways in the Northern Maya Lowlands: New Approaches to Archaeology in the Yucatán Peninsula.* Tucson: University of Arizona Press.

Mathews, Jennifer P., and Gillian P. Schultz. 2009. *Chicle: The Chewing Gum of the Americas, from the Ancient Maya to William Wrigley.* Tucson: University of Arizona Press.

Mathews, Jennifer P., and Justine M. Shaw, eds. 2005. *Quintana Roo Archaeology.* Tucson: University of Arizona Press.

Matthiessen, Peter, and Eliot Porter. 1972. *The Tree Where Man Was Born.* New York: E. P. Dutton.

Maugh, Thomas H., II. 2010. Tomb May Hold Early Maya King. *Los Angeles Times,* July 26, A4.

McAnany, Patricia A., and Tomás Gallareta Negrón. 2009. Bellicose Rulers and Climatological Peril: Retrofitting Twenty-first-Century Woes on Eighth-Century Maya Society. In *Questioning Collapse: Human Resilience, Ecological Vulnerability, and the Aftermath of Empire,* ed. Patricia A. McAnany and Norman Yoffee, 142–175. Cambridge: Cambridge University Press.

McKillop, Heather. 2004. *The Ancient Maya: New Perspectives.* New York: W. W. Norton.

Menchú, Rigoberta. 1984. *I, Rigoberta Menchú: An Indian Woman in Guatemala.* London: Verso.

Miller, Loretta Scott. 2003. *A Yucatan Kitchen: Regional Recipes from Mexico's Mundo Maya.* Gretna, La.: Pelican Publishing Company.

Miller, Mary, and Simon Martin. 2004. *Courtly Art of the Ancient Maya.* New York: Thames & Hudson.

Miller, Mary, and Karl Taube. 1993. *An Illustrated Dictionary of the Gods and Symbols of Ancient Mexico and the Maya.* London/New York: Thames & Hudson.

Montgomery, John. 2004. *Maya (Yucatec) Dictionary & Phrasebook.* New York: Hippocrene Books.

Morley, Sylvanus G. 1983. *The Ancient Maya.* Stanford: Stanford University Press.

Morrison, Bethany A., and Roberto Cózatl-Manzano. 2003. Initial Evidence for Use of Periphyton as an Agricultural Fertilizer by the Ancient Maya Associated with the El Edén Wetland, Northern Quintana Roo, Mexico. In *The Lowland Maya Area: Three Millennia at the Human-Wildland Interface,* ed. Arturo Gómez-Pompa, Michael F. Allen, Scott L. Fedick, and Juan J. Jiménez-Osornio, 401–413. New York: Food Products Press.

Nigh, Ronald. 2008. Trees, Fire and Farmers: Making Woods and Soil in the Maya Forest. *Journal of Ethnobiology* 28(2): 231–243.

Ortiz, Simon J. 2000. *From Sand Creek.* Tucson: University of Arizona Press.

Oster, Patrick. 2002. *Mexicans: A Personal Portrait of a People.* New York: Rayo.

Patch, Robert W. 1993. *Maya and Spaniard in Yucatan, 1648–1812.* Stanford: Stanford University Press.

———. 2002. *Maya Revolt and Revolution in the Eighteenth Century.* Armonk, N.Y.: M. E. Sharpe.

Peissel, Michel. 1963. *The Lost World of Quintana Roo.* New York: E. P. Dutton.

Perry, Richard, and Rosalind Perry. 1988. *Maya Missions: Exploring the Spanish Colonial Churches of Yucatan.* Santa Barbara: Espadaña Press.

Pollan, Michael, 2001. *The Botany of Desire: A Plant's-Eye View of the World.* New York: Random House.

———. 2004. A Flood of U.S. Corn Rips at Mexico. *Los Angeles Times,* April 23.

———. 2006. *The Omnivore's Dilemma.* New York: Penguin Press.

Quinones, Sam. 2001. *True Tales from Another Mexico.* Albuquerque: University of New Mexico Press.

Raban, Jonathan. 1999. *Passage to Juneau.* New York: Pantheon Books.

Re Cruz, Alicia. 1996. *The Two Milpas of Chan Kom.* Albany: State University of New York Press.

Redfield, Robert. 1941. *The Folk Culture of Yucatan.* Chicago: University of Chicago Press.

Redfield, Robert, and Alfonso Villa Rojas. 1934. *Chan Kom: A Maya Village.* Washington, D.C.: Carnegie Institution.

Reed, Nelson. 2001. *The Caste War of Yucatán.* Revised ed. Stanford: Stanford University Press.

Reents-Budet, Dorie, and Justin Kerr. 1994. *Painting the Maya Universe: Royal Ceramics of the Classic Period.* Durham/London: Duke University Press.

Restall, Matthew. 1998. *Maya Conquistador.* Boston: Beacon Press.

Rice, Prudence M., Arthur A. Demarest, and Don S. Rice. 2004. The Terminal Classic and the "Classic Maya Collapse" in Perspective. In *The Terminal Classic in the Maya Lowlands: Collapse, Transition, and Transformation,* ed. Arthur A. Demarest, Prudence M. Rice, and Don S. Rice, 1–11. Boulder: University Press of Colorado.

Rivero, Piedad Peniche. 2003. Milpero and Lunero to Henequenero: A Transition to Capitalism in Yucatán, Mexico. In *The Maya Lowland Area: Three Millennia at the Human-Wildland Interface,* ed. Arturo Gómez-Pompa, Michael F. Allen, Scott L. Fedick, and Juan J. Jiménez-Osornio, 571–584. New York: Food Products Press.

Romero, Rolando J. 1992. Texts, Pre-Texts, Con-Texts: Gonzalo Guerrero in the Chronicles of Indies. Discussion Paper No. 87, University of Wisconsin–Milwaukee. https://pantherfile.uwm.edu/pfister/www/projects/clacs/resources/pubs/pdf/romero87.pdf.

Ross-Ibarra, Jeffrey. 2003. Origen y domesticación de la chaya (*Cnidoscolus aconitifolius* Mill I. M. Johnst): La espina-

ca maya. *Mexican Studies/Estudios Mexicanos* 19 (2) (Summer): 287–302.

Roys, Ralph L. 1952. *Conquest Sites and the Subsequent Destruction of Maya Architecture in the Interior of Northern Yucatan.* American Anthropology and History, no. 54. Publication 596. Washington, D.C.: Carnegie Institution of Washington.

———. 1967. *The Book of Chilam Balam of Chumayel.* Norman: University of Oklahoma Press.

———. 1972. *The Indian Background of Colonial Yucatan.* Norman: University of Oklahoma Press. Reproduced from the first edition: Civilization of the American Indian, Vol. 118. Washington, D.C.: Carnegie Institution of Washington, 1943.

Rugeley, Terry. 1995. *Yucatán's Maya Peasantry & the Origins of the Caste War.* Austin: University of Texas Press.

———, ed. 2001. *Maya Wars: Ethnographic Accounts from Nineteenth-Century Yucatán.* Norman: University of Oklahoma Press.

Rzedowski, Jerzy. 1978. *Vegetación de México.* Mexico City: Editorial Limusa.

Sabloff, Jeremy A. 1989. *The Cities of Ancient Mexico: Reconstructing a Lost World.* London/New York: Thames & Hudson.

———. 1990. *The New Archaeology and the Ancient Maya.* New York: Scientific American Library.

———, ed. 2003. *Tikal: Dynasties, Foreigners, and Affairs of State.* Santa Fe: School of American Research Press.

Sabloff, Jeremy A., and William Laurens Rathje. 1975. The Rise of a Maya Merchant Class. *Scientific American* 233: 72–82.

Saragoza, Alex. 2004. Tourism in Baja: Of Marinas and Mirages. *Berkeley Review of Latin American Studies* (Fall 2004): 6–7, 40–41.

Schele, Linda, and David Freidel. 1990. *A Forest of Kings: The Untold Story of the Ancient Maya.* New York: William Morrow.

Schele, Linda, Peter Mathews, Justin Kerr, and Macduff Everton. 1998. *The Code of Kings: The Language of Seven Sacred Maya Temples and Tombs.* New York: William Morrow.

Schele, Linda, and Mary Ellen Miller. 1986. *The Blood of Kings: Dynasty and Ritual in Maya Art.* New York: George Braziller.

Schlesinger, Victoria. 2001. *Animals & Plants of the Ancient Maya.* Austin: University of Texas Press.

Sharer, Robert J., and Loa P. Traxler. 2006. *The Ancient Maya.* Stanford: Stanford University Press.

Standage, Tom. 2005. *A History of the World in 6 Glasses.* New York: Walker & Co.

Stephens, John L. 1963. *Incidents of Travel in Yucatan.* New York: Dover.

———. 1969. *Incidents of Travel in Central America Chiapas and Yucatan.* New York: Dover.

Sullivan, Paul. 1989. *Unfinished Conversations: Mayas and Foreigners between Two Wars.* New York: Knopf.

———. 2004. *Xuxub Must Die: The Lost Histories of a Murder on the Yucatan.* Pittsburgh: University of Pittsburgh Press.

Taube, Karl A. 1985. The Classic Maya Maize God: A Reappraisal. In *Fifth Palenque Round Table,* ed. Merle Greene Robertson, 171–181. San Francisco: Pre-Columbian Art Research Institute.

———. 2003. Ancient and Contemporary Maya Conceptions about Field and Forest. In *The Lowland Maya Area: Three Millennia at the Human-Wildland Interface,* ed. Arturo Gómez-Pompa, Michael F. Allen, Scott L. Fedick, and Juan J. Jiménez-Osornio, 461–492. New York: Food Products Press.

Tedlock, Dennis. 1985. *Popol Vuh.* New York: Touchstone.

———. 1992. The Popul Vuh as a Hieroglyphic Book. In *New Theories on the Ancient Maya,* ed. Elin C. Danien and Robert J. Sharer, 229–240. Philadelphia: University Museum of the University of Pennsylvania.

Terán, Sylvia, and Christian H. Rasmussen, eds. 1992. *Relatos del centro del mundo.* Mérida: Instituto de Cultura de Yucatán.

Terzani, Tiziano. 1997. *A Fortune-Teller Told Me: Earthbound Travels in the Far East.* New York: Harmony, Random House.

Thompson, Edward Herbert. 1932. *People of the Serpent.* Boston: Houghton Mifflin Company.

Thompson, Ginger. 2005. Uneasily, a Latin Land Looks at Its Own Complexion. *New York Times,* May 19, A4.

Thompson, J. Eric S. 1954. *The Rise and Fall of Maya Civilization.* Norman: University of Oklahoma Press.

Tozzer, Alfred M. 1941. *Landa's Relación de las cosas de Yucatán.* Washington, D.C.: Carnegie Institution of Washington.

Vandervort, Bruce. 2006. *Indian Wars of Mexico, Canada and the United States, 1812–1900.* New York/London: Routledge.

Villa Rojas, Alfonso. 1945. *The Maya of East Central Quintana Roo.* Washington, D.C.: Carnegie Institution of Washington.

Warman, Arturo. 2003. *Corn & Capitalism: How a Botanical Bastard Grew to Global Dominance.* Chapel Hill: University of North Carolina Press.

Wauchope, Robert. 1962. *Lost Tribes & Sunken Continents: Myth and Method in the Study of American Indians.* Chicago: University of Chicago Press.

Webster, David L. 2002. *The Fall of the Ancient Maya: Solving the Mystery of the Maya Collapse.* London/New York: Thames & Hudson.

Weller, Anthony. 2004. *The Siege of Salt Cove.* New York: W. W. Norton & Company.

Wells, Allen, and Gilbert M. Joseph. 1996. *Summer of Discontent, Seasons of Upheaval: Elite Politics and Rural Insurgency in Yucatán, 1876–1915.* Stanford: Stanford University Press.

Wilkinson, Tracy. 2008a. Strategies for Mexico's Drug War. *Los Angeles Times,* December 30.

———. 2008b. U.S. War on Drugs Has Failed, Report Says. *Los Angeles Times*, November 27.

Willey, Gordon Randolph. 1987. *Essays in Maya Archaeology.* Albuquerque: University of New Mexico Press.

Wilson, Carter. 1965. *Crazy February.* Berkeley: University of California Press.

Wilson, James. 1999. *The Earth Shall Weep: A History of Native America.* New York: Atlantic Monthly.

Woodfield, Andrew R. 1995. Having the Last Word. *Nonesuch: The University of Bristol Magazine*: 34–36.

Wright, Ronald. 1989. *Time among the Maya: Travels in Belize, Guatemala, and Mexico.* New York: Weidenfeld & Nicolson.

———. 1992. *Stolen Continents: The Americas through Indian Eyes since 1492.* Boston: Houghton Mifflin Company.